PRECIOUS INDIAN WEAPONS

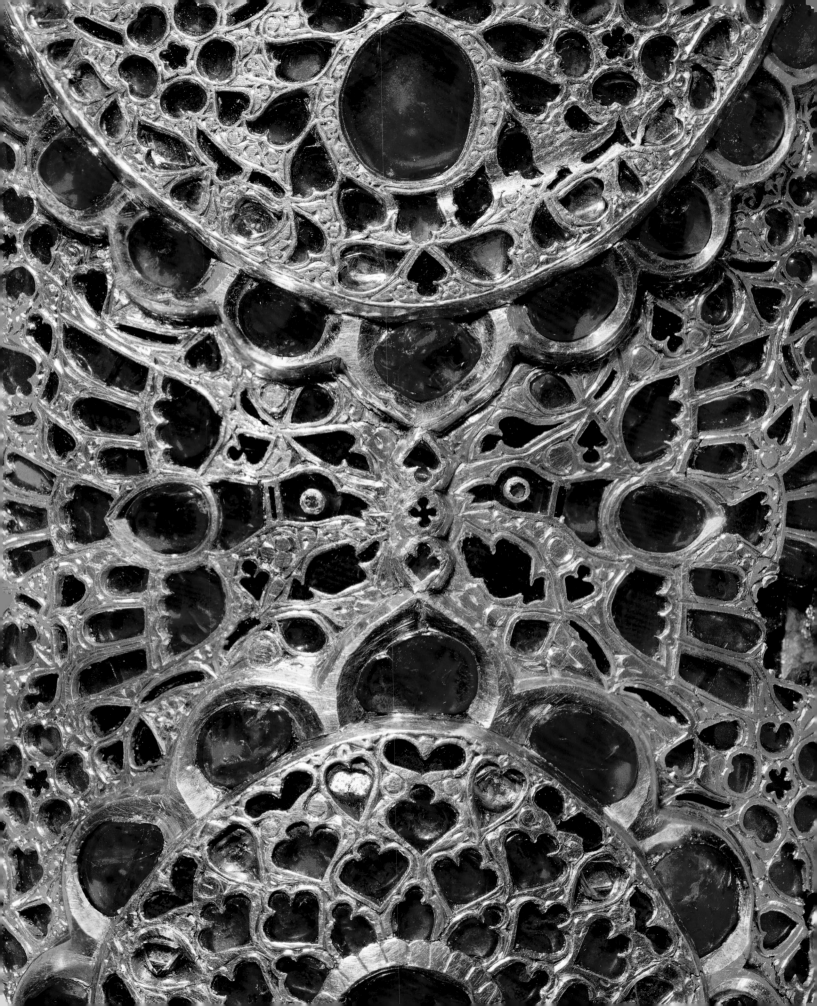

PRECIOUS INDIAN WEAPONS
AND OTHER PRINCELY ACCOUTREMENTS

SALAM KAOUKJI

Dar al-Athar al-Islamiyyah The al-Sabah Collection, Kuwait

FRONTISPIECE
Detail of scabbard, Cat. 27 (LNS 25 J b)

First published in the United Kingdom in 2017
by Thames & Hudson Ltd, 181A High Holborn, London WC1V 7QX

Precious Indian Weapons © 2017 Gulf Museum Consultancy Company,
WLL, Kuwait

Text © 2017 Salam Kaoukji

Series editor: Salam Kaoukji

Photography: Muhammad Ali and Robert Lorenzo

Design: Mark Bracey

British Library Cataloguing-in-Publication Data
A catalogue record for this book is available from the British Library

ISBN 978-0-500-97080-5

Printed and bound in China by Artron

Please note that all measurements of objects in this catalogue
have been rounded to the nearest half-centimetre.

CONTENTS

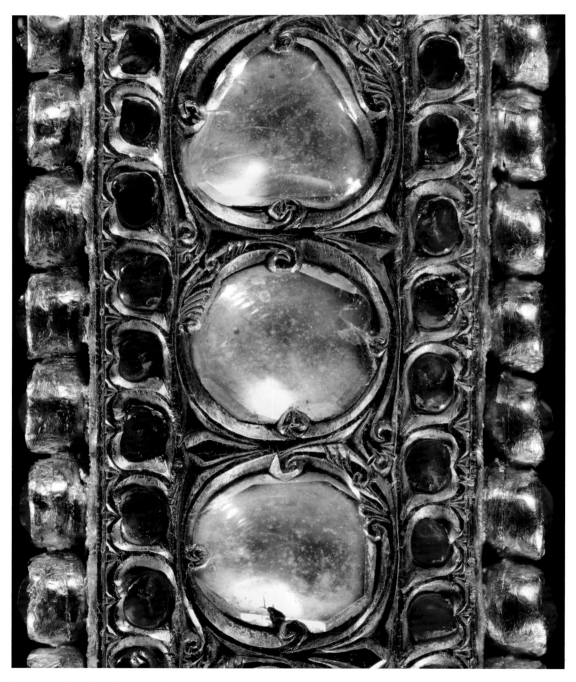

Intricate gold work and gem-setting
on *katar* side-bar, Cat. 4 (LNS 2159 J)

FOREWORD
Sheikh Nasser Sabah al-Ahmad al-Sabah

Over years of travel, and many visits to museums around the world, I became aware that among the many celebrated arts of India, those associated with weaponry and military accoutrement have long been overlooked by non-specialists. Distinct from the conventional range of Indian art, and typically regarded as purely utilitarian objects, or even shunned as instruments of violence, precious weapons are too often the sole prerogative of specialized scholarship, confined to display in the arms and armour galleries of museums, or as select pieces included in more broad-ranging general exhibitions. Their artistic significance and spectacular craftsmanship have rarely received the attention from the wider public that they deserve.

I first became fascinated by Indian precious weapons many years ago when, in the kiosk of a small antiques market on the subcontinent, I discovered a miniature lead *katar*, which was quite likely an archaeological find. Intrigued, I immediately shared my discovery with my wife, and director of the Collection, Hussah Sabah al-Salem al-Sabah, my curator Manuel Keene and Salam Kaoukji. Later, during a tour of Beijing's Forbidden City, I learned of Emperor Qianlong's love and appreciation of the magnificent arts of Mughal India and was amazed by the collection of unfinished edged weapons on display in his palace workshops, which I was able to examine during my visit.

These experiences kindled in me a desire to fill this regrettable gap in the history of Indian jewelled arts. As I continued to collect and study these intriguing objects, it became clear that they did not differ greatly from other jewelled arts of India in their decorative styles and techniques. The beautifully gold-ornamented *jawhar*-steel blades, the lively enamel renderings, the outstanding gemstone settings and the exquisite hardstone and ivory carvings all bear witness to the wide artistic scope of jewelled arts during this period. Moreover, the weapons and accoutrements of the Indian royal courts evoke the refinement and opulence of the patrons who commissioned them as symbols of power and status. The aesthetic pleasure afforded by contemplating the accomplished skill and subtle artistry in this array of masterpieces produced by courtly workshops is considerable. Perhaps some of their owners were of the opinion that the beauty of these weapons served to alleviate the pain resulting from the sharpness of their blades!

It gives me immense satisfaction to see this selection of masterpieces finally brought together in this publication by Salam Kaoukji, presented and described with a sensitivity and precision worthy of their makers, and explored in the wider context of the various manifestations of the jewelled arts. This book represents the fulfilment of a longstanding desire to make Indian craftsmanship during the Mughal period a source of inspiration to future generations.

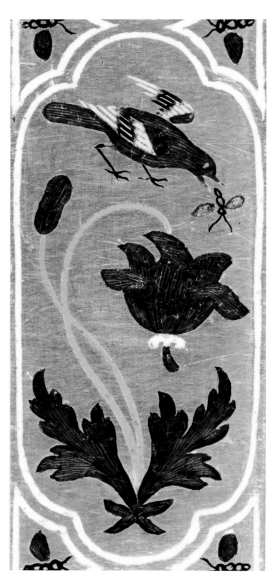

Enamel and gem-set decorations of
birds and flowers on *katar* side-bars,
Cat. 5 (LNS 1743 J)

ACKNOWLEDGMENTS

I should first and foremost like to express my deepest gratitude to Sheikh Nasser and Sheikha Hussah al-Sabah for giving me the opportunity to work with the outstanding objects in their collection. A collection that never ceases to amaze and stimulate, and drive one to explore new and previously uncharted territories, all of which is complemented by a unique work environment – in short, I thank them for having provided me with immeasurable joy!

I am especially indebted to Manuel Keene for introducing me to the discipline; for his constant and valuable guidance and encouragement over the years; and, most of all, for generously passing on to me his vast knowledge of the arts.

Particular thanks go to my colleague Katie Marsh for her continuous support, professional and personal, and especially for her assistance and crucial role in providing much-needed essential help for both this publication and a large number of other projects.

Special acknowledgments are due to my former and current colleagues and staff of The al-Sabah Collection for their valuable assistance and unrelenting commitment at all times: museum assistants Benjamin Hilario, Georges Hilario and Honorio Lim; photographers Muhammad Ali al-Awadi, Robert Lorenzo and Michael Tejero; departmental assistants Juanna Fernandes and Shifana Shabdeen; conservators Abd al-Aziz al-Duweesh, Frances Halahan, Lieve Vandenbulcke, Maria Mertzani and Sophie Budden; curatorial department members Mutlaq al-Juraid and Deborah Freeman; librarian Muhammad Sururi; and, from the administrative and exhibition departments, Abdulkarim al-Ghadban, Fahad al-Najadah, Katherine Baker and Zaina Tarhini.

I am also very thankful to Giovanni Curatola for drawing my attention to a number of interesting references, and most of all for patiently reading my text, offering me helpful advice and encouraging me to waste no time in having it published.

I extend my profound gratitude to friends and colleagues for generously providing me with numerous references derived from their years of research and study: especially Manijeh Bayani and Robert Skelton; Ada Adamova at the State Hermitage Museum; Leila Badr at the Archaeological Museum of the American University of Beirut; Alain George at the University of Edinburgh; Navina Haidar at the Metropolitan Museum of Art, New York; Fatemeh Karimi of *The Great Islamic Encyclopaedia*, Teheran; Philip Mansel of the Institute of Historical Research; Assadullah Souren Melikian-Chirvani at the Aga Khan Museum; and Susan Stronge at the Victoria and Albert Museum.

I should also like to thank Mona al-Mamoun for her endless patience in supplying references; Mahrukh Tarapor for her guidance and generous efforts in organizing significant contacts with individuals and institutions whose knowledge and skills are essential to our field; Stuart Pyhrr, curator of the Arms and Armour Department at the Metropolitan Museum of Art, for taking the time to advise me on a particular subject; Agnes Stillfried and Matthias Pfaffenbichler at the Kunsthistorisches Museum, Vienna, for organizing a viewing of the arms and armour collection; Barry Ager, Venetia Porter and Susan La Niece from the British Museum, for supplying me with references related to objects in their care; Robert Elgood, for communications related to his field of expertise; Andrew Topsfield, keeper of Eastern Art at the Ashmolean Museum, for assistance with the Devanagari inscriptions; and Deborah Roldan and Aimee Froom at the Museum of Fine Arts, Houston, for arranging photography of one of our daggers on loan to their collection.

I am also most grateful to Jamie Camplin for his expert advice and encouragement from the start of our collaboration with Thames & Hudson, and to Flora Spiegel, Susanna Ingram and Merle Read, who devoted their time to this and numerous publications of the Collection in such an effective and gratifying manner.

Last but not least, my warmest thanks go to my very dear and much-loved friends, young and old, in Kuwait and abroad, without whose love and support my life would not have been as pleasurable and interesting as it is.

Finally, I dedicate this volume to my parents, my husband Ossama and my children, Tariq, Dwan and Nur, without whose love nothing I undertook in life would have been possible.

Example of *kundan* gem setting, Cat. 11 (LNS 114 J)

Example of enamelling, Cat. 9 (LNS 1822 J)

Example of inlaid hardstones, Cat. 42 (LNS 300 J)

Example of steel overlaid with gold, Cat. 21 (LNS 902 M)

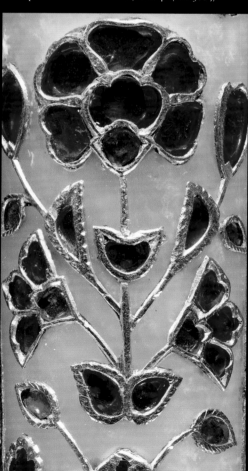

INTRODUCTION

For millennia humankind has had a fascination with edged weapons, an attraction that to a great extent, notwithstanding the primary importance of weapons in hunting and combat, arose from the custom of displaying them to magnify the status of the owner. Among the assemblages of jewels and precious objects found in grave furniture of millennia-old royal cemeteries from Egypt and Sumer, jewelled weapons were included in burials to accompany deceased kings in the afterlife,[1] and in ancient cultures throughout the world, monumental sculptures and commemorative reliefs routinely depicted sovereigns armed with weapons, representing them as conquerors and communicating their power to all who laid eyes on them. This trend endured over centuries, as magnificent weapons and accoutrements continued to play an essential role in displaying the splendour and wealth at the disposal of monarchs, princes and courtiers, both in asserting their authority to the public at large and in eliciting the admiration of their personal entourages. The custom of portraying rulers wielding or wearing magnificent blades has persisted into modern times, demonstrating the timelessness of the association between authority and weapons.

The collection of outstanding precious weapons and accoutrements from the Indian subcontinent presented here was assembled over many years by Sheikh Nasser and Sheikha Hussah al-Sabah. It bears witness to the legendary wealth and opulence of the Indian courts and to their tradition for fine and artistic craftsmanship during the sixteenth to the eighteenth centuries CE. Only the exceptional refinement and elegance of these Indian courts, coupled with both the importance they allocated to martial arts and their connoisseurship of the jewelled arts, could have produced the marvellous objects that are presented in this volume.

These uniquely Indian weapons display decorative features derived from ancient and medieval traditions of Central Asia, the Iranian world and China, as well as from Renaissance Europe, as a result of centuries of contact through trade, travelling craftsmen and warfare. Although these contacts influenced the Indian art of weaponry, it was the long-standing Indian artistic traditions and native custom of fine craftsmanship for a class of enlightened patrons that raised this art to elevated heights, producing objects of sublime, uplifting beauty.

It is worth mentioning here that these jewelled weapons were functional and not just ceremonial or worn only for parade. This is revealed by the condition of some of their blades, which were heavily repolished on account of frequent usage, or replaced following breakage.

THE DECORATIVE TECHNIQUES INVOLVED IN THE ART OF INDIAN WEAPONRY

GEMSTONE SETTING

Unique to India, and possibly dating as far back as the start of the first millennium CE,[2] is the setting of gemstones in *kundan* technique, which allowed Indian jewellers nearly limitless artistic freedom. In simple terms, the technique involves hyper-purifying flat strips of gold to the point at which the metal becomes malleable at room temperature. Once these gold strips are applied to a surface and piled up to achieve the required thickness, tools are used to exert pressure, producing a molecular fusion that turns the gold strips into a single mass. The jeweller is then able to set gems on any part of the soft, gold-covered surface by packing additional gold foil around the stones to hold them in place. By virtue of this technique, which can be applied to any rigid surface, jewellers were able to dispense with setting gemstones in protruding and unwieldy collets, holding them in place with claws or by means of the more laborious ancient technique of hammered-cloison settings.[3] It also allowed craftsmen to set gemstones close together in the configuration they desired and to enhance the gold surfaces surrounding them with engraved patterns.

The famous so-called "Ruby Dagger" (Cat. 27) and the locket from a *katar* scabbard (Cat. 1) demonstrate the advantages of the *kundan* technique and the artistic liberty it afforded the craftsman. A splendid example that exhibits unparalleled forms of decoration is the *katar* Cat. 5 executed with a blend of *kundan* work and enamel.

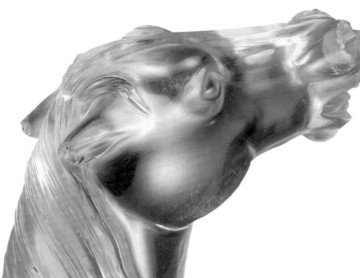

Carved rock-crystal horse-head hilt, Cat. 69 (LNS 82 HS)

ENAMELLING

India is just as famous for its highly decorative styles of
enamelling as it is for gemstone setting, but it is interesting
to note that neither champlevé nor basse-taille enamel, and
for that matter any form of enamel work, existed in the area
prior to the sixteenth century CE, except for a few scattered
examples from the Graeco-Bactrian period (250–125 BCE).

Introduced to the Indian courts in the sixteenth and
early seventeenth centuries by European jewellers who had a
fine command of the art, enamelling provided a new source
of inspiration that stimulated the creativity of the Indian
jewellers.[4] Although it has been said, without supporting
evidence, that the art of enamelling was introduced to India
by enamellers from Lahore and Punjab who migrated to
Amber and Jaipur, it is likely that this misleading assumption
arose from nineteenth-century accounts on the subject,
written when Jaipur was an important enamelling centre.

The two principal techniques utilized by Indian jewellers
were champlevé and basse-taille enamelling. The champlevé
technique involved carving depressions in the metal and
filling them with enamel, often of the opaque variety,
whereas in the basse-taille technique the recesses were chased
and patterned and filled with transparent enamels, which
produced a modelled effect. The two techniques could be
used in combination (see, for example, Cat. 104), yielding
tasteful, yet lively, results that exemplify the rapid absorption
and mastery of the art by Indian jewellers. Indian enamellers
not only assimilated the basic techniques, but also became
highly attuned to the nuances of colour modelling, and even

produced such effects on very small objects such as archery
rings (Cats. 133, 135 and 139). In addition, their first-hand
observation and deep appreciation of nature, compounded
with their native aesthetic sensibilities, drove them to decorate
weapons with exquisite enamelled floral motifs that one would
generally not expect to find on this type of object.

HARDSTONE CARVING

India was duly celebrated for its ancient and distinguished
achievements in sculptural arts and carving. The considerable
body of exquisitely carved hardstone hilts, maces and archery
rings in stylized non-representational, vegetal and animal
forms that have come down to us testify to this prolific and
refined hardstone carving tradition.

Indian artists skilfully utilized all the types of stone that
were available to them in expressing their penchant for three-
dimensional sculpture. Some of the most prized raw material
for hardstone carving was not readily available in India
and had to be transported from afar, but wealthy patrons
spared no effort in obtaining it. These imported materials
included emeralds, which are said to have originated in the
South American Muzo and Chivor mines of Colombia,
notwithstanding reports that some were mined in Panjshir or
Siberia; nephrite jade that had to be carried from Khotan and
Kashgar on the south-western and western ends of the Tarim
Basin; and walrus ivory from the northern hemisphere.

Bearing in mind the Indian fascination with colour,
manifest in the vibrant tones of stones associated with the
gem-setting tradition, it is important to note that objects
carved from more subtly coloured hardstones such as nephrite
jade, rock crystal or agate were as prized as those set with
rubies and emeralds, which says a great deal about the
sophisticated and eclectic taste of Indian patrons.

Carving most hardstone material was a laborious
undertaking. Coarse and cryptocrystalline quartzes and jade
were too hard to cut with steel tools, and could only be cut,
carved, ground and polished by grits that were harder than
the raw material. Abrasive grits and powders of corundum,
garnet or diamond affixed on rotary wheels or rods were thus
required to grind the stones to the desired form, and were

worked in conjunction with water or oil to avoid overheating and cracking the material. Despite the technically demanding and time-consuming nature of the process, Indian craftsmen produced many carved hardstone masterpieces, such as the horse-head hilt dagger Cat. 66 and the floral-pommel daggers Cats. 84 and 85. Some pieces, such as the cloven-pommel daggers Cats. 42 and 43, involved inlaying hardstones and setting them with gemstones, an even more painstaking process requiring superior control. Hardstone carving could also be used for the inlaid gemstones themselves, as in the tiny ruby lions adorning the *katar* side-bars of Cat. 10. It is clear from the skilfully carved examples that abound in this collection that the difficulties of hardstone carving did not deter the lapidaries, whose command of the raw material at hand allowed them to obtain the finest results.

JAWHAR-PATTERNED BLADES

India, more specifically the area surrounding Hyderabad, was famed for the exceptional quality of its *wootz* steel, which had been exported all over the world since antiquity, and from which were produced the many marvellous examples of *jawhar*-patterned blades that are fitted on a large number of weapons in this collection.

Clearly *wootz* steel was of long-standing repute, since it is reported that when Alexander the Great invaded India in 327 BCE he returned with a large amount of Indian *wootz* steel, which he subsequently ordered to be forged into weapons. Furthermore, owing to the arms *fabricae* (factories) of shields and arms founded in Damascus by the Roman emperor Diocletian (245–313 CE), blade patterning was for a long time incorrectly referred to as "Damascus steel", despite the fact that the city's reputation for superior blades was largely due to the quality of the imported Indian steel used by swordsmiths in the *fabricae*.[5] It is also significant that the composition and treatment of *wootz* steel that produced the *jawhar* patterns was achieved at the billet stage, prior to the billets leaving India, and thus before the blades were manufactured. The treatment of the alloy and its high-carbon content produced flexibility as well as toughness, and attained the prized patterns of *wootz* blades during forging.

GOLD INLAY AND OVERLAY

Despite being practised in Egypt, Byblos, Mycenae and Pylos from around the middle of the second millennium BCE,[6] in Spain around the third and fourth century BCE,[7] and as far away from the Mediterranean basin as China,[8] it appears that the process of inlaying edged weapons with gold and silver, which involved engraving a pattern in a substrate and inlaying and hammering the gold or silver in place, only spread to other parts of the world from around the fourth century CE.

A different process of decorating metal by overlaying (as opposed to inlaying), which involved cross-hatching the substrate to allow the adhesion of silver or gold sheet that was subsequently burnished onto the surface, appears to have emerged in China during the Western Han period[9] and in the West around the time of the European tribal migrations.[10] The use of this method, which necessitated applying only thin coats or strips of precious metal and allowed for a larger variety of detailing in designs, is generally easily discernible when the surface of an object displays wear. Evidence of cross-hatched surfaces can be seen clearly on metal fittings from the period of the tribal migrations, as well as on fittings from the Merovingian period,[11] which demonstrates that the technique was known in the West by the seventh century. Interestingly, although the medieval European treatise *Diversarum artium schedula*, probably written in the early twelfth century, gives a detailed description of the procedure for overlaying metals,[12] it has been claimed that the technique was not encountered in Europe until the fifteenth century.[13] The patchy accounts available to us make it difficult to determine with certainty when and where the technique originated, and how and when it spread.

From further east, a reference to a Tibetan sword, dated to the thirteenth or fourteenth century and displaying overlaid decoration applied by means of cross-hatching, suggests that the Chinese associated the technique with Muslim armourers.[14] This, together with evidence of overlaid silver on the tribal migration fittings, allows one to surmise that the technique developed in the East, possibly in Central Asia or eastern Iranian territories, and from there gradually spread to the West via the "Silk Road".

Towards the end of the fifteenth century, a helmet wrongly identified as booty taken from the Nasrid sultan Abu Abdallah al-Zughubi (known in the West as "Boabdil") at the battle of Lucena in 1483 was entirely overlaid with gold by means of cross-hatching or "damascening", as was the blade of an "eared" dagger, which was in fact taken as trophy from the Nasrid sultan during the battle of Lucena.[15] But it is not until the first half of the sixteenth century that signed and dated "damascened" armour makes an appearance in European courts, especially in the Iberian peninsula and Italy.[16] Of particular interest here regarding a possible connection between the Iberian peninsula and India are the damascened eared daggers signed by the sixteenth-century Spanish swordsmith Diego de Çaias, who also produced maces for the French king Henry II. These Spanish eared daggers feature pseudo-Kufic inscriptions, arabesques and scenes evocative of the Indian repertoire, more specifically settings represented on Indian inlaid wood travelling caskets.[17] Unfortunately, nothing is known about de Çaias's training or his whereabouts prior or subsequent to his employment at European courts, but his style of decoration leads one to assume there must have been some form of connection with the East, and more specifically with India, whether directly or via existing contacts between the Iberian peninsula and India.

On that assumption it would seem likely that the West was instrumental in reintroducing to the East, and more specifically to the Indian courts, an earlier Eastern trend (in this case a technique), as was the case with the eared dagger that derived from an eastern prototype and was introduced in India in the second half of the sixteenth century.[18] Although there is no solid evidence of a connection between Diego de Çaias and India, it is by no means unlikely that he had some form of exposure to the Indian court and its artists, especially considering the appearance of a European eared dagger in the *Hamza-nameh* manuscript of *c.* 1562–77.[19]

BLADE ATTRIBUTION AND REPLACEMENT

It has been noted that the gold-inlaid Imperial Umbrella mark, which would signify Mughal royal ownership, does not feature on any of The al-Sabah Collection blades. Its absence, however, is not unexpected, given the frequent replacement of blades due to breakage and wear, and the relatively small number of surviving examples of the mark in other collections of Mughal weapons.[20] Evidence for blade replacement abounds, such as the blade aperture on the base of the emerald hilt of Cat. 35 (see p. 117), which clearly indicates that the standard double-edged blade suited to this type of knife was replaced with a single-edged blade. Another interesting example of blade replacement is the sword blade of Cat. 112, which is engraved with an inscription that associates it with Gujarat, whereas the hilt features an inscription that attributes it to Hyderabad. In addition, a large number of blade inscriptions and symbols were added after the manufacture of the weapon to add to its cachet, but the quality and style of calligraphy generally does not sustain the claim of distinction they proffer. By way of illustration, it is clear that the gold-inlaid inscription on the sword blade of Cat. 113 post-dates the sword and probably the blade, and that it is implausible that the quantity of blades "signed" by the legendary blade maker Asad Allah Isfahani could have been produced by the same person over a period of two hundred years. Furthermore, the clearly unfounded claim that a number of extant swords allegedly belonged to the Prophet Muhammad or to the Orthodox Caliphs serves to exemplify that a weapon attribution cannot be made on the basis of an inscription or symbol on a blade.

The al-Sabah Collection holds one of the finest and richest collections of princely weapons in the world. Even though misattributions are bound to have arisen in this book, it gives me great pleasure to present such aesthetically pleasing objects so that the reader can delight in their beauty and fine workmanship.

Jawhar-patterned *katar* dagger blade with gold inlay, Cat. 23 (LNS 901 M)

NOTES

1 See e.g. Zettler and Horne 1998, p. 16, fig. 15, gold dagger and sheath found in the royal Sumerian tombs of Ur, mid third millennium BCE, and p. 169, cat. 146, gold dagger; also Harding 1989, pp. 10–11, gold dagger found in the tomb belonging to the mother of Pharaoh Ahmosis I (r. 1569–1545 BCE) at Thebes, and the fourteenth-century BCE jewelled dagger from the tomb of Tutankhamun, also from Thebes.

2 Keene 2004a, pp. 198–99, esp. figs. 9 and 10, showing early *kundan* work on an earring in The al-Sabah Collection (LNS 242 J, first century BCE–second century CE).

3 For a résumé of ancient gem-setting techniques, see Keene and Kaoukji 2001, p. 18, and for a more extensive account and illustration showing the crumpling of gold foil resulting from *kundan* work, see Keene 2004a, pp. 190–202.

4 Keene 2004b, pp. 99–123.

5 Maryon 1960, pp. 52–60.

6 See Harding 1989, p. 12, for gold and silver inlaid bronze dagger blades excavated at Mycenae, and p. 10 for the gold blade inlaid with silver and niello bearing the names and titles of Pharaoh Ahmosis (r. 1569–1545 BCE). Also, Aruz et al. 2008 publish a better reproduction of Ahmosis's dagger, p. 121, cat. 68, a silver and gold inlaid bronze sickle sword from Byblos, p. 58, cat. 30, and a Late Helladic bronze dagger inlaid with gold and silver from Pylos, p. 122, fig. 36.

7 Lavin 1997, p. 13.

8 Uldry 1994, p. 84, cat. 24.

9 A bronze blade overlaid with silver and gold in the Metropolitan Museum of Art, New York (inv. no. 65.74.1).

10 We are grateful to Dr Barry Ager, curator of the Department of Medieval and Later Antiquities at the British Museum for supplying us the article about the tribal migration fittings: Ager 1997, p. 141, fig. 2 (reg. no. 1902, 11-8,92). The cross-hatching is clearer when seen with the naked eye, which is feasible because the object is on display in the Tribal Migrations galleries of the British Museum.

11 See e.g. the worn surface on a seventh-century Merovingian bronze buckle, Roth 2000, p. 299, fig. 24.13.

12 Lavin 1997, pp. 14–15.

13 Lavin 1997, p. 18.

14 Lavin 1997, pp. 14–15; Elgood 1979, pp. 2–3.

15 The so-called "Boabdil" helmet and the eared dagger in the Real Armeria in the Palacio Real (C.361) are published both by Lavin 1997, pp. 16–17, and by Blair 1970, pp. 158–63.

16 Of interest is the armour signed by Filippo Negroli dated 1533 made for Charles V, the Holy Roman Emperor, who ruled Spain as Charles I from 1516 to 1556, and married Isabel of Portugal; Pyhrr and Godoy 1998, pp. 16–17, especially cat. 20.

17 Regarding the style of decoration, Claude Blair states: "A possible source is suggested by the superficial resemblance some of the more pastoral ones bear to Islamic miniatures in the general treatment of their subjects." Blair 1970, p. 165, especially fig. 28. And for such a casket, see Jenkins et al. 1983, p. 123.

18 Regarding the Luristani/ear dagger connection, see the introduction to Chapter 4, p. 128.

19 Stronge 2002, p. 24, pl. 9.

20 See, for example, the Imperial Umbrella mark on the blade of a dagger inscribed with a title of Emperor Shah Jahan, Stronge 2014, p. 62, Cat. 24; and another on the blade of a sword that reportedly belonged to Emperor 'Alamgir who gave it to a courtier in his service, Elgood 2015, pp. 110–11, Cat. 78.

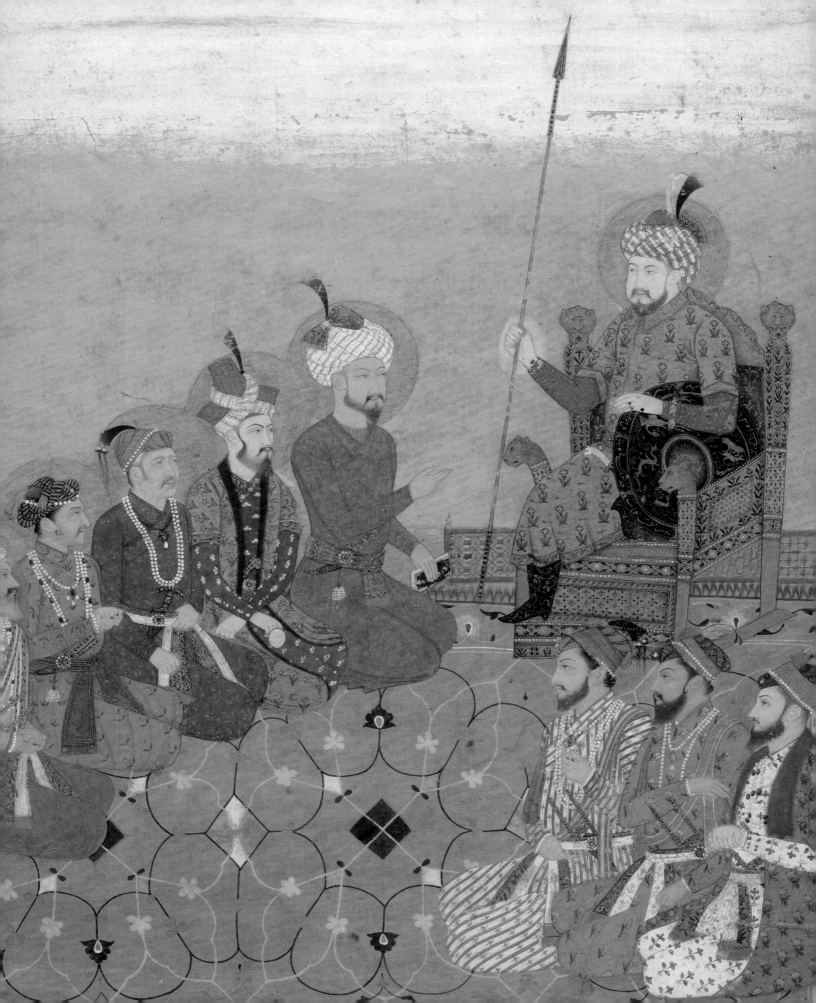

A HISTORICAL OVERVIEW

Home to a great ancient civilization, India is comparable to few other regions in history with its wealth of diverse cultures, which continue unabated to the present day. Although contacts with other civilizations influenced particular aspects of the arts of India, and frequently reinvigorated them, India nonetheless retained its distinctive and unparalleled body of artistic, craft and stylistic traditions, ranging from tribal and village types to those of regional centres that enjoyed princely patronage into the nineteenth century. An overview of the historical and cultural periods during which the objects in this book were produced, and brief biographies of the sultans of the Deccan and Mughal emperors and their historical backgrounds will facilitate an understanding of the milieu in which they thrived.

SULTANATES OF THE DECCAN[1]

Although waves of significant incursions by Muslim armies into the Indian subcontinent started around the tenth century, they did not result in long-term rule and were largely confined to the Punjab and the northern territories. From the early thirteenth century, however, invasions of the Indian subcontinent from the Iranian world and Central Asia led to the establishment of the Delhi Sultanate, which ruled mostly from Delhi over large swathes of Indian territory. This flow of foreigners prompted exposure to various cultures that was reflected in the arts and traditions, and persisted long after the decline of the Delhi Sultanate around the middle of the fourteenth century and the ensuing foundation of the sultanates of the Deccan in south-central India.

Although less well known than the Mughals, the sultans of the Deccan were highly cultured, learned rulers, and munificent patrons of the arts. It is interesting to note that, because of their geographic positions, several of these kingdoms were better placed than others in the sixteenth century to benefit from foreign cultural and artistic introductions. The importance of these courts in the assimilation of new artistic styles which so stimulated Indian developments in the period are still far from well recognized.

THE BAHMANID SULTANATE (1347–1518)

After rebelling against the Tughluq dynasty, the last sultans who ruled from Delhi, one of the amirs, Hasan Gangu, founded the Bahmanid dynasty. As Gangu claimed Iranian descent, hence the name "Bahman" (one of the heroes of the *Shah-nameh*), he assumed the title Sultan 'Ala' al-Din Bahman Shah (r. 1347–58). He ruled most of the Deccan from his capital, Gulbarga, and divided the country into four provinces: Gulbarga, Dawlatabad, Berar and Bidar, each administered by governors who maintained armies that he could call on in time of need. During most of his reign the sultan was engaged in warfare against the surrounding Hindu kingdoms and was therefore unable to devote much attention to the arts.

A succession of rulers brought temporary peace to the kingdom, transforming it into a centre of learning with an emphasis on Persian culture. Embassies were exchanged with foreign powers and skilled Turks, Persians and Arabs were appointed internally to help administer the state. But court intrigue, as well as the influx of foreigners, led to rivalries that ultimately resulted in the violent deaths of most of the Bahmanid rulers and the decline of the dynasty.

In 1432 the capital was transferred from Gulbarga to Bidar, and a new era was ushered in with the appointment of the chief minister Mahmud Gawan, a merchant of Iranian descent and an efficient administrator, who through successful military campaigns expanded the frontiers of the Bahmanid state from the eastern to the western coasts of India. He also excelled in trade, and was known as *Malik al-Tujjar* (King of Merchants) for his skills in widespread trade enterprises. He patronized the arts and sponsored building activities, such as the renowned madrasa in Bidar, completed in 1472, that bears his name. Members of the court resented his influence and growing power, however, and treacherously plotted to convince the ruler, Muhammad III Shah bin Humayun, to order his execution in 1482.

After a long, troubled period that weakened the kingdom following the division of the Bahmanid Sultanate into provinces, a move towards regional autonomy emerged that the reforms of Mahmud Gawan failed to suppress. Consequently, between 1490 and 1518 the Bahmanid Sultanate, which had

Miniature painting depicting Mughal emperors and princes with their ancestor Amir Timur, Mughal India, *c.* 1658

ruled most of the Deccan, dissolved into five independent kingdoms ruled by the Barid Shahis in Bidar, the Nizam Shahis in Ahmadnagar, the 'Adil Shahis in Bijapur, the 'Imad Shahis in Berar, and the Qutb Shahis in Golconda and Hyderabad.

THE BARID SHAHIS OF BIDAR (c. 1487–1619)

Qasim Barid, originally a Turkish slave, was chief minister of the Bahmanids. Although he became de facto ruler of Bidar under the weakening Bahmanid state, neither he nor his son proclaimed their independence or assumed the title of sultan. In 1543 his grandson 'Ali bin Amir Barid assumed the royal title of shah and *Malik al-Muluk* (King of Kings) and officially declared himself sultan of Bidar.

As Bidar had been the capital of the Bahmanids after Gulbarga, it had been embellished with many fine buildings, an activity which its new rulers continued. Furthermore, the city was celebrated for its production of distinctive bidri-ware, vessels fashioned in a blackened alloy of zinc, copper and tin inlaid with decorative motifs in silver and/or brass.

The Bidar Sultanate was seized and annexed by the 'Adil Shahis of Bijapur in 1619.

THE NIZAM SHAHIS OF AHMADNAGAR (1490–1636)

In 1490 Ahmad Nizam, son of a Bahmanid vizier and governor of Junnar, declared his independence from the declining Bahmanid kingdom and established the Nizam Shahi Sultanate in Ahmadnagar. The kingdom grew into an important centre of artistic activity, in great part due to the wealth obtained from the war waged on the Hindu Vijayanagara empire, which ended in the defeat of the Hindu army at the battle of Talikota in 1565. By the same token, determined to expand their territory, the Nizam Shahi conquered the neighbouring sultanate of Berar in 1574.

Following a decline in governance, the Nizam Shahis ruled under the regency of the able Ethiopian general Malik 'Ambar, who succeeded in raising the state's finances and rehabilitating its military. After his death in 1626 his son Fath Khan continued to rule until 1636, when the Nizam Shahis were defeated by the Mughal armies.

THE 'ADIL SHAHIS OF BIJAPUR (1490–1686)

Yusuf 'Adil Shah grew up in Iran and was subsequently assigned to the service of the Bahmanid minister Mahmud Gawan. In time he was nominated provincial governor of Bijapur, and proclaimed his independence from the Bahmanid state in 1489. He was the first sultan to introduce Shi'ism into the area, which in due course became the faith of three of the five states that broke away from the Bahmanids.

The 'Adil Shahis were continuously engaged in warfare with their Muslim neighbours and, most importantly, with the great Hindu empire of Vijayanagara, which they defeated with the help of the neighbouring sultanates at the battle of Talikota. Although the 'Adil Shahi rulers devoted enormous amounts of time to warfare, they also turned their capital into one of the great centres of learning, where architecture, Persian literature, music, the arts of the book and the decorative arts flourished.

After 1636 the Mughals wrested territory from the 'Adil Shahis, and forced them to acknowledge Mughal suzerainty and pay them a large annual tribute, which sapped the treasury. Following this the Marathas from the western Deccan, led by Chhatrapati Shivaji Maharaj, allied themselves with the Mughal emperor 'Alamgir, invaded Bijapur and laid to waste much of the land. In 1686 'Alamgir conquered Bijapur and annexed it to the Mughal Empire.

THE 'IMAD SHAHIS OF BERAR (1491–1574)

In 1485 Fathallah Darya Khan 'Imad al-Mulk, governor of Berar, proclaimed his independence from the Bahmani state, and in 1491 his son 'Ala' al-Din assumed the title of shah, thus becoming the official ruler of the 'Imad Shahi dynasty of Berar in the northern Deccan. Fathallah Darya Khan was a Hindu convert to Islam, and, together with the Barid Shahis, his was the only Sunni principality among the dynasties that broke away from the Bahmanids.

The reign of the 'Imad Shahis was mostly spent in warfare with the 'Adil Shahis and Nizam Shahis. They were eventually conquered by the Nizam Shahis, who annexed their lands in 1574.

Dagger-cord ornament, Cat. 170 (LNS 1262 J)

THE QUTB SHAHIS OF GOLCONDA/ HYDERABAD (1496–1687)

Sultan Quli Qutb Shah was a Turkmen who migrated from Iran to Bidar during the reign of the Bahmanids, rose to power, and was appointed governor of Telingana and its fortress at Golconda. With the decline of the Bahmanid dynasty, its founder, Sultan Quli Qutb Shah, an able military commander and strategist, was given free rein to actively expand his territory, which was further enriched and strengthened by wealth obtained from victory over the Vijayanagara empire. The prolific Golconda diamond mines, the chief supplier of diamonds to the world until the eighteenth century, and the source of some of the most renowned stones in history, gave rise to much commerce between the kingdom and the West, which was instrumental in promoting wealth and developing widespread trade routes.

Persian culture flourished during the reign of the Qutb Shahi dynasty, especially influencing the arts of the book. Its sultans also commissioned important architecture, as well as hospitals and gardens, and initiated the building of dams and waterworks in Hyderabad. In 1591 Muhammad Quli Qutb Shah transferred the capital from Golconda to Hyderabad, which was ruled by the Nizams of Hyderabad after the Mughal invasion. The Qutb Shahi dynasty was the most long-lived in the Deccan and was the last sultanate to fall to the Mughals, in 1687.

THE MUGHALS[2]

EMPEROR ZAHIR AL-DIN MUHAMMAD BABUR (r. 1526–1530)

A number of Muslim dynasties, mainly based in Delhi, ruled over most of northern India from the thirteenth century until they were overthrown by the Mughals, led by the Chaghatai Timurid prince Zahir al-Din Muhammad Babur, who successively defeated the armies of the Lodi Sultans of Delhi and a coalition of Rajput princes and Afghans ruling in eastern India. The victory brought enormous wealth to Babur, and the jewelled weapons and precious gifts distributed by the emperor as a token of his appreciation to his family and entourage are repeatedly mentioned in the emperor's autobiography, the *Babur-nameh*.[3]

Raised as a Timurid prince, Babur was cultured and learned, and his autobiography demonstrates his interest in political and military activities, in which he was engaged most of his life, as well as his fascination with the people and traditions of India, its architecture, and its flora and fauna.

EMPEROR NASIR AL-DIN MUHAMMAD HUMAYUN (r. 1530–1540 and 1555–1556)

Emperor Babur was succeeded by his eldest son, Humayun, who featured prominently in his father's campaigns and for a few years assisted in expanding the empire and consolidating Mughal power over a vast territory. Accounts of opulent courtly life reported by his sister Gul Badan Begum in her memoirs the *Humayun-nameh* frequently refer to the wealth of jewelled objects and military appurtenances distributed at court during her father's and brother's reign.[4] But by 1540 control passed to the Afghan commander Sher Shah Suri, and in a series of reversals caused by his brothers actively plotting against him, Emperor Humayun was forced to flee India. Part of his exile was spent at the court of the Safavid ruler Shah

Tahmasp, who later dispatched troops to assist Humayun in reclaiming his territory. As a result of his exile in Iran and Shah Tahmasp's renouncing his interest in and patronage of the arts, Humayun returned to India accompanied by prominent Iranian scholars and painters, who contributed to the introduction and formation of new aesthetic styles in India. By 1555 Humayun had defeated the forces of the Suris and recaptured the throne of Delhi, but died a few months later from a fall on the staircase of his library.

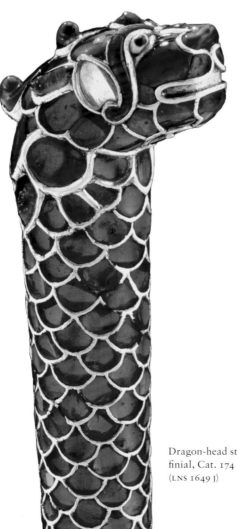

Dragon-head staff
finial, Cat. 174
(LNS 1649 J)

EMPEROR ABU 'L-FATH JALAL AL-DIN MUHAMMAD AKBAR (r. 1556–1605)

Emperor Humayun's son Akbar was born in 1542 in the Rajput fort of Umarkot in Sindh during his father's exile, and was raised in Kabul by his father's brothers Mirza Askari and Mirza Kamran. The prince ascended the throne at the age of thirteen and was guided at the start of his reign by Bairam Khan, chief commander of the armies, who had served under both his grandfather and father. The glory of the Mughal Empire was established under the reign of Emperor Akbar, who expanded and consolidated Mughal rule over most of the Indian subcontinent. His exceptional intellect and his interest in military strategy and reforms in state governance were matched by his religious tolerance. He encouraged theological debate to reconcile differences between Muslims, Hindus, Zoroastrians and Christians, and this cooperation was instrumental in the remarkable achievements of his reign. Considerable information about the emperor's royal administration was recorded by his minister Abu 'l-Fazl 'Allami in the *Akbar-nameh* and the *A'in-i Akbari*, which also elaborated on matters related to the departments and subdivisions of various disciplines of the jewelled arts. His insightful patronage of the arts, and support for the existing artistic traditions of India, made his court a flourishing centre for arts and learning. For these reasons he is widely regarded as the true architect of the magnificent Mughal Empire and one of the great rulers in world history.

EMPEROR NUR AL-DIN MUHAMMAD JAHANGIR (r. 1605–1626)

Praying for a son to succeed him, Emperor Akbar resorted to visiting the Sufi shrine of Sheikh Salim Chishti who reportedly performed wonders. Soon after the visit his Rajput wife Princess Heer Kunwari bore him a son, whom he named Nur al-Din Muhammad Salim in honour of the sheikh. In 1601 Prince Salim, later known as Emperor Jahangir, eager to accede to the throne, rebelled against his father, settled in Allahabad and proclaimed himself ruler. His mother and another of his father's wives eventually resolved matters between father and son, and brought the

prince back to the court in 1603. Although Emperor Akbar favoured his grandson Prince Khurram, later Shah Jahan, on his deathbed he placed his turban on Prince Salim's head and proclaimed him emperor.

Emperor Jahangir inherited a vast and relatively stable empire, and ruled with the support of his powerful wife Nur Jehan, who wielded great influence on affairs of the state. He maintained a magnificent court and, continuing the family tradition of patronage of the arts, the emperor, who had wide-ranging interests, presided over a particularly fertile phase of India's artistic development. Sensitive to all forms of beauty, the emperor was captivated by the flora and fauna of India, which he describes at long length in his memoirs, the *Tuzuk-i Jahangiri*, which is also an unusually rich source of information on the jewelled arts.[5]

EMPEROR SHIHAB AL-DIN MUHAMMAD SHAH JAHAN (r. 1626–1658)

Tensions at court between Prince Khurram, his stepmother Nur Jehan and his brothers caused the prince to rebel against his father, Emperor Jahangir, in 1617, but his successful military campaigns against the Rajputs and the Deccan sultanates served to consolidate his power at court, and led his father to forgive him and endorse him as crown prince.

Emperor Shah Jahan continued the wise administration and general prosperity of his predecessors, although with much less tolerance towards other religions. He was fully engaged in the running of the empire, and during his time territorial gains were made in the Deccan. A magnificently illustrated chronicle of his reign, the *Padshah-nameh*, is preserved in the Royal Library at Windsor Castle.

Like his predecessors the emperor was involved in artistic patronage of all types, especially of architecture. He is famed as the builder of the Taj Mahal (the mausoleum of his beloved wife Mumtaz Mahal), the Red Fort and the Jami'-i Masjid of Delhi. He is also reported to have been a practising jeweller, and acknowledged as a great connoisseur of gemstones.

When Emperor Shah Jahan fell ill in 1658, protracted wars of succession erupted between his sons. Eventually Prince Awrangzib declared his father unfit to rule and confined him to the fort in Agra, where he remained until his death in 1666.

EMPEROR ABU AL-MUZAFFAR MUHI AL-DIN MUHAMMAD 'ALAMGIR (r. 1658–1707)

Emperor 'Alamgir (whose princely name was Awrangzib), spent most of his life on military campaign and in largely fruitless wars which resulted in the depletion of the treasury. His reign is marked by religious intolerance and general artistic decline attributable to his lack of interest in the arts, which has been put down to his religious orthodoxy. His death marks the effective end of the Great Mughal Empire and the diminishment of central control in favour of regional rulers.

THE DECLINE OF THE MUGHALS

From 1707 a succession of nineteen inexperienced and incompetent Mughals ruled amid court intrigue and rebellion. In 1739 the reign of Emperor Nasir al-Din Muhammad Shah (r. 1719–48) was marred by the sack of Delhi and the looting of the imperial treasury by the forces of Nadir Shah, ruler of Iran. Following this the decline accelerated until 1858, when the last nominal Mughal ruler, Emperor Siraj al-Din Muhammad Bahadur Shah Zafar, was exiled to Rangoon by the British.

NOTES

1 On the Delhi Sultans, see Bosworth 2004, pp. 300–05; on the sultans of the Deccan, see ibid., pp. 319–21, 324–28 and 339, and Haidar and Sardar 2015, pp. 3–13, 29–32, 45–54, 79–82, 173–77 and 197–200.
2 On the Mughals, see Bosworth 2004, pp. 331–34.
3 Babur 1987, p. 528: jewelled weapons were among the gifts granted by the emperor to princes, notables and officers on the occasion of the end of the month of fasting (Ramadan). See also the introduction to Chapter 1, note 20.
4 See e.g. Gul Badan Begam 1983, pp. 95–96, Emperor Babur's distribution of precious gifts; p. 118, the celebration of Emperor Humayun's safe return from Chunar; p. 124, the jewelled armour housed in the "House of Dominion" (*Khane-i Dawlat*) during a feast commemorating the accession of the emperor Humayun; and pp. 126–29, the distribution of gifts on the occasion of his brother Mirza Hindal's wedding.
5 Jahangir 1978.

CHAPTER ONE
THE *KATAR*
A QUINTESSENTIALLY INDIAN DAGGER

ON POSSIBLE ORIGINS OF THE *KATAR* OR "PUNCH-DAGGER"

The punch-dagger is a uniquely Indian weapon that has been dubbed *katar* or *jamdhar* and variants thereof. Its peculiar grip comprises two side-bars, providing control for the wrist, and a transverse grip-bar, allowing the hand to apply the full strength of the arm to the thrust. Although the type is clearly a well-designed and effective weapon, affording considerable advantages that should have given rise to widespread demand, for unknown reasons the *katar* never spread beyond the Indian subcontinent and its immediately adjacent territories.

Although *katar*s are mentioned in early literary sources, I am not aware of any extant visual representations of them in Indian paintings or architectural reliefs that would suggest a background prior to the later fifteenth century for weapons remotely resembling *katar*s or *pata*s.[1] The latter are gauntlet swords closely related to *katar*s in the structure of their hilts.

In the *Kautilya Arthashastra*, a treatise on the governance and administration of the state reportedly written by Kautilya, chief advisor of the Maurya emperor Chandragupta in the fourth century BCE, the author mentions *katar*s (*kuṭhāra*) and *pata*s (*paṭṭāsa*), but other than associating both weapons and defining them as "razor" sharp, there is no further description of their structure.[2] The same is true of the account by Abu Rayhan al-Biruni, who in around 1030 CE reports in *Kitab fi Tahqiq ma li-'l-Hind* (*Alberuni's India*) that idol worshippers killed sheep and buffaloes with *katārāt* to nourish themselves with their blood, and that Hindus "fasten around the right-hand side of their waist a *katāra*, which is a dagger".[3] Furthermore, Naser-e Khusraw, while visiting Makkah in 442 H (1050 CE), adds to the puzzle of the type's origins when he likens Yemeni pilgrims to Hindus in their physical appearance and garb in his *Safar-nameh* (Book of Travels), adding that they wear: "Qatifi daggers called *kattāra* at their waists, like Hindus. They say that the Hindus originated from the Yemen, and that *kattāra* is originally from the Arabic *qattāla*" (the variants of the word reflect different spellings

and interpretations in Arabic and Persian texts, as well as a lack of familiarity with the type).[4] This account undoubtedly demonstrates that Naser-e Khusraw associated the *kattāra* with Hindus, but once again the author does not describe the weapon, and so one cannot be certain of the type of dagger to which he alludes. A further reference to the *katāra*, without description of the weapon, is made in the thirteenth-century treatise *Adab al-Harb wa 'l-Shaja'ah* (The Morals of War and Bravery), by Fakhr-e Modabber and dedicated to the Mamluk Sultan Iltutmish, which indicates that Sultanate India, where the treatise originated, was familiar with this type of weapon.[5]

IBN BATTUTA AND THE RELATIONSHIP BETWEEN THE *KATAR* AND THE *PATA*

One remarkable and intriguing account may throw light on the possible background and evolution of the punch-dagger. In 743 H (1342–43 CE) the famous traveller Ibn Battuta Shams al-Din Abu 'Abdallah al-Tanji, while visiting the area south of Gwalior, wrote about a *qatāra*, a weapon that he likened to a "plough-share" with a blade two cubits long and a guarded hilt that protected the hand and forearm with a plate:

واجتمع عليه أهل القرية فضربه أحدهم بقتارة ، والقتارة حديدة شبه
سكة الحرث ، يدخل الرجل يده فيها فتكسو ذراعه ، ويفضل منها مقدار
ذراعين . وضربتها لا تبقى.[6]

In their famous dictionary, Yule and Burnell, in addition to defining the word "Kuttaur", included the corresponding passage of Ibn Battuta's *Voyages*, rendered in English from the French translation by Defremery and Sanguinetti (1858):[7]

c. 1343.– "The villagers gathered round him, and one of them stabbed him with a kattāra. This is the name given to an iron weapon resembling a plough-share; the hand is inserted into it so that the forearm is shielded; but the blade beyond is two cubits in length, and a blow with it is mortal" – *Ibn Batuta*, iv. 31–32.

Drawing of a prince, possibly Burhan II Nizam Shah of Ahmadnagar (r. 1591–95) at a royal picnic wearing a *katar* tucked in his sash, Ahmadnagar, *c.* 1590–95

A *pata* illustrated in the *Kitab Nujum al-'Ulum* manuscript
(The Stars of Science), dated 978 H/1570 CE

As the weapon described by Ibn Battuta presents strong similarities with the Indian gauntlet sword or *pata* (the hilt of which is fitted with the same transverse grip-bars as the *katar*), it seems likely that Ibn Battuta misconstrued the terms, since the two weapon types were related, as already established in the *Kautilya Arthashastra* from the fourth century BCE.

Some authors have suggested that the *pata* evolved from the *katar*.[8] It seems more logical, however, that the *katar* would have descended from the *pata*, having retained and perfected its most useful features, without the inconvenience of an unwieldy guard-plate strapped to the upper arm.[9]

We know that the basic structure of the *pata* was certainly established as early as the fourteenth century, not only from Ibn Battuta's description of the *qatāra*, but also because a *pata* is illustrated in the *Kitab Nujum al-'Ulum* (The Stars of Science) manuscript from Bijapur, dated 14 Rabi' al-Awwal 978 H (16 August 1570 CE).[10] Considering the impracticality of the *pata* as a weapon, it is most likely that it was just never as widespread as the *katar*. This is furthermore corroborated by the scarcity of its representation in miniature paintings, whereas it is obvious that the *katar* became a weapon of choice towards the middle of the sixteenth century, and then steadily gained in popularity, both in areas under Mughal rule and in the South.[11]

Interestingly, representations of *katar*s occur in a folio from a Jain *Kalpa Sutra* manuscript attributed to Gujarat or Rajasthan, 1475–1500 CE,[12] and in an illustrated *Dhola-Maru* folio from Mewar, dated 1592 CE.[13] The *katar*s in the *Kalpa Sutra* miniature are depicted with exactly the same form as the weapons represented in this chapter, which supports the assumption that the manuscript illustrated an already existing type.

THE PUNCH-DAGGER UNDER THE MUGHALS

Under the reign and patronage of Emperor Akbar (r. 963–1014 H/1556–1605 CE) various indigenous styles, including attire and accoutrements, were subjected to considerable transformation. In this connection one sees a gradual introduction of the *katar* in paintings from the early period of his reign. There are fewer than ten representations of *katar* daggers in the Cleveland Museum of Art copy of the *Tuti-nameh* manuscript, which was commissioned by Emperor Akbar early in his reign, *c.* 1560–65; all of the *katar*s occur towards the end of the manuscript, suggesting that their popularity increased while the manuscript was in production.[14] Depictions of *katar*s are slightly more frequent in the Chester Beatty Library copy of the *Tuti-nameh* manuscript from *c.* 1580.[15] In later miniatures, when the emperor is represented as an adult, he generally wears a *katar* tucked in his sash.[16] By contrast, when the emperor is portrayed as a young prince, as in a miniature from an album in the Fitzwilliam Museum, Cambridge, attributed to *c.* 1555–60 (that is, earlier than the production of the Cleveland *Tuti-nameh*), he is shown hunting with a bow and arrow and with a sword suspended from his belt.[17]

By 1562–77, when the manuscript of the *Hamza-nameh* was being produced in Emperor Akbar's court ateliers, the *katar* appears to have been fully adopted as a favoured weapon, judging from the number of *katar*s depicted in the manuscript,[18] as is also the case in most other paintings dating from Emperor Akbar's reign.[19] The *katar* continued to be depicted frequently in visual art throughout the reigns of emperors Jahangir, Shah Jahan and 'Alamgir.

PROBLEMS RELATED TO NOMENCLATURE

Whereas the terms *katar*, *jamdhar* and variants thereof were mentioned in sixteenth- and seventeenth-century gift-presentation lists[20] and dictionaries,[21] no contemporaneous descriptions of their physical structure exist, as was also the case when these terms were used in the other manuscript sources discussed previously. Similarly, the unlabelled representation of a *katar* in the *Kitab Nujum al-'Ulum* fails to shed light on the origins of its nomenclature.

Furthermore, looking through the inventory of Indian arms compiled by Wilbraham Egerton in the second half of the nineteenth century, one is under the impression that no strict rules governed the nomenclature of daggers. In addition, one would have hoped that in their survey of Indian weapons, Egerton and his contemporaries might have relied on current local appellations that would have reflected the regional popularity of specific weapons. Alas, this does not appear to have been the case, and punch-daggers, as well as other types of dagger, are invariably referred to as *katar* and *jamdhar* in regions as far apart as Sindh, Lucknow and Tanjore.

What is more, Egerton reproduces a copy from an "original drawing" of the *'Ain-i Akbari* manuscript published in 1821 by L. M. Langlès, in which a dagger with a hilt of the disc-and-dome pommel type is labelled *katarah*, whereas three punch-daggers on the same plate are labelled *jamdhars*.[22] On further plates punch-daggers from the armoury of Tanjore are designated as *katars*,[23] and in a plate grouping weapons from Nepal, a dagger of the "eared" pommel type is labelled *katar bank*, and two *chilanum* daggers, both from Nepal, are labelled *jamdhar katari*.[24] Egerton also illustrates two punch-daggers, reportedly from Vijayanagara, one of which he labels *pattani jamdadu*,[25] and the other, which is fitted with a hand guard, *bara jamdadu*,[26] which the Indian arms and armour scholar G. N. Pant states is a Maratha form of *jamadhar*.[27]

*Katar*s also appear to have gone through some form of structural change: in a few paintings attributed to the period of Emperor Akbar's reign they are depicted with an additional vertical bar protecting the back of the hand, but in all likelihood this did not warrant a complete change of name.[28]

Further complicating the issue of nomenclature, Pant writes that:

> it has now been proved beyond doubt that the correct name for this type of dagger is *jamadhar* and not *katar*. The etymology of the word *jamadhar*, as given by J. Shakespear, is *jam* (from the Sanskrit *yama* i.e., death or God of Death) and *dhar* (from *dhaar* or sharp edge or *dadh* i.e., tooth). On the blade of one of the *jamadhar*s the name of the weapon together with its explanation is explicitly given. The inscription in Sanskrit reads 'this *Kadarika jamadhar* in the hands of Bundirajam, Lord of Bundi, is capable of piercing the temples of elephants and hence is called *jamadhar* i.e., the tooth of the God of Death'.[29]

Thus the confusion resulting from indeterminate references in early accounts, and the disagreements over terminology from later accounts, leaves us no choice but to rely on visual depictions of the *katar* in miniatures and architectural reliefs. Although there is evidence to show that *katar*s were in use by the end of the fifteenth century,[30] one can conclude that the use of the punch-dagger was probably not widespread prior to the sixteenth century. As regards appellation, since in present-day India almost everyone seems to refer to punch-daggers as *katar*s, ultimately this issue of nomenclature can be laid to rest.

*Katar*s depicted in a folio from the *Kalpa Sutra* manuscript, the sacred book of Jains, Gujarat or Rajasthan, 1475–1500 CE

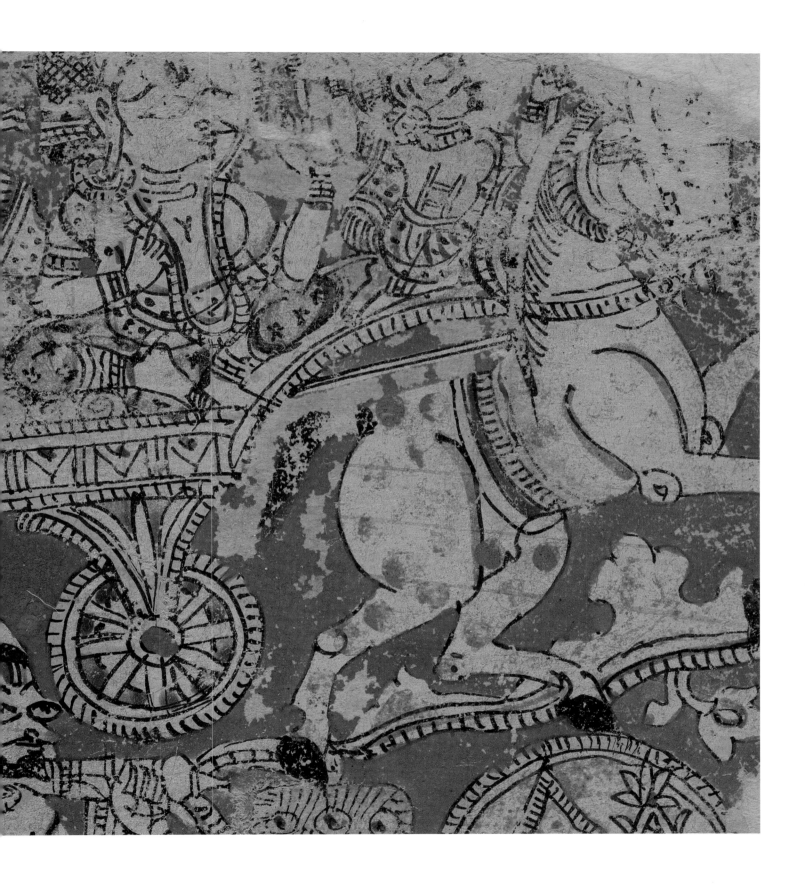

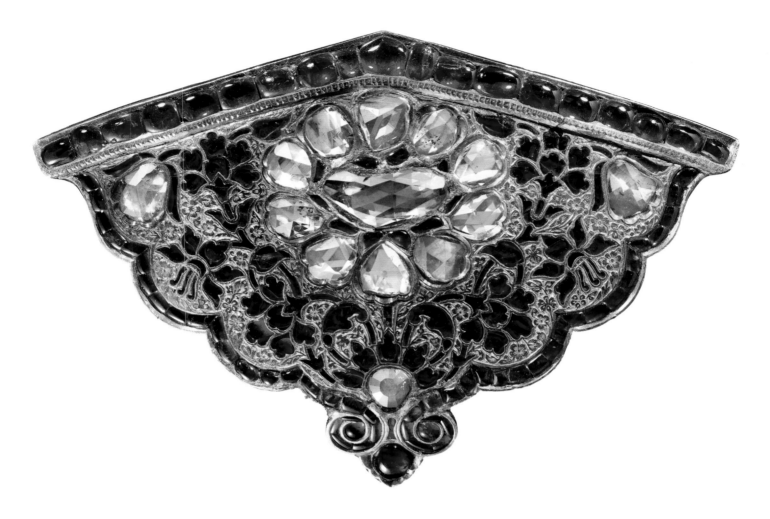

Cat. 1 LOCKET FROM THE SCABBARD OF A *KATAR* DAGGER
Mughal dominions, probably first quarter of the seventeenth century
Fabricated from gold; worked in *kundan* technique and set with diamonds, rubies and emeralds, engraved and chiselled
Dimensions: Height 5.5 cm; width 8 cm
Provenance: Art market 1981
Published: Sotheby's, Geneva, 7–8 May 1981, lot 778; Keene and Kaoukji 2001, cat. 5.1; Stronge 2010, pl. 138
Inv. no. LNS 19 SH

This masterpiece of subtle artistry was undoubtedly produced in a royal workshop, and is unfortunately the only survivor of what must have been a superb *katar* and scabbard ensemble. Its size notwithstanding, it exemplifies a perfect blend of the jewellery-making techniques and styles that were in favour during the reign of Emperor Jahangir, and is comparable to the *chilanum* Cat. 27, especially in its blend of spectacular gemstones and intricately engraved gold ground.

The faceted diamonds of the main lotus blossom and buds in partially lobed gold settings stand proud of the surface, and the contrast afforded by the flat ruby vines bearing lotuses and martagon lilies with emerald calyces characterize the virtuosity and tastefulness of the artist who created this object.

Ruby vines unfurl from the diamond and ruby blossom that nests in the ruby and emerald trefoil on the lower tip of the locket, and interweave on an intricately engraved gold ground of meandering vines that issue a multitude of blossoms and leaves detailed with hachures.

The large channel-set ruby border on the upper edge of the locket, and the smaller channel-set rubies outlining the trefoil on the tip of the locket and contouring its lobed edges, serves as a means of visually containing the decoration.

Tip of locket showing engraved gold surface and variety in gem-setting

Cat. 2 *KATAR* DAGGER OVERLAID
WITH GOLD
Deccan, sixteenth century
Hilt, steel overlaid with gold;
blade, steel, European, repolished
Dimensions: Length 48.5 cm; width 5 cm
Provenance: Art market 1980s
Inv. no. LNS 273 M

Of elongated proportions with convex
blade guard and lobed-arch side-bar
terminals typical of the Deccan,[31] this *katar*
is entirely covered with relief-cast gilded
inscriptions in *thulth* style. The religious,
pious and apotropaic inscriptions feature
the famous invocation to Imam 'Ali,
which in this case also invokes the Prophet
Muhammad,[32] clearly indicating that the
object was produced in a Shi'a milieu.

The invocation to Imam 'Ali and the
Prophet Muhammad are featured on the
exterior of one side-bar and continued on
the underside of the blade guard together
with the appeal to Imam 'Ali (O 'Ali, O
'Ali, O 'Ali). The upper surface of the blade
guard is inscribed with the legend "Orbit
of Religion and Trustee of God" and the
name "Muhammad 'Ali Shah", which could
be an indication that there is an association
between the invocation to Imam 'Ali and
the Prophet Muhammad and the name of
the presumed owner of the *katar*:

مـدار الديـن ولي/
الله محمـد عـلي شـاه

"Trustee of God" is known to apply to
Imam 'Ali, and when listed in Hadith,
"Orbit of Religion" is applicable to the
tenets of religion rather than to individuals.
One of the few instances in which "Orbit
of Religion" was associated with kingship
was by the Egyptian historian al-Nuwayri
(d. 733 H/1333 CE), quoting the Andalusian
poet Ibn 'Abd Rabbihi on attributes of
kings and their comportment (*fi sifati
'l-malik wa akhlaqihi*, "with regard
to the king's attributes and his ethics").[33]

As the legend on the blade guard
appears in association with the name
Muhammad 'Ali Shah, one could assume
that he was a ruler from the Deccan, since a
number of its rulers went by that name and

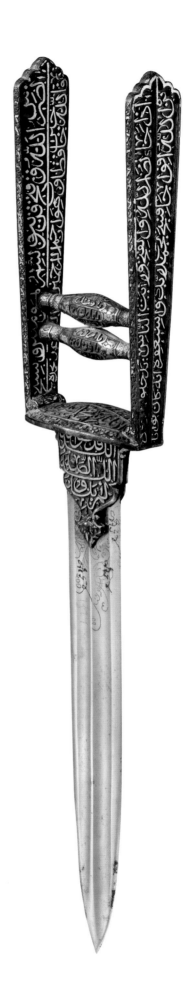

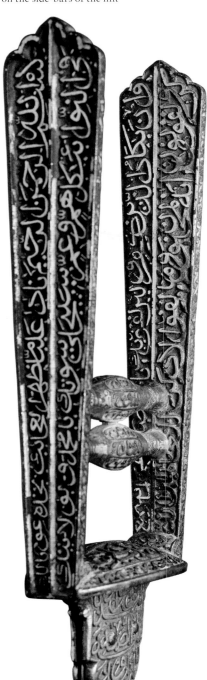

Verses from the Qur'an and the invocation to Imam 'Ali featured on the side-bars of the hilt

this style of *katar* seems to originate from the area. We also know of a Shi'a ruler of this name who governed Kashmir from 1570 to 1579,[34] an area far removed from the Deccan; however, as craftsmen moved around, and precious weapons formed an important part of gift exchanges, it would not be implausible to find a dagger produced in the Deccan as far away as Kashmir.

All inscriptions featured on the hilt are in two registers, proceeding from one side-bar to the other, onto the underside of the blade guard, in the following order: Surat al-Saff (Chapter 61: v. 13) and Surat al-Nasr (Chapter 110: vv. 1–3), praising God, expressing gratitude and attributing [one's] victory to God's assistance; Surat al-Ra'd (Chapter 13: v. 13), which proclaims that thunder and the angels submit to God; Surat Yusuf (Chapter 12: v. 64), proclaiming that God is the Supreme Protector, and the Most Merciful; and Surat al-Qalam (Chapter 68: vv. 51–52), stating that God's message is one of truth that will endure and is a cure against all evil.

Scrolls of counterchanging half-palmettes and quatrefoils, closely related to the floral scrolls featured on the gold-inlaid steel *katar* Cat. 20, outline the edges of the hilt. The grip-bars are bordered by floral motifs and cross-hatching and feature alternating repetitions of one of the ninety-nine Beautiful Names of God, *ya Fattah* (O Granter of victory), and the words *ya Buduh* (O Buduh), a talismanic formula, often found on blades, represented by the numerical values of the letters.[35]

The plaquettes that are riveted onto the ricasso feature Surat al-Ikhlas (Chapter 112: vv. 1–4), proclaiming the Oneness of God. They are bordered on the upper edge with cross-hatched elliptical cartouches alternating with circlets and terminate

with pendent palmettes that presumably would have straddled the median ridge of the original blade. The long European double-edged blade with twin fullers has been buffed to a shiny finish and displays worn incised vegetal motifs with stippled numbers 1215, probably an armoury inventory number, as well as undeciphered etched blackened inscriptions.

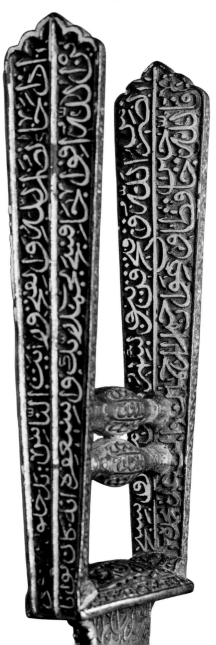

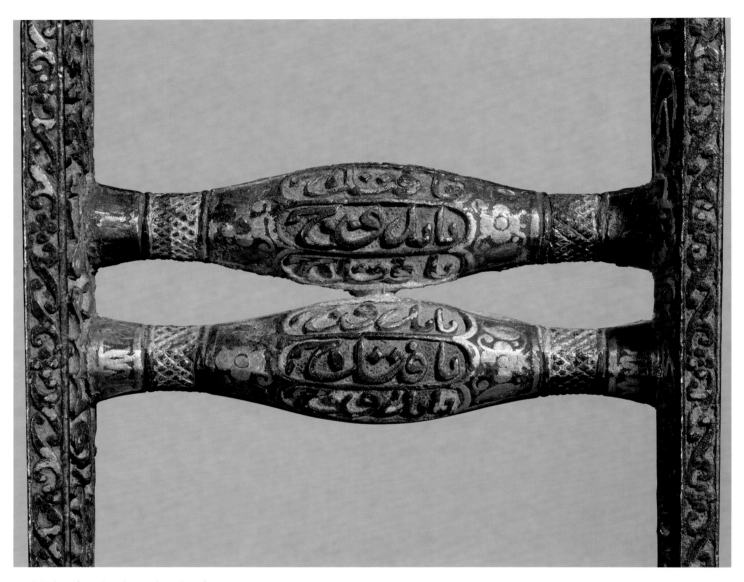

Grip-bars featuring the words *ya Fattah*
and *ya Buduh*, Cat. 2 (LNS 273 M)

"Orbit of Religion" (above) and
"Muhammad 'Ali Shah" (below)
featured on the blade guard

Cat. 3 **JEWELLED *KATAR* DAGGER
WITH SCABBARD AND
CHAPE**
**Deccan, probably
late sixteenth–early
seventeenth century**
Hilt and chape, gold over an iron
core, worked in *kundan* technique
and set with rubies, emeralds and
diamonds; blade, steel, pierced
through and partially overlaid
with gold; ricasso covered with a
hammered and chased gold sheet
plaque, the ground ringmatted
(as is that of the hilt and the gold
overlaid areas of the upper blade);
scabbard, wood covered with
purple and gold brocade with
metal thread trimmings
Dimensions: Length of dagger 53.5 cm; width
9 cm; length of scabbard 36 cm
Provenance: Art market 1999
Published: Christie's, London, 6 October
1999, lot 197; Prior and Adamson
2000, p. 53; Keene and Kaoukji
2001, cat. 3.7; Calza 2012, p. 162,
cat. IV.13
Inv. no. LNS 2220 J ab

Considering the number of *katar*s of
comparable size and configuration
depicted in paintings from the period, this
proportionally long *katar* can confidently
be attributed to the late sixteenth or early
seventeenth century.[36]

The side-bar alignment was probably
altered by pressure, as evidenced by the
slight cracks just above the grip-bars,
which atypically have small cartouche-like
bases where they join the side-bars, and are
joined by a gold flange in the centre flanked
by collets set with rubies and emeralds.[37]
The grip-bars are of hexagonal section
in the centre and five-sided at the outset,
where four of the facets are set with rubies
and emeralds, and the fifth features pairs
of emerald buds.

Characteristic of this magnificent
baroque dagger are the atypical stylized
plant forms in salient gold settings
that line the side-bars and blade guard,
composed of ruby and emerald blossoms
with diamond calyces. Containing the
decorative motif is a border of rubies
interspersed with emeralds that outlines
the edges of the hilt.

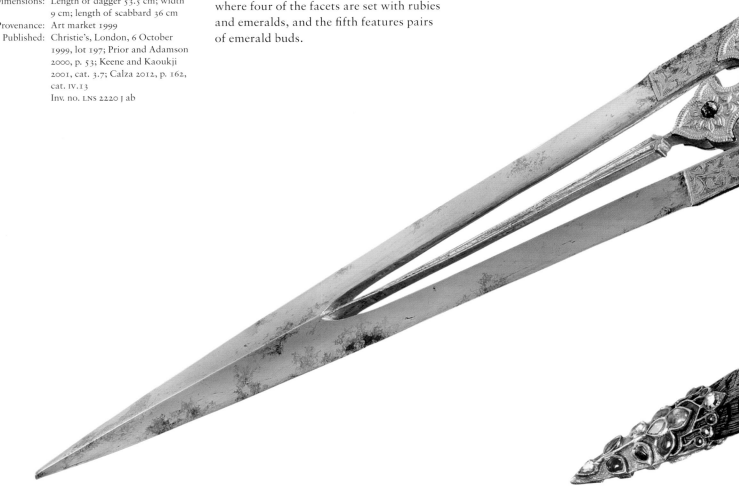

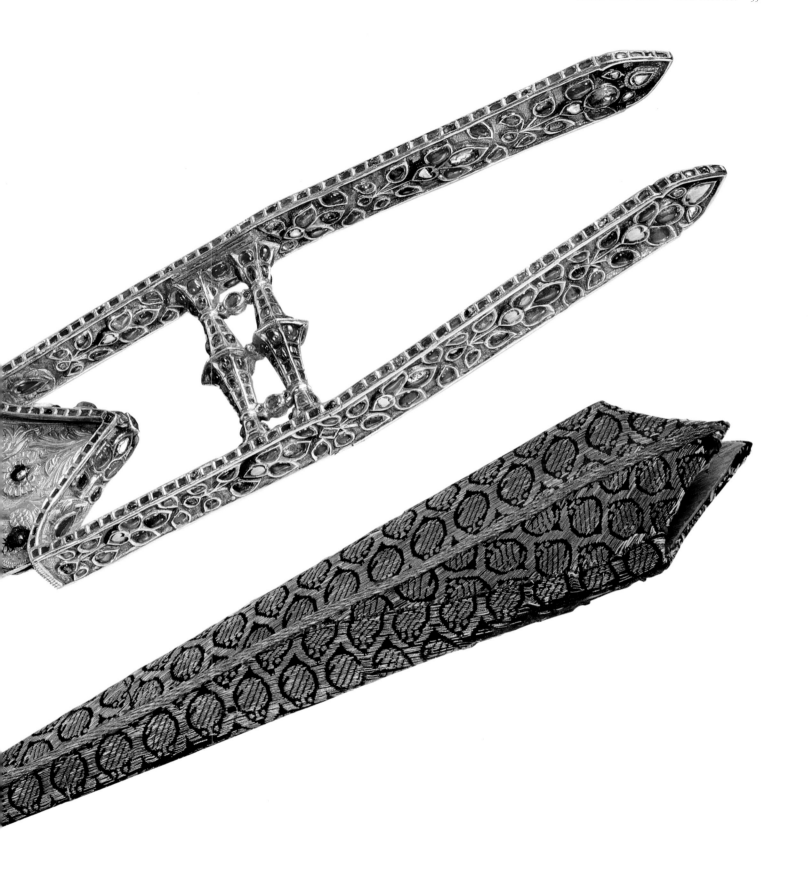

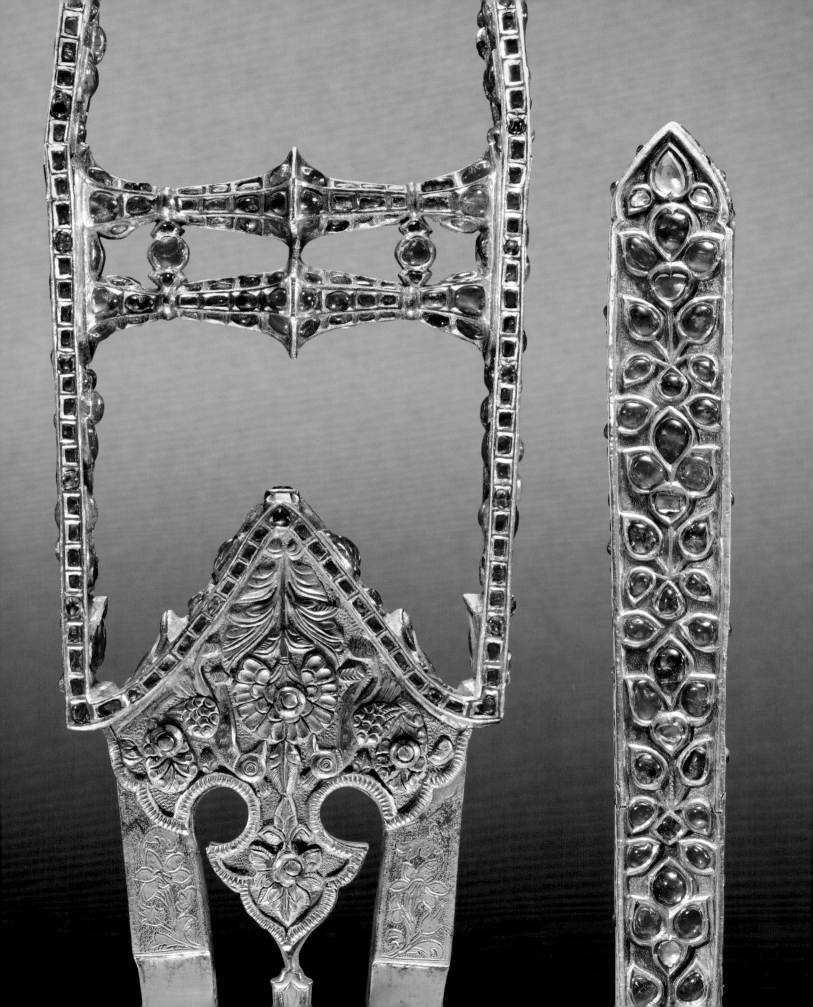

Grip-bars joined by gem-set collets, side-bar with salient gem-setting on ringmatted ground and gold plaquettes on the ricasso featuring peacocks flanking a flower, Cat. 3 (LNS 2220 J)

Further distinctive traits are the pairs of large upswept gold lotus blossoms, set with rubies and worked in high relief, which rise to a pronounced point at the juncture of the side-bars and blade guard, and the square-shaped emerald on the cusp of the angular blade guard.[38]

On the ricasso, gold plaquettes recalling cloud-collar forms are worked in high relief against a ringmatted ground with beautifully detailed peacocks flanking

a composite flower. Four gilded rivets, awkwardly set without consideration for the surrounding decorative motif, suggest work related to a later replacement of the blade.

The double-edged blade, which is probably a replacement, is pierced through, thick and bevelled on both the edges and the tip. It is overlaid with gold on the stylized cypress in the centre of the blade and with floral motifs on either side of the gold plaquettes.

Upswept lotus blossoms at the junction of the blade guard and side-bars

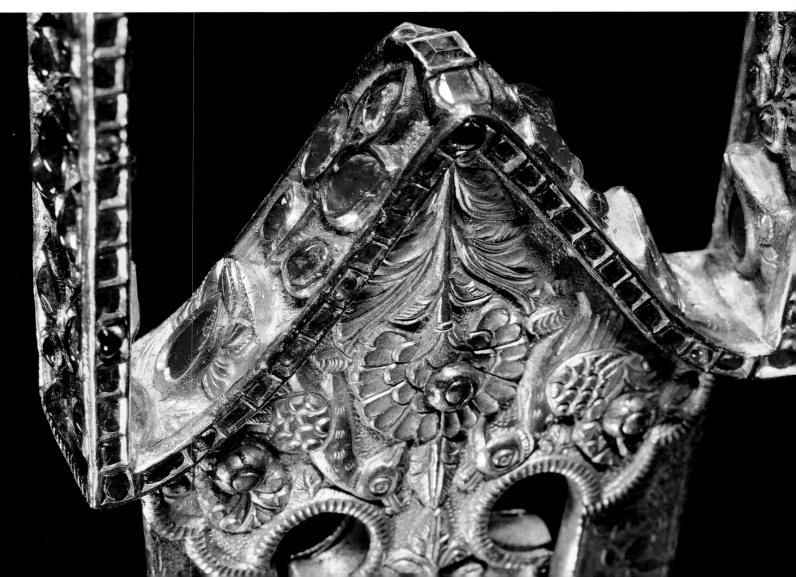

Cat. 4 JEWELLED *KATAR* DAGGER
South India, early
seventeenth century
Hilt, gold over an iron core,
worked in *kundan* technique and
set with rubies, emeralds and
diamonds, and with collet settings
fabricated from gold sheet; blade,
steel; ricasso covered with a
hammered and chased gold
sheet plaque, the ground
matted with textured chisels
Dimensions: Length 43 cm; width 8 cm
Provenance: Art market 1999
Published: Keene and Kaoukji 2001, cat. 3.6;
Keene 2004a, figs. 1 and 2
Inv. no. LNS 2159 J

The hilt of this *katar* is atypically bordered
with rubies in collet settings, a type of
setting apparently favoured in south
India,[39] as, it would seem, is the distinctly
arched blade guard below which are
gold plaquettes fastened onto the ricasso
by means of rivets.[40] Likewise rather
uncommon is the long and slender curving
blade, now heavily corroded.

The exquisite detailing of the gold
settings of the diamonds on the side-bars
and blade guard is unparalleled in other
edged weapons, but is closely related to
the gold-inlaid decoration on a Deccan
or Mughal rock-crystal spheroidal box of
probable late sixteenth–early seventeenth
century date,[41] especially the spearhead
fleur-de-lys motifs encircling the centre of
the box, as well as the gold settings of a
South Indian ceremonial or areca-nut case
dating from the first half of the seventeenth
century in The al-Sabah Collection.[42]

On the exterior of the side-bars the
diamonds are bordered by reciprocal gold
scrolls of slender half-palmettes, which
cover the edge of each diamond along
one quarter of its perimeter and curl on
their tips to form one of four small volutes
that emulate "claws". In between the

Elaborate gold settings on blade guard

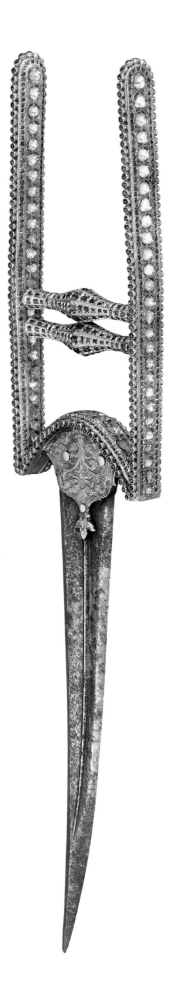

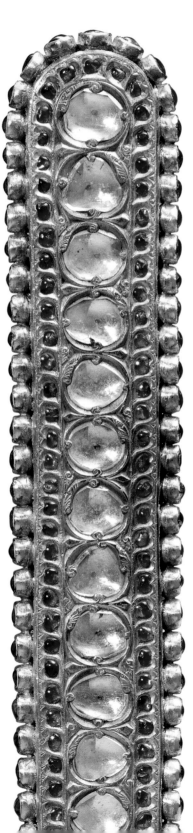

Variety of intricate gold settings on side-bars

diamond settings reciprocal spearheads in conjunction with the small spiralling volutes form fleur-de-lys motifs.

Equally fine are the gold settings of sweeping lotus petals set with small rubies that outline the diamond settings on the hilt, a motif that recalls the border outlining the gold *katar* Cat. 22 and the lid of a jewelled box in The al-Sabah Collection.[43]

The colour of gold in the centre of the grip-bars appears to differ from that of the flared ends that connect them to the side-bars. Although these elaborately lobed and cusped gold settings on the grip-bars, detailed with chip-carving, are of fine manufacture and related to the settings on the side-bars, they are clearly not as fine as the decoration on the rest of the hilt, and could be an indication of later replacement.

Covering the ricasso are gold plaquettes decorated with a flowering plant, with overturned petals and sweeping leaves detailed with cross-hatching and stippling against a stippled ground, outlined with a beaded border culminating in a finely detailed pendant trefoil. This motif evokes the lively treatment and detailing of vegetal decoration depicted on kalamkaris from the Golconda region, as well as on the medallion of a dagger in the Metropolitan Museum of Art, especially in relation to the outlining beaded borders.[44]

Just as with the previous *katar* (Cat. 3), the gold plaquettes have been fastened by means of rivets without consideration of the surrounding decorative motif. It is most likely that the heavily corroded curved double-edged blade is a replacement, as there are signs of patching where the plaquettes join the hilt. Ungainly strips of gold have been applied along the edge of the blade and plaquettes, and flank the edges of the blade, probably to conceal a gap once filled by a broader blade.

Cat. 5 ENAMELLED AND JEWELLED *KATAR* DAGGER

Deccan or Mughal dominions, early seventeenth century

Hilt, gold over an iron core, champlevé enamelled (small amount of overpainted details) and set in *kundan* technique with rubies; blade of *jawhar* steel

Dimensions: Length 38 cm; width 9 cm
Provenance: Art market 1997
Published: Keene and Kaoukji 2001, cat. 6.13
Inv. no. LNS 1743 J

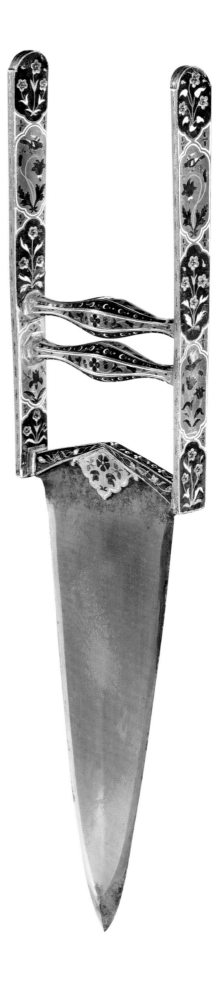

Produced in an exquisite and unparalleled decorative style that points towards a blend of Deccan and Mughal traditions, this *katar* incorporates enamels and gemstones subtly laid out on its side-bars in cartouches defined by fillets of white enamel, with red-winged insects in the intervening areas. The cartouches are alternately decorated with flowering plants set with rubies flanked by yellow cloud-bands on a ground of green enamel, and enamelled flowering plants with birds swooping down on orange-winged insects against a gold ground. Although associated with objects produced in areas under Mughal rule,[45] representation of insects in idyllic botanical settings was likewise favoured in the Deccan, examples of which can be seen in album pages attributed to Golconda and Bijapur.[46]

This type of decorative motif, whether combining clusters of flowers retained by a bow-like arrangement of leaves, cloud bands and insects, or, alternatively, flowers with cloud bands or just clusters of flowers, can also be seen on the borders of album pages and on carpets produced during the reigns of emperors Jahangir and Shah Jahan. Even though it has not been determined whether the album page borders attributed to the reign of Emperor Jahangir are original to the paintings, or if the paintings were remounted with borders commissioned during the reign of Emperor Shah Jahan, it nevertheless narrows down the type to a specific period.[47]

Emperor Jahangir's famous love of nature is apparent in his memoirs, the *Tuzuk-i Jahangiri*, especially in a passage written in 1620 describing the flora of Kashmir: the emperor states that Ustadh Mansur painted over one hundred species of flowers found in the region.[48]

Blend of enamel and gem-set
decorations on side-bars

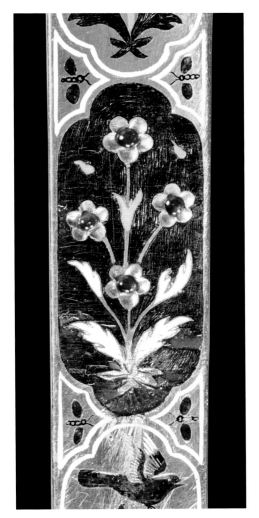 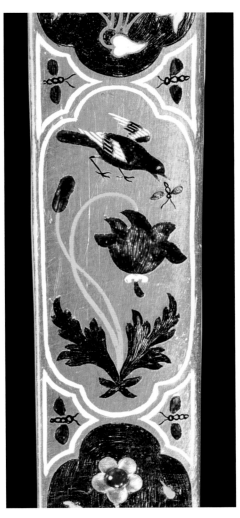

But most importantly it should be noted that Emperor Jahangir had the same type of decorative motifs, including cloud bands, carved on Emperor Akbar's marble cenotaph, attributed to *c.* 1611–13,[49] which makes it likely that the genre originated during his reign, and specifically around the time of the cenotaph's construction.

Most unusual is the motif featured on the edges of the side-bars, which are slightly stepped on the top, composed of gold dotted quatrefoils alternating with undulating tiger stripes highlighted with black enamel in reserve on a ground of pale-green enamel. The tiger-stripe motif harks back to the Timurid period and is famously associated with the pattern depicted on the coat of Rustam, the Iranian hero of the *Shah-nameh*. Although rarely encountered on weapons from the period,

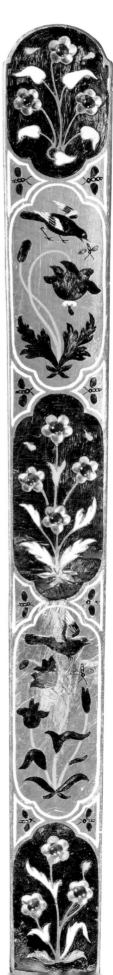

tiger stripes and dots interestingly feature on Sultan Ibrahim 'Adil Shah II's elephant saddle cloth,[50] as well as on a lota and the underside of the rim of a basin, the latter two objects both attributed to Bidar.[51]

A further detail pointing to the Deccan is featured on the grip-bars, which are divided into eight facets alternately decorated with enamelled floral scrolls on a gold ground, and white crescentic motifs and yellow dots on a green ground. Crescentic motifs in conjunction with tiger stripes occur on the borders of folios from a manuscript made for Maharajah Jaswant Singh of Marwar, produced in Aurangabad in 1669,[52] and it is worthy of note that floral motifs composed of dots are frequently featured on bidri-ware.

The blade guard features delicate white and yellow floral scrolls on a green ground, and the lobed pendant on the ricasso, a flowering plant and insects with colourless enamel wings on a gold field outlined by a white fillet. The attenuated shape of the blade guard and type of pendant were clearly standard during the period, as can be seen on other *katar*s (Cats. 6, 7 and 9).

The blade, which retains most of its original *jawhar* pattern, is of thin rhomboid section and thickens slightly at the tip.

Birds, insects, flowers and cloud bands on side-bar, Cat. 5 (LNS 1743 J)

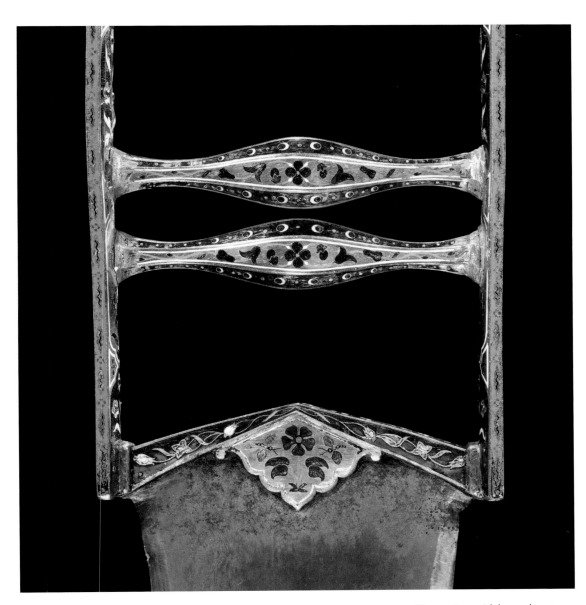

Tiger stripes with leopard spots
(*cintamani*) on the edges of the side-
bars, and crescentives on grip-bars

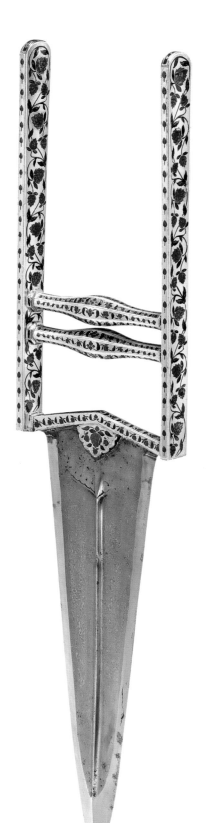

Cat. 6 ENAMELLED *KATAR* DAGGER WITH SCABBARD AND CHAPE
Probably Deccan, first half of the seventeenth century
Hilt, gold over an iron core, champlevé enamelled; blade of *jawhar* steel; scabbard, wood overlaid with green velvet and metal thread trimming; chape, gold, champlevé enamelled *en suite* with the hilt
Dimensions: Length of dagger 40 cm; width 9 cm; length of scabbard 23.5 cm
Provenance: Art market 1983
Published: Keene and Kaoukji 2001, cat. 6.19
Inv. no. LNS 223 M ab

Enamelled vines issuing champlevé-detailed red blooms and buds, possibly representing the globe amaranth (*Gomphrena globosa* or Sanskrit *rakthamallika*),[53] undulate gracefully along the side-bars against a gold ground bordered by fillets of white enamel. As on the preceding example (Cat. 5), the eight faces of the grip-bars, each of which features a quatrefoil issuing scrolling vines of red buds, are outlined with white enamel. The faces of the blade guard are decorated with similar scrolls and suspend small lobed pendants decorated with a large bloom surrounded by buds outlined with white fillets.

The edges of the side-bars feature alignments of stemmed red buds that are related to the buds outlining the side-bar edges of a jewelled gold *katar* (Cat. 10),[54] and that appear to be a form of decoration particular to the Deccan. Interrupting the buds on the upper end of the bars are bands of red enamel on which small gold dotted quatrefoils alternate with crescentic motifs that recall the decoration on the grip-bars of Cat. 5.

The gold chape, which is original to the dagger, is likewise bordered with white enamel, and decorated with three blossoms growing from a trefoil flanked by pale-blue cloud bands. This decoration, here again, bears comparison with the decoration on the chape of Cat. 10.

The double-edged blade retains most of its original *jawhar* pattern, features a pronounced median ridge and thickens at the tip. The ricasso retains signs of having once been fitted with a larger medallion, which is possibly an indication that the blade is a replacement.

Floral scrolls on side-bars, grip-bars
and blade guard, and stemmed
buds on edges of side-bars

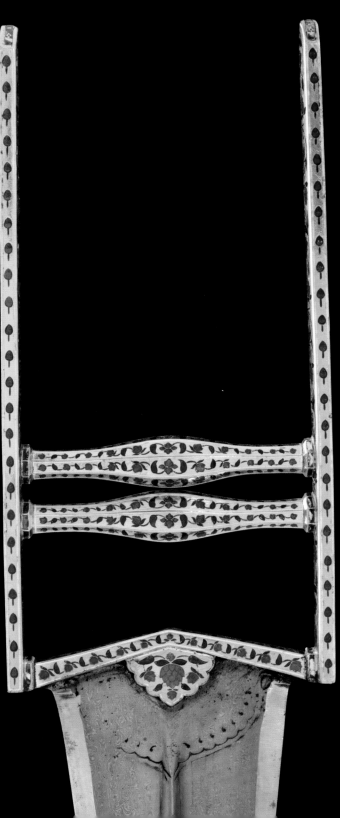

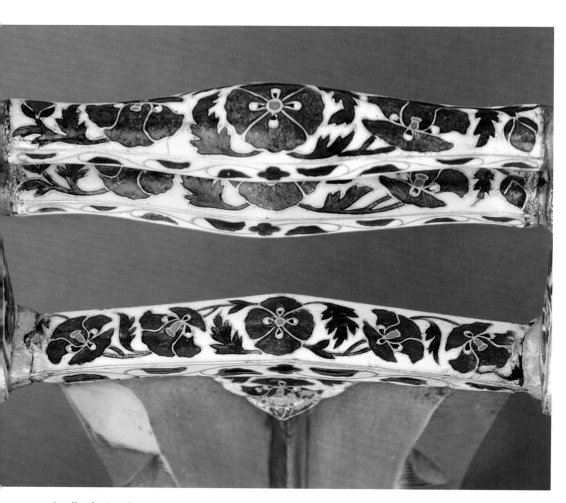

Scrolls of oriental poppies on grip-bars
and blade guard

Continuous scroll of
poppies on side-bar

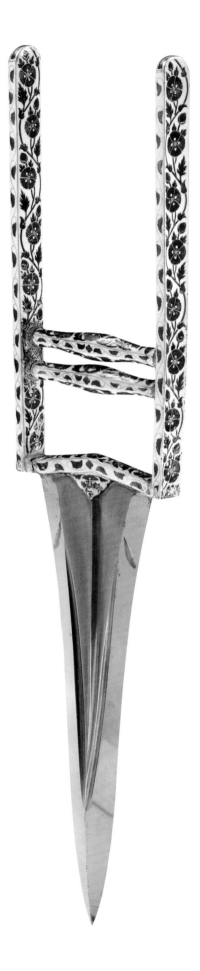

**Cat. 7 ENAMELLED *KATAR*
DAGGER WITH SCABBARD
AND CHAPE**
**Probably Deccan, first half
of the seventeenth century**
Hilt, gold over an iron core,
champlevé enamelled; blade of
jawhar steel; scabbard, wood
overlaid with green velvet with silk
and metal thread trimming; chape,
gold, champlevé enamelled *en suite*
with the hilt
Dimensions: Length of dagger 44 cm; width
9 cm; length of scabbard 27 cm
Provenance: Art market 1983
Published: Qaddumi 1987, p. 154; Keene and
Kaoukji 2001, cat. 6.18
Inv. no. LNS 222 M ab

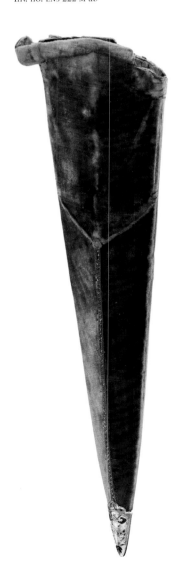

In contrast with the previous example,
Cat. 6, the hilt of this *katar* is covered with
white enamel outlined with reserved gold
fillets, as are the facets of the grip-bars.

Vines issuing from bracts, most likely
derived from a European Renaissance
revival of a Classical decorative motif,[55]
bear red poppies with pale-green centres
detailed with overpainted black enamel,
and scroll along the side-bars in an
uninterrupted fashion, with no conventional
start or end to the vine.[56] Of interest here
are the black and white patches on the base
of the petals (typical of oriental poppies),
an artistic convention that apparently first
made an appearance in scrolls featured
on the southern wall of the mid-fifteenth
century *chawkhandi* tomb of Shaykh
Khalilallah in Bidar.[57] This was a building
which, according to Elizabeth Schotten-
Merklinger, was designed in Persian style,
resembling pavilions such as the Namakdan
at Gazur Gah, except for the southern wall,
which is "Hindu in spirit".[58]

Identical scrolls decorate the upper face
of the blade guard, and the upper and lower
edges of the grip-bars. Complementing
them are fine gold vines outlining the
edges of the hilt, which, as in the preceding
example (Cat. 6) are interrupted at the
upper ends of the bars by bands of plain red
enamel, and by a quatrefoil in the centre of
the blade guard. The blade guard suspends
small lobed pendants decorated with poppy
blooms issuing serrated leaves.

The double-edged blade thickens along
the edges and at the tip, features a *jawhar*
pattern in the ground depression, and has a
median ridge and chevron fullers.

The lobed chape, which is most likely
original to the dagger, retains only part of
its white enamel ground, and is decorated
with a flowering poppy plant growing from
a serrated leaf, a common composition in
jewelled objects from the period.[59]

Details of Cat. 8 showing incorrect
reassembly of side-bars and blade
guard of Cats. 8 and 9: the poppy
plants and pale-blue cloud bands on the
side-bars match the blade-guard motif
of Cat. 9 (shown overleaf)

**TWO ENAMELLED *KATAR*
DAGGERS**
**Probably Deccan, first half
of the seventeenth century**

Cat. 8 Hilt, gold over an iron core,
champlevé enamelled (small
amount of overpainted details);
blade of *jawhar* steel
Dimensions: Length 39 cm; width 9 cm
Provenance: Art market 1997, reportedly from
Hyderabad
Published: Keene and Kaoukji 2001, cat. 6.17
Inv. no. LNS 1821 J

Cat. 9 Hilt, gold over an iron core,
champlevé enamelled (small
amount of overpainted details);
blade of *jawhar* steel
Dimensions: Length 42 cm; width 9 cm
Provenance: Art market 1997, reportedly from
Hyderabad
Published: Keene and Kaoukji 2001, cat. 6.16
Inv. no. LNS 1822 J

These two fine *katar*s are missing their
crossbars, and were apparently dismantled
in the past but not accurately reassembled,
as their side-bars have been interchanged.
The *katar* Cat. 8 has been fitted with a
blade guard featuring flowers (martagon
lilies or hibiscus) issuing three small trefoils
that match the decoration on the interior of
the side-bars of the *katar* Cat. 9. Likewise,
the edges of the side-bars of the *katar* that
combine cup-shaped flowers issuing trefoils
and whirling and drooping lilies (Cat. 9)
match the decoration on the edge of the
blade guard of the *katar* featuring poppy
blooms (Cat. 8).

That said, the rendering of the blooms,
which is closely related to flowers depicted
in page-borders of albums assembled
during the reigns of emperors Jahangir and
Shah Jahan, and the purity and intensity
of the red enamel as well as the opaque
white enamel of both *katar* daggers are of
exceptional quality.

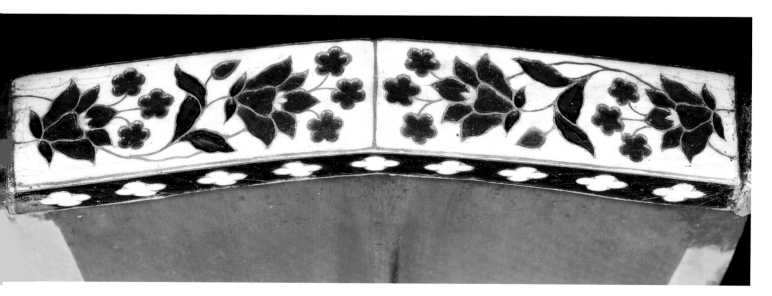

Blade guard, Cat. 8, with scroll motif of hibiscus and quatrefoil border on edge, matching the side-bar and edges of Cat. 9

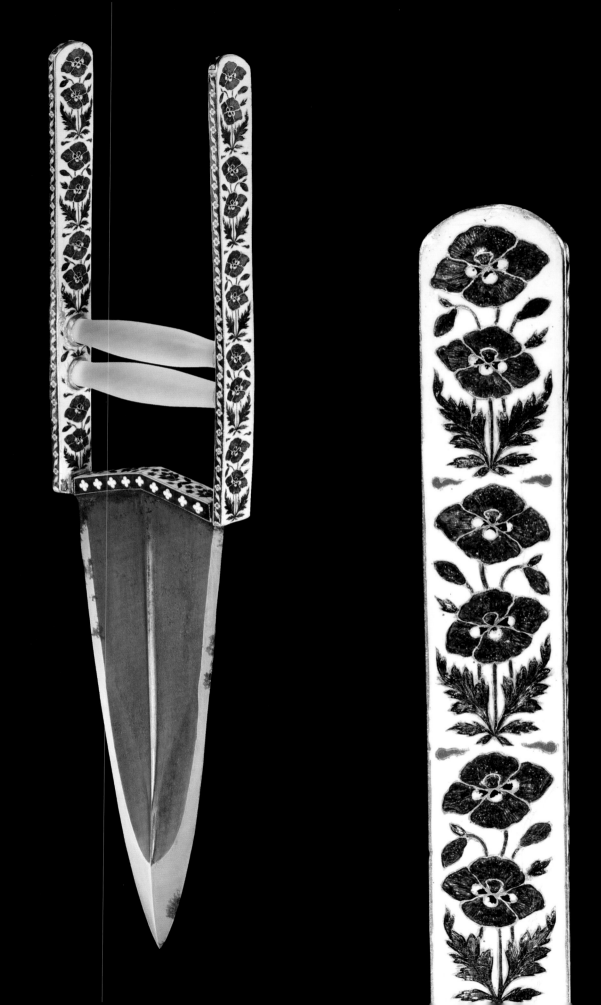

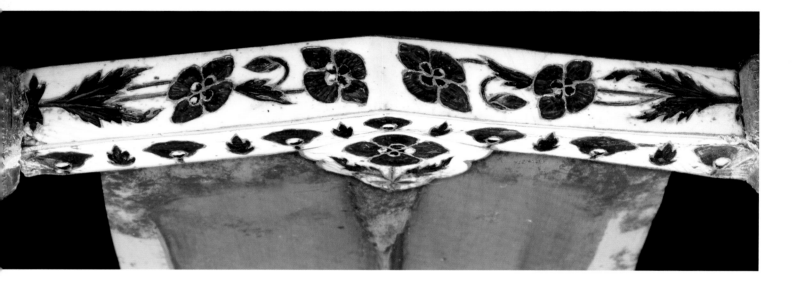

Poppy plants on blade guard of Cat. 9, matching the side-bars of Cat. 8

The lilies represented on Cat. 9 convey a joyful sense of movement, and whereas on the exterior of the side-bars they grow from five evenly laid-out clusters of leaves, on the interior they issue from a gold vine in reserve on the white ground that scrolls along the length of the bar.

The poppy blooms featured on the exterior and interior of the side-bars of the *katar* Cat. 8 are of more formal mien and have little cloud bands in the intervening areas.

The blades of both *katar*s have retained their original *jawhar* pattern and both thicken at their tips. It appears quite likely, however, that the blade of Cat. 9, which has a median ridge and chevron fullers, is possibly a replacement, as its narrow proportions do not match the width of the blade guard.

Side-bars of Cat. 9, featuring floral scrolls on their interiors (centre) that match the blade guard of Cat. 8

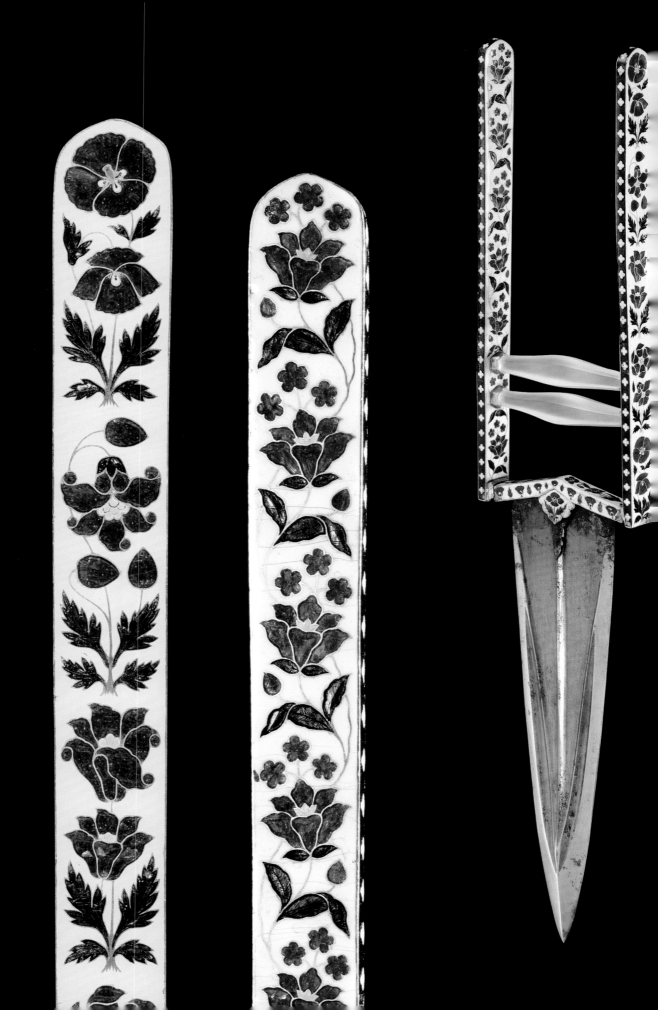

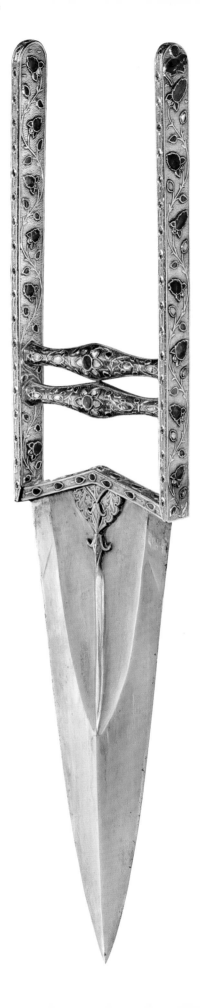

Cat. 10 JEWELLED *KATAR* DAGGER WITH SCABBARD, LOCKET AND CHAPE

Probably Deccan, first half of the seventeenth century

Hilt and chape, gold over an iron core, worked in *kundan* technique and set with rubies, emeralds and diamonds; locket, gilded copper, worked in *kundan* technique and set with rubies, emeralds and a single diamond; blade of *jawhar* steel inlaid with gold; scabbard, wood, covered with red velvet with metal thread trimmings

Dimensions: Length of dagger 45 cm; width 9.5 cm; length of scabbard 27 cm

Provenance: Art market 1989, reportedly from Calcutta

Published: Keene and Kaoukji 2001, cat. 10.2; Curatola and Kaoukji 2016, cat. 177

Inv. no. LNS 163 J ab

Ruby and diamond buds with emerald leaves gathered with a bow arrangement of leaves, typical of both Deccan and Mughal art, scroll against the wavy pattern of inlaid gold on the blued-steel ground of the side-bars and blade guard of this *katar*. What is more, the upper ends of the side-bars feature relief-carved ruby lions, with carved manes, surmounted by lion heads in frontal view,[60] and with two minuscule auspicious gold cloud bands on the upper ends of the grip-bars.

As in the enamelled *katar* Cat. 6, the edges of the side-bars and the blade guard are lined with stemmed ruby buds, wherein the buds on the blade guard are oriented towards a ruby quatrefoil. On the grip-bars diamond and ruby flowers issue scrolling vines bearing diamond and ruby buds and emerald leaves.

The matching chape features a plant with three ruby buds growing from a minuscule ruby bud and a pair of overturned emerald leaves, and is flanked by cloud bands. The gilded copper "locket", which most likely is not original to the piece but is nonetheless of fine craftsmanship, is rendered in openwork with a pendant medallion decorated with a fine flowering plant and fitted with a gold loop for the attachment of the sash cord.

The broad and heavy blade displays a fine *jawhar* pattern, thickens at the tip and edges, and is decorated on the ricasso with a two-tiered foliate pendant inlaid with gold and prolonged by the median ridge.

Opposite: Exterior decoration of side-bars with carved ruby lions and lion heads, minuscule gold cloud bands, and scrolls of ruby buds against a wavy gold pattern

Cat. 11 JEWELLED *KATAR* DAGGER WITH SCABBARD AND LOCKET

Probably Mughal dominions, first half of the seventeenth century

Hilt, gold over an iron core, worked in *kundan* technique and set with rubies, emeralds and diamonds; locket, gold, worked in *kundan* technique and set with rubies, emeralds and diamonds; blade of *jawhar* steel (repolished), overlaid with gold; scabbard, wood covered with red silk and green velvet

Dimensions: Length of dagger 35.5 cm; width 10 cm; length of scabbard 20.5 cm

Provenance: Art market 1980s

Published: Pal et al. 1989, fig. 172; Keene and Kaoukji 2001, cat. 13.5

Inv. no. LNS 114 J ab

Distinguished by the dense and masterful gemstone settings on its hilt and locket, this broad *katar*, which clearly issues from a royal workshop, is decorated with an interesting blend of exuberant baroque and restrained styles.

The exterior of its side-bars is lavishly carpeted with irregularly formed diamond flowers with ruby centres, their form principally dictated by the shapes of the stones, as Indian jewellers were averse to reducing the size of beautiful gemstones unless compelled to do so. Emerald cartouches separate the diamond flowers, and small emerald and ruby trefoils (or halved quatrefoils) fill the

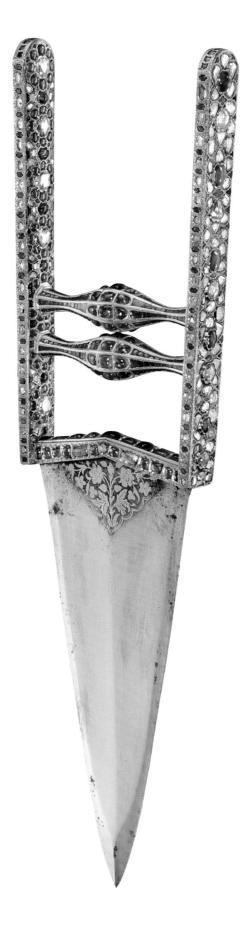

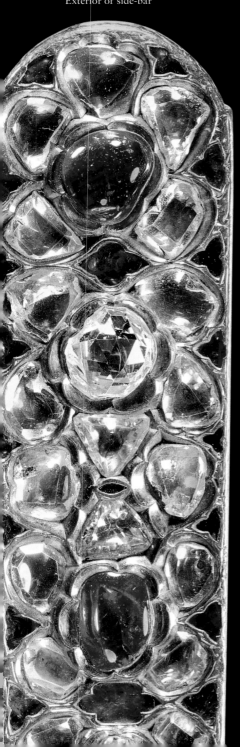

Exterior of side-bar

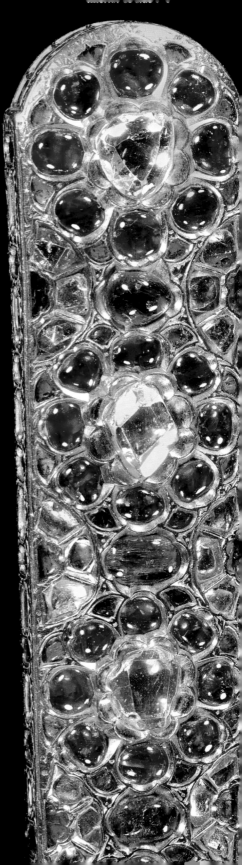

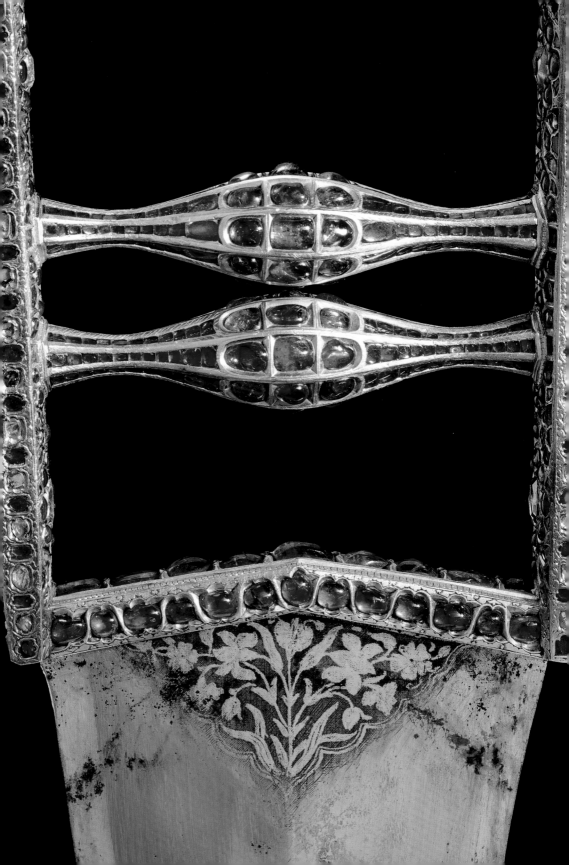

interstices along the outer edges of the side-bars, thus creating the effect of an uninterrupted geometric pattern.

Given Indian artists' inclination to explore varied decorative modes, it is not surprising that they would be driven to synthesize elements of vegetal decoration with non-representational geometric art, which ultimately resulted in this superb stylistic development. One only has to be mindful of the magnificent display of vegetal and geometric decoration on the mausoleum of I'timad al-Dawla to pay tribute to the patrons, artists and craftsmen of the period.

On the interior of the side-bars the ruby flowers with diamond centres and small emerald petals (or sepals) between the ruby petals are laid out in an orderly manner and separated by large emeralds in lobed settings. As on the exterior of the side-bars, halved diamond rosettes with emerald centres border the edges of the side-bars. It is worthy of note that the gold settings on the interior and exterior of the side-bars, which mainly serve to outline the stones, feature engraving of diminutive foliage in the intervening areas.

The edges of the side-bars are covered with horizontally and vertically oriented ruby and diamond cartouches in a comparatively large expanse of gold engraved with foliage and scrolls. On the upper ends of the side-bars cartouches are set with emeralds and rubies.

The grip-bars feature large ruby and emerald cabochons in their centres flanked by flat channel-set rubies with chevron engraving on the outlining gold bands.

On the upper edge of the blade guard large rubies and emeralds in lobed settings are bordered by "pricked" lotus petals, and on the sides, cup-shaped floral settings in counterchanging orientation are set with rubies and emeralds flanking a single diamond on a gold ground engraved with foliate motifs.

Bands of channel-set rubies, with emeralds in the centre and on each of the sides, outline the upper edge of the locket. The front features a large diamond and emerald lotus blossom in a surround of ruby, diamond and emerald petal-like forms surmounted by a loop for the attachment of the sash cord. In some of the intervening areas the lobed gold settings are engraved with detailed foliate motifs.

The broad double-edged blade, which was repolished and has thus lost most of its *jawhar* pattern, is of thin rhomboid section slightly reinforced at the tip, and is overlaid with gold with a lobed medallion enclosing a flowering plant in which the stems issue from bracts, in the same manner as on the scrolling vines of the enamelled *katar* Cat. 7.

Grip-bars with channel-set rubies, side-bars with ruby and diamond cartouches on an engraved gold ground, and gold overlay lobed medallion on blade, Cat. 11 (LNS 114 J)

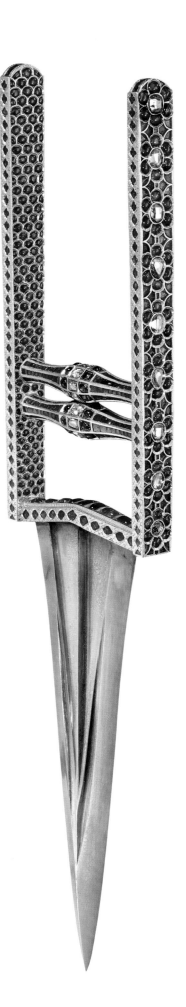

Cat. 12 JEWELLED *KATAR* DAGGER
Mughal dominions, *c.* mid
seventeenth century
Hilt, gold over an iron core,
worked in *kundan* technique,
set with rubies, emeralds and
diamonds and engraved; blade
of *jawhar* steel

Dimensions: Length 37.5 cm; width 9 cm
Provenance: Art market 1991
Published: Atil 1997, no. 99; Keene and
Kaoukji 2001, cat. 13.7
Inv. no. LNS 211 J

The decorative scheme of this *katar* hilt
centres on a stained-glass effect afforded
by the patterns of the gold settings on
the interior and exterior of the side-
bars. On the exterior, ruby rosettes with
diamond centres linked to one another
by a "string" of minuscule rubies are set
against a ground of emeralds in a pattern
of tangent circles that are halved by the
edges of the side-bars, once again evoking
an uninterrupted geometric pattern. The
interior of the side-bars is covered with an
imbricated pattern of rubies.

The decoration of the grip-bars and
the upper edge of the blade guard is related
in a general manner to the decoration on
the previous jewelled *katar* (Cat. 11), and
here, as well, the small rubies flanking the
diamonds and emeralds in the centre of the
bars are channel set.

On the edges of the hilt, flat ruby
quatrefoils are set against a gold ground
finely engraved with quatrefoils that
are halved by the edges of the side-bars,
recalling the uninterrupted pattern effect
featured on the exterior and interior of the
side-bars.

The narrow double-edged blade
thickens at the tip and edges, has retained
its original *jawhar* pattern, and features a
median ridge and chevron fullers.

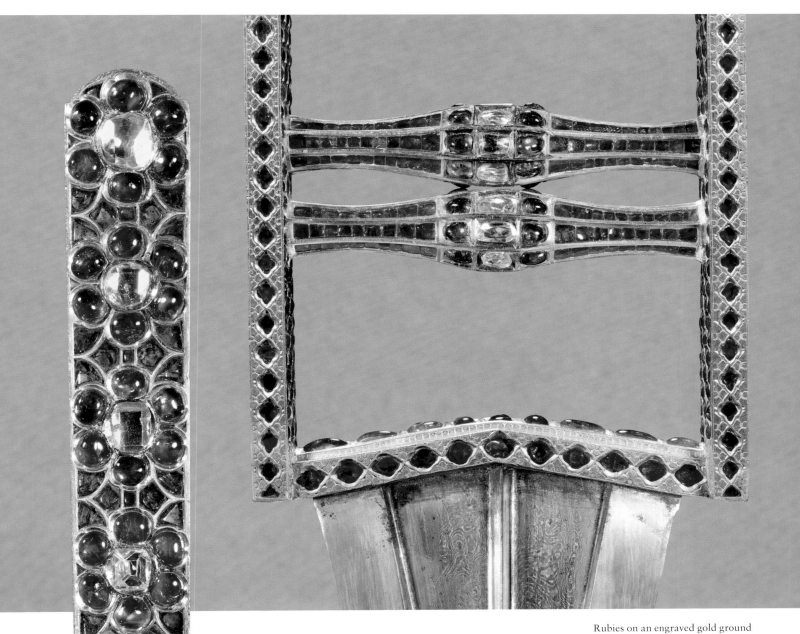

Rubies on an engraved gold ground
outlining the edges of the side-bars
and blade guard

Exterior of side-bar

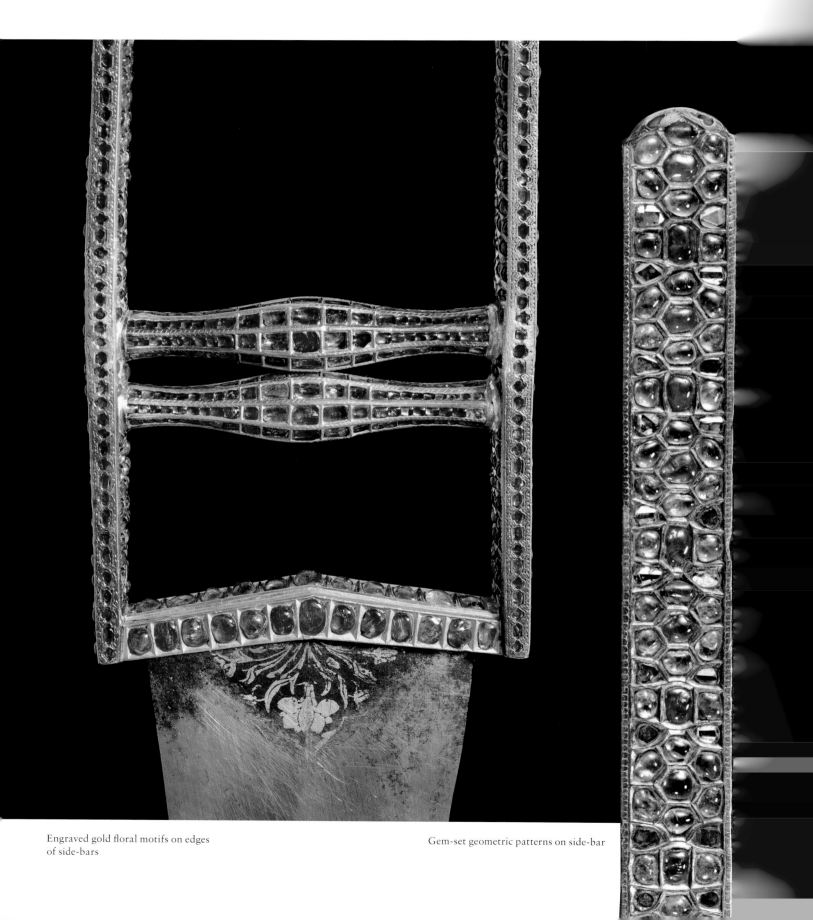

Engraved gold floral motifs on edges
of side-bars

Gem-set geometric patterns on side-bar

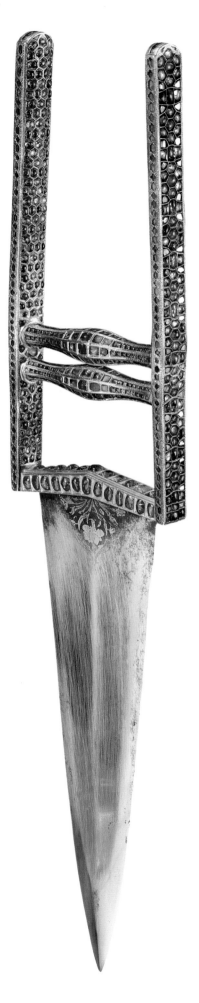

Cat. 13 JEWELLED *KATAR* DAGGER
Mughal dominions, *c.* mid
seventeenth century
Hilt, gold over an iron core,
worked in *kundan* technique and
set with rubies, emeralds and
diamonds; blade of *jawhar* steel
overlaid with gold (the watered
surface destroyed by repolishing)
Dimensions: Length 42 cm; width 9 cm
Provenance: Art market 1980s
Published: Curatola et al. 2010, cat. 271
Inv. no. LNS 116 J

A quasi-geometric floral pattern based
on irregular hexagonal cells covers the
exteriors of the side-bars on the hilt of this
katar. The flowers composed of emerald
petals with ruby centres alternate with a
row of rubies of rhomboid form flanked
by emeralds. On the interiors, an all-over
pattern of hexagons is set with emeralds,
with single rubies on each alternate
row, and likewise conveys the effect of a
geometric floral pattern. Ruby quatrefoils
and cartouches on the side-bar edges are set
against an expanse of gold engraved with
foliate scrolls.

The grip-bars are decorated in the same
fashion as the preceding examples (Cats.
11 and 12), with large rubies and emeralds
flanked by channel-set rubies, and the blade
guard is set with large emeralds and rubies.

The narrow double-edged blade, which
has suffered much repolishing, is overlaid
with a gold iris among swaying leaves
on the ricasso, has a median ridge and is
reinforced at the tip.

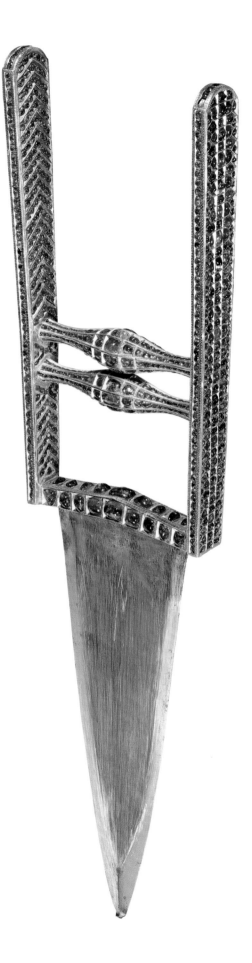

Cat. 14 **JEWELLED *KATAR* DAGGER**
**Mughal dominions, *c*. mid
seventeenth century**
Hilt, gold over an iron core,
worked in *kundan* technique and
set with rubies, emeralds and
diamonds and engraved; blade
of *jawhar* steel (repolished)
Dimensions: Length 38.5 cm; width 9 cm
Provenance: Art market 1989
Published: Keene and Kaoukji 2001, cat. 13.8
Inv. no. LNS 117 J

Considered in conjunction with the
previous and following examples of
jewelled *katar*s (Cats. 13 and 15), this
katar likewise appears to be an instance
of the use of decorative geometric floral
patterns, wherein the geometric pattern
on the exterior of the side-bars could be
interpreted as depicting overlapping
flower-heads.

It appears as though the motif was
intended to represent superimposed
emerald quatrefoils with ruby centres and
ruby petals in the interstices. If the motif
is to be interpreted as an overlapping
geometric pattern, the central emerald
petal should be viewed as "shared" by two
flowers, which is not infrequent in such
patterns. Although less likely, the motif
could also represent wide and narrow
superimposed cartouches, alternately
set with a ruby flanked by emeralds and
vice-versa. The small rubies in cusped
settings bordering the motif could be
interpreted as either the tips of petals
or the ends of cartouches, in either
case suggestive of a continuous pattern
interrupted by the edges of the side-bars.

On the interior of the side-bars,
channel-set rubies are set in a chevron
pattern augmented with small emeralds
around the bases of the grip-bars. The
grip-bars are set in the centre with large
emeralds flanked by large rubies and
small channel-set rubies.

The edges of the side-bars are
channel-set with rubies outlined with gold
"pricked" lotus petal borders, and the three
faces of the blade guard are set with large
emeralds in quadrangular settings.

The double-edged blade, which has
suffered much repolishing, is of thin
rhomboid section and is slightly reinforced
at the tip.

Geometric floral pattern
on exterior of side-bar

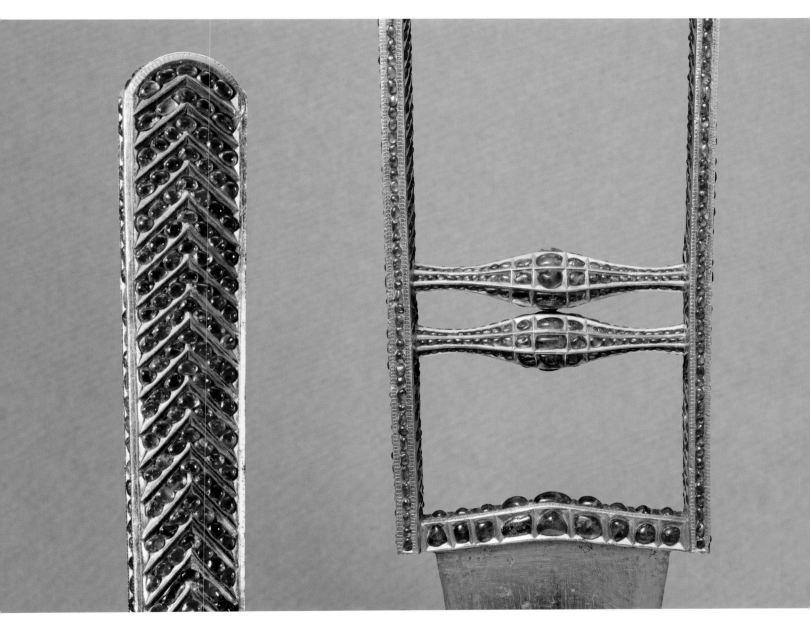

Channel-set ruby chevron
pattern on interior of side-bar

Blade guard and grip-bars with large
emeralds in quadrangular settings

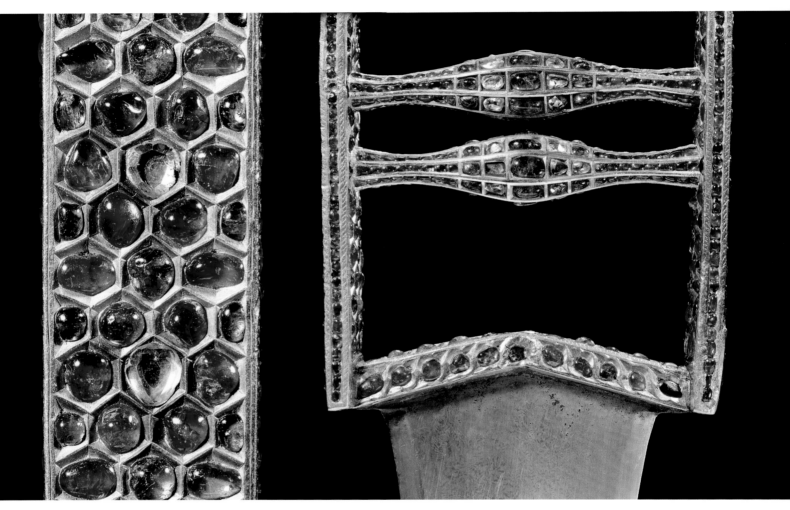

Exterior of side-bar

Channel-set rubies on side-bar
edges and grip-bars

Cat. 15 JEWELLED *KATAR* DAGGER
WITH SCABBARD AND
CHAPE
**Mughal dominions, *c*. mid
seventeenth century**
Hilt and chape, gold over an iron
core, worked in *kundan* technique
and set with rubies, emeralds and
diamonds; blade of *jawhar* steel;
scabbard, wood, covered with blue
velvet with sheet gold seam cover
stitched with gold wire
Dimensions: Length of dagger 38.3 cm; width
9 cm; length of scabbard 21 cm
Provenance: Art market 2005
Published: Sotheby's, London, 25 May 2005,
lot 93
Inv. no. LNS 4465 J ab

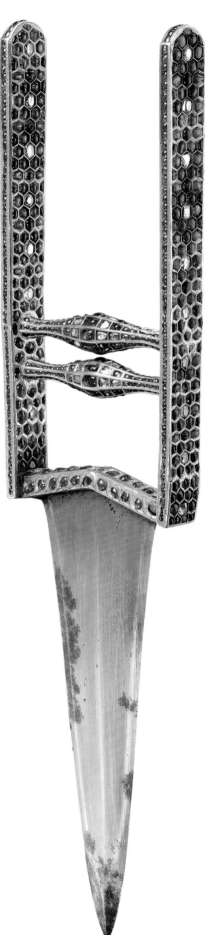

Chape with floral motif and
imbrication of rubies

The all-over pattern of hexagons that covers
the exterior and interior of the side-bars
is yet another example of a geometric
floral pattern of overlapping flower heads.
On both faces of the side-bars flower
heads composed of six ruby petals with
a diamond centre (some with an emerald
centre, possibly a replacement) in hexagonal
settings share two of their petals, and
when viewed at a distance appear to be set
against a ground of emeralds. The edges of
the side-bars are outlined with channel-set
rubies, and the grip-bars are decorated with
diamonds and emeralds flanked by channel-
set rubies in the same manner as on the
preceding *katar*s (Cats. 11, 12, 13 and 14).

It appears as though the blade guard
is a replacement, as there are traces of
reworking at its juncture with the side-
bars, and its thickness, which does not
match the width of the side-bars, has
been evened out by a series of engraved
elongated petals. Large rubies alternating
with emeralds decorate the top of the blade
guard, whereas the gold settings of the
rubies on the edges are worked in such a
manner as to simulate movement, evoking
a continuously unfurling scroll.

The narrow double-edged blade retains
a fine *jawhar* pattern but exhibits areas
of corrosion; it has a minimal median
ridge and is slightly reinforced at the tip.
It might not belong with the replacement
blade guard, as the upper ends of the blade
project beyond the guard, suggesting that
they are not a good fit.

Although the chape is obviously a
replacement, as its style of decoration differs
from that on the hilt, it is nevertheless of
fine manufacture. It is composed of an
imbrication of rubies encircled by a band
of channel-set emeralds and a floral motif
set with rubies and a diamond.

**Cat. 16 JEWELLED *KATAR* DAGGER
WITH SCABBARD AND
CHAPE**
**Deccan or Mughal dominions,
c. mid seventeenth century**
Hilt, gold over an iron core,
worked in *kundan* technique
and set with rubies, emeralds
and diamonds; lug and chape
fabricated from gold, worked in
kundan technique and set with
rubies, emeralds and diamonds;
blade of *jawhar* steel; scabbard,
wood overlaid with green velvet
and metal thread trimming
Dimensions: Length of dagger 45 cm; width
10 cm; length of scabbard 26 cm
Provenance: Art market 1991
Published: Keene and Kaoukji 2001, cat. 13.6
Inv. no. LNS 214 J ab

Rows of stylized lotus buds on minuscule
ruby stems growing from triangular ruby
mounds decorate the side-bars, which are
slightly stepped near the upper end, as in the
enamelled and jewelled *katar* Cat. 5. The
large buds, alternately diamond and ruby,
issue minuscule ruby stems bearing smaller
buds and emerald leaves, in which the large
ruby buds issue small diamond buds and the
large diamond buds issue small ruby buds.

The intervening gold ground is densely
engraved with foliate motifs, and the edges
of the side-bars are outlined with small
rubies and a band of channel-set rubies on
their upper ends, as on the *katar* Cat. 10 and
the enamelled versions on Cats. 6 and 7.

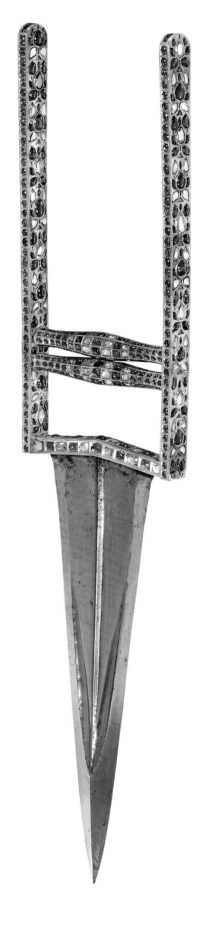

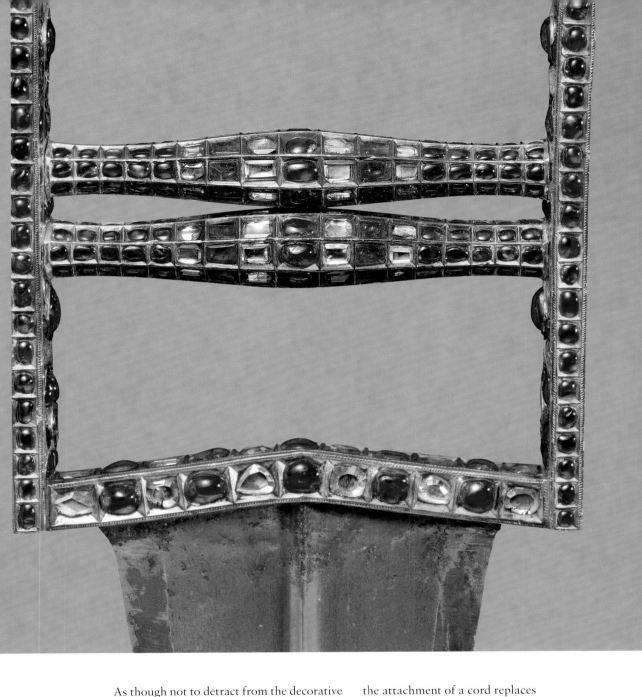

As though not to detract from the decorative motif of the side-bars, the grip-bars and blade guard, which are generally of the same type as the previous *katar*s (Cats. 11, 12, 13 and 14), are set with striking gemstones, namely rubies, diamonds and emeralds, but in unostentatious settings.

The narrow double-edged blade, which retains most of its original *jawhar* pattern, is reinforced at the tip, and has a median ridge and chevron fullers.

A ruby rosette fitted with a loop channel-set with minuscule rubies for the attachment of a cord replaces the more typical locket.

The chape, although of very fine manufacture, nonetheless appears to be a replacement, owing to the fact that the style of floral decoration clearly differs from that of the hilt. It features a ruby flower with a large diamond centre in a lobed setting, with small channel-set emerald calyx and stems issuing ruby buds and emerald leaves set into a gold ground densely engraved with foliate motifs.

Stylized lotus buds, stems and leaves on exterior of side-bars

Above: Gem-setting on edges of side-bars and blade guard

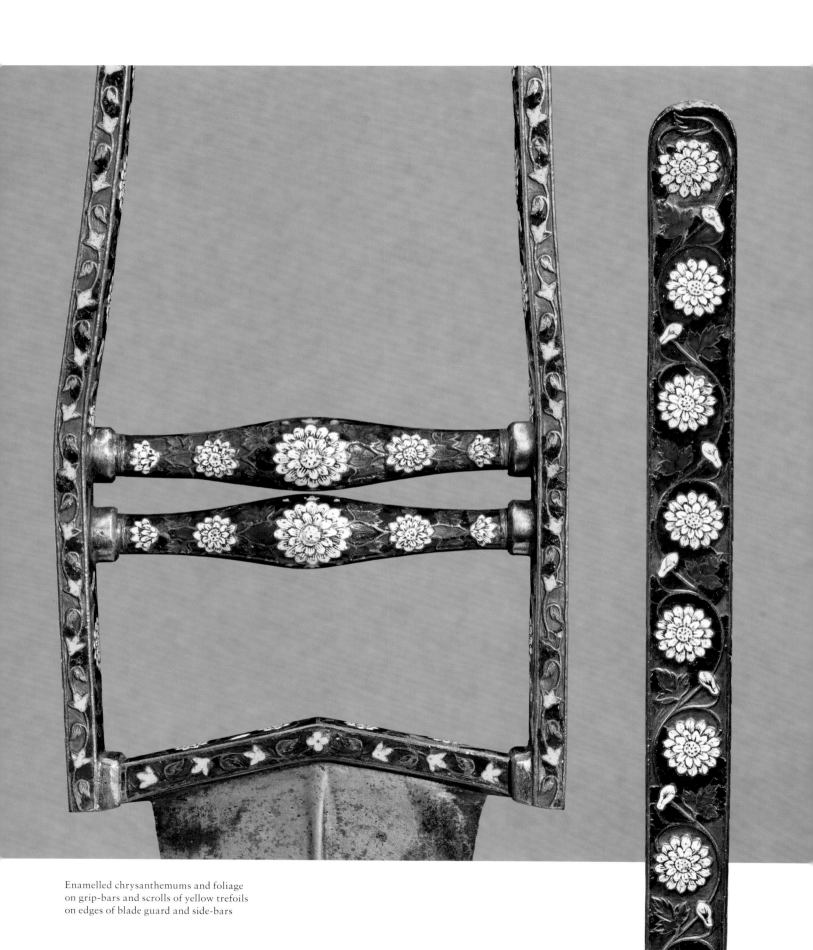

Enamelled chrysanthemums and foliage
on grip-bars and scrolls of yellow trefoils
on edges of blade guard and side-bars

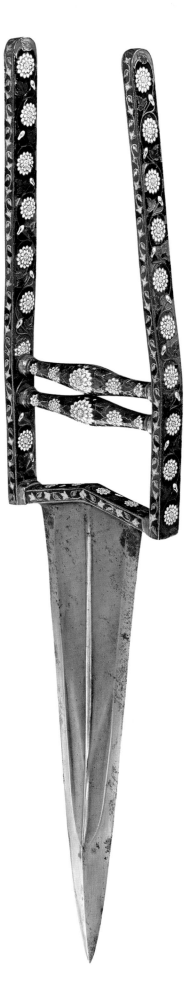

Cat. 17 **ENAMELLED *KATAR* DAGGER**
Probably Deccan, *c.* mid seventeenth century
Hilt, gilded silver over an iron core, with champlevé and painted enamels; blade of *jawhar* steel
Dimensions: Length 41.5 cm; width 9 cm
Provenance: Art market 1982
Published: Keene and Kaoukji 2001, cat. 6.35
Inv. no. LNS 169 M

Just above the grip-bars, pressure or cracks have altered the side-bar alignment of this *katar*, which must have destabilized the hilt, resulting in the need to fit out the ends of the grip-bars and lower ends of the side-bars with silver collets for reinforcement.

Decorating the dark-green enamel hilt are chrysanthemum blooms and buds, rendered in white enamel detailed with overpainted yellow and black enamel, that issue from scrolling silver vines retaining traces of gilding. It is noteworthy that the naturalistic serrated leaves are rendered in a lighter shade of green than the background.[61]

On the grip-bars a large chrysanthemum bloom issues small yellow trefoils and graduated blooms amid leaves with tendrils terminated by yellow enamel buds. The general colour scheme and usage of overpainted enamels evoke the decoration of the *chilanum* Cat. 29.

The scrolling vines that outline the edges of the hilt issue yellow trefoils that overlap the vine and partially enamelled halved silver leaves.

The narrow double-edged blade, which retains most of its original *jawhar* pattern, is reinforced at the tip and has a median ridge and chevron fullers.

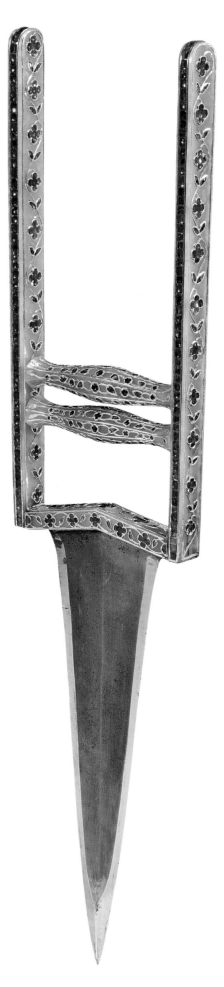

**Cat. 18 JEWELLED JADE *KATAR*
DAGGER WITH SCABBARD,
LOCKET AND CHAPE**
Deccan, perhaps Bidar,
c. **mid seventeenth century**
Hilt, locket and chape of nephrite
jade, inlaid with gold in *kundan*
technique and set with rubies and
emeralds; blade of *jawhar* steel;
scabbard, wood overlaid with green
velvet with metal thread trimming
Dimensions: Length of dagger 41 cm; width
9 cm; length of scabbard 24.5 cm
Provenance: Art market 1991
Published: Keene and Kaoukji 2001, cat. 2.15
Inv. no. LNS 68 HS ab

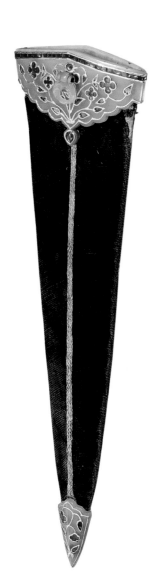

Carved from five pieces of jade, the hilt of
this *katar* is reinforced with iron on the
lower end of the hilt and grip-bars.

Gold vines of graduated quatrefoils
talab-set with rubies and emerald leaves
decorate both faces of the side-bars and the
blade guard; the larger ruby flowers have
a square ruby in their centres onto which
abut four other rubies forming a single
uninterrupted *talab*-set ruby field. The
effect of an uninterrupted colour field is
replicated along the edges of the side-bars
with channel-set rubies.

A different style of ruby quatrefoils and
emerald leaves, here set in gold detailed
with engraving that evokes bidri-ware
"chain link" decoration,[62] develops from
the centre of the grip-bars and blade
guard.

The locket and chape are original
to the *katar*, and decorated with the
same type of floral ornament borne by
undulating stems. Channel-set rubies
outline the upper edge of the locket, and
the only cabochon-cut gem on the dagger
is set in the bud on the tip of the locket.
The lug suspends a bail, typically in the
form of a pair of converging half-palmettes
inlaid with gold on their outer edges.

The double-edged *jawhar* blade is of
thin rhomboid section, slightly reinforced
at the tip, and is probably a replacement,
as there are traces of reworking, and
applied gold sheet flanking the blade on the
underside of the blade guard, most likely to
conceal gaps once filled by a broader blade.

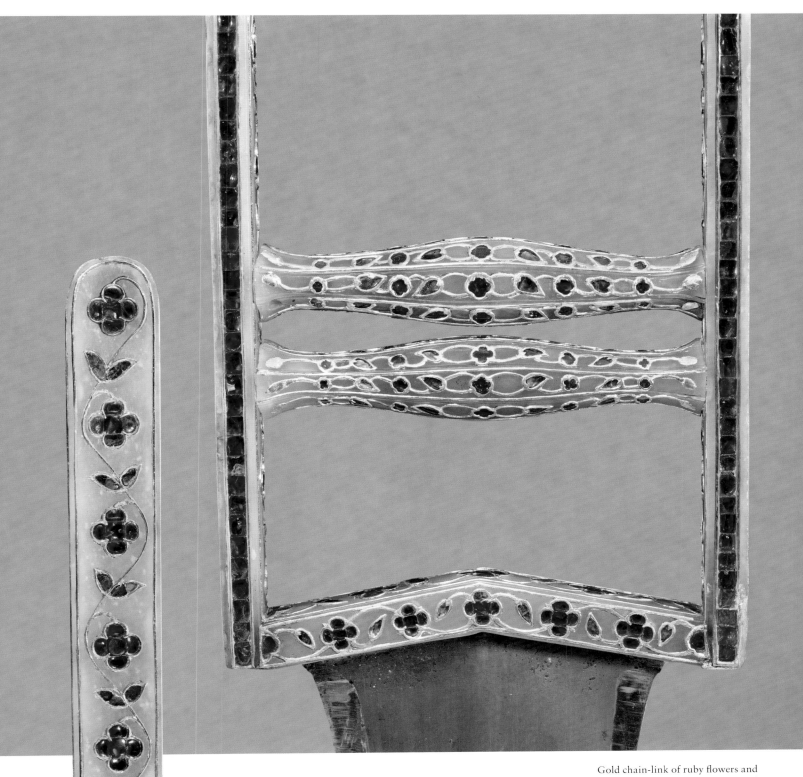

Scroll of graduated ruby quatrefoils
and emerald leaves on side-bars

Gold chain-link of ruby flowers and
emerald leaves on grip-bars, and
channel-set rubies on edges of side-bars

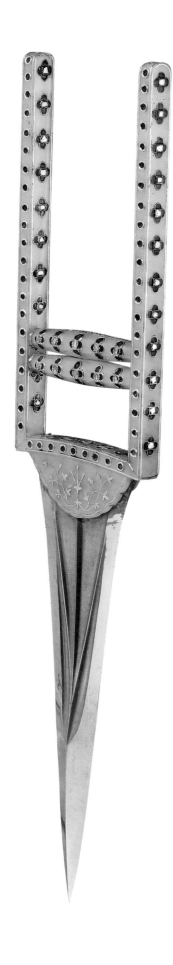

Cat. 19 JEWELLED JADE *KATAR* DAGGER WITH SCABBARD, LOCKET AND CHAPE
Deccan or Mughal dominions, probably early nineteenth century
Hilt of nephrite jade, inlaid with gold in *kundan* technique and set with rubies and diamonds; blade of *jawhar* steel; scabbard, wood overlaid with green velvet, fitted with gold champlevé-enamelled locket and chape

Dimensions: Length of dagger 44.5 cm; width 9 cm; length of scabbard 28 cm

Provenance: Art market 2003

Published: Sotheby's, London, 15 October 2003, lot 85; Curatola et al. 2010, cat. 272

Inv. no. LNS 3909 J ab

In contrast to the preceding seventeenth-century *katar* (Cat. 18), which has a jade hilt similarly decorated with scrolls of ruby flowers, the overall heavy proportions of this *katar*, as well as the lack of vitality in its decoration, are undoubtedly indications of a later period of manufacture.

Ruby quatrefoils with diamond centres decorate the side-bars, grip-bars and upper end of the blade guard, and circlets of rubies outline the edges of the hilt, which is entirely outlined with engraved gold fillets.

Straddling the blade on the ricasso is a lobed jade medallion inlaid with gold with a spindly floral motif, a further indication of late manufacture.

The double-edged blade thickens along the edges and at the tip, has retained its *jawhar* pattern, and features a median ridge and chevron fullers. The blade is probably a replacement, since it is proportionately narrower than the blade guard, as indicated by the patches of gold that flank the blade on the underside of the blade guard, apparently placed to conceal gaps once filled by a broader blade.

The locket and chape, which are decorated with red enamel on an opaque white ground, are most likely not original to the piece, but were intended to match the decoration of the hilt.

Cat. 20 *KATAR* DAGGER INLAID
WITH GOLD
**Deccan, *c.* mid
seventeenth century**
Hilt, steel, inlaid with two
colours of gold and silver;
blade of *jawhar* steel
Dimensions: Length 42 cm; width 9 cm
Provenance: Art market 1998
Published: Christie's, London, 28 April 1998,
lot 134; Bonhams, London, 14
October 1998, lot 223; Keene
and Kaoukji 2001, cat. 7.5
Inv. no. LNS 1008 M

The disproportionately long and slender
side-bars of this *katar* dagger are decorated
with atypical gnarled stems issuing small
stumps and detailed flowering plants in
their bends. The handling of the vegetal
motifs, in which blossoms and leaves all
differ from one another, distinctly evokes
the decoration on kalamkari or palampore
furnishings associated with Golconda and
the Coromandel coast.[63] Furthermore,
the rendering of two colours of gold and
silver recalls the decorative treatment of
a number of examples of bidri-ware.[64]

On the front and back of the grip-bars
the floral motifs are outlined with gold
fillets, whereas the remaining surface is
of undecorated steel.

The edges of the hilt are outlined
with gold split-leaf scrolls interrupted by
greenish gold "dotted" quatrefoils, which
evoke the quatrefoils adorning bidri-ware.
Overlaid gold bands, of which only some
of the thicker layers remain, once covered
the upper ends of the side-bars, in a manner
comparable to the jewelled and enamelled
side-bar terminals of the *katar*s Cats. 6, 7
and 10. It is worthy of note that these are
the only gold-overlaid surfaces on the hilt.

The double-edged blade retains some
of its original *jawhar* pattern, although it
exhibits corrosion; it thickens along the
edges and at the tip, and has a median
ridge and chevron fullers.

Scrolls of gnarled stems issuing a
multitude of blossoms and foliage
on side-bar

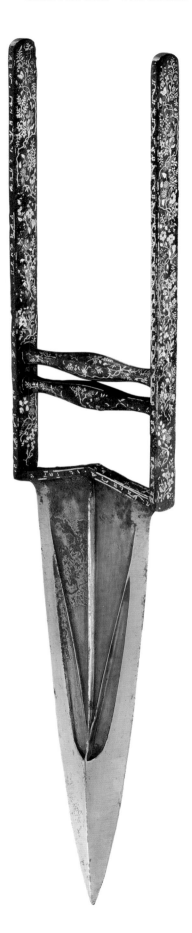

**Cat. 21 *KATAR* DAGGER OVERLAID
WITH GOLD**
**Probably Deccan, *c.* mid
seventeenth century**
Hilt, steel, overlaid with gold;
blade, steel (repolished)
Dimensions: Length 34.5 cm; width 8 cm
Provenance: Art market 1997
Published: Christie's, London, 14 October
1997, lot 231; Keene and Kaoukji
2001, cat. 7.4
Inv. no. LNS 902 M

Five clusters of flowering plants in thick
overlaid modelled gold cover the side-
bars of this dagger; although varying in
rendering and growing from different
patches of leaves, their undulating stems
produce the visual effect of uniform,
continuous scrolls. Although it would be
reasonable to assume, on the basis of their
slightly differing floral decorations, that the
side-bars did not belong together – which
is conceivable considering the incorrect
reassembly of the enamelled *katar*s Cats.
8 and 9 – this notion can immediately
be dispelled since the decoration on the
exterior of one side-bar matches that on the
interior of the opposite side-bar. Of further
interest are the auspicious cloud bands that
have been incorporated on the side-bars.

The flowering plants bear varieties of
flowers that differ from one another and
include auspicious *Prunus* blossoms and
lotuses, "dotted" and compounded flowers,
as well as a multitude of leaves. The side-
bars are outlined with paired gold fillets,
and the edges of the hilt are covered with
a rope pattern of serrated leaves.

The grip-bars are connected in the
centre, and decorated on the front and back
with flowering plants growing from one
end of the grip-bars in the same style as the
side-bars, whereas the remaining surface is
overlaid with gold.

The upper edge of the blade guard is
decorated with two panels enclosing a
smaller version of the side-bar motifs.

A composite substance, probably a
form of lac, was applied on the ground, and
once dry the surplus was polished off, thus
producing a high contrast between the gold
decoration and the background.

The blade exhibits large areas of
corrosion, is reinforced at the tip, and has
a median ridge and chevron fullers.

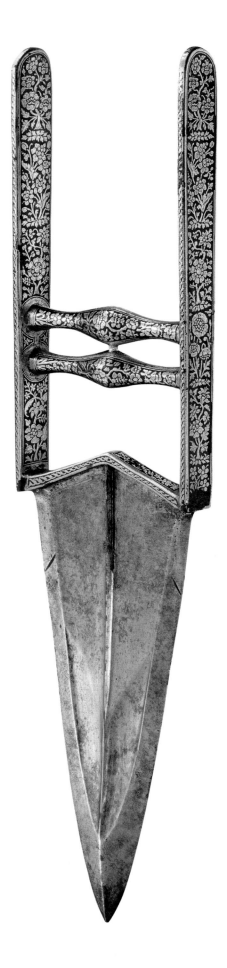

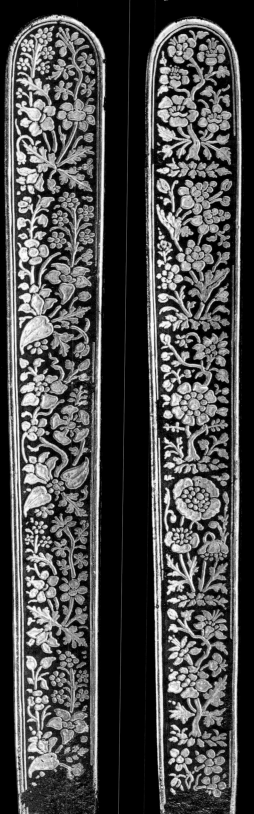

Side-bars with differing clusters of
flowering plants, and minuscule cloud
bands in the upper quarter of the
side-bar at left and in the centre
of the side-bar at right

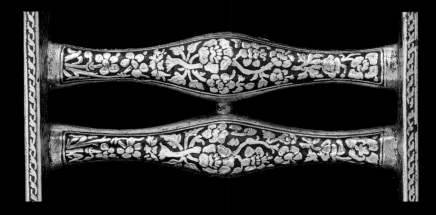

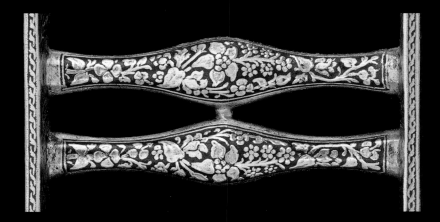

Different flowering stems decorating
the front and back of the grip-bars

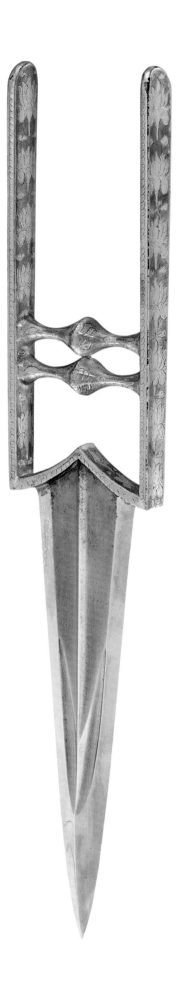

**Cat. 22 *KATAR* DAGGER OVERLAID
WITH GOLD**
**Deccan or Mughal dominions,
c. mid seventeenth century**
Hilt, steel overlaid with gold in two
colours, tooled and ringmatted;
blade of *jawhar* steel
Dimensions: Length 45 cm; width 8 cm
Provenance: Art market 1991
Published: Keene and Kaoukji 2001, cat. 7.3
Inv. no. LNS 304 M

It appears that around the middle of the
seventeenth century edged weapons,
worked in the *koftagari* technique – either
inlaid or overlaid with gold – had become
the trend, as examples of the type are
clearly represented in a portrait of Sultan
Muhammad 'Adil Shah of Bijapur, from *c*.
1635,[65] and in the battle scene representing
the seizure of the fortresses at Orchha and
Dhamuni, from *c*. 1638, in the manuscript
of the *Padshah-nameh*.[66]

The concave side-bars of this *katar*
dagger's hilt are decorated in thick-
modelled gold with a row of beautifully
rendered naturalistic irises set against
a ground of ringmatting. On a par with
the best painting traditions of the period,
the irises that issue from calyces have
fluid overturned petals with central
petals undulating in counterchanging
orientation.[67] Likewise, unfurling iris
buds with petals in counterchanging
orientation decorate the cusped blade
guard and flank the central bloom on
the pronouncedly swelling grip-bars.[68]
Sweeping lobed petals detailed with
a median vein against a ground of
ringmatting border the edge of the hilt.

As on the *katar*s Cats. 5, 8, 9 and 10,
small cloud bands of thick gold are set in
the intervening areas.

The double-edged blade thickens on
the edges and at the tip, and exhibits a fine
jawhar pattern with a median ridge and
chevron fullers.

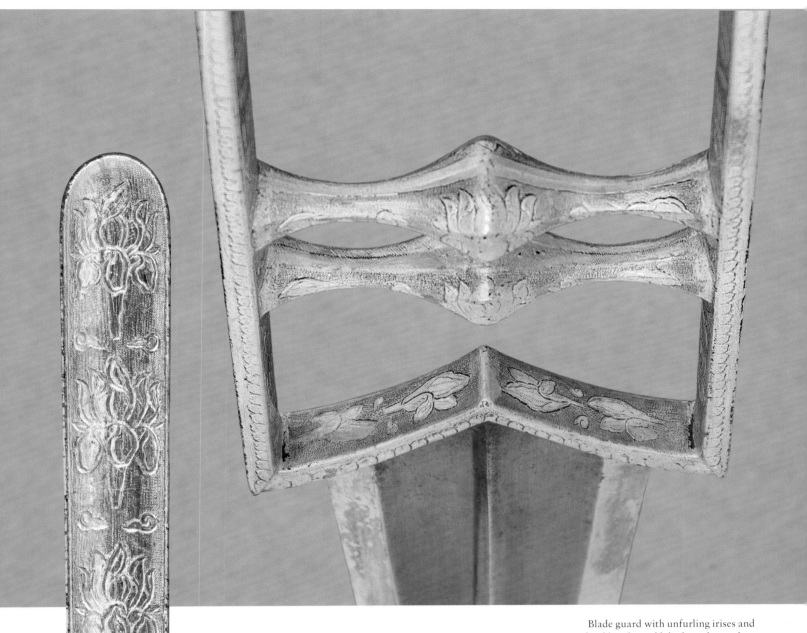

Blade guard with unfurling irises and
cloud bands, and lobed petals on edges

Irises with overturned petals
in counterchanging orientation
and cloud bands on side-bars

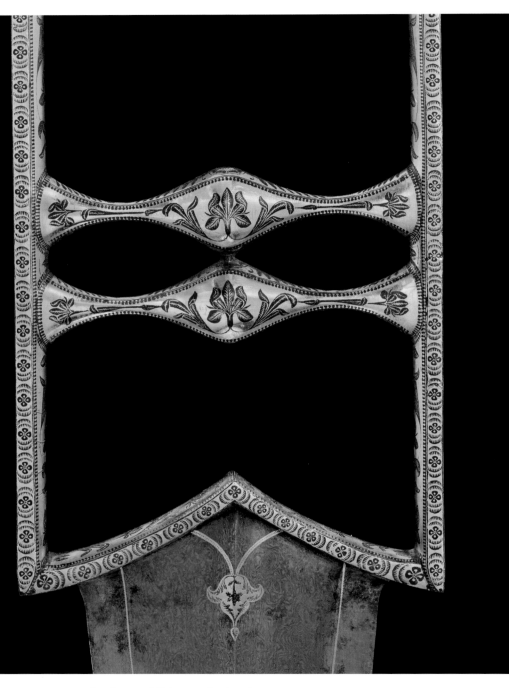

Small quatrefoils between hachured
brackets on edges of side-bars and
blade guard, and gold trefoil pendant
on blade

Side-bar with scrolls of irises in
reserve on gold ground

Cat. 23 *KATAR* DAGGER INLAID
WITH GOLD
**Probably Deccan, late
seventeenth century**
Hilt of patinated steel inlaid with
gold; blade of *jawhar* steel, inlaid
with gold
Dimensions: Length 44 cm; width 8 cm
Provenance: Art market 1997
Published: Keene and Kaoukji 2001, cat. 7.2
Inv. no. LNS 901 M

The concave side-bars of this *katar*
dagger are covered with gold decorated
in reserve with scrolling vines of finely
detailed, graduated iris blossoms and leaves
overturned on their tips, which, although
of more formal and rigid mien, recall the
scrolling vines and leaf representation
on the enamelled *katar* Cat. 9. A smaller
version of the same scrolling vines issuing
irises decorates the upper edge of the
cusped blade guard.

The grip-bars feature single irises
between pairs of curling leaves, and irises
and starburst rosettes issuing tendrils
and long feathery pinnate leaves on the
underside, evocative of the type depicted
on Deccan kalamkaris and on bidri-ware.[69]
On the underside of the blade guard,
pairs of chevron-like cypress trees grow
from stepped mounds on either side of the
blade, with minuscule pinnate leaves in the
interstitial areas.

Outlining the faces of the side-bars is a
miniscule crenellated motif, and the edges of
the hilt are covered with reserved quatrefoils
between paired hachured brackets.

The double-edged blade thickens along
the edges and at the tip, and features a fine
jawhar pattern outlined with a gold fillet,
and a detailed pendant trefoil, virtually
identical to the one on the blade of the
following example (Cat. 24), that straddles
the median ridge.

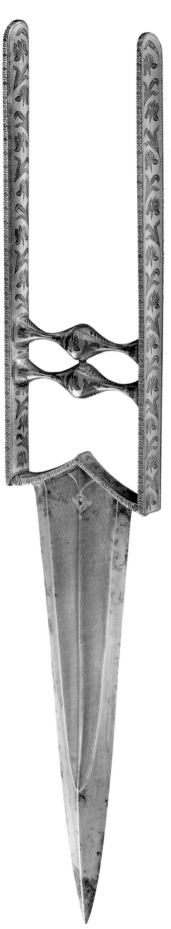

Cat. 24 *KATAR* DAGGER INLAID WITH GOLD
Probably Deccan, late seventeenth century
Hilt of patinated steel inlaid with gold; blade of *jawhar* steel, inlaid with gold
Dimensions: Length 44 cm; width 9 cm
Provenance: Art market 1991
Published: Keene and Kaoukji 2001, cat. 7.1
Inv. no. LNS 303 M

Probably produced in the same workshop as Cat. 23, this dagger hilt is decorated with a fine leaf and floral lattice outlined on the side-bars with minuscule circlets reserved in the blued steel, using a method involving heating to preserve steel from rust that was practised in Europe from the early fifteenth century and was quite likely introduced to India around the sixteenth century.[70] The lattice of serrated leaves with small quatrefoils on their points of intersection recalls similar motifs on bidri-ware.[71] The enclosed, stemmed flowers with overturned petals are halved on the edges of the side-bars, thus once again evoking an uninterrupted geometric pattern. The edges of the side-bars are covered with quatrefoils made up of four circlets.

The flared prismatic ends of the grip-bars feature serrated leaves, which are replicated on the lobed edges of the blade guard and probably represent acanthus leaves, a motif frequently featured on the quillon-borders of daggers.

As in the preceding example, the upper edge of the cusped blade guard is decorated with a smaller version of the lattice featured on the side-bars, and on the underside a pair of cypress trees border the edges of the blade, with small pinnate leaves in the interstitial areas.

The double-edged blade thickens along the edges and at the tip, and features a fine *jawhar* outlined with a gold fillet and a fine detailed pendant trefoil, virtually identical to the trefoil on Cat. 23.

The similarity in the treatment of the dagger decoration and details thereof, as well as the blade, allows one to assume that both *katar*s were produced in the same workshop.

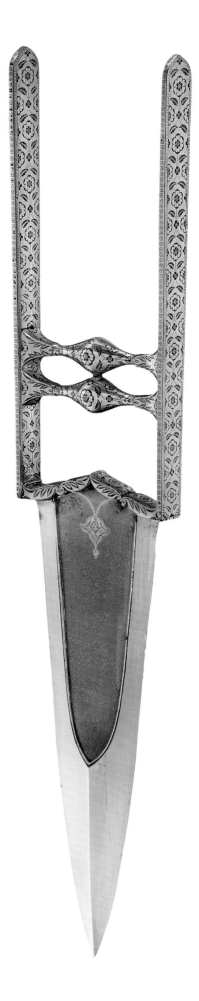

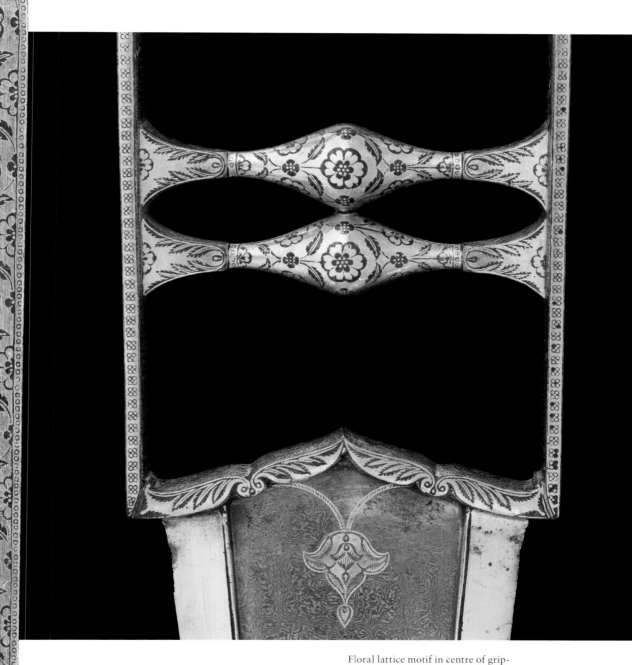

Floral lattice motif in centre of grip-bars, large serrated leaves on grip-bars and edges of blade guard, and gold trefoil pendant on blade

Lattice of serrated leaves enclosing blossoms on side-bars

Cat. 25 *KATAR* DAGGER OVERLAID
WITH COPPER AND
INLAID WITH SILVER
AND GOLD
**Deccan, late seventeenth–
early eighteenth century**
Hilt, steel, overlaid with copper
and inlaid with silver and gold;
blade, steel (repolished), with
etched Devanagari inscription
Dimensions: Length 48 cm; width 9 cm
Provenance: Art market 1980s
Published: Keene and Kaoukji 2001, cat. 7.14
Inv. no. LNS 185 M

The uninterrupted pattern of silver
stylized lotus leaves or poppy flowers,
inlaid on a copper ground and outlined in
gold, covering the entire hilt, represents
yet another instance of geometric floral
patterns on the hilt of a *katar*.[72] The
blending of metals of different colours
and the motif of stemmed fan-shaped
leaves must have been quite popular in the
Deccan, as it is frequently represented on
vessels from the period.[73]

The same floral pattern decorates
the blade guard and grip-bars, which are
connected in the centre and related in form
to the grip-bars of Cats. 22, 23 and 24.
The side-bar edges are outlined with silver
rectangles on the copper ground.

The blade guard is pronouncedly
cusped, and, as is the case with the *katar*s
Cats. 23 and 24, is made to appear as
though it suspends the trefoil straddling
the median ridge of the blade. The heavily
corroded double-edged blade thickens
along the edges and at the tip, and features
a ground depression acid-etched with a
Devanagari inscription reading: *ra ki po 1*.[74]

Traces of clumsy solder outline the edge
of the blade on the underside of the blade
guard where the blade joins the hilt.

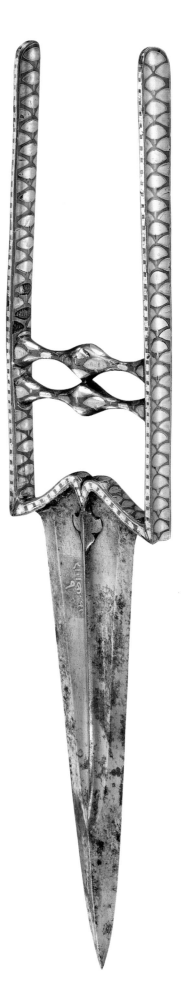

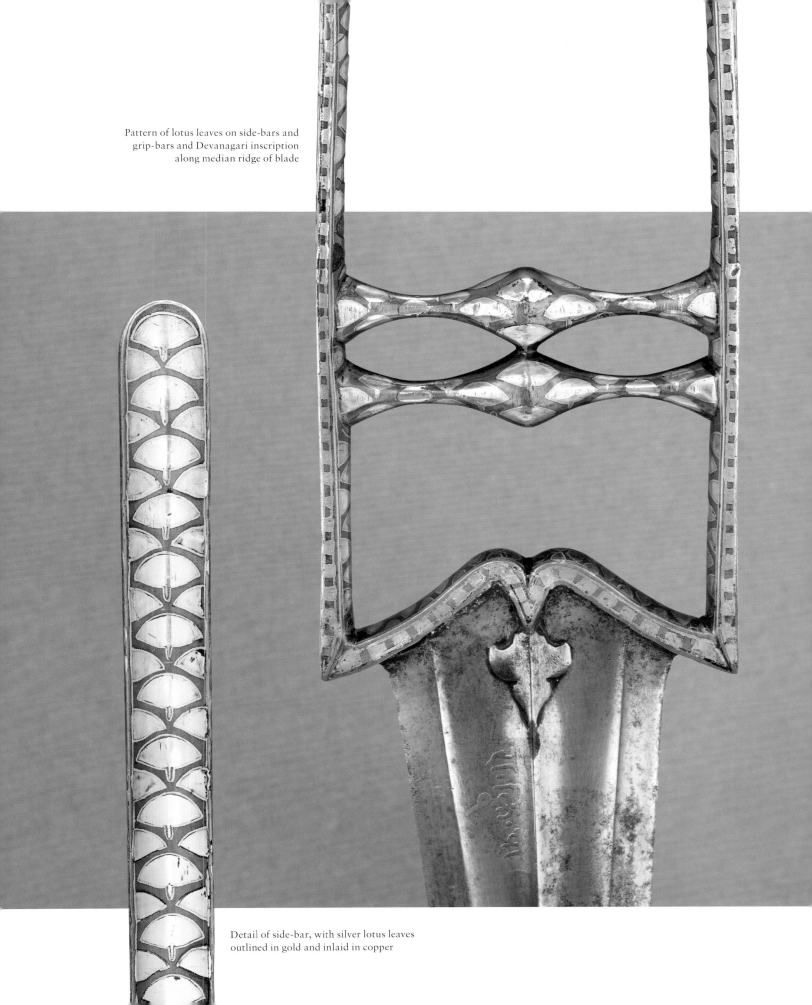

Pattern of lotus leaves on side-bars and
grip-bars and Devanagari inscription
along median ridge of blade

Detail of side-bar, with silver lotus leaves
outlined in gold and inlaid in copper

NOTES

1 Most armour represented in early Indian wall-paintings or sculpture consists of bows and arrows, swords, daggers, lances and spears, clubs, maces, axes, tridents and shields, for which see: Behl 1998; Czuma 1985; Huntington and Huntington 1999; Knox 1992; Meister et al. 1988; Pal 1986; Rosenfield 1967; Sivaramamurti 1977, especially the eleventh-century Chandella friezes of the Khajuraho, Lakshmana temple, pp. 402–08.

2 Kangle 2003, vol. II, p. 133, n. 14: "Kuṭhāra, paṭṭāsa … are razor-type weapons." Certain authors have suggested that the *maustika*, mentioned in Indian epics and described as a "fist" weapon a span long, might have been a *katar*: Frederick Wilkinson, "India and Southeast Asia", in Coe 1989, p. 186.

3 Biruni 1958, pp. 92 and 145. It is worth mentioning here that in E. C. Sachau's translation of the same (Sachau 1989, p. 120), they are referred to as "*kuṭâra*" instead of "*katārāt*" and called "axes", about which there is no mention in the Arabic text.

4 Naser-e Khusraw 1986, pp. 70 and 80.

5 Elgood 2004a, in the Glossary, p. 250, refers to Simon Digby, who supplied him with the reference to *katar*s in *Adab al-Harb*: "The katārā is a weapon of Hindus and the reckless and rebels." Elgood adds, "From this Digby concludes that the weapon had already been adopted by non-Hindus by about 1300 … This is confirmed by another passage in the manuscript where the katārā appears high on the list of suitable presents to be sent in embassies." Elgood confirms our observation that the *katar* is "conspicuously missing from early Hindu sculptures as well as from the mid-fifteenth century *Laur Chanda* (in the Staatsbibliothek zu Berlin Preussischer Kulturbesitz which is vaguely attributed to central India)".

6 Ibn Battuta 1966, p. 355 and n. 3, pp. 362 and 367.

7 Yule and Burnell 1996, pp. 496–97, and Ibn Battuta 1990, vol. III, p. 169.

8 See e.g. Stone 1961, p. 345, "Among the Mahrattas the gauntlet sword, pata, was evolved from the katar," and on pp. 484–85, where he purports to trace the structural development from *katar* to *pata*: "Pata. The Indian gauntlet sword, which is an evolution from the katar … It was a favorite weapon with the Mahrattas, but was also used by most of the Indian nations. It has been said that it was not used by the Mohammedans but this is not the case." Reinforcing that view, Pant 1980, p. 61, states: "Patta or Pata. It is the typical Indian gauntlet sword and seems to have evolved from *jamadhar* (commonly known as *katar*)." He quotes Stone as having rightly remarked "that the gauntlet sword (i.e., *patta*) of the Marathas was evolved from the *jamadhar* (*katar* of G. C. Stone)" (p. 111) and says: "It has wrongly been suggested that the prototype of *patta* was the long South Indian dagger with a transverse grip and shell guard known as *bara jamdadu*. Bara jamdadu is of a later origin and has nothing to do with the *patta*

which might, as said earlier, have evolved from the *jamadhar*" (p. 63).

9 Stone 1961, p. 485: "The gauntlet sword deprives a man of the use of his wrist and would be a very awkward weapon for fencing, and it was only used by cavalry."

10 Elgood 2004a, p. 211, fig. API.6.

11 Ibid., p. 157, fig. 15.27, showing a "muslim" rider with a *katar* in his belt from a late sixteenth-century relief of the Vardhamana temple, and p. 160, figs. 15.35 and 15.36, details of seventeenth-century reliefs from Madurai, both from the Tamil Nadu area.

12 Pal 1993, vol. I, pp. 110–11, cat. no. 22. Consultations with Robert Skelton confirm that this must be the earliest-known occurrence. This is but another instance of his ever-generous help.

13 Andhare 1971, fig. 631.

14 Chandra 1976.

15 Leach 1995a, pp. 22ff.

16 Stronge 2002, p. 43, pl. 27; p. 78, pl. 50; and p. 80, pl. 52, all of which are attributed to 1590–95; it is likewise worth mentioning that of twenty-two instances in which the emperor is depicted with weapons in the Victoria and Albert Museum *Akbar Nama* manuscript, he is represented with a *katar* in thirteen miniatures and with various other weapons in nine miniatures. See also Alexander 1996, pp. 138–39, in a miniature attributed to c. 1590; Brand and Lowry 1985, p. 41, fig. 16, in a miniature attributed to 1590–95, and p. 53, fig. 18, in a miniature attributed to c. 1604; Leach 1995a, pp. 249–53, cat. 2.101, 2.102 and 2.103, in miniatures attributed to 1603–05; and Kossak 1997, p. 41, cat. 13, in a miniature attributed to c. 1604, and p. 51, cat. 22, in a posthumous album page attributed to c. 1630.

17 For a discussion of the painting, see Beach 2000, fig. 12, pp. 20 and 24: "The most important page in the Fitzwilliam Album is *Prince Akbar Hunting a Nilgae*. It must be an exact depiction of an event that occurred on 20 July 1555, as Humayun returned to Delhi following his exile … The narrative details of the scene … all correspond to the event as described in the verbal passage. This is therefore a documentary image of an historical subject, and there is no reason to doubt that it was painted at the time of the hunt."

18 Seyller 2002.

19 Semsar 2000, p. 152, in a manuscript of the *Jami' al-Tawarikh* dated 1596 in the Golestan Library, Tehran.

20 Babur 1987, p. 528, lists gifts granted by the emperor to princes, notables and officers on the occasion of the end of the month of fasting (Ramadan): "2 items (*rā's*) of *tīpuchāk* horses with saddles; 16 items (*qabża*) of poinards, set with jewels, etc.; 8 items (*qabża*) of purpet [perpet] over-garments; 2 items (*tob*) of jewelled sword-belts; – items (*qabża*) of broad daggers (*jamd'har*) set with jewels; 25 items of jewelled daggers (*khanjar*); – items of gold-hilted Hindī knives (*kārd*); 51 pieces of purpet." Gul Badan Begam 1983, p. 124, has a description of armour housed in the "House of Dominion" (*Khane-i Dawlat*) during a feast commemorating

the accession of the emperor Humayun "such as a jewelled scimitar and gilded armour, a broad dagger (*jamdahr*, جمدهر, p. 33 in the Persian text), and a curved dagger." See also Lowe 1973, p. 144: "When the Emperor [Akbar] arrived in the neighbourhood of Mīrt'ha, news came that a Rājpūt at Sarohī having come as an ambassador had struck Khāni Kalān with a *jamd'har* [translator's note: "Sanskrit *jamd'hara* 'death-bearer,' a large dagger with a basket hilt"], which is the name of a weapon well-known among the people of Hind. The weapon pierced his breast and came out at the shoulder-blade, but the wound was not mortal."

21 It is noteworthy that there is no mention of *katar* or *jamdhar* in medieval Arab dictionaries, and that in the Persian dictionaries, the *Farhang-e Jahangiri* compiled in 1017 H/1608–09 CE (Inju Shirazi 1975, vol. I, p. 696) and the *Loghatnameh-ye Dehkhoda* compiled in the first half of the twentieth century (Dehkhoda, vol. XII, p. 18167), both authors have entries for *katara* and *katala* and cite passages from early medieval sources (including Naser-e Khusraw and al-Bayhaqi) in which such a dagger is referred to mostly in association with India, but the dagger in question is not described. Furthermore, in the *Borhan-e Qati'* compiled in 1062 H/1651–52 CE (Borhan-e Qate'-Mo'in 1979, vol. II, p. 586), the author lists the weapon under *jamdar* and says that in India it is called a *katar*. We are deeply grateful to Manijeh Bayani for her generous help in supplying the information from the above-mentioned dictionaries.

22 Egerton 1880, pl. I, figs. 21, 26, 27 and 32, and quoting Langlès, *Monuments de l'Hindoustan*, vol. I, p. 228.

23 Egerton 1880, pl. VII and p. 55.

24 Ibid., pl. IX, figs. 335, 344 and 345.

25 Ibid., pl. X, fig. 512.

26 Ibid., pl. X, fig. 513, and related entry on p. 116.

27 Pant 1980, pp. 151–52: "Bara Jamadadu. It is a Maratha form of *jamadhar* intermediate in size between the usual *jamadhar* and the gauntlet (*patta*) sword. The name literally means 'big *jamadhar*' (*jamadhadu* is the corrupt form of *jamadhar*). As has already been explained it will be wrong to assume that *patta* has evolved from *bara jamadadu*. Bara Jamadhadu is of a later origin and has nothing to do with the *patta* which, of course, seems to have evolved from the *jamadhar*." Elgood 2004a, p. 236, confirms that: "Bārā-Jamdadu Marāṭha *katār* with a long blade and a guard covering the back of the hand."

28 On a folio from a *Darab-nameh* attributed to c. 1577–80 a courtier wears a *katar* with a bar protecting the back of the hand (Seyller 2002, p. 49, fig. 19), and on a page from the *Salim Album* attributed to 1595–1600 a nobleman seated beneath a tree wears the same type of *katar* (Dye 2001, p. 240, cat. no. 80b).

29 Pant 1980, p. 163. Our thanks go to Robert Skelton for bringing this passage to our attention.

30 See note 12.

31 Elgood 2004a, ch. 15, pp. 145–62, esp. p. 145, fig. 15.1.

32 A bowl dated 1089 H (1678–79 CE), inscribed with the invocation to Imam 'Ali including an invocation to the Prophet Muhammad, is, according to A. Melikian-Chirvani, "a variant not found in earlier versions" (Melikian-Chirvani 1982, cat. no. 155, pp. 336–37).

33 I am grateful to Dr Alain George for bringing to my attention the usage of "*madar al-din*" in al-Nuwayri, *Nihayat al-'Arab fi Fununi 'l-'Adab*, Beirut, 2004, vol. VI, p. 7.

34 C. E. Bosworth, *The New Islamic Dynasties: A Chronological and Genealogical Manual*, Edinburgh, 2004, pp. 310–11.

35 A system in which the letters of the Arabic alphabet are assigned numerical values, and their cumulative values often used for dating.

36 Generally *katar*s depicted in paintings from the late sixteenth and early seventeenth centuries have long and at times curving blades as well as prominent blade guards. For such representations, see Seyller 2002, cat. 38, in a painting from the *Hamza-nameh* dated to c. 1570, and in a painting from a *Darab-nameh*, dated to c. 1577–80, p. 49, fig. 19. See also Leach 1995a for *katar*s depicted in the c. 1580 *Tuti-nameh*, cats. 1.2, 1.5, 1.8, 1.44, and in the c. 1595 *'Iyar-i Danish*, cats. 1.103 and 1.165; Brand and Lowry 1985, p. 83, fig. 52, for the *katar* in the c. 1585 portrait of a "Muslim courtier"; Stronge 2002, pl. 60, in a painting from the 1598 *Razm-nameh*; Pal 1993, respectively cats. 57 and 64, a *katar* depicted in a *Gulistan* of Sa'di from c. 1595 and in the portrait of a falconer from c. 1600–05; Welch 1978, a long *katar* worn by Emperor Akbar in a painting by Manohar from c. 1604, pl. 15, and a long *katar* in the portrait of an Abyssinian from Ahmadnagar, c. 1633, pl. 34.

37 Related elements join the grip-bars of a *katar* depicted in a painting attributed to Ahmadnagar, c. 1590–95; Losty 2015, cat. 2, detail p. 11.

38 A long *katar* with pronounced angular blade guard can be seen in what is said could be a portrait of Sultan Ibrahim 'Adil Shah II of Bijapur (r. 1580–1627), dated to the early seventeenth century, and in a drawing representing a "royal picnic" attributed to Ahmadnagar, c. 1590–95; Haidar and Sarkar 2015, p. 118, cat. 43, and p. 68, cat. 17.

39 See e.g. Untracht 1997, p. 96, cat. 156, and p. 232, cat. 490.

40 Although the large majority of weapons presented to the Prince of Wales by Indian princes and nobles during his visit to India in 1875–76 have not been given date attributions when registered in Sandringham, and given that one cannot rely on provenance as weapons tended to move around, it is nevertheless interesting that all examples of *katar*s with arched blade guards have been attributed to areas in southern India. See e.g. Clarke 2008b, group P, nos. 259 and 260, and group D, no. 373.

41 Keene and Kaoukji 2001, cat. 2.11, a box either used to contain lime paste to bind ingredients in the preparation of paan, or to contain a bezoar stone, a prized and sought-after spheroidal excretion found in the stomachs of certain ruminants that was believed to serve as an antidote to poison. For a similar container, see Komaroff 2011, cat. 132, fig. 242. An open case displaying a bezoar stone can also be seen on the Metropolitan Museum of Art site (inv. no. 2004.244a–d, http://www.metmuseum.org/art/collection/search/454738).

42 Keene and Kaoukji 2001, cat. 13.3; for the same type of gold work, see also the settings separating the stones on the finger ring, cat. 1.15.

43 Ibid., cat. 13.4a.

44 Haidar and Sarkar 2015, pp. 268–77; p. 145, cat. 63.

45 For representation of insects on an enamelled *huqqa* ring in The al-Sabah Collection, Keene and Kaoukji 2001, cat. 6.14 (inv. no. LNS 2 J).

46 Haidar and Sarkar 2015, p. 23, fig. 16, and p. 132, cat. 54; p. 213, cat. 106, attributed to Golconda 1630–40.

47 See e.g. the borders composed of flowers, cloud bands and insects from the Minto, Wantage and Kevorkian albums, Stronge 2002, pls. 88, 94, 95, 101, 102, 107, 124, 127 and 131; also Welch et al. 1987, cats. 10–12, 14, 16, 18, 20–22, 24, 44, 45, 50, 48, 52, 53, 65–67, 69, 77, 78.

48 Jahangir 1978, vol. II, p. 145.

49 The marble end panel of Emperor Akbar's cenotaph reproduced in Stronge 2002, pl. 134.

50 Haidar and Sardar 2015, cat. 31, as well as cat. 47.

51 In Zebrowski 1997 fig. 526 features rows of tiger stripes and dotted quatrefoils, and fig. 242, staggered rows of tiger stripes.

52 Haidar and Sarkar 2015, pp. 292–93, cat. 169.

53 For a similar but stylized representation on a bidri ewer and basin dated to the seventeenth century, see Zebrowski 1997, p. 168, cat. 238.

54 A decorative motif that likewise occurs on cats. 6, 61 and 76, the edge of the locket of cat. 48, and on the edges of the chapes of cats. 63 and 106.

55 See e.g. the Hellenistic scrolls in Pfrommer 1993, figs. 23–26.

56 See e.g. what appears to be a white enamelled *katar* with red blossoms tucked in the sash of an unidentified nobleman, Akimushkin 1996, pl. 227.

57 Schotten-Merklinger 1981, p. 84, fig. 143.

58 Schotten-Merklinger 1976/77, pp. 155–56.

59 See cat. 65, note 5.

60 See e.g. the feline faces in the album pages depicting the *waqwaq* theme, Haidar and Sarkar 2015, p. 135, fig. 55, and p. 213, cat. 106.

61 See Clarke 2008a, case N, no. 282, for a *katar* of similar configuration and with what appears to be closely related decoration described as having "an enameled floral design of white flowers and green leaves on a green ground".

62 Zebrowski 1997, p. 190, no. 283; p. 229, no. 372; p. 230, no. 374; p. 231, no. 377; p. 249, no. 423; p. 250, no. 425; col. pl. nos. 486, 507, 512.

63 Anand 1979, especially the vegetal representations on a floorspread from Golconda from about 1630, p. 98, fig. 1, and on a rumal or napkin likewise from Golconda, probably from the second half of the seventeenth century, p. 102, fig. 3.

64 Haidar and Sarkar 2015, cats. 81, 82, 84, 86–89.

65 Ibid., p. 131, cat. 53.

66 Beach and Koch 1997, esp. fig. 51, detail of cat. 36, attributed to Payag.

67 Similar representations of unfurling iris buds can be seen on an enamelled lidded cup and tray, in which the buds on the cup and on the tray undulate in counterchanging orientation, Keene and Kaoukji 2001, cat. 6.38 (LNS 2191 J).

68 For a painting attributed to Ahmadnagar c. 1565–95 depicting a *katar* with swelling grip-bars flared at their ends, Haidar and Sarkar 2015, p. 65, cat. 14. Interestingly, although most of the Indian weapons housed in Marlborough House are not dated, one of the *katar*s attributed to the early seventeenth century displays pronounced swelling in the centre of the grip-bars which flare on their ends, and is described as being damascened with gold in floral designs, Clarke 2008a, case A, no. 4.

69 Zebrowski 1997, see e.g. pp. 228–29, and p. 233, cats. 382, 384 and 386, and p. 274, cat. 473.

70 Pyhrr and Godoy 1998, p. 15.

71 For leaf lattice motifs punctuated by quatrefoils at the points of intersection, see Zebrowski 1997, p. 133, cat. 161; p. 260, cat. 442; and p. 190, cat. 283; and the leaf lattices, p. 233, cat. 387, and p. 274, cat. 470; also the leafy lattice punctuated with quatrefoils featured on a carpet fragment in The al-Sabah Collection, attributed to Hyderabad, Spuhler 2012, p. 166, cat. 40.

72 For similar floral representation, see the floral lattice on a mango-shaped bidri vessel, Zebrowski, p. 240, cat. 410, and on carpet weights, p. 132, cat. 160; for the same type of flower on palanquin finials, see Haidar and Sarkar 2015, pp. 246–47, cat. 142.

73 From The al-Sabah Collection, an enamelled box (inv. no. LNS 2175 J), a *huqqa* mouthpiece (LNS 171 J) and a bracelet (LNS 162 J) feature identical vegetal motifs, Keene and Kaoukji 2001, respectively, cats. 6.48, 6.49 and 6.55; also, the decoration on a dagger and scabbard reportedly from the Deccan in the Khalili Collection (inv. MTW 1146), Shcherbina 2014, cat. 127, pp. 224–25.

74 We are grateful to Robert Skelton for reading the inscription on the blade, which he suggested might refer to an abbreviation of treasury "po[t?]" and either to an inventory number, "k 1", or the type of property stored therein, "ki".

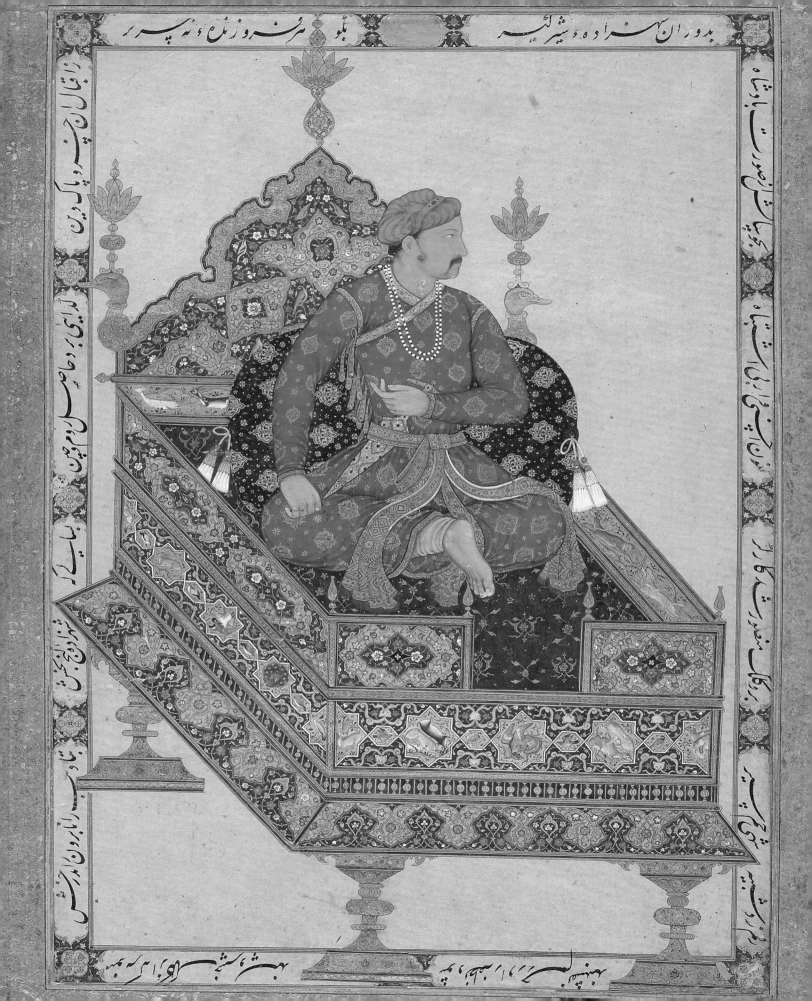

CHAPTER TWO
THE *CHILANUM*
AN UNINTERRUPTED TRADITION

Indian edged weapons with pommels in the form of bars appear to have evolved from forged copper weapons of the so-called "antennae" hilt type from the second millennium BCE that were reportedly found in Fathgarh, Uttar Pradesh.[1] Although there is evidence of the type from archaeological sites spanning a wide geographical and temporal range,[2] it seems only to have been in India that this hilt retained its basic structure over an extended period, as is borne out by daggers attributed to the first century CE excavated at Taxila.[3] In fact it is quite likely that with time this simple forged linear bar evolved into more appealing and elaborate forms, as can be seen on a second-century BCE sword from Bharhut composed of slanting bars with a knob finial in the centre, and on a fourth- to fifth-century CE sword with undulating bars from the Gupta period.[4]

Scattered examples of the "pommel bar" or *chilanum* hilt, with either linear or curved bars and a knob finial can be seen in Indian painting and stone reliefs from the sixth to the twelfth centuries CE, almost uninterruptedly, and mostly in the territories of north-central India.[5] Having said that, related daggers with somewhat comparable "fleur-de-lys"-shaped hilts are worn by figures depicted in temple mandapas from the sixteenth century in Kanchipuram and in Hampi.[6]

THE CONNECTION WITH
NORTH-WESTERN INDIA

From around the middle of the fifteenth to the middle of the sixteenth century, these daggers – either with plain horizontal bars or with bars that undulate and curl at their ends, closely related in form to the seventh-century dagger on the relief of the god Revanta in Sarnath[7] – appear to have become a dagger of choice. Manifestations of this type of hilt, fitted on daggers but less often on swords, are frequently represented in so-called "Western Indian" paintings, such as in a manuscript of the *Shah-nameh* attributed to "probably central India", *c.* 1450;[8] in a manuscript of the *Laur-Chanda* with a possible attribution to late fifteenth-century Uttar Pradesh;[9] on two folios from the *Bhagavata Purana*, ascribed to the Delhi-Agra area, around the first half

of the sixteenth century;[10] worn by Sultan Husayn Nizam Shah I of Ahmadnagar, in a painting dated 1554;[11] on a folio from the *Hamza-nameh* attributed to 1562;[12] and on two folios from a *Laur-Chanda*, which Basil Gray attributes to the middle of the sixteenth century, with a connection to Gujarat.[13]

The association with Gujarat seems deep-rooted, as daggers of the *chilanum* type without a knuckle guard, like Cat. 26, are illustrated by the Gujarati painter Sur Das in the *c.* 1603–05 manuscript of the *Akbar-nameh*, in which all the members of a Gujarati delegation visiting the emperor Akbar are depicted wearing such daggers tucked in their sashes.[14] Furthermore it has been said that: "Sur Das was assigned the entire narration of the emperor Akbar's Gujarati campaign and is responsible for a particularly striking illustration of western natives presenting themselves to Akbar in local dress."[15] In addition, interconnections from adjacent areas can be seen in a folio of Nizami's *Khamsah* copied in Lahore in 1597–98, where Gujaratis are depicted wearing the same type of dagger,[16] and in a *c.* 1580 portrait of Tansen, the great musician at Akbar's court, who was reportedly from Gwalior.[17] It is clear from these examples that most representations of the type are depicted in paintings from the north-central parts of India, mainly Gujarat, Rajasthan, Haryana, Maharashtra and the Delhi-Agra area, and as the "antennae" swords from the second millennium BCE were found in Uttar Pradesh, it is therefore quite likely that the type was most widely used in that area.

After the middle of the sixteenth century this type of hilt, with either linear or curling bars, with or without a central moulding, becomes increasingly fashionable and a large number suddenly appear in manuscripts from the early period of Emperor Akbar's reign.[18] It is curious, however, that the emperor, who was known to have played a significant role in setting new styles of dress at court, is more frequently depicted with *katar* daggers tucked in his sash. Nevertheless, a number of *chilanum* daggers are featured in manuscripts of the *Tuti-nameh* from *c.* 1560–65 (Cleveland Museum)[19] and from *c.* 1580 (Chester Beatty Library).[20]

A painting from the St Petersburg Muraqqa' album, depicting Prince Nur al-Din Muhammad Salim, the future Emperor Jahangir, wearing a *chilanum* tucked in his sash, by Manohar and Mansur, *c.* 1601

POMMEL-BAR HILTS WITH KNUCKLE GUARDS

It is not until towards the end of the sixteenth century that baluster-shaped grips were introduced, and what is probably one of the earliest representations of the type can be seen in a portrait of one of Emperor Akbar's favoured courtiers, the nobleman Ram Das Kachhwaha, dated to *c.* 1590–95.[21] Subsequently, among the earliest examples combining baluster-shaped grips and knuckle guards, is one worn by an officer of Mun'im Khan, Emperor Akbar's commander-in-chief, and another by a courtier depicted in a folio entitled "Courtiers Await News of Akbar's Health", in the *c.* 1603–05 copy of the *Akbar-nameh* manuscript from the Chester Beatty Library.[22] Also, in a painting representing Emperor Jahangir with Prince Khurram dated to *c.* 1600–10, the emperor is depicted wearing a *chilanum* with knuckle guard tucked in his sash.[23]

Although it has been suggested by some arms and armour specialists that knuckle guards derived from European prototypes introduced by Western travellers to the Mughal court,[24] it is noteworthy that swords fitted with knuckle guards are brandished by warriors on Tamil Chola temple reliefs from as early as the eleventh and twelfth centuries CE.[25] Furthermore, a *chilanum* dagger and swords with knuckle guards are illustrated in the *Nujum al-'Ulum* (Stars of Sciences) manuscript,[26] dated 14 Rabi' al-Awwal 978 H (August 1570 CE),[27] produced for the Deccan Sultan of Bijapur. Since the Mughals did not rule the Chola territories of southern India, or conquer Bijapur until the later part of the seventeenth century, there appear to be some grounds for the argument. Thus it is conceivable that in territories under Mughal dominion the practice of fitting hilts with knuckle guards did derive from a fashion introduced by Europeans,[28] as it is not until the 1560s to the 1580s, following the arrival

of Westerners at the court, that swords fitted with knuckle guards make an appearance – though patchy – in painting from the area.[29]

Interestingly, however, although swords fitted with knuckle guards are featured in the *Hamza-nameh* dated to 1567–82,[30] and even though a number of daggers with pommel-bar hilts are depicted in the manuscript, none of the latter are fitted with knuckle guards. This is despite the fact that a few examples fitted with knuckle guards (which appear to be the first occurrences from the period) are represented in manuscripts from around the same period, such as in the Cleveland Museum manuscript of the *Tuti-nameh*.[31] A number of illustrations from the manuscript have reportedly suffered some overpainting, however, which casts doubt on the date and accuracy of its depiction of the pommel-bar hilts.

Furthermore, a dagger with a knuckle guard, of a type closely related to those fitted on swords in the *Hamzah-nameh* in that the upper end of the knuckle guard is disconnected from the pommel bar, is depicted in a folio from Jami's *Nafahat al-Uns*, copied at Agra during Emperor Akbar's forty-ninth regnal year (1604–05).[32]

A TYPE FAVOURED BY THE COURT

It is likely that the adoption of this type of dagger at the court might have been brought about by Prince Salim, the future Emperor Jahangir, as he is portrayed in a painting attributed to Allahabad (Uttar Pradesh, where many of the antecedent hilt types emerged), 1601, wearing what appears to be a jewelled *chilanum* dagger without a knuckle guard, but with a scabbard closely related to the scabbard of the jewelled dagger Cat. 27.[33] Prince Salim is likewise depicted wearing the same type of dagger with a baluster-shaped grip in a folio from the *Divan* of Amir Hasan Dihlawi copied at Allahabad and dated 27 Muharram 1011 H (1602–03 CE),[34] both surely

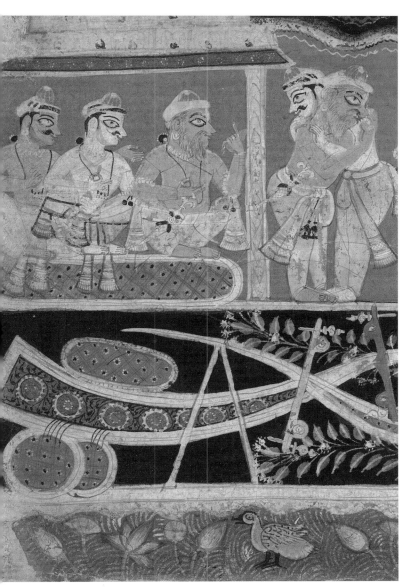

an indication that the future emperor favoured this type of dagger.

During the early period of Emperor Jahangir's reign, jewelled *chilanum* daggers, with and without knuckle guards, are represented with increasing frequency in connection with princes and dignitaries of the Mughal court. The type most likely grew more fashionable as it became known that it was favoured by the emperor, who was depicted wearing a jewelled *chilanum* closely related to Cat. 27 in a formal portrait with his father-in law and advisor, I'timadudaula, dated to *c.* 1615, as well as in a folio from a dispersed copy of the *Jahangir-nameh* dated to *c.* 1620.[35]

Clearly the taste for this type of dagger passed from father to son, as Shah Jahan is represented wearing a jewelled *chilanum* in a portrait from 1616–17 of him as a prince in his twenty-fifth year, in a portrait of him as emperor dated 1041 H (1631–32 CE),[36] and in a folio from the *Padshah-nameh* manuscript of *c.* 1640, illustrating an event that occurred in 1617.[37]

It is not known why the type seems to have lost its appeal from the late seventeenth century onwards. Representations of the *chilanum* dagger gradually diminish in paintings from the period, despite the weapon only a few decades earlier having been deemed sufficiently important to be decorated in such an opulent manner as our example Cat. 27 and once so frequently depicted worn by Mughal princes and emperors. Sadly, we shall probably never know the answer.

Attendants wearing *chilanum*s look on as Nanda greets Vasudeva in a manuscript of the *Bhagavata Purana* (Ancient Stories of Lord Vishnu), Delhi-Agra area, *c.* 1520–30

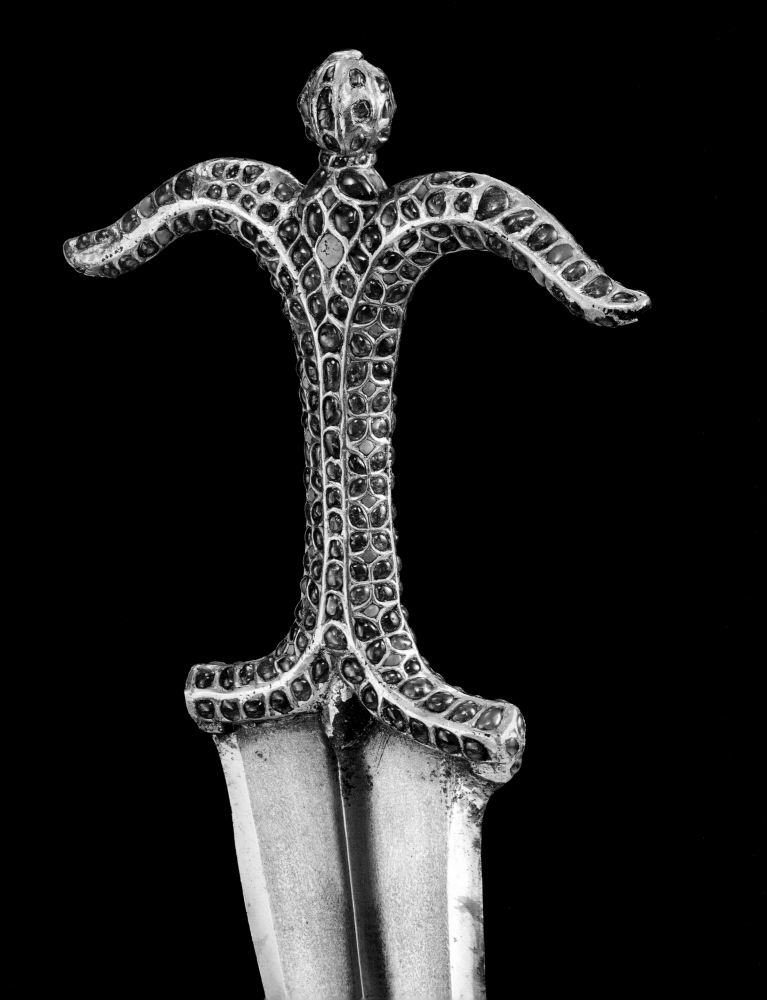

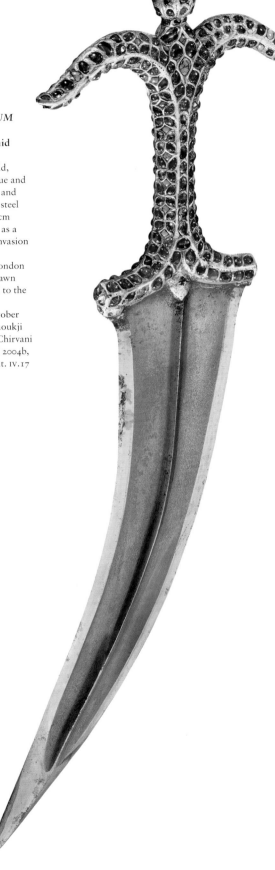

Cat. 26 JEWELLED *CHILANUM* DAGGER
Mughal dominions, *c.* mid sixteenth century
Hilt, iron overlaid with gold, worked in *kundan* technique and set with rubies, turquoises and emeralds; blade of *jawhar* steel
Dimensions: Length 34 cm; width 10.5 cm
Provenance: Art market 1980s (missing as a consequence of the Iraqi invasion of Kuwait in August 1990; recognized at auction in London in 1996; graciously withdrawn from the sale and returned to the Collection)
Published: Sotheby's, London, 17 October 1996, lot 46; Keene and Kaoukji 2001, cat. 13.1; Melikian-Chirvani 2004, p. 22, fig. 14; Elgood 2004b, p. 80, fig. 5; Calza 2012, cat. IV.17
Inv. no. LNS 113 J

Floral pattern on hilt

Of a type frequently depicted in paintings from around the middle of the sixteenth to the beginning of the seventeenth centuries, the graceful hilt of this dagger to a great extent retains the basic structure of the "antennae" hilts from the second millennium BCE.[38]

The hilt is heavily overlaid with gold (unfortunately, subjected to later reworking) and decorated with a geometric floral pattern composed of overlapping "circles" forming ruby quatrefoils with turquoises in the intervening areas, which recalls the motif on the upper edge of the renowned sixteenth-century Mughal gem-set gold spoon in the Victoria and Albert Museum.[39] Interrupting the geometric pattern is the row of petal-like rubies, randomly interspersed with pale emeralds, that develops from the tip of the quillon and follows the outline of the hilt extending along the centre of the prismatic grip to the ends of the sinuous pommel bars, which are encircled just before their tips with turquoises.

Ruby quatrefoils decorate the quillon terminals, and ruby and turquoise petals in a lotus configuration encircle the base of the bud finial, a form that seems to anticipate the more angular version that occurs below the finials in three later *chilanum* daggers in the Collection (Cats. 27, 30 and 31). The bud finial is set with an alignment of rubies interspersed with pale emeralds, and is capped with a single ruby.

The double-edged curved blade, the shape of which is typical of this type of dagger, has a fine *jawhar* pattern, with median ridge and attenuated chevron fullers, is reinforced at the tip and features a small, raised escutcheon-shaped pendant that retains traces of overlaid gold at the outset of the ridge just below the quillon.

Cat. 27 JEWELLED *CHILANUM* DAGGER AND SCABBARD
Mughal dominions, probably first quarter of the seventeenth century

Hilt and front of scabbard, iron overlaid with gold, engraved and chiselled, and set in *kundan* technique with 1,685 rubies, 271 natural unpolished diamonds, 62 emeralds, 321 pieces of transparent emerald-green glass, 39 pieces of transparent dark middle-blue glass, 9 pieces of ivory and 6 layered agates (grand total of 2,393 "stones", as per Manuel Keene's findings, to which another 26, now missing, must be added, for an original total of 2,419); blade of *jawhar* steel (repolished), overlaid with gold; scabbard, wood covered on the back with gold sheet hammered in relief

Dimensions: Length of dagger 33 cm; width 12 cm; length of scabbard 25 cm
Provenance: Art market 1981
Published: Jenkins et al. 1983, p. 126; Welch 1985, cat. 127; Qaddumi 1987, pp. 121, 153; Amsterdam 1990, p. 165; Atil 1990, cat. 99; Qaddumi 1996, fig. 8b and front cover; Swarup 1996, fig. 50; Bloom and Blair 1997, p. 404, fig. 220; Khalidi 1999, p. 74; Thackston 1999, p. 309; Keene and Kaoukji 2001, cat. 5.2; Melikian-Chirvani 2004, p. 22, fig. 15; Elgood 2004b, p. 90, fig. 15; Vaughan 2004, p. 489; Stronge 2010, pl. 137
Inv. no. LNS 25 J ab

This outstanding dagger, lavishly carpeted with rubies, is a tribute to the eminent skill and virtuosity of artists in the royal workshop from which it originated, and to all who contributed to its elaborate manufacture.

Elephant and horse-head terminals
on quillon and knuckle guard

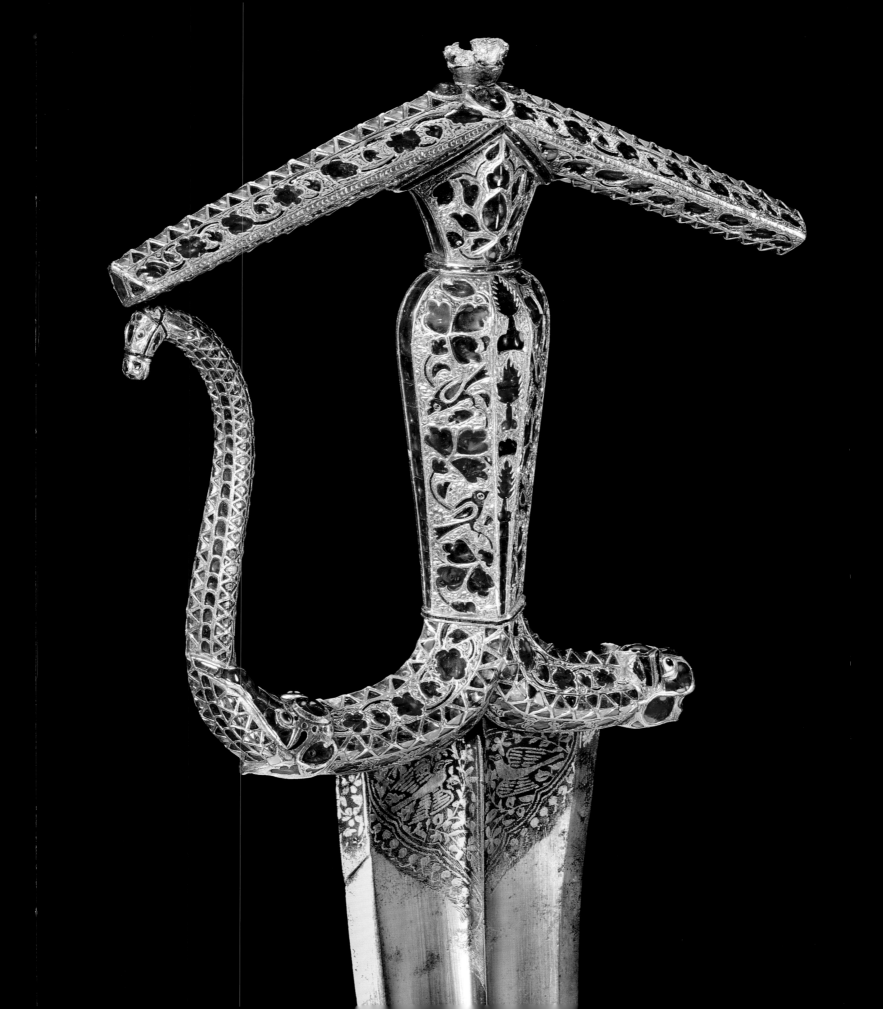

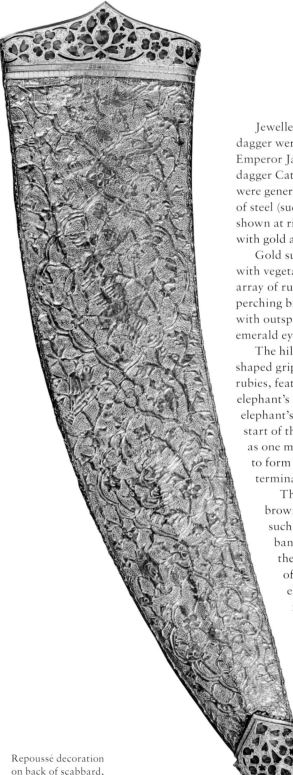

Repoussé decoration
on back of scabbard,
Cat. 27 (LNS 25 J)

Jewelled examples of this type of
dagger were manifestly favoured by
Emperor Jahangir.[40] X-ray analysis of the
dagger Cat. 26 has demonstrated that they
were generally forged from a single piece
of steel (such as the steel core LNS 1023 M,
shown at right) and subsequently overlaid
with gold and set with gems.

Gold surfaces intricately worked
with vegetal motifs complement the wide
array of ruby and emerald cypress trees,
perching birds, scrolling vines and birds
with outspread wings and minuscule
emerald eyes.

The hilt, with its prismatic baluster-
shaped grip outlined with channel-set
rubies, features a tiger's head and an
elephant's head on the quillons. The
elephant's trunk falls onto one side at the
start of the knuckle guard and does not,
as one might think at first glance, extend
to form the knuckle guard, which
terminates in a diminutive horse's head.
The animals' eyes are carved from
brown-and-white banded agate cut in
such a manner as to utilize the white
bands to represent the sclera and
the brown bands to form the iris
of the eye. The tiger's teeth and
elephant's tusks are carved
from ivory.

Most of the hilt's surface
is set with flat, carved
and near-flat channel-set
gemstones, except for the
cross-guard quillons, which
are set with cabochons.
Unfortunately, only the
lower end remains of
the bud finial that
once surmounted
the pommel bar.

Undecorated steel core
(LNS 1023 M) for a dagger
of the same type as Cat. 27

Series of graduated natural octahedral
diamond crystals, each set with only two
faces exposed, define the edges of the
knuckle guard, the cross guard, the upper
and lower edges of the pommel bars, and
the edges of the "chape" (which is integral
to the tip of the scabbard, rather than a
separate fitting). The large quantity of
natural diamonds that must have been
available to enable the jewellers to select
such a graduated series for this dagger
throws light on the exchanges between
areas under Mughal dominion and the
diamond mines of the Deccan. It is worthy
of note that an Indo-Parthian finger ring
in The al-Sabah Collection attributed
to around the middle of the first century
CE is set with a natural diamond crystal,

and inscribed both in Greek and Middle Indian Kharoshti script with the name of the owner.[41]

On the scabbard, raised medallions consisting of rosettes with ruby petals set in the centre with large rubies from which radiate stellated patterns of rubies, emeralds and diamonds evoke carpet and bookbinding designs. The interstitial areas are filled by birds with outspread wings on a ground carpeted with floral vines and lotus blossoms, set with near-flat gemstones. The gem-set upper end that encircles the scabbard, and the tip of the scabbard – which appear to emulate a locket and chape – are adorned with ruby lotuses amid scrolling vines. All the raised decorative elements on the front of the scabbard are linked along the centre by small, raised rhomboid gold settings that call to mind a necklace of rosettes.

The back of the scabbard, which displays much wear, is worked in repoussé, in an arrangement recalling the decorations on the front, consisting of abutted lobed and cusped medallions. Here the ground displays avian and floral designs and ringmatting.

It is noteworthy that green and blue glass was utilized in the decoration of the dagger, but only for very small areas where emeralds and sapphires would lose their intense colour if cut into slices of the required thinness.

The curving double-edged blade is ridged and reinforced at the tip. It has suffered much repolishing due to frequent use, which shows that this sumptuous dagger was not solely for ceremonial purposes. A gold overlaid lobed medallion is filled with a pair of birds flying amid foliage on the ricasso.

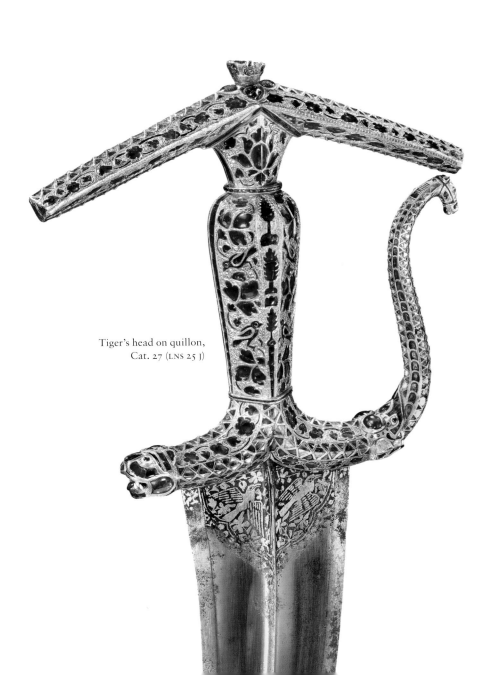

Tiger's head on quillon,
Cat. 27 (LNS 25 J)

Cat. 28 JADE *CHILANUM* DAGGER
Deccan or Mughal
dominions, probably early
seventeenth century
Hilt carved from nephrite jade;
blade of *jawhar* steel
Dimensions: Length 36 cm; width 6.5 cm
Provenance: Art market 1997
Published: Keene and Kaoukji 2001, cat. 8.28
Inv. no. LNS 275 HS

With a pommel closely related in form to that of a dagger that appears in a seventh-century relief of the god Revanta in Sarnath, Uttar Pradesh,[42] this finely carved jade hilt displays exquisitely subtle workmanship, especially with regards to the bud finial carved with three layers of delicate petals, in which the two outer layers are very gently everted along their edges.

Equally well crafted are the four veined deltoid leaves pendent from the bud finial, corresponding to a similar arrangement of four leaves on the enamelled *chilanum* Cat. 29. The four leaves are superimposed on delicately carved acanthus leaves that enfold the pommel bars and curl at their ends, and are comparable to the acanthus decoration on the quillon.

The usage of acanthus leaves evokes the influences of Classical and Renaissance art during the Mughal period. It is not certain whether the Mughals' familiarity with and inclination towards Classical decoration was a survival of their exposure to artistic styles of the Hellenized East,[43] or if it was a consequence of India's closer relations with the West during the Classical revival in European Renaissance art, or a complex blend of both influences.

Whatever the case may be, striking Classical elements frequently occur in hardstone carving during the Mughal period, which abounds with acanthus-leaf motifs, vines issuing from bracts and flowers with overturned petals, and most certainly spread to the Deccan sultanates.[44]

The lower edge of the quillon is slightly stepped back, in all likelihood to accommodate a band of precious metal, probably set with gemstones, that is now missing.

The double-edged recurving *jawhar*-patterned blade is fullered, has a median ridge and thickens at the tip.

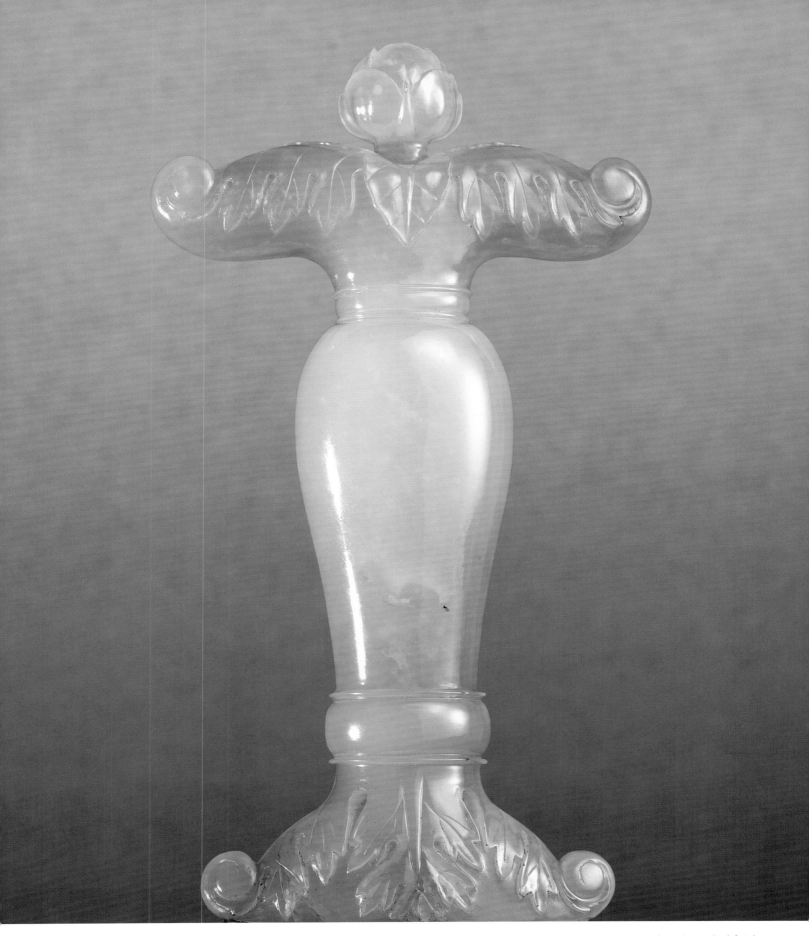

Vegetal carving on bud finial,
pommel bar and quillon

Cat. 29 **ENAMELLED *CHILANUM* DAGGER WITH SCABBARD, LOCKET AND CHAPE**
Probably Deccan, *c.* mid seventeenth century
Hilt, silver over an iron core; locket and chape, silver, champlevé and painted enamels; blade of *jawhar* steel (repolished); scabbard, wood covered with leather, lacquer painted

Dimensions: Length of dagger 40.5 cm; width 9 cm; length of scabbard 30 cm

Provenance: Ex collection: Henry W. Bass Jr. Research Foundation, Texas
Art market 1998

Published: Christie's, London, 13 October 1998, lot 113; Keene and Kaoukji 2001, cat. 6.36; Stronge 2010, pl. 183
Inv. no. LNS 1004 M ab

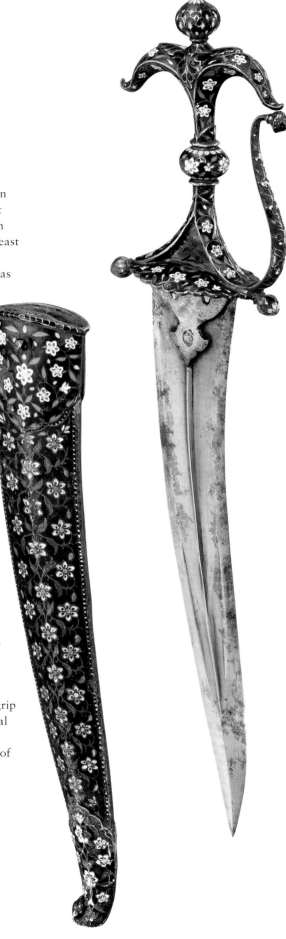

Displaying interesting developments in the overall form of the type, especially in its sculptural leaf-like pommel bars that recall the "fleur-de-lys"-shape hilts from the sixteenth-century temples of south-east India,[45] this fine enamelled dagger most likely hails from around the same area, as does the following example, Cat. 30.

The hilt features fleshy, sinuous leaf-like pommel bars, with a central knob whence the grip bifurcates and stands astride a convex blade guard with projecting buds. One end of the grip then recurves uninterrupted to form the knuckle guard that appears to be an extension of the grip and terminates in the form of a bud. It is worthy of note that in later examples of the type the knuckle guard does not develop from the tip of the grip, as it does here and on Cat. 30, but instead develops inelegantly from unrelated parts of the grip or blade guard.[46]

The hilt is replete with delightful details, such as the four gracefully modelled leaves that straddle the undulating pommel bars from which emerges the dome-like bud finial, which recall a similar configuration of leaves below the finial on Cat. 28; the bracts above and below the central knob from which the upper and lower ends of the grip seem to develop; and the enamelled floral motif on the reinforcing gilded element that fills the gap between the lower end of the grip and the blade guard.

The decorative scheme consists of scrolling floral and foliate vines, which converge to form cordate leaf motifs on the edges of the pommel bars and grip, as well as on both sides of the locket. This style of decoration is closely related to that on the waisted rock-crystal hilt Cat. 37, and evokes arabesques often found on bidri-ware.[47]

The silver vines are set against a ground of transparent dark-green enamel, and issue white enamel flowers detailed with overpainted pale-blue and yellow enamel, as well as yellow buds and pale-green enamel leaves. The general colour scheme, and use of overpainted enamels, evokes that of the *katar* Cat. 17.

The buds projecting from the pommel bars and guard plate are decorated with petals in an imbricated pattern rendered in dark and pale green augmented with yellow enamel. On the other hand, the bud on the end of the knuckle guard features petals in green, yellow and turquoise enamel, a colour also found on the bracts above and below the knob at the centre of the grip.

A thick gilded plaquette terminated by a trefoil is riveted onto the recurving double-edged ridged and fullered blade, which is reinforced at the tip and has suffered much repolishing on account of usage.

The painted scabbard is fitted with matching silver chape and locket, with a cuboctahedral lug on the front of the locket for suspension from a sash.

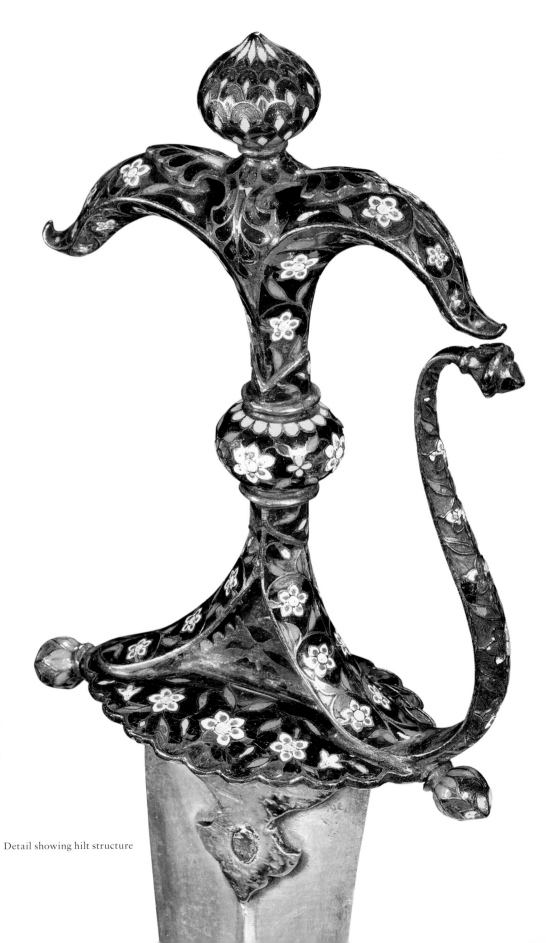

Detail showing hilt structure

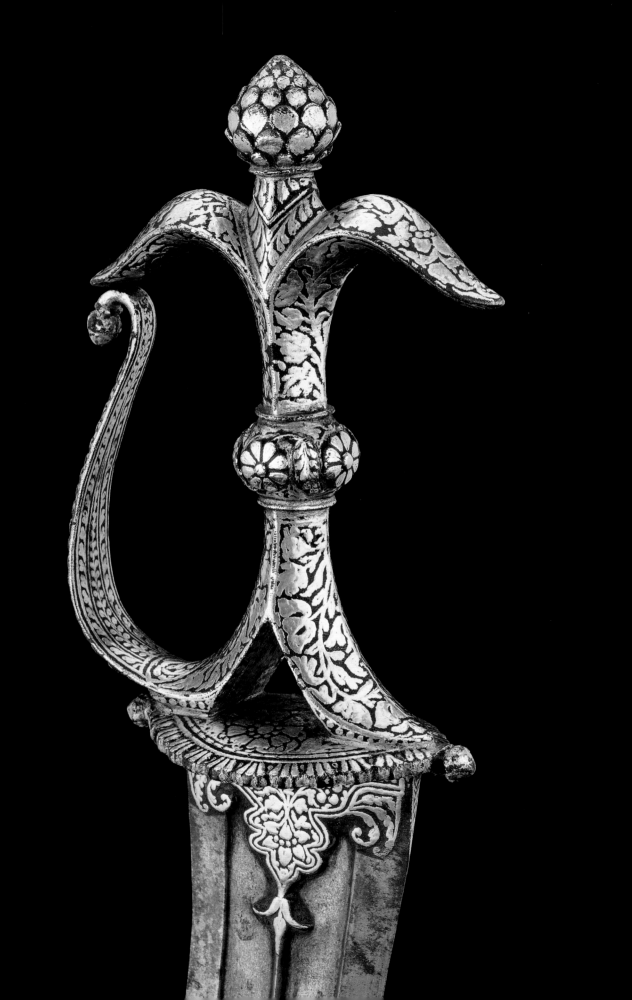

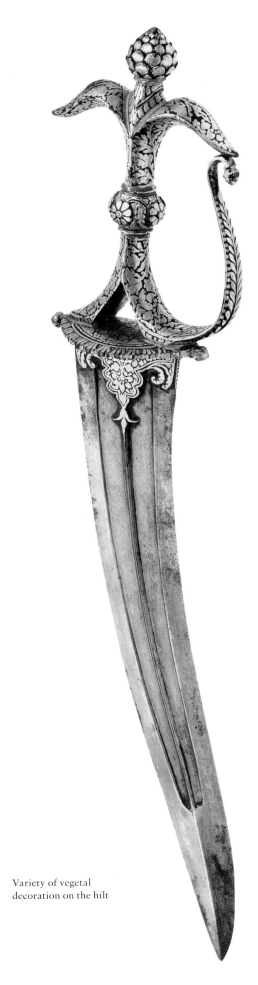

Variety of vegetal
decoration on the hilt

Cat. 30 *CHILANUM* DAGGER
OVERLAID WITH GOLD
**Probably Deccan, second half
of the seventeenth century**
Hilt, steel, cast and engraved,
overlaid with gold; blade of
jawhar steel
Dimensions: Length 28.5 cm; width 8 cm
Provenance: Art market 1994
Inv. no. LNS 689 M

The striking hilt of this dagger incorporates
many of the decorative features of Cat. 29,
but here the leaves that straddle the
pommel bars on Cats. 28 and 29 have been
replaced by a rhomboid support for the
bud finial that features two tiers of stylized
leaves, which more resembles the shape of
the bud support on Cat. 27.

The treatment of the petalled bud finial
closely resembles the unusual pinecone-
shaped centres of floral palanquin finials
attributed to Golconda in the second half
of the seventeenth century.[48]

The undulating pommel bars extend
uninterrupted to the knob in the centre
of the grip, which is decorated in relief
with rosettes issuing downward-swirling
pennate leaves. The grip bifurcates and
recurves to form the knuckle guard, which
is decorated with a pennate leaf that rises
from among a series of dots in a fashion
closely related to decorative motifs on
bidri-ware vessels[49] and terminates in the
form of a bud.

The two-pronged lower end of the grip,
which to a certain degree is also leaf-like,
is set astride a gently convex blade guard
with projecting buds and bordered by
tripartite petals.

The hilt and guard plate are covered
with undulating foliate stems issuing
composite blossoms rendered in thick layers
of modelled gold, comparable to the gold
work on the *katar* Cat. 21.

Suspended from the blade guard, an
elaborate plaquette with a pendant trefoil
blends with the median ridge. The double-
edged recurving blade is reinforced at the
tip and has ground depressions exhibiting
a *jawhar* pattern.

Cat. 31 JADE *CHILANUM* DAGGER
**Deccan or Mughal dominions,
late seventeenth century**
Hilt carved from nephrite jade;
blade of *jawhar* steel (with much
surface damage)
Dimensions: Length 36 cm; width 7.5 cm
Provenance: Ex collection: Christensen Fund,
California, and Sunde Collection,
Copenhagen
Art market 1997
Published: Sotheby's, London, 8 May 1997,
lot 49
Inv. no. LNS 251 HS

Although slightly oriented at an angle,
which suggests a later date for the
type, this dagger is quite elegant in its
slender proportions and simplicity. The
comparatively minimal decoration of the
hilt suggests that its maker wished to draw
attention to the colour and purity of the
material from which it was carved.

The structure of the hilt is generally
related to those of Cats. 29 and 30 with
an unusual onion-dome shaped bud finial
rising between undulating pommel bars.[50]
In all likelihood, the lower end of the hilt
once stood on a blade guard that has been
ground down following breakage, along
with the lower ends of the bifurcating
hilt and the angular leaf-like motif in the
intervening surface, which is truncated at
its tip. The knuckle guard, which unlike
those of the two previous *chilanum*s does
not develop from the lower end of the grip,
is carved at its base with three elongated
leaves and terminates in an elongated bud.

The ridged and fullered double-edged
recurved blade has suffered much surface
damage, and the ricasso retains traces of a
foliate motif.

Detailing on outer surface of
knuckle guard and bud finial

Cat. 32 JEWELLED JADE
CHILANUM DAGGER
WITH SCABBARD,
LOCKET AND CHAPE
Mughal dominions, probably
late seventeenth century
Hilt, locket and chape carved from
nephrite jade, inlaid with gold in
kundan technique and set with
diamonds, rubies and emeralds;
blade of _jawhar_ steel, overlaid
with gold; scabbard, wood
overlaid with red velvet

Dimensions: Length of dagger 39 cm; width
7 cm; length of scabbard 29 cm

Provenance: Art market 2005

Published: Sotheby's, London, 25 May 2005,
lot 71; Curatola et al. 2010,
cat. 279
Inv. no. LNS 728 HS ab

Essentially of the same form as the
pommel-bar type, but of plumper
proportions, the pommel of this _chilanum_
is more akin to that of a dagger depicted
worn by Mahajanaka, king of Mithila,
in a painting in the Ajanta Caves dating
from the early sixth century CE.[51]

The densely decorated pommel and
blade guard feature gold vines issuing
flowers in three stages of development:
ruby blossoms with diamond
centres in lobed settings,

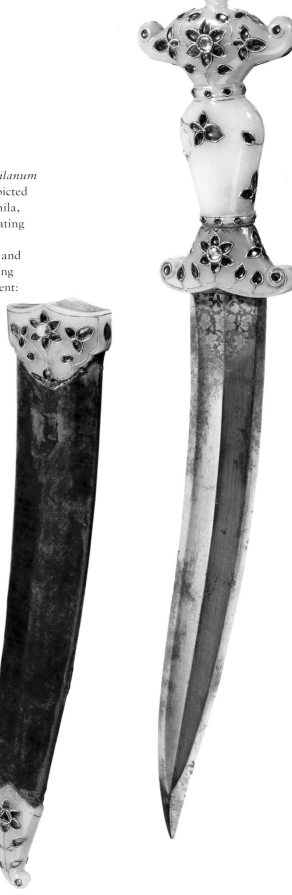

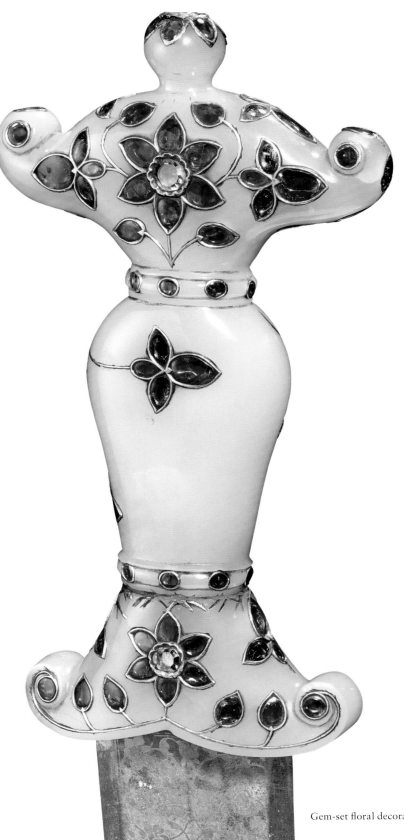

Gem-set floral decoration on hilt

unfurling ruby buds with emerald sepals and small unopened ruby buds.

In contrast with the symmetrical floral arrangements decorating the pommel and blade guard, unfurling buds and vines bearing smaller buds curl around the grip in a free-flowing manner.

A gold vine, from which issue a ruby and diamond flower and swaying ruby buds, outlines the lower edge of the quillons, terminating in rubies that punctuate its curling ends.

Similar flowers and buds decorate the matching locket and chape, wherein the floral spray on the locket grows from a single downturned leaf, and one of its faces is fitted with a jade lug for the attachment of a cord. It is conceivable that the peculiar orientation of this leaf, which appears frequently in jewelled objects from the period,[52] might derive from the treatment of clusters of plants in Persian painting from the late fourteenth century onwards. In such painting, when leaves were depicted in the foreground or at the outset of a tuft of foliage, they were most often oriented downwards, probably to convey a sense of perspective.[53]

The double-edged recurved *jawhar*-patterned blade is of thin rhomboid section, reinforced at the tip, and features a fine lobed medallion enclosing floral sprays in two shades of gold on the ricasso.

The scabbard velvet features an old label recording that the dagger was recovered from the first Siege of Seringapatam in 1791.

Cat. 33 JADE *CHILANUM* DAGGER
Mughal dominions,
probably late seventeenth–
eighteenth century
Hilt carved from nephrite jade
with gilded bronze finial; blade of
jawhar steel
Dimensions: Length 38 cm; width 7 cm
Provenance: Art market 1980s
Inv. no. LNS 14 HS

It appears as though the bud finial of this
dagger was broken off and replaced with
a gilded bronze bud, which, recalling the
similar decoration surrounding the intact
bud finials of Cats. 28 and 34, is fitted in
the centre of four carved leaves.

Two minuscule stems issue from the
curling ends of the pommel, bearing
what appear to be bunches of grapes or
perhaps mulberries (see, for example,
Cat. 91), which is a rather unusual form
of decoration on a pommel bar. More
typical are the lily blossoms and buds that
issue from between the leaves encircling
the moulding, which is carved with a
counterchanging scroll bearing blossoms
and buds. Identical lilies issue from the
acanthus leaves that border the lower edge
of the quillons.

The double-edged ridged blade is gently
curved and *jawhar*-patterned. It is of thin
rhomboid section and thickens at the tip.

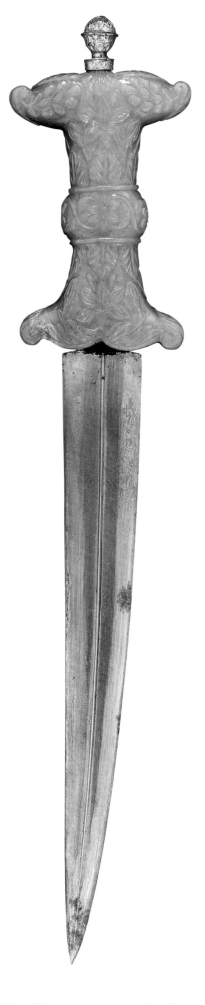

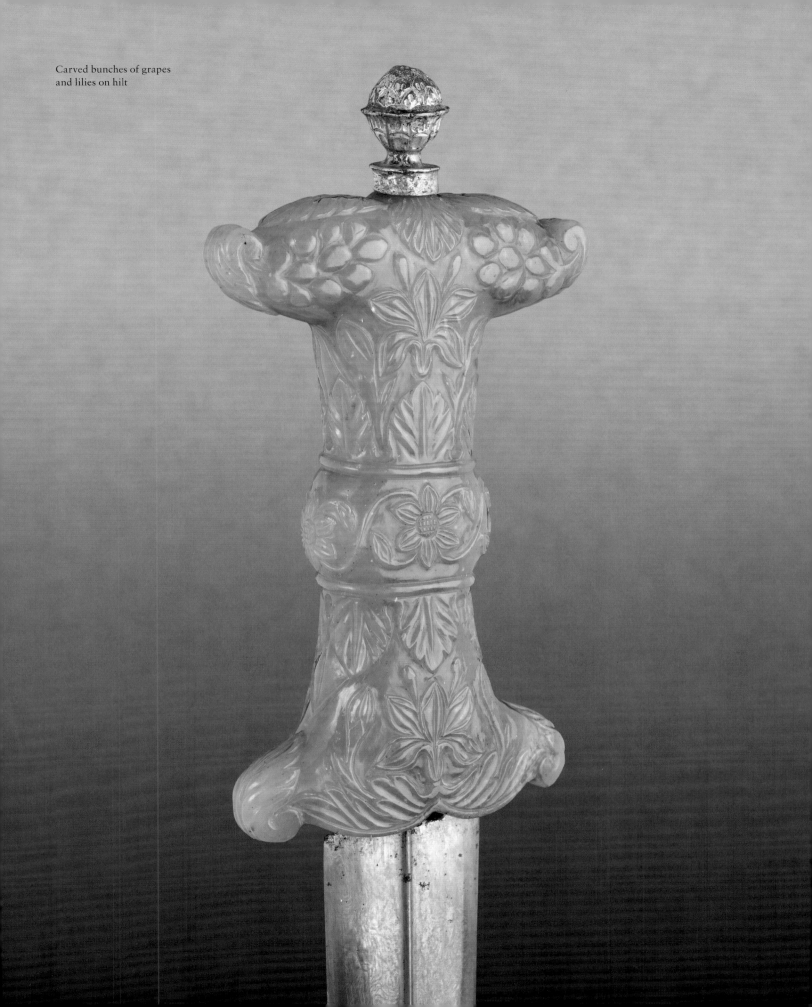

Carved bunches of grapes
and lilies on hilt

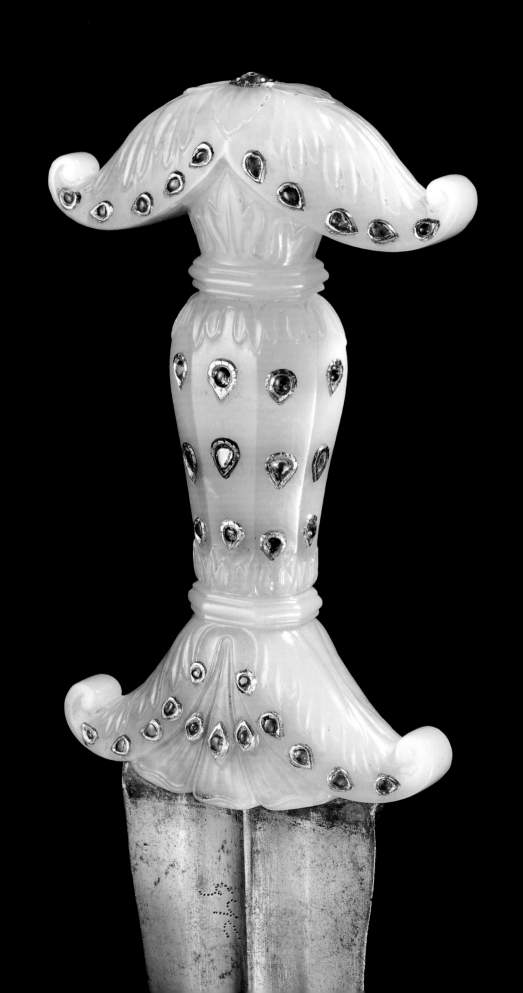

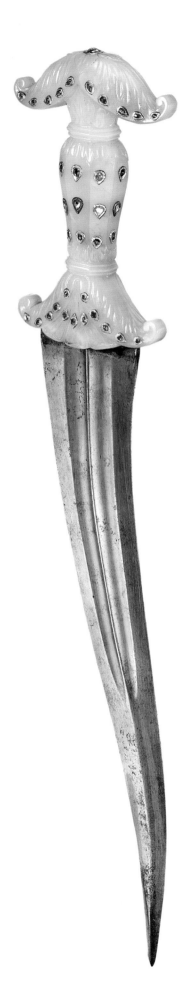

Cat. 34 JADE *CHILANUM* DAGGER
Mughal dominions, probably eighteenth century
Hilt carved from nephrite jade, later inlaid with gold in *kundan* technique and set with rubies, diamonds and emeralds; blade of *jawhar* steel
Dimensions: Length 39 cm; width 7 cm
Provenance: Art market 2004
Published: Sotheby's, London, 12 October 2004, lot 96
Inv. no. LNS 659 HS

Once carved with decoration centring on acanthus leaves, this jade hilt was supplemented in an ungainly manner, and most certainly at a later date, with bud motifs set with rubies, emeralds and diamonds. Furthermore, it appears as though the original bud finial, which must have broken off, was replaced with a large ruby inlaid in the centre of four carved leaves on the pommel.[54]

Rather poorly carved acanthus leaves enfold the curling pommel bars as well as the curling quillons, between which are three large petals overturned along their edges.

The prismatic baluster-shaped grip is set off from the pommel and guard by ridged mouldings bordered by small and rather rigid acanthus leaves.

The ridged, recurving double-edged blade is fullered and has suffered much surface damage. It is inscribed in stippled Devanagari script with the number 958, possibly representing an armoury number.

Opposite: Carved jade hilt, later supplemented with gemstones

NOTES

1 Temple 1905, p. 237 and pl. III.
2 From the last quarter of the third millennium BCE a dagger with a "pommel bar" from the Ikiztepe burial mound on the Black Sea (Samsun Museum, inv. no. 10–46/1985), Çagman and Ölçer 2004, p. 53; a fourth-century BCE sword with a "pommel bar" from the Filipovka burial in the Southern Ural mountain region, Aruz 2000, cat. 5; and an iron sword and dagger from a late Sarmatian burial mound, Malashev and Yablonski 2004, p. 275, fig. 14 (1 and 2).
3 Marshall 1975, vol. III, pl. 164, figs. 61 and 62, entry in vol. II, p. 554.
4 Both examples represented on sculptures, Pant 1980, p. 5, no. 4, fig. 7, and no. 8, fig. 7, respectively.
5 From the early sixth-century Ajanta caves, Mahajanaka, King of Mithila, can be seen wearing a dagger with horizontal bars, Behl 1998, pp. 90–91 (detail on p. 92); on a seventh-century relief from Uttar Pradesh the god Revanta wears a dagger with curved bars, Pal 1986, pp. 254–55, cat. S132; from 740 CE, daggers with horizontal bars can be seen in the Mallikarjuna temple in Karnataka, Randhawa and Randhawa 1985, p. 136, fig. 102; on the eleventh-century Chandella friezes of the Lakshmana temple of Khajuraho a number of swords are represented with horizontal pommel bars, Sivaramamurti 1977, pp. 402–08, as well as on a folio from a *Pancharaska* manuscript, Bihar, dated 1160–61 CE, Pal 1993, p. 66, fig. 7b; and on a twelfth-century relief from Haryana an effigy of the god Varaha can be seen with a broad-bladed dagger with horizontal bars, Khanna and Michell 2000, cat. 37.
6 Elgood 2004a, pp. 164–65.
7 See note 5 and Pal 1986, pp. 254–55, cat. S132.
8 Goswamy 1988, p. 21, fig. 31 (fol. 190v).
9 Khandalavala 1971, p. 23, pl. 2, and p. 25, pl. 3.
10 Kossak 1997, p. 27, cat. 2, attributes it to *c.* 1520; Leach 1986, cat. 8, fig. 8i, attributes the same to *c.* 1525–50.
11 Haidar and Sardar 2011, p. 220, fig. 2.
12 Seyller 2002, p. 83, cat. 19 (held by Amir Hamza); p. 90, cat. 23; p. 98, cat. 27; p. 136, cat. 41; p. 168, cat. 54.
13 Gray 1981, fig. 6 (in the second tier one can see the pommel of such a dagger tucked in the sash of one of the seated raja's attendants) and fig. 9 (in the lower tier the attendant holding a napkin wears such a dagger tucked in his sash).
14 Leach 1995a, pp. 274–75, cats. 2.128 and 2.129.
15 Ibid., p. 237.
16 Barry 2004, p. 266.
17 Brand and Lowry 1985, p. 83, fig. 55.
18 See e.g. the daggers in a painting from the *Hamza-nameh* attributed to *c.* 1570, p. 169, cat. 54.

19 Chandra 1976, fols. 30r, 46v, 84r, 122v, 132v, 135v, 168v, 247r, 267r, 317r, 318v, 321v, 338r (facsimile).
20 Leach 1995a, cats. 1.11, 1.12, 1.24, 1.27 and 1.51.
21 Ibid., cat. 1.236.
22 Ibid., p. 280, cat. 2.142, and p. 243, cat. 2.109. A few examples with baluster-shaped grips but no knuckle guard can be seen in a folio of the *Hamza-nameh*, worn by 'Umar, Calza 2012, p. 185, cat. IV.36; tucked in the belt of a Hindu personage from Emperor Akbar's *kitabkhana* in a folio from the *Razm-nameh* dated 1007 H (1598–99 CE), Calza 2012, p. 215, cat. V.21; and in the V&A copy of the *Akbar-nameh* dated to *c.* 1590–95, ibid., p. 27, fig. 9.
23 Shcherbina 2014, p. 20.
24 North 1989, p. 140.
25 Elgood 2004a, p. 79.
26 Ibid., p. 215, fig. API.10 (left); Haidar and Sardar 2011, pp. 227–28, figs. 10 and 11.
27 Leach 1995b, pp. 819, 822, 834 and 841.
28 Seyller 2002, cat. 57; shown on a few other swords in the *Hamza-nameh*, published by Calza 2012, cat. IV.36, p. 185, and cat. IV.42, p. 193.
29 See e.g. the sword with knuckle guard carried by a man in European dress, Leach 1995a, vol. I, p. 129, cat. 1.235, and the sword of the disc-pommel type fitted with a knuckle guard depicted in the Cleveland Museum manuscript of the *Tuti-nameh*, Chandra 1976, facsimile, f. 99v.
30 Seyller 2002, cats. 19, 23, 27, 28, 30, 35, 43, 44, 46, 50, 53 and 84.
31 Chandra 1976, pl. 14, and facsimile fols. 66r and 99v.
32 Ibid., p. 314, cat. 2.171.
33 Akimushkin 1996, pl. 154/fol. 3r, entry on p. 100.
34 Beach 1978, pp. 34 and 37, cat. 1.
35 Welch et al. 1987, p. 110, cat. 16; Welch 1978, pl. 17.
36 Stronge 2002, p. 128, pl. 93, and p. 152, pl. 114.
37 Beach and Koch 1997, pp. 35–36, cat. 8.
38 See the introduction to the chapter.
39 Published showing the upper edge of the handle in Zebrowski 1997, p. 51, fig. 28 (Victoria and Albert Museum, inv. no. IM 173-1910).
40 Akimushkin 1996, pl. 154/fol. 3r, entry on p. 100; Welch 1978, pl. 17; Welch et al. 1987, p. 110, cat. 16.
41 Carter 2013, p. 154, cat. 78.
42 See Pal 1986, pp. 254–55.
43 On this subject, see especially "The East after Alexander the Great" in Boardman 1994, pp. 109–44.
44 For the style of Classical examples that might have exerted an influence on the area, see Pfommer 1993, fig. 43, a silver bowl attributed to second-century BCE Fayyum, and cats. 67 and 76, a cup and a bowl attributed to first-century BCE Graeco-Bactrian workshops.

45 Cf. the reliefs of the Tamil Nadu Vardhamana temple, Kanchipuram, Elgood 2004a, pp. 164–65.
46 See e.g. the knuckle guards that spring from the blade guard in Mohamed 2007, pp. 213–14, cats. 204 and 205.
47 Zebrowski 1997, p. 252, pl. 431; p. 253, pl. 432; p. 265, pl. 447; and col. pls. 496, 504 and 513; Haidar and Sardar 2015, cat. 83.
48 Haidar and Sarkar 2015, pp. 246–47, cat. 142.
49 Ibid., p. 187, cat. 87, and esp. cat. 89.
50 For a related piece with almost identical jade hilt, see Missilier and Ricketts 1988, p. 98, no 159.
51 Behl 1998, pp. 90–91, and detail on p. 92.
52 Cf. the locket of cat. 65.
53 For late fourteenth-century representations, see e.g. the plant clusters in a Jalayirid manuscript of *Kalila wa Dimna*, dated 1391, O'Kane 2003a, figs. 45, 46 and 48, as well as various depictions in Persian painting from the fifteenth century onwards.
54 For a related dagger in the Powis Castle Collection, see Skelton 1982a, cat. 413, and Marsden and MacKenzie 1987, cat. 19.

CHAPTER THREE
THE HOURGLASS-SHAPE HILT
A WIDESPREAD AND FUNCTIONAL FORM

Hilts of hourglass-shape and variants thereof are typically flared at both ends, allowing the user to keep a firm grip on the hilt. This basic and instinctual form endured over millennia across wide stretches of territory although, as might be expected, it was subjected to minor modifications to meet the demands of users; however, it never really departed from its fundamental design, which consisted primarily of flaring ends narrowing at the waist, thus providing a comfortable grip. The type probably evolved from hilts of the second millennium BCE fitted with flat pommel discs,[1] which were of standard use in places as far removed from each other as Scandinavia, Greece and Iran,[2] as well as China during the late first millennium BCE.[3]

Interestingly, a development of the overall form in which the grip flares from the centre towards the pommel and guard was found in the *c.* 1581–1541 BCE burial from the Hyksos period at Saqqara,[4] in a fourteenth-century BCE tomb complex of Pharaoh Tutankhamun at Thebes,[5] and in north-eastern China and Korea *c.* 900–700 BCE, where the archaeological site of the Liaoning culture has yielded related bronze and stone daggers.[6]

Spoils of battle, and the movement of gifts, travellers and merchants were all conducive to the dissemination of weapon forms, which resulted in their basic structures undergoing some development and change. Around the Late Bronze Age period and slightly later one finds examples from Europe with more curvilinear grips,[7] and some with pommels of more rounded form, such as the sword hilt of the storm god Baal represented on a stela attributed to Ugarit in north-western Syria, from the fifteenth to the thirteenth centuries BCE.[8]

THE SAME STRUCTURE WITH SLIGHT VARIATIONS

Although it would be difficult to determine when or if ever the hourglass-shape hilt attained a definite form, it is clear that, from the seventh century BCE until around the first centuries CE, multiple variants, either represented on reliefs or objects, or fitted on excavated short swords or daggers and on the *akinakes* (short swords mainly used by Scythians and Iranians), proliferated in Iran, the Caucasus, Central Asia and the Indian subcontinent.[9] It is likewise worthy of note that in the same areas and during the same period, variants of such hilts – slightly differing in form, but essentially retaining the same basic structure – were fitted with mushroom-like, spherical or flat pommels; with horizontal or down-curling quillons; and with a grip that was either upright or bulged in the centre.

Hilts that flare to a mushroom-like pommel can still be seen on Iranian reliefs from Susa and Persepolis during the sixth century BCE,[10] but seem to disappear in around the fifth and fourth centuries BCE, when they are replaced by hilts with rounded pommels around the areas of the Black Sea and Central Asia.[11]

Around the first centuries CE, the pommel form begins to resemble that of hilts from later periods, as can be seen in representations on a second-century gold necklace excavated north of the Black Sea and a bone quiver-case from around the area of Samarqand,[12] on the third-century Sasanian cameo "Victoire de Shapur Ier sur l'Empereur Valérien"[13] and on the fifth-century wall paintings from the Qizil Peacock cave in Central Asia.[14]

Dagger with hourglass-shape hilt depicted on a folio from the manuscript of *Anwar-i Suhayli* (The Lights of Canopus), by Abu 'l-Hasan, dated between 1604 and 1610

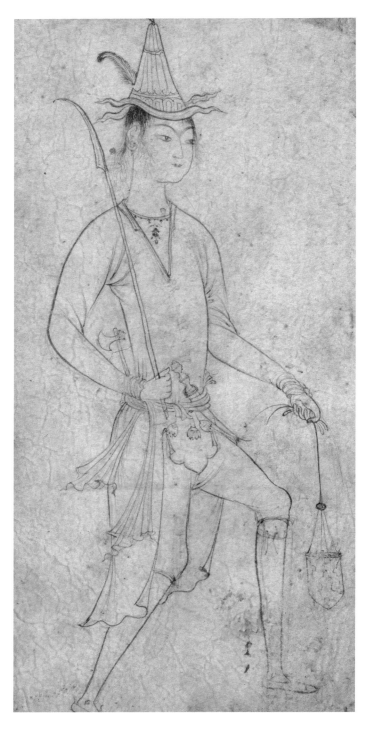

PREVALENCE IN THE LATE MEDIEVAL ISLAMIC WORLD

In the Eastern Islamic world various hilts of the type are represented in paintings, mainly ascribed to Tabriz, from around the early fourteenth to the turn of the sixteenth century.[15] This most likely gave rise, in the second half of the sixteenth century, to an additional variety that sports a rounded conical pommel and guard separated by a spheroidal knob in the centre of the grip, which essentially recalls earlier versions, and refashions the central mouldings featured in the hilt of the type represented by Cats. 35 and 36.

In view of the fact that the hourglass type of hilt was so functional, it is not surprising that it prevailed and was so widespread until the nineteenth century CE in areas as far removed from each other as Turkey, Iran and India.[16]

Dervish wearing a dagger with an hourglass-shaped hilt, from an album page attributed to Qazvin, mid-sixteenth century

Cat. 35 **EMERALD DAGGER AND
SCABBARD**
**Hilt, Deccan or Mughal
dominions, early seventeenth
century; ferrule and
blade, perhaps Deccan,
seventeenth century**[17]
Hilt carved from emerald and
drilled; blade of *jawhar* steel;
scabbard, wood covered with red
velvet with metal thread trimmings;
locket and chape, gilded silver set
with diamonds; gold lion-head
finial set with rubies, probably
late nineteenth century

Dimensions: Length of dagger 38 cm; width
4 cm; length of scabbard 30 cm

Provenance: Art market 1999

Published: Keene and Kaoukji 2001, cat. 11.9;
Elgood 2004b, p. 86, fig. 12;
Calza 2012, cat. IV.16
Inv. no. LNS 2194 J ab

During their conquest of South America in
the mid sixteenth century, the Spaniards
encountered glorious emeralds in Colombia
and embarked on an unstoppable
programme to discover their source. Once
this had been accomplished, they began to
export to the Old World large quantities
of the finest emeralds ever seen, for which
India was the world's largest market.

India has been renowned since
antiquity for its unparalleled skill in the
carving of precious stones, exemplified by
precise cutting and absence of wastage,
qualities that are evident in the carving of
the emeralds that make up the hilt of this
spectacular dagger.

The three large emerald segments that
constitute the hilt are threaded onto an
iron rod that also serves as a tang for the
blade. The single-edged blade, which is
probably a later addition and not suited
to this type of dagger (see the illustration
on p. 117, showing the aperture made to
accommodate a double-edged blade), is
forged and features a stylized makara-
head ferrule with teeth that recall the
decorations surrounding the mouth of the
mid sixteenth-century Malik-e Maidan
cannon in Ahmadnagar.[18]

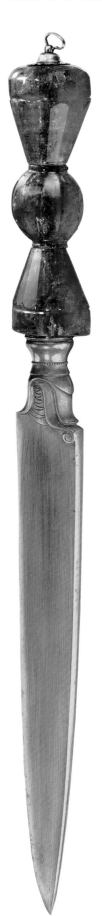

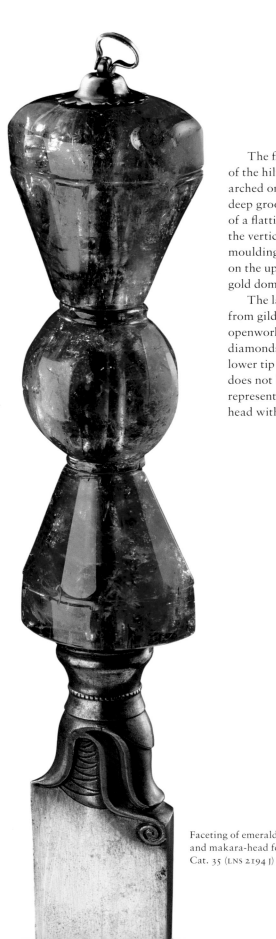

The flaring upper and lower segments of the hilt are carved with vertical facets arched on their ends and outlined with deep grooves. The central segment consists of a flattish spheroidal bead faceted in the vertical axis and bordered by fine mouldings. The upper segment is rounded on the upper edge and fitted with a later gold domed rosette and a suspension bail.

The later locket and chape are fabricated from gilded silver in an over-elaborate openwork floral configuration set with diamonds. The small gold finial on the lower tip of the chape, which obviously does not belong with the scabbard, represents a well-modelled gold lion head with ruby eyes.

Scabbard with later locket and chape

Faceting of emerald hilt, and makara-head ferrule, Cat. 35 (LNS 2194 J)

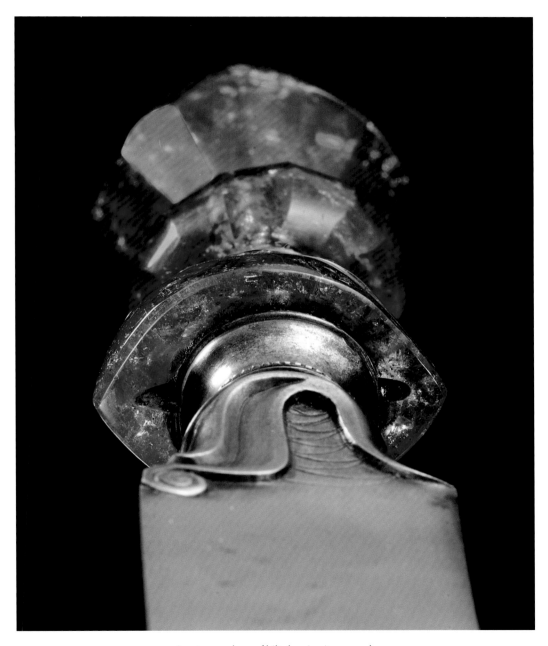

Aperture on base of hilt showing it was made
to accommodate a double-edged blade

Cat. 36 SAPPHIRE KNIFE HILT
Deccan or Mughal dominions,
early seventeenth century
Carved from light-blue sapphire
Dimensions: Length 7 cm; width 2 cm
Provenance: Art market 2003
Inv. no. LNS 614 HS

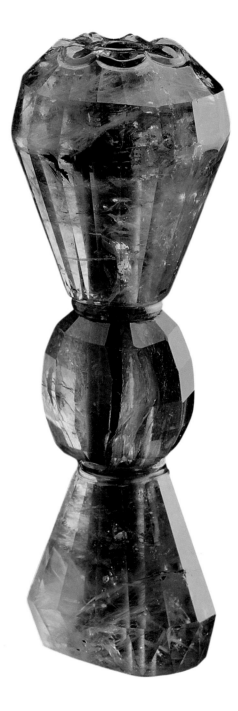

This exquisite and delicate hilt served as
a handle for a small knife and is carved
from three pieces of translucent light-blue
sapphire, probably an import from Sri
Lanka, where the oldest sapphire mines
were found.

The three gemstones are drilled
through and were once threaded onto
an iron rod that would have served as a
tang for the blade but is no longer extant.
The walls of the hole exhibit cobalt blue
pigment, probably applied to conceal the
metal rod and to enhance the colour of the
sapphires. All three stones are faceted in
such a manner as to allow the reflection of
light and further enhance their colour.

The central segment is faceted in a
square-grid arrangement and bordered
by fine mouldings, whereas the upper and
lower elements are faceted on the vertical
axis and bevelled around their extremities.
The upper section is relief-carved with
a flower surrounding the hole in which
would have nested the finial that capped
the metal rod.

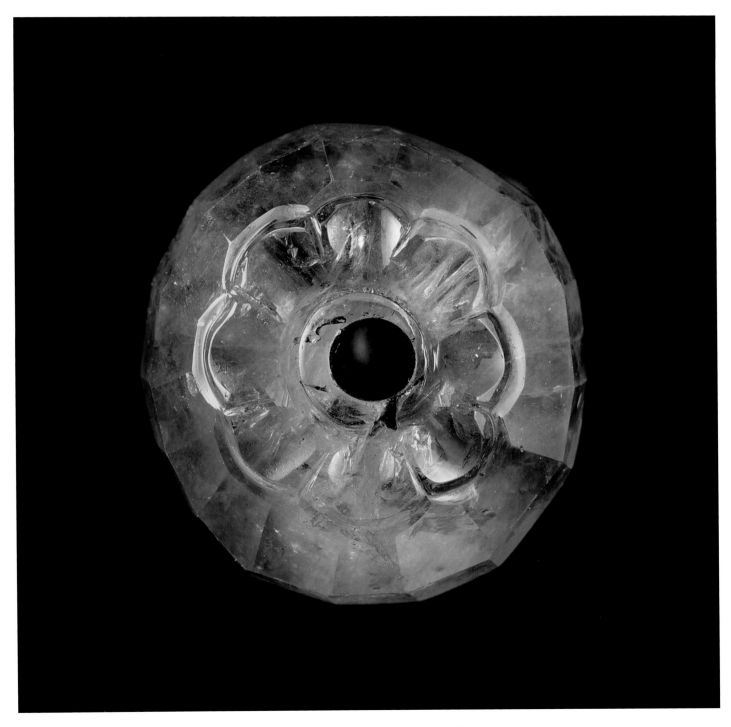

Floral carving and faceting on upper part of hilt

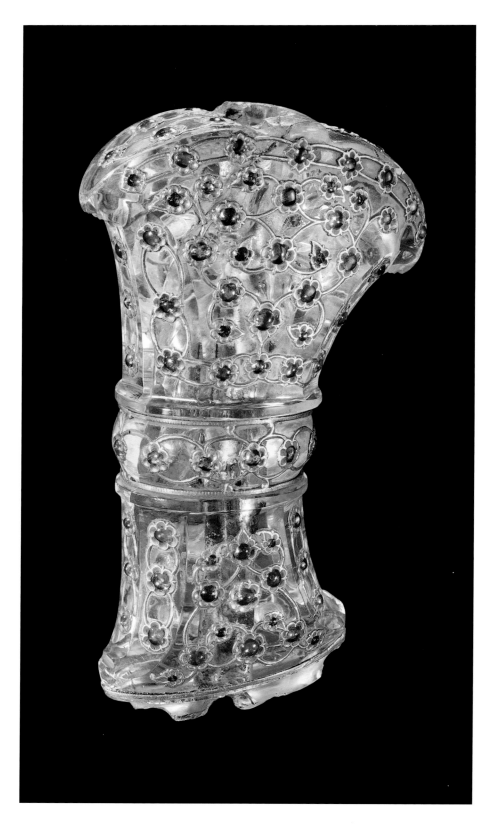

Cat. 37 JEWELLED ROCK-CRYSTAL HILT
Deccan, probably Bidar,
seventeenth century
Carved from rock crystal; inlaid
with gold in *kundan* technique
and set with rubies and emeralds
Dimensions: Length 11 cm; width 6 cm
Provenance: Art market 1980s
Published: Keene and Kaoukji 2001, cat. 2.8
Inv. no. LNS 118 J

Essentially of hourglass shape with a
moulding in the centre, this rounded hilt is
gently tilted to one side, is flat on the upper
end, save for a transverse ridge, and is cut
along both sides with three vertical facets.

It appears as though the hilt suffered
a blow that generated cracks all the way
through it, along a plane diagonal to its
axis, and broke off the stump for inserting
the blade tang on the underside of the hilt
(for intact tang stumps see Cats. 50 and 69).
The hilt was subsequently drilled halfway
up from the bottom and fitted with an iron
tube into which is inserted an iron post for
reinforcement. The remains of the stump,
which displays conchoidal fractures, has
been partially ground down.

On the faces of the hilt, both above
and below the moulding, the scrolling
vines interspersed with ruby rosettes and
emerald leaves centre on cordate leaf motifs
evocative of Timurid arabesques and bidri-
ware.[19] Equally characteristic of bidri-ware
are the decorative bands of "chain links"
straddled with rubies in lobed settings that
border the upper edges[20] and fill the top
and side facets and the grip torus, issuing
small tendrils.

Cat. 38 JADE DAGGER HILT
Probably Deccan,
seventeenth century
Carved from nephrite jade
Dimensions: Length 11 cm; width 5 cm
Provenance: Art market 1999
Published: Christie's, South Kensington,
14 October 1999, lot 75
Inv. no. LNS 392 HS

Carved from virtually uniform celadon
green jade polished to a satiny finish, the
beauty of this elegant hilt resides mainly in
its harmonious proportions.

The flutes that decorate the upper and
lower halves of the grip are outlined with
arched bevelled grooves, and angular ridges
serve to outline the gentle curvature of the
rounded moulding.

The slender rhomboid socket on the
underside of the hilt that would have
accommodated a double-edged blade
retains parts of the blade tang.

Cat. 39 JADE DAGGER
Probably Deccan,
seventeenth century
Hilt carved from nephrite jade;
blade of *jawhar* steel
Dimensions: Length 39 cm; width 5.5 cm
Provenance: Art market 1999
Inv. no. LNS 278 HS

Carved from mottled celadon green jade,
the hilt is gently rounded at the top and
fluted on the upper and lower halves of
the grip, which are outlined with arched
bevelled grooves. Fine angular ridges
border the rounded moulding in the centre
of the grip.

The double-edged *jawhar*-patterned
steel blade is pronouncedly curved, ridged
and slightly reinforced at the tip.

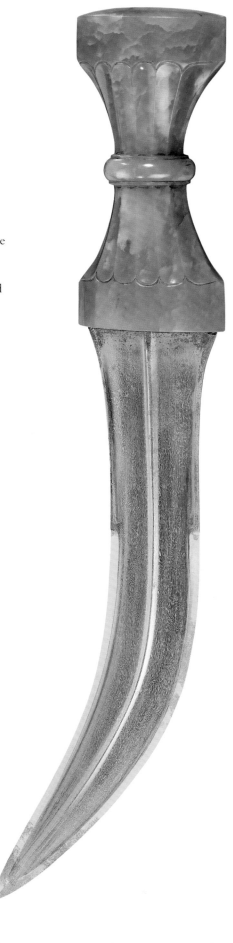

Detail of fine fluting on hilt

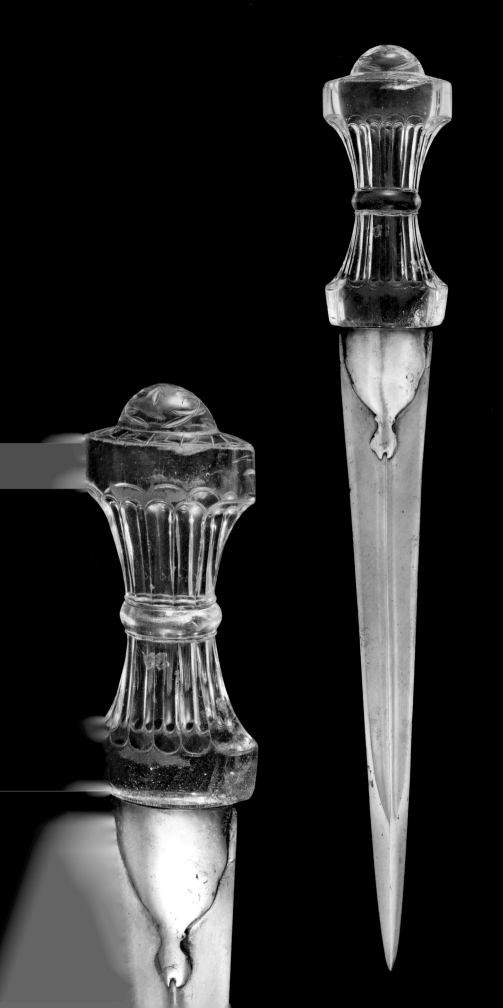

Cat. 40 **ROCK-CRYSTAL DAGGER**
Probably Deccan,
seventeenth century
Hilt carved from rock crystal;
blade of *jawhar* steel
Dimensions: Length 39 cm; width 6 cm
Provenance: Art market 2009
Published: Sotheby's, London, 7 October
2009, lot 129
Inv. no. LNS 1005 HS

Carved from flawless rock crystal and
fluted on either side of the central
moulding, this hilt is of essentially the
same form as the previous jade examples,
but features an oval domical knob finial.
The hilt has retained its tang stump,
concealed by the rounded pendant
medallion on the ricasso of the blade.
This arrangement is used in most limpid
rock-crystal hilts to prevent the blade tang
from being visible through the transparent
hilt, as, for example, in Cats. 50 and 69.

The pommel is engraved on the knob
with a pair of foliate vines growing from
the edges of the knob and touching in
the centre, and is surrounded on the flat
surface by ungraceful angular petals. It
is likely that the pommel decoration was
applied during a later period, as it does
not match the quality of the carving on
the rest of the hilt.

The double-edged blade has suffered
repolishing on account of usage, thickens
at the tip and is fitted with a pendant
medallion with a trefoil that blends with
the median ridge.

Far left: Detail of hilt showing
rounded medallion concealing the
blade tang stump on the ricasso

NOTES

1 For example, a dagger with a gold hilt from the Middle Minoan II period, excavated in Crete, Coe, 1989, p. 13.
2 Harding 1989, pp. 14–20.
3 Richardson 1989, pp. 173–74.
4 Aruz et al. 2008, pp. 116–17, cat. 65.
5 Harding 1989, p. 11.
6 Chang 2012, p. 47.
7 See e.g. the hilt of the Bavarian sword, Harding 1989, p. 16.
8 Caubet and Pouyssegur 1998, p. 117.
9 See e.g. Reeder et al. 1999, cats. 8, 9, 105 and 132; Aruz 2000, cat. 111; Boardman 1994, fig. 4.44; and Behl 1998, p. 181.
10 Curtis and Tallis 2005, cats. 88 and 22.
11 See e.g. the weapon on the fifth-century BCE granite stele representing a Scythian from north of the Black Sea, Reeder et al. 1999, cat. 132, and the weapon held by a reclining warrior, on a gold quiver case, also from north of the Black Sea, cat. 105; also, the weapon represented on the fourth-century BCE bone figurine from Ufa (north of the Aral Sea), Aruz 2000, cat. 111.
12 Chuvin 1999, cats. 28 and 136.
13 Demange 2006, cat. 145.
14 Bussagli 1979, p. 79.
15 Hillenbrand 1977 cat. 129, possibly Tabriz, dated 1307–8; Digard 2002, cat. 123, attributed to Tabriz or Baghdad from the second half of the fourteenth century; Roxburgh 2005, cat. 134, attributed to fourteenth-century Central Asia; Pope 1939, vol. V, pl. 891B, attributed to Herat, c. 1500, and pl. 893A, attributed to Tabriz, dated 1525, and pl. 901B and pl. 904, dated to the middle of the sixteenth century; Gray 1977, attributed to Tabriz, 1526, p. 131, and Tabriz, 1529, p. 133.

16 Interesting varieties of the type can be seen in the *Shah-nameh* of Shah Tahmasp from Tabriz in the first half of the sixteenth century in Canby 2014; Melikian-Chirvani 2007, cat. 24; and Welch 1972, pp. 92–93, 100, 102, 112, 120–21, 136–37, 144–46 and 152–54.
17 The blade was previously attributed to the eighteenth or nineteenth century, but, according to Robert Elgood (pers. comm.), it is rather rare and should be attributed to the first half of the seventeenth century, and is related to a blade in the Saint Louis Art Museum (inv. no. 14.22) that was previously in the A. U. Pope Collection and inscribed "Mustapha Quli the Qashgai".
18 Haidar and Sardar 2015, p. 92, fig. 47.
19 Zebrowski 1997, p. 252, pl. 431; p. 253, pl. 432; p. 265, pl. 447; and col. pls. 496, 504 and 513.
20 Ibid., p. 190, no. 283; p. 229, no. 372; p. 230, no. 374; p. 231, no. 377; p. 249, no. 423; p. 250, no. 425; col. pls. 486, 507, 512.

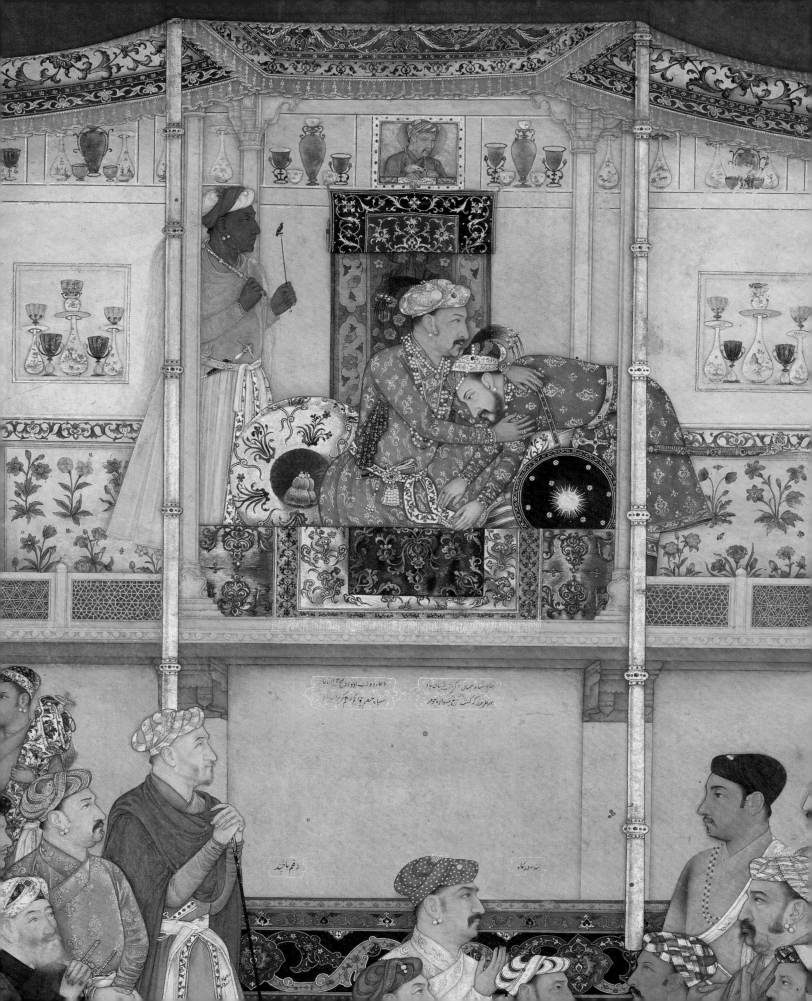

CHAPTER FOUR
THE EARED- OR CLOVEN-POMMEL HILT
A SHARED LINEAGE

Daggers with hilts of the cloven-pommel type begin to appear in Mughal painting at the start of Emperor Jahangir's reign.[1] Although such hilts were also depicted worn by Shah 'Abbas I and members of the court in a few Safavid paintings from the period, the representations were not as frequent, and were moreover on a few occasions executed by painters of the Mughal court;[2] strictly speaking, the type was clearly not current in either India or Iran before the first quarter of the seventeenth century.

One of the features that bears this out is the fact that when such daggers first appeared at the Mughal court they were depicted in paintings with the cloven part of the pommel in an unnatural orientation, that is, twisted in relation to the guard and blade. This was clearly done to highlight the distinctive feature of the pommel, which might otherwise not have been evident had the hilt been illustrated in its natural orientation with respect to the guard and blade.

Since the emperor was most often depicted in his favourite attire, or clad in styles he had introduced to the court, and since Emperor Jahangir is often depicted wearing such daggers, it is not surprising that they were destined to find favour among members of the Indian elite,[3] and that when an individual was portrayed wearing one it was important for the artist to draw attention to the special feature of the pommel.

As these cloven-pommel daggers became more familiar in the Mughal court, it was no longer necessary for paintings to emphasize their distinctive structure, and one begins to see the hilts depicted as they should be: that is, in the correct orientation with regard to the blade and quillons.

A POSSIBLE PRECURSOR WITH EUROPEAN AFFINITIES
A dagger with cloven pommel and flaring ears, which most probably was the precursor of the Mughal cloven-pommel

dagger, is worn by 'Umar, one of the main characters of the *Hamza-nameh*, in a manuscript illustration dated to *c.* 1562–77.[4] It appears to be the earliest representation of this type of dagger in Indian painting prior to the seventeenth century, and interestingly, here as well, the pommel is represented in the same unnatural orientation in relation to the blade that is found in portraiture dating from Emperor Jahangir's reign.

Most importantly, the hilt of the dagger featured in the *Hamza-nameh* displays close affinities to European eared daggers, the earliest example of which is a fourteenth-century bronze dagger on display in the National Archaeological Museum, Madrid, which was reportedly found in Puerta del Colodro, Cordoba.[5] That the style remained popular in the Iberian peninsula is evidenced by the fifteenth-century eared dagger with ivory facings that belonged to the last Nasrid sultan, Abu Abdallah al-Zughubi (known in the West as "Boabdil"), and that was associated with the trophies taken in 1483 by Diego Fernández de Córdoba following the battle of Lucena.[6] Thereafter, it appears as though the type, fitted with ivory or horn facings, became fashionable in Europe, as examples attributed to the fifteenth and sixteenth centuries abound in armouries and museums, and are depicted in paintings from the period.[7]

Of interest regarding a connection between Europe and India are the eared daggers manufactured and signed by the Spanish swordsmith Diego de Çaias.[8] He used inscriptions in Kufic style to decorate some of his daggers, and as these inscriptions are undecipherable, it implies he copied them from existing models without understanding the script. More importantly, de Çaias included inscriptions in Kufic style on a sixteenth-century mace he made for King Henri II of France, which also depicts scenes from an Indian repertoire, such as domed architectural structures displaying flags with crescents, and camels and especially elephants bearing howdahs that clearly tie the iconography to India.[9]

Emperor Jahangir wearing a dagger of the cloven-pommel type in an illustration from the *Padshah-nameh* manuscript, by Balchand, Mughal, *c.* 1635

A further connection with Renaissance Europe comes in the form of the blade and guard of the "*Hamza-nameh* dagger", which are almost identical to the High Renaissance Italian *cinquedea* daggers.[10] I am grateful to Stuart W. Pyhrr, curator in charge of the Department of Arms and Armor at the Metropolitan Museum of Art, New York, who, upon my bringing up the similarity between the *cinquedea* and the dagger in the *Hamza-nameh*, confirmed that the wide triangular blade and the deep crescentic guard were "very *cinquedea*-like", and indicated that the slender grip with prominent knop in the centre and the bifurcated pommel were "more purely Indian in form".

In view of the links between Western Europe and India during the sixteenth century, which is when Diego de Çaias was active, it seems quite likely that such weapons could have been introduced to the Mughal court by Western travellers, and would have aroused the interest of the court. Furthermore, a sword hilt deriving from European types depicted in the *Hamza-nameh* manuscript suggests that European types of weapons had an impact on Indian painters during this period.[11]

Although both the *Hamza-nameh* and European eared dagger pommels have outward-flaring ears, whereas the Mughal dagger of the cloven-pommel type has upright ears, nevertheless, the general structure, and more specifically the cloven area or outset of the ears in the Renaissance eared dagger and the Mughal dagger, is too similar to be ignored.[12]

A SHARED LINEAGE

Sir Guy Francis Laking and Anthony North, the renowned arms and armour specialists, demonstrated that the eared dagger of Luristani type from the first-millennium BCE was the prototype for the European Renaissance eared dagger.[13] This must assuredly be the case, since not only

their pommels, but also the lower end of their grips, are very closely related in form, and few types of pommels feature such a configuration.

It has likewise been put forward that this type of first-millennium BCE eared dagger from Luristan was the prototype for the yataghan in that its pommel is composed of ears. The yataghan's hilt is generally manufactured from bone and has the overall appearance of a stylized femur bone, from which the eared shape probably originated. Considering that the manufacturing of tools and weapons evolved from material at hand during the earliest periods of civilization, and that animal bones were always readily available, it is most likely that the shape of the yataghan's hilt had been in continuous use since antiquity. Moreover, a bone hilt dating from the second millennium BCE that clearly evokes the form of eared dagger pommels, and was most likely the prototype of such pommels, was excavated at Tell al-Ghasil in the Bekaa valley, Lebanon, which corroborates the relationship between the ancient form and all its descendants.[14]

For reasons that are yet undetermined, the type must have journeyed from East to West over an extended period of time, since examples of bronze eared pommels from the fourth century BCE have surfaced in Atienza, Spain, and in England from the first century BCE and the third century CE, which indicates that the type most likely endured until the fourteenth century in the Iberian Peninsula,[15] and never went out of use.

Whatever the case may be, it is interesting that the pommel structure of a weapon originating in north-west Iran in the tenth century BCE could have journeyed such great distances over time and served as inspiration for Western daggers of the medieval and Renaissance periods, which in turn most likely inspired the weapon makers of the Mughal court when they developed their hilts with cloven pommels.

Dagger with eared pommel and *cinquedea* blade depicted in a folio from the *Hamza-nameh* manuscript, reportedly by Kesava Das, *c.* 1567

Cat. 41 **JEWELLED DAGGER
AND SCABBARD
Mughal dominions,
late sixteenth–early
seventeenth century**
Hilt and chape, gold over an iron
core, set in *kundan* technique
with rubies and emeralds, the
chape with diamonds, rubies and
emeralds; blade of *jawhar* steel
(heavily corroded); scabbard,
wood overlaid with red velvet,
and with metal thread trimmings
Dimensions: Length of dagger 26.5 cm; width
7 cm; length of scabbard 19 cm
Provenance: Art market 1991
Inv. no. LNS 215 J ab

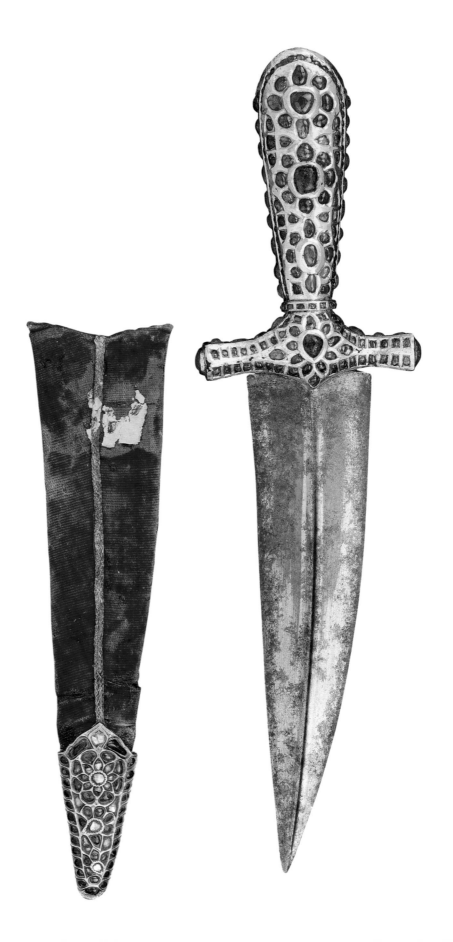

It is likely that this dagger is of the early cloven-pommel type on account of the similarity between its proportions and those of a dagger worn by a guest in a painting illustrating celebrations on the occasion of Emperor Jahangir's accession to the throne, signed by Abu 'l-Hasan and dated 1014 H (1605–6 CE).[16] Soon after the turn of the seventeenth century, when the jewelled arts were subjected to stylistic changes and generally evolved into a daintier genre during the reign of Emperor Jahangir, the cloven-pommel type underwent changes in form and decoration.

The hilt is set on its faces with three large ruby lotuses, and small ruby and emerald trefoils (or halved quatrefoils) fill the intervening areas along the edges – possibly an attempt at creating an uninterrupted geometric floral pattern, as previously seen in the side-bars of a number of *katar*s.[17] Unfortunately, the heavily disturbed surface of the gold has obliterated any original details or engraving, save for some of the lobes outlining petals. Both faces of the hilt are outlined with minuscule channel-set rubies, and the edges of the grip and upper ends of the quillons are set with a row of emeralds that crosses the pommel area, thus separating the "ears", each of which features a ruby rosette. A moulding set with rubies separates the hilt from the blade guard. The guard features a large ruby and emerald blossom flanked by rows of rubies outlining the prismatic quillons, which are set with large emeralds on their ends.

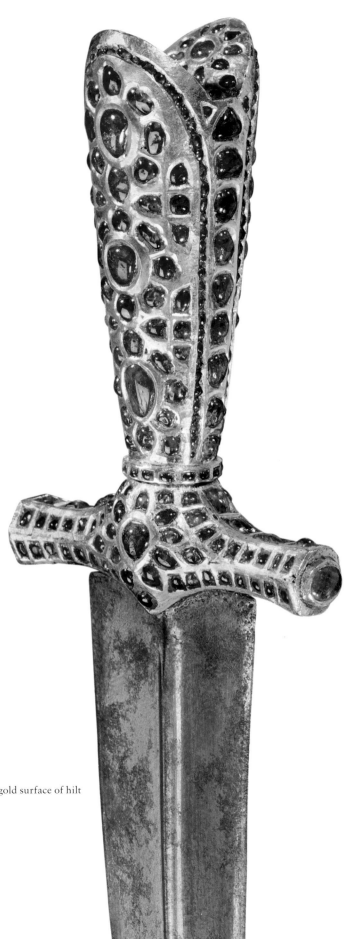

Detail showing disturbed gold surface of hilt

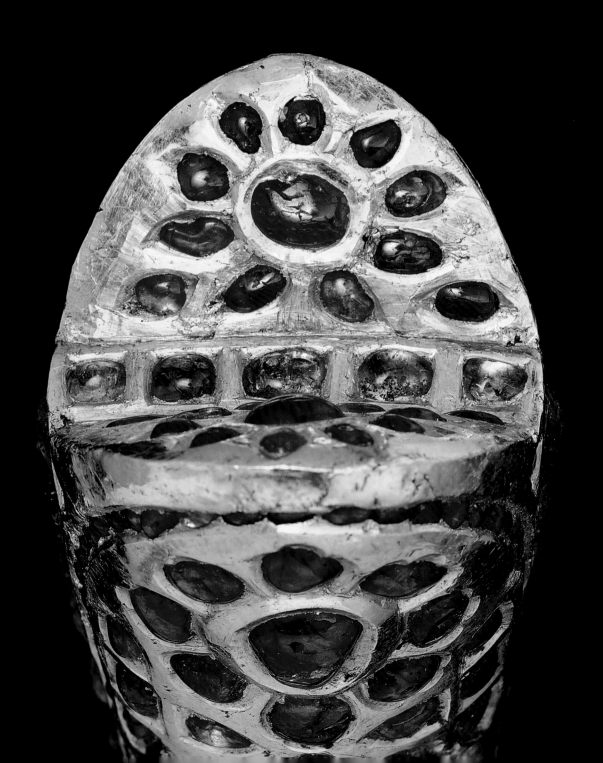

Floral decoration and emerald band
crossing the pommel, Cat. 41 (LNS 215 J)

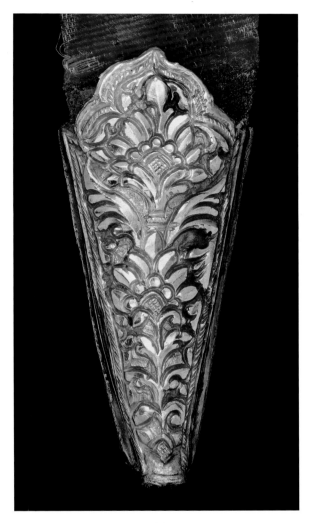

Repoussé decoration on back of chape

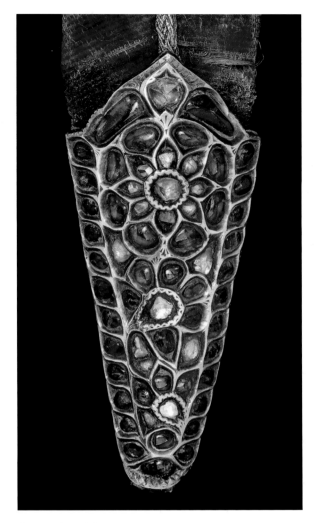

Gem-set face of chape

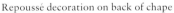

The chape, which clearly does not belong with this dagger and could be of later manufacture, features a large flowering plant, below which are two blossoms in counterchanging orientation issuing from the emerald-outlined edge. The gold back is worked in repoussé with floral motifs.

The ridged double-edged blade exhibits traces of rust and is curved, which is unusual as daggers of this type typically have straight blades. This, together with traces of disturbed gold on the underside of the guard, suggests that the blade does not belong with the hilt.

**Cat. 42 JEWELLED JADE DAGGER
AND SCABBARD
Mughal dominions, early
seventeenth century**
Hilt, locket and scabbard's sash-
cord ornament carved from
nephrite jade, inlaid with gold
in *kundan* technique and set
with rubies and emeralds; the
gold cross-bar worked in *kundan*
technique and set with rubies and
emeralds, engraved and chiselled;
blade of *jawhar* steel (crudely
resharpened); scabbard, wood
overlaid with red velvet with metal
thread trimmings
Dimensions: Length of dagger 28.5 cm; width
6 cm; length of scabbard 20.5 cm
Provenance: Art market 1992
Published: Keene and Kaoukji 2001, cat. 5.5;
Stronge 2010, pl. 32
Inv. no. LNS 300 J ab

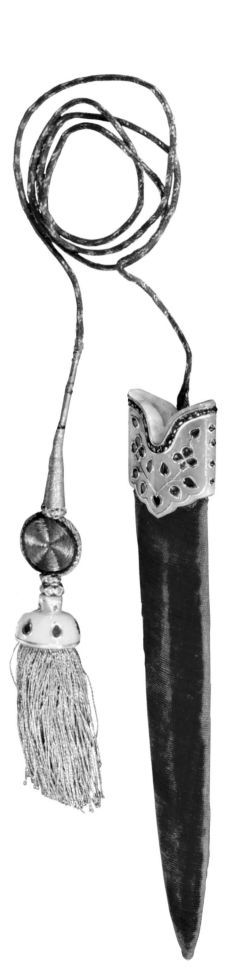

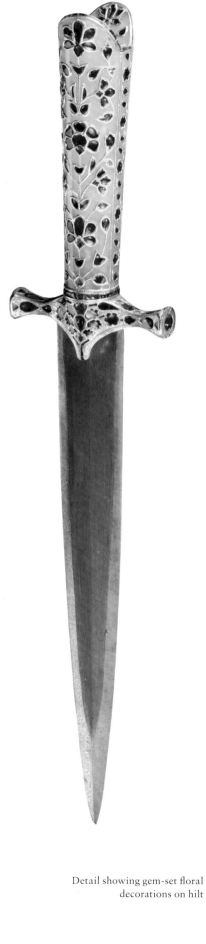

Detail showing gem-set floral
decorations on hilt

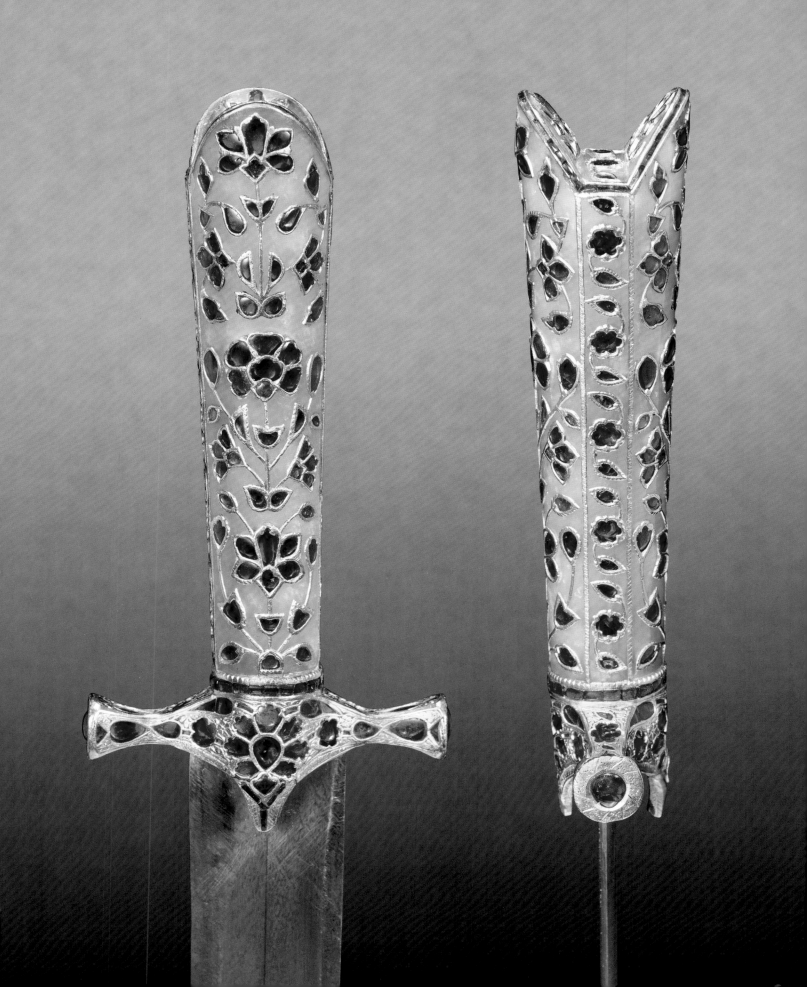

The stylistic treatment of the inlaid decoration on this dagger is composed of three flowering plants issuing ruby blossoms with emerald calyces, set with near-flat gemstones outlined with detailed gold, all flush with the surface of the hilt.

Along the flat edges of the grip a series of ruby rosettes issue pairs of ruby leaves in a reciprocal arrangement that extends to fill the flat surface separating the "ears" of the pommel. Each pommel-ear features a single ruby blossom with an emerald calyx and upswept ruby leaves, and is outlined by a minuscule band of channel-set rubies. Channel-set rubies likewise serve to separate the grip from the guard, which is set in the centre with a lotus blossom issuing small ruby stems that bear flowers and buds against a gold ground densely engraved with floral motifs.

The straight, double-edged *jawhar*-patterned blade is of thin rhomboid section thickening at the tip, and possibly replaces a thicker blade as a resin fill has been wedged between the blade and guard.

The jade locket, which is original to the piece, is also bordered with channel-set rubies and decorated with ruby and emerald floral motifs. It has been fitted with a cord that serves to attach the dagger to a sash; the cord ends with a tassel-cap encircled with stemmed ruby buds and small emerald circlets.[18]

Floral decoration and scroll crossing the pommel, Cat. 42 (LNS 300 J)

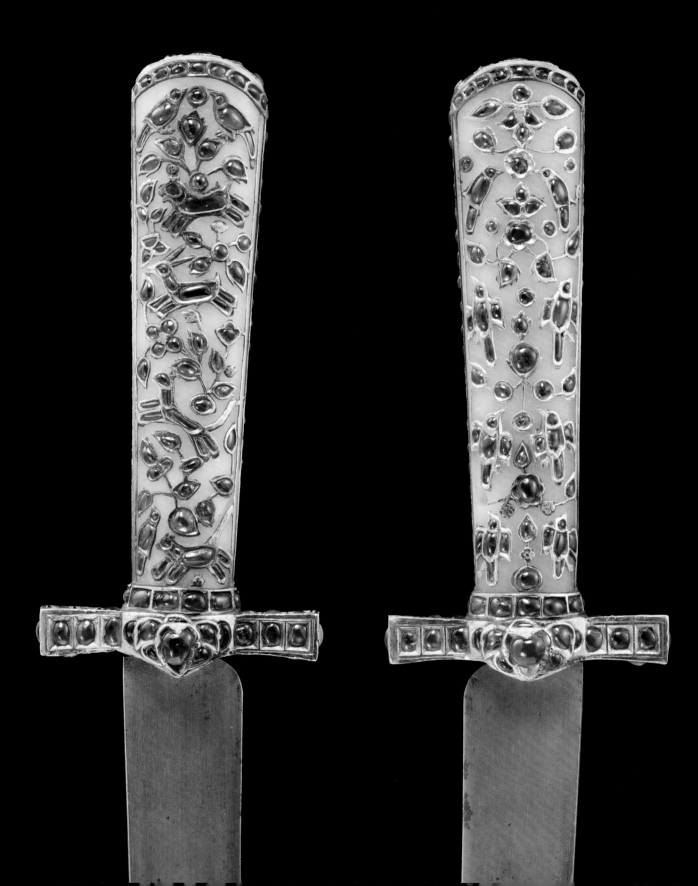

Cat. 43 JEWELLED JADE CHILD'S (?) DAGGER
Mughal dominions, first half of the seventeenth century
Hilt carved from nephrite jade, inlaid with gold in *kundan* technique and set with rubies, emeralds and a single sapphire; cross-bar, probably iron, heavily covered with gold worked in *kundan* technique and set with rubies and emeralds; blade of *jawhar* steel (of the broad period but not original to this piece)
Dimensions: Length 23.5 cm; width 4.5 cm
Provenance: Art market 1991
Published: Keene and Kaoukji 2001, cat. 2.10
Inv. no. LNS 75 HS

Birds and floral decoration on one face of the hilt, and awkward depiction of quadrupeds and floral decoration on the opposite face

Although this dagger's "ears" are virtually non-existent and the upper end of the hilt is rounded, it clearly displays features associated with the type, especially in the overall form of its hilt and guard, as well as in basic decorative approach. The craftsmanship of the hilt is manifestly skilful, but the rendering of the decoration of one of its faces is so unusual and imbued with such playfulness that it is conceivable that the dagger was commissioned for a very young patron, or that some of its decoration might even have been designed by a child.

On one of its faces four quadrupeds represented in awkward and childlike manner are set with rubies and a single large sapphire, whereas the three birds are fairly well rendered, as are the peculiar ruby and emerald plant forms that fill the intervening surfaces. On the opposite face, which is otherwise more conventional in style, pairs of birds flank series of further strange plant forms composed of ruby flowers, buds and emerald leaves set in artful lobed and engraved gold settings.

At variance with the type of decoration on the faces of the grip, and more in line with the conventional type, the top of the grip is of a formal four-part symmetry, with a single ruby flower issuing stems bearing small ruby blossoms and buds, with emerald leaves. A continuous band of rubies borders the edges and top of the hilt, and a raised gold ring set with rubies outlines it just above the guard.

In further contrast, the guard is splendidly set with a large ruby in a floral arrangement bordered by rubies and emeralds in stepped levels, and each quillon features rubies in "shadow box" gold settings, with a single emerald on the underside.

The underside of the guard (in the area flanking the cavity for insertion of the blade tang) is disturbed and damaged, with indications that a corroded blade was probably removed and replaced by the present one. The single-edged *jawhar*-patterned blade is incompatible with this type of dagger, which normally would have been fitted with a double-edged blade, and was most likely incorporated at a later date because it was emplaced with synthetic resin.

Cat. 44 LAPIS LAZULI KNIFE
Probably Deccan, early
eighteenth century
Facings carved from lapis lazuli,
the iron strip running around the
entire edge of the hilt overlaid with
gold; blade of *jawhar* steel inlaid
with gold
Dimensions: Length 28 cm; width 2 cm
Provenance: Art market 1995
Published: Sotheby's, London, 19 October
1995, lot 215
Inv. no. LNS 1464 J

Of pronouncedly slender proportions,
this hilt is fitted on each face with three
slabs of lapis lazuli riveted onto the iron
framework. The iron edging that runs
along the sides of the hilt and separates the
"ears" is overlaid with gold, with a series of
circlets on the side of the blade's sharp edge
and a continuous foliate scroll bordered by
circlets on the blunt edge.

The upper end of the single-edged
blade, which has retained its *jawhar*
pattern in pristine condition, is inlaid with
gold with a Shi'a invocation to Imam
'Ali – "O 'Ali extend your assistance":

يا / علي / مدد

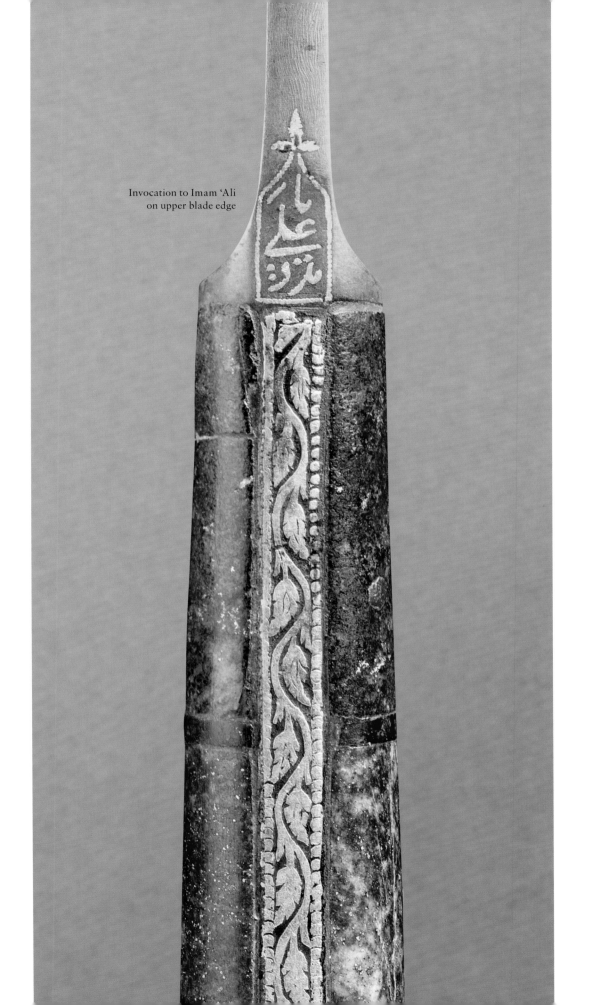

Invocation to Imam 'Ali
on upper blade edge

Cat. 45 **JEWELLED AND
ENAMELLED DAGGER
AND SCABBARD
Deccan, probably Hyderabad,
eighteenth century**
Hilt, locket and chape, gold set in
kundan technique with diamonds,
rubies and emeralds and champlevé
enamelled; blade of *jawhar* steel
overlaid with gold; scabbard, wood
overlaid with red velvet with metal
thread trimmings
Dimensions: Length of dagger 31 cm; width
3 cm; length of scabbard 28 cm
Provenance: Art market 2003
Inv. no. LNS 3900 J ab

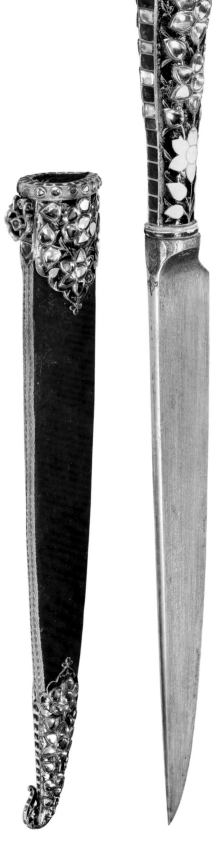

This dagger is particularly significant as it
combines features of the cloven-pommel
type in conjunction with those of the *pish-
qabz* – which is itself akin to the yataghan[19]
– and is furthermore a dagger of the deep-
sheathed type.[20]

Interestingly, the lower end of the
hilt, which is covered when the dagger
is sheathed, is decorated with enamels
echoing the colour of the gems set on the
upper end of the hilt, and when the dagger
is sheathed the gems decorating the locket
offset the effect.

Gold leafy stems in reserve on the
enamelled green ground bear large flowers
set with diamonds, and similar but smaller
diamond flowers decorate the dagger's
"ears"; the same style of flowers, rendered
inversely in white enamel, cover the lower
half of the grip.

A band of rubies and diamonds, which
is extended by a band of red enamel when
the dagger is sheathed, lines the edges of
the hilt. The band separating the "ears"
is covered with pale-blue enamel, which
recurs together with a band of red enamel
around the lower end of the hilt.

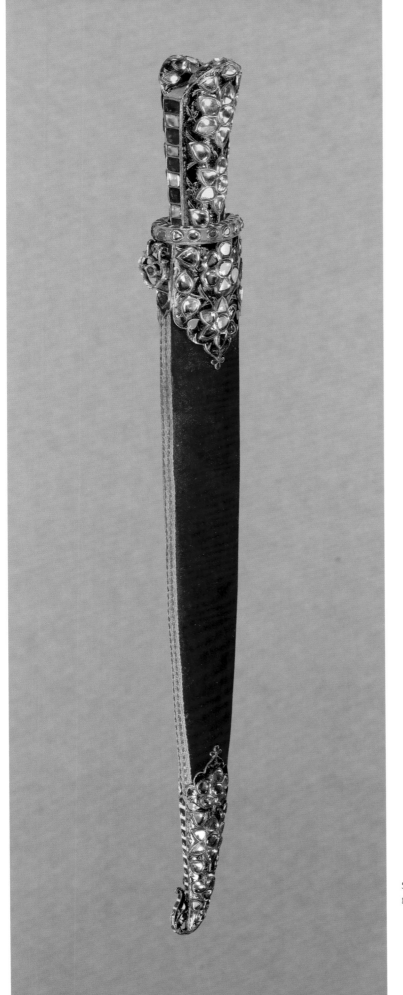

The sheath is fitted with the original locket and chape, both of which are decorated with diamond flowers on a green enamel ground and detailed with pale blue, red and white enamel. The back edge of the locket features a flat band set with diamonds and rubies, and serves as an extension of the diamond and ruby band lining the edge of the hilt. The locket is fitted with a bail set with a ruby on one face and an emerald on the other.

The single-edged *jawhar*-patterned blade is engraved around the upper end with quatrefoils bracketed by hachures that terminate in the form of a trefoil on the upper edge of the blade, which recalls the decoration on the *katar* Cat. 23. The ricasso retains traces of overlaid gold decoration.

Sheathed dagger showing continuity of gem-set decoration on hilt and scabbard

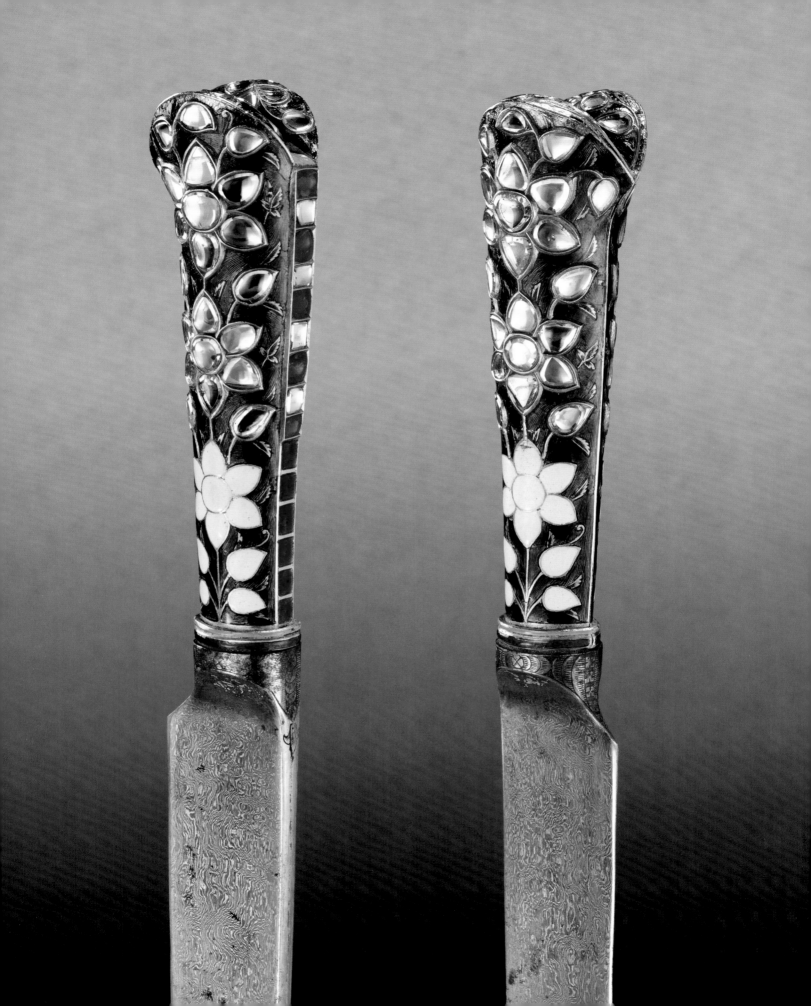

Two views of the unsheathed dagger, displaying combined gem-set and enamelled decoration on side and back of hilt, Cat. 45 (LNS 3900 J)

NOTES

1 A Central Asian (?) ambassador wears a dagger of the cloven-pommel type in a miniature attributed to c. 1605 or 1615, entitled "Festivities on the Occasion of the Accession of Emperor Jahangir", Akimushkin 1996, pl. 176/fol. 21r, pp. 105–06. In a painting by Abu 'l-Hasan, from c. 1615–20, entitled "Jahangir entertaining Sheikhs", the emperor wears a dagger of the cloven-pommel type tucked in his sash, Beach 1978, p. 61, cat. 13. A painting dated to c. 1618 from the *Leningrad Album*, entitled "Jahangir Embracing Shah Abbas", depicts both Emperor Jahangir and Asaf Khan wearing daggers of the cloven-pommel type, Beach 1981, pp. 170–71, and plate on p. 78.

2 Shah 'Abbas I wears a dagger of the cloven-pommel type in a miniature portrait by Bishn Das, "who was at Isfahan in 1613–19", which is dated accordingly, Rogers 2006, p. 94, fig. 60; and a Safavid prince, "perhaps Shah 'Abbas II", wears such a dagger in a page from the Polier album attributed to the period of Shah Jahan, ibid. pp. 103–04, fig. 72.

3 Good examples depicting such illustrations can be seen in a portrait of Shah Jahan published by Susan Stronge in Jackson and Jaffer 2004, pl. 22.14, and especially in the close-up of an early seventeenth-century Safavid portrait of a "reclining youth", Adamova 1996, cat. 17.

4 Stronge 2002, p. 24, pl. 9. Another dagger displaying a similar blade and crescentic guard is depicted worn by one of Emperor Babur's amirs, in a *Babur-nameh* of c. 1589, Alexander 1996, cat. 143.

5 Two bronze eared daggers (inv. nos. 50.827 and 52.392) in the National Archaeological Museum, Madrid, 1935.

6 Lavin 1997, pp. 16–17.

7 Rodriguez Lorente 1964, pp. 67–68 and p. 86, as well as p. 73, where the author refers to an article by Dona Pilar Fernandez Vega in the *Anuario del Cuerpo de Archiveros y Bibliotecarios*, Madrid, 1935, which provides information about representations of eared daggers on Italian and Spanish monuments and paintings.

8 "The so-called ear dagger which became briefly popular across Western Europe in the sixteenth century was considered to be a Spanish invention, so it is probably no coincidence that the maker of one of the finest extant examples was the Spanish swordsmith Diego de Çaias, who is known from lists of wages as having served at the courts of François I and Henry II of France and Henry VIII of England; and that Edward VI (son of Henry VIII) in a portrait from the Royal Collection at Windsor Castle attributed to c. 1546, holds such a dagger in his hand." LaRocca 1989, p. 55.

9 Lavin 1997, p. 20; Blair 1970, pp. 158–62, figs. 11–14 and 17–22.

10 Coe 1989, p. 49, publishes a good example of a *cinquedea*.

11 Zumurrud Shah's sword hilt in Seyller 2002, cat. 57.

12 A good representation of the cloven area of an eared dagger can be seen in Blair 1970, p. 153, fig. 2.

13 North 1989, p. 137; Rodriguez Lorente 1964, p. 67.

14 American University of Beirut Archaeological Museum, inv. no. T.Gh.72.50. My thanks go to Dr Leila Badr for providing me with the necessary references for the thigh-bone hilt in her care at the museum.

15 See e.g. daggers from Luristan, Amarlu and Ardebil with attributions ranging from the twelfth to the ninth centuries BCE in Khorasani 2006, pp. 381–82, pp. 391–92 and pp. 403–05; a "Luristani" dagger in the Musée du Louvre (inv. no. AO 21103), attributed to the middle of the sixth century BCE; the ivory facing of a dagger hilt excavated at Taxila attributed to about the fifth century BCE ("or earlier"), Marshall 1975, vol. III, pl. 200a, and text, vol. I, pp. 88 and 101–02. Also, the pommel structure of a fourth-century BCE sword from Atienza, Spain; the pommel of a Roman dagger, also with ear-like projections, from Hod Hill, Dorset, mid-first century CE; and finally a Roman dagger with similar pommel from Copthall Court, London, attributed to the third century CE, Connolly 1989, pp. 24, 27 and 28.

16 A hilt of heavy proportions in the belt of a Central Asian-looking personage wearing a red headdress in the foreground of the painting entitled "Festivities on the Occasion of the Accession of Emperor Jahangir", Akimushkin 1996, pl. 176/ fol. 21r, pp. 105–06. I am grateful to Dr A. S. Melikian-Chirvani for deciphering the date on the painting.

17 See e.g. the decorative motif on the *katar* cat. 11 inter alia.

18 Emperor Jahangir is depicted wearing a dagger of the type with a tassel-cap and pendant pearls secured to his belt in a folio from the *Padshah-nameh* attributed to c. 1635, Beach and Koch 1997, cat. 37.

19 For the type, see Chapter 9 and the introduction to the present chapter regarding the relation between the eared dagger and the yataghan.

20 For the type, see Chapter 8.

CHAPTER FIVE
THE PISTOL-GRIP OR BIRD-HEAD HILT
A UBIQUITOUS ANCESTRY

VESTIGES FROM THE MEDITERRANEAN BASIN, THE IRANIAN WORLD AND INDIA

Pommels of this type, which in an Indian milieu should appropriately be labelled of the "parrot-head" type, are very functional, particularly in thrusting, which explains why they were found in many different parts of the world for considerable lengths of time. Evidence of a "bird-head" pommel hilt from around the first half of the second millennium BCE, although in this case representing the god Horus (who among other attributes served as god of war), is represented on a dagger worn by King Tutankhamun.[1] The same type of dagger is featured on a fifth-century BCE black-figured Attic vase from Gela, southern Italy,[2] and on a carved marble Roman pillar from the first century CE in the Galleria degli Uffizi, Florence.[3] The type seems to have endured in the area, as the Tetrarchs of Venice are portrayed carrying weapons with bird-head pommels on a porphyry relief in St Mark's Basilica, with a possible attribution to Egypt at the turn of the fourth century CE.[4]

Whether or not this is an indication of variables in the adoption of the type, it is nevertheless noteworthy that it appears to have spread eastward, as the Sasanian ruler Shapur II is represented on a silver dish, from the first quarter of the fourth century CE, wearing a sword with a bird-head pommel suspended from his belt.[5] From further south, in around the fifth to the sixth century, a group of rajas and ranis were depicted holding swords with bird-head pommels on a wall painting of the Ajanta Caves.[6]

Painted miniature of a prince hunting deer with a pistol-grip dagger tucked in his sash, Bijapur, c. 1660–70

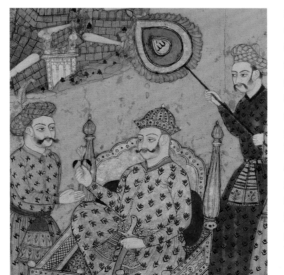

A sultan holding a sword with a parrot-head hilt pommel in a history of the Qutb Shahi Sultans of Golconda, dated 1019 H/1610–11 CE

RE-EMERGENCE IN THE IRANIAN WORLD AND INDIA

Although representations of these hilts remain patchy during the ensuing periods, in an almanac preserved in The al-Sabah Collection, which was probably prepared for a governor of the Khwarazm Shahs and includes the date 25 Dhu 'l-Hijjah 615 H (14 March 1219 CE), the planet Mars is represented holding a sword that could conceivably be of the pistol-grip type.[7] Additionally, in a painting attributed to Herat c. 1490, an interesting example of a weapon with a pommel in the form of a parrot is depicted tucked in the belt of a man holding a green parrot.[8]

For undetermined reasons, during the first half of the sixteenth century "bird-head" pommel hilts appear quite frequently and almost simultaneously in Europe and India,[9] but probably only the Indian examples were intended to represent parrots, as in a manuscript of the *Bhagavata Purana* attributed to the first half of the sixteenth century.[10] From the second half of the sixteenth century onwards, parrot-head pommels are frequently depicted in the manuscript of the *Hamza-nameh*[11] and most notably in the *Nujum al-'Ulum* (Stars of Sciences) manuscript produced for the Sultan of Bijapur, dated 14 Rabi' al-Awwal 978 H (August 1570 CE).[12]

Given the prominence of the parrot or *toti* in Indian lore, and considering the number of jewelled ornaments in the form of parrots also dating from the sixteenth century,[13] it is conceivable that the emperor Akbar, who took a keen interest in matters related to Indian culture, might have endorsed the style. Unfortunately, considering the frequent contacts between the West and the Indian subcontinent during this period, it is difficult to determine whether the appearance of parrot-head hilts in India should be attributed to a native resurgence of the trend or to Western stylistic influences.

Cat. 46 JEWELLED DAGGER AND SCABBARD

Probably Deccan, late sixteenth–seventeenth century

Hilt, locket and chape, gold over an iron core, set in *kundan* technique with emeralds, rubies and diamonds; blade of *jawhar* steel overlaid with gold; scabbard, wood overlaid with silk woven in floral designs, with metal thread trimmings

Dimensions: Length of dagger 37.5 cm; width 6 cm; length of scabbard 29.5 cm

Provenance: Art market 1991

Published: Atil 1997, no. 100; Keene and Kaoukji 2001, cat. 13.10

Inv. no. LNS 212 J ab

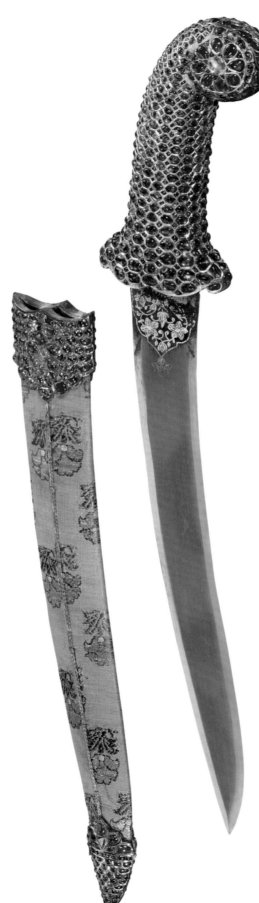

This rare example of purely geometric ornamentation on a weapon recalls the decoration on a seventeenth-century Indian jewelled flask in the State Hermitage Museum.[14] It is also reminiscent of the treatment of geometric decoration on domical structures in Islamic architecture, in which a pattern is subtly modified to accommodate a curving or narrowing surface. Here, the hexagonal cells set with emeralds that cover the lean and near rectilinear grip, with rubies in their interstices, are subtly replaced by octagonal cells to accommodate the widening surface of the grip as it spreads to form the quillon block.

Although the down-swept quillon tips are most likely inspired by the hilts of Timurid weapons, it is clear that the style lingered on during the Akbari period, as two examples are represented in folios of the *Hamza-nameh* attributed to *c.* 1570.[15] Interestingly, the only Indian weapons in The al-Sabah Collection with down-swept quillon tips are this dagger, Cat. 47, Cat. 61 and Cat. 113, the jewelled sword with a parrot-head pommel.

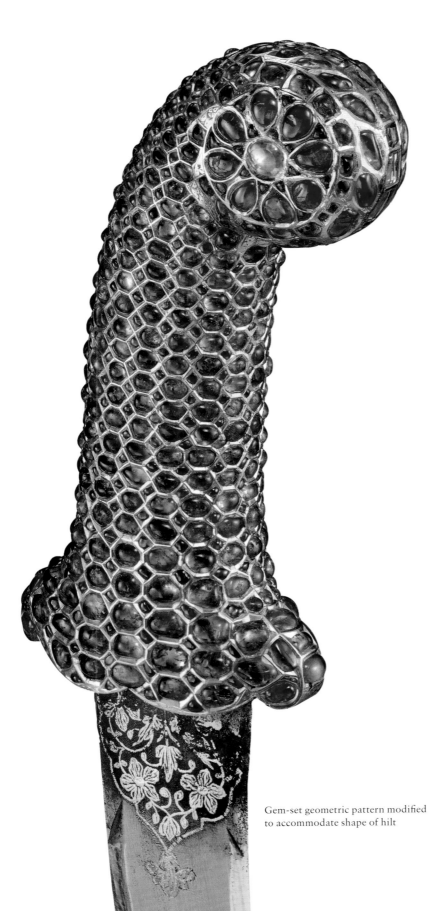

Gem-set geometric pattern modified
to accommodate shape of hilt

Characteristic of this type of dagger are the cypress-tree and acanthus-leaf motifs that outline the upper edge of the pommel, issuing vines that curl around the pommel and end in the form of large blossoms filling the sides of the pommel. In this example a stylized cypress tree set with diamonds and rubies grows from a large triangular ruby mound on the inner curve of the pommel, and ruby and diamond flowers fill the sides of the pommel.

It is noteworthy that some of the minute intervening gold surfaces on the pommel and lower edges of the quillon block are engraved with foliate motifs. Some of the gold surfaces were, however, apparently planed and then reworked and there is great disparity between the quality of the original engraving and the later, sketchier additions.

The pattern of imbricated rubies on the locket and chape is augmented on the locket with an emerald and diamond flower and on the chape with a ruby, emerald and diamond floral motif above an encircling band of channel-set emeralds. Although of fine workmanship, it is unlikely that the locket and chape belong with the dagger due to their differing style of design.

The double-edged *jawhar*-patterned blade is of thin rhomboid section and gently drops before it recurves towards the tip. It has been stabilized with small steel plates and resin. A gold-overlaid lobed medallion on the ricasso suspends a flowering plant arabesque with what appears to be an iris-blossom finial.

Cat. 47 JADE DAGGER
Probably Deccan, first half
of the seventeenth century
Hilt carved from nephrite jade;
blade of *jawhar* steel
Dimensions: Length 37 cm; width at quillons
5 cm
Provenance: Art market 1991
Published: Keene and Kaoukji 2001, cat. 9.29
Inv. no. LNS 79 HS

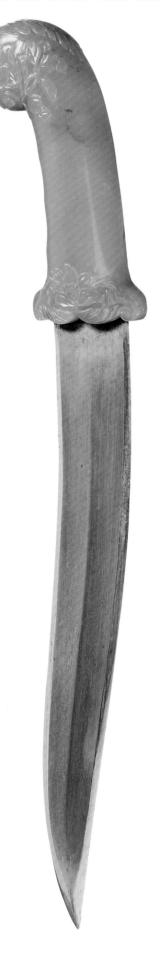

The hilt of this exquisitely carved dagger
extends in an unbroken line from the
pommel to the down-swept quillon block.
It is akin in form and proportions to the
jewelled dagger Cat. 46, except that, owing
to the slippery surface of the jade, it has
been carved with three finger-rests on the
front to afford a good grip of the hilt, a
widespread practice that dates as far back
as the Bronze Age.[16]

On the butt of the pommel a blossom
issues a pair of acanthus leaves flowing in
opposite directions, one serving to outline
the upper edge of the pommel, and the other
the inner curve. The leaf outlining the inner
curve issues a pair of fluid floral vines, each
of which curls around and fills the sides of
the pommel with lively lilies and entwined
foliate vines issuing overturned leaves
and tendrils.

On the quillon block a large lily with
overturned petals, leaves and buds develops
between the halved acanthus leaves that
border the lower edge of the block, contour
the downturned quillon tips and extend
onto the lower ends of the grip. A similar
decorative feature in which the acanthus
leaves contouring the quillons extend to
the lower end of the grip can be seen on
the horse-head dagger Cat. 60, although
in Cat. 60 only part of the acanthus leaf
remains because of breakage necessitating
the replacement of the quillon.

The double-edged *jawhar*-patterned
blade is of thin lozenge section, gently
dropping before it recurves towards the
reinforced tip.

Carved lilies on pommel
and quillon

**Cat. 48 JEWELLED JADE DAGGER
WITH SCABBARD, LOCKET
AND CHAPE
Deccan, first half of the
seventeenth century**
Hilt, locket and chape carved
from nephrite jade, inlaid with
gold in *kundan* technique and
set with rubies, emeralds and
diamonds; blade, steel (probably
jawhar, subsequent polishing
having obscured the "watering");
scabbard, wood, covered with red
and gold silk velvet (supplementary
weft of gold thread)
Dimensions: Length of dagger 35.5 cm; width
5 cm; length of scabbard 26 cm
Provenance: Art market 1980s
Published: Jenkins et al. 1983, p. 129; Atil et
al. 1985, fig. 74; Qaddumi 1987,
p. 154; Atil 1990, cat. 100; Keene
and Kaoukji 2001, cat. 2.16;
Michell 2007, cat. 54, pp. 220,
272; Stronge 2010, pl. 37;
Curatola and Kaoukji 2016,
cat. 180
Inv. no. LNS 12 HS ab

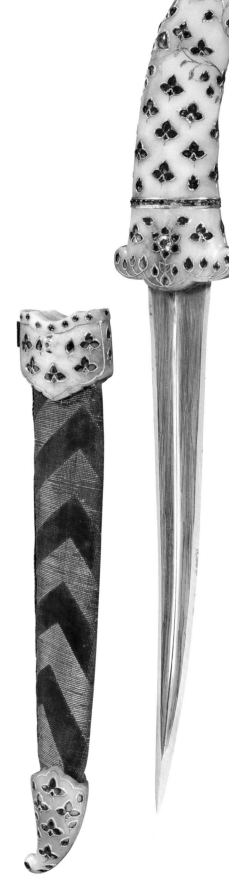

The decorative scheme of this near
rectilinear hilt centres on four stages of
floral representations set with rubies:
blossoms of the lotus type with high,
faceted diamond centres surrounded by
lobed ruby petals; *talab*-set ruby trefoils
with emerald calyces, closely related to
the ruby trefoils with emerald calyces on
the chapes Cats. 63 and 64, both of which
reportedly come from Hyderabad; ruby
buds; and, on the spine of the hilt, three
large unfurling ruby buds with emerald
calyces, set in an atypical fan-shaped
arrangement and gathered at the base
with two small emerald leaves.

A stylized cypress-tree motif channel-
set with emeralds bordered by lobed
ruby petals outlines the upper edge of the
pommel. On the pommel butt, a trefoil
that is pendent from the cypress tree issues
a pair of gold undulating vines, which, in
keeping with the decoration on this type of
hilt, curl around the sides of the pommel,
bearing ruby lotuses with prominent
diamond centres, buds and emerald leaves
that create a continuum from the upper
edge of the hilt to the sides of the pommel.

A lateral and elaborate network of
fluid gold vines issuing trefoils surrounds
the unfurling buds in the fan-shaped
arrangement on the back of the hilt. These
vines originate from a single trefoil situated
below the pommel butt, bearing further
trefoils and buds as well as engraved gold
leaves, and touch on the trefoil below the
unfurling buds.

The remaining surface of the grip is filled with staggered rows of ruby trefoils with emerald calyces, and is set off from the quillon block by a band of channel-set emeralds. The lobed quillon block is bordered on the edge by a gold vine issuing ruby buds and an emerald leaf, from which develops a stemmed ruby blossom with a prominent diamond centre issuing further buds flanked by trefoils.

The gently recurved double-edged blade has been heavily ground down, is ridged and is reinforced at the tip.

The scabbard has retained its original red and gold silk-velvet covering, as well as its original locket and chape. Adorned with stemmed ruby buds, which appear to be associated with a type of decoration originating in the Deccan,[17] and trefoils, the locket and chape are outlined with gold fillets, and along the upper edge of the locket are small ruby quatrefoils. The locket is carved with an integral lug for the attachment of a cord.

Prominent diamonds on pommel and quillon and ruby floral decoration on hilt

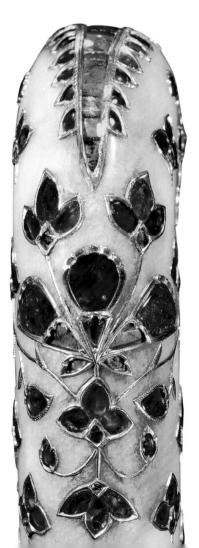

Pommel outlined with emerald and ruby cypress tree motifs, and fan-shaped arrangement of ruby buds on back of grip

**Cat. 49 JEWELLED JADE DAGGER
WITH SCABBARD, LOCKET
AND CHAPE**
**Probably Deccan, first half
of the seventeenth century**
Hilt, locket and chape carved from
nephrite jade, inlaid with gold in
kundan technique and set with
nephrite jade and rubies; blade
of *jawhar* steel; scabbard, wood
covered with red fabric with metal
thread trimming
Dimensions: Length of dagger 39 cm; width
5 cm; length of scabbard 30 cm
Provenance: Art market 1980s
Published: Keene and Kaoukji 2001, cat. 10.5
Inv. no. LNS 115 J ab

Although carved from dark-green jade,
the hilt of this dagger has a near-black
appearance, which contrasts strikingly with
the inlaid white jade and rubies of the floral
decoration, as well as with the matching
white jade locket and chape.

As in Cat. 47, a pair of acanthus
leaves oriented in opposite directions
and separated by a fluted jade and ruby
quatrefoil outline the upper edge of the
proportionately large pommel. The leaf
situated on the curve of the butt issues a
pair of gold vines that typically curl around
the sides of the pommel issuing buds and
large flowers with fluted petals overturned
on their tips.

With the exception of the buds that
issue from the leaves bordering the edge
of the quillon block, and the buds above
the tips of the quillon curls, the remaining
surface of the near rectilinear hilt is covered
with staggered rows of fluted buds with
ruby sepals issuing gold tendrils, which
resemble the gold tendrils issuing from the
ruby blossoms on the locket of the floral
dagger Cat. 87.

Channel-set rubies border the edge of
the locket, which together with the chape
is outlined with gold fillets and inlaid with
rubies and fluted dark-green jade buds and
flowers with overturned petals. On the
front of the locket, an integral lug exhibits
a depression that must have once held a
gemstone and is pierced with a minuscule
hole, probably for the attachment of a bail.

The double-edged blade still retains
traces of the *jawhar* pattern and is of thin
rhomboid section, gently dropping before it
recurves towards the slightly reinforced tip.

Near-black jade hilt inlaid with
carved white jade and ruby blossoms

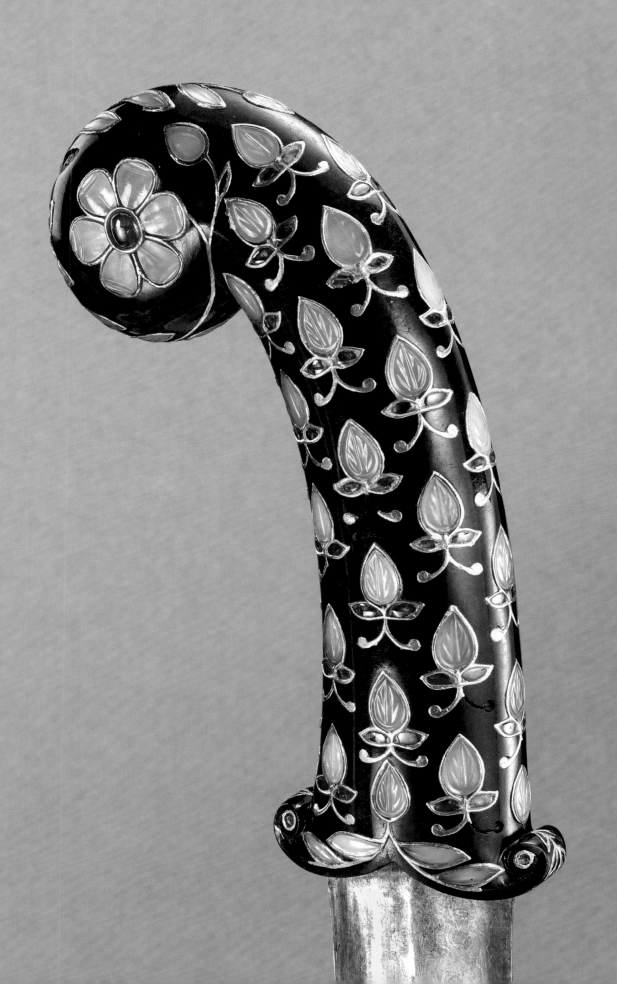

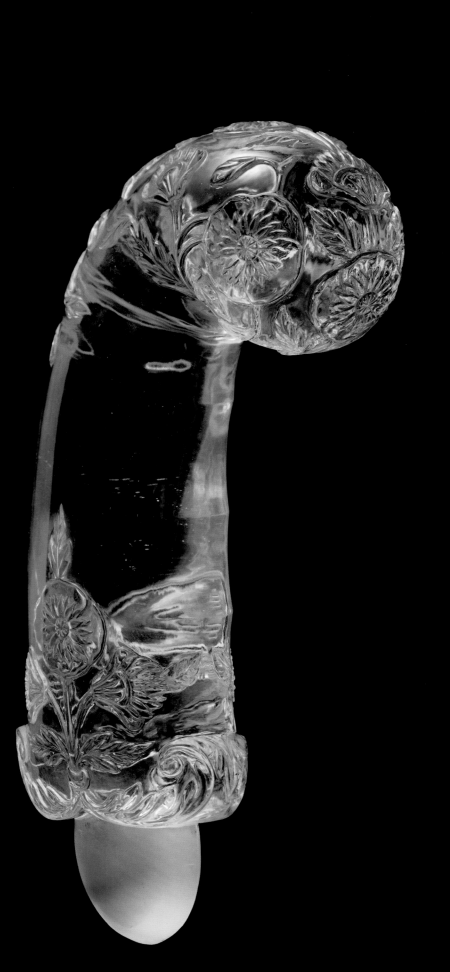

Cat. 50 ROCK-CRYSTAL HILT
Mughal dominions or
Deccan, first half of the
seventeenth century
Carved from rock crystal
Dimensions: Length 15 cm; width 5 cm
Provenance: Art market 1991
Published: Keene and Kaoukji 2001, cat. 9.28
Inv. no. LNS 78 HS

This hilt of generally rounded proportions
is finely carved from a large piece of
flawless rock crystal with three finger-rests
on the front of the slightly flaring grip, and
compact, upswept quillons.

The unpolished stump projecting from
the quillon block, as in most rock-crystal
hilts (such as the horse-head hilt Cat. 69)
was inserted with the blade tang and
prevented it from being visible through
the transparent hilt as in Cat. 60. The
stump would have been concealed under a
medallion fitted on the blade ricasso, as is
the case in the dagger Cat. 51.

On the pommel butt a vine issues from
a small cup-like vase bearing three poppy
blooms and foliage that outline the upper
edge of the pommel, and suspend a stem
bearing large toothed leaves and buds along
the upper end of the grip.

Two further vines issue from the base
of the small vase and typically curl around
each side of the pommel, terminating with
poppies in full bloom and foliate vines
bearing smaller blossoms and buds.

The stems of the acanthus leaves that
border the lower edges of the quillon
block are gathered at the cusp by a
crescentic bracket from which develops
a poppy blossom flanked by unfurling
poppies and leaves.

Carved rock-crystal hilt showing
unpolished blade-tang stump

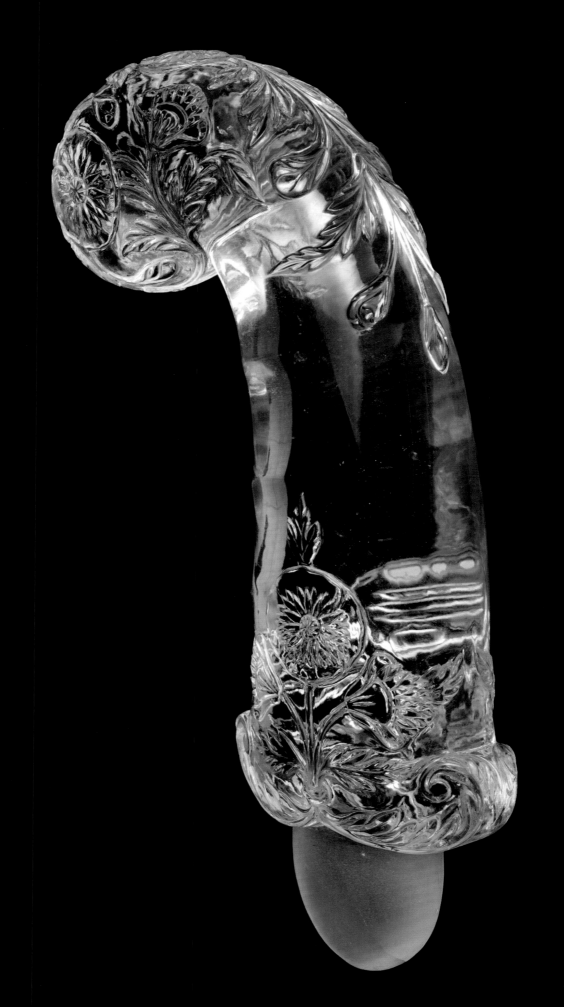

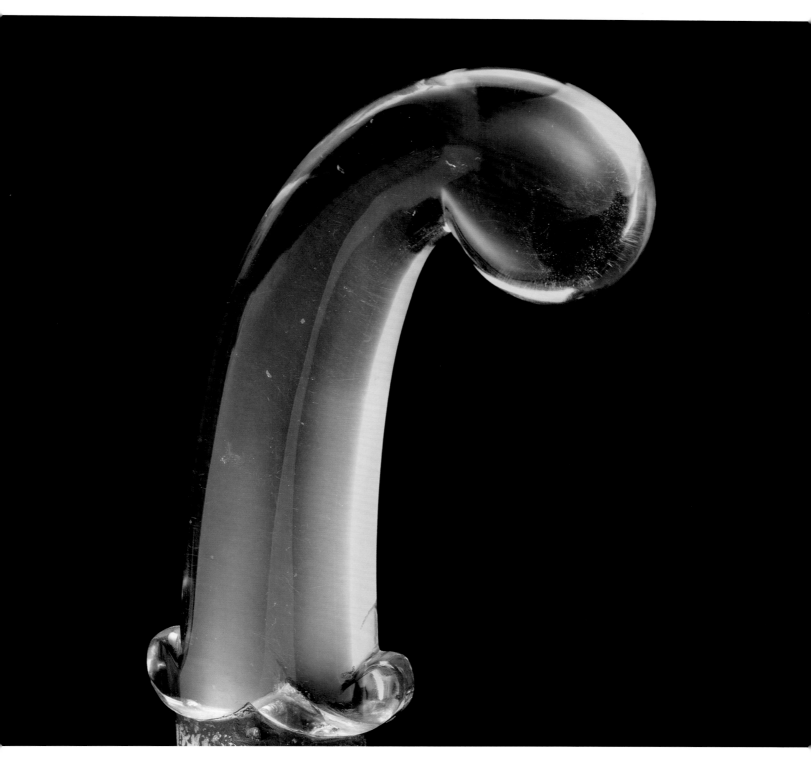

Detail showing elegant proportions of hilt

Cat. 51 ROCK-CRYSTAL DAGGER
Deccan, *c*. first half of the
seventeenth century
Hilt carved from rock crystal;
blade of *jawhar* steel; steel
medallion overlaid with gold
Dimensions: Length 39 cm; width 5.5 cm
Provenance: Art market 1997
Published: Sotheby's, London, 8 May 1997,
lot 45
Inv. no. LNS 250 HS

The appeal of this elegant dagger lies
mainly in the perfect proportions of its
hilt, and the exceptional purity of the
material from which it was carved.
It is a superb example of the refined taste
of Indian patrons who valued objects
as much for their form and material
as for their lavish style of adornment.

The slight curvature of the hilt and
gently flaring grip with its subtly gabled
back edge, and especially the finely
carved quillon block, bear witness to
the skill and discernment of the master
craftsman who produced this dagger.

On the ricasso a curved medallion
conceals the customary stump that held
the blade tang in transparent rock-crystal
hilts, as in Cats. 50 and 69. The lobed
medallion, which displays much wear,
is overlaid with gold in an elaborate
floral arabesque displaying blossoms
composed of series of dots in a fashion
closely related to decorative motifs
on bidri-ware vessels.

The ridged double-edged blade has
suffered much repolishing, drops and
recurves at the reinforced tip, and has
been pierced with two holes on either
side of the ridge just below the medallion.

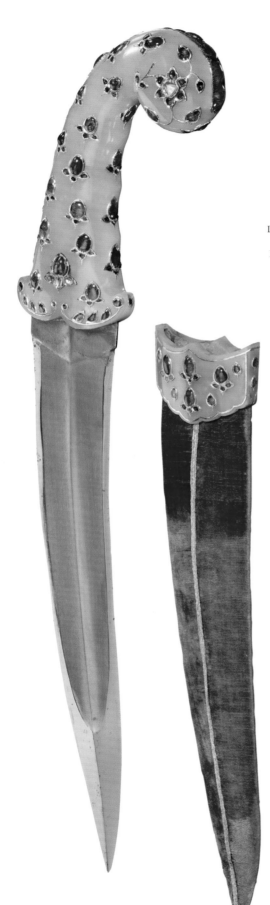

Cat. 52 JEWELLED JADE DAGGER WITH SCABBARD AND LOCKET
Probably Deccan, *c.* mid seventeenth century
Hilt and locket carved from nephrite jade, inlaid with gold in *kundan* technique and set with rubies, emeralds and diamonds; blade of *jawhar* steel; scabbard, wood overlaid with red velvet, with metal thread trimming
Dimensions: Length of dagger 40 cm; width 6 cm; length of scabbard 29 cm
Provenance: Art market 1991
Published: Keene and Kaoukji 2001, cat. 2.31
Inv. no. LNS 69 HS ab

This dagger is of slender proportions and related to the dark-green jade example Cat. 49 with regard to its type of decoration, which here is generally more restrained. The gemstones that adorn the dagger are held in finely detailed and scalloped gold settings, with sparing use of minute chiselled detailing in some of the gold settings.

The cypress tree that typically outlines the upper edge of the pommel is channel-set with large rubies and linked by a gold vine to a ruby bud on the pommel butt. Also typical is the pair of gold vines that issue from the bud and encircle the sides of the pommel, terminating in ruby and diamond blossoms on either side of it. These blossoms in turn issue gold vines with emerald leaves in a rotational pinwheel configuration on the sides of the pommel.

Rows of large ruby buds nesting in emerald calyces occupy the remaining surface of the grip as well as that of the matching locket. This pattern is interrupted only by the ruby buds with diamond calyces set just above the cusp of the quillon block on both faces of the hilt. As in Cats. 48 and 49, gold fillets issuing emerald leaves border the edge of the block.

The double-edged *jawhar*-patterned blade is of rhomboid section, gently drops before it recurves at the reinforced tip and has been fitted with steel plaques on both sides of the ricasso.

Detail of hilt showing the rotational pinwheel configuration on the side of the pommel

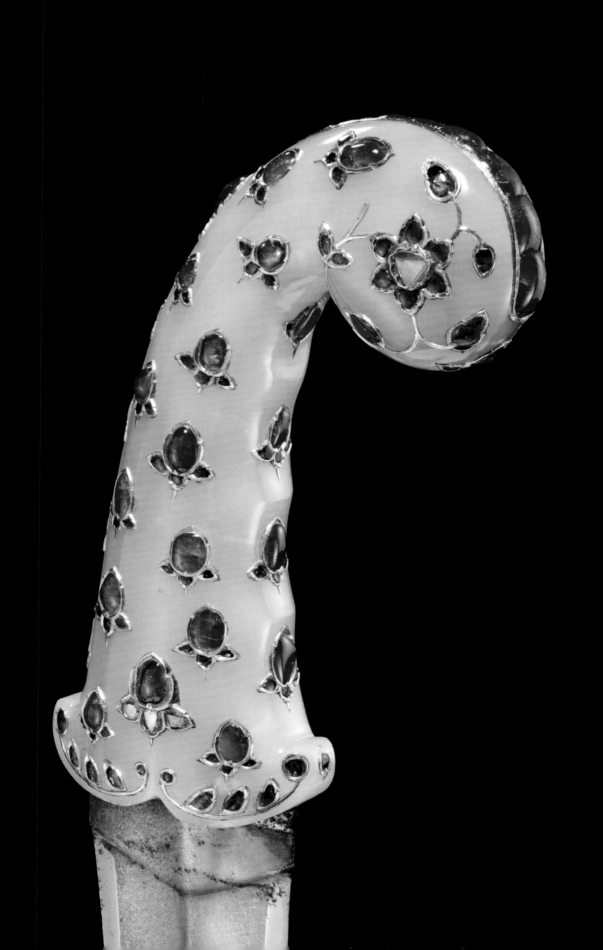

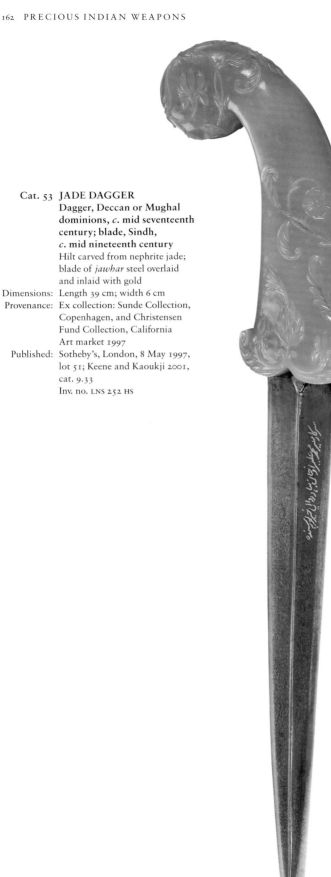

Cat. 53 JADE DAGGER
Dagger, Deccan or Mughal
dominions, *c.* mid seventeenth
century; blade, Sindh,
c. mid nineteenth century
Hilt carved from nephrite jade;
blade of *jawhar* steel overlaid
and inlaid with gold
Dimensions: Length 39 cm; width 6 cm
Provenance: Ex collection: Sunde Collection,
Copenhagen, and Christensen
Fund Collection, California
Art market 1997
Published: Sotheby's, London, 8 May 1997,
lot 51; Keene and Kaoukji 2001,
cat. 9.33
Inv. no. LNS 252 HS

The gently flaring and flattish grip of this
disproportionately large dagger is finely carved on
the pommel with a vine interspersed with blossoms
and sweeping, fluid leaves outlining the upper end of
the pommel. The vine bifurcates on the butt of the
pommel and curls around the sides, where tendrils
branch off bearing irises in full bloom and sweeping
leaves oriented towards the back of the pommel.

On the back of the grip a vine develops from the
curl of the quillon tips, issuing floral stems entwined
with curling leaves that flow from the back towards
the front of the grip.

Halved acanthus leaves typically border the
edge of the quillon block and issue a pair of
upswept irises flanking a multi-petalled bud, from
which issues a swaying stem with an unfurling iris.
The bud possibly represents the globe amaranth
(*Gomphrena globosa* or *rakthamallika* in Sanskrit),
matching the buds that decorate the *katar* Cat. 6.

The ridged double-edged *jawhar*-patterned
blade gently drops and recurves at the reinforced
tip, and features a small raised panel overlaid with
gold on the cusp of the quillon block.

On the blade, a gold-inlaid inscription in
nasta'liq gives the owner's name and title:

سـركار مـير محـمد عليمـراد خـان بـهـادر والـي
خيربور سنده

His Lordship Mir Muhammad
'Ali Murad Khan Bahadur, Governor
of Khayrpur, Sindh.

The blade is undoubtedly of later manufacture than
the hilt, as the Talpur ruler Mir Muhammad 'Ali
Murad Khan Bahadur governed Khayrpur from
1842 until 1894. Moreover, the blade aperture
of the quillon block was clearly made for a larger
blade, further demonstrating that this blade
did not originally belong with the hilt.

Fine, meandering floral-vine
carving on hilt

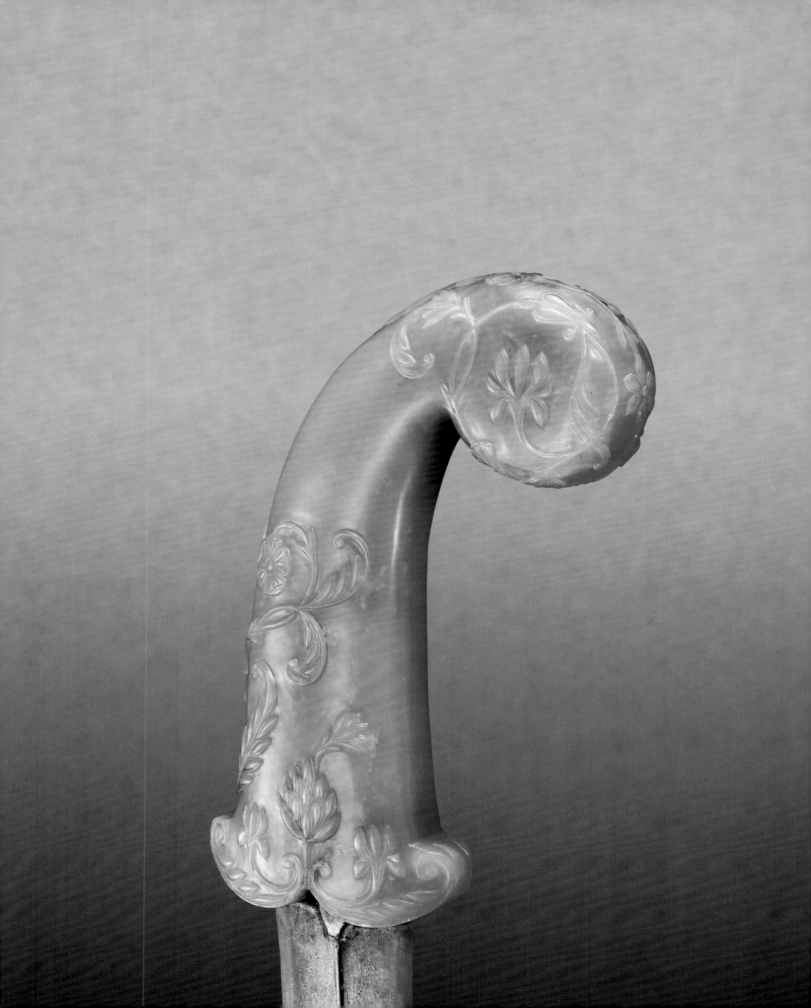

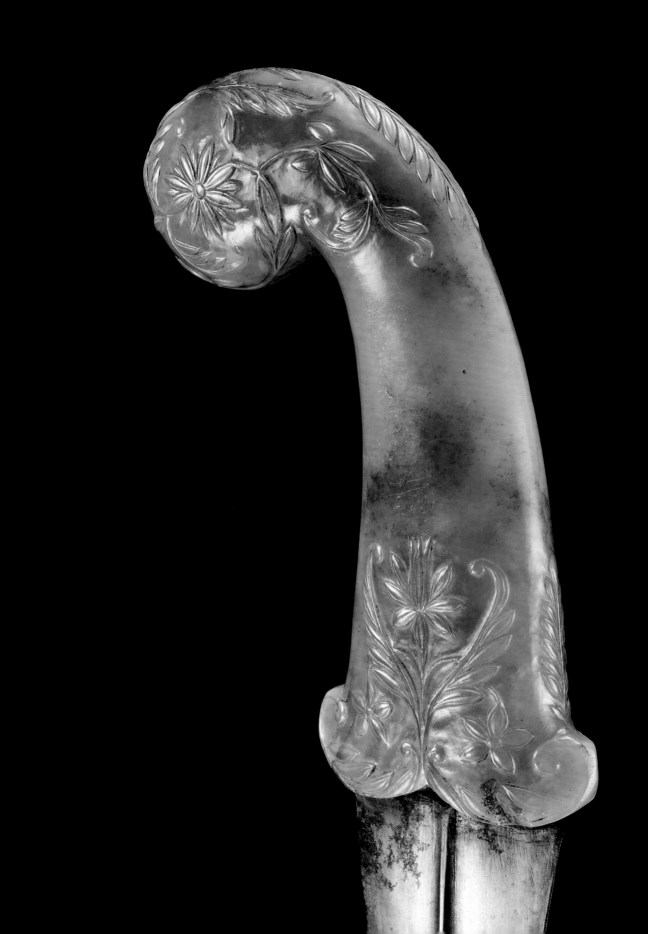

**Cat. 54 JADE DAGGER
AND SCABBARD**
**Deccan or Mughal dominions,
c. mid seventeenth century**
Hilt carved from nephrite jade;
blade of *jawhar* steel (subsequent
polishing has obscured the
"watering"); locket and chape
fabricated from silver; scabbard,
wood overlaid with velvet, with
metal thread trimming
Dimensions: Length of dagger 36 cm; width
5 cm; length of scabbard 26.5 cm
Provenance: Art market 1999, reportedly
from Hyderabad
Inv. no. LNS 265 HS

Detail showing entwined vines on
the pommel that are similar to those
of Cats. 53, 55 and 56

Of slender proportions and gently tilted,
the hilt of this dagger was apparently
intentionally fitted with a blade that is
markedly curved in the opposite direction,
yielding a peculiar undulating effect. The
hilt is finely carved along its upper edge
with a pinnate leaf that develops from a
trefoil on the butt, and issues entwined
leafy vines and tendrils that curl around
the sides of the pommel bearing irises and
multi-petalled flowers.

A striking floral configuration fills
the centre of the quillon block, which is
characteristically bordered by acanthus
leaves that curl in the centre of the block,
issuing leaves that enfold an iris blossom
and suspend curling floral stems.

The double-edged blade has suffered
much repolishing and has signs of
damage along its edges. It is ridged,
and is reinforced at the tip.

Cat. 55 **JADE DAGGER**
Deccan or Mughal
dominions, *c.* **second half of**
the seventeenth century
Hilt carved from nephrite jade;
blade of *jawhar* steel

Dimensions: Length 46.5 cm; width 6 cm

Provenance: Ex collection: Sunde Collection,
Copenhagen, and Christensen
Fund Collection, California
Art market 1997

Published: Sotheby's, London, 8 May 1997,
lot 56; Keene and Kaoukji 2001,
cat. 9.32

Inv. no. LNS 253 HS

Large, with a slender and slightly
oversized pommel, this dagger is carved
in unusually high relief in comparison
with other daggers of the type. A pair of
acanthus leaves separated by a hibiscus
outline the upper edge of the pommel,
while the leaf covering the butt issues
a pair of fluid vines that curl around
the pommel sides bearing hibiscus with
overturned petals, entwined with buds.

The near rectilinear grip is carved with
three finger-rests and extends seamlessly
to the quillon block with its accented
upturned curls, carved with a *Hibiscus
syriacus* (which, in spite of its name, is
not native to Syria) developing from the
acanthus leaves that border the edges of the
block, and a small stylized leaf in the cusp.

The gently curving double-edged
jawhar-patterned blade is ridged, drops
and recurves, and is reinforced at the tip.

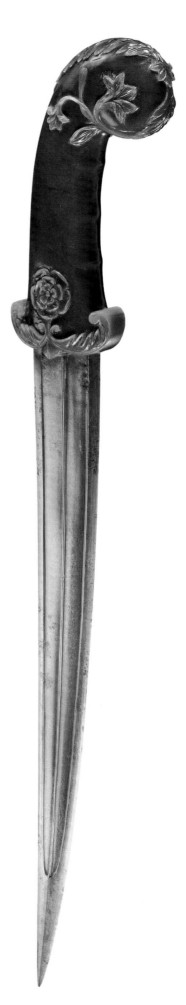

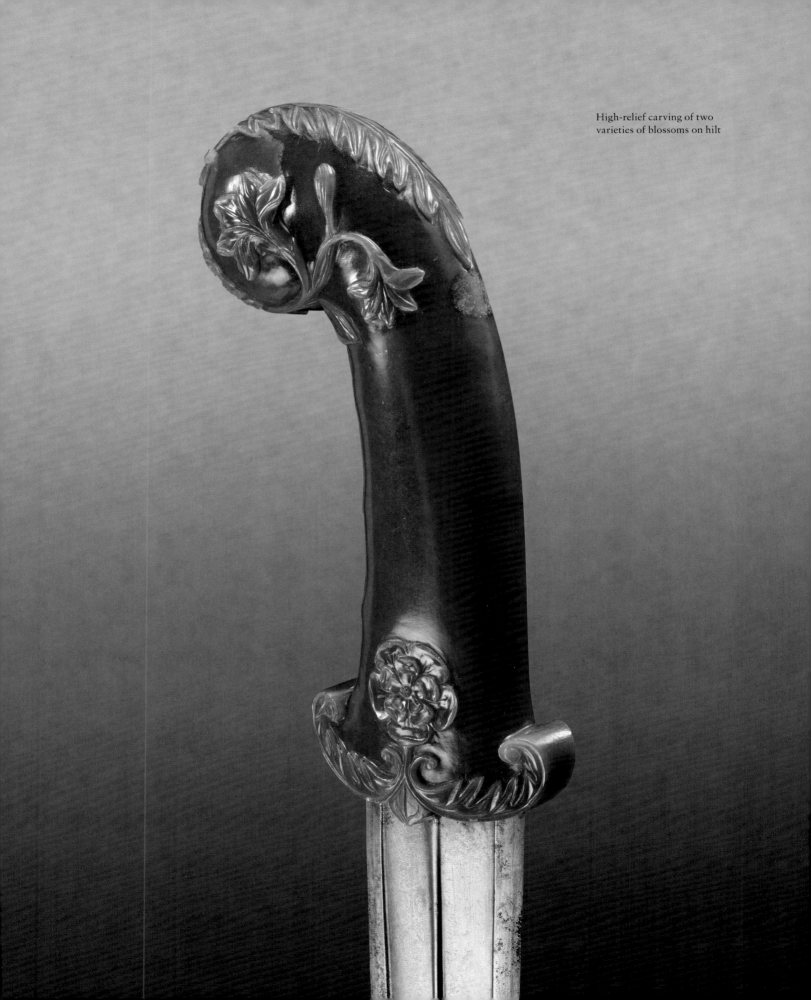

High-relief carving of two
varieties of blossoms on hilt

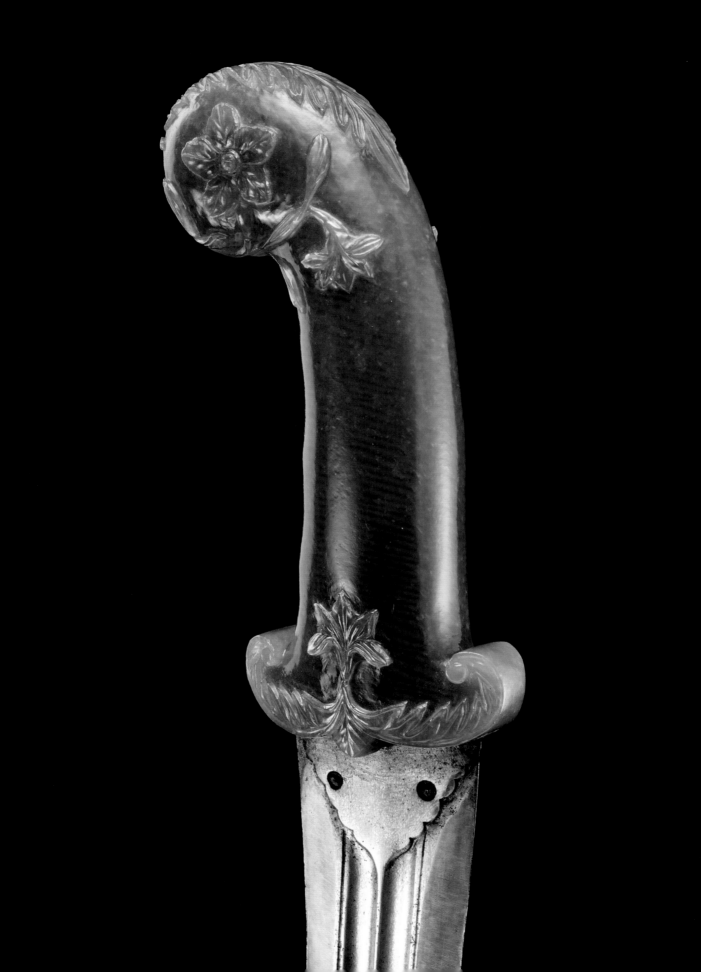

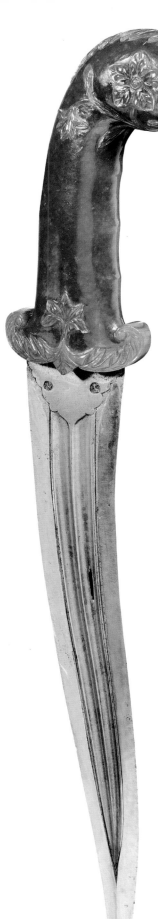

Cat. 56 JADE DAGGER
Deccan or Mughal dominions,
c. **mid seventeenth century**
Hilt carved from nephrite jade;
blade of *jawhar* steel

Dimensions: Length 39 cm; width 5.5 cm
Provenance: Art market 1997, reportedly
from Hyderabad
Published: Keene and Kaoukji 2001, cat. 9.31;
Michell 2007, cat. 57
Inv. no. LNS 264 HS

Probably produced in the same workshop
and by the same master carver as the
preceding example, Cat. 55, this hilt with
its relatively large pommel and slender
grip, which extends seamlessly to the
quillon block and features three finger-
rests, is likewise carved in comparatively
high relief.

An acanthus leaf outlines the upper
edge of the pommel and suspends a hibiscus
from which a pair of floral and foliate
vines curl around the sides of the pommel,
issuing hibiscus in full bloom entwined
with unfurling blooms and buds.

The quillon block is carved with a
large hibiscus that develops from the pair
of acanthus leaves bordering the edge
of the block and its markedly upturned
quillon tips, and suspends a small fluted
leaf in the cusp.

The double-edged *jawhar*-patterned
fullered blade is worn through in the
centre, gently drops before it recurves and
is reinforced at the tip. The blade is fitted
with an escutcheon-shaped panel riveted
onto the ricasso, which is prolonged by a
prominent median ridge.

Atypical high-relief floral
carving on hilt

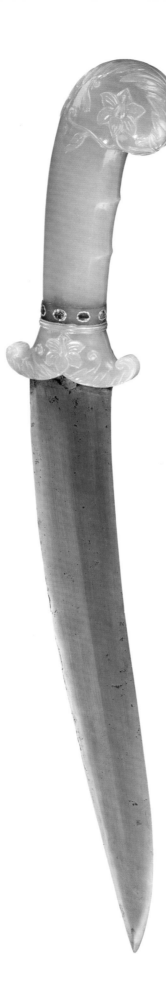

Cat. 57 JEWELLED JADE DAGGER
Deccan, second half of the
seventeenth century
Hilt carved from three pieces of
nephrite jade, inlaid with gold in
kundan technique and set with
rubies; blade, steel (repolished)
Dimensions: Length 38 cm; width 5.5 cm
Provenance: Art market 1997, reportedly
 from Hyderabad
Published: Keene and Kaoukji 2001, cat. 9.30
 Inv. no. LNS 263 HS

The hilt of this dagger is generally related
in its style of decoration to those of Cats.
47 and 53–56, and probably derives from
the Deccan. This hilt differs, however, in
the proportion of its grip relative to the
quillon. Additionally, the grips of Cats. 47
and 53–56 extend in an unbroken line to
the quillon block, whereas in this dagger a
jewelled band of darker jade separates the
grip and the quillon block, suggesting that
damage or breakage to the lower end of the
hilt necessitated some form of repair that is
now concealed by the band.

The large acanthus leaf that nearly
covers the upper edge of the pommel
develops from a pendant trefoil on the butt,
and issues a pair of vines that curl around
the sides of the pommel bearing large
hibiscus blooms with overturned leaves and
tendrils. The front of the near rectilinear
grip is carved with two finger-rests, and the
band of darker jade decorated with rubies
in lobed gold settings separates it from the
flaring quillon block, which is encircled by
a moulding.

The upswept quillon tips are unusually
long in proportion to the block and are
bordered by halved acanthus leaves issuing
tendrils that converge towards the hibiscus
blossom carved in the centre of the block.

The double-edged blade is of thin
rhomboid section and gently drops before it
recurves towards the tip.

Detail showing fine carving of
hibiscus blossom on pommel and
band of darker jade set with rubies,
separating grip from quillon

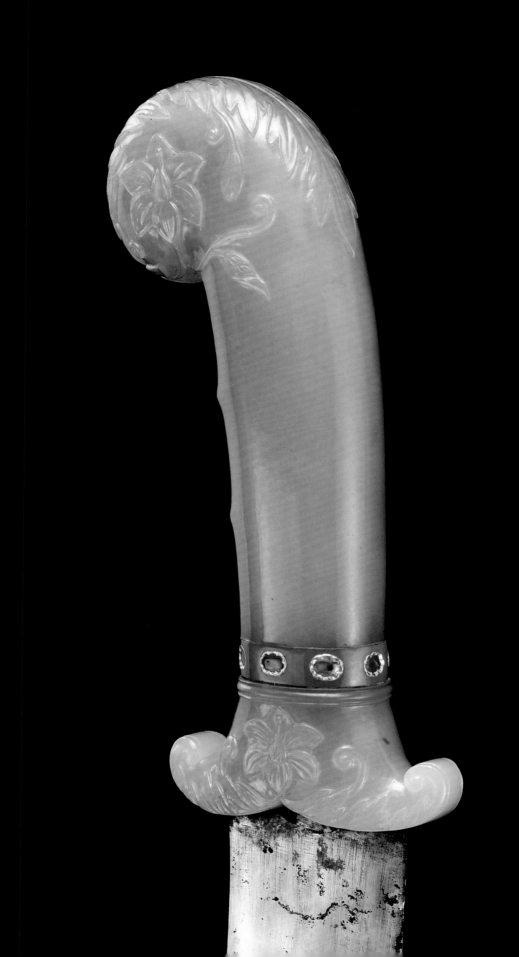

Detail of hilt, with fine gold stems and cloud bands in reserve on enamel ground of pommel and quillon

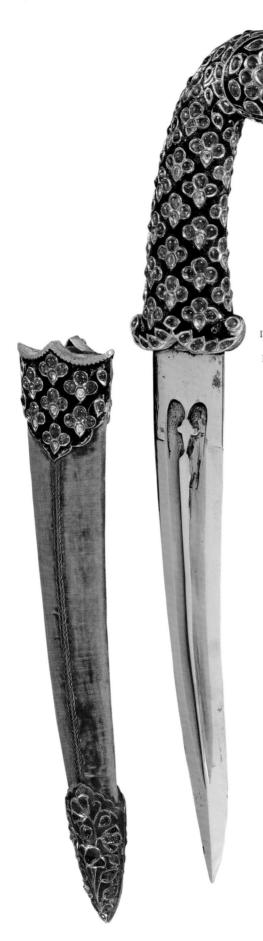

Cat. 58 JEWELLED AND ENAMELLED DAGGER WITH SCABBARD, LOCKET AND CHAPE
Deccan, probably Hyderabad, early eighteenth century

Hilt and locket, gold over an iron core, champlevé enamelled, set in *kundan* technique with diamonds and rubies, the chape only with rubies; blade, steel (repolished); scabbard, wood overlaid with red velvet with metal thread trimmings

Dimensions: Length of dagger 37 cm; width 5.5 cm; length of scabbard 26.5 cm

Provenance: Art market 1980s

Published: Jenkins et al. 1983, p. 128; Keene and Kaoukji 2001, cat. 6.52; Michell 2007, cat. 94

Inv. no. LNS 26 J ab

Of a later date than the preceding examples of the type with near rectilinear slender grips and relatively small pommels, the hilt of this dagger is set with ruby trefoils nesting in diamond calyces against a green enamel ground and displays a slight variation in the decorative style of its pommel.

Here the vines that contour the sides of the pommel and develop characteristically from the base of the plant form outlining the upper edge of the pommel are bordered along one edge by ruby petals issuing very fine gold whirling stems with ruby buds. Gold whirling stems with ruby buds likewise issue from the large ruby rosettes on the sides of the pommel.

A number of its decorative features locate the origin of this dagger firmly in the Deccan.[18] These include the ruby trefoils with diamond calyces and the general colour scheme, particularly the green enamel ground; the shape of the ruby blossom on the cusp of the quillon block; and, also on the quillon block, the reserved pair of minuscule flowers issuing curling leaves, which resemble cloud-band motifs.[19] An additional decorative trait characteristic of the Deccan is the fine band of gold notched rectangles in reserve on pale-blue enamel, outlining the underside of the block, that recall the pale-blue petals outlining the locket.

Pale-blue enamel petals outline the upper end of the locket. The gem-set decoration and the gold foliate motifs in reserve on the green enamel ground that borders the lower edge of the locket recall the decorative scheme of the hilt.

The chape, which is clearly not original to this dagger on account of its different style of decoration, was probably chosen as a replacement as it is also set with ruby blossoms on a ground of green enamel.

The double-edged blade, featuring a raised trefoil prolonged by a tapering ridge, gently drops before it recurves at the reinforced tip.

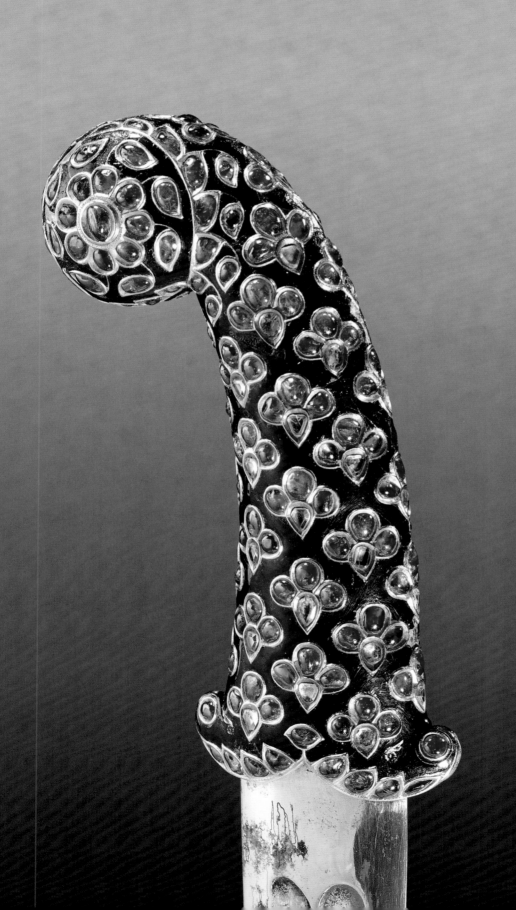

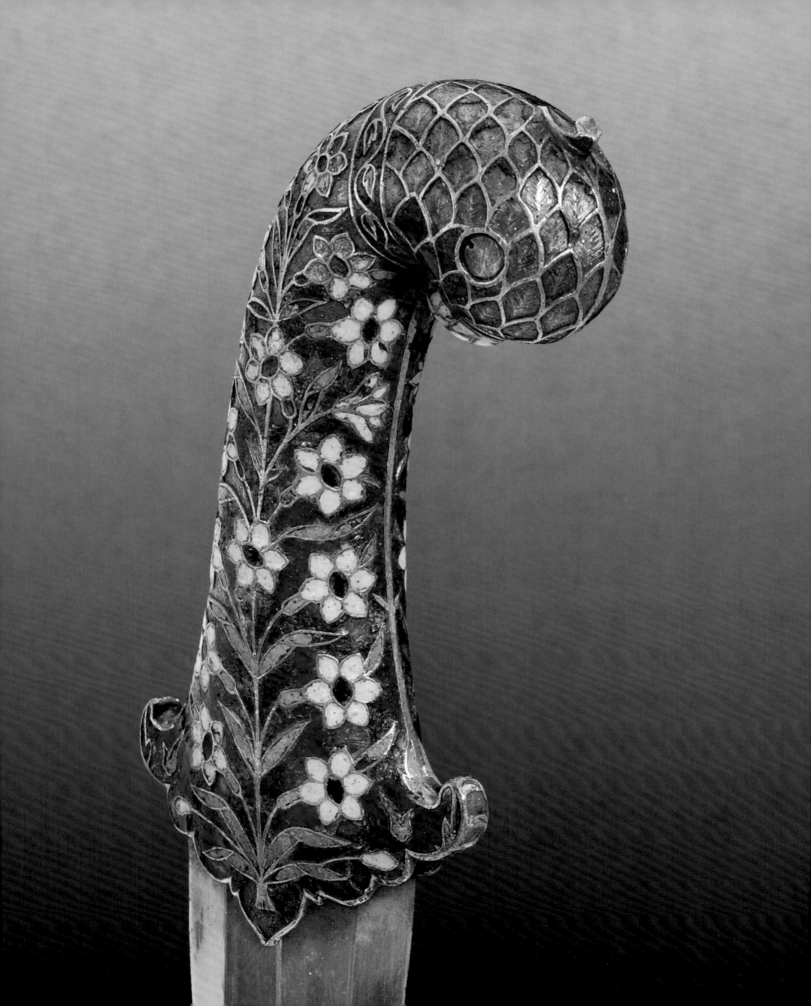

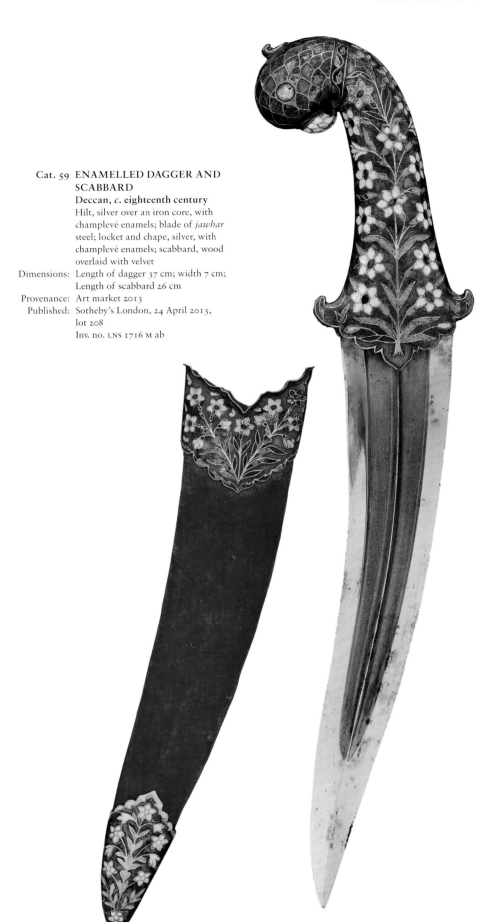

Cat. 59 ENAMELLED DAGGER AND SCABBARD

Deccan, *c.* eighteenth century
Hilt, silver over an iron core, with
champlevé enamels; blade of *jawhar*
steel; locket and chape, silver, with
champlevé enamels; scabbard, wood
overlaid with velvet
Dimensions: Length of dagger 37 cm; width 7 cm;
Length of scabbard 26 cm
Provenance: Art market 2013
Published: Sotheby's London, 24 April 2013,
lot 208
Inv. no. LNS 1716 M ab

In the form of a crested parrot head, the
pommel on this dagger is covered in an
imbricated pattern of green and yellow
enamel outlined in silver. Sadly, however,
the enamel on the crest and eyes has flaked
off on account of the extensive wear
suffered by the enamel, especially on
the pommel.

A fine band of foliate scrolls separates
the pommel from the slender flaring
grip, where the surface is covered with
a flowering plant, possibly related to
the crocus family. Yellow flowers with
manganese purple centres and unfurling
buds, and light-green lanceolate leaves,
some of which are overturned, grow from
the tip of the lobed quillon block and are
closely related in rendering and colour
scheme to an eighteenth-century *pandan*
box attributed to northern India.[20] The
quillon tips feature green acanthus leaves
in their curls, and two green cloud bands
on their faces.

Yellow cloud bands border the upper
end and sides of the locket,[21] which features
the same plant as the hilt and is bordered
with small green leaves. The chape, which
is of later manufacture, is enamelled with
a flowering plant in an attempt to emulate
those on the hilt and locket.

Opposite: Basse-taille pattern of
feathers on parrot-head pommel
revealed by the flaked-off enamel

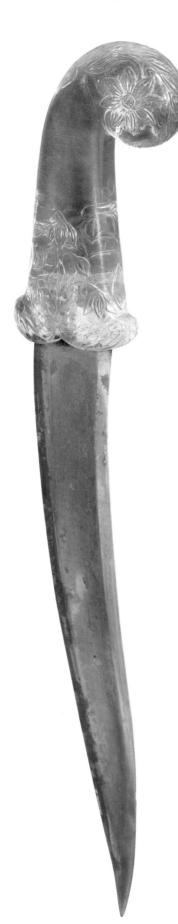

Cat. 60 ROCK-CRYSTAL DAGGER
Probably Deccan, early
eighteenth century
Hilt carved from rock crystal;
blade of *jawhar* steel (subsequent
polishing has obscured the
"watering")
Dimensions: Length 36 cm; width 5 cm
Provenance: Art market 1999
Inv. no. LNS 77 HS

The hilt of this generally well-proportioned dagger has been carved from flawless rock crystal, with a large acanthus leaf covering the upper end of the pommel that develops from a trefoil on the butt. The trefoil issues short vines that culminate in large multi-petalled flowers covering the sides of the pommel.

The overall carving of the floral decoration is not of the same high quality as most of the preceding examples, which might account for a later date of manufacture or could be a sign that the dagger was produced for commercial purposes, outside the courtly milieu.

Acanthus leaves bordering the edge of the quillon block curl in the centre of the block and issue a large toothed leaf from which develop curling stems and bell-shaped flowers. That the blade tang is visible through the quillon block and obstructs the decoration is not typical of rock-crystal hilts; it appears that the blade was fitted on the hilt at a later stage, since the underside of the hilt displays a rough surface, probably as a result of the rock-crystal tang stump being ground down (compare Cats. 50 and 69).

The outer edges of the quillon tips are carved with single leaves, and the back edge of the hilt features a single, relatively large stem with a cup-like blossom (tulip?) and buds.

The double-edged blade displays damage, and has suffered extensive repolishing.

Blade tang visible through
carving on quillon

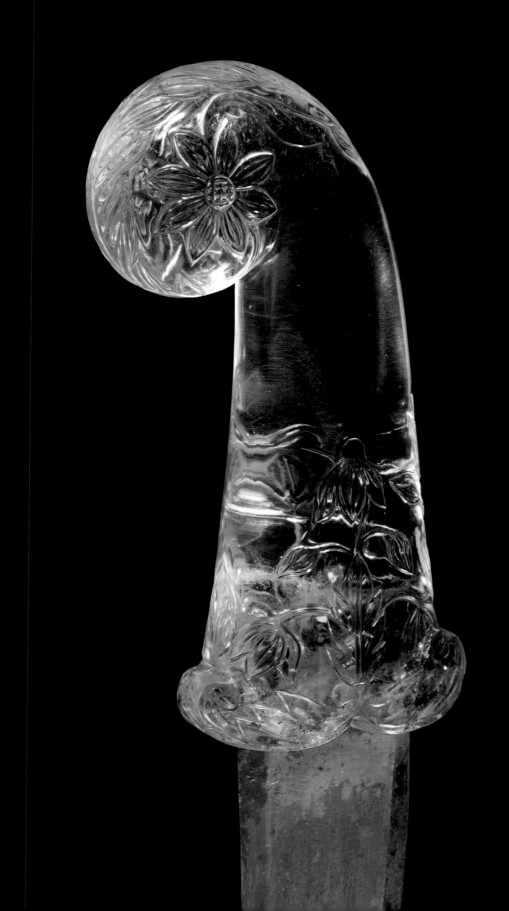

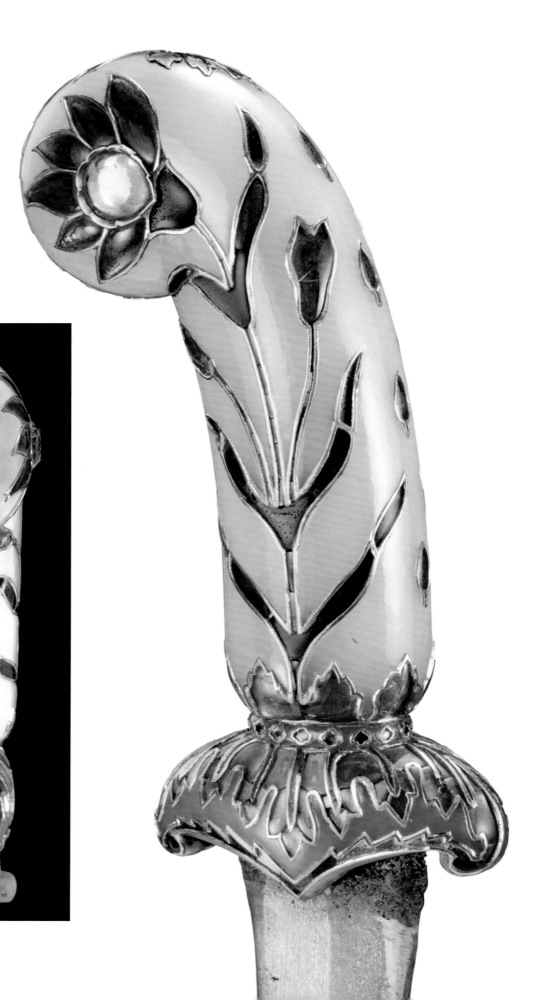

Atypical layout of vegetal decoration
on pommel and quillon

Cat. 61 JEWELLED JADE DAGGER
WITH SCABBARD AND
LOCKET
Deccan, eighteenth century
Hilt and locket carved from
nephrite jade, inlaid with gold
in *kundan* technique and set
with rock crystal underlaid with
coloured foils; blade of *jawhar*
steel; scabbard, wood, overlaid
with red velvet
Dimensions: Length of dagger 36.5 cm; width
7 cm; length of scabbard 25.5 cm
Provenance: Art market 1991
Published: Curatola et al. 2010, cat. 281
Inv. no. LNS 76 HS ab

The jade hilt of this dagger varies, in both
form and decorative scheme, from more
widely encountered examples of the type.
The grip is singularly constricted just above
the bulbous quillon block with inward-
curling quillon tips that come to a point
in the centre. In addition it is decorated
with an atypical floral motif in an unusual
variety of colours, which are largely
produced by the colour foils underlying
the rock-crystal settings.

A dark-green toothed-leaf motif
develops from the butt and outlines the
upper edge of the pommel but is otherwise
separated from the red buds aligned on the
inner and outer edges of the grip. Unusual
plant forms bearing red buds and issuing
leaves emulating the overturned effect by
means of gold outlining cover the sides of
the grip,[22] and culminate in the standard
large floral element that fills the sides of
the pommel. Coronas of orange leaves
radiate from the moulding, decorated
with minuscule quatrefoils, that separates
the grip from the quillon block. A jagged
version of the standard halved acanthus
leaf borders the lower edge of the block.

The upper edge of the locket, which
is a perfect fit for the guard, is decorated
with circlets of a colour echoing that
of the coronas of leaves covering the
quillon block, and its sides are outlined
with the typical stemmed-buds motif.[23]
The flowering plants occupying the front
and back of the locket develop from
a small downturned leaf, a frequently
employed motif that might derive from
the representations of clusters of plants in
paintings (see Cat. 32; and Cat. 65, note 5).

The double-edged *jawhar*-patterned
steel blade has been narrowed by
resharpening, is of rhomboid section, and
drops and recurves at the reinforced tip.

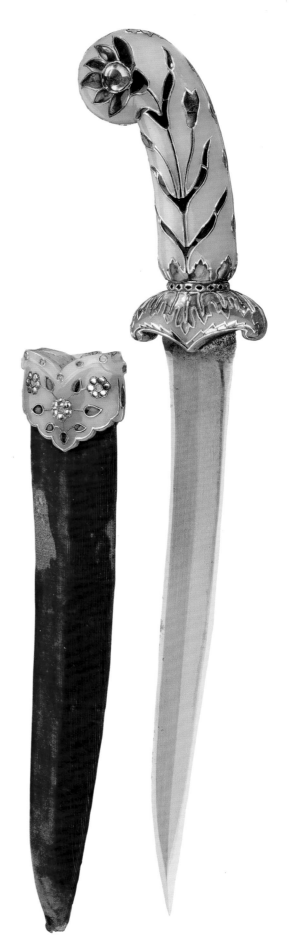

Cat. 62 JEWELLED JADE DAGGER
Deccan, eighteenth century
Hilt carved from nephrite jade,
inlaid with gold in *kundan*
technique and set with rubies at a
later date; blade of *jawhar* steel
Dimensions: Length 36.5 cm; width 5 cm
Provenance: Art market 1999, reportedly
from Hyderabad
Inv. no. LNS 272 HS

This dagger is clearly of later manufacture
as the substandard nature of its decoration
does not match the fine quality of carving
exhibited on the previous examples. The
typical acanthus leaf outlining the upper
edge of the pommel develops from a
large lotus issuing floral vines that flow
towards the back of the grip and encircle
the sides of the pommel, culminating in
a large nondescript blossom with a single
overturned petal.

The quillon block is bordered with a
profusion of acanthus leaves that issue a
large blossom growing from a short and
stubby stem, and also features a single
downturned petal. Large acanthus leaves
develop from the curls of the quillon tips on
either side of the grip.

At a later date the hilt was set with rows
of rubies along its sides and edges that are
incompatible with the carved decoration;
some of these are now missing.

The fullered double-edged *jawhar*-
patterned blade has a median ridge, and
drops and recurves at the reinforced tip.

Hilt with low-relief carving, later
supplemented with gems

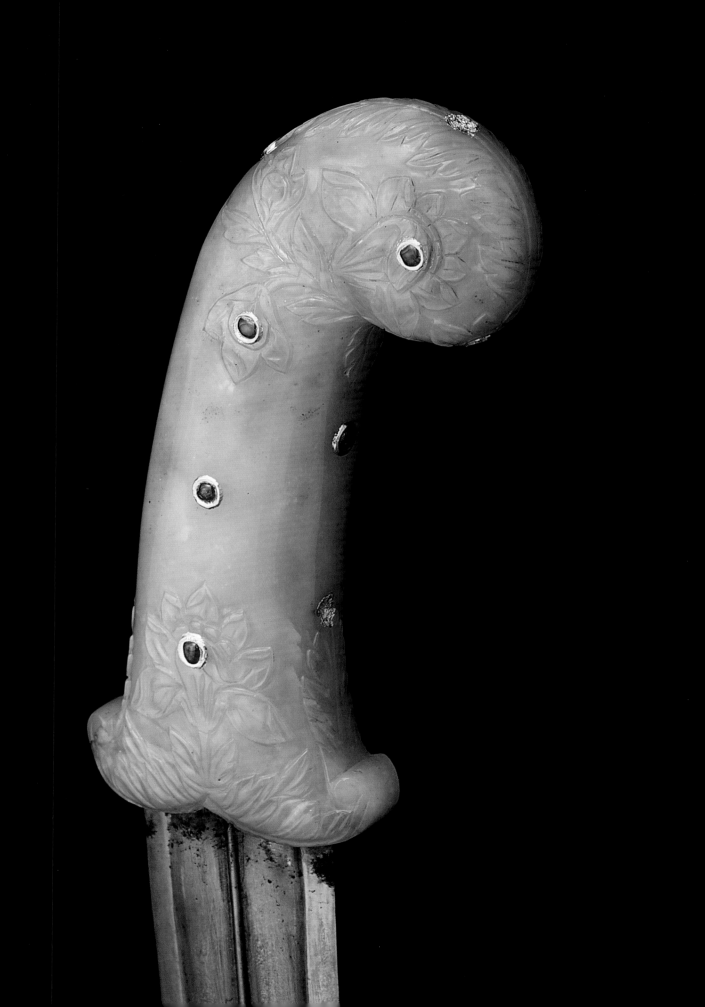

**Cat. 63 JEWELLED JADE CHAPE
FROM A DAGGER
SCABBARD**
**Deccan, probably early
seventeenth century**
Carved from nephrite jade, inlaid
with gold in *kundan* technique
and set with rubies, diamonds
and emeralds
Dimensions: Length 4.5 cm; width 2 cm
Provenance: Art market 1997, reportedly
from Hyderabad
Published: Keene and Kaoukji 2001, cat. 2.21
Inv. no. LNS 286 HS

This chape, from the scabbard of a
dagger with a curved blade, is decorated
with ruby blossoms with emerald calyces
growing from inverted ruby buds. The
centres of the blossoms are set in partially
lobed settings with small "ticked" cusps
in the interstices of the lobes. One of

the blossoms is set with a high conical
diamond in its centre, in the same style as
the ruby flowers on the dagger Cat. 48.

Three stemmed ruby buds, which
recall the decoration typically featured on
the edges of *katar*s, lockets and chapes –
including on the locket and chape of Cat.
48, the locket of Cat. 52, as well as on the
back of the dagger Cat. 61[24] – are aligned
along the flat edge of the chape. The gold
outlining fillet that originates from the
lobed ruby blossom on the tip stops short
of the curling tip on the flat edge.

On the edge of the curling tip a carved
cavity that once held a gemstone retains
traces of gold inlay and four tiny holes,
drilled deeper into the cavity, to hold the
inlay in place.

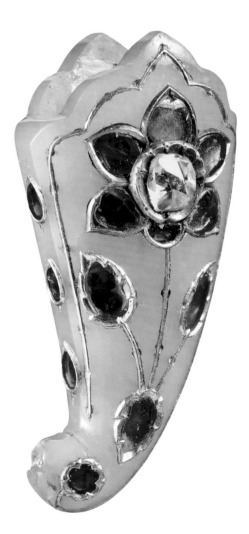

Cat. 64 **JEWELLED JADE CHAPE FROM A DAGGER SCABBARD**
Deccan, first half of the seventeenth century
Carved from nephrite jade, inlaid with gold in *kundan* technique and set with rubies and emeralds
Dimensions: Length 5.5 cm; width 3 cm
Provenance: Art market 1997, reportedly from Hyderabad
Published: Keene and Kaoukji 2001, cat. 2.20
Inv. no. LNS 285 HS

As with the preceding example, this chape would have been fitted on the scabbard of a dagger with a curved blade. Its upper edge is outlined with a gold fillet, and two emerald leaves originating from a ruby circlet gather the flowering plants that adorn it.

The main *talab*-set ruby blossoms nest in emerald calyces, with emerald centres in lobed and "ticked" cusped settings. The *talab*-set ruby trefoils that nest in emerald calyces are closely related to the ruby trefoils on the hilt of the dagger Cat. 48.

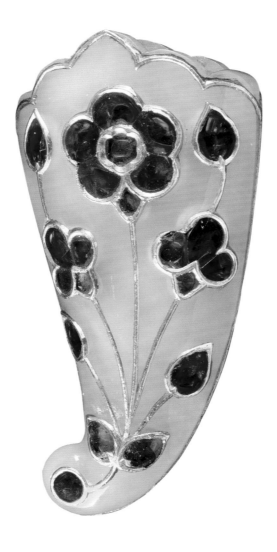

NOTES

1 The dagger is featured on a stone statue of King Tutankhamun in the Egyptian Museum, Cairo, Ziegler 2002, p. 61, cat. 10.

2 Charbonneaux et al. 1969, p. 242, fig. 274.

3 Pyhrr and Godoy 1998, p. 11, fig. 21.

4 Boardman 2001, pl. XXIV and p. 336, cat. 340.

5 Trever and Lukonin 1987, pl. 8, cat. 3 (inv. no. S-253).

6 Behl 1998, Cave 17, p. 204 (lower left).

7 *Ruz-nameh*, The al-Sabah Collection, inv. no. LNS 270 MS, fol. 5v, Adamova and Bayani, 2015, cat. 4. And although doubt has been cast on its authenticity, an eleventh-century drawing reportedly found in Fustat depicts a personage wearing a sword with a "pistol grip" pommel, Barrucand 1998, pp. 102–03.

8 Barry 2004, p. 387.

9 A pommel of the pistol-grip type can be seen in a 1530 woodcut by Jacob Breu of *The Investiture of Ferdinand I*, which reportedly must have represented an eyewitness account by the artist (Coe 1989, p. 53), and on a tapestry representing the triumphal entrance of D. Joao de Castro in Goa, attributed to c. 1555–60 (Trnek and Vassallo e Silva 2001, fig. 2). And from 1537, a stone figure in the Vardhamana temple mandapa, Kanchipuram, wears what appears to be a parrot-head pommel knife tucked in his belt, Elgood 2004a, p. 165, fig. 16.7.

10 Two men wear swords with pistol-grip type pommels in a page from a dispersed *Bhagavata Purana*, attributed to the Delhi-Agra area, c. 1520–30, Kossak 1997, cat. 2, p. 27; also from the *Bhagavata Purana*, attributed by Linda Leach to the early sixteenth century, a sword hilt of the pistol-grip type is depicted in Satadhanva's hand, Beach 1981, p. 49, cat. 3b.

11 Seyller 2002, p. 210, cat. 69, esp. the soldier in the upper left-hand corner of the double-spread detail on the following pages, attributed to c. 1570; Martin 1968, pl. 84, a portrait of Murad Akkuyunli attributed to Farrukh, a court painter of Akbar, attributed to c. 1580; and Adamova 1996, p. 197, cat. 9, in an album page depicting a "prisoner", attributed to sixteenth-century Iran.

12 Elgood 2004a, p. 216, fig. API.11.

13 See e.g. Keene and Kaoukji 2001, cats. 4.5, 5.6, 6.27, 8.36 and 8.38–8.41.

14 Zebrowski 1997, p. 68, fig. 46.

15 See e.g. the quillon tips of the daggers depicted in Seyller 2002, cat. 36, detail on pp. 116–17, and cat. 64, detail on pp. 192–93.

16 See e.g. a dagger from Bronze Age Ras Shamra (1600–1185 BCE), Galliano and Calvet 2004, cat. 157; a dagger hilt depicted on a seventh-century silver Sogdian dish, Chuvin 1999, cat. 210; and finger grooves on sword hilts from the eighth-century Central Asian Pandjikant wall paintings, ibid., cat. 208. Finger grooves can also be seen on one edge of the grip of a silver dagger attributed to twelfth- or thirteenth-century Syria or Palestine, Digard 2002, cat. 57, and Mohamed 2008, cat. 148.

17 See e.g. the edges of the side-bars of cats. 6 and 10; the edges of the locket of cat. 61; the edges of the chapes of cats. 63 and 106; and the back of the hilt of cat. 76.

18 See e.g. Keene and Kaoukji 2001, the near identical treatment of the blossoms on cat. 6.50, the unmistakable allusion to Hyderabad in the inscription of cat. 6.51, minuscule gold leaves in reserve on the green enamel ground in cat. 6.55, and the colour scheme of cats. 6.48 and 6.49, all of which are reportedly from Hyderabad.

19 For similar leaf-like cloud bands, see the border of the central medallion of a ewer, Zebrowski 1997, p. 162, cat. 227.

20 Zebrowski 1997, p. 92, cat. 85.

21 See e.g. similar leaf-like cloud bands bordering the central medallion of a ewer, Zebrowski 1997, p. 162, cat. 227.

22 The same approach can be seen on a pistol-grip hilt in the Furusiyya Art Foundation, Mohamed 2008, cat. 180.

23 A decorative motif that also occurs on the edges of the side-bars of cats. 6 and 10; on the locket of cat. 48; on the edges of the chapes of cats. 63 and 106; and on the back of the hilt of cat. 76.

24 As e.g. on the edges of the side-bars of cats. 6 and 10; on the locket of cat. 48; on the edges of the chape of cat. 106; and on the back of the hilt of cat. 76.

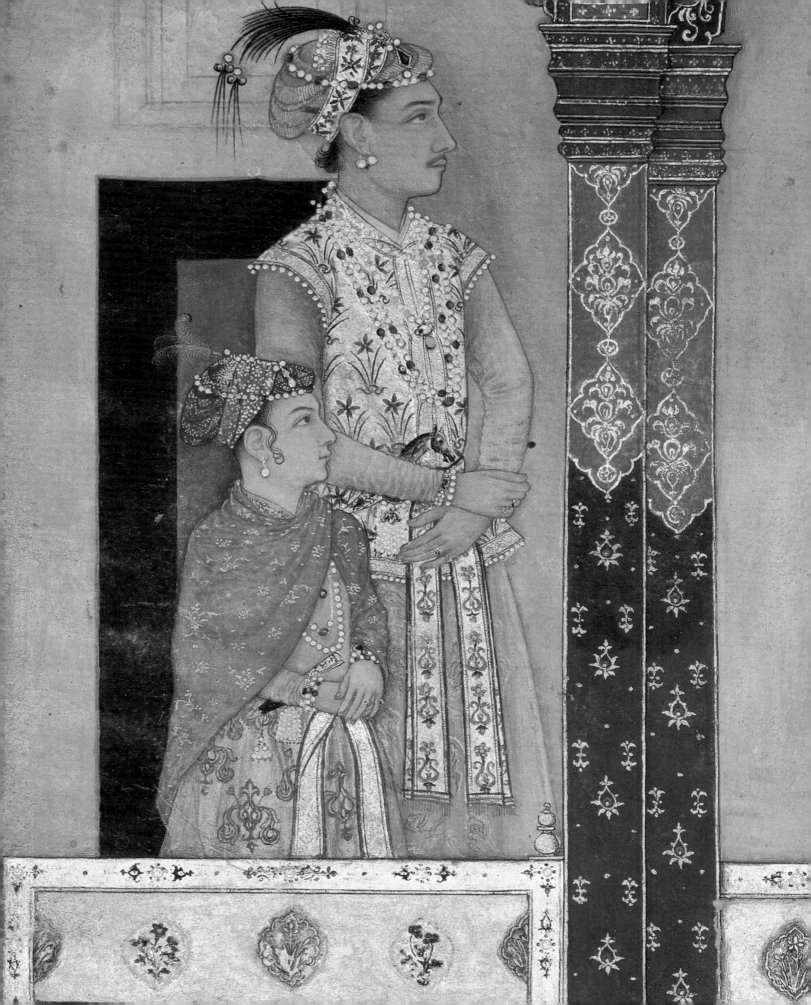

CHAPTER SIX
ANIMAL-HEAD HILTS
A RECOLLECTION OF NOMADIC ANCESTRY

Notwithstanding a few scattered examples from Egypt and Western Asia,[1] animal-headed knives and short swords have been linked with the eastern Eurasian steppes since around the middle of the second millennium BCE.

The various nomadic tribes that populated the steppes interacted a great deal among themselves through herding, raiding and warfare, which, in conjunction with other shared regional and societal features, led to a great deal of uniformity in their art and material cultures. This high level of tribal intercontact was instrumental in spreading, among other weapon forms, animal-headed knives and short swords throughout the area.

Although different types of pommels prevailed in the steppes alongside animal-headed ones,[2] the fact that the latter at first mainly comprised ibexes, rams and elks is quite puzzling, considering that animals such as horses, camels, raptors, wolves, felines and bears must all have been familiar to the tribes roaming the area, and would have had various symbolic connotations. Yet it appears that it was not until around the eleventh to the tenth century BCE that hilts with pommels in the form of horse and raptor heads appear in the area, as evidenced by finds excavated in wood-chambered tombs in Baifu (in the suburbs of modern-day Beijing), dated by carbon-14 analysis of the wood lining the tomb walls. And as no written records have come down to us from the peoples of the steppes, most evidence of animal-headed knives has only consisted of finds from burials.[3]

Although the type endured in the steppe lands for a fairly long period, a change in the character of knife-hilt decoration nevertheless occurred from around the eighth century BCE onwards, most likely resulting from contacts with other cultures. Following this shift, hilt decorations diversified, featuring larger varieties of animal heads, as well as complete animals in the round serving as pommels; anthropomorphic representations; swagged or volute-like pommels with animal-head terminals (often referred to as antennae-pommels); ring and disc pommels; and rattle pommels.

The later part of the first millennium BCE witnessed increased contact between steppe peoples and civilizations from further west in the form of wars, alliances and trade, along with the arrival of tribes displaced by Alexander the Great's eastern campaigns, bringing with them new types of weapons and artistic styles that had a major impact on the art and weaponry of the area. For a while the arts of the region became imbued with Hellenistic influences, although local traditions were never abandoned, which produced an artistic culture with a distinctive international flavour.

The influences of these nomadic peoples on the subsequent art and culture of neighbouring civilizations are manifest in various forms, but strangely enough the trend of hilts terminating with animal heads seems to have died out towards the end of the first millennium BCE. During the Mughal period, however, a remodelled and naturalistic version of the type seems to have emerged in the form of hilts terminating in horse heads, as well as ram heads, goat heads and the heads of large felines such as lions, tigers, leopards and cheetahs. It seems likely that these designs were inspired by earlier models, and that the revival of the trend arose from the Mughals' interest in the art and customs of their Central Asian ancestors.

Prince Dara Shikoh wearing a dagger with horse-head pommel tucked in his sash in an illustration from the *Padshah-nameh* manuscript by Balchand, Mughal, *c.* 1635

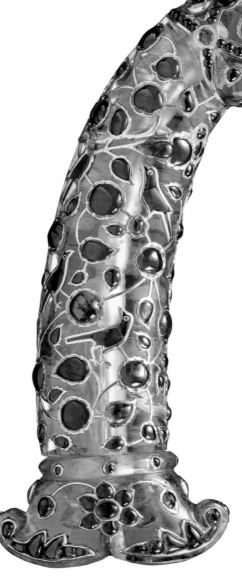

Cat. 65 JEWELLED ROCK-CRYSTAL HORSE-HEAD HILT WITH LOCKET AND CHAPE
Mughal dominions, early seventeenth century (with later alterations and additions)
Carved from rock crystal; inlaid with gold in *kundan* technique and set with rubies, emeralds and banded agate
Dimensions: Length of hilt 13 cm; width 7 cm; length of locket 3 cm; width 4 cm; length of chape 4 cm; width 2 cm
Provenance: Art market 1997
Published: Keene and Kaoukji 2001, cat. 2.3
Inv. no. LNS 256 HS a–c

Upon examining this suite of dagger mounts it is immediately clear that several areas of the hilt and locket suffered a serious blow that resulted in breakage, cracks and repairs. The hilt must have broken on the upper part of the horse's neck, which accounts for the drill hole and rod that can be seen extending from the centre of the grip to the top of the horse's neck to connect and reinforce the cracked and broken sections.

Furthermore, part of the horse's lower jaw has cracked away and was significantly ground down to smooth the broken edges. The ears, likewise, must have broken off as they have been replaced by inadequately shaped emerald drops, set too far back on the head, and display *kundan* work different from that of the original settings. The locket is broken on both sides along its edges, and held together with gold wire.

The hilt is adorned with gold vines bearing ruby and emerald flowers on which perch ruby birds with minuscule emerald eyes. Although this is an atypical form of decoration for animal-head hilt types, it appears as though the decoration is original. There are also traces of clumsy *kundan* settings on the front upper end of the neck, most likely carried out subsequent to the breakage to conceal the damage.

As in some other animal-head hilts (such Cat. 27 and Cat. 174), the horse's eyes are set with brown-and-white layered agate, carved in such a manner as to position the dark-brown layer of the stone in the centre of the eye to form the "iris".

The horse's bridle is adorned with channel-set rubies, with emeralds at the intersections of the straps. The brow

Detail showing the rod extending to the horse's head, with its broken jaw, and the disturbed gold surfaces on the bridle and neck

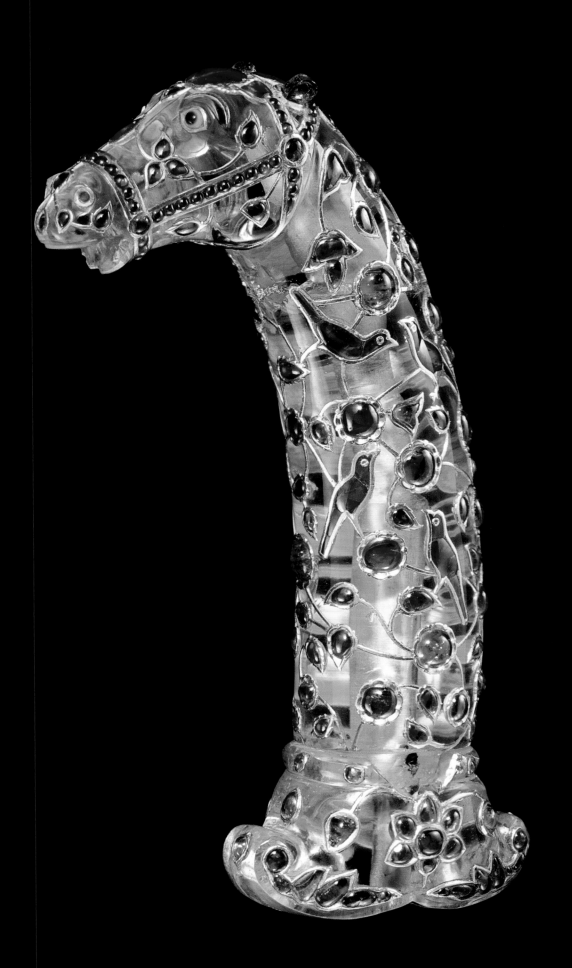

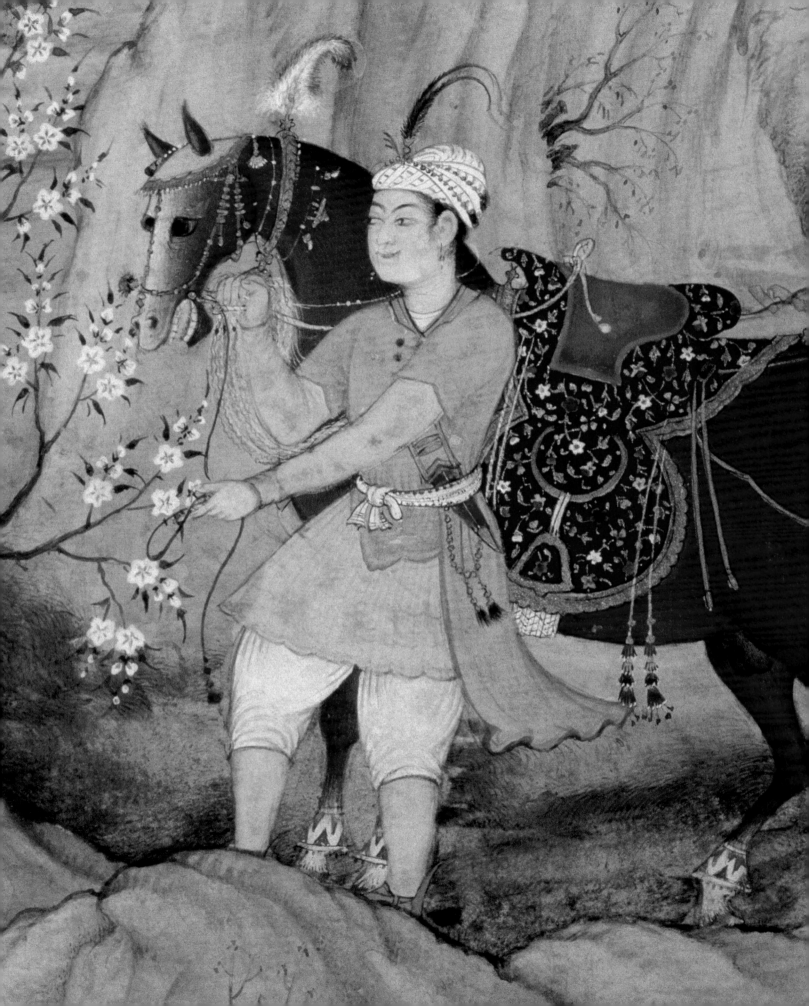

band that connects on top of the horse's head features a large ruby "poll cap" in a lobed setting flanked by three smaller rubies and an emerald;[4] this is an embellishment of horse trappings apparently introduced in India during the later part of Emperor Akbar's reign, and which endured until around the 1630s.

Protective or decorative poll caps existed as far back as the second millennium BCE, and can be seen fitted with plumes on the horses leading King Tutankhamun's war chariot, as depicted on the side of a wooden chest from his tomb that is now housed in the Museum of Egyptian Antiquities, Cairo. The custom seems to have spread over a widespread area, from the Assyrian period, as recorded in numerous reliefs of battle and hunting scenes, to the Chinese Qin dynasty of the third century BCE, when horses in a bronze horse-carriage model, now housed in the Museum of Terra Cotta Warriors and Horses of Qin Shi Huang, Shaanxi, were depicted wearing small domical caps surmounted by plumes. It lasted at least until the seventh century CE, as a horse wearing a cap can be seen on one of the Panjikent wall-painting fragments displayed at the State Hermitage Museum, St Petersburg.

The poll cap might have evolved into the shaffron (or horse's frontal), and if so, must have been concurrent with the introduction of protective gear for horses in the Islamic world. Although the first shaffrons apparently spread to the West and Asia by the ninth century BCE,[5] and appear to have endured until around the sixth century CE, the earliest representations of shaffrons from the Islamic world can be seen in a miniature from a *Shah-nameh* attributed to Tabriz, *c.* 1370.[6] In the ensuing periods such depictions seem to increase, and in early Mughal paintings poll caps look very much like reduced frontals, suggesting that once again a style that apparently originated in the East was introduced to India by Emperor Akbar.[7]

Groom holding a horse wearing a poll cap in an illustration from the *Akbar-nameh* manuscript by Mahesh and Kesav, *c.* 1590–95

Ruby poll cap between the horse's
emerald "ears", Cat. 65 (LNS 256 HS)

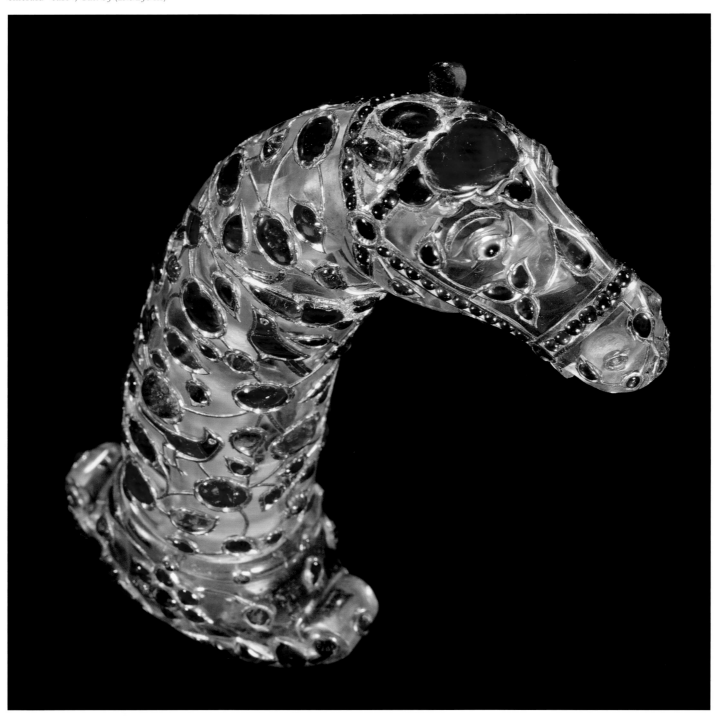

The quillon block is carved from a separate piece of rock crystal, and the moulding that separates it from the grip, and which is now missing a small segment, is set with rubies. In the centre of the quillon block a ruby-and-emerald rosette issues gold vines with emerald leaves, and the lower edge is bordered with *talab*-set emerald acanthus leaves.

The locket and chape are both decorated with gold vines bearing rosettes, leaves and buds that develop from a small downturned leaf, a frequently occurring decorative feature in jewelled objects from the period (see, for instance Cat. 32 and Cat. 61).

The peculiar orientation of the leaf could indicate that the convention derived from the treatment of clusters of plants in Persian painting from the late fourteenth century and onwards. In such paintings, when leaves were depicted in the foreground or at the outset of a tuft of foliage they were most often oriented downwards, probably to convey a sense of perspective.[8]

Cracked locket with repairs,
and the chape

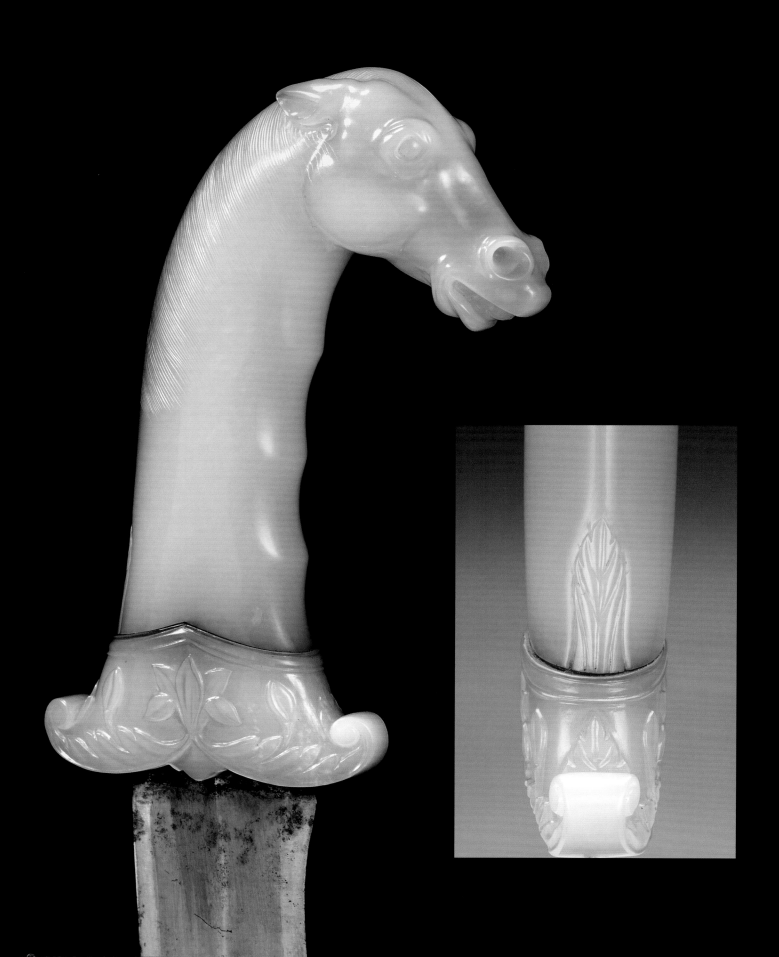

Cat. 66 JADE HORSE-HEAD DAGGER
Mughal dominions, first half of the seventeenth century
Hilt carved from nephrite jade; blade of *jawhar* steel
Dimensions: Length 38 cm; width 9.5 cm
Provenance: Art market 1991
Published: Keene and Kaoukji 2001, cat. 8.17; Curatola and Kaoukji 2016, cat. 178
Inv. no. LNS 70 HS

Detail of hilt showing masterful carving of horse-head features; the trimmed acanthus leaf on the back of the grip (inset) suggests that the quillon block is a replacement

Even though this type of hilt was fairly widespread around the middle of the seventeenth century, and is repeatedly featured in the *Padshah-nameh*,[9] the chronicle of Emperor Shah Jahan's reign, and alluded to in the *Diwan* of Abu Talib Kalim, the emperor's poet laureate,[10] in terms of both material and carving this example is undoubtedly unique and bears witness to the virtuosity of Indian craftsmen.

Carved in the form of a spirited Arabian horse's head, the hilt of this magnificent dagger is rendered in naturalistic and animated manner, with the ears pinned back in combative mood, eyes wide open, nostrils flared and lips pulled back to reveal individually outlined teeth.

The slender and near rectilinear grip is finely engraved with a flowing mane and carved with three finger-rests, the usage of which reflects a seemingly uninterrupted ancient tradition dating back to the second millennium BCE.[11] On the back of the hilt an acanthus leaf, the lower end of which seems to have been trimmed, extends from the moulding that separates the hilt from the quillon block in much the same manner as in Cat. 47, which suggests that some form of breakage occurred that required the replacement of the original quillon block.

The present quillon block was carved from a different piece of jade and features the typical upswept acanthus-leaf border, here issuing an iris blossom and buds, and smaller acanthus leaves that develop from the inner curls of the quillon tips.

The *jawhar*-patterned double-edged blade is of thin rhomboid section and gently drops before it recurves at the tip.

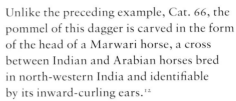

Cat. 67 JEWELLED JADE HORSE-HEAD DAGGER
Mughal dominions, first half of the seventeenth century
Hilt carved from nephrite jade, eyes inlaid with rock crystal (painted details underneath), hilt later inlaid with gold in *kundan* technique and set with rubies and an emerald; blade of *jawhar* steel
Dimensions: Length 37 cm; width 9 cm
Provenance: Art market 1992
Published: Keene and Kaoukji 2001, cat. 8.18
Inv. no. LNS 172 HS

Unlike the preceding example, Cat. 66, the pommel of this dagger is carved in the form of the head of a Marwari horse, a cross between Indian and Arabian horses bred in north-western India and identifiable by its inward-curling ears.[12]

The upper end of the horse's neck is rounded, and its ears are gently pinned back, its nostrils flared and its lips pulled back, revealing outlined teeth. The horse's eyes are set with rock crystal backed with painted surfaces representing the sclera, a pale-brown iris and a large black pupil, a practice that stretches as far back as the third millennium BCE and can be seen on the famous statues of Pharaoh Rahotep and his wife Nofret from Meidum, now in the Museum of Egyptian Antiquities, Cairo, as well on statues of Egyptian scribes from the same period.[13]

The channel-set ruby halter and the single emerald in a lobed setting between the horse's ears are both obviously later additions, as is clear from the poorly executed gold *kundan* work of the halter, which does not come full circle under the horse's head, but is prolonged by a gold fillet, as well as the ungainly headstall interrupted by the horse's forelock.

The gently flaring, flattish hilt is finely engraved with a flowing mane that falls in strands, and carved with three finger-rests. The quillon block is bordered on the lower edge with curling leaves issuing a poppy blossom with fluted petals and small petaloids forming the centre of the flower. Both the blossom and the overturned leaves are closely related in form to a carved poppy on a Mughal emerald bead from the first half of the seventeenth century in The al-Sabah Collection[14] and to the blossoms carved on the quillon block of Cat. 84.

The *jawhar*-patterned blade is flat at the upper end or spine, and double-edged where it begins to drop before recurving at the tip.[15]

Detail showing the later and poorly executed halter

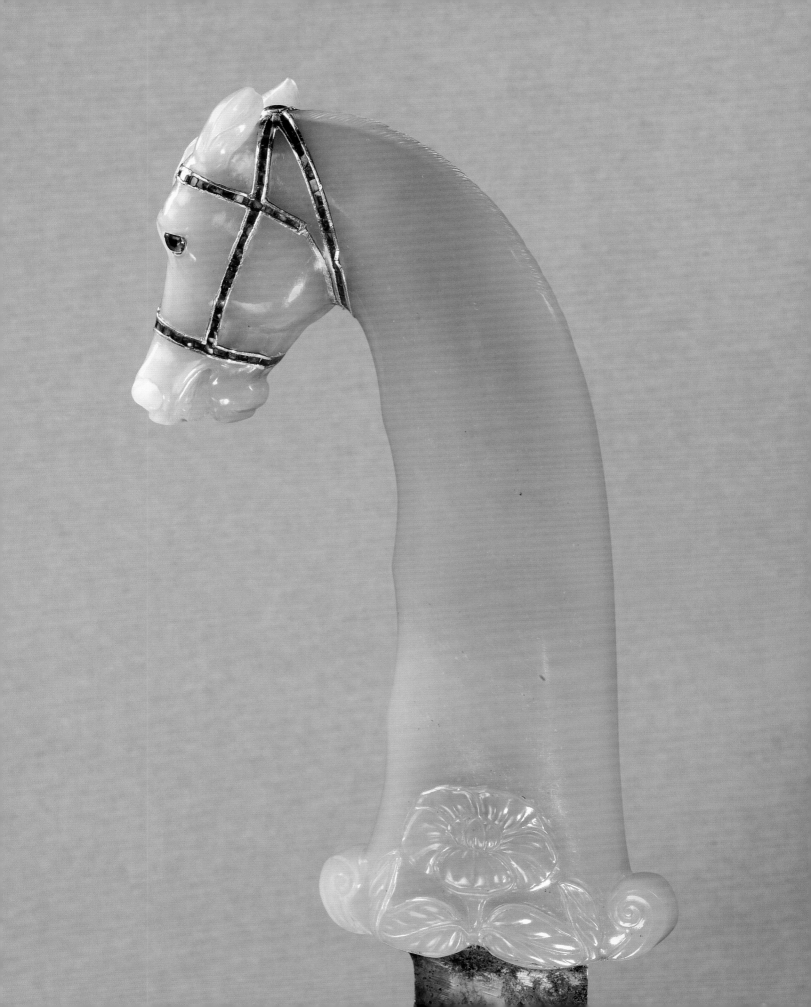

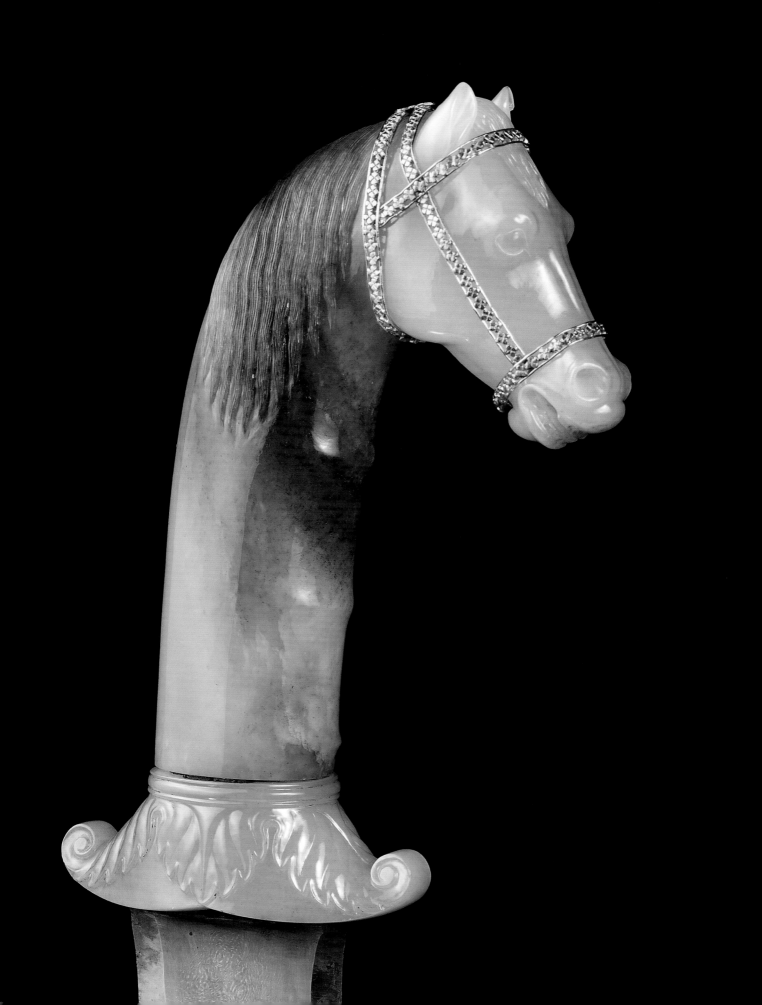

**Cat. 68 CAPARISONED JADE
HORSE-HEAD DAGGER**
**Mughal dominions, first half
of the seventeenth century**
Hilt carved from nephrite jade,
later fitted with a fabricated gold
halter; blade of *jawhar* steel
Dimensions: Length 38.5 cm; width 9 cm
Provenance: Art market 1992
Published: Keene and Kaoukji 2001, cat. 8.19
Inv. no. LNS 173 HS

This dagger with an Arabian horse-head
pommel was adorned at a later date with a
loose gold halter composed of quatrefoils
bordered by gold wire. The horse's lively
features are detailed, although not as
masterfully carved as the white jade
example Cat. 66, and the horse is depicted
with an alert and watchful expression,
its ears pricked up. The upper part of
the rounded hilt is finely engraved with a
flowing mane ingeniously made to fall in
strands on the darker surfaces of the jade.
The front of the grip is carved with three
finger-rests.

The short and flaring quillon block is
separated from the grip by a moulding that
suspends finely carved acanthus leaves. The
atypically elongated and upturned quillon
tips recall the quillon block of Cat. 57,
which is reportedly from Hyderabad.

The *jawhar*-patterned double-edged
striated blade drops before it gently
recurves at the tip.[16]

Detail showing ingenious carving of a
darker patch of jade for the horse's mane

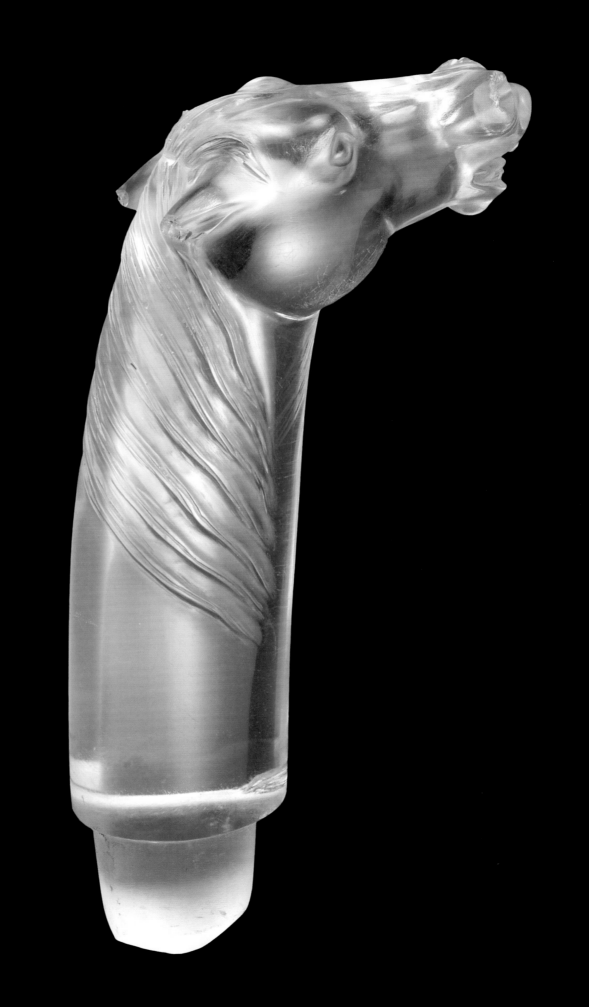

Cat. 69 **ROCK-CRYSTAL HORSE-**
HEAD KNIFE HILT
Mughal dominions, first half
of the seventeenth century
Carved from rock crystal
Dimensions: Length 7 cm; width 3.5 cm
Provenance: Art market 1991
Published: Keene and Kaoukji 2001, cat. 8.21
Inv. no. LNS 82 HS

In contrast with most horse-head hilts known to us, the head of this small, exquisitely carved hilt is pointing upwards.[17]

The rounded grip comes to a point at the front of the neck, and was probably slightly longer and ground down at a later date as a result of damage to the lower end of the hilt. This attempt at repair probably accounts for the poorly executed stump that projects from the bottom of the hilt and does not conform with the rest of its fine carving.

This type of stump, as in most rock-crystal hilts, was fitted with the blade tang, which avoided the need to insert it into the hilt, where it would be visible through the transparent grip. The stump would have been concealed by a metal encasement, as can be seen in the dagger Cat. 51.

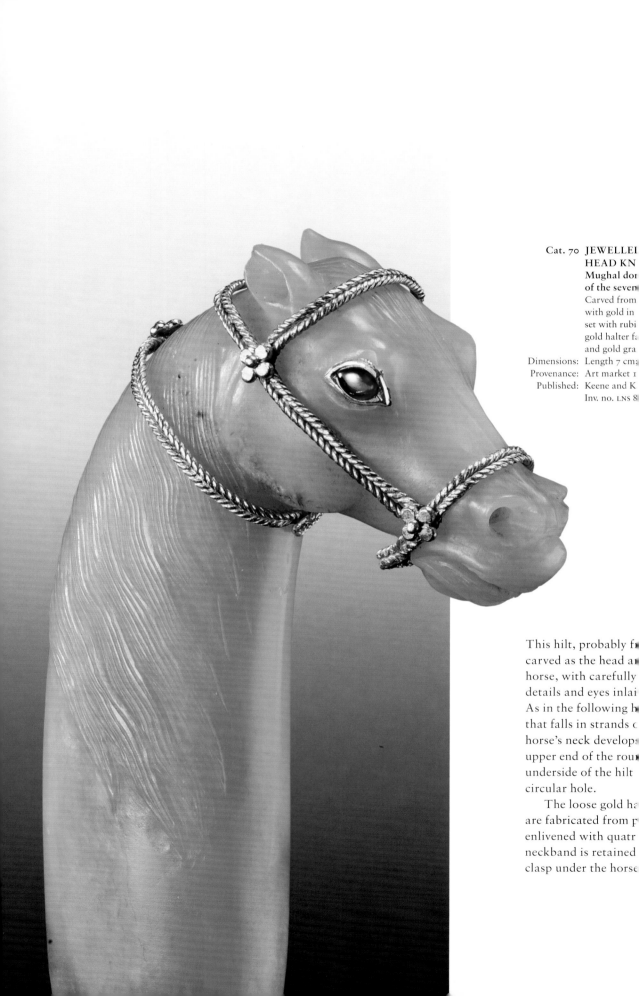

**Cat. 70 JEWELLE[...]
HEAD KN[...]**
Mughal do[...]
of the seven[...]
Carved from [...]
with gold in [...]
set with rubi [...]
gold halter fa [...]
and gold gra [...]
Dimensions: Length 7 cm; [...]
Provenance: Art market 1 [...]
Published: Keene and K [...]
Inv. no. LNS 8 [...]

This hilt, probably f[...]
carved as the head a[...]
horse, with carefully [...]
details and eyes inlai [...]
As in the following h[...]
that falls in strands [...]
horse's neck develop[...]
upper end of the rou[...]
underside of the hilt [...]
circular hole.

The loose gold ha[...]
are fabricated from p[...]
enlivened with quatr[...]
neckband is retained [...]
clasp under the horse[...]

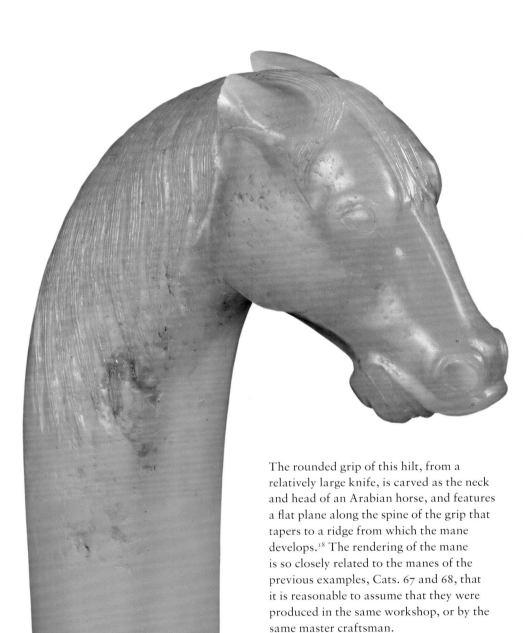

**Cat. 71 JADE HORSE-HEAD
KNIFE HILT
Mughal dominions, *c.* first half
of the seventeenth century**
Carved from nephrite jade
Dimensions: Length 12 cm; width 6 cm
Provenance: Art market 1989
Published: Keene and Kaoukji 2001, cat. 8.22
Inv. no. LNS 50 HS

The rounded grip of this hilt, from a
relatively large knife, is carved as the neck
and head of an Arabian horse, and features
a flat plane along the spine of the grip that
tapers to a ridge from which the mane
develops.[18] The rendering of the mane
is so closely related to the manes of the
previous examples, Cats. 67 and 68, that
it is reasonable to assume that they were
produced in the same workshop, or by the
same master craftsman.

As is the case in Cat. 67, the horse's
features include pinned-back ears, an
atypical forelock that falls on the horse's
forehead, flared nostrils and lips drawn
back to reveal outlined teeth.

The hilt is drilled on the bottom with
a hole encircled by a rough moulding.

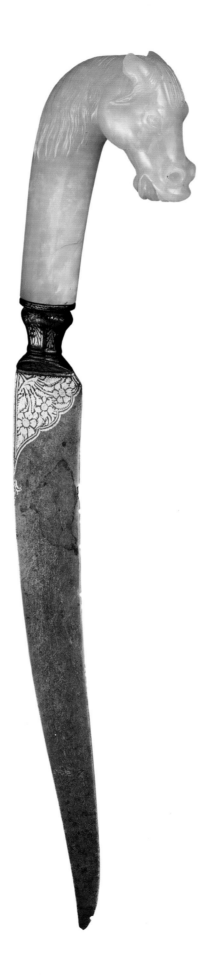

Cat. 72 JADE HORSE-HEAD KNIFE
Mughal dominions, first half
of the seventeenth century
Hilt carved from nephrite jade;
blade of *jawhar* steel, overlaid
with gold; ferrule, steel, overlaid
with gold

Dimensions: Length 29 cm; width 5.5 cm
Provenance: Art market 1999
Published: Sotheby's, London, 14 October
1999, lot 167
Inv. no. LNS 393 HS

The hilt of this knife is carved in the form of a horse's head, probably that of an Arabian because of the head's characteristic shape, with a markedly curved neck, wavy mane and flowing forelock. The horse's ears are gently pinned back, its nostrils flare and its lips are pulled back, revealing outlined teeth. As with Cat. 71, a flat plane along the back edge of the grip tapers to a ridge from which the mane develops.

The baluster-shaped ferrule is overlaid with bands of gold foliate motifs and rosettes. The lobed medallion on the ricasso encloses a bunch of flowers and leaves rendered in a thick layer of modelled gold with a trefoil finial. The upper edge of the blade is decorated with a cartouche of undulating foliate scrolls terminating in a trefoil.

The single-edged blade is nicked on the sharp edge, retains patches of *jawhar* pattern, and curves pronouncedly before it recurves at the tip.

Detail of hilt showing
treatment of horse's forelock
and gold floral decoration on
ferrule and blade ricasso

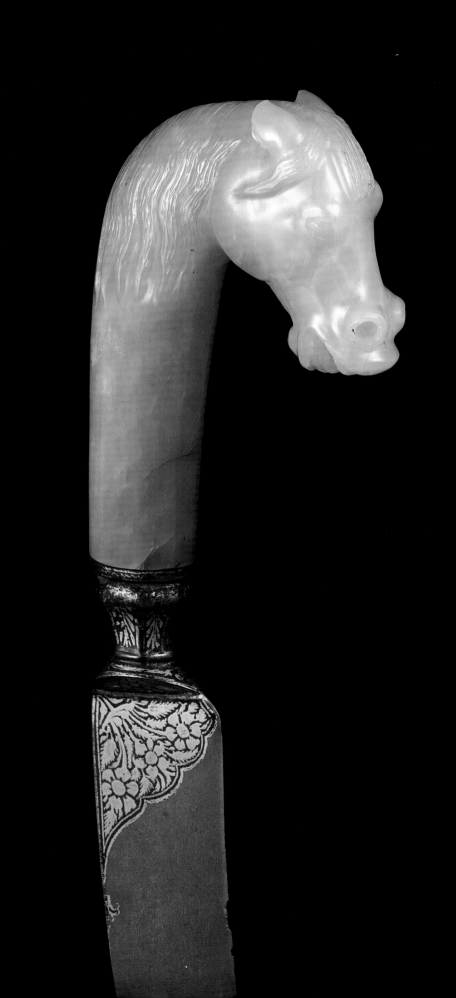

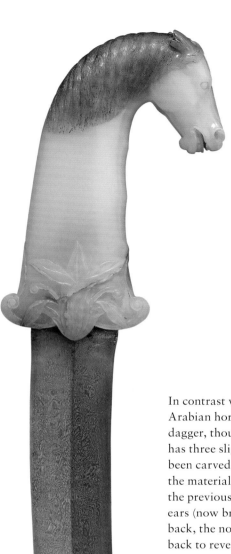

Cat. 73 JADE HORSE-HEAD DAGGER
Mughal dominions, probably mid seventeenth century
Hilt carved from nephrite jade; blade of *jawhar* steel
Dimensions: Length 37 cm; width 8.5 cm
Provenance: Art market 2003
Published: Sotheby's, London, 30 April 2003, lot 107
Inv. no. LNS 620 HS

In contrast with the preceding examples of Arabian horse-head hilts, the grip of this dagger, though well-carved, is quite heavy and has three slight finger-rests. The wavy mane has been carved ingeniously into a darker surface of the material, and the forelock flows back as in the previous example, Cat. 72. The finely carved ears (now broken off at their tips) are pinned back, the nostrils flare, and the lips are pulled back to reveal a tongue and outlined teeth.

The quillon block is finely carved with a blossom whose overturned petals issue tendrils, two of which border the lower edges of the block and curl up on the sides. Acanthus leaves develop from the curls, one of which is overturned in line with a crack in the material.

The double-edged *jawhar*-patterned blade is of thin rhomboid section and gently drops before it recurves towards the tip.

Detail of hilt, with atypical representation of a blossom and acanthus on the quillon block

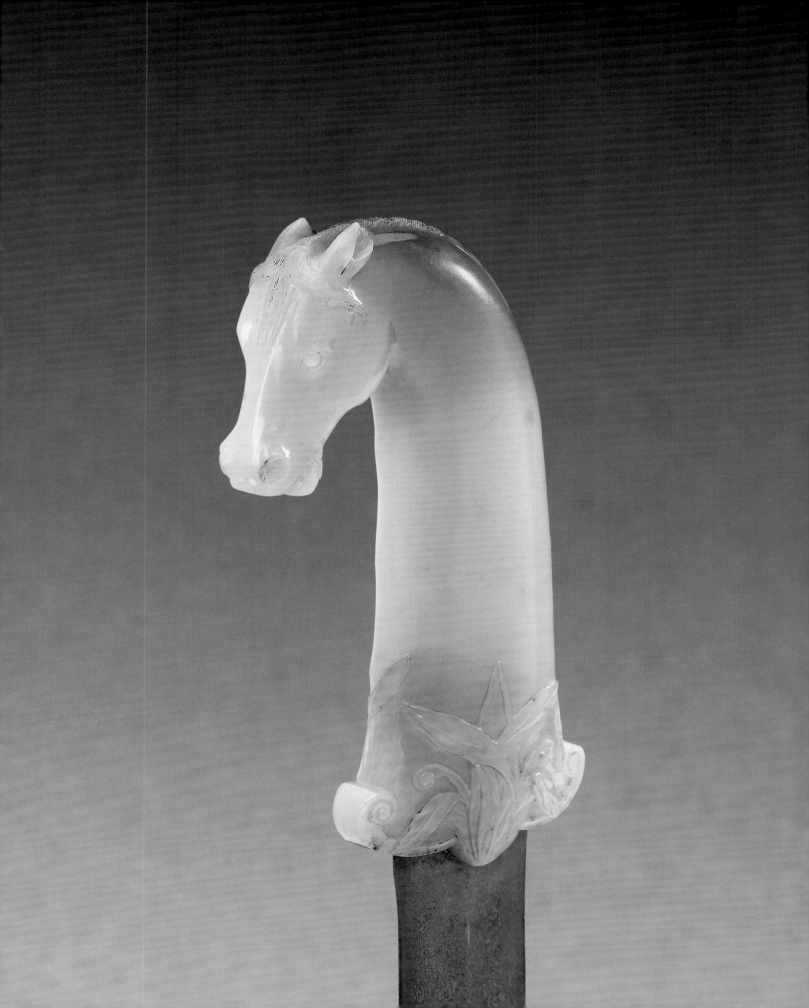

Cat. 74 IVORY LION-HEAD KNIFE
Mughal dominions, *c.* first half
of the seventeenth century
Hilt carved from walrus ivory
(eyes formerly inlaid); blade of
jawhar steel

Dimensions: Length 30 cm; width 4 cm
Provenance: Art market 1997
Published: Sotheby's, London, 8 May 1997,
lot 98; Keene and Kaoukji 2001,
cat. 8.14
Inv. no. LNS 84 I

Hilts with lion-head pommels start to appear in Mughal paintings early in the seventeenth century, and gradually become more popular throughout the first half of the seventeenth century.[19]

This naturalistic head of a young lion or lioness is subtly carved from walrus ivory,[20] a material not so readily available in India as elephant ivory, but its choice is certainly not coincidental, as the walrus ivory beautifully evokes the colouring of the animal's pelt.

The mane is cropped between the ears, the fronts of which are detailed with tufts of hair; a moulding encircling the face represents more of the mane. The hollow eye-sockets are drilled with three tiny holes to hold the gold inlay, which was probably set with gemstones that have since fallen off. The interior of the mouth is detailed with a tongue bordered by outlined teeth, but the two upper canines are now broken off.

The grip typically comes to a point at the front, and has a flat, narrow edge on the back that turns into a gentle ridge just below the head.

The *jawhar* pattern of the fine single-edged blade appears to be in pristine condition.

Detail of hilt, showing subtle carving of
the lion's mane, tongue and teeth

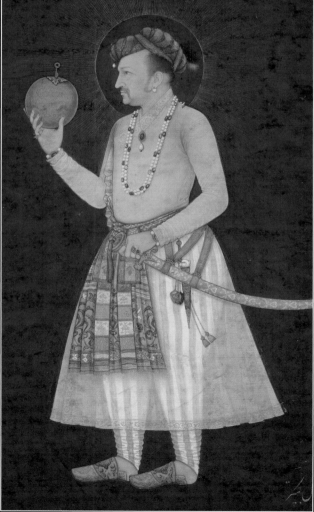

Portrait of Emperor Jahangir wearing
a dagger with a lion-head pommel
suspended from his belt, by Bichitr, *c.* 1620

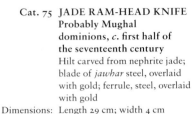

Cat. 75 JADE RAM-HEAD KNIFE
Probably Mughal
dominions, *c.* first half of
the seventeenth century
Hilt carved from nephrite jade;
blade of *jawhar* steel, overlaid
with gold; ferrule, steel, overlaid
with gold
Dimensions: Length 29 cm; width 4 cm
Provenance: Art market 1991
Published: Keene and Kaoukji 2001, cat. 8.16
Inv. no. LNS 71 HS

It is clear from representations in paintings from the first half of the seventeenth century that ram- and goat-head terminated hilts were fashionable in the Mughal court. It is possible that this trend was inspired by Emperor Jahangir's interest in these animals, which are described in great detail in his memoirs.[21]

The carving of this knife hilt is anatomically very accurate, from the handling of the muzzle and wide-open eyes to the smooth facial features and the finely textured horns and fur on the neck, sides and back of this solemn-looking ram's head.[22]

The flaring grip is of rounded section and has a flat edge on the back that is interrupted by a collar just below the ram's head.

The ferrule is overlaid with gold and decorated with two bands of floral scrolls. Gold cloud volutes extend along most of the back edge of the single-edged and downward-curving *jawhar*-patterned blade.

Detail of the hilt, with a fine, naturalistic representation of a ram-head on the pommel

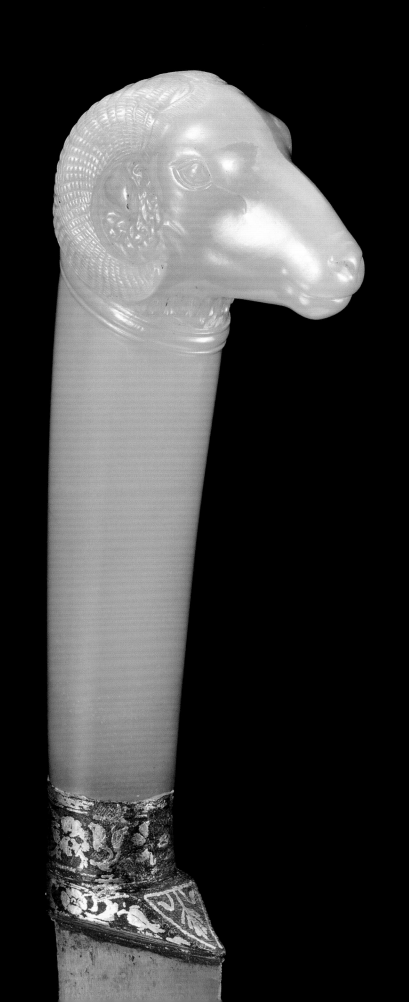

Cat. 76 JEWELLED JADE RAM-HEAD KNIFE
Mughal dominions or Deccan, probably second half of the seventeenth century
Hilt carved from nephrite jade, inlaid with gold in *kundan* technique and set with rubies, chalcedony and banded agate; blade of *jawhar* steel, overlaid with gold
Dimensions: Length 30 cm; width 4.5 cm
Provenance: Art market 1980s
Published: Keene and Kaoukji 2001, cat. 8.23
Inv. no. LNS 17 HS

This hilt is carved as the neck and head of a ram with fine handling of anatomical features, textured but somewhat clumsily carved horns, and curling fur that in the virtuosity of its rendering matches that of the ram-head pommel on Cat. 75.[23]

The ram's eyes and collar are set with rubies. The flat plane on the back of the rounded grip has an alignment of ruby buds in detailed gold settings, which might be a later addition, but evokes the recurring motif that was used to line the edges of *katar*s, lockets and chapes, and that is associated with a Deccan form of decoration.[24]

On the front of the hilt, the decoration, which is beyond doubt a later addition, is composed of stylized petals set with carved amber-coloured chalcedony outlined with gold to create an overturned-petal effect, which develops from a three-part stylized calyx set with rubies. Encircling the base of the hilt, petals of dark-brown layered agate, some traversed across their centres by a white vertical band,[25] were likewise set at a later date.

The ferrule is overlaid with plain gold, and with a finely rendered poppy blossom and foliate scroll that extends from the back of the ferrule onto the upper end of the blade's edge.

The blade ricasso is overlaid with a poppy blossom. The single-edged *jawhar*-patterned blade drops before it recurves towards the reinforced tip.

Opposite: Back of hilt, showing naturalistically carved ram-head pommel and later gem-setting, with the possible exception of the line of ruby buds down the back

Cat. 77 JEWELLED SHEEP-HEAD KNIFE

Mughal dominions, *c.* first half of the seventeenth century

Hilt carved from nephrite jade, eyes inlaid with gold in *kundan* technique and set with yellow sapphires (painted details underneath); blade of *jawhar* steel

Dimensions: Length 27 cm; width 4 cm
Provenance: Art market 1991
Published: Keene and Kaoukji 2001, cat. 8.24
Inv. no. LNS 73 HS

Detail of sheep-head pommel, with its beautifully carved fleece

The hilt of this knife is carved in the form of a sheep's head, with an engraved collar just below the animal's head and yellow sapphire eyes backed with painted surfaces. The fleece texture on the head and neck of the sheep is masterfully carved, but differs from the usual treatment of fleece on this type of animal-headed hilt in that it is carved as a pattern of straight-grooved curls.

The rounded hilt comes to a point on the front and has a flat plane on the back. It is capped by an undecorated steel ferrule and fitted with a straight single-edged *jawhar*-patterned blade.

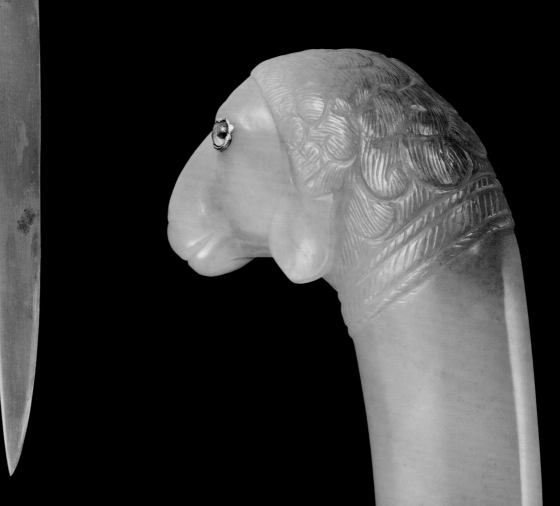

Cat. 78 JADE RAM-HEAD HILT
Mughal dominions or Deccan,
probably second half of
the seventeenth century
Carved from nephrite jade
Dimensions: Length 7.5 cm; width 2.5 cm
Provenance: Art market 2005
Published: Sotheby's, London, 25 May 2005,
lot 86
Inv. no. LNS 729 HS

This hilt is carved in the form of a
ram's head with pricked-up ears,
curling horns and fine detailing of the
wide-open eyes and nostrils. As in
the carved ram on the hilt of Cat. 76,
the horns are textured but somewhat
clumsily carved.

The grip is finely carved with four
fleshy, overlapping acanthus leaves.
The projecting stump that would
have fitted into a metal encasement or
ferrule for the attachment of a blade is
chipped on one side.

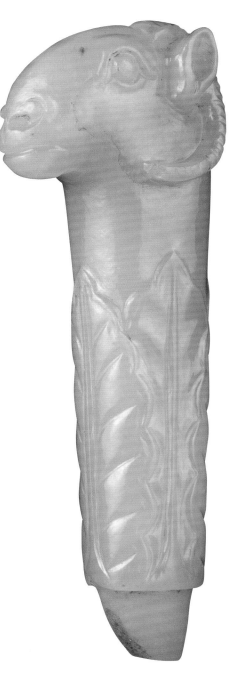

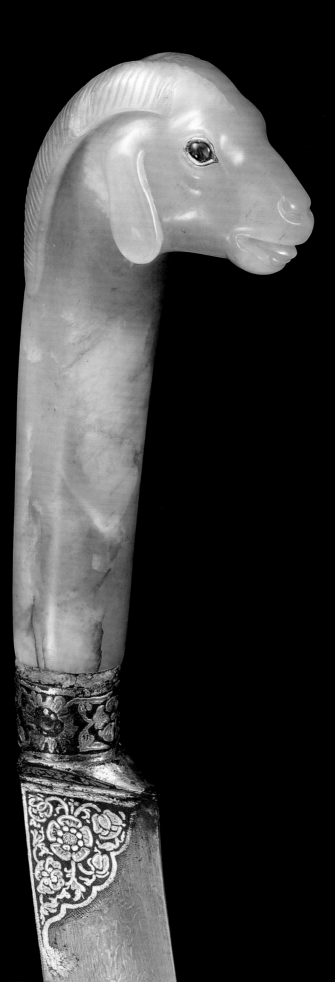

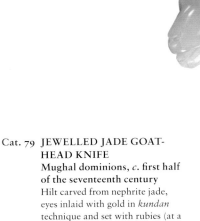

Cat. 79 JEWELLED JADE GOAT-HEAD KNIFE
Mughal dominions, *c.* first half of the seventeenth century
Hilt carved from nephrite jade, eyes inlaid with gold in *kundan* technique and set with rubies (at a later date?); blade of *jawhar* steel, overlaid with two colours of gold
Dimensions: Length 27.5 cm; width 4 cm
Provenance: Art market 1991
Published: Keene and Kaoukji 2001, cat. 8.25; Curatola and Kaoukji 2016, cat. 179
Inv. no. LNS 72 HS

The carved hilt of this knife depicts the neck and head of a typically Indian goat with pendulous ears and long, gently curving grooved horns. Its eyes are set with rubies, and its open muzzle, despite its small size, reveals a tongue and individually outlined teeth.

The rounded grip has a flat plane on the back, and is capped by a ferrule overlaid with yellow gold floral scrolls, detailed with greenish gold, from which extends a foliate scroll bearing trefoils along most of the back edge of the blade.

The single-edged downward-curving *jawhar*-patterned blade drops before it recurves towards the tip, and is decorated on the ricasso in two tones of gold with a flower issuing smaller unfurling flowers in a pinwheel configuration.

Detail of carved goat-head pommel, and gold foliate scrolls on ferrule and blade ricasso

Cat. 80 JADE AND AGATE GOAT-HEAD KNIFE
Mughal dominions, *c.* first half of the seventeenth century
Hilt carved from banded agate and pommel carved from nephrite jade; blade of steel inlaid with gold
Dimensions: Length 23.5 cm; width 2 cm
Provenance: Art market 2005
Published: Sotheby's, London, 25 May 2005, lot 92
Ex collection: probably King Charles I of England (r. 1625–49); Archibald Philip Primrose, fifth Earl of Rosebery (1847–1929)
Inv. no. LNS 730 HS

The pommel of this elegant little knife is exquisitely carved from translucent white jade in the form of a goat's head of minuscule proportions, with prominent ribbed horns (one now broken off),[26] beautifully engraved eyes, detailed fleece on the back of the head, a slightly open muzzle revealing the tip of a tongue, and a beard. A corolla of rounded petals fluted around their edges encircles the base of the animal's neck.

Although the banded agate grip is interrupted in the centre by a gold band, on account of breakage still visible on the back of the grip (probably concurrent with the loss of the horn and an ear), it is noteworthy that the presence of the gold band does not interfere with the pattern created by the bands.

The baluster-shaped ferrule is inlaid with gold, with a pattern of foliate scrolls enclosing blossoms. The single-edged blade, which displays extensive damage, is stamped on one face with a crowned "CR" mark.

This stamped mark resembles ones used on the back of pictures belonging to King Charles I, and a search through his inventory revealed references to daggers with hardstone handles, which unfortunately were not described in detail.[27]

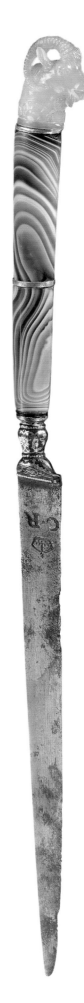

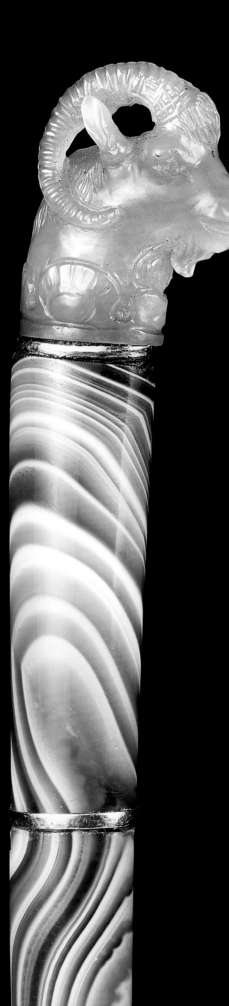

Detail of minuscule carved jade goat-head
pommel, and banded agate grip

Crowned "CR" mark on blade

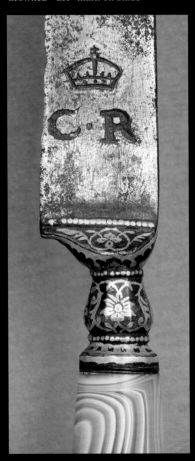

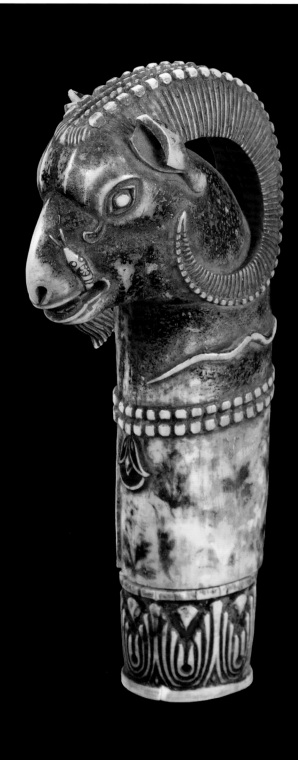
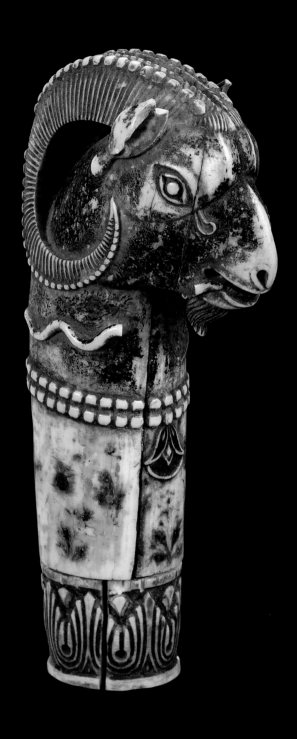

Cat. 81 IVORY GOAT-HEAD HILT
Perhaps Deccan,
seventeenth century
Carved from elephant ivory,
painted and gilded
Dimensions: Length of upper part (a) 10 cm;
width 6 cm; length of lower part
(b) 2 cm; diameter 2.5 cm
Provenance: Art market 2008
Published: Christie's, New York, 16 September
2008, lot 430
Inv. no. LNS 177 I

Naturalistically carved in the form of a slightly fierce-looking goat that is about to swallow a snake wound around its muzzle and neck, this hilt retains traces of gilding as well as black and red paint, and must have looked even more striking in its original state than it does at present. The lower part of the hilt, which is carved with stylized acanthus leaves, was sliced off for reasons that are unclear. It is separated from the upper part by a metal band.

The goat on the hilt most likely represents a wild goat or Sindhi ibex (*Capra hircus blythi*) on account of the knobbly shape of its horns. It has been suggested that the goat might represent a markhor goat on account of the confusion arising from the name of the breed, which in Persian translates as "snake eater", even though markhor goats do not actually eat snakes; however, the horns on this goat do not resemble the distinctive twisted horns of the markhor.

The "snake and stag" theme was a widely propagated ancient symbol, especially associated with the triumph of good over evil. The subject can be found in Roman, Sasanian and early Christian literary sources and art, and was carried forward to the early Islamic world, from which the iconography appears to have migrated to India, as witnessed by seventeenth-century miniature paintings in which goats tackling snakes are depicted without any apparent connection to the painting's subject matter.[28] It is therefore unsurprising that such a representation should be found on the hilt of a seventeenth-century Indian weapon.

The goat's naturalistic anatomical features match those of the previous caprid examples in the virtuosity of their rendering, down to the preorbital scent glands that extend from the corners of the goat's eyes. Unlike the smooth and soft features of the animal-head hilts carved from hardstone, however, the rendering of this goat's head differs in that it has an almost forbidding appearance, which must have been enhanced by the choice of colours with which it was painted.

Above the gilded, beaded collar, the head of the goat was once covered with black paint detailed with small gold dots. The ribs of the prominent horns were originally gilded and the sunken depressions painted in a contrasting red. The snake was engraved and patterned in black, although most of the engraving has now worn off, and it is broken off on the side that projects from the muzzle and curls around the neck.

Below the collar are traces of two staggered rows of stemmed blooms (possibly carnations), and naturalistic acanthus leaves painted in red and gold detailed with black.

Cat. 82 JADE NILGAI-HEAD DAGGER
Mughal dominions, *c.* mid seventeenth century
Hilt carved from nephrite jade; blade of *jawhar* steel

Dimensions: Length 36 cm; width 5 cm
Provenance: Art market 1991
Published: Keene and Kaoukji 2001, cat. 8.26
Inv. no. LNS 81 HS

The flattish jade hilt of this dagger is carved as the neck and head of a male nilgai (*Bocelaphus tragocamelus*) or nilgau (blue cow), a large and typically Asian antelope, of a type not frequently encountered among animal-headed hilts. The grip has a flat plane on the back of the neck that develops into a ridge just below the delicately rendered head, which unfortunately now has a broken ear.

The quillon block is bordered with upswept acanthus leaves curling at their ends and issuing a cupped flower and tendrils.

The double-edged *jawhar*-patterned blade is of thin rhomboid section and gently drops before it recurves towards the tip.

Detail of finely carved nilgai-head pommel

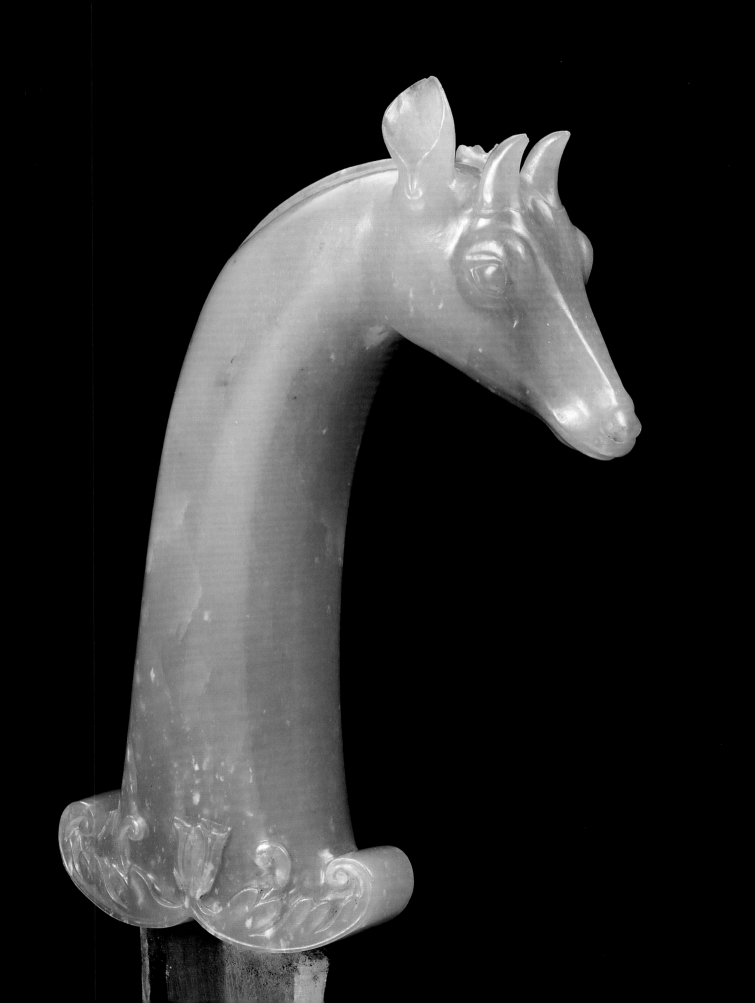

**Cat. 83 JEWELLED JADE CAMEL-
HEAD HILT**
**Mughal dominions, probably
late seventeenth century**
Carved from nephrite jade; inlaid
with gold in *kundan* technique
and set with rock crystal,
emerald and a ruby
Dimensions: Length 11 cm; width 4 cm
Provenance: Art market 2003
Published: Christie's, Hong Kong,
27 October 2003, lot 835
Inv. no. LNS 617 HS

Although the camel represented on this hilt resembles the Bactrian breed, its tongue-like *dulla*,[29] which extends from the side of its muzzle, is more typical of the male dromedary's means of asserting dominance over another male or its mating display to attract a female.[30]

Camels were frequently painted by Mughal artists. A *Gulistan* of Sa'di, ascribed to Nar Singh, *c.* 1595, depicts a scene that takes place on the road to Makkah, during which a camel with its projecting *dulla* is "moved to energetic dancing" and throws a pious man off its back.[31]

The maker of this hilt was obviously quite familiar with the features of a camel, with its protruding lower lip, slit nostrils, and mane on the head and around the throat, and was thus confident enough to produce a representation that is at once naturalistic and stylized.

The eyes are set with rock crystal, and the gold bridle is set with emeralds at its points of intersection. Interestingly the camel has been fitted with a feathered turban ornament set with a ruby, which probably affords it a status of some sort.

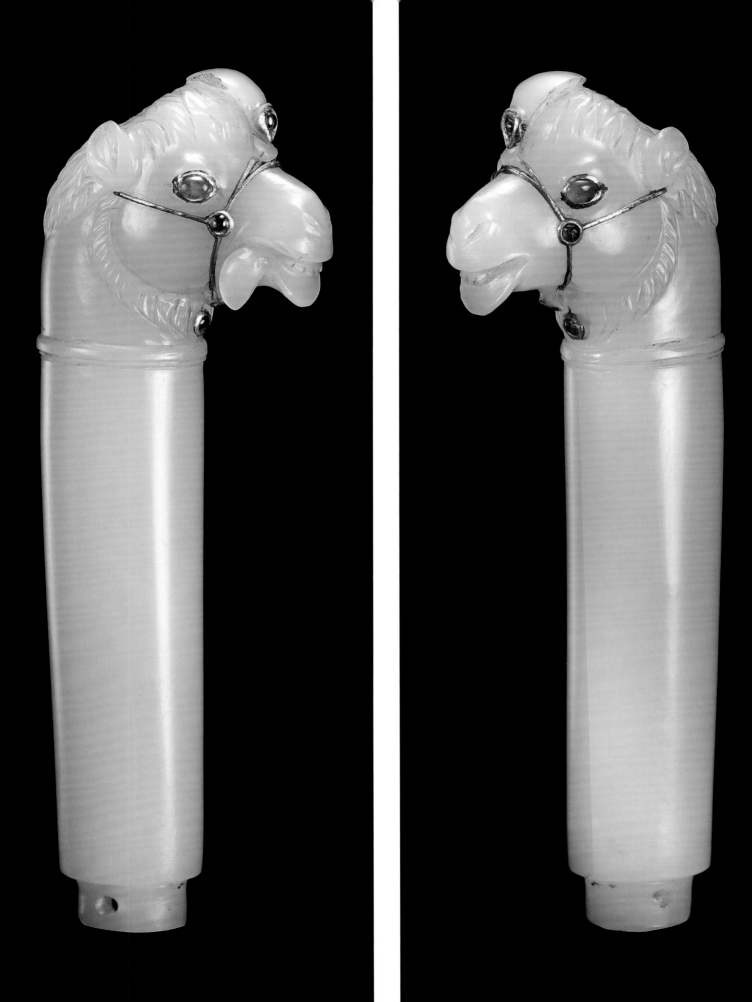

NOTES

1 King Tutankhamun's dagger with a pommel in the form of a falcon head symbolizing the god Horus, probably because Horus was the god of war, Ziegler 2002, p. 61, cat. 10; the late second-millennium animal-head dagger from west Iran, Mahboubian 1997, p. 299, cat. 381; the horse-head dagger hilts on the ninth- and eighth-century BCE Assyrian reliefs, Collins 2009, pp. 57 and 70; and the Achaeminian gold sword with addorsed lion-head pommel from around the sixth or fifth century BCE said to be from Hamadan, Curtis and Tallis 2005, p. 233, cat. 430.

2 Bunker 1997, cats. 3, 5, 19–24.

3 Ibid., p. 19.

4 It is likely that the original ears were positioned in the loci now occupied by the two smaller rubies, set beside the "cap", which was most likely original to the hilt.

5 Pyhrr et al. 2005, p. 8.

6 Gray 1977, p. 43.

7 The first occurrence of a "poll cap" can be seen in a painting by Abd al-Samad attributed to c. 1585, Das 1998, p. 22, following which a large number are depicted in the Victoria and Albert Museum manuscript of the Akbar-nameh, attributed by Susan Stronge to c. 1590–95, and in the British Library/Chester Beatty Akbar-nameh, attributed by Linda Y. Leach to c. 1603–05. Although scattered representations endure up until c. 1633, it seems as though the greatest concentration prevailed between 1585 and 1605.

8 For late fourteenth-century representations, see e.g. the plant clusters in a Jalayirid manuscript of Kalila wa Dimna, dated 1391, O'Kane 2003a, figs. 45, 46 and 48, as well as various depictions in Persian painting from the fifteenth century onward.

9 Beach and Koch 1997, esp. two paintings attributed to c. 1650 showing white jade horse-head daggers worn by a prince (probably Dara Shikoh), cat. 19, and by a courtier, cat. 11.

10 "The handle of his dagger is in the form of a horse / For victory to ride on the day of battle," Schimmel 2004, p. 184 (quoted from the Indian court poet Abu Talib Kalim Kashani, d. 1651, Diwan, ed. Partaw Baydai, Tehran, 1957).

11 See e.g. the hilt of a bronze dagger with finger-ridges from Ras Shamra in northern Syria, Galliano and Calvet 2004, p. 172, cat. 157. Also, much later from Central Asia in the seventh and eighth centuries, knives with finger-rests depicted on a bronze dish in the State Hermitage Museum, St Petersburg, and in the wall paintings from Panjikent, Chuvin 1999, respectively, cats. 210 and 208, and a dagger with a nielloed silver hilt with finger-rests attributed to Syria or Palestine, c. twelfth–thirteenth century, Digard 2002, cat. 57.

12 My thanks go to Robert Elgood for bringing to my attention the special feature of Marwari horses' ears.

13 Tiradritti 2000, Rahotep and Nofret, pp. 62–63, and the scribes, pp. 76 and 84.

14 Keen and Kaoukji 2001, p. 112, cat. 9.3.

15 According to Robert Elgood, the blade might be a cut-down sword blade.

16 According to Robert Elgood, the multiple striations on the blade reflect sixteenth- and early seventeenth-century Hindu traditions and can probably be attributed to "early Bijapur" (pers. comm.).

17 To the best of our knowledge, the only other example of a horse-head hilt with the head pointing upwards, but carved from jade, is in the Museum of Fine Art, Houston, inv. no. 2010.17.

18 Interestingly, a number of animal-headed daggers and knives feature this flat plane on the spine. See e.g. a jade hilt with a nilgai head in the Furusiyya Foundation, Mohamed 2008, cat. 185.

19 Shah 'Abbas I is represented wearing a dagger with a lion-head pommel in a painting from the Leningrad Album, attributed to c. 1618, Beach 1981, pp. 170–71, pl. 78; Emperor Jahangir is portrayed in a folio from the Minto Album, attributed to c. 1620, suspending a knife with a lion-head pommel from his sash; one of Prince Dara Shikoh's attendants wears a dagger with a lion-head pommel, c. 1640–50, Leach 1995a, p. 387, cat. 3.15, and p. 402, cat. 3.17; a nobleman is represented wearing a dagger with a lion-head pommel in a folio from the Padshah-nameh, c. 1650, Beach and Koch 1997, p. 57, cat. 19; and courtiers wear daggers with lion-head pommels in a painting attributed to the middle of the seventeenth century, Akimushkin 1996, pl. 65, fol. 26v.

20 See cat. 101 regarding walrus ivory.

21 References in the Tuzuk-i Jahangiri, Emperor Jahangir's memoirs, illustrate how well informed the emperor was about such animals: Jahangir 1978, pp. 84, 88, 109, 113, 122. See also e.g. the ram-head terminated staff of a courtier in a painting dated 1628–29, Leach 1995a, p. 362, fig. 3.3.

22 An attendant of Prince Dara Shikoh wears a deep-insertion ram-head knife in a painting attributed to 1635–40, Akimushkin 1996, pl. 4, fol. 16r.

23 For a similar treatment, see also the crutch head cat. 118.

24 As e.g. on the edges of the side-bars of cats. 6 and 10; on the edges of the lockets of cats. 48 and 61; and on the edges of the chapes of cats. 63 and 106.

25 For a similar treatment of layered agate, see the petals on the armband in Keene and Kaoukji 2001, cat. 1.19.

26 For similar prominent horns, see the goat-headed jade hilt in the Powis Castle Collection, Skelton 1982a, cat. 409.

27 Although the Sotheby's sales catalogue associated the mark with King Charles 1, Robert Elgood believes that the crowned "CR" mark is more likely that of Charles II (r. 1660–85), and that the mark does not mean that the dagger was the personal possession of the king.

28 For more on the subject of "the snake-eating stag", see Ettinghausen 1984, pp. 674–92, esp. figs. 1–3, 7, 11–13.

29 The dulla is an inflatable organ in the throat of dromedaries, which when inflated and projecting out of the muzzle resembles a tongue.

30 See Skelton 1982a, cat. 363, for a camel-head jade hilt with an extended dulla, and cat. 407, for a dagger with rock-crystal hilt and camel-head pommel.

31 Smart et al. 1985, p. 19, cat. 3b.

CHAPTER SEVEN
FLORAL HILTS
A DISTINCTIVELY INDIAN TYPE OF ORNAMENT

Although flowers and floral decoration have captivated humankind since its earliest origins, flowers and everything they evoke – a love of nature, a striking aesthetic and the many symbolic meanings of individual species – were particularly revered and favoured in the Indian subcontinent. Exuberant use and displays of flowers filled the lives of Indian society at large, not only for those in the ruling classes, but also among the less privileged.

Flowers served as a prime decorative motif on surfaces as diverse as architecture and the decorative arts, paintings, textiles and carpets. Floral decoration was especially favoured in the jewelled arts, where sparkling gemstones and bright-coloured enamels were considered especially appropriate materials to emulate the colour and brightness of flowers. Indian artists developed a blend of naturalistic and stylized floral motifs, whether represented in arabesques or scrolls, or integrated in geometric patterns. More often than not, these floral motifs were accurately depicted with respect to the botanical structure of specific flowers and plant morphology generally, evidence of the love and detailed knowledge of the natural world on the part of both artists and their patrons.

During the Mughal era the Indian love of nature was felt so keenly that floral ornamentation was deemed suitable for the decoration of weapons. It is worthy of note that a very large number of weapons, if not most, were decorated with or shaped in the form of flowers, which might seem peculiar considering the ultimate function of this type of object. Evidently, there were no preconceived views with regard to adornment, which was primarily driven by a pronounced sense of aesthetics and a love of nature.

Groom wearing a dagger with floral pommel, in a miniature painting attributed to Farrukh Husayn, Bijapur, *c.* 1600–10

Cat. 84 JADE DAGGER
Mughal dominions or
Deccan, first half of the
seventeenth century
Hilt and locket carved from
nephrite jade; blade of *jawhar* steel
Dimensions: Length 36.5 cm; width 9.5 cm
Provenance: Art market 1992
Published: Keene and Kaoukji 2001, cat. 9.27
Inv. no. LNS 174 HS

The flattish grip of this outstanding
dagger tapers to an exquisitely carved bud
with petals that are subtly overturned on
the tips, and that appears as though it is
supported by the tips of four stemmed
leaves.[1] The leaves issue from a moulding
encircling the pommel, from which is
suspended a pair of overlapping leaves just
above the three finger-rests.

Fluted petals encircle the lower end of
the grip, and a moulding separates it from
the quillon block, which is decorated with
a flower that has small upright petaloids
in the centre and a corona of four finely
carved petals issuing two small leaves.

Halved acanthus leaves border the
edges of the quillon block and their curling
ends emerge gracefully from behind the
flower. In addition, large fan-shaped leaves
issue from the curls of the quillons and
straddle the sides of the block.

The double-edged *jawhar*-patterned
blade is of thin rhomboid section and gently
drops before it recurves towards the tip.

Detail showing exquisitely carved bud-shaped
pommel and floral decoration on quillon

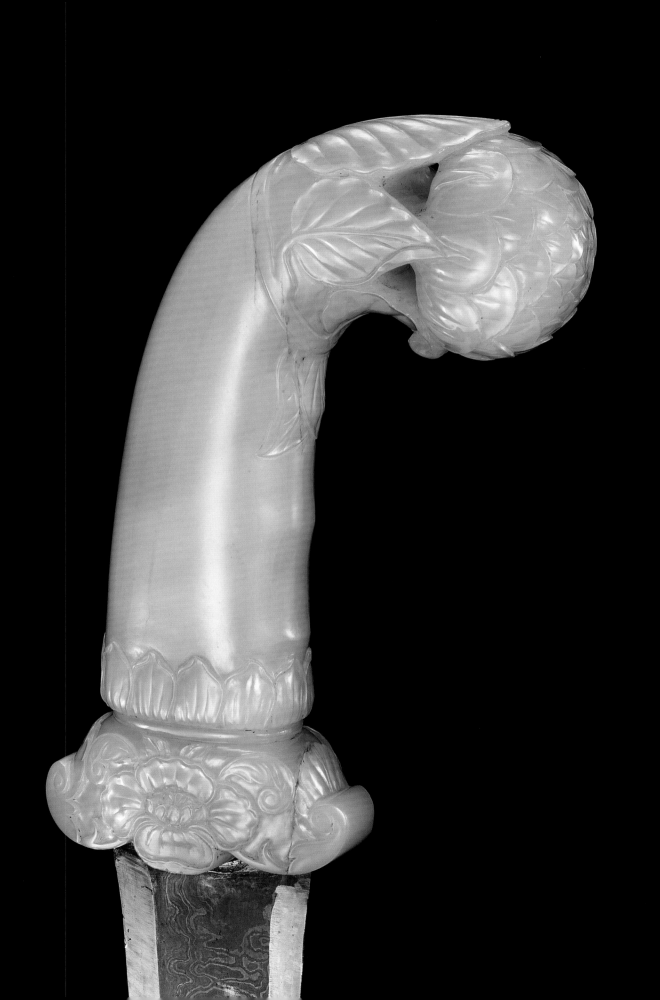

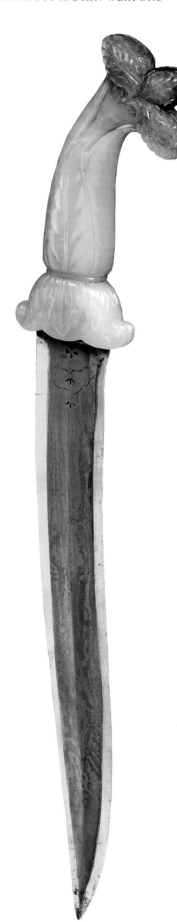

Cat. 85 DAGGER
Mughal dominions or
Deccan, first half of the
seventeenth century
Hilt carved from nephrite jade,
inlaid with gold in *kundan*
technique and set with a ruby and
diamonds at a later date; blade of
jawhar steel
Dimensions: Length 39.5 cm; width 8.5 cm
Provenance: Art market 1991
Published: Keene and Kaoukji 2001, cat. 9.26;
Michell 2007, cat. 56
Inv. no. LNS 80 HS

Of generally flattish proportions, the hilt
of this beautiful dagger is subtly carved in
the form of four lanceolate leaves enfolding
an iris blossom.[2] Along the sides of the grip
the two longer leaves curl out, echoing the
curve of the iris petals, whereas the two
shorter leaves reveal the stem and sepals of
the blossom.

The iris bloom is rendered in three
parts, each composed of four ribbed and
fluted overlapping petals grouped in a
bud-like formation. The upright petals are
set with a ruby on the tip, and diamonds
in detailed settings on two of its sides.
On one of the hilt's faces a diamond in a
gold trefoil-shaped setting punctuates the
juncture of the three groups of petals.

Acanthus leaves cover the quillon block,
and the longer leaves straddling the sides of
the block curl at the tips of the quillons.

The double-edged *jawhar*-patterned
blade is of thin rhomboid section, gently
drops before it recurves at the tip, and is
engraved on the ricasso with escutcheon-
shaped medallions suspending trefoils.

Detail showing subtle carving of leaves
enfolding a stemmed iris blossom

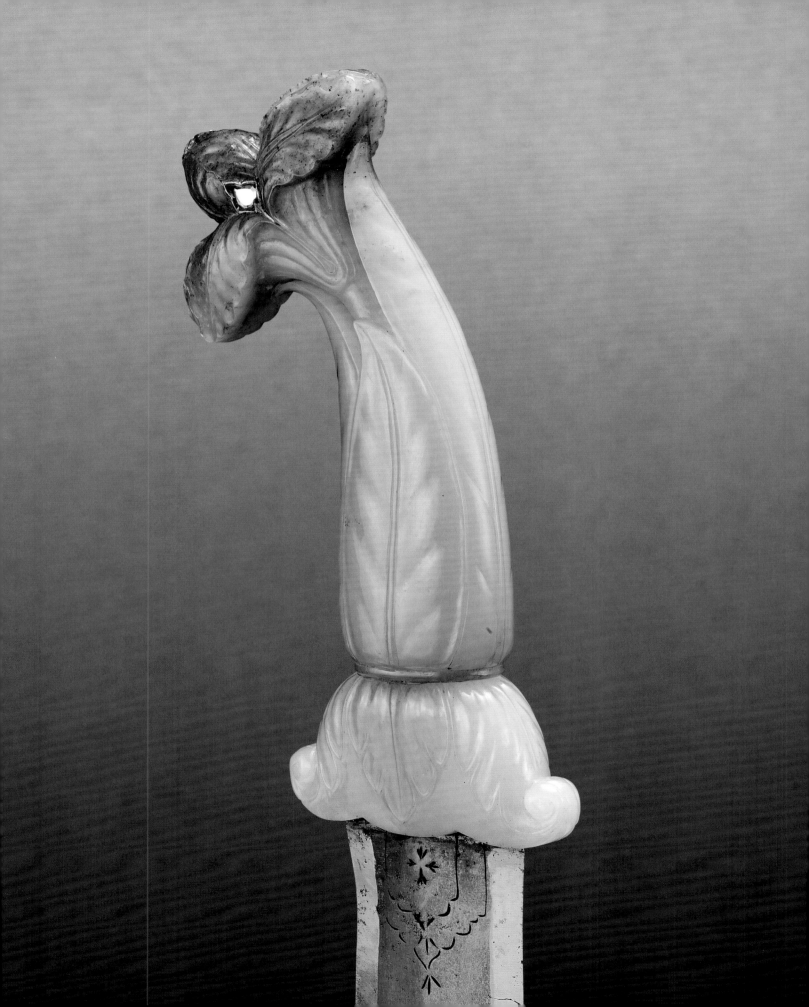

Cat. 86 DAGGER
Probably Deccan, first half
of the seventeenth century
Hilt of nephrite jade, inlaid
with gold and set with rubies
and emeralds in *kundan* technique;
blade of *jawhar* steel, overlaid
with two colours of gold
Dimensions: Length 39.5 cm; width 9 cm
Provenance: Art market 1999
Published: Habsburg Feldman, Geneva,
29 June 1988, lot 294; Christie's,
London, 6 October 1999, lot 198;
Keene and Kaoukji 2001, cat. 1.12;
Stronge 2010, pl. 180
Inv. no. LNS 2221 J

The decorative approach of this unusual
jade hilt centres on various different floral
motifs, each repeated eight times on the
pommel, grip and quillon block, possibly
an allusion to the planet Saturn (Shani),
the planet of karma and protection,
which rules the number eight in Indian
numerology.

The flaring pommel evokes the form
of a flower with its two projecting leaf-
like elements carved in one piece with the
pommel and set with emeralds in engraved
gold settings. The large ruby in the centre
of the flower on the pommel is set in a
jade collet, which was likewise carved
with the pommel as a single piece.
Further accenting the floral character
of the decoration are the *talab*-set ruby
rosettes, wherein ruby petals are held in
place by both the outlining gold and the
gold settings of their small emerald
centres. These rosettes appear on the
front and back of the pommel and
on the quillon block.

Eight auspicious Chinese cloud-band
motifs, channel-set with rubies, encircle
the upper end of the grip, and cartouche-
like bands of channel-set rubies decorate
the moulding, which is bordered by leaf
motifs channel-set with an emerald and
a ruby in gold settings engraved with
diagonal strokes.

The double-edged *jawhar*-patterned
blade is of thin rhomboid section, gently
drops before it recurves at the tip and
displays heat-drawn discolouring on the
blade surface. The ricasso is decorated
with fine bicoloured gold-overlaid floral
arabesques.

Detail showing back of the flower-shaped
pommel with floral and Chinese cloud-band
decoration, and floral decoration on the blade

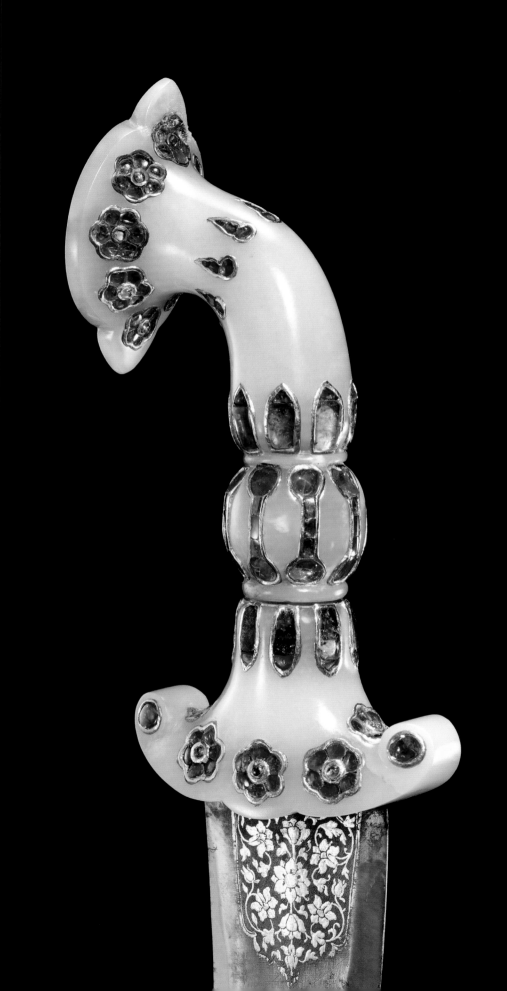

Cat. 87 DAGGER AND SCABBARD
Probably Mughal dominions,
hilt, locket and chape *c*. mid
seventeenth century; scabbard,
early eighteenth century
Hilt, chape and locket carved from
nephrite jade, inlaid with gold in
kundan technique and set with
rubies, emeralds and diamonds;
blade of *jawhar* steel; scabbard,
wood overlaid with gold and
champlevé enamelled
Dimensions: Length of dagger 35.5 cm; width
5 cm; length of scabbard 28 cm;
width 4.5 cm
Provenance: Art market 1980s
Published: Curatola et al. 2010, cat. 280
Inv. no. LNS 13 HS ab

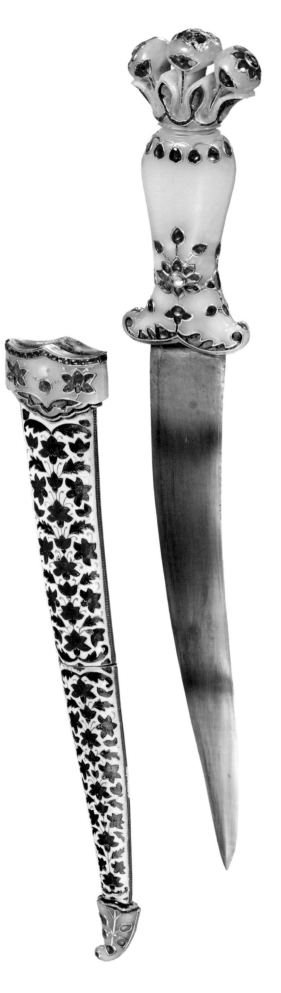

A special feature of this hilt is the
pommel composed of three carved buds
projecting from a whorl of sepals,[3] a
type that appears to have been popular
in the Rajput states, as several examples
carved from jade, ivory and agate are in
the Jodhpur and Jaipur royal collections.
Capping each jade bud are *talab*-set
ruby flowers with emerald centres. On
the sides of each bud, channel-set ruby
stems define the bud stalks and bear
talab-set ruby blossoms represented in
profile, possibly in an attempt to convey
two different views of the flower.
Encircling the whorl of jade sepals, a
festoon of channel-set rubies bears ruby
buds and emerald leaves, forming quite
an exuberant floral ensemble.

The grip, which is carved from a
different piece of jade, is separated
from the pommel by paired mouldings,
below which is an inverted gold festoon
suspending ruby buds and an emerald
leaf on the front and back of the grip.
On the lower end of the grip, emerald and
ruby flowers issuing buds and cup-shaped
blossoms conceal the join between the
grip and quillon block, as well as a crack,
and a jade plug was inset between the
flowers to fill a crack or hole. Bordering
the edge of the block, a pair of rather
ungraceful halved *talab*-set emerald
leaves issue a *talab*-set ruby blossom
with emerald calyx.

The slightly wobbly double-edged
blade dips and recurves, and thickens
at the tip. Its surface, which has
suffered repolishing, shows heat-drawn
discolouring along most of its length.

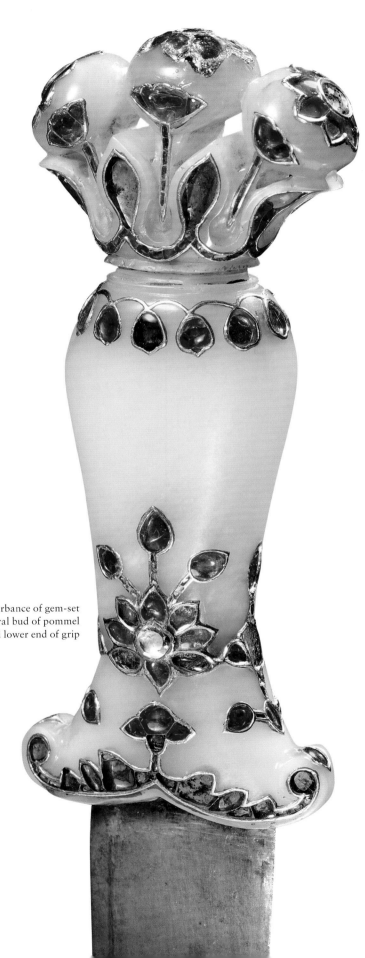

The later enamelled gold scabbard is made in two sections, possibly to accommodate the size of the enamelling kiln. Its decoration, which was most probably designed to match the decoration of this dagger, includes an alignment of graduated red hibiscus flowers and unfurling buds against white enamel, and is bordered with bands of light-blue enamel. The jade locket, which probably does not belong with this dagger, is bordered with channel-set rubies and features *talab*-set ruby blossoms growing from a pair of emerald leaves. The chape, which appears to have been ground down, might or might not be original to the dagger, and is set with a gold stem of ruby buds and a minuscule emerald on its curling tip.

Detail showing disturbance of gem-set decoration on central bud of pommel and around lower end of grip

NOTES

1 See Elgood 2015, cat. 19, for a related but later dagger.
2 For a similar jade hilt in the Bharat Kala Bhavan museum, inv. no. 3/7541, see Morley 1971, fig. 243, and for examples carved from ivory, see Elgood 2015, cats. 37 and 38.
3 For a related hilt carved from jade in the Furusiyya Foundation, see Mohamed 2008, cat. 189, and for a hilt carved from ivory in the Jaipur Royal Collection, see Elgood 2015, cat. 35.

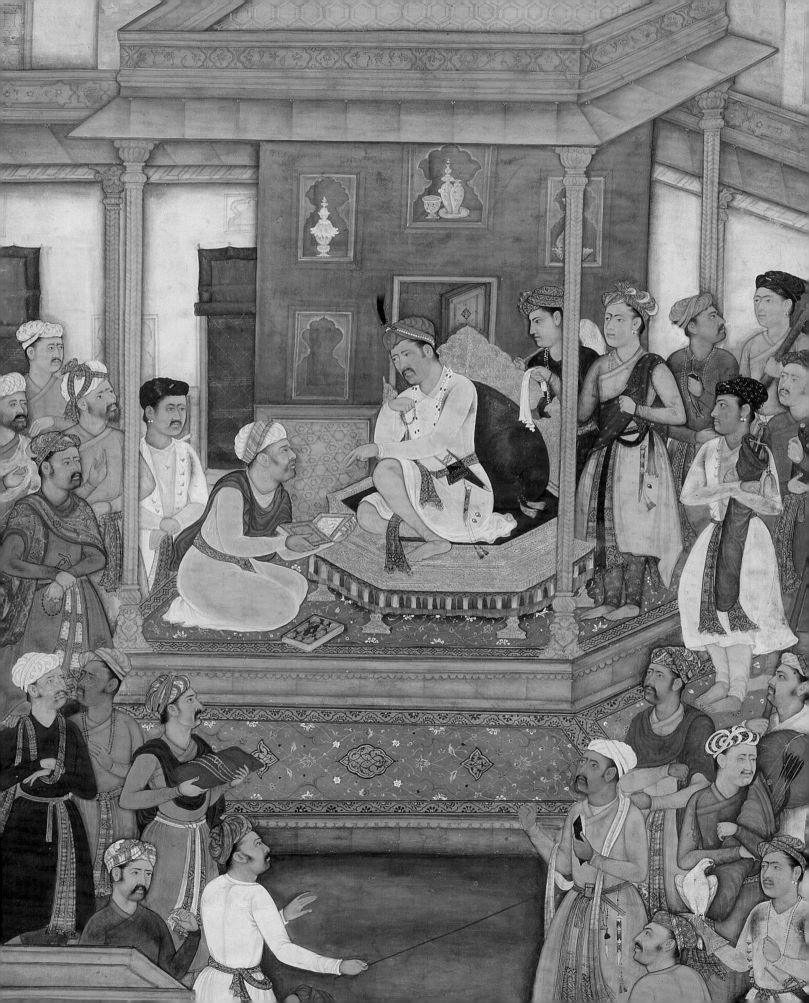

CHAPTER EIGHT
DEEP-SHEATHED KNIVES AND SCABBARDS
A DESCENDANT FROM CENTRAL ASIA

Deep-sheathed knives and similar weapons were not fitted with a guard or quillon block, which entailed the use of scabbards that concealed most of the blade and hilt except for the pommel. This type most likely originated early on among the nomadic tribes of Central Asia, where, from around the first half of the seventh century CE, personages are frequently depicted on wall paintings wearing such knives, as well as a number of other accessories, suspended from their belts.[1]

The use of short swords was evidently advantageous since they were easier to wield on horseback than long swords, and less cumbersome to transport on long journeys. The trend clearly spread along the caravan routes or silk roads, as demonstrated by a late ninth-century silk banner from Dunhuang that depicts a travelling monk with two small deep-sheathed knives suspended from his belt.[2]

At around the turn of the fourteenth century, depictions of deep-sheathed knives proliferate in paintings from the Mongol sphere of influence, such as the illustrations in the manuscript of the *Jami' al-Tawarikh*,[3] and become more widespread from the middle of the fourteenth[4] and throughout the fifteenth century.[5]

Interestingly, in a painting by Bihzad attributed to Herat, *c.* 1490, illustrating Amir Khusraw's *Hash Bihisht*, a man holding a green parrot wears a deep-sheathed knife with a bird-head pommel.[6] By the sixteenth century such knives were frequently depicted in paintings,[7] often worn by members of the court as well as by attendants performing their duties in banqueting scenes.

Illustration from a manuscript of the *Jami' al-Tawarikh* (Compendium of Chronicles), showing a court attendant wearing a deep-sheathed knife, 706 H/1306–07 CE

Emperor Akbar wearing a deep-sheathed knife suspended from his belt in an illustration from the *Akbar-nameh* manuscript, by Govardhan, *c.* 1603–05

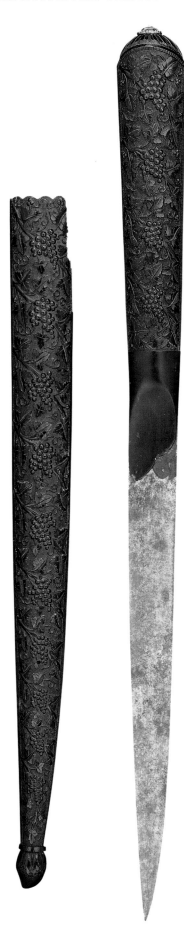

Cat. 88 EBONY KNIFE AND SCABBARD
Mughal dominions, first half of the seventeenth century
Hilt and scabbard carved from ebony wood, set with rock crystal; blade of *jawhar* steel (with much surface damage)
Dimensions: Length of dagger 34 cm; width 2.5 cm; length of scabbard 26 cm
Provenance: Art market 2008
Published: Bonhams, London, 10 April 2008, lot 255
Inv. no. LNS 1572 M ab

This hilt and scabbard have been exquisitely carved from ebony with an uninterrupted motif of vine leaves and bunches of grapes, a motif which, although apparently popular at the Mughal court, in this instance might have been carved by a European working at the court, as the treatment of the carving and style is not in keeping with traditional Indian types.

In the middle of the seventeenth century the French gem merchant Jean-Baptiste Tavernier mentions in *Les Six Voyages de Jean-Baptiste Tavernier* that Emperor Shah Jahan planned to decorate the walls of his divan with a ruby and emerald vine and grape trellis, which was much talked about at court, but apparently never materialized for lack of funds.[8] It is noteworthy that the motif of scrolling vines with bunches of grapes was apparently favoured at the court of Shah Jahan and can be seen decorating a large number of borders of paintings from the St Petersburg Muraqqa'.[9]

The faces of the lenticular hilt and scabbard come to a point along one edge, whereas the opposite edges feature a narrow recessed plane. The plane is carved with vines, tendrils, leaves and bunches of three grapes or berries, which extend along the back of the hilt and the upper half of

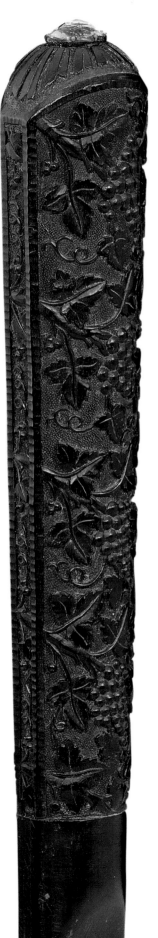

the scabbard, where this plane is prolonged by a tapering ridge.

On the upper end of the hilt rather angular rays spread from a faceted rock-crystal gem in a silver bezel. The rock crystal is either a later replacement or, if original, intended as an inexpensive simulation of a diamond, despite the precious wood and rich carving surrounding it.

On both faces of the hilt and scabbard short individual vines unfurl obliquely from one edge to the other, each issuing a single bunch of grapes, leaves and tendrils, as well as short vines surmounted by single berries.

The edges of the hilt and scabbard are outlined by fine fluted ridges (probably for reinforcement), and the scabbard finial comprises a bud enveloped by toothed leaves.

An ebony "ferrule" covers the upper end of the single-edged corroded blade.

Detail of hilt, with grapevines issuing from the edge of the hilt and rays emanating from the rock-crystal finial

Cat. 89 KNIFE
Hilt, Mughal dominions, first half of the seventeenth century; blade dated 1215 H (1800–01 CE)
Hilt carved from nephrite jade; blade, steel, inlaid with gold

Dimensions: Length 29.5 cm; width 2 cm
Provenance: Art market 1999
Published: Christie's, London, 20 April 1999, lot 387; Keene and Kaoukji 2001, cat. 9.16
Inv. no. LNS 365 HS

Of flaring octagonal section, this jade hilt is carved on the pommel with a beautifully laid-out floral composition contained by a moulding. Enfolding the upper end is a flower, which has a domical centre detailed with grooves and a corolla of large and small subtly modelled petals.

Below this flower, four flower-bearing stems grow from pairs of minuscule leaves that straddle alternate corners of the octagonal hilt. Two of these stems bear a single flower flanked by a pair of buds issuing tendrils, and the remaining stems bear a trefoil flanked by a pair of flowers with downturned petals and a pistil from which project three filaments.

The ferrule, which is a later addition decorated in the same manner as the later single-edged blade (dated 1215 H/1800–01 CE on its edge), is encircled with strips of swaged gold dots forming petals. Foliate arabesques adorn both sides of the blade and swaged, dotted strips extend along its entire upper edge.

Detail of carved blossom enfolding upper part of pommel, and surrounding floral composition

Cat. 90 JEWELLED JADE KNIFE
Deccan or Mughal
dominions, first half of
the seventeenth century
Hilt carved from white nephrite
jade, inlaid with gold in *kundan*
technique and set with rubies; the
gold cap champlevé enamelled;
blade of *jawhar* steel, overlaid
with gold (blade and integral
socket historic and Indian, but
not original to this hilt)
Dimensions: Length 22 cm; width 1.5 cm
Provenance: Art market 1994
Published: Keene and Kaoukji 2001, cat. 2.14
Inv. no. LNS 211 HS

Small, precious knives such as this one were most likely used for domestic purposes among the upper echelons of society, to carve fruit and other comestibles, and can be seen in paintings of dining scenes starting from the late sixteenth and early seventeenth centuries.[10]

The hilt is of rounded section with a flat edge on the back and is capped with a bud finial set in an enamelled, stemmed calyx atop a gold cap. The bud is delicately carved with layers of petals, on top of which are remains of "claw grooves" corresponding to those in which the tips of the enamelled calyx are set, and which are now largely obscured by the synthetic ruby set in the bud. The enamelled gold cap, stem and bud assemblage incorporates heavily altered (and possibly non-original) elements. The tubular stem, for example, which appears to have been broken off at the top, has been crudely ground down, and upon examination was found to incorporate a modern iron pin. The green enamelled top of the gold cap, which is decorated in reserve with pairs of swaged leaves between which are small stemmed buds, exhibits an area of disturbed gold at the base of the stem.

Both ends of the grip are encircled by rows of ruby buds borne on the cusps of a festoon formerly inlaid with gold, the loss of which most likely occurred because the jade grip was ground down at both ends. The lower end of the hilt fits into a cup-shaped steel ferrule (the upper edge of which has also been recently ground down), which displays remains of overlaid gold decoration extending onto the back edge of the blade.

Taking into consideration all the evidence of reworking, disturbance and assembly of elements, one should note that the attribution to the first half of the seventeenth century relates to the carved jade bud finial with its enamelled gold calyx and cap, as well as the inlaid jade grip. Furthermore, despite the ground-down edges, there is evidence that the hilt and gold cap were originally associated in something close to their present configuration: there appears to be an identical frequency of swags and cusps in the festoons on the upper and lower edges of the hilt and in the reserved gold festoon around the edge of the cap, and if the sections of the two elements were precisely aligned the festoons would likewise be aligned.

Despite their resemblance in both material and refined craftsmanship, it is unclear whether or not the carved bud and grip were originally together.

It is also likely that the single-edged *jawhar*-patterned blade is not original to the hilt on account of its disproportionately large size.

Carved bud finial held by
enamelled calyx, and ruby buds
with traces of festoons once inlaid
with gold

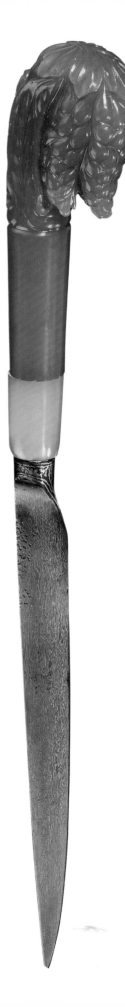

Cat. 91 KNIFE
Mughal dominions or Deccan,
seventeenth century
Hilt carved from nephrite jade;
blade of *jawhar* steel
Dimensions: Length 35 cm; max. width 6.5 cm
Provenance: Art market 1991
Published: Keene and Kaoukji 2001, cat. 8.27
Inv. no. LNS 74 HS

In all likelihood used for domestic purposes, this small jade knife sports a pommel of unusual type, and a grip fitted just above the ferrule with a segment of white jade. The grip is carved below the pommel with four upright acanthus leaves, one of which is overturned on its tip and issues a short stem bearing a large toothed leaf, below which are bunches of grapes or a cluster of mulberries. A related knife with a similarly carved pommel can be seen in the Jodhpur armoury.[11]

Representations of mulberry on knives, although quite rare,[12] should not be considered a strange choice of motif. Since mulberry leaves are the most important food source for silkworms, and it is common knowledge that India was an important silk-weaving centre, it is no surprise that Indian craftsmen were familiar with the tree and its fruit.

The ferrule and the upper edge of the single-edged *jawhar*-patterned blade are overlaid with gold, with vegetal scrolls and plant forms outlined by paired fillets.

Detail of pommel with toothed leaf
on its top, suspending mulberries or
bunches of grapes, and overturned
acanthus leaf on the grip

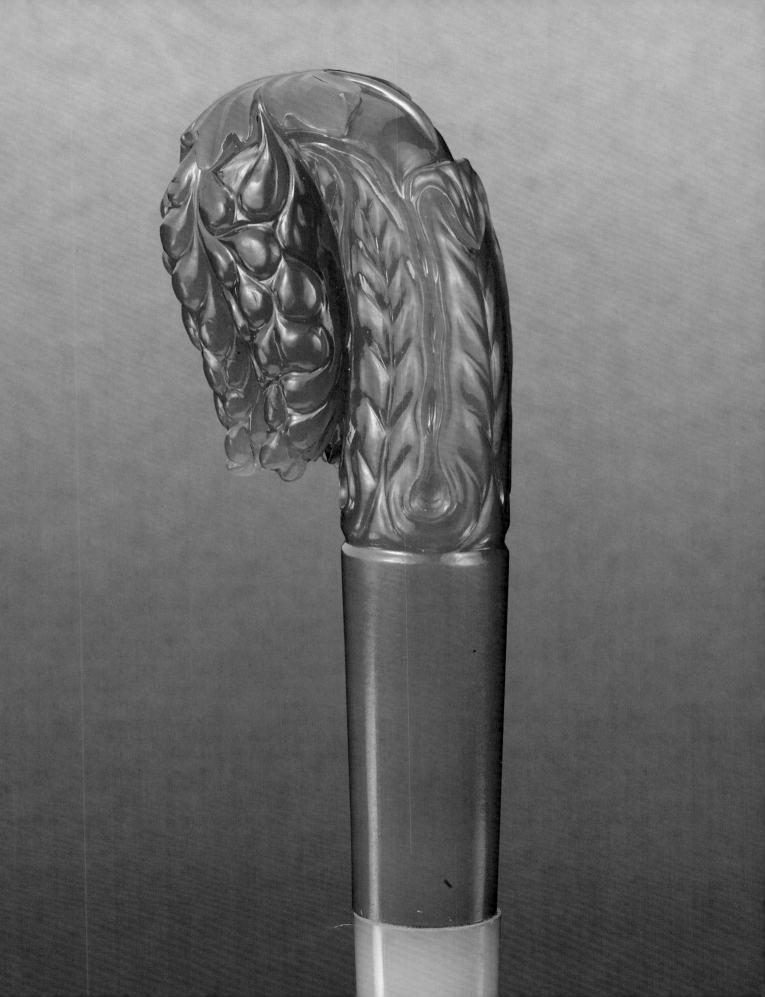

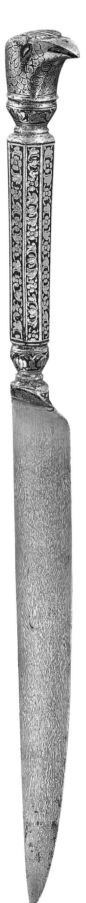

Cat. 92 KNIFE WITH A FALCON-HEAD POMMEL
Probably Mughal dominions, first half of the seventeenth century
Steel hilt inlaid with gold; blade of *jawhar* steel
Dimensions: Length 24.5 cm; width 2 cm
Provenance: Art market 2004
Published: Bonhams, London, 29 April 2004, lot 368
Inv. no. LNS 1444 M

This slender and elegant knife would have been worn suspended from a belt and deeply inserted in a scabbard revealing only the bird's head, as worn by Emperor Jahangir in a painting dated to *c*. 1640.[13]

The bird's crown is slightly flat and ribbed and tapers to a point at the nape, the eyes are pronouncedly slanting, and the remaining surface of the head has been treated as small feathers, save for two bands of spirals that stretch from below the beak to the base of the throat. The grip is bound on the top by a cup-shaped segment and on the bottom by a cup-shaped ferrule somewhat related in form to the ferrule of Cat. 90. Both cup-shaped elements are decorated with festoons of gold blossoms, and the prismatic grip is decorated with reserved gold floral scrolls on each of its faces.

The single-edged *jawhar*-patterned blade features a small plant form at its outset, extending the decoration of the ferrule.

Detail of falcon-head pommel with gold-inlay feathers, and prismatic hilt decorated with floral scrolls

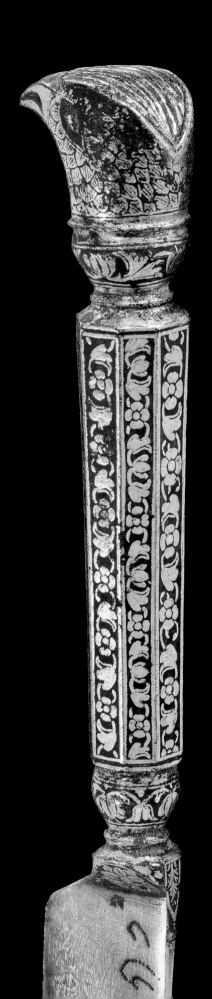

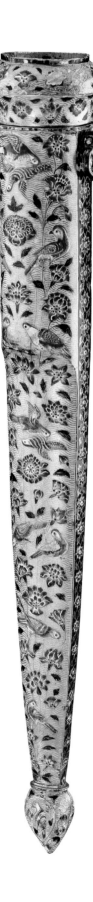

**Cat. 93 SCABBARD FOR A DEEP-
SHEATHED KNIFE**
**Possibly Mughal dominions,
early eighteenth century**
Fabricated from gold, with
champlevé and painted enamels
Dimensions: Length 31 cm; width 4 cm
Provenance: Art market 1996
Published: Sotheby's, New York, 19 September
1996, lot 222; Keene and Kaoukji
2001, cat. 6.40
Inv. no. LNS 1658 J

Scabbards for deep-sheathed knives are
generally wider for one-third of their
length below the "mouthpiece" in order
to accommodate the hilt, and then taper
pronouncedly to provide a closer fit for
the blade. Most also have a bud-shaped
terminal to serve as additional protection
for the metal tip.

The surface of this scabbard is covered
with a wavy pattern of opaque white
enamel, revealing the gold ground and
serving as a background for floral stems
and perching birds. The gold stems grow
from clusters of leaves just above the bud
finial, extend along the entire scabbard, and
end just below the cup-shaped mouthpiece.
The plants comprise white enamel lotus
blossoms and buds overpainted in tones
of pink detailed with yellow and black
enamel, and have green calyces and serrated
leaves. At the wider end of the scabbard
pairs of birds in various positions perch
on branches, whereas the narrower end
features single birds. A single bird also
occupies the flat face of the bud finial, which
is decorated around its edges with foliate
scrolls and quatrefoils. The lower end of the
cup-shaped mouthpiece features a festoon
of lotus blossoms alternating with unfurling
blossoms issuing green leaves against a
whirling pattern of white enamel bands; the
upper edge features blossoms issuing leaves
interspersed with birds, and is bordered on
both ends by bands of green enamel.

The middle-blue enamel edge is
decorated with graduated stellated blossoms
rendered in the same manner as the rest of
the flowers on the scabbard, and between
them are pairs of alternately upswept
and down-swept gold leaves. The bail is
bordered with green enamel and features
a pendent lotus blossom flanked by halved
blossoms with overpainted pink enamels.

Detail of mouthpiece, with birds and
flowering plants against a pattern of
wavy white enamel on a gold ground

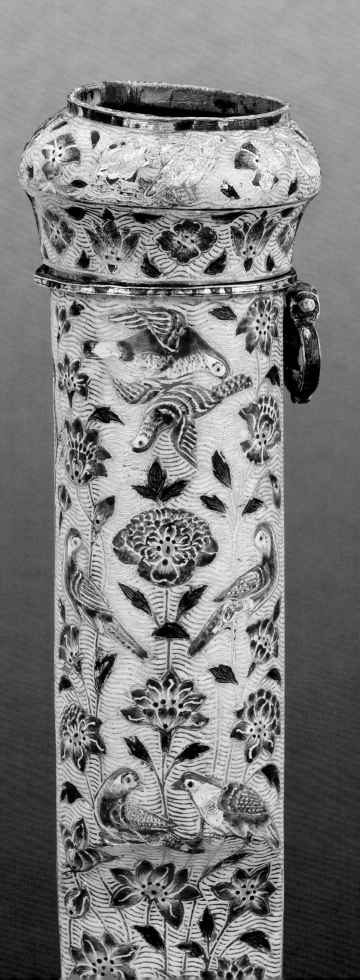

**Cat. 94 SCABBARD FOR A DEEP-
SHEATHED KNIFE
Possibly Mughal dominions,
eighteenth century**
Fabricated from gold, champlevé
enamelled

Dimensions: Length 31.5 cm; width 4.5 cm
Provenance: Art market 1980s
Published: Keene and Kaoukji 2001, cat. 6.41
Inv. no. LNS 27 J

Virtually identical in form to the preceding
example, Cat. 93, this scabbard is
decorated with ogival medallions and floral
motifs rendered in opaque cobalt-blue and
white enamel detailed with overpainted
middle-blue and cobalt-blue enamels
against a gold ground. The graduated
green enamel ogival medallions enclose
bunches of flowers reserved in the gold and
augmented with opaque white overpainted
with middle-blue enamel. In the interstices
of these medallions blue irises issue from
pairs of upward-curling vines bearing
white flowers detailed in two tones of blue.
Bands of green enamel border the edges of
the scabbard, and on its single flat edge is a
green enamel scroll issuing leaves and white
enamel flowers detailed with blue enamel.
The mouthpiece is bordered with bands of
green enamel, and is circumscribed by a
green enamel vine-festoon issuing leaves,
flowers and buds. The bud finial features
a flowering plant on its flat faces and floral
scrolls in white and middle-blue enamels
on the edges, and the lobed bail is bordered
with green enamel.

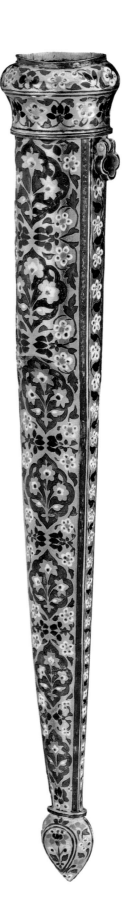

Detail of mouthpiece, with green
enamel medallions, bunches of gold
flowers, and cobalt-blue and white
flowers in the interstices

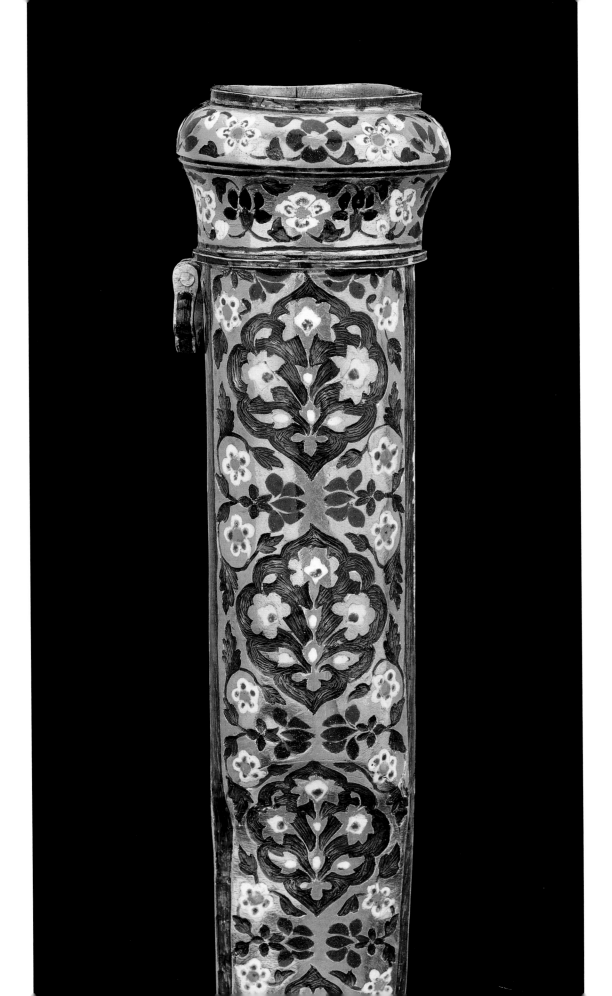

NOTES

1 Sims 2002, cat. 47, p. 128.

2 Roxburgh 2005, cat. 173, p. 222.

3 See e.g. the *Jami' al-Tawarikh* compiled in Tabriz in 706 H (1306–07 CE), Rice and Gray 1976, pp. 48–49, cat. 5, the personage wearing a Mongol cap standing to the left of Shah Jamshid, and pp. 174–75, cat. 68, the personage with a Mongol cap and braid kneeling before Sultan Sanjar. Likewise from Tabriz, in a manuscript of the *Jami' al-Tawarikh* attributed to *c*. 1330, Rogers et al. 1986, cat. 44, attendants are depicted wearing deep-sheathed knives.

4 In Jalayrid paintings from *Kalila wa Dimna*, attributed to *c*. 1375–85, two personages wear deep-sheathed knives, O'Kane 2003a, p. 126, pl. 39, and p. 158, pl. 64 respectively.

5 An onlooker admiring the castle of Khwarnaq wears a pair of deep-sheathed knives in a painting from Sultan Shah Rukh's manuscript of the *Khamsah*, Herat 1431, Sims 2002, cat. 89. Also, Roxburgh 2005, cats. 216 and 218, in paintings depicting a procession scene and an enthronement scene, both attributed to *c*. 1470–90, wherein attendants wear paired deep-sheathed knives, and cat. 201, the attendant carrying a cup, in a *Divan* of Sultan Husayn Mirza, dated the "last ten days" of Sha'ban 897 H (17–26 June 1492 CE).

6 Barry 2004, p. 387.

7 See e.g. the deep-sheathed knives tucked in the belts of the "people with elephant ears" in a folio from the *Hamza-nameh* attributed to *c*. 1557–77, Calza 2012, p. 175, cat. IV.28, and the deep-sheathed knife worn by a "prisoner", attributed to sixteenth-century Iran, Adamova 1996, p. 197, cat. 9.

8 "Avant que d'entrer dans ce Divan il y a une galerie qui lui sert de vestibule, & le dessein de Cha-gehan estoit de la revêtir par tout d'une treille de rubis & d'émeraudes, qui auroient représenté au naturel les raisins verts & ceux qui commencent à rougir: mais ce dessein qui a fait grand bruit par tout le monde, & qui demandoit plus de richesses qu'il n'en peut fournir, est demeuré imparfait, n'y ayant que deux ou trois seps d'or avec leurs feüilles, comme tout le reste devoit estre, & emaillez de leur couleurs naturelles, des émeraudes & des rubis & grenats faisant les grapes." Tavernier 1679, vol. II, ch. 7, p. 75.

9 Akimushkin 1996, pls. 60 and 61, fols. 44r and 46r; pls. 102 and 103, fols. 37r and 8r; pls. 106 and 107, fols. 32r and 31 r; pls. 154 and 155, fols. 3r and 24r; pls. 176 and 177, fols. 21r and 22r; pls. 190 and 191, fols. 97r and 99r.

10 See e.g. the cutlery in the "European dining scene" from *c*. 1590 in Leach 1986, cat. 30, and in a painting by Abu 'l-Hasan from a *Bustan* of Sa'di, from *c*. 1605–6, McInerney 2004, p. 82, fig. 3.

11 A copper disc attached to the hilt is stamped with the number 673.

12 See e.g. the mulberries represented on the pommel bars of cat. 33. Also, a reveller in a yellow shirt and mauve salwar wears this type of knife tucked in his belt in a folio from the *Hamza-nameh*, Calza 2012, p. 192, cat. IV.41. Pant 1980, p. 175, fig. 533, illustrates a related dagger with a jade hilt and pommel carved "like a bunch of grapes".

13 Beach and Koch 1997, cat. 9.

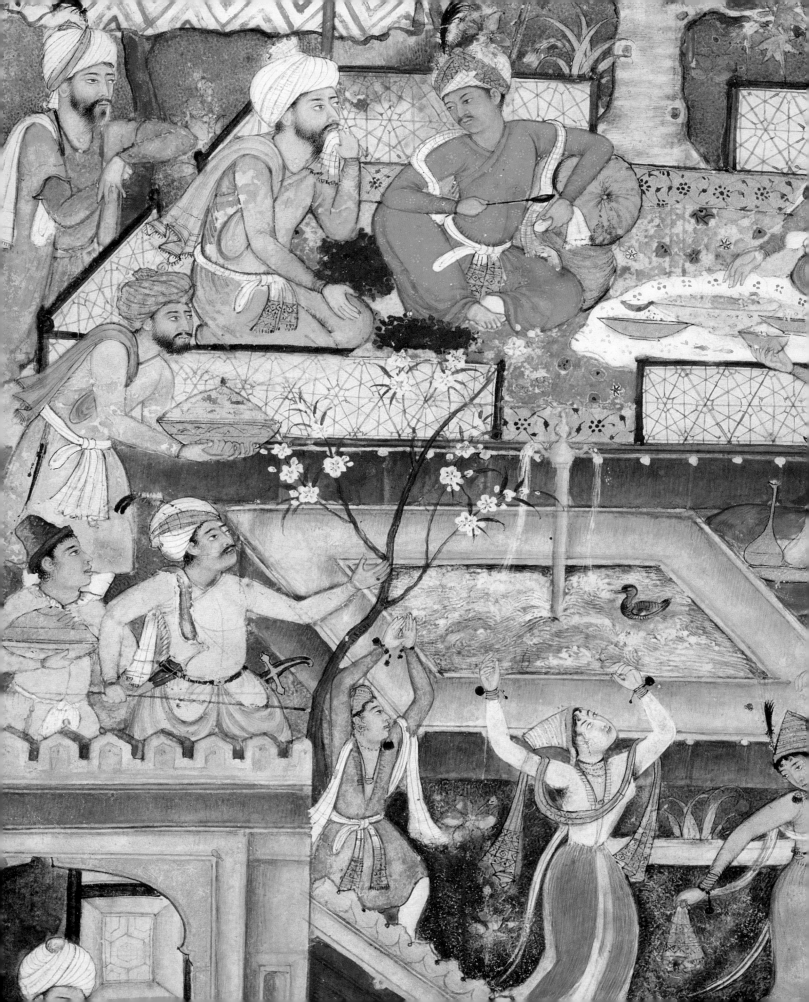

CHAPTER NINE
THE *PISH-QABZ*
A BLEND OF ANCIENT TYPES

The *pish-qabz*, a type of weapon whose name combines Persian and Arabic (*pish*, Persian for "fore", and *qabz*, or more precisely *qabd*, Arabic for "grip" or "handle"), probably originated in Central Asia and Afghanistan. It was most likely introduced to India during the Afghan incursions and indigenization in the north-eastern territories from the eleventh century CE onwards and survived as a type for an extended period of time. As is very often the case, its general form was slightly altered to produce the type we recognize today.

In different areas the type is called *karud*,[1] *chura*, *bytshaq*, *Khyber salawar* and *Khyber yataghan*, which reflects the geographical spread of what was probably once a utilitarian tribal knife. Interestingly, the name is listed in very few Persian or Indian dictionaries,[2] and then defined only as "a type of weapon" with no further description, which suggests that it was a commonplace knife, not worthy of detailed consideration.[3] As the name of the dagger includes the word "fore" (*pish*), it has been suggested that it might have arisen from an assumption that the type was worn tucked in the front of a belt. The idea is improbable, however, given the particularly long and pointed shape of the *pish-qabz* blade. Unlike the Arabian and African *janbiyah*, which was convenient to wear tucked in the front of a belt, the pronounced curved tip of the *pish-qabz* blade would certainly have made it awkward and hazardous to wear tucked anywhere in the belt other than at the side.

Features common to the *pish-qabz* type of edged weapon incorporate particulars of blades and hilts, either conjointly or independently. Their hilts are generally straight on the back and curved on the front with slightly beaked pommels, and a full tang extending to the upper end of the hilt. The peculiar single-edged blades are pronouncedly wide at the ricasso and jut out on the sharp edge, as do the blades

of yataghans and some *kard*s (a type of knife with a straight single-edged blade, no quillon and a vertical hilt, which is worn partially covered by the scabbard); they then generally taper pronouncedly and are either straight or recurve at the tip. Despite the fact that the overall shape of the blade may vary, the majority have "T"-section spines for extra rigidity and taper to a point, which is sometimes reinforced, hence the claim that the *pish-qabz* was especially well-suited to piercing chainmail.

As the form of the *pish-qabz* hilt could not have sprung from nowhere, on account of its shape it appears plausible that it might have descended from Sogdian and Sasanian sword hilts that have beaked pommels and form an arc on the inner side of the hilt.[4] Furthermore, the manner in which the blade juts forward on the ricasso can be seen on different types of earlier edged weapons, such as the Greek *kopis* from the sixth century BCE and its descendant the *falcata*, from the third- or second-century BCE Iberian peninsula.[5] Considering the functionality of this type of blade, both ideal as a thrusting weapon and possessed of appreciable hacking and slicing qualities, it is not surprising that it would have been an enticing tool for those who encountered it, namely societies in the areas permeated by Hellenistic culture, such as Central Asia and Afghanistan. And, since weapons are portable objects capable of travelling great distances, it is also not surprising that the inhabitants of eastern lands who were exposed to a Greek presence through wars and contacts between the Scythians, Persians and Greeks – even before Alexander[6] – adopted this type, which survived in Afghanistan, Central Asia and Iran for prolonged periods.

Similar features can be seen on the so-called Bukharan swords, and the Bukharan *bytchak* knives, which display similar hilts and blades as the *pish-qabz*,[7] as well as on yataghans, which are fitted with closely related blades.

Miniature painting from a manuscript of the *Baburnama* depicting a courtier in a yellow coat wearing a *pish-qabz* tucked in his sash in the foreground of the painting, *c.* 1590

Further emphasizing the longevity of the type in the area is an eleventh- or twelfth-century example from Afghanistan, now in the collection of the Furusiyya Art Foundation, with a closely related blade that juts out at the ricasso and has a T-section spine, but widens at the tip.[8] In all likelihood the *pish-qabz* is in fact a blend of very ancient types that endured as popular utilitarian knives over a long period of time, as can be inferred from the basic materials (bone, horn and steel) from which most *pish-qabz* hilts were and still are fabricated.

That said, two *pish-qabz* daggers in the Collection have hilts decorated with mother-of-pearl in comparable manner to a casket that was in the collection of King Francis I of France, whose spouse Eleanor of Austria had lived at the Lisbon court when she was previously married to the king of Portugal, Manuel I. Regarding her exposure to Indian *objets d'art* in Portugal, it is said that Queen Eleanor assisted her second husband Francis in the formation of his collection, among

which was a Gujarati mother-of-pearl casket with gilded mounts added in 1532–33 by the court goldsmith, Pierre Mangot.[9] Mother-of-pearl was evidently valued in France and India, as "some beautiful objects made of *nacre*" are singled out in a list of gifts sent to Emperor Akbar in 1595 by his son Murad Mirza, who was posted in Gujarat.[10]

Clearly this type of dagger, which is rarely depicted in early paintings, could not have been in high demand prior to the eighteenth century, possibly because it was associated with utilitarian practices, and it appears only to have gained popularity with the Nawabs of Awadh (1722–1856), possibly to draw attention to their Afghan ancestry; they are frequently portrayed wearing *pish-qabz* daggers with hilts made from precious materials tucked in their belts.

It therefore appears as though the widely adopted theory of an eighteenth- or nineteenth-century origin for *pish-qabz* knives might be laid to rest.

Fragment of a painting showing members of the family of Nawab Muhammad Ali Khan of Arcot and the Carnatic wearing *pish-qabz* daggers tucked in their sashes, by Tilly Kettle (1734/5–1786)

Cat. 95 MOTHER-OF-PEARL *PISH-QABZ* DAGGER
**Probably Gujarat,
perhaps sixteenth–early
seventeenth century**
Hilt, wood facings covered with
lac and fitted with mother-of-pearl
plaquettes; iron strip around the
edge of the hilt and ferrule overlaid
with gold; finial strung with a
gilded silver bail; blade of *jawhar*
steel (later repolished)
Dimensions: Length 44 cm; width 4 cm
Provenance: Art market 1980s
Inv. no. LNS 98 M

Although most daggers of this type have
generally been attributed to the eighteenth
century, the similarity between the hilt's
mother-of-pearl decoration and the
decoration on a casket produced in India
in the first half of the sixteenth century,
renders an eighteenth-century attribution
questionable. This casket, now in the
Musée du Louvre, is confidently dated to
the first half of the sixteenth century due to
the fact that it was fitted with gilded silver
mounts by the goldsmith of King Francis
I between 1532 and 1533.[11] Furthermore, a
number of objects overlaid with plaquettes
of mother-of-pearl produced in India,
both for the local market and for export,
made their way to Europe in the sixteenth
century,[12] which leaves no doubt that this
type of decoration was in high demand
during that period, and that it was
produced in significant quantities.

Each face of the grip is fitted with
mother-of-pearl plaquettes set in a
continuous wavy chevron pattern, wherein
each plaquette is riveted onto the wood
support by three gilded copper rivets.[13]
The iron strips that outline the grip are
decorated on the back of the hilt with a
floral and foliate scroll that is replicated on
the ferrule and extends to the upper end
of the blade, where it ends in a trefoil. The
finer strips that contour the front of the
hilt and outline the upper end of the ferrule
are decorated with foliate scrolls. The bud
finial is fitted with a gilded silver bail.

The hollow-ground and bevel-edged
blade, which has suffered extensive
repolishing, curves very gently, and its
T-shaped spine extends to the tip.

Pommel dipping on front of hilt
and bud finial with suspension bail

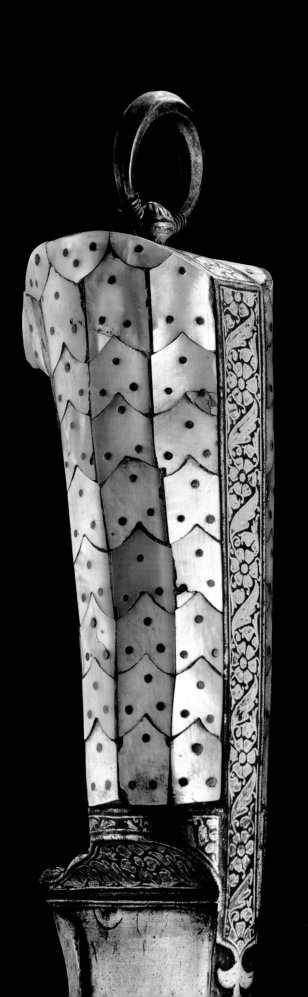

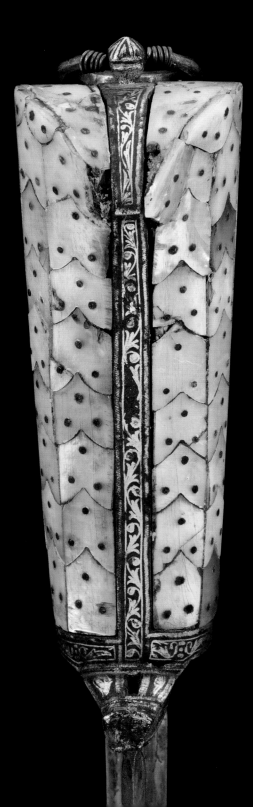

Front and back views of grip showing
mother-of-pearl plaquettes, and variety of
gold floral decoration on iron strip and ferrule

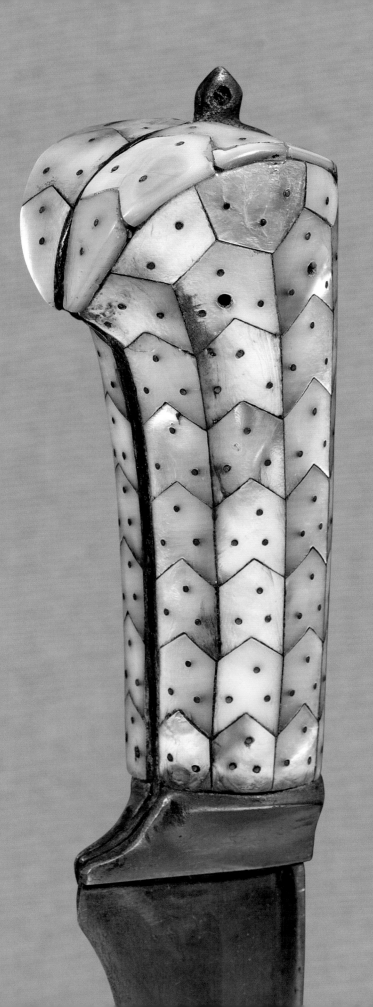

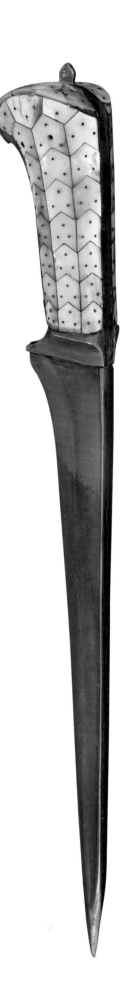

Cat. 96 MOTHER-OF-PEARL *PISH-QABZ* DAGGER
Probably Gujarat,
perhaps sixteenth–early
seventeenth century
Hilt, wood facings covered with
lac and fitted with mother-of-pearl
plaquettes; steel strip borders
on the edge of the hilt; blade of
jawhar steel

Dimensions: Length 42 cm; width 6 cm
Provenance: Art market 2009
Published: Sotheby's London, 7 October 2009,
lot 130
Inv. no. LNS 1617 M

As in the previous example, Cat. 95, the
faces of the grip of this dagger are fitted
with mother-of-pearl plaquettes set in a
continuous wavy chevron pattern, and
here as well the plaquettes are riveted onto
the wood support by three gilded copper
rivets.[14] The ferrule is undecorated, as are
the exposed steel strips that outline the
grip, and the small pierced lug that projects
from the pommel area.

The hollow-ground and bevel-
edged blade has retained some of its
jawhar pattern, is almost straight and
has a T-shaped spine that extends to the
reinforced tip.

View of hilt showing chevron-patterned
riveted mother-of-pearl plaquettes

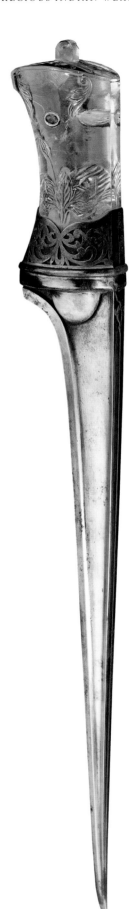

Cat. 97 ROCK-CRYSTAL *PISH-QABZ* DAGGER
Deccan or Mughal dominions, probably seventeenth century
Hilt carved from rock crystal, overlaid with silver and inlaid with gold in *kundan* technique and set with a ruby and an emerald; blade of *jawhar* steel; scabbard, wood overlaid with velvet; locket and chape cast in bronze
Dimensions: Length 46 cm; width 5.5 cm
Provenance: Art market 1980s
Inv. no. LNS 11 HS ab

The rock-crystal hilt of this *pish-qabz* has been fitted with an openwork arabesque silver sleeve, probably to conceal cracks in the hilt and a disproportionately long blade tang. As the blade is fitted with a silver plaquette on the ricasso that serves to conceal the stump that normally projects from rock-crystal hilts to prevent the blade tang from being visible, it is thus most likely that this blade was not intended for this hilt. Otherwise, the plaquette intended to conceal the stump would have been more compatible with the blade. Nonetheless, the shielding sleeve does not obstruct the fine carving of iris blossoms with overturned petals, each of which issues a swaying stem and bud in the same manner as the blossom on the dagger Cat. 53.

On the upper end of the hilt, a pair of acanthus leaves issuing trefoils flank the lug, and touch on the curling tips of four acanthus leaves that are pendent from the edge of the pommel area. Both faces of the grip have been inlaid with gold and set with a ruby on one of the faces and an emerald on the other.

The hollow-ground and bevel-edged blade retains only traces of its *jawhar* pattern. The blade curves very gently, and the T-shaped spine that extends to the tip is engraved with a trefoil on its upper end.

Rock-crystal hilt with openwork silver sleeve, and blade-tang stump covered with silver plaquette just below the base of the hilt

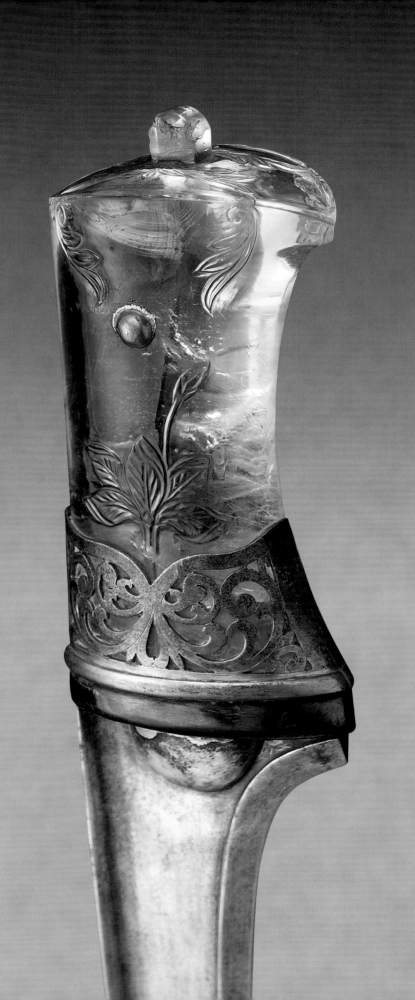

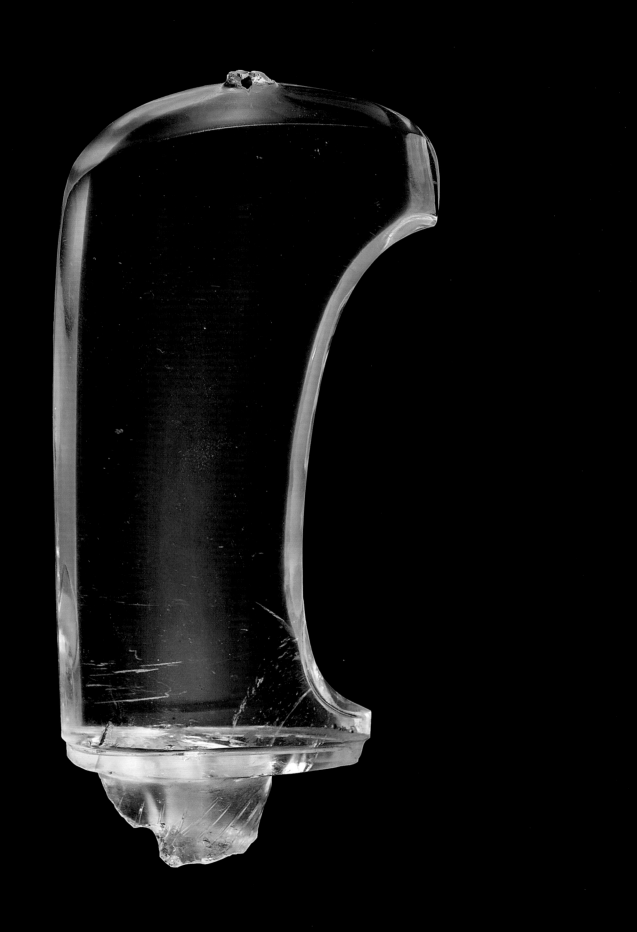

**Cat. 98 ROCK-CRYSTAL *PISH-QABZ*
HILT
Deccan or Mughal dominions,
probably seventeenth century**
Carved from rock crystal
Dimensions: Height 13 cm; width 6 cm
Provenance: Art market 1999, reportedly from
Hyderabad
Inv. no. LNS 279 HS

The beauty of this dagger hilt lies mainly in
the subtle carving of the exceptionally pure
material from which it was created.

The pommel area slants gently towards
the back of the grip where it develops into a
flat edge that extends along the entire back
of the grip. On the front of the grip a large
lens-shaped petal is carved on the receding
curve just above the lower extremity.

The bottom of the hilt is stepped
back to accommodate a ferrule, and the
unpolished stump in which the blade tang
would have been inserted is broken in half,
revealing the hole drilled to accommodate
the tang.

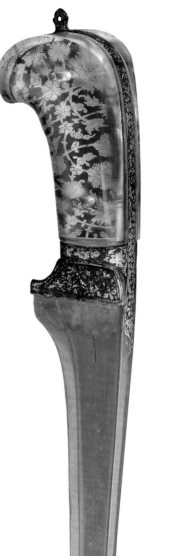

Cat. 99 *PISH-QABZ* WITH PAINTED
**TANG AND ROCK-
CRYSTAL FACINGS**
Deccan, seventeenth century
Hilt facings carved from rock
crystal; blade of *jawhar* steel,
the blade tang faces painted,
and the edges and ferrule overlaid
with gold
Dimensions: Length 40 cm; width 4 cm
Provenance: Art market 2006
Published: Sotheby's, London, 5 April 2006,
 lot 154
 Inv. no. LNS 777 HS

In his *Handbook of Indian Arms*,
Wilbraham Egerton described a *pish-qabz*
from Lahore with rock-crystal facings
"beneath which are seen native paintings
of mythological subjects",[15] which indicates
that, although not a traditional decorative
technique, such rock-crystal facings were
nonetheless familiar by the end of the
nineteenth century.

Secured by gilded rivets to the blade
tang, the rock-crystal facings are backed
with painted surfaces of fine gold lotus-
blossom arabesques against a red ground.
The edge of the tang is overlaid with gold
with a floral scroll that diminishes in size
on the front of the grip, and typically
ends with a trefoil on the upper edge of
the blade. A scroll of irises encircles the
upper end of the ferrule, which features
a composite flowering plant including a
multi-petalled blossom flanked by irises
on the lower end.

The hollow-ground and bevel-edged
blade retains only traces of its *jawhar*
pattern, and has a T-shaped spine that
extends to the recurring tip.

Side of hilt showing surfaces decorated with floral
scrolls beneath rock-crystal facings, and back of hilt
demonstrating that the decoration is painted on the
tang surfaces, rather than on the rock-crystal facings

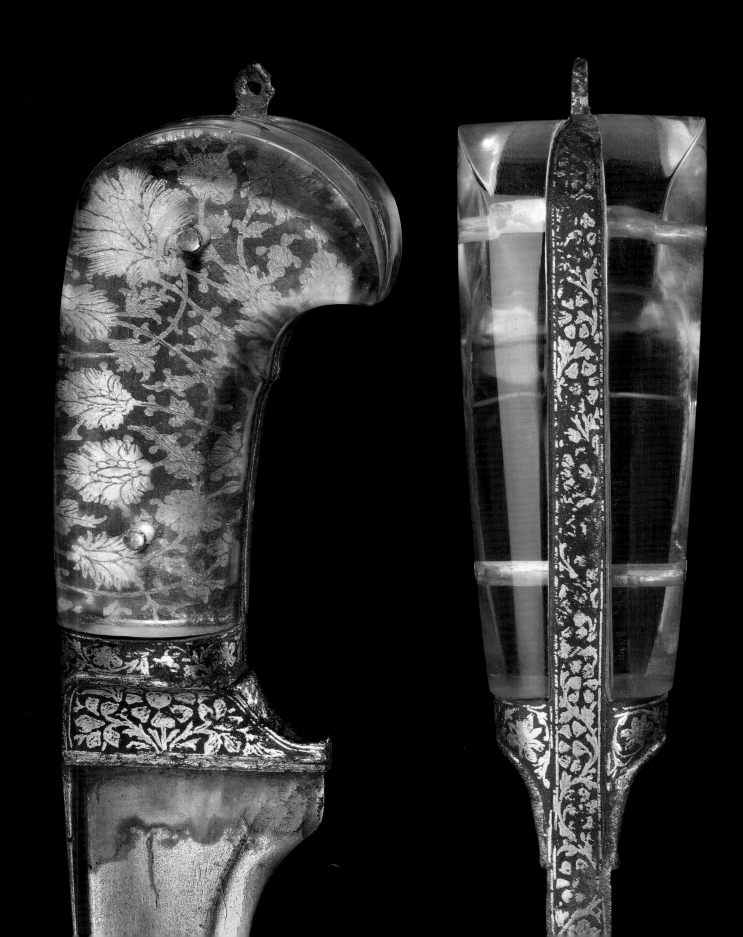

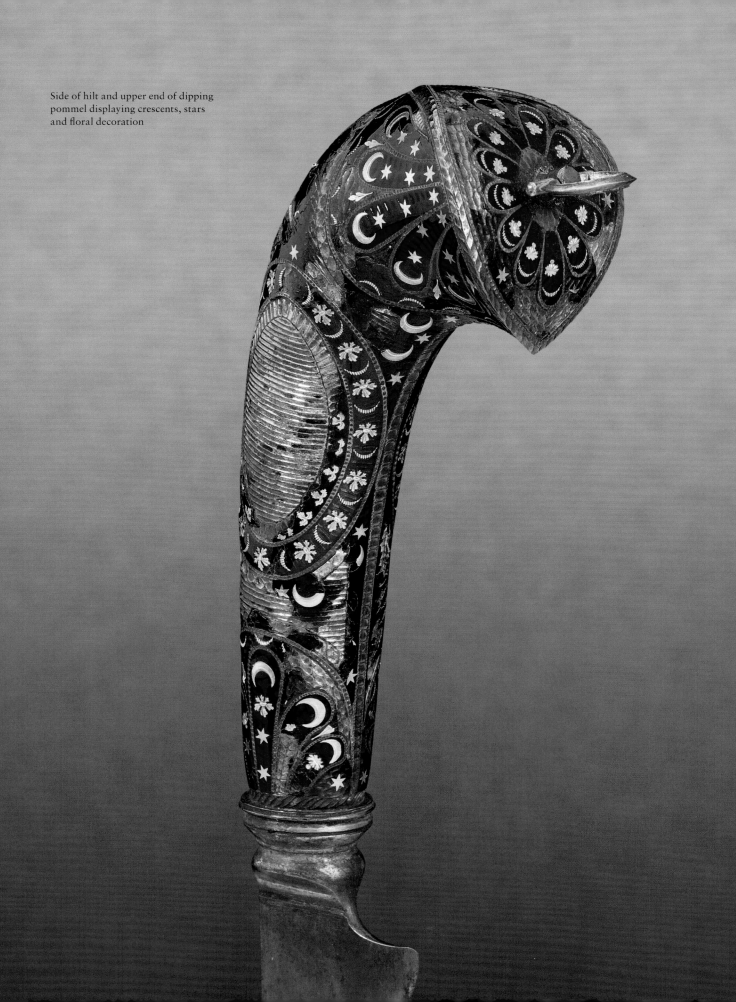

Side of hilt and upper end of dipping
pommel displaying crescents, stars
and floral decoration

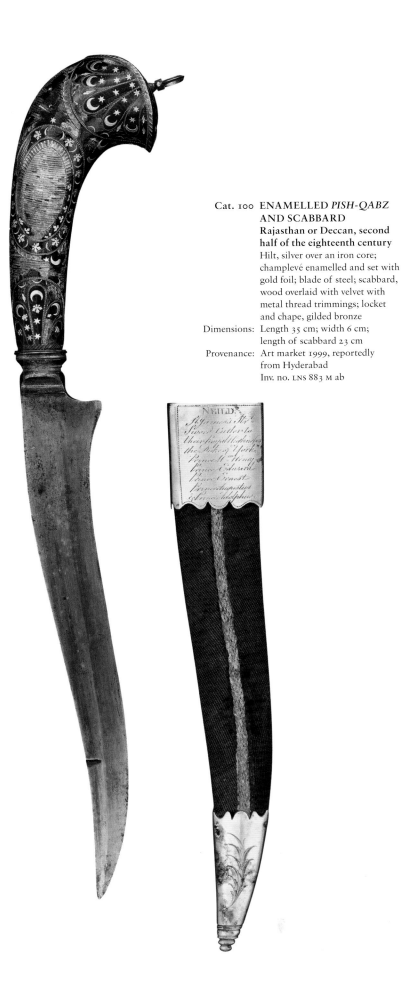

**Cat. 100 ENAMELLED *PISH-QABZ*
AND SCABBARD**
**Rajasthan or Deccan, second
half of the eighteenth century**
Hilt, silver over an iron core;
champlevé enamelled and set with
gold foil; blade of steel; scabbard,
wood overlaid with velvet with
metal thread trimmings; locket
and chape, gilded bronze
Dimensions: Length 35 cm; width 6 cm;
length of scabbard 23 cm
Provenance: Art market 1999, reportedly
from Hyderabad
Inv. no. LNS 883 M ab

The Ottomanizing decorative scheme of
this *pish-qabz*, with its stars, crescents
and floral motifs of gold foil fused onto
the surface of the cobalt-blue and green
enamel, evokes the *thewa* or Pratapgarh
technique typical of Rajasthan.[16] Even
though the patterned gold foil fused onto
the vitreous enamel substrates is similar in
appearance to *thewa* work, the technique
and style testify either to a different
production centre, or to a craftsman
familiar with the *thewa* technique,
and a patron with a penchant for
Ottoman styles of decoration.

Surrounding the suspension bail
a cobalt-blue floral motif, detailed with
gold crescents and flowers on a ground
of green enamel detailed with gold stars,
is enhanced by the champlevé or engraved
work of the silver below the enamel.

Compartments filled with larger
cobalt-blue petals detailed with stars and
crescents on a green ground decorate the
sides of the pommel and the lower end of
the grip. In the centre of the grip large
oval-shaped medallions, which have now
lost most of their enamel save for fragments
of a cobalt-blue surface decorated with
trefoils, are framed by a green border
detailed with floral motifs and crescents.
The remaining surface is covered with
cobalt-blue enamel that still retains
crescents and star motifs.

The hilt appears proportionately too
long for the length of the blade, which is
pronouncedly curved and recurves at the tip.

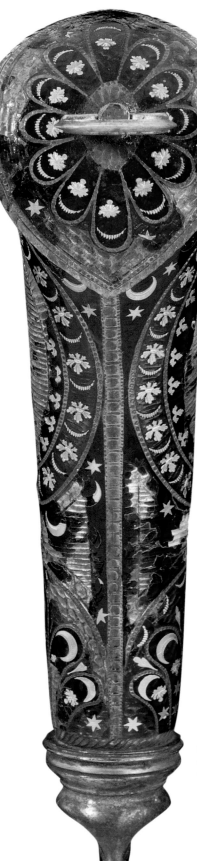

The scabbard is overlaid with green velvet and fitted with a locket engraved on one face with a coat of arms, which includes a sword, a large crescent moon enclosing a small moon, a battleaxe and a mace surmounted by a small crescent in a sun-ray medallion. On the back an inscription records: "Neild, St. James's Str., Sword Cutler to their Royal Highnesses the Duke of York, Prince Wm Henry, Prince Edward, Prince Ernest, Prince Augustus, & Prince Adolphus." On the basis of the names and titles of the young English princes, sons of King George III, Dr Philip Mansel dated the scabbard between *c.* 1784, when Prince Frederick was created Duke of York, and before 1789, when Prince William Henry was created Duke of Clarence.[17]

Upper part of pommel and front
of grip showing oval medallions,
Cat. 100 (LNS 883 M)

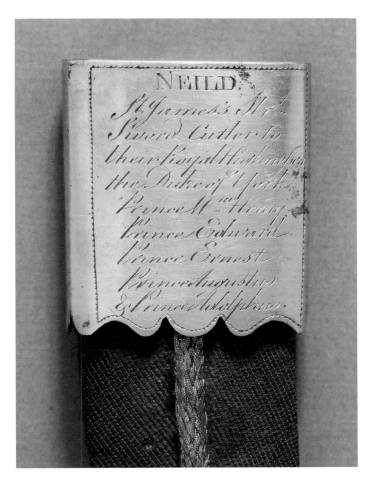

Back of locket, recording the
name of Neild, sword cutler to
the young sons of King George III

Front of locket, with crescents,
sword, battleaxe and mace
blazon in sun-ray medallion

NOTES

1 Possibly a variant of *kard*.

2 We are very grateful to Manijeh Bayani for consulting a number of dictionaries on our behalf, namely the *Sihah al-Furs* compiled in 728/1328; the *Tohfat al-Sa'adah* compiled in 916/1510; the *Tohfat al-Ahbab* compiled in 1530; the *Majma' al-Furs* compiled in 1008/1599–1600; the *Farhang-e Jahangiri*, 2nd edn completed in 1032/1622 (in which there apparently is also no entry for the word *shamshīr*, sword); the *Borhan-e Qate'* compiled in 1062/1651; and the *Farhang-e Rashidi* compiled in 1064/1654.

3 As in the *Bahr al-'Ajam* compiled in 1162/1748–49, the *Ghiyath al-Loghah* compiled in 1242/1824 and the *Farhang-e Anandraj* compiled in 1306/1888–89.

4 Richardson 1989, p. 177, shows Sasanian swords attributed to the sixth–seventh centuries CE.

5 Connolly 1989, p. 22, shows the evolution from the Corsican and Greek *kopis* to the Spanish *falcata*.

6 Boardman 1994, p. 99; 2000, pp. 256–66.

7 Flindt 1979, cats. 22–26 and 29.

8 Mohamed 2008, cat. 146.

9 Jackson and Jaffer 2004, cat. 3.9, pp. 35–38, and p. 365, ch. 3, n. 24.

10 Payne 1926, p. 65.

11 Jackson and Jaffer 2004, cat. 3.9, pp. 35–38, and p. 365, ch. 3, n. 24. A chalice decorated in the same technique is listed in an inventory of Francis I, dated 1529, recording payment to one Pierre Lemoyne, a merchant based in Portugal, for a chalice: "marqueté à feuillage de nacle de perle faict aux payx d'Indye" (ibid., p. 365, n. 23); see also the introduction to this section.

12 Jackson and Jaffer 2004, p. 253, in which a Dutch traveller (1563–1611) relates that objects overlaid with mother-of-pearl are very common in India, and that sizable quantities of the type are exported to Portugal and "elsewhere".

13 For references to *pish-qabz* types of daggers with mother-of-pearl hilts, see Egerton 1880, nos. 382 and 718.

14 A related *pish-qabz* with mother-of-pearl hilt, formerly in the collection of Krishna Riboud, is attributed to northern India, seventeenth–eighteenth century, Bordeaux 1998, p. 106, cat. 33; especially of interest is cat. 34, a "coupe" overlaid with mother-of-pearl, which was reportedly listed in the 1674 inventory of the Danish royal collections.

15 Egerton 1880, p. 130, cat. 619.

16 Pratapgarh is a small Rajput principality in Rajasthan, famous for the *thewa* jewellery-making technique practised by members of one family of jewellers, and which reportedly originated in around the middle of the eighteenth century.

17 Personal correspondence with Dr Philip Mansel, to whom I am very grateful for this information.

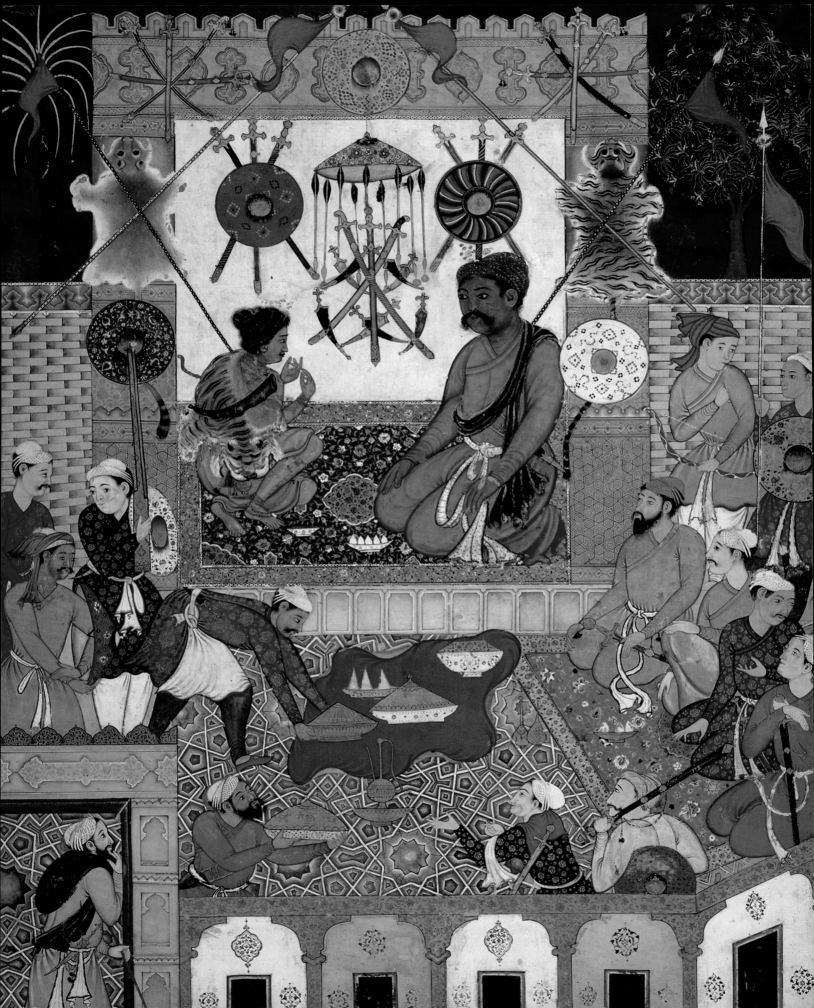

CHAPTER TEN
SWORDS
NON-NATIVE AND NATIVE TYPES

THE NON-NATIVE TYPE

Bearing in mind the network of influences and reciprocal exchanges between India and its western and northern neighbours, it is more than likely that sword hilts with both curved and beaked pommels were introduced to India from the Iranian world and Central Asia. Representations in paintings make it manifestly clear that these types were already in circulation during the Sultanate period and in the Deccan prior to the reign of Emperor Akbar.[1]

Shapes of hilts always differed a little over time as well as within a single period, and this especially applies to hilts of the Cat. 101 type, in which the degree of curvature of the pommels varied, particularly with regard to their representation in paintings.[2] This evolution of hilt shape is clearly apparent in an illustrated folio from the *Hamza-nameh*, attributed to *c.* 1570,[3] in which weapons are depicted displayed by type on the wall of a residence, and it is worth noting that the same applies to representations in paintings from the Iranian world.

Nevertheless, despite countless representations of the Cat. 101 type in paintings from the period of Emperor Akbar's reign,[4] which indicates that it was popular, it appears that the trend did not endure long afterwards.

Beaked hilts such as Cat. 102 were a long-standing tradition in Central Asia,[5] although they were not as widespread as curved-pommel hilts. They were evidently introduced in India by the sixteenth century, as evidenced by the knife carried by Khosh-Khiram in a folio from the *Hamza-nameh*.[6] In a seventeenth-century painting of an Uzbek ambassador visiting the court of Shah 'Abbas II, the ambassador is depicted wearing a beaked-hilt dagger tucked in his belt, implying that this weapon type was considered a characteristic Uzbek accessory, since it was a convention in portraiture of the period to show individuals wearing garments and weapons associated with their cultural milieu.[7]

Both Cats. 101 and 102 have hilt facings carved from walrus ivory, which as evidenced by early written sources, including a few firsthand narratives, was highly valued both in ancient times and during the early medieval Islamic period. A rare reference in which the material is identified specifically as walrus ivory occurs in a record of tribute paid by the cities of Phoenicia to the Assyrian Monarch Ashurnasirpal II (r. 883–859 BCE) that lists "ivory from walrus tusk",[8] demonstrating that the ivory was known to have come from a walrus, at least on this occasion, and that it must have been a highly valued commodity since it was offered to a ruler.

Unfortunately, in most early Arabic sources it is generally impossible to determine whether the ivory referred to derives from walrus, elephant, hippopotamus or mammoth. In addition, the uncertainty associated with the identification of walrus ivory prevailed for a considerable length of time, in spite of the fact that the eminent medieval scholar Abi al-Rayhan Muhammad al-Biruni (973–1048 CE) distinguishes it from other types of ivory in his treatise on mineralogy, in which he also speaks of its reaction to poison[9] and, what is more, associates it with the bezoar,[10] because both were believed to react or exude in the presence of poison. Walrus ivory was equally valued by the Liao, Chinese and Eastern Turks, who apparently were also acquainted with its alleged properties in relation to poison.

Al-Biruni reports that walrus ivory or *khutu* – a term that undoubtedly stems from the Chinese-Khitan *ku-tu-si*,[11] hence the Turkish *hutu* – was brought by the Bulgars from the northern sea to Khwarizm, and that cutlers used it to carve knife-hafts, and that a man from Khwarizm pared off the surface of a tooth and carved knife-hilts and daggers from the core.[12] To emphasize the appeal of walrus ivory, he adds that the Khwarizmi took a small piece to Mecca and sold it to Egyptians who valued it so highly that they paid a vast amount of money to acquire it.

Nonetheless, with only a few exceptions, both Chinese authors and those from the Islamic world variously defined *khutu* as bone from the foreheads of bulls from Kirghizia, snake horns, bones from the foreheads or beaks of giant birds, and rhinoceros horn, which indicates that most of their accounts were not based on personal experience, but simply repeated from other sources without verification.

Folio from the *Hamza-nameh* manuscript attributed to Dasawanta and Mithra, depicting Misbah the grocer and the spy Parran surrounded by attendants, and swords with curved pommels displayed on the wall behind them, *c.* 1570

Al-Biruni dismisses the existing notions about the provenance of the ivory, and states that it was obtained from a marine animal, because when burned it gave off a fishy smell, which gave weight to the theory that it derived from a sea-dwelling creature. It has been suggested that al-Biruni might have been referring to the tusk of the narwhal, but as he reported that the walrus tooth was around a cubit (*dhira'*) long,[13] this explanation seems unlikely, since the narwhal tusk is much longer and, moreover, spiral in shape, a feature he would certainly have touched upon.[14]

Regarding the texture and colour of walrus ivory, in his text al-Biruni refers to al-Ikhwan Raziyan. The brethren were reportedly active in Ghazni during the late tenth–eleventh centuries and were called upon by the Ghaznavid ruler Mahmud ibn Sebuktegin to identify gems in his treasury. According to al-Biruni, they claimed that the finest-quality walrus ivory was crinkled and of a reddish-yellow colour, followed in decreasing order by: a waxy camphor-like colour, white, apricot, tan tinged with black, bone-like colour (*khardandana*) and lastly peppery colour, and al-Biruni concludes that by the same token they had covered both the patterns and colours of the material.

Another rare accurate account of walrus ivory from approximately the same period comes from the Chinese author Hung Hao (1090–1155 CE), who is said to have spent fifteen years among the Jin (Kin) in the Khitai territory of northeastern China. His description of walrus ivory or *ku-tu-si* indicates he was familiar with the material, which he describes in the *Sung mo ki wên* (historical memoranda regarding the Jin Dynasty) as follows: "The *ku-tu-si* is not very large. It is veined like ivory, and of yellow color. It is made into swordhilts (or knife handles). It is a priceless jewel."[15]

The value of walrus ivory clearly endured: in a Turkish treatise on mineralogy written in 917 H (1511–12 CE), the author, Yahya ibn Muhammad al-Gaffari, reports that an Egyptian merchant sold a small piece in Mecca for a thousand gold pieces.

Clearly walrus ivory continued to be a precious and sought-after commodity for a long period of time. It is not known, however, whether its value was due to a prevailing belief in its alleged ability to detect the presence of poison, or if its repute as a precious material endured on other, long-forgotten, grounds.

Portrait of Shah 'Abbas I wearing a sword with a beaked pommel and a dagger of the cloven-pommel type, by the court painter of Emperor Jahangir, Bishn Das, *c.* 1618

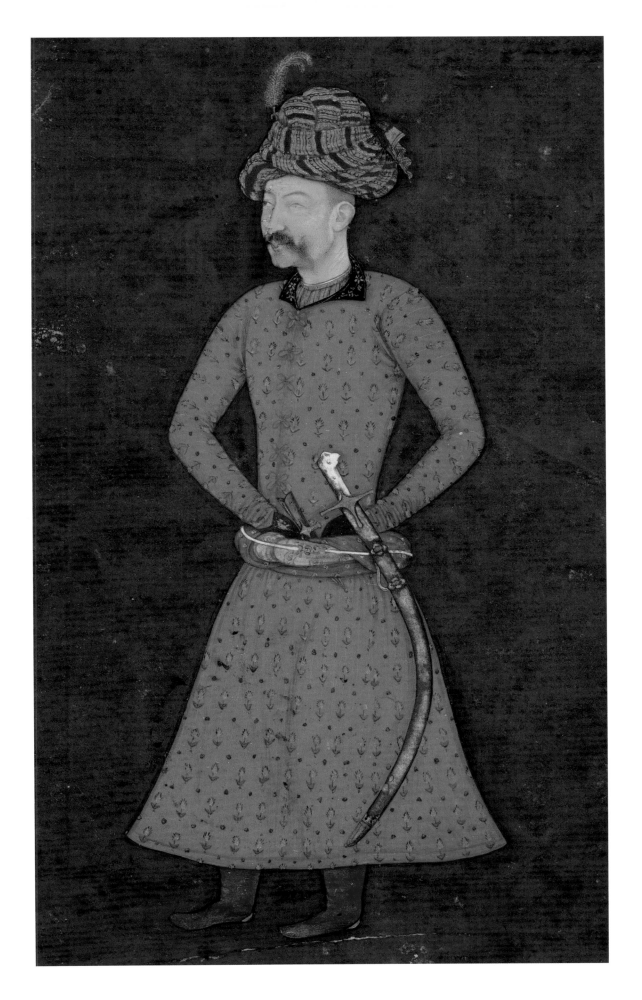

**Cat. 101 SWORD HILT, CROSS
GUARD AND LOCKET**
**Deccan or Mughal dominions,
probably mid sixteenth century**
Hilt facings carved from walrus
ivory, inlaid with gold in *kundan*
technique; iron strip bordering the
edge of the hilt covered with a layer
of gold and engraved; backing and
edges of the quillons and locket
fabricated from gold and engraved
Dimensions: Length of assembled elements
22.5 cm; width 12 cm
Provenance: Art market 1998
Published: Keene and Kaoukji 2001, cat. 2.1
Inv. no. LNS 97 I a–c

This type of sword hilt was frequently
attributed to Iran owing to related sword
representations in Persian painting and was
most likely inspired by Persian examples.
The type evidently spread over various
parts of the subcontinent,[16] and the fact
that the gold decoration is worked in
kundan technique leaves no doubt that this
example originated in India.

Faced with slabs of walrus ivory riveted
onto the metal tang, the hilt of this suite of
sword mounts is outlined with a flat iron
strip overlaid with a band of engraved gold.
The gold edging and the lining of the locket
and cross guard are of late nineteenth- to
earlier twentieth-century manufacture, and
are carved with foliate scrolls.

The decoration is
characterized by gold inlaid
vines that are strongly
"proud" of the surface, and
the sculptured rendering of the
lotuses, buds and trefoils, stylistically typical
of India during the rule of Emperor Akbar,
are let into a ground punctuated with gold
dots framed by gold filets.

A sizable amount of gold inlay is
missing from the surface of the hilt, which
makes it possible to see the grooves and
small holes carved deep into the ivory to
anchor the *kundan*-inlaid gold.

On each face of the hilt a vine develops
from a minuscule spiralling tendril on
one side of the lower end of the grip, a
seemingly popular decorative device from
the period,[17] and extends along the same
edge bearing lotuses, which in turn issue
vines from their upper petals that run
parallel to the main vine. On the locket

Gold foliate scrolls originating from spiralling tendrils on upper and lower tiers of locket decoration

Detailed gold scrolls on hilt

the vines also originate from small spiralling tendrils and, uniquely among the three elements of this set, bear globular ribbed fruits in addition to lotuses, buds and trefoils. The stylized guilloche separating the two registers is punctuated with gold globules, each of which is divided into four equal parts by barely visible lines. On the edge of the locket a gold lug suspends an ivory bail, which has now lost most of its gold inlay. The bail is of typical form, comprising two slender half-palmettes converging onto a pendant bud. The lobes that border the lower end of the locket converge onto a trefoil held only by the recent gold lining.

Whereas the vegetal decoration on the cross guard is identical to that on the hilt and locket, the treatment of the design is generally of more formal appearance. Its square-section finials feature a trefoil on each of their four sides, and, on the finials' rounded ends, four trefoils converge onto a quatrefoil.

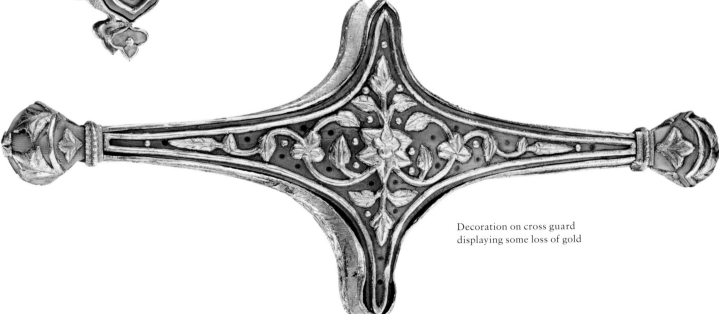

Decoration on cross guard displaying some loss of gold

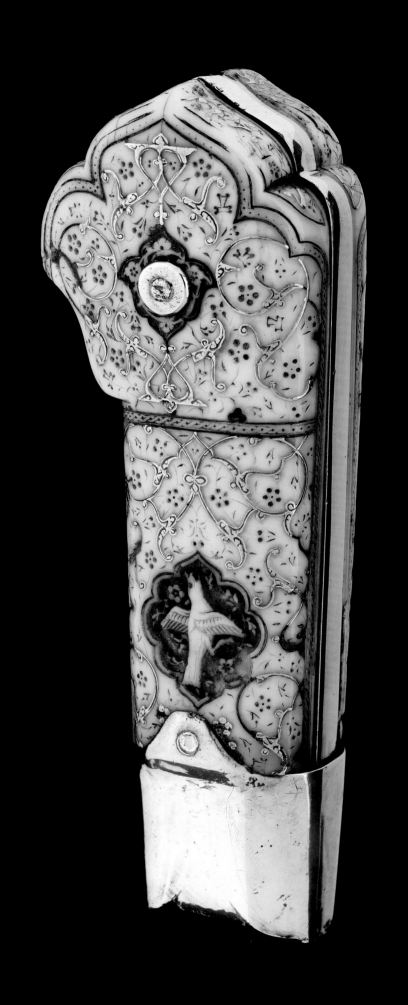

Cat. 102 **BEAKED SWORD HILT**
Deccan, probably Bijapur,
dated 1044 H (1634–35 CE)
Hilt facings carved from walrus
ivory, inlaid with gold and
engraved; iron strip bordering
the hilt iron framework covered
with plain gold
Dimensions: Length 11 cm; width 4 cm
Provenance: Art market 1980s
Published: Keene 1984, no. 39; Keene
and Kaoukji 2001, cat. 2.3
Inv. no. LNS 37 I

The ivory slabs that make up this hilt are inlaid with gold in an intricate and symmetrical arabesque of finely detailed split palmettes. A counterpoint to this gold-inlaid network is furnished in the intervening areas by a lightly carved arabesque (never inlaid and exhibiting considerable wear) of spiralling scrolls issuing sprigs and small rosettes composed of somewhat deeply drilled depressions in "cinquefoil" arrangement.

On the grip the recessed lobed medallion is carved in two planes with a bird in flight encircled by a floral wreath; likewise in the centre of the "pommel area" a cusped palmette is carved in two planes with a circular floral wreath, most of which is obscured by a later silver rivet.

Framing the surface of each ivory slab, and separating the grip from the pommel area, are deeply carved paired filets that retain no inlay, and enclose a carved cable motif exhibiting great wear.

The upper edges of the hilt are inscribed in *nasta'liq* interspersed with flowers with Chapter 21, verse 69, from the Qur'an (*Surat al-Anbiya'*), and the date 1044 H (1634–35 CE):

[قل] يا نار كوني بردا/

وسلاما على ابراهيم/

في/

سنه ١٠٤٤

We said, "O fire, be thou cool / and a means of safety for Ibrahim [Abraham]" / In / the year 1044

Although the date on the hilt (1634–35) post-dates the death of Sultan Ibrahim Adil Shah II of Bijapur by almost a decade, it is known that the Sultan availed himself of verses associated with his namesake, the prophet Ibrahim, and that the practice was also perpetuated after his demise.[18] Since this specific verse features on Sultan Ibrahim's *rauza* (tomb) in Bijapur, which was probably completed between 1633 and 1635,[19] it is most likely that it was specifically chosen, possibly by one of the Sultan's descendants or a member of his court, as a means of protection against persecution, as is alluded to in the inscribed verse from the Qur'an in relation to the prophet Ibrahim (or Abraham) when he rebelled against idolatry and the rulers of his ancestral lands.

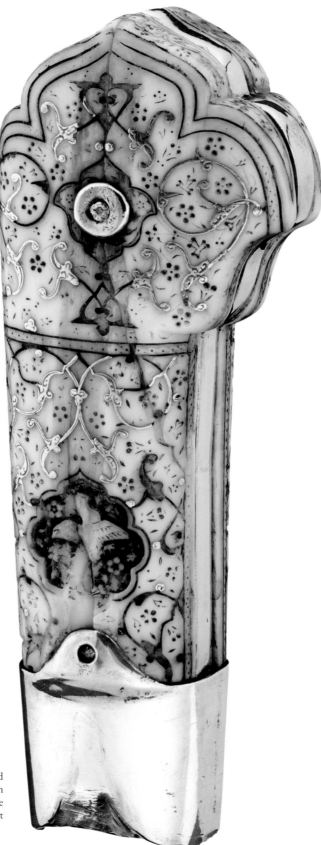

Upper end of pommel inscribed with a verse from the Qur'an, and dated 1044 H (1634–35 CE), Cat. 102 (LNS 37 I)

View of hilt showing recessed medallion with bird in flight and cusped palmette obscured by a rivet

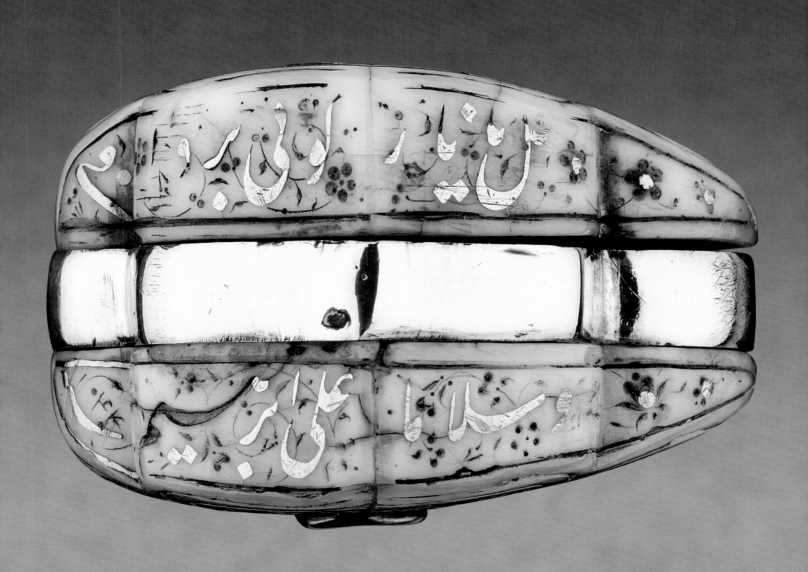

THE *TALWAR* AND OTHER INDIAN TYPES

The typically Indian sword is mostly referred to in India as *talwar*, *tulwar* or *tarwar*, which various popular etymologies connect to the size and shape of some of their blades that broaden at the tip as exemplified by Cats. 109 and 112. Depictions of the type can be seen on wall paintings of the Ajanta Caves attributed to the end of the fifth century CE.[20] Furthermore, the types of hilts from which the *talwar* appears to have evolved are likewise represented on the Khajuraho Lakshmana temple friezes from around 930–50,[21] as well as in a painting from a Bihari *Pancharaksha* manuscript dated 1160–61,[22] which confirms that the type had an extended history in India, and it is worthy of note that such hilts are not found outside of India. Unfortunately, most written sources that mention swords do not offer detailed descriptions of the type: for example, in a description of the armour housed in the *Khan-e Dawlat* (House of Dominion), during a feast commemorating Emperor Humayun's accession to the throne, his sister Gul Badan Begum refers to a sword as *shamshir* (the generic Persian word for sword), with no further description other than noting when a weapon was jewelled.[23] This is but one problem incurred with the nomenclature of weapons.

Consequently, once again the only option is to rely on visual representations, despite variations in the depiction of weapons due to artistic license and conventions of portraiture, to establish the point in time when a type of *talwar* was in demand.

Although few *talwar*s can be seen in paintings ascribed to the early period of Emperor Akbar's reign, when pommels had a more rounded configuration, a number of *talwar*s are represented in the Cleveland Museum manuscript of the *Tutinameh*, attributed to *c*. 1560–65, and some of them are even fitted with knuckle guards.[24] In the *Kitab Nujum al-'Ulum* manuscript from Bijapur dated 14 Rabi' al-Awwal 978 H (16 August 1570 CE), a *talwar* is labelled "*shamshir*".[25]

Representations of *talwar*s with pommels of the type represented in this section begin to appear frequently in paintings dated to the reign of Emperor Jahangir, which suggests that this was when the hilt of the *talwar* acquired its characteristic configuration. Following that period, representations increase in paintings, but, strangely enough, no *talwar*s are depicted in paintings from the Deccan, with the exception of a few examples from the area of Golconda.

It is interesting, however, that whereas visual representations show that most types of hilt encountered in India were used more or less randomly on either daggers or swords, this does not seem to have been the case for disc-and-dome type hilts, which are generally only represented fitted on swords such as the *talwar*s in this chapter.

Shah Jahan and an elderly courtier wearing *talwar*s suspended from their sashes in an album page by Hashim, *c*. 1650

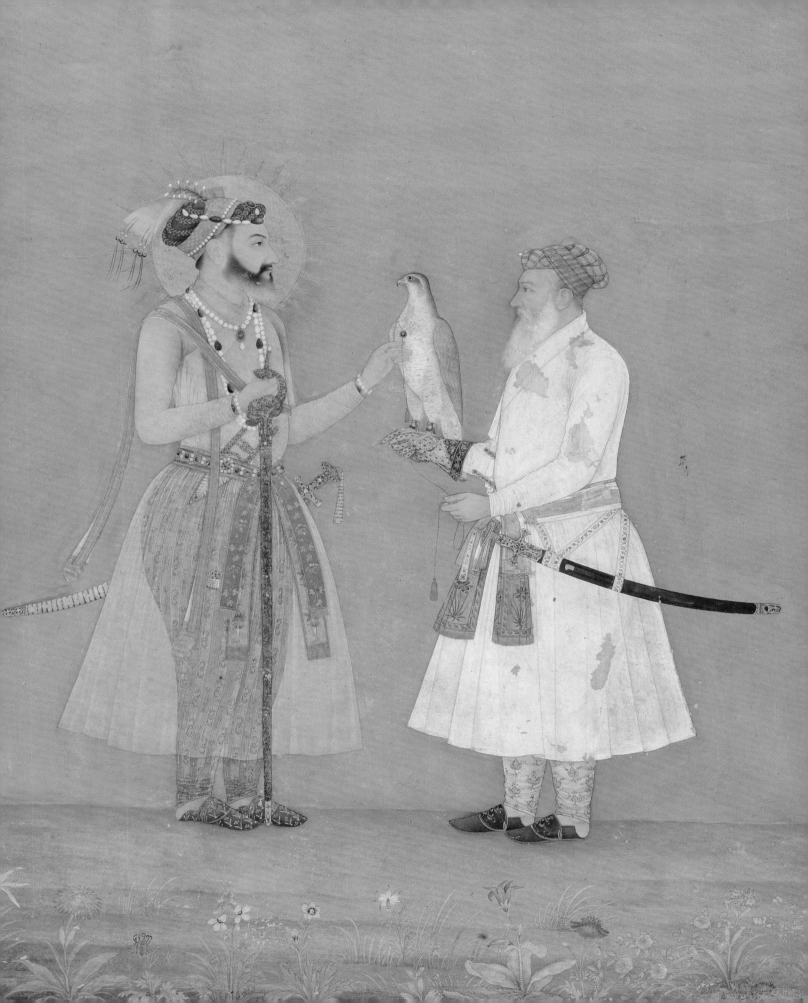

Diamond petals and ruby buds
against a ring-matted ground
outlined with channel-set rubies
on pommel disc

Cat. 103 SWORD HILT, LOCKET AND CHAPE
Deccan, probably first half of the seventeenth century

Hilt, gold over an iron core, with locket and chape fabricated from gold; ringmatted, worked in *kundan* technique and set with rubies, emeralds and (the hilt and chape) diamonds

Dimensions: Length of hilt 18.2 cm; diameter 6 cm; length of locket 6.6 cm; width 5.5 cm; length of chape 14.5 cm; width 4 cm

Provenance: Art market 1999

Published: Keene and Kaoukji 2001, cat. 1.4; Chadour-Sampson and Israel 2004, p. 78, fig. 3; Elgood 2004b, p. 78, fig. 3; Calza 2012, p. 163, cat. IV.15

Inv. no. LNS 2158 J a–c

The proportions and decorative scheme of this hilt are not representative of the regular "disc and dome" pommel variety, a type that seems to have evolved from pre-Mughal Indian sword hilts.[26] This hilt has a relatively small disc with a wide upturned edge, and a small dome fitted with a disproportionately large bail, alongside a raised channel-set cap on the upper end of the grip, and fairly short quillons.

The decoration revolves around a vertical alignment of floral vines, in salient lobed settings of rubies, emeralds and diamonds against a ringmatted ground, which to a certain extent is related to the *katar* Cat. 3. Additional floral motifs adorn the pommel disc, which, when seen from above, is treated as a flower, with large diamond petals and small ruby buds encircling the ten-sided dome and bud finial set with rubies and emeralds. The interior and exterior edges of the pommel disc are bordered with rubies, diamonds and emeralds in detailed arched settings, and the underside has radiating clusters of floral vines. The quillon ends are treated as ruby flowers with diamond centres.

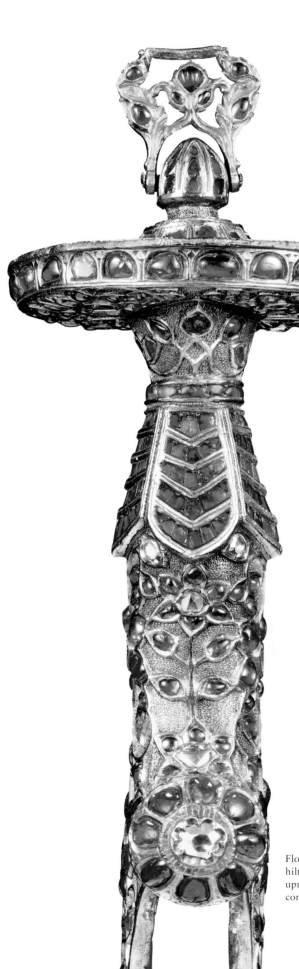

En suite with the chevron motif adorning the upper end of the grip, the backs of the locket and chape are decorated with salient channel-set chevron bands, and have an undercut in their sidewalls, as if to hold further gems. This theory is substantiated by the fact that the gold surfaces of the hilt, as well as the front of the locket and chape, have been ringmatted or treated as "finished" surfaces, whereas on the backs of the locket and chape the gold surface between the chevron bands is smooth and apparently unfinished.

The bail, which consists of an intricate openwork arrangement of undulating engraved gold leaves, is set on both sides with rubies and emeralds surrounding a ribbed emerald.

Chevron motif, with missing stones, on back of locket and chape, Cat. 103 (LNS 2158 J)

Floral decoration on side of hilt and quillon terminal with upright bail comprising leaves converging on a bud

Jewelled stemmed plants on underside of pommel disc

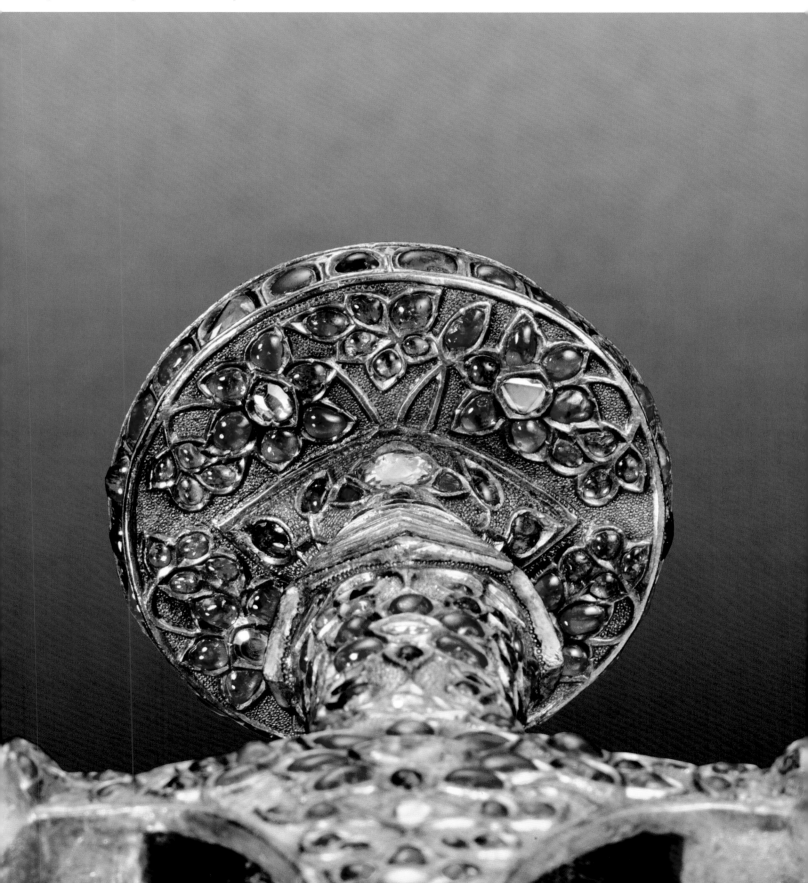

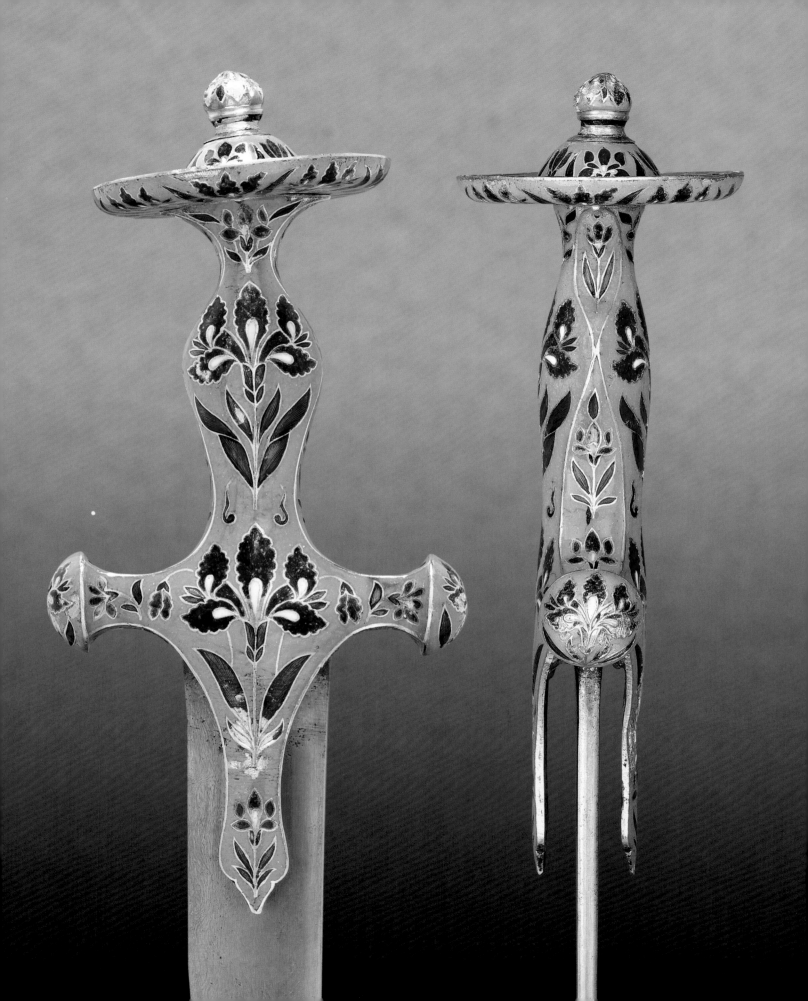

**Cat. 104 SWORD, SCABBARD,
LOCKET AND CHAPE**
Deccan or Mughal dominions,
c. mid seventeenth century
Hilt, gold over an iron core,
champlevé enamelled; blade of
jawhar steel; scabbard, wood
overlaid with carmine velvet
with metal thread trimming
Dimensions: Length of sword 88 cm; width
8.5 cm; length of scabbard 80.5 cm
Provenance: Art market 1999
Published: Christie's, London, 20 April 1999,
lot 407; Keene and Kaoukji 2001,
cat. 6.26; Chadour-Sampson and
Israel 2004, p. 88, fig. 14
Inv. no. LNS 1016 M ab

The sword hilt decoration revolves
around beautiful naturalistic renderings
of irises with lanceolate leaves in red,
white and green enamel against a middle-
blue ground.[27] Two large iris blooms
cover the front and back of the grip, with
green cloud bands in between the irises
and drooping buds emerging from behind
the iris in the centre of the guard. Smaller
blooms decorate the quillons, as well as the
flat surfaces on the sides of the grip and
upper edges and terminals of the quillons.
The pommel area is decorated on the
underside, upper edge and dome with gold
festoons of iris blossoms flanked by curling
leaves, and the upper half of the knob finial
is enveloped in iris petals.

The locket, which is a later
replacement, is essentially an openwork
encasement composed of various border
motifs in polychrome enamels, including
leaf and bud crenellations, chevrons and a
pale-pink quatrefoil in the band traversing
the languet channel. The chape is original
to the sword and decorated with a large iris
plant issuing pairs of buds.

The single-edged *jawhar*-patterned
blade is curved and tapers to a point.

Front and side views of hilt,
with naturalistic irises and
cloud bands on grip

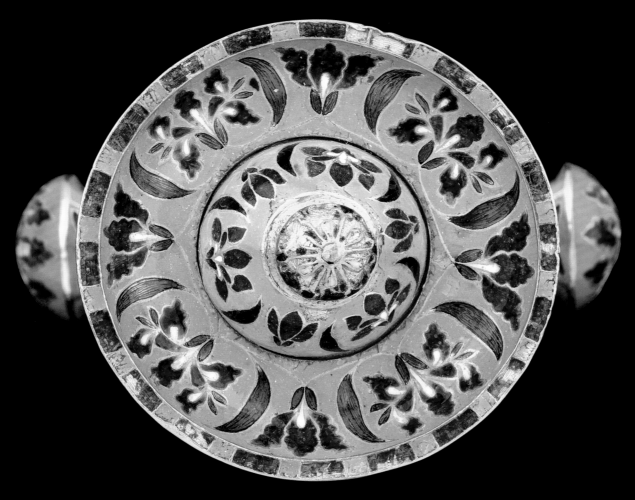

Festoons of iris blossoms on upper
part and underside of pommel disc
Cat. 104 (LNS 1016 M)

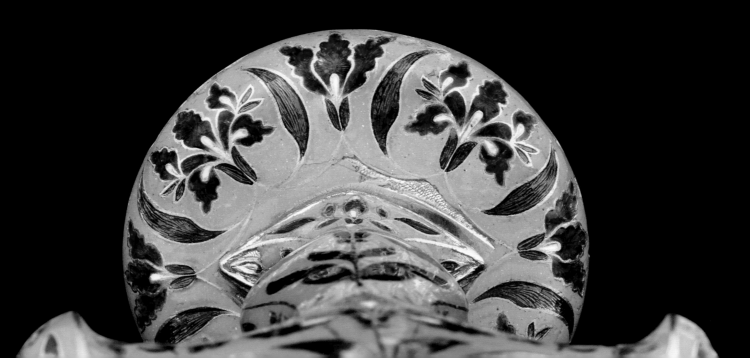

Chape, with iris plant with
unfurling blossoms and buds

Polychrome enamelled
locket of later manufacture

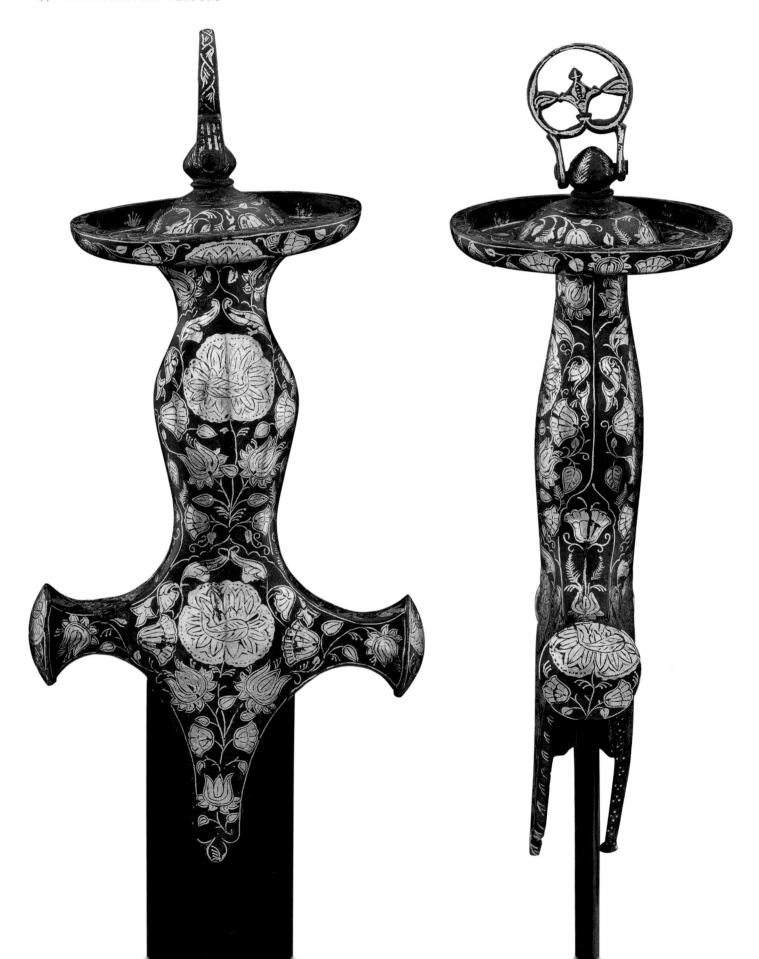

Cat. 105 **SWORD HILT**
Probably Deccan, mid
seventeenth century
Steel, inlaid with gold
Dimensions: Length 16 cm; width 8 cm
Provenance: Art market 1991
Published: Keene and Kaoukji 2001, cat. 7.8;
Michell 2007, cat. 96
Inv. no. LNS 295 M

The rounded grip of this sword hilt is gently ridged along its centre, and its relatively small disc has a thick upturned edge, with a small dome and bud finial fitted with a proportionately large bail. The short prismatic quillons are rounded at their ends and closely related in form to the quillons of Cat. 109.

On the grip an upright vine develops from a blossom on the tip of the languet, issuing fine meandering vines bearing peonies in various stages of florescence. Fine gold fillets outline the floral motifs on the front, back and sides of the hilt and come together forming lobed ogee arches just above the two large peonies, as well as above the peonies on the sides of the grip.

The fanciful treatment of the floral motifs, small feathery leaves and wispy tendrils evokes flower-patterned fabric and borders in Deccan painting.[28] The main blossoms are composed of three large petals with corollas of smaller petals crossed in their centre by a curling leaf,[29] and the unfurling blossoms with downturned sepal borders are treated in a manner generally found in painting. The domical ends of the quillons feature halved representations of the large peonies and unfurling blossoms, and a flowering stem develops from the upper edge of the quillons halfway up the edge of the grip. Stemmed blossoms are featured on the underside of the quillons.

Counterchanging floral and foliate scrolls fill the upper surface of the pommel disc and dome, and wispy foliate scrolls border its edge. The bud finial is decorated with feathery leaves and is fitted with a large foliate bail suspending a bud.

Interestingly, it appears as though more consideration was given to the decoration of the underside of the disc, whereby two unfurling blossoms situated on opposite edges of the disc issue pairs of vines bearing a variety of blossoms and leaves that touch on two large peonies.

The edges of the languets are alternately decorated with configurations of dots and weeds.

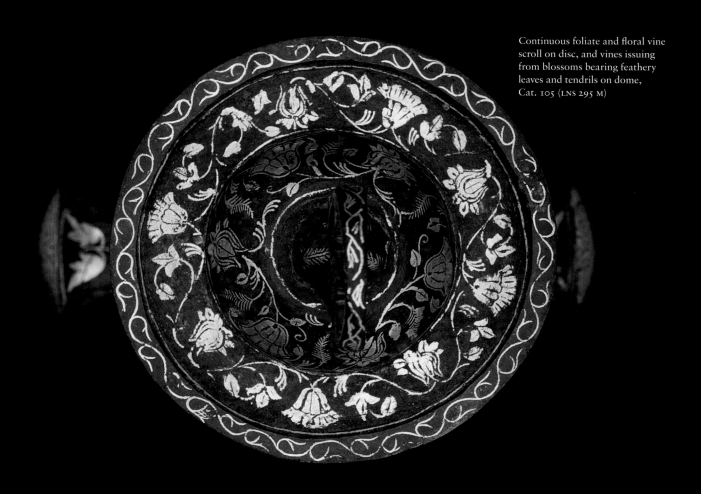

Continuous foliate and floral vine scroll on disc, and vines issuing from blossoms bearing feathery leaves and tendrils on dome, Cat. 105 (LNS 295 M)

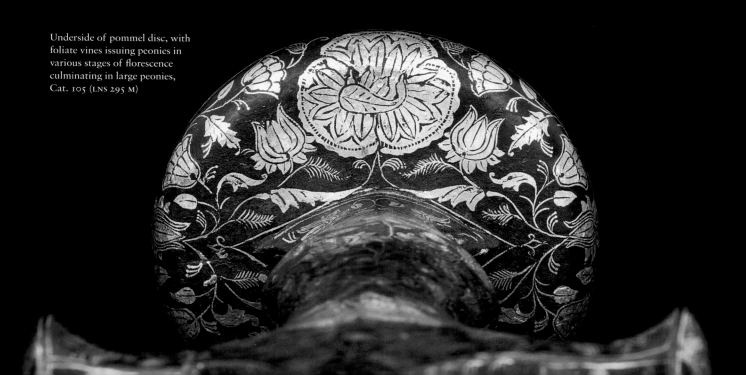

Underside of pommel disc, with foliate vines issuing peonies in various stages of florescence culminating in large peonies, Cat. 105 (LNS 295 M)

Cat. 106 CHAPE
Probably Deccan, mid
seventeenth century
Steel, inlaid with gold
Dimensions: Length 6.5 cm; width 3.5 cm
Provenance: Art market 1991
Published: Keene and Kaoukji 2001, cat. 7.9
Inv. no. LNS 311 M

As in the preceding example, Cat. 105,
the two fine peonies featured on this sword
scabbard chape are rendered in a manner
that evokes miniature painting, and the
decorative motif is also outlined with a
gold fillet. The peony featured in the lower
register grows from a cluster of small
leaves and is flanked by two drooping
buds. Its stem is surrounded by a bunch of
leaves, one of which curls gracefully and
is upswept on its end. The peony in the
upper register is rendered in more formal
mien, grows from a bud amid upswept
leaves overturned on their ends and is also
flanked by buds.

The field is covered with rows of linear
cloud bands, as well as with clusters of
weeds in the lower register. The single flat
edge features stemmed buds that recall the
recurrent motif utilized to line the edges of
hilts, lockets and chapes.[30]

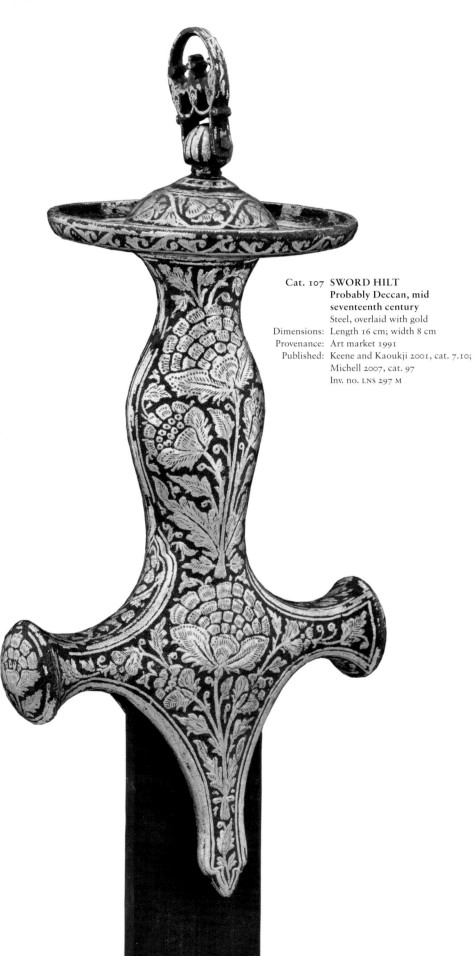

Cat. 107 SWORD HILT
Probably Deccan, mid
seventeenth century
Steel, overlaid with gold
Dimensions: Length 16 cm; width 8 cm
Provenance: Art market 1991
Published: Keene and Kaoukji 2001, cat. 7.10;
Michell 2007, cat. 97
Inv. no. LNS 297 M

Although not as fine in its execution, this hilt is virtually identical in form and decorative scheme to the previous sword hilt, Cat. 105, which suggests that it might have been produced in the same workshop, but by a less skilful craftsman.

Here, two gently undulating foliate stems, gathered at their bases by pairs of small leaves in a bow configuration, spread along the centre of the grip bearing large stylized peonies. The edges of the hilt, quillons and languet are outlined with bands of plain gold bordered by fillets. As in Cat. 105, the domical quillon terminals depict flowering plants, and the sides of the grip feature panels in the form of trefoil arches, but here they are charged with floral scrolls instead of a flowering plant. Stemmed blossoms are featured on the underside of the quillons.

The upper surface and edge of the pommel disc and the dome are encircled by counterchanging floral and foliate scrolls, and the bud finial is decorated with radial gold bands and fitted with a foliate bail suspending a bud.

Interestingly, once again, it appears as though more consideration was given to the decoration of the underside of the disc, which features two large blossoms situated on opposite edges of the disc issuing sweeping fluid leaves and blossoms.

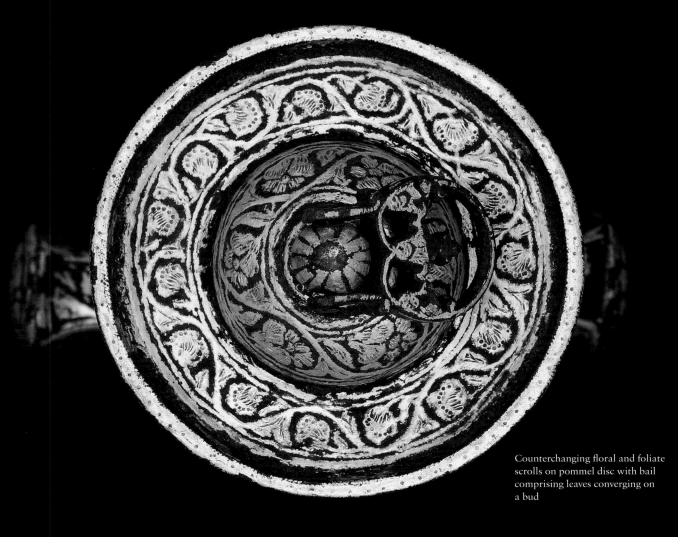

Counterchanging floral and foliate scrolls on pommel disc with bail comprising leaves converging on a bud

Blossoms issuing sweeping leaves and smaller blossoms on underside of pommel disc

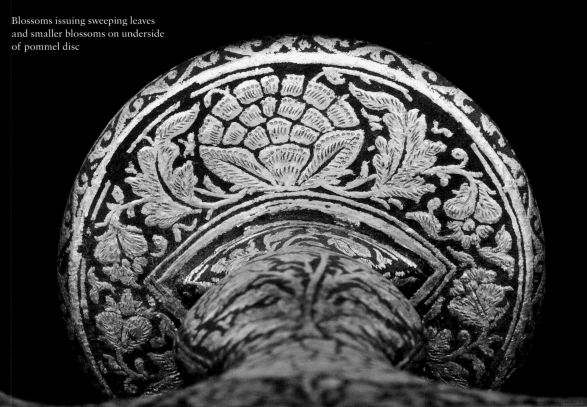

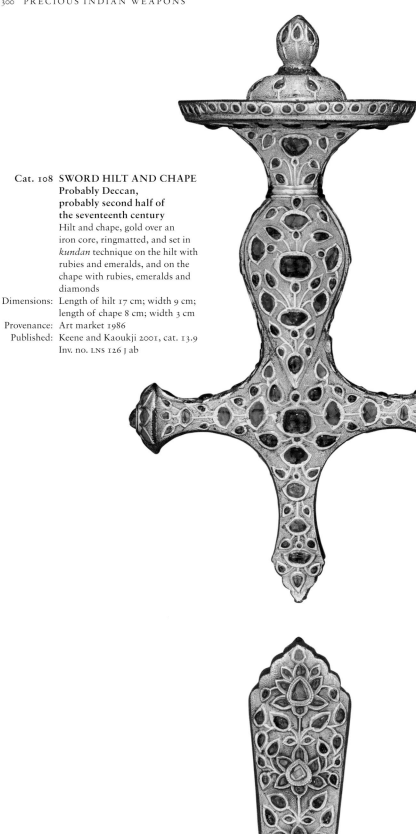

Cat. 108 SWORD HILT AND CHAPE
Probably Deccan,
probably second half of
the seventeenth century
Hilt and chape, gold over an
iron core, ringmatted, and set in
kundan technique on the hilt with
rubies and emeralds, and on the
chape with rubies, emeralds and
diamonds
Dimensions: Length of hilt 17 cm; width 9 cm;
length of chape 8 cm; width 3 cm
Provenance: Art market 1986
Published: Keene and Kaoukji 2001, cat. 13.9
Inv. no. LNS 126 J ab

This hilt and chape are sparsely set with
rubies and emeralds against a large expanse
of densely ringmatted gold, a decorative
style that recalls the treatment of the *katar*
Cat. 3 and the hilt Cat. 103, which together
with the fan-shaped lotus blossoms are
decorative schemes closely associated with
the Deccan.[31]

By around the middle of the seventeenth
century, the practice of featuring pointed
ovate panels enclosing flowering plants on
the grips of *talwar*s seems to have become
a stylistic convention.[32] The type is clearly
depicted on the hilt of a *talwar* worn by a
nobleman following Emperor Jahangir in
a folio from the *Tuzuk-i Jahangiri*,[33] and
worn by a courtier in a folio illustrating the
weighing of Emperor Shah Jahan in a folio
from the *Padshah-nameh*.[34]

On the grip three large emeralds in
partially lobed and detailed settings – one
below the disc, one in the centre of the grip
and one in the centre of the guard – form
an axis from which develop flowering
plants that fill the surface on both faces
of the hilt. The stems issuing from the
emerald in the centre of the guard extend to
the ends of the quillons and to the tip of the
languet bearing ruby lotuses and buds and
emerald leaves. On the raised ovate panel,
the plants grow from a small downturned
emerald leaf on the tip of the panel. Just
below the disc, emerald and ruby plants
grow from the moulding, which suspends
ruby buds on either side of the grip.

The domical ends of the quillons
feature the standard gem-set rosettes, here
with an emerald centre and ruby petals.
Three large ruby lotuses issuing minuscule
stems and ruby buds extend from the ends
of the quillons to the middle of the grip.

Detail from the border of a folio from the Late
Shah Jahan Album depicting retainers examining
weapons, Mughal, attributed to Payag, *c.* 1650–58

A row of ruby lotuses alternating with emerald leaves on minute gold stems borders the edge of the slanting pommel disc, and a raised gold trefoil crenellation and stemmed ruby buds encircle the small dome. The bud finial is covered with a row of stemmed emerald leaves and is capped with a ruby. On the underside of the disc, ruby petals encircle the grip and are bordered by an atypical arrangement of ruby lotuses and emerald leaves on swaying stems that appear to hover above the lotuses. The edge of the disc is typically set with ruby circlets.

On one face of the chape a vertical stem growing from a small ruby mound bears three blossoms with ruby petals and diamond centres issuing emerald leaves, whereas on the other face the blossoms have emerald petals and issue ruby buds.

The chape displays wear on its end that reveals the iron beneath the gold, and although it apparently matches the grip, it appears as though a different craftsman or an apprentice might have executed it, because the quality of workmanship on the chape is somewhat inferior to that of the hilt.

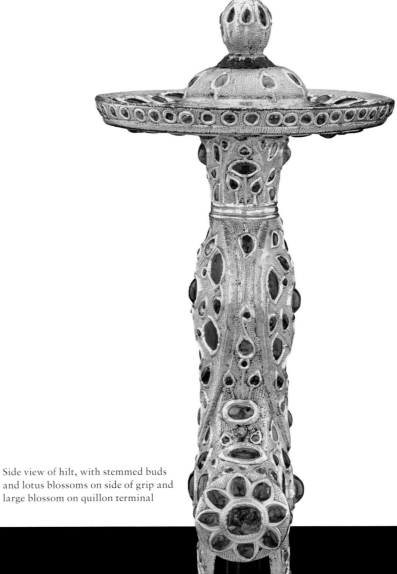

Side view of hilt, with stemmed buds and lotus blossoms on side of grip and large blossom on quillon terminal

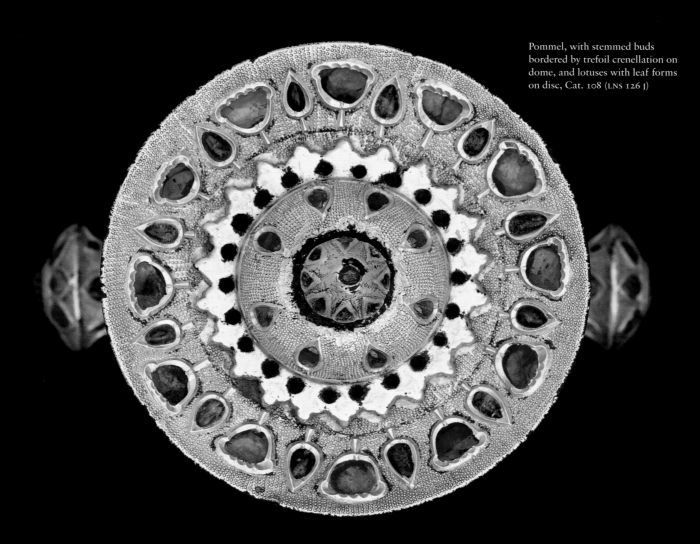

Pommel, with stemmed buds
bordered by trefoil crenellation on
dome, and lotuses with leaf forms
on disc, Cat. 108 (LNS 126 J)

Underside of pommel disc, with
ruby petals encircling the grip in a
surround of lotuses and leaves on
swaying stems, Cat. 108 (LNS 126 J)

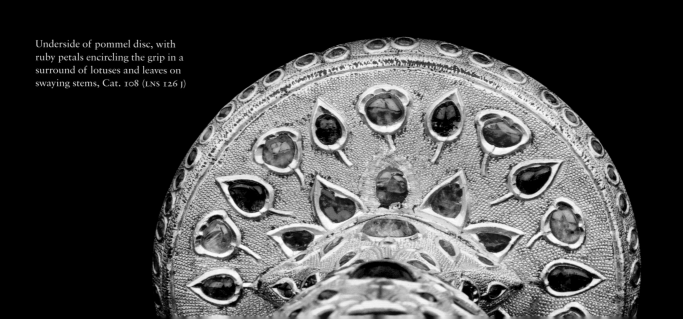

Cat. 109 SWORD, SCABBARD, LOCKET AND CHAPE
Probably Deccan, second half of the seventeenth century

Hilt, gold over an iron core, champlevé enamelled, set in *kundan* technique with diamonds and emeralds; blade, steel (probably *jawhar*, but obscured by repolishing); scabbard, wood overlaid with embroidered dark blue velvet; locket and chape, gold, champlevé enamelled and set in *kundan* technique with diamonds and emeralds

Dimensions: Length of sword 86 cm; width 10 cm; length of scabbard 76.5 cm

Provenance: Art market 1999, reportedly from Hyderabad

Published: Habsburg-Feldman, Geneva, 29 June 1988, lot 51/285; Keene and Kaoukji 2001, cat. 6.32

Inv. no. LNS 2157 J ab

This fine sword ensemble is decorated with plants and scrolls of diamond blossoms with emerald calyces and leaves in detailed gold settings against a ground of red enamel. Of interest is the fact that whereas the gold surface under the enamel of the hilt and locket is plain, it is treated in champlevé on the chape, which could indicate that it was produced by a different craftsman and that workshop supervisors afforded craftsmen some creative licence.

On the faces of the hilt, plants grow from the tip of the languet to the centre of the guard and extend in the form of scrolls to the tips of the quillons. The short, angular quillons, which are related to the quillons of Cat. 105, are rounded on their ends, which are decorated with a faceted conical diamond encircled by a festoon of diamond rosettes and emerald leaves. Scrolling vines issuing diamond blossoms and emerald leaves develop from the tip of the quillons and extend along their upper edges to the upper sides of the grip.

As on the preceding example, Cat. 108, the grip features a raised ovate panel filled with a flowering plant, and smaller stemmed blossoms and leaves develop from the green enamelled moulding below the disc.

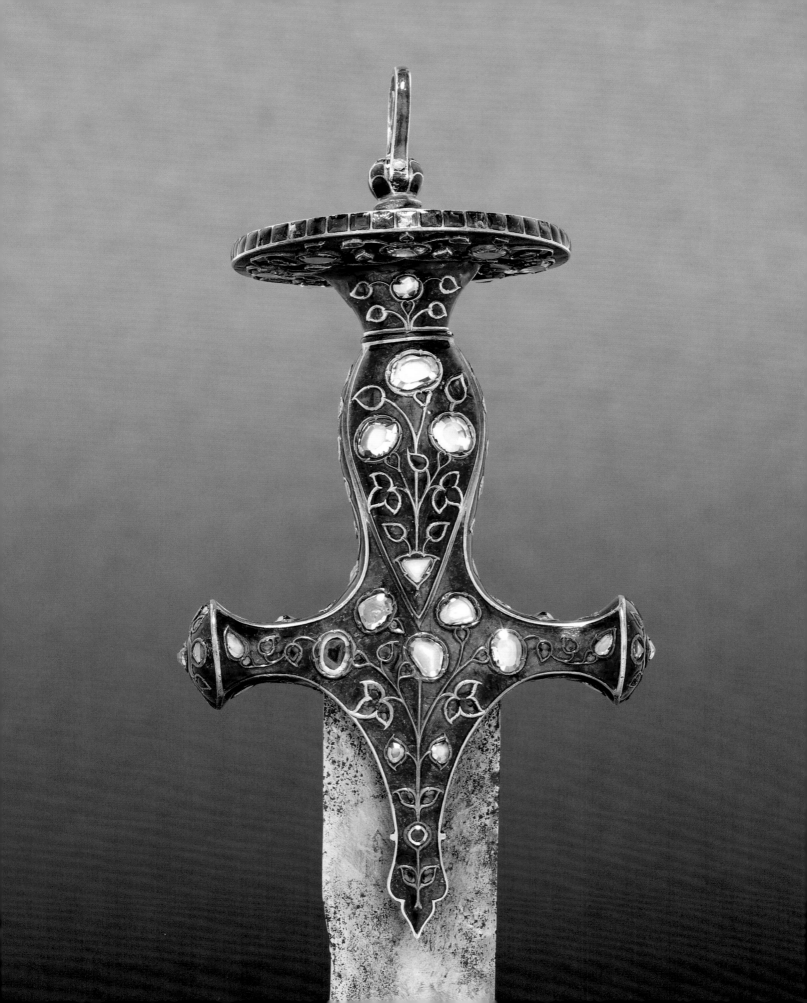

On the upper end of the disc pommel, small flowering stems radiate from a corona of lobed diamond petals that encircle the small dome decorated with diamond buds and leaves. The bud finial is surrounded by engraved gold petals and covered with red enamel petals that culminate in a high faceted conical diamond. The bail consists of a trilobed poppy blossom detailed with opaque white and black enamel borne on the cusp of two red and white enamel leaves.

Interestingly, the edge of the disc, instead of being set with emeralds, which are quite brittle and might have been subjected to chipping or breakage in such a prominent spot, is enamelled to emulate the appearance of emeralds; this was achieved by working the underlaid gold surface in such a manner as to simulate a table-cut gem, and then covering it with transparent green enamel with a convex profile. The underside of the disc differs slightly in the style of its decoration in that it features S-shaped scrolls issuing emerald leaves with large diamond blossoms at their centres and points of tangency.

Both the locket and chape are decorated with flowering plants and scrolls, and their edges emulate emeralds in the same manner as on the edge of the pommel disc, save for the bottom of the chape, which is covered with green enamel setting off a scroll of white enamel flowers and leaves.

The single-edged curving blade, though displaying much damage, retains traces of its original *jawhar* pattern. It broadens on the tip where it is refashioned as a double-edged blade. The dark blue velvet covering the wooden scabbard is embroidered with floral motifs in ochre and pink.

Detail of hilt showing green enamel emulating emeralds on edge of pommel disc

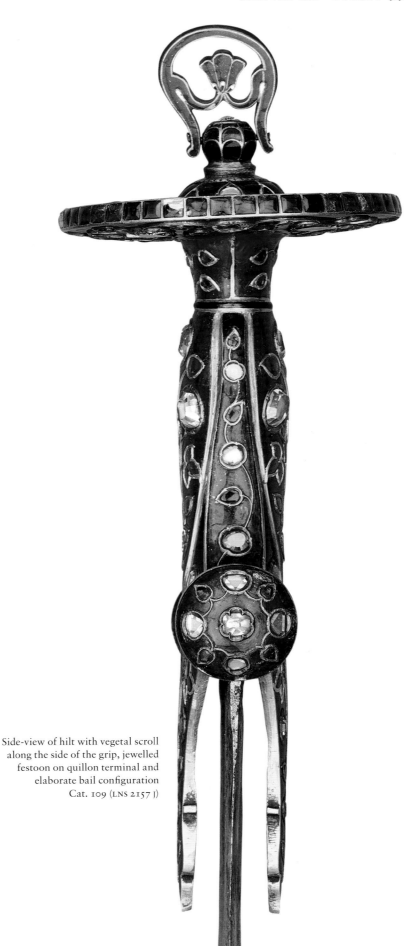

Side-view of hilt with vegetal scroll along the side of the grip, jewelled festoon on quillon terminal and elaborate bail configuration
Cat. 109 (LNS 2157 J)

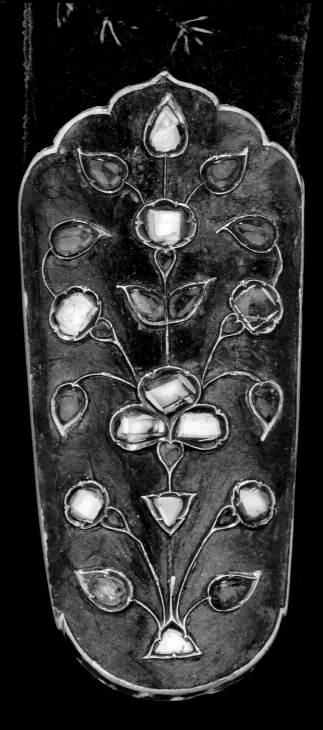

Diamond and emerald flowering
plants on locket and chape
Cat. 109 (LNS 2157 J)

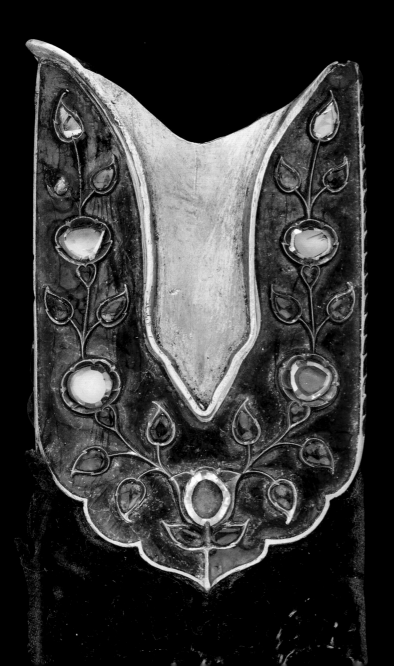

Gold petals surrounding the
bud finial, and diamond petals
bordering the base of the pommel
dome, from which issue diamond
flowers with emerald leaves

Scroll of diamond flowers on
underside of pommel disc

**Cat. 110 SWORD, SCABBARD
AND CHAPE**

**Deccan, seventeenth century;
blade probably second half
of the eighteenth century**

Hilt, gold over an iron core,
champlevé enamelled and set in
kundan technique with diamonds,
rubies and emeralds; blade of
jawhar steel, inlaid with gold;
scabbard, wood overlaid with
purple velvet with metal thread
trimmings; chape, gold, champlevé
enamelled and set in *kundan*
technique with diamonds, rubies
and emeralds

Dimensions: Length of sword 88 cm; width:
10 cm; length of scabbard 80.5 cm
Provenance: Art market 1999, reportedly from
Hyderabad
Published: Christie's, London, 13 October
1998, lot 134; Keene and Kaoukji
2001, cat. 6.39
Inv. no. LNS 2193 J ab

The surface of this sword hilt and its chape
are covered with a wavy pattern of opaque
white enamel on a gold ground, a form of
decoration generally used as a ground for
aquatic motifs on bidri trays. The pattern
can be seen on two seventeenth-century
bidri trays from Bidar published by M.
Zebrowski and on a bidri tray of similar
provenance in The al-Sabah Collection, as
well as on a Deccan pendant from the first
half of the seventeenth century adorned
with ducks swimming among lotus leaves.[35]
The same decorative scheme applies to the
katar Cat. 10, decorated with stemmed
buds, which are also associated with a
Deccan style of decoration.

Likewise popular in the Deccan was the
motif of lobed lotus leaves, here in green
enamel with minute gold stems that fill the
ovate panel on the grip and the underside of
the slanting pommel disc.[36] Equally popular
in the Deccan were the chevron borders
that feature on both sides of the grip in pale
blue enamel on gold.

At the centre of the guard a diamond
and ruby flower issues diamond lotus-leaf-
like flowers, ruby buds and emerald leaves,
yielding a rotational effect highlighted by

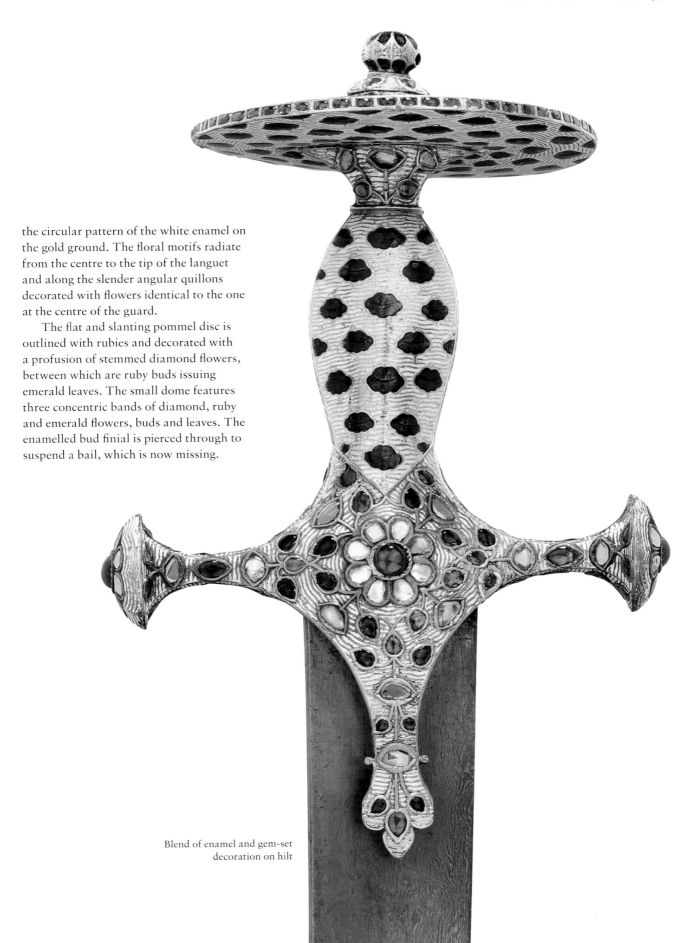

the circular pattern of the white enamel on the gold ground. The floral motifs radiate from the centre to the tip of the languet and along the slender angular quillons decorated with flowers identical to the one at the centre of the guard.

The flat and slanting pommel disc is outlined with rubies and decorated with a profusion of stemmed diamond flowers, between which are ruby buds issuing emerald leaves. The small dome features three concentric bands of diamond, ruby and emerald flowers, buds and leaves. The enamelled bud finial is pierced through to suspend a bail, which is now missing.

Blend of enamel and gem-set
decoration on hilt

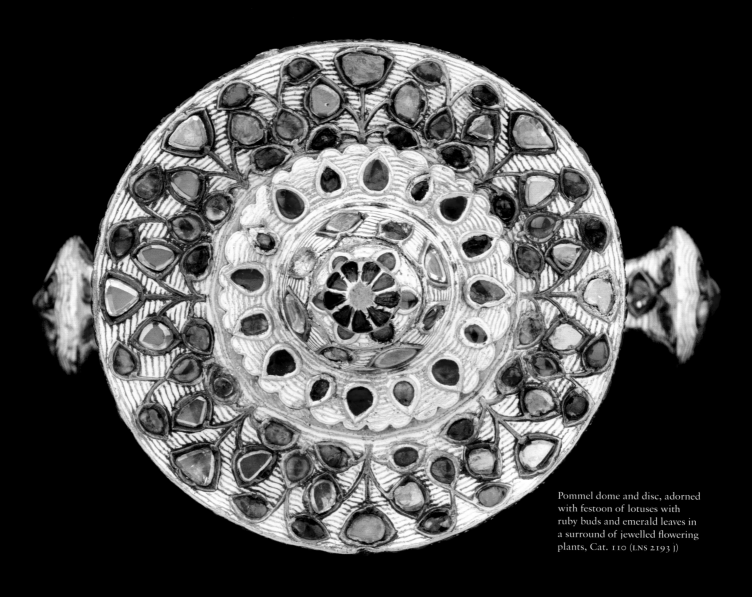

Pommel dome and disc, adorned
with festoon of lotuses with
ruby buds and emerald leaves in
a surround of jewelled flowering
plants, Cat. 110 (LNS 2193 J)

Staggered rows of lotus leaves on
the underside of the pommel disc

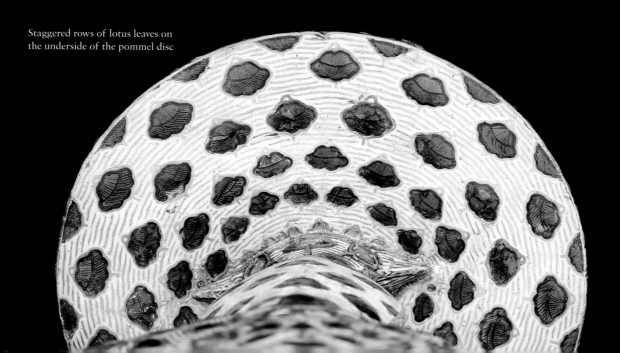

The curved single-edged *jawhar*-patterned blade is inlaid with a gold square inscribed with the letters of the talismanic formula *buduh* and a cartouche inscribed in *nasta'liq*: "made by Isma'il son of Asad Allah al-Isfahani".

A number of Iranian and Indian blades feature the name of the renowned Iranian swordsmith Asad Allah al-Isfahani.[37] A few bear the name of his son Isma'il, notably a blade in the Royal Collection, Windsor, dated 1186 H (1772 CE), that also includes a talismanic square and was recorded by Ludvik Kalus, who refers to further undated examples listed by L. A. Mayer in *Islamic Armourers and Their Works*.[38] Although it is generally accepted that not all the signed blades are attributable to Asad Allah al-Isfahani, the dated example in the Royal Collection allegedly signed by his son provides a reasonable estimate for the manufacture date of the blade of Cat. 110, whether or not the blade was originally made for this sword.

The chape is decorated with floral stems issuing tendrils growing in a vertical arrangement from three ruby buds and emerald leaves, wherein the main blossoms issue further groups of flowers and leaves. The upper edge of the chape is bordered with green enamel leaves in which nests a diamond bud capped by a gold trefoil. Along the lower edges of the chape are green enamel bands divided into rectangular compartments, once again probably emulating an emerald border.

Chevron of pale-green enamel on side of hilt, and flower on end of slender quillon

Cartouche on blade inscribed in *nasta'liq*: "Made by
Isma'il son of Asad Allah Isfahani", and square enclosing
the letters forming the talismanic formula *buduh*,
Cat. 110 (LNS 2193 J)

Matching chape with multi-tiered flowering
plant growing from a sprig of buds

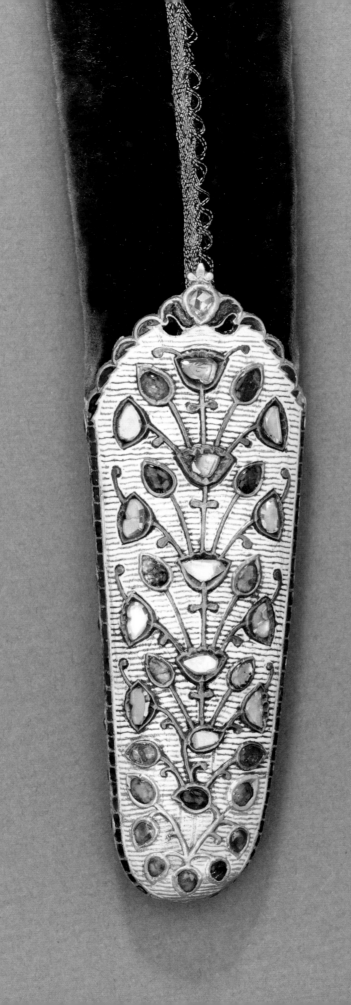

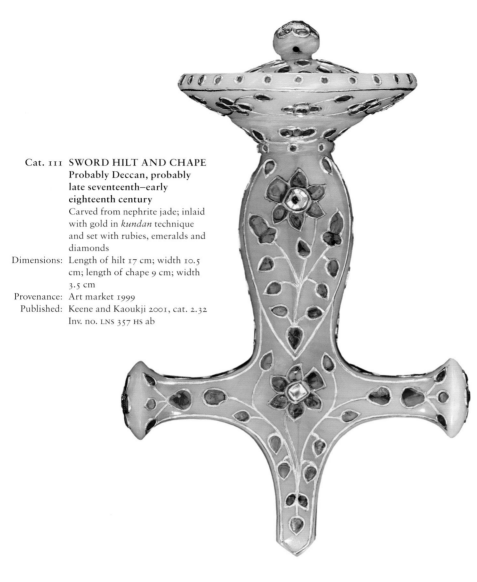

Cat. 111 SWORD HILT AND CHAPE
**Probably Deccan, probably
late seventeenth–early
eighteenth century**
Carved from nephrite jade; inlaid
with gold in *kundan* technique
and set with rubies, emeralds and
diamonds
Dimensions: Length of hilt 17 cm; width 10.5
cm; length of chape 9 cm; width
3.5 cm
Provenance: Art market 1999
Published: Keene and Kaoukji 2001, cat. 2.32
Inv. no. LNS 357 HS ab

The rendering of the ruby and diamond
flowering plants decorating this sword hilt
is fairly rigid, but the greatest peculiarity
lies is the manner in which one of the
flower petals is wedge shaped and larger
than the rest of the petals. As this type
of flower is found on other objects and
therefore not an isolated representation,
one could assume that a craftsman might
have misinterpreted the cup or trumpet of
a narcissus-type flower, and his incorrect
depiction of it might then have been
replicated by other craftsmen, as is often
the case in art objects.

On the faces of the hilt one of the two
flowering plants grows from the tip of
the languet to the centre of the guard and
extends halfway to the tips of the angular
quillons, where it is supplemented by large
ruby buds issuing three smaller buds.

Gold fillets outline the short quillons,
stopping short of the domical terminals
that are covered with ruby and diamond
rosettes, and touch the ovate panel that
covers the grip in the same style as on
Cats. 108, 109, 110 and 114.

Decorative motifs aligned on the sides
of the hilt include ruby trefoils and the
stemmed buds.

The underside of the slanting pommel
disc and the edge of the squat dome are
encircled with gold festoons of ruby flowers
and buds. The upper end of the bud finial
features a ruby and diamond flower that
recalls the flowers of the quillon terminals.

The chape is decorated with a gold
ogival lattice enclosing ruby trefoils, and
on its edges are the stemmed ruby buds that
were favoured in the Deccan.

Side view of hilt and quillon terminals,
with ruby and diamond rosettes that lack
the peculiar wedge-shaped petal of the
flowers on the front and back faces

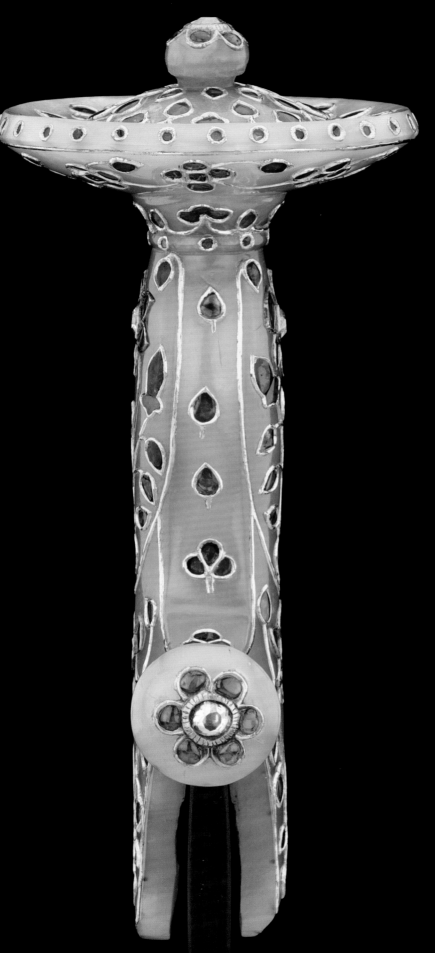

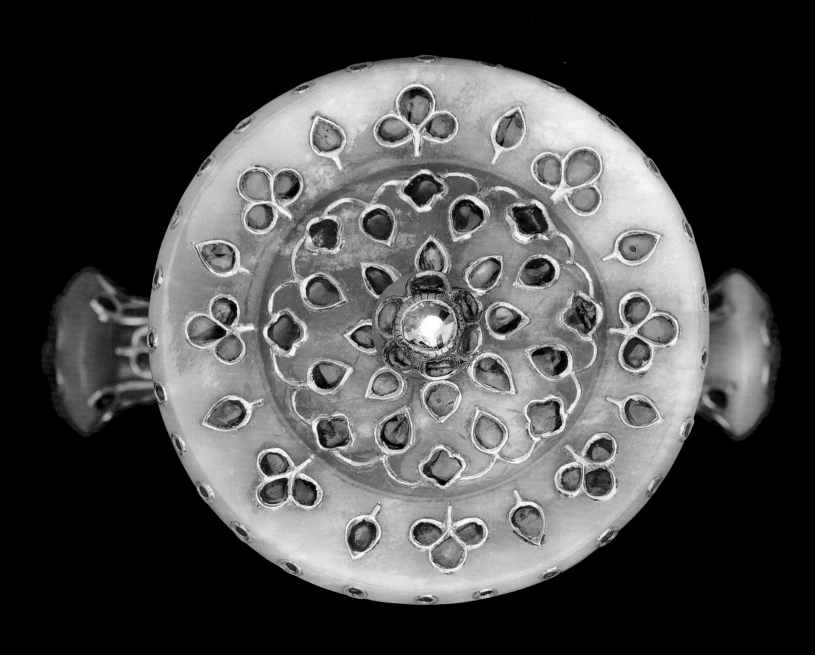

Pommel disc and dome, decorated
with ruby quatrefoils, trefoils and
buds, Cat. 111 (LNS 357 HS)

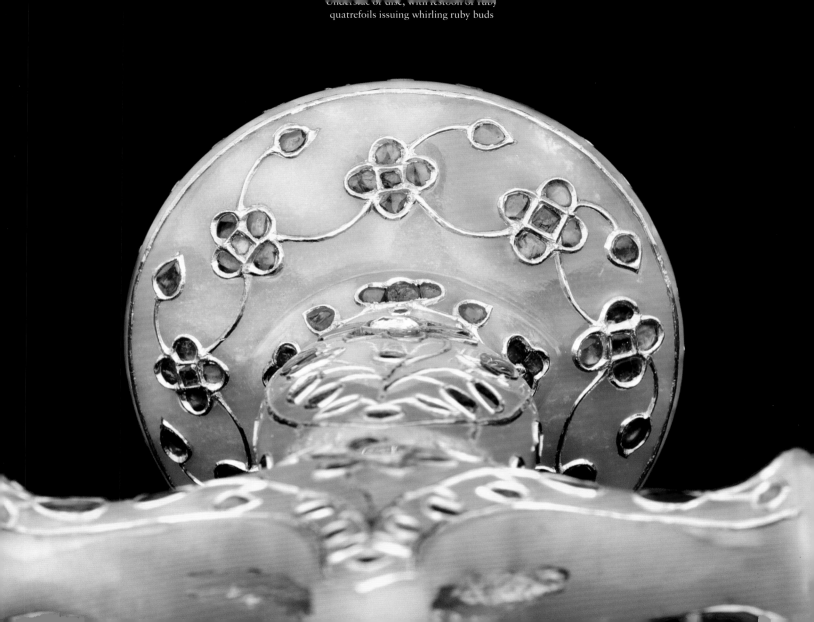

Cat. 112 SWORD, SCABBARD AND CHAPE
Hyderabad, Deccan, dated
1213 H (1798–99 CE)
Hilt, gold over an iron core, champlevé enamelled, set in *kundan* technique with diamonds and rubies; blade, steel (repolished), stamped with "European" type marks, the spine with a punch-marked Devanagari inscription; scabbard, wood overlaid with purple velvet with metal thread trimmings; chape, gold, champlevé enamelled and set in *kundan* technique with diamonds

Dimensions: Length of sword 88.5 cm; width: 8.5 cm; length of scabbard 85.5 cm

Provenance: Art market 1998

Published: Bonhams, 14 October 1998, lot 231; Keene and Kaoukji 2001, cat. 6.51; Chadour-Sampson and Israel 2004, p. 112, fig. 20

Inv. no. LNS 2154 J ab

Unlike most decorative schemes on *talwar* hilts, the hilt of this sword is divided into four vertical registers, each charged with fine gold vines and minuscule gold leaves in reserve on the green enamel ground that issue large diamond trefoils and buds. Each vine issues from a quatrefoil below the pommel disc that apparently suspends the blossoms and buds, as they are all rendered pointing downwards. The vines bifurcate to fill the angular quillons and are interrupted on the languets.

The small pommel disc and dome are decorated with the same diamond trefoils and buds, and are fitted with a bud finial and a green enamel bail featuring a pair of parrots with ruby eyes and diamond wings flanking a pendent diamond bud.

Under the pommel disc, two green enamel panels filled with reserved gold blossoms and foliage detailed with hachures are separated by gold surfaces inscribed in *nasta'liq* in middle-blue enamel. These inscriptions (see p. 321) give the name of the owner, Nawab Mir Akbar Ali Khan Sikandar Jah Asaf Jah III (1771–1829), who succeeded his father as Nizam of Hyderabad in 1802, and an invocation to Imam 'Ali for intercession with God:

His Valiant Highness Sikandar Jah
O 'Ali my succour.

The gold quillon terminals are encircled with small green petals and inscribed in *nasta'liq* in middle-blue enamel with the date on one end and the words *Tayyari Haydara Bad* on the other, probably intended as a wordplay on the name of the city of Hyderabad and the bynames of Imam 'Ali (Haydara, one of the names of the lion by which Imam 'Ali was known) and his brother Imam Ja'far, also known as al-Tayyar, or "he who flies or arises",[39]

Detail of hilt, showing peculiar vertical division of decoration, and downward orientation of flowering plants and buds

and the word *Bad* which can also mean "to thrive". As the future Nizam's name was 'Ali,[40] and as there would otherwise be no apparent reason to include the word *Tayyari* in the inscription, one could be justified in assuming the inscription was meant to imply "[may 'Ali] the lion arise and thrive":[41]

سركار نواب سكندر جاه بهادر
يا علي مددي طياري
حيدر أباد
سنة ١٢١٣هجري

In opposition to their orientation on the hilt, the vines and blossoms featured on the chape grow from the lower end towards the upper edge.

The curved single-edged blade has suffered severe repolishing, is gently fullered along its length, and broadens and is double-edged before the tip.

The upper part of the blade is inscribed in Devanagari script: *Ko Ta Ri* [*Shri?*] *1748* [*Shri?*] *Fa Pa Ra Gujarat 1472*, which, since the hilt features an inscription that clearly attributes it to Hyderabad, is yet another instance of blade replacement.[42]

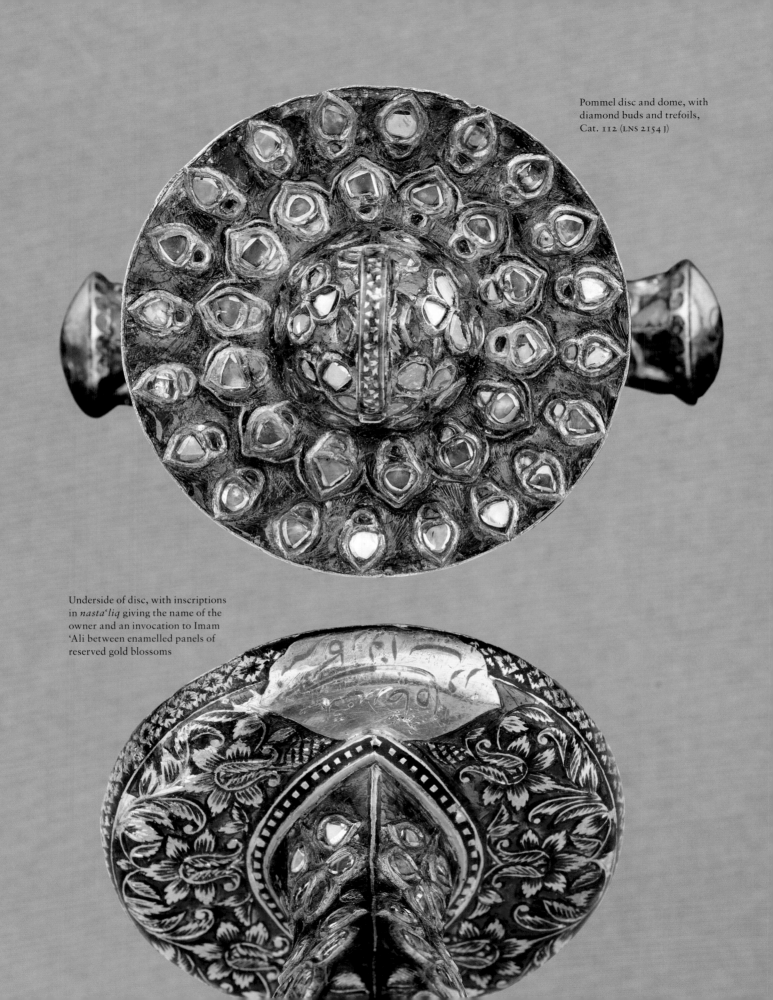

Pommel disc and dome, with diamond buds and trefoils, Cat. 112 (LNS 2154 J)

Underside of disc, with inscriptions in *nasta'liq* giving the name of the owner and an invocation to Imam 'Ali between enamelled panels of reserved gold blossoms

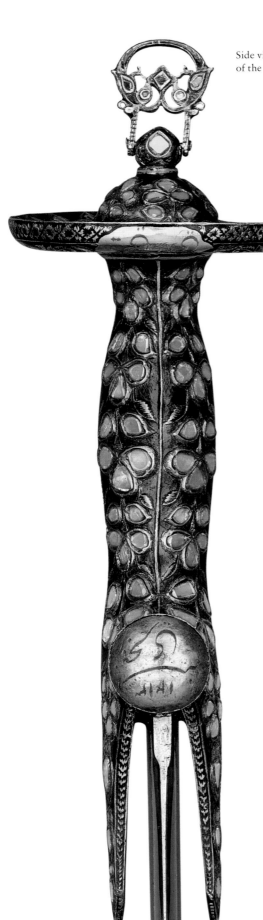

Side view of hilt showing the orientation
of the inscription on quillon terminal

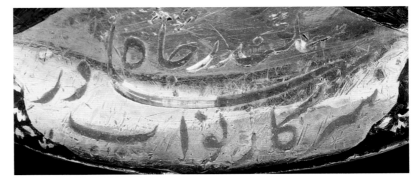

Underside of pommel disc inscribed in *nasta'liq*:
"Sarkar Nawab Sikandar Jah Bahader"

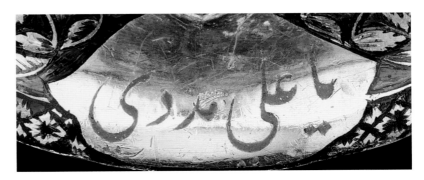

Inscription on opposite side of disc: "O 'Ali my succour"

Inscriptions on quillon terminals: "year 1213 H [1798–99 CE]"
(left) and *Tayyari Haydara Bad* (right)

Cat. 113 JEWELLED SWORD
Deccan or Mughal
dominions, late sixteenth–
early seventeenth century
Blade of *jawhar* steel (mounted the
wrong way round at a later stage),
overlaid with gold; hilt of gold over
an iron core, partially engraved
and set in *kundan* technique with
rubies, emeralds and diamonds
Dimensions: Length 90 cm; width 7.5 cm
Provenance: Art market 1999
Published: Christie's, London, 20 April 1999,
lot 401; Curatola et al. 2010,
cat. 273
Inv. no. LNS 2195 J

For some undetermined reason the pommel of this sword
screws onto the grip, and since the only apparent motive
would be to allow the owner the option of substituting a
different pommel, which seems unlikely, the matter must
unfortunately remain unresolved.

The contrast between the quality of work in the
imbricated pattern of rubies and emeralds covering
the head of the parrot, and that of the finely detailed
floral settings of the ruby and faceted diamond eyes, the
diamond crest and the expanse of gold detailed with half-
palmettes surrounding the ruby beak, is such that they
might have been executed by different craftsmen.

An emerald collar sets off the pommel from the
grip, which is set with a chevron pattern of emeralds
alternating with paired ruby bands straddled with
emerald trefoils on the front, back and sides of the grip.

The down-swept quillons end in buds set with rows of
rubies and emeralds, and are of a variety that originated
in antiquity and endured throughout the medieval
Islamic period, when it was illustrated in the *Maqamat*
of al-Hariri dating from the first half of the thirteenth
century.[43] This quillon type was also popular during the
Timurid period, when down-swept quillons were often
fitted with the dragon heads so popular in the East, and
the style persisted afterwards in Iran and India.[44]

The single-edged *jawhar*-patterned blade, which
may or may not be original, was mounted the wrong
way around in recent times and is now tightly stuck in
place with modern glue. It broadens towards the tip
and is inlaid in gold with degenerate inscriptions
(probably recent) enclosed in both a medallion and
a pendent star blossom.

Late and degenerate
inscriptions on blade

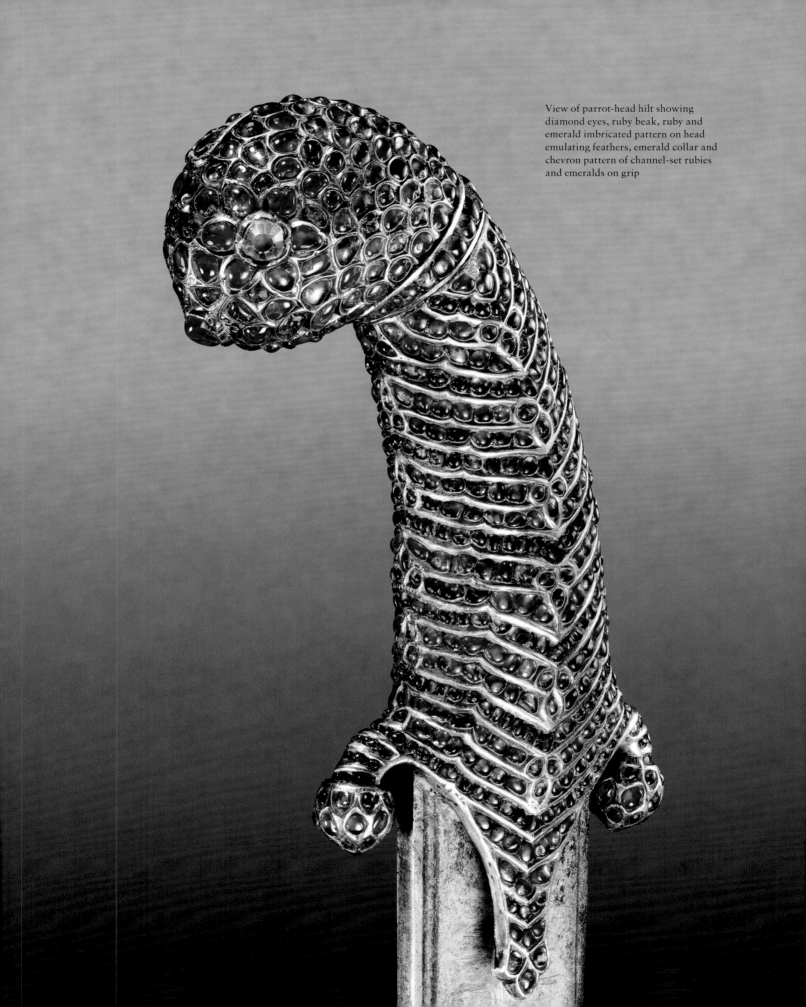

View of parrot-head hilt showing
diamond eyes, ruby beak, ruby and
emerald imbricated pattern on head
emulating feathers, emerald collar and
chevron pattern of channel-set rubies
and emeralds on grip

Back of parrot-head pommel,
displaying a diamond crest,
Cat. 113 (LNS 2195 J)

Front of pommel, with parrot's
ruby beak surrounded by engraved
gold, and threaded shaft allowing
the pommel to be unscrewed

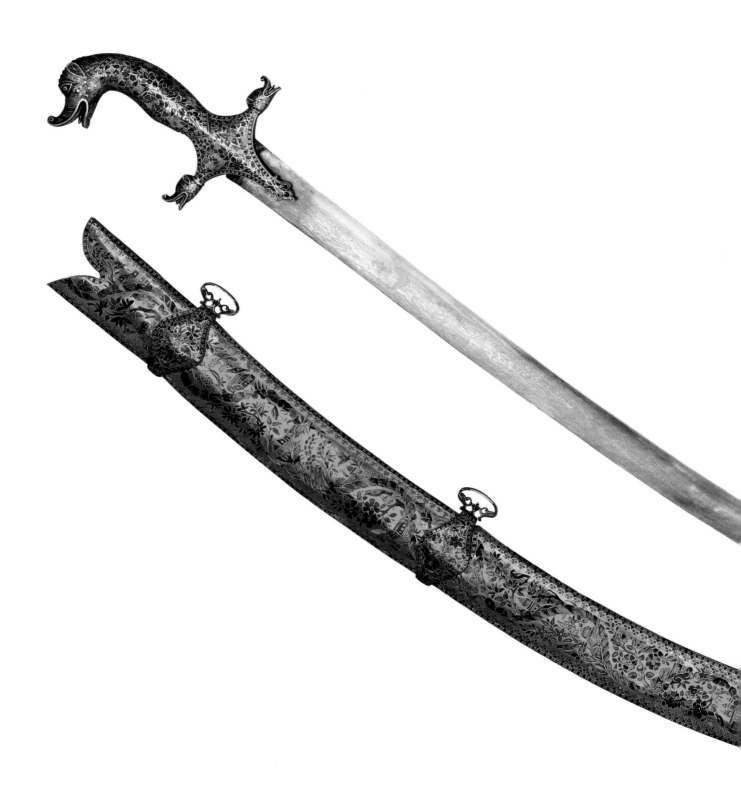

**Cat. 114 ENAMELLED SWORD
AND SCABBARD
Probably Lucknow,
eighteenth century**
Hilt and scabbard, silver,
champlevé enamelled and gilded;
blade of *jawhar* steel
Dimensions: Length of sword 99 cm;
width of hilt 10 cm;
length of scabbard 87 cm
Provenance: Art market 2000
Published: Spink & Son, London, 1 October
2000, cat. 35; Keene 2004b, pp. 107,
112–16; Markel 2010, p. 205,
cat. 93; Curatola and Kaoukji
2016, cat. 176
Inv. no. LNS 1124 M ab

The makara, or aquatic monster, which constitutes the major decorative element of the hilt of this sword, symbolizes protection in Hindu mythology and was also adopted as a motif in areas under Muslim rule. The makara, whose name means "aquatic dragon" in Sanskrit, served as a vehicle for some of the Hindu gods, and was depicted as early as the third century BCE in the Maurya period rock-cut cave of Lomas Rishi.[45] It must also have been a symbol of power and military might as it adorned the tip of the club of Kanishka I, emperor of the Kushan dynasty, who reigned in the second century CE.[46]

The sword hilt curves gently to form a crested makara head with a wide-open, curling snout exhibiting an articulated tongue and minuscule teeth, while smaller versions of the makara head (bar the articulated tongue) serve as quillon terminals. In contrast with the remaining surface of the sword, which is decorated with floral motifs, birds and pavilions set in landscapes, the larger makara head has been provided with detailed features befitting the monster. The large eyes are outlined with long, curling and bristly eyebrows, the folds on the curling snout are detailed with bands of cobalt-blue and turquoise enamel, the ears are upright and alert, and on the front and sides of the head detailed tufts of fur under transparent turquoise enamel (much of which has now flaked off) are augmented with gold dots, whereas on the back of the head the tufts of fur are covered with cobalt-blue enamel.

Once again, as in Cats. 108–111, an ovate panel covers the grip[47] and encloses a profusion of flowers rendered in stencil effect with bright transparent and opaque enamels, including turquoise, purple, cobalt blue, pale blue, yellow and shades of green. Outlining the grip and guard are cobalt-blue enamel bands with reserved quatrefoils, comparable to the border of the archery ring Cat. 141 and to bands outlining a cloven-pommel dagger in the Freer Gallery of Art dating from the second quarter of the seventeenth century.[48]

The palette of enamels that decorates the scabbard includes all the colours used on the hilt, as well as a bright orange.[49]

On the scabbard front a scrolling torsade separates different landscape scenes, much in the style of rocks or streams in Persian painting from the Timurid period.[50] The scenes include architectural structures sheltered by outsized trees on which perch outsized birds, possibly to convey a sense of perspective. On the back an impressive scroll of split acanthus leaves issues a variety of floral sprays in the scroll bends and blossoms in the leaf bracts.

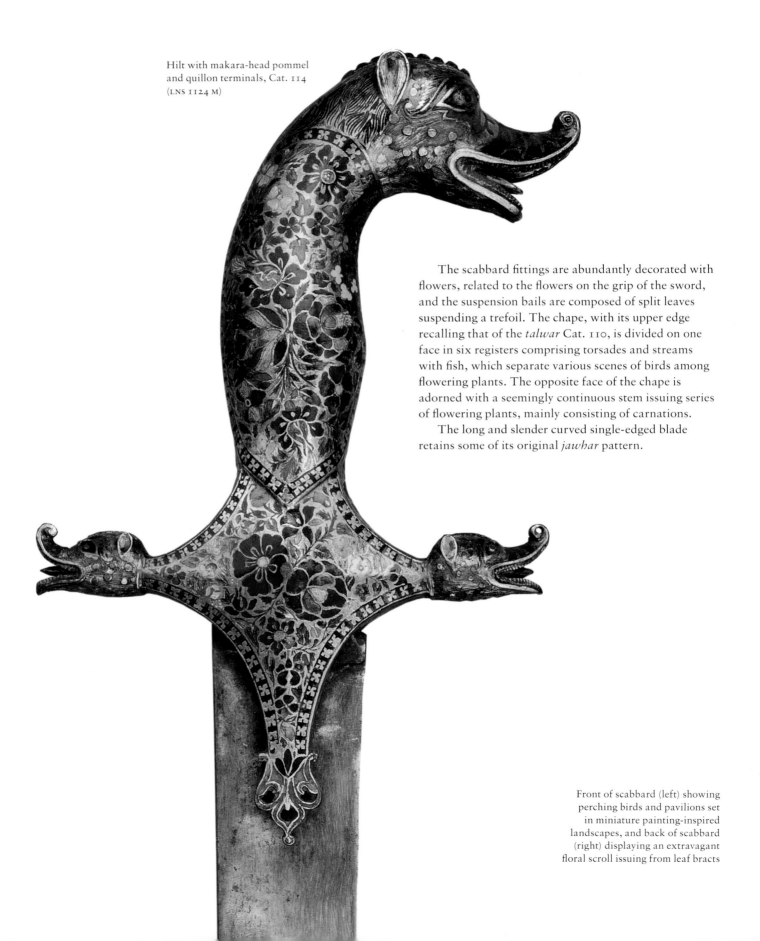

Hilt with makara-head pommel and quillon terminals, Cat. 114 (LNS 1124 M)

The scabbard fittings are abundantly decorated with flowers, related to the flowers on the grip of the sword, and the suspension bails are composed of split leaves suspending a trefoil. The chape, with its upper edge recalling that of the *talwar* Cat. 110, is divided on one face in six registers comprising torsades and streams with fish, which separate various scenes of birds among flowering plants. The opposite face of the chape is adorned with a seemingly continuous stem issuing series of flowering plants, mainly consisting of carnations.

The long and slender curved single-edged blade retains some of its original *jawhar* pattern.

Front of scabbard (left) showing perching birds and pavilions set in miniature painting-inspired landscapes, and back of scabbard (right) displaying an extravagant floral scroll issuing from leaf bracts

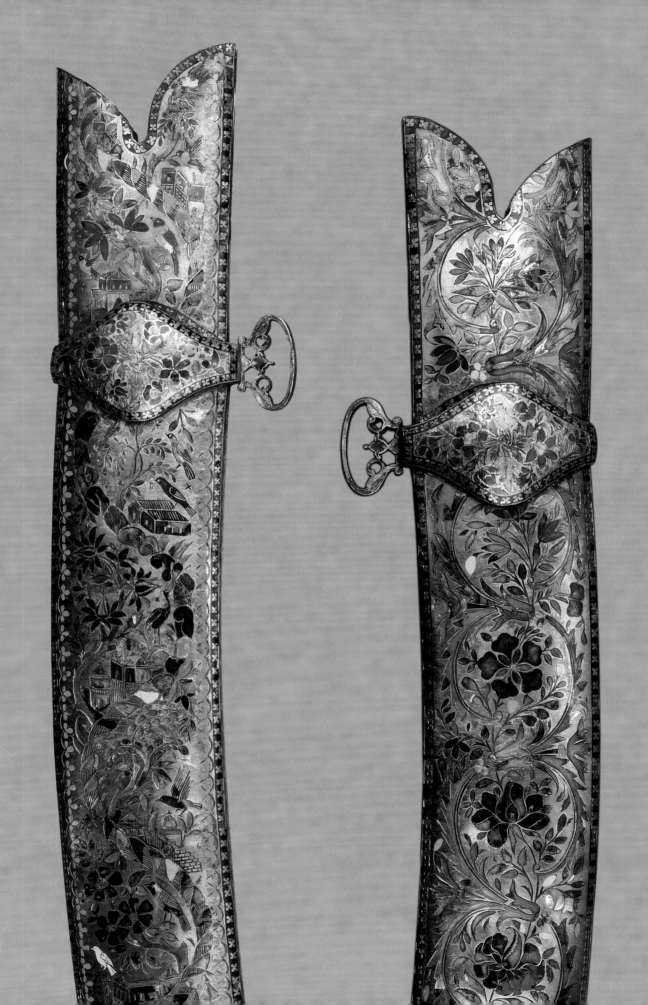

NOTES

1 For representations of such hilts in manuscripts from the Sultanate period, see Goswamy 1988, cats. 3, 5, 6, 9 and 17, and from the Deccan, see Zebrowski 1983, p. 25, fig. 12, col. pl. XVII.

2 Seyller 2002, p. 168, cat. 54, depicting two swords of the same type in which the curve of one is more pronounced than the other.

3 Ibid., detail pp. 202–03, cat. 66.

4 Numerous representations of the type of cat. 101 can be seen in the *Hamza-nameh*, ibid.

5 Two swords with related pommels attributed to the sixth–seventh century CE can be seen in Richardson 1989, p. 177 (bottom).

6 Seyller 2002, cat. 66, detail on p. 202.

7 Sims et al. 2002, p. 274, cat. 192.

8 Jidejian 2006, p. 89, refers to the Assyriologist A. Leo Oppenheim's "Babylonian and Assyrian Historical Texts" in *ANET* [*Ancient Near Eastern Texts*], 1969, p. 276.

9 Biruni 1984, pp. 208–10.

10 An organic substance found in the stomachs of antelopes which was believed to serve as an antidote against poison.

11 Laufer and Pelliot 1913, pp. 353–54 (a Chinese term which is now no longer in use in China, for which see Laufer 1916, p. 353).

12 Biruni 1984, p. 209.

13 A *dhira'* is a unit of measurement now equivalent to the length of an arm.

14 The length of narwhal (*Monodon monoceros*) tusks varies from 2 to 3 metres.

15 Biruni 1984, pp. 318–19 and 328.

16 Palace guards from the *Simhala Avadana* and a hunter of the King of Benaras from the *Mriga Jataka* (both from cave 17), attributed to the end of the fifth century CE, appear to carry swords with related types of hilts, Behl 1998, pp. 224 and 232.

17 See Deva 1990, vol. II, esp. p. 421, fig. 18.

18 In this case the pommel is fitted on a dagger, Pal 1993, pp. 66–67, cat. 7B.

19 Gul Badan Begam 1983, p. 33 in the Persian text.

20 Chandra 1976, facs. fols. 27R, 36V, 66R (with a knuckle guard), 99V (with a knuckle guard) and 321V.

21 Leach 1995b, figs. 9.27, 9.73, 9.51 and 9.108; Elgood 2004a, figs. API 3, API 6, API 10 and API 11.

22 Several examples of the type can be seen in the armouries of Rajput states: see e.g. Elgood 2015, cats. 84 and 85, especially the quillon of cat. 84, which most likely hails from the Deccan.

23 See e.g. cat. 105.

24 Regarding verses from the Qur'an referring to the prophet Ibrahim, see references to inscriptions on the Ibrahim Rauza, Haidar and Sardar 2011, pp. 245–46, 252, 255–56.

25 Ibid., pp. 252 and 256, n. 6.

26 Related sword hilts can be seen in the Khajuraho Lakshmana temple friezes from *c.* 930–50, Deva 1990, vol. II, esp. p. 421, fig. 18, and the Ajanta Caves, esp. in the *Simhala Avadana* and the *Mriga Jataka* (both from cave 17), attributed to the end of the fifth century CE, Behl 1998, pp. 164, 217, 224 and 232; also, the same type of pommel is fitted on a dagger depicted on a folio from a *Pancharaksha* manuscript, Bihar, dated 1160–61 CE, Pal 1993, pp. 66–67, cat. 7B.

27 A *talwar* with floral decoration closely related to this example can be seen in a border of *The Late Shah Jahan Album* attributed to *c.* 1650–58, Leach 1995a, cat. 3.49, esp. the detail on p. 436.

28 Haidar and Sardar 2015, cats. 27, 28, 32, 33, 54, 56 and 57.

29 A petal crossing the centre of a blossom can be seen on a bidri tray, Haidar and Sardar 2015, cat. 92.

30 See e.g. the edges of the side-bars of cats. 6 and 10, the edges of the lockets of cats. 48 and 61, the edges of the chapes of cats. 63 and 106, and on the back of the hilt of cat. 76.

31 See Keene and Kaoukji 2001, an enamelled box (cat. 6.48), a *huqqa* mouthpiece (cat. 6.49), a bracelet (cat. 6.55), and a *katar* (cat. 7.14) featuring identical vegetal motifs, and the decoration on a dagger and scabbard reportedly from the Deccan in the Khalili Collection (inv. MTW 1146), Shcherbina 2014, cat. 127, pp. 224–25.

32 The same style applies to cats. 109, 110 and 111, and on the enamelled sword with a makara-head pommel, cat. 114.

33 Leach 1995a, p. 351, pl. 52.

34 The type is clearly visible on the sword worn by the courtier depicted wearing a red turban and green jama, on a folio attributed to *c.* 1635, Beach and Koch 1997, pl. 13, esp. the detail, p. 112.

35 Zebrowski 1997, pls. 440 and 441; The al-Sabah Collection inv. no. LNS 822 M (unpublished), and Keene and Kaoukji 2001, cat. 10.3.

36 For a similar rendering of lobed lotus leaves, see Zebrowski 1997, pls. 440 and 469.

37 Active during the reign of Shah 'Abbas I (1571–1629).

38 Kalus 1980, p. 46, cat. 20 (with ref. to Mayer, Geneva 1962, p. 44).

39 Imam Ja'far al-Tayyar lost both arms and was killed in battle against the Byzantines, and was reportedly named "Ja'far al-Tayyar" by the Prophet Muhammad, who had a dream of him arising or flying to heaven on two bloody wings.

40 It is noteworthy that one of his titles was Lion of the State (*Asad al-Dawlah*) – *asad* being yet another name for the lion in Arabic.

41 We are grateful to Manijeh Bayani for helping us to interpret the inscription.

42 We are grateful to Anupam Sah for confirming the reading of the inscriptions on the blade.

43 Bibliothèque Nationale de France, MS Arabe 3929, e.g. *maqama* 32, fol. 85r, and *maqama* 38, fol. 129r.

44 For a similar treatment of quillon tips, see cat. 46.

45 On both ends of the arched doorway carved with elephants of the Lomas Rishi Caves, Barabar Hills, Bihar.

46 Rosenfield 1967, fig. 2b.

47 See note 17 to cat. 108.

48 Atil et al. 1985, cat. 34.

49 For the enamels on this sword and scabbard, see Keene 2004b, pp 99–125, esp. figs. 21–26.

50 Especially, a painting from a *Khamsah* of Nizami made for Sultan Shah Rukh, dated 1431, Adamova 1996, cat. 1.3, pp. 100–01. A dagger and scabbard in the Furusiyya Art Foundation feature closely related decoration, Mohamed 2008, cat. 220.

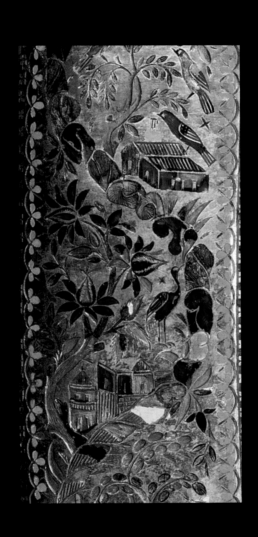

CHAPTER ELEVEN
CRUTCHES, A STAFF FINIAL AND A PERCH
A POSSIBLE ASSOCIATION WITH CHINESE DAOISTS

Crutch armrests of the type represented here do not seem to be part of the Iranian and pre-Mughal Indian repertoire. They only begin to appear in India fitted above long staffs carried by palanquin (*palki*) bearers in paintings from the end of the sixteenth and very early seventeenth centuries.[1] In all likelihood, other than serving as a support, the palanquin bearers' staffs were fitted with concealed blades that would have been indispensable if the need arose to protect themselves from the attacks of humans or animals. Cat. 119 is the only example in the Collection fitted with such a blade.

Towards the middle of the seventeenth century, crutches of the type fitted with short staffs (such as Cat. 125) can be seen in paintings associated with holy men and ascetics who use them as arm- or hand rests when seated on the ground.[2] These crutches would also have been used for protection during their ascetic wanderings through the wilderness.

It is conceivable that such crutches used by holy men might have their origins (or share a common lineage) with the Daoist Eight Immortals, whose representation as a consistent group was established during the Yuan period.[3] The Immortal Li T'ieh-kuai, who was identified by such a crutch, practised mental and physical purity and reportedly dwelt, scantily dressed, in a rocky hermitage or mountain cave.[4] These attributes appear to correspond with depictions in miniatures of Indian holy men, whose reported wanderings as far as the borders of China could contribute to our understanding of the seemingly sudden adoption of this type of crutch in paintings. Strangely enough, the type does not appear in paintings representing the upper echelons of Indian society, who are generally depicted leaning on long staffs with knob-like or upright finials,[5] although in all likelihood crutch-heads carved from precious materials would only have been intended for the elite and their retinue.

The Daoist Immortal Li T'ieh-kuai (Iron-Crutch Li) portrayed
with his crutch in a sixteenth-century Ming painting by Zhang Lu

Detail of miniature painting depicting the religious ascetic Mulla Shah
Badakshi in meditation, with armrest in the foreground, Mughal, 1627–28

THREE UNUSUAL ARMRESTS

Most armrests are carved with flower-head or bud finials, and more rarely with animal heads such as the ram finials of Cat. 118. These three uncommon armrests (Cats. 115–117) are exceptionally carved in the form of Indian blackbucks (*Antilope cervicapra*), and to our knowledge are the only extant examples other than one in the Salar Jung museum, Hyderabad,[6] and another from a private collection shown during the Indian Heritage exhibition at the Victoria and Albert Museum in 1982.[7]

As the fine and naturalistic renderings of blackbucks on Cats. 115 and 116 are related in style and composition, and these two armrests stand above Cat. 117 in craftsmanship, it is conceivable that they were carved by the same person. Whatever their relationship, they are a tribute to the artistic sensitivity and skill of whoever carved them. And had one not first laid eyes on these two examples, the third, Cat. 117, would certainly have been of great interest, as it is also beautifully carved.

With rigorous naturalistic realism and a marked sensitivity to anatomical detail, special attention was given to rendering the blackbuck's features: its undulating ribbed horns, prominent eyes and, in the case of Cats. 115 and 116, to the preorbital-gland secretion oozing out of the corner of the eyes.

Interestingly, all known examples of carved blackbucks are bridled with delicately rendered corded nosebands and reins that encircle the animals' mouths, cross over their preorbital glands and under their ears, and are retained under their chins with buckle-strap loops that join the nosebands to the reins. In addition, the blackbucks on Cat. 115 are adorned with necklaces and pendants, with a button clasp on the top of the animals' heads between their horns, and one end of the cord and a tassel (*funda*) hanging just below the ear on one side of the blackbucks' heads.

As in Cat. 118, the base of Cat. 116 nests in a poppy blossom with overlapping and fluted petals, from which unwinds a small cord that touches on a smaller blossom carved in high relief in the centre of the armrest. Cat. 117 nests in a stylized acanthus leaf, and Cat. 115 in four naturalistic veined acanthus leaves. The shaft stem of Cat. 116 is encircled with finely carved minuscule petals, whereas that of Cat. 115 is carved with mouldings.

All three are drilled with large holes, which would have been fitted with the tang of a blade or staff.

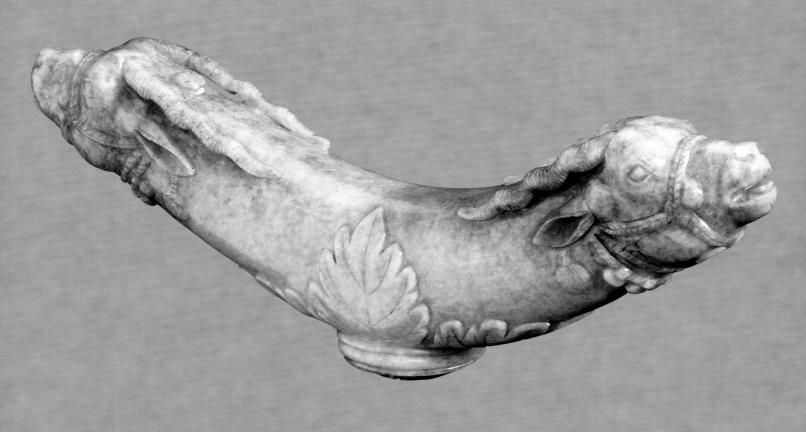

Cat. 115 **CRUTCH ARMREST**
Deccan, first half of the
seventeenth century
Carved from nephrite jade

Dimensions: Height 5 cm; width 15 cm
Provenance: Art market 2014
Published: Sotheby's, London, 24 April 2013,
lot 209
Inv. no. LNS 1029 HS

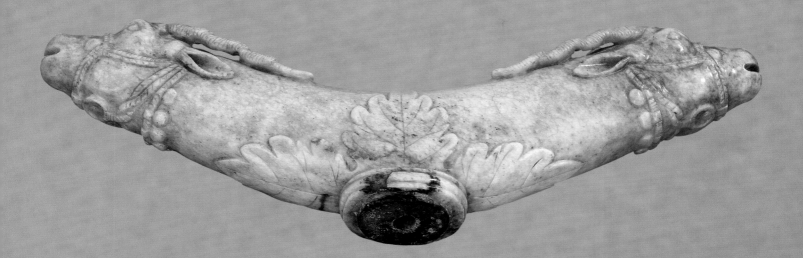

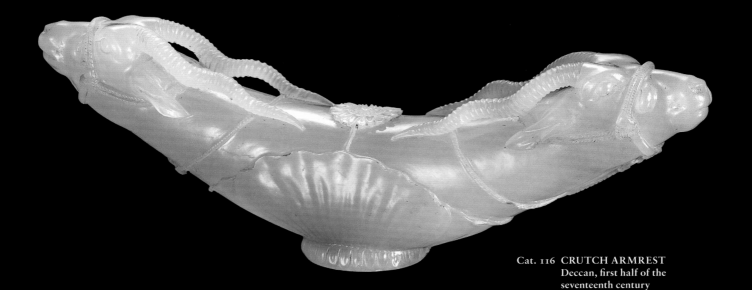

Cat. 116 CRUTCH ARMREST
Deccan, first half of the
seventeenth century
Carved from nephrite jade
Dimensions: Height 4.5 cm; width 13 cm
Provenance: Art market 2004
Published: Curatola et al. 2010, cat. 282
Inv. no. LNS 633 HS

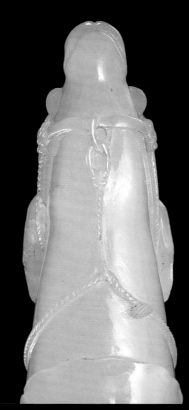

Top of armrest showing the small
blossom and undulating horns

Underside showing the reins,
carved corded noseband and
buckle strap loops

Cat. 117 CRUTCH ARMREST
Deccan, mid seventeenth
century
Carved from nephrite jade
Dimensions: Height 6 cm; width 16.5 cm
Provenance: Art market 2004
Inv. no. LNS 632 HS

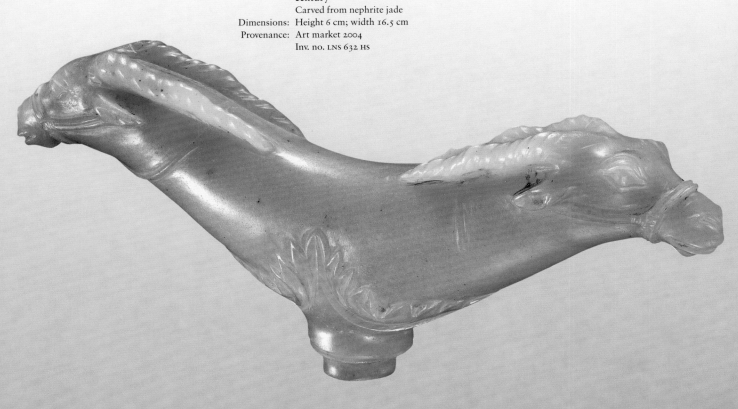

Cat. 118 CRUTCH ARMREST
Deccan or Mughal
dominions, first half of
the seventeenth century
Carved from nephrite jade
Dimensions: Height 7.5 cm; width 14 cm
Provenance: Art market 1994
Published: Keene and Kaoukji 2001, cat. 8.15
Inv. no. LNS 213 HS

Finely carved with two superbly anatomically observed collared ram-head finials, this armrest is supported by a short cylindrical stem that once capped a staff. Worthy of note are the detailed rendering of the snout, with a slightly open mouth and a fine groove suggesting the tongue; the prominent eyes, above which develop the ribbed faceted horns; the modelled ears that emerge from tufts of hair and overlap parts of the curling horns; and the back of the head, which is carved to suggest tufts of fur.

The armrest is undecorated, save for the underside, which features a relief-carved poppy with overlapping petals wherein each petal is carved with a small petal-like device at its base, representing the dark patches on the base of poppy petals.

Deeply grooved linear stems project from between the larger petals, most likely a later intervention to receive gold inlay, of which they retain traces, since they do not match the style of the rest of the carving.

Separating the armrest from the support is a moulding with a chevron pattern, from which radiate relief-carved acanthus leaves that enfold most of the cap. The cap features a recessed circular disc on the bottom, and is drilled through with a large hole to receive the tang of a blade or staff.

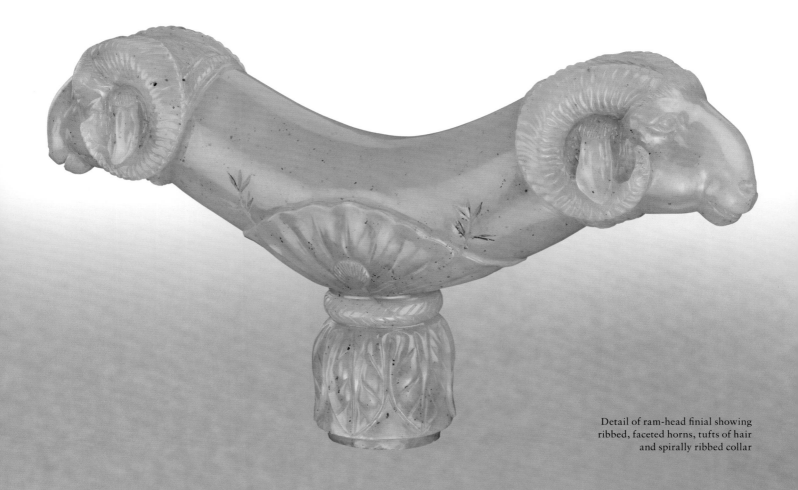

Detail of ram-head finial showing
ribbed, faceted horns, tufts of hair
and spirally ribbed collar

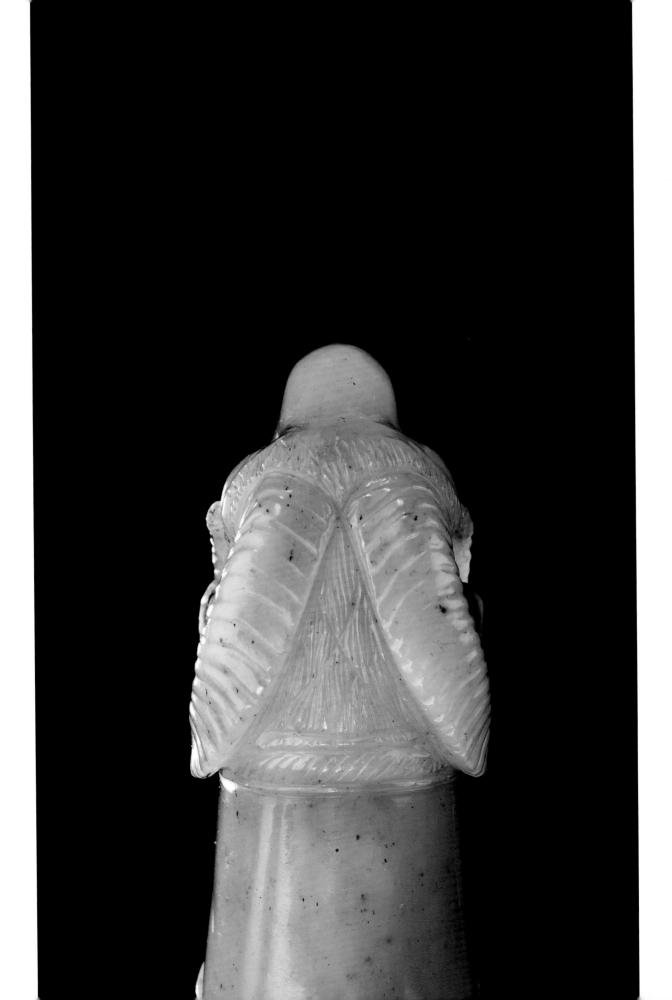

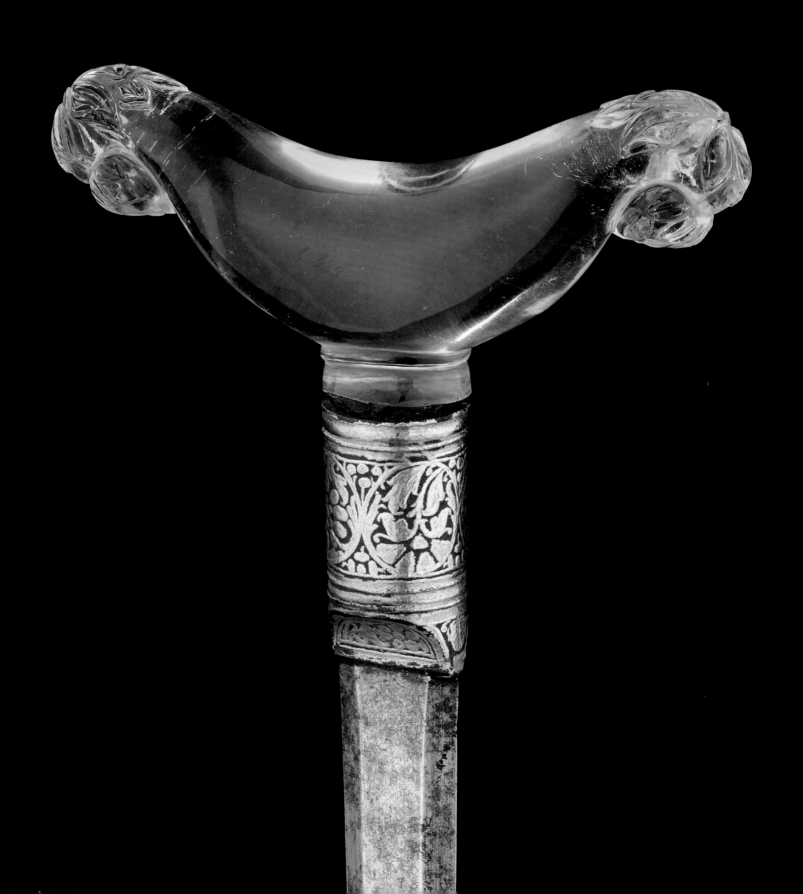

Cat. 119 **CRUTCH ARMREST WITH BLADE**
Probably Deccan, probably mid seventeenth century
Handle carved from rock crystal; blade of *jawhar* steel; steel ferrule overlaid with gold
Dimensions: Height 47 cm; width 10 cm
Provenance: Art market 1980s
Inv. no. LNS 10 HS

This armrest is of pleasingly ample proportions, tapering to finely carved undulating sepals and leaves suspending stemmed bud finials. These finials recall the handles of some Mughal and Deccan seventeenth-century jade vessels[8] and the unusual pommel of Cat. 91, which has a leaf suspending a bunch of berries.

Three graduated layers of finely carved sepals and leaves cover the upper ends of the finials, and single layers of leaves partially conceal the stems that suspend the buds. A relief-carved layer of veined sepals enfolds the upper ends of the buds, whereas the remaining petals are merely detailed with carving.

The steel ferrule is decorated with a gold-overlaid spiralling floral scroll with berries in the intervening areas that evoke floral decoration on bidri-ware. The long, faceted double-edged blade exhibits surface corrosion.

Detail of armrest, with finials comprising sepals and leaves suspending buds, and ferrule decorated with floral scrolls

Cat. 120 **STAFF FINIAL**
Deccan or Mughal dominions,
late sixteenth–first half of
the seventeenth century
Carved from patterned agate;
fitted with a copper alloy ferrule
for mounting on a shaft
Dimensions: Height including ferrule 4 cm;
diameter 4 cm
Provenance: Art market 1999
Published: Christie's, London, 12 October
1999, lot 122; Keene and Kaoukji
2001, cat. 9.23
Inv. no. LNS 374 HS

Long staffs fitted with variously shaped finials can be seen in many Indian paintings, but this particular type of finial seems to have been the fashion towards the later part of the sixteenth century, as it appears quite frequently in the *Akbar-nameh* manuscript from *c.* 1590–95.[9]

This finial was carved in the form of a poppy blossom by a master cutter whose skill and good grasp of the material enabled him to work the three layers of petaloids into the concentric pale grey and white bands of agate on the top of the finial.

Five large drooping and overlapping petals overturned along their edges encircle the petaloids, and are carved with rounded petal-like protuberances representing the dark patches on the base of poppy petals.

One of the large petals features a natural circular inclusion of white and black material.

Cat. 121 CRUTCH ARMREST
Deccan, probably mid
seventeenth century
Carved from nephrite jade; set with
foiled rock-crystal at a later date

Dimensions: Height 5 cm; width 14 cm;
thickness 2.5 cm

Provenance: Art market 1998, reportedly
from Hyderabad

Published: Keene and Kaoukji 2001, cat. 9.24

Inv. no. LNS 343 HS

This armrest is of typical form, and comprises three
pieces of jade. The deep-green central segment is
carved with an integral ring that serves to cap the staff,
which is encircled by four broad leaves carved in subtly
rounded relief.

Virtually identical but slightly smaller leaves encircle
the terminals and issue spiky calyces (mostly broken off
at their tips) that support the white-jade bud finials.

The bud finials are composed of four layers
of finely carved, lobed petals. The rock-crystal
cabochons, backed with red foil to simulate rubies,
were set in the centre of the buds at a later date,
disrupting the surrounding carving.

Detail of finely carved jade bud
finial with later foil-backed rock-
crystal cabochon emulating a ruby

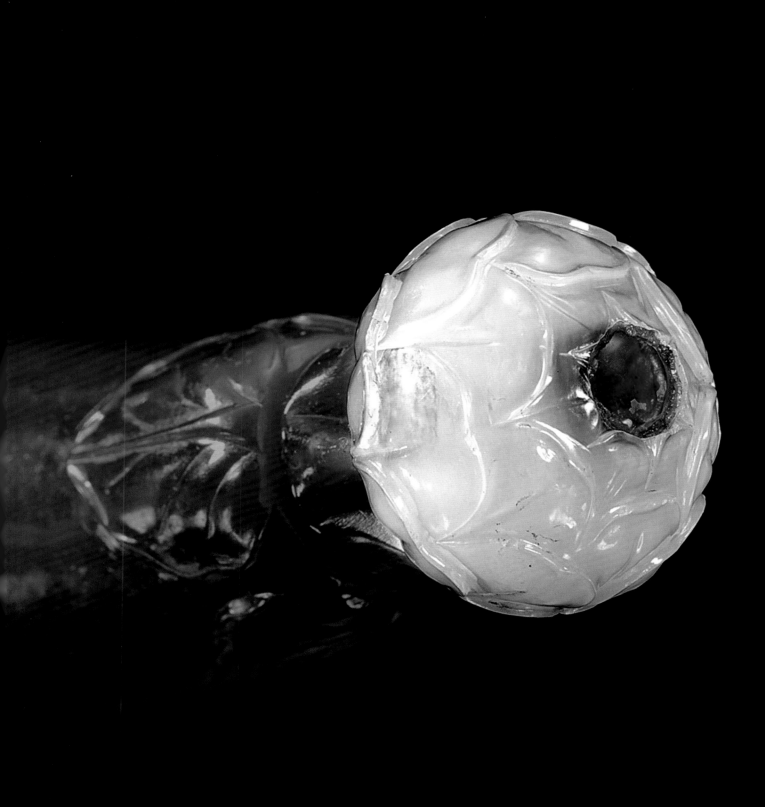

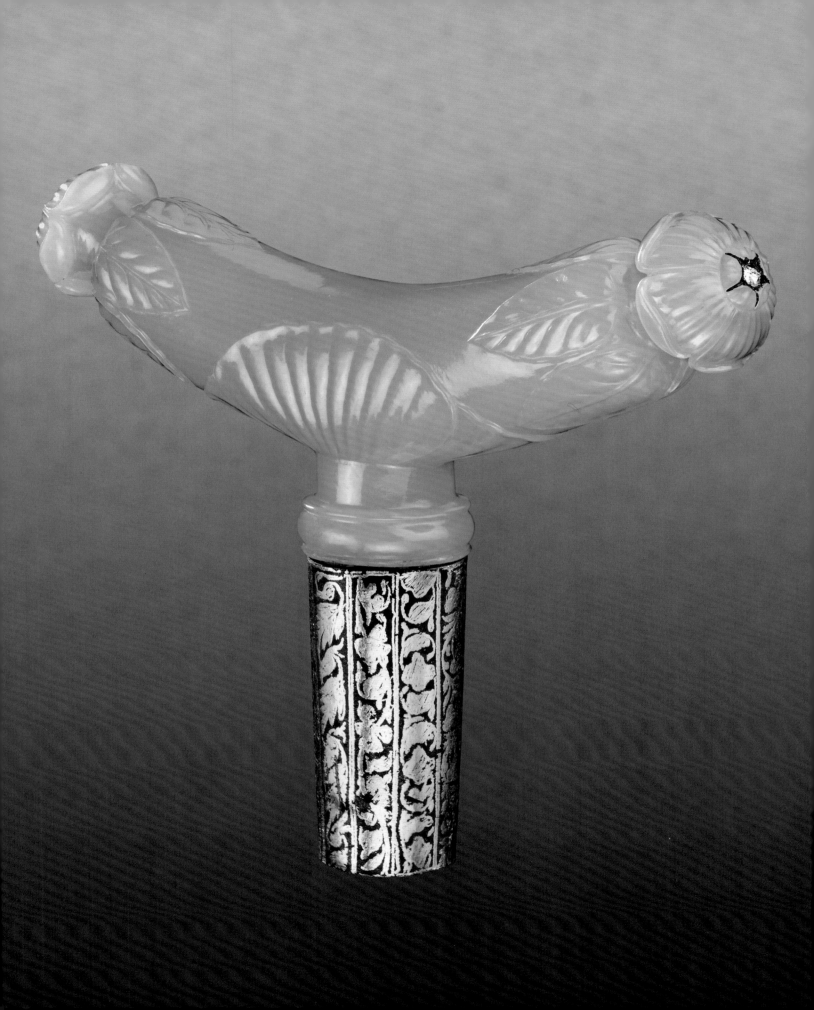

Cat. 122 **CRUTCH ARMREST**
Probably Deccan, probably
mid seventeenth century
Carved from nephrite jade; inlaid
with gold and set with a gemstone
in *kundan* technique; steel ferrule
overlaid with gold
Dimensions: Height 8.5 cm; width 11.5 cm
Provenance: Art market 1992
Published: Sotheby's, London, 29 and 30 April
1992, lot 472; Keene and Kaoukji
2001, cat. 9.25
Inv. no. LNS 124 HS

The underside of this armrest is carved with a large ribbed
poppy blossom with overlapping petals. Five veined leaves
carved in subtly rounded relief encircle the terminals. The
finials are treated as stemmed flower-heads with drooping
ribbed petals overturned along their edges, which once
again recall the bud finials of seventeenth-century
Mughal and Deccan jade vessels.[10] The flower centres are
composed of five minuscule petals converging towards a
gemstone (now lost), of which only part of the gold inlay
remains.

The tubular ferrule, inside which are wire-formed
threads for screwing the armrest onto a shaft, is decorated
with vertical bands of counterchanging foliate scrolls, and
it is worthy of note that each of these scrolls differs from
the others.

Cat. 123 CRUTCH ARMREST
Probably Deccan, probably
mid seventeenth century
Carved from nephrite jade; inlaid
with gold in *kundan* technique and
set with rubies, rock crystal, lapis
lazuli and jade
Dimensions: Height 3.5 cm; width 12 cm
Provenance: Art market 1994
Published: Keene and Kaoukji 2001, cat. 2.29
Inv. no. LNS 214 HS

This armrest is carved from three pieces of jade, comprising two bud finials and a
central segment drilled on the bottom for fitting onto a staff.

Encircling the centre of the armrest are three foiled rock-crystal rosettes with
ruby centres. The intense golden yellow of the crystal rosettes is imparted by underlaid
coloured foil.

The rosette on the upper centre of the armrest is set apart from the rosettes on the
front and back, which issue curling gold vines bearing dark-green jade veined leaves.
Gold festoons border the ends of the central segment and suspend carved lapis lazuli
iris blossoms on their central cusp, each of which issues a pair of dark-green jade buds
and a veined jade leaf.

Both bud finials are set on their extremities with rock crystal carved as multi-petalled
flowers. The flowers have ruby centres that recall the flowers carved on the staff finial
Cat. 120, and they are foiled in the same deep yellow as the rosettes in the centre of the
armrest. Each rock-crystal rosette nests in a surround of jade fluted petals with fluted
dark-green jade sepals in gold settings of high silver content.

These settings, together with the gold fillets that separate the middle section from
the terminals, are engraved with transverse lines forming compartments that are ticked
in their centres.

Detail of bud finial, with foil-backed multi-petalled
rock-crystal flower set with a ruby cabochon

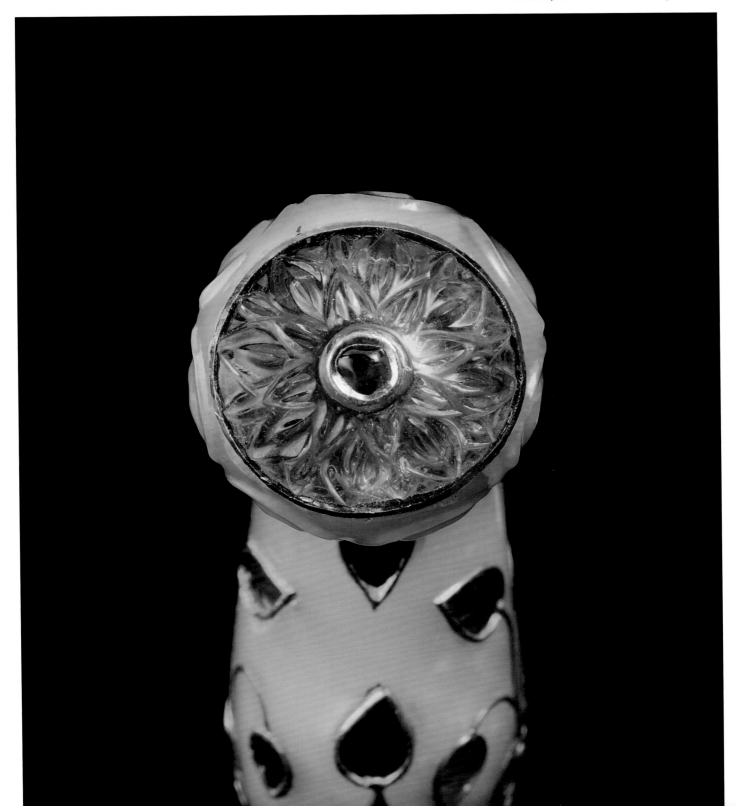

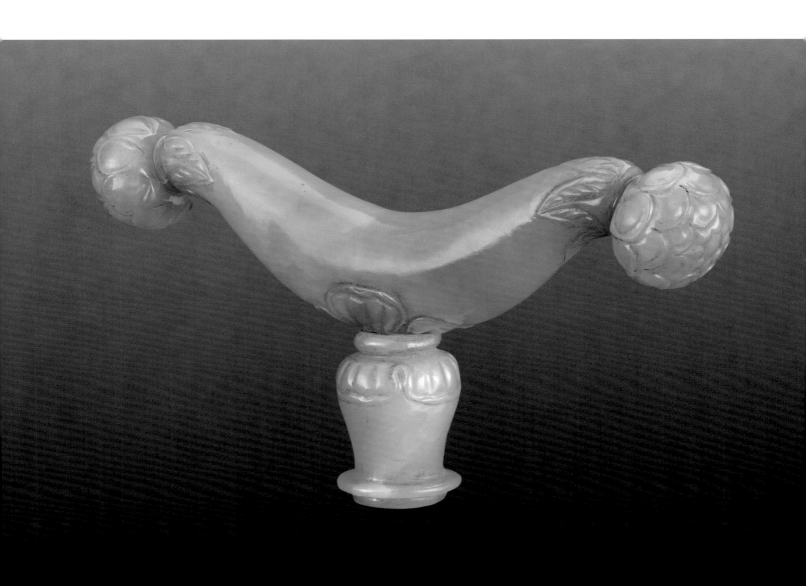

Cat. 124 CRUTCH ARMREST
Mughal dominions or Deccan,
probably eighteenth century
Carved from nephrite jade;
steel tang
Dimensions: Height 5.5 cm; width 12 cm
Provenance: Art market 2004
Published: Christie's, London, 12 October
2004, lot 162
Inv. no. LNS 658 HS

Unlike previous examples (Cats. 118–19 and 121–23) the central segment of this armrest is unusually slender and curvilinear, and inordinately constricted at the finials and above the baluster-shaped cap, which still retains the iron tang of a former blade or shaft.

Despite the fact that the object displays signs of having come from a tradition of fine carving, such as the rendering of the bud finial petals, the treatment of the leaves encircling the finials and the attempt at overturned edges on the petals encircling the shaft cap, the carving is clearly not of the same quality as examples from the sixteenth and seventeenth centuries.

Cat. 125 CRUTCH
Probably Deccan, perhaps
late seventeenth or early
eighteenth century
Handle carved from rock crystal;
shaft carved from wood and fitted
with a copper ferrule and cap
Dimensions: Height 51 cm; width 10 cm
Provenance: Art market 1991, reportedly from
Hyderabad
Inv. LNS 67 HS

As in the following armrest, Cat. 126, the finials of the armrest of this crutch are decorated in the same manner as the pommels of pistol-grip hilts, in that pinnate leaves line their upper edges.

The decoration differs from that of pistol-grip hilts in that it centres on a quatrefoil carved in the upper centre of the armrest, issuing pinnate leaves that dangle over its sides.

On the front and back of the armrest are iris blossoms, and fluted pinnate leaves develop from either side of the shaft and extend to the finials.

The tubular wooden shaft is fitted with a plain copper ferrule and has a copper cap on its lower tip.

Top of armrest with carved
quatrefoil and pinnate leaves
covering finials

Side of armrest with carved
dangling leaves and iris blossom

Cat. 126 **CRUTCH ARMREST**
**Probably Deccan, perhaps
late seventeenth or early
eighteenth century**
Carved from rock crystal
Dimensions: Height 7 cm; width 21 cm
Provenance: Art market 2000
Published: Sotheby's, London,
12 October 2000, lot 200
Inv. no. LNS 507 HS

Although slender and elongated crutch handles are frequently represented in miniature paintings from the first half of the seventeenth century,[11] the decorative scheme of this armrest does not place it during that period.

This armrest differs from the typical variety in that its upper edges and finials are treated in the same manner as the pommels of pistol-grip hilts: long pinnate leaves cover the upper edges of the armrest and finials and issue vines in the curl of the finial that coil around the sides, ending in large flower-heads.

In the centre of the armrest a large lobed and cusped medallion features a small flower-head in its centre. Four stylized acanthus leaves extend to the finials along the underside of the armrest, while the tips of the leaves on the front and back overlap the lobed medallion in the centre.

A faceted honeycomb-pattern fills the intervening surfaces.

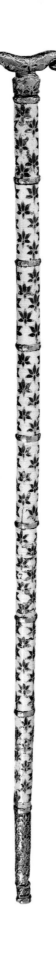

Cat. 127 PERCH FOR A SMALL BIRD
Mughal dominions or Deccan,
late seventeenth century
Gold, champlevé enamelled
Dimensions: Length 37 cm; width 3 cm
Provenance: Art market 1989
Published: Keene and Kaoukji 2001, cat. 6.42
Inv. no. LNS 286 M

Although it is unlikely that this object, which resembles a miniature crutch, ever concealed a blade in its shaft or served as an armrest on account of its small size, we have included it in this section since its design is so similar to that of armrest crutches.

It is likely the object served as a perch for a small bird, as an analogous object with a perching bird is held by I'tibar Khan, one of Emperor Jahangir's attendants, in a painting from the *Padshah-nameh*, dated to *c.* 1635 (see p. 126).[12]

The perch has curling bud finials, which recall the handles of jade vessels, and is constricted above the cap of the tapering staff in a manner that recalls the jade armrest Cat. 124.

The staff is separated into segments by gold rings, but appears to have lost its bottom segment. Both the perch and the staff are decorated with red enamel flowers with green sepals against a ground of white enamel, which has flaked off on most of the perch and the lowermost segment of the staff. The flowers are laid out in staggered rows on the staff, and pairs of flowers occupy the top and underside as well as the front and back of the perch.

The four gold bands encircling the upper end of the staff retain traces of a chevron motif and traces of red and green enamel, whereas the remaining bands are plain.

Detail of gold perch with bud
finials, and staff decorated with
staggered rows of flowers

NOTES

1 See e.g. the *palki* bearers carrying crutches in
 folios from a *Mrigavat* manuscript, fol. 196,
 fig. 88, and fol. 28, fig. 89, published in an article
 by Karl Khandalavala entitled "The *Mrigavat*
 of Bharat Kala Bhavan" in Krishna 1981, which
 he dates to about 1525–75 (see arg. pp. 29–30)
 and perhaps 1540–50 (p. 32); the *palki* bearers
 with crutches in a painting attributed to 'Abd
 al-Samad, *c*. 1580, in Canby 1998, cat. 81; the
 palki bearers with crutches in a folio from a *Yog
 Vashisht* manuscript dated 1602, Leach 1995a,
 cat. 2.5; the *palki* bearers represented in folios
 from a *Raj Kunwar* manuscript, dated 1603–04,
 ibid., cat. 2.89, pl. 28, and cat. 2.91; and the *palki*
 bearers of Emperor Akbar's mother, in an *Akbar-
 nameh* folio from *c*. 1603–05, ibid., cat. 2.101.
 Also, see the bearers carrying a dead lioness, in
 a painting attributed to *c*. 1600–04, in Stronge
 2002, p. 119, pl. 84.

2 The "Three dervishes seated by a fire" in an
 album page from *c*. 1645, Topsfield 2008, cat. 42;
 a seated ascetic using his crutch as a shoulder-rest
 in a border (right-hand corner), from the *Late
 Shah Jahan Album*, *c*. 1640, Leach 1995a, cat.
 3.59; an album page from *c*. 1640, in which a yogi
 rests his hand on a crutch, ibid., cat. 3.79; and a
 miniature depicting two of a group of fakirs with
 crutches from a group "intoxicated with *bhang*"
 from *c*. 1730–50, ibid., cat. 4.40. Also Leach 1986,
 cat. 28i, the ascetic depicted in the upper border.

3 I am grateful to Professor Giovanni Curatola for
 drawing my attention to the possibility of there
 being such a connection.

4 Yetts 1916, pp. 803–05; Cunningham et al. 1998,
 pp. 88–89; Soame Jenyns and Watson 1963,
 cat. 65; and the immortal from the Istanbul
 album drawing (H. 2153, fol. 36v) identified as
 Li T'ieh-kuai by Watson 1981, p. 72 and fig. 103.

5 The courtier Raisal Darbari is depicted leaning
 on a crutch, where the crutch-head is clearly of
 the type in question on a page from the *Salim
 Album*, attributed to *c*. 1600–05, Leach 1995a,
 cat. 2.162, pl. 43. Long staffs with knob finials are
 depicted held by overseers in the forefront of the
 c. 1590 *Akbar-nameh* painting the "Construction
 of Fatehpur Sikri", Brand and Lowry 1985, cat. 15,
 and on a folio from the *Hamza-nameh* attributed
 to *c*. 1570, in which "Baba Junayd" is depicted
 holding a staff with such a finial, Seyller 2002,
 cat. 37.

6 Nigam 1979, fig. 25.

7 Skelton 1982a, cat. 359.

8 See e.g. Keene and Kaoukji 2001, cat. 8.7.

9 Stronge 2002, p. 64, pl. 43; Calza 2012, p. 27.

10 See e.g. Keene and Kaoukji 2001, cats. 8.5
 and 8.8.

11 See e.g. the portrait of an ascetic attributed to
 c. 1610, Pal 1993, cat. 69, and the painting entitled
 "A Maulvi meditating" from *c*. 1630, Barret and
 Gray 1978, p. 111.

12 Beach and Koch 1997, cat. 5.

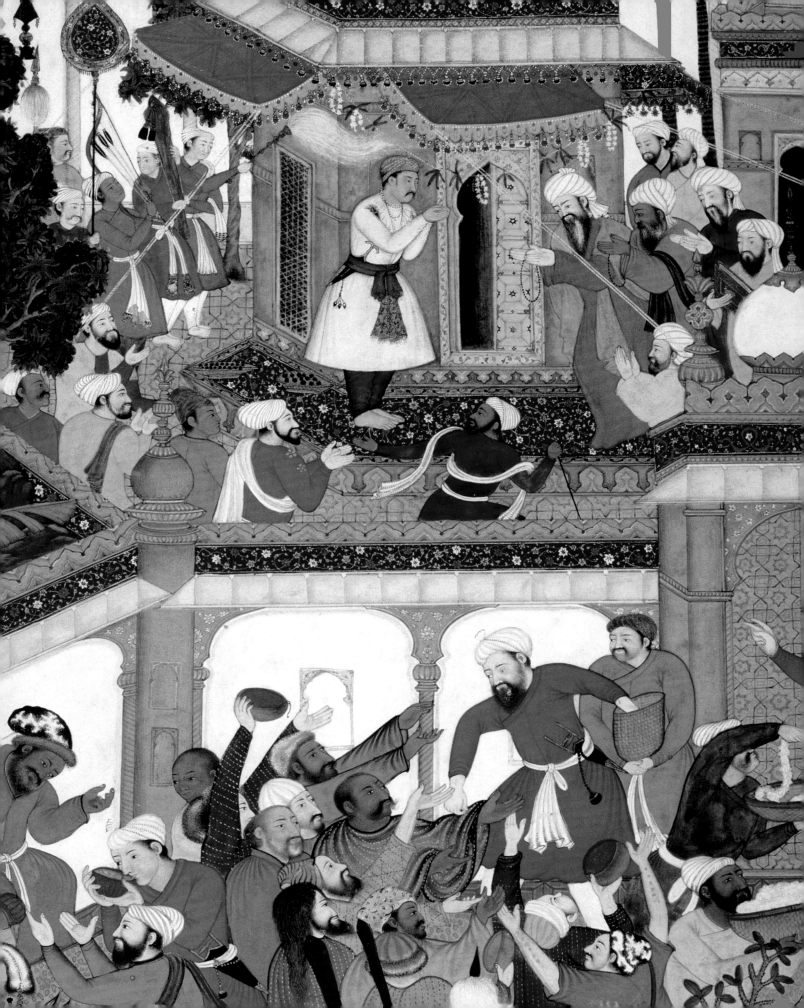

CHAPTER TWELVE
THE ARCHERY RING
A LINK WITH CENTRAL ASIAN PRINCELY REGALIA

Archery had an indisputably prominent role in hunting and warfare throughout the ancient and medieval world. The types of bows used, as well as the techniques for discharging arrows from them, varied significantly according to historical period and geographical region. Since this chapter is primarily concerned with the introduction of the archery ring to India, we will focus on the "Mongolian release" method of drawing bowstrings, which necessitated wearing such rings.

The method consisted of drawing the bowstring with the thumb and folding the index finger over the tip of the thumb to aid in restraining the string. Once the bowstring was released, the skin on the inner thumb would have been exposed to injury, necessitating some form of protection, which most likely led to the development of the thumb- or archery ring. The protective braces depicted on ninth-century BCE Assyrian reliefs, however, were worn on the arm and hand that held the bow, whereas the archery ring was worn on the hand that drew the bowstring.[1]

The Mongolian-release method most likely originated in China. Archery rings have been found in archaeological contexts in eastern China dating from as early as *c.* 1200 BCE.[2] Although there are indications of a few isolated examples excavated in Nubian territories, which is not surprising considering that Nubia was regarded as the "Land of the Bow", the finds are rather patchy.[3]

The tradition must have spread westward from China to Central Asia, and thereafter there is written evidence that the method spread to the Iranian world by the eleventh century CE, and to Syria by the twelfth century. Nevertheless, the Mongolian-release method does not appear to have caught on in India at this time when, to judge from various artistic depictions of archers, bowstrings usually seem to have been drawn back with the tips of the archer's four fingers.[4] What is more, in the *Kautiliya Arthashastra*, a comprehensive and detailed treatise on state governance and administration compiled in India in around the fourth century BCE,[5] the author makes no mention of archery rings in his notes on archery.[6] It is therefore something of a surprise that examples of archery rings abound (both as surviving artifacts and as depictions in paintings) during the reigns of the Mughal emperors Akbar, Jahangir and Shah Jahan when there seems to be so little evidence for the use of archery rings in a broader Indian context, especially in pre-Mughal Indian painting,[7] indicating that this mode of drawing bowstrings was not adopted in India prior to the Mughal period.

THE MONGOLIAN-RELEASE METHOD
The term "Mongolian release" was coined in the early twentieth century by Edward S. Morse, in his study on archery *Additional Notes on Arrow Release*,[8] who, in researching various modes of discharging arrows from around the world, associated this method with "Asiatic races" and "Persians".

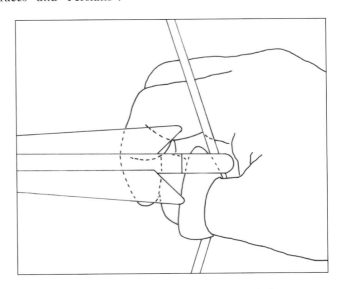

Illustration of the Mongolian-release method of discharging arrows by E. S. Morse, 1885

Emperor Akbar wearing archery rings suspended from his sash while visiting the shrine of Mu'in al-Din Chishti, in an illustration from the *Akbar-nameh* manuscript by Basawan with Ikhlas and Nanha, Mughal, *c.* 1590–95

In support of this connection, an early and interesting example from the Iranian world illustrating the use of this method by a mounted archer is depicted on a "post-Sasanian" dish dated to the eighth century CE.[9] On this dish the archer's index finger clearly bends over his thumb in the manner of the Mongolian release, which demonstrates that the method was undoubtedly practised in the Iranian world during this period. Henceforth, over a period of roughly five hundred years, occasional references to archery rings appear in written sources from the eastern and western Islamic lands, and, from around the fourteenth century onwards, representations in paintings increase steadily, establishing that this particular method of discharging arrows prevailed in the area.

THREE WRITTEN ACCOUNTS ON THE USE OF THUMB-PROTECTION DEVICES

A passage from the *Shah-nameh*, the celebrated Iranian national epic completed by Firdausi in around 1010 CE, refers to the use of the thumb-protection device, which in all likelihood would only have been essential if the archer were practising the Mongolian-release method of discharging arrows:

> He [Bahram Chubina] chose an arrow with
> a glittering point,
> plumed with four eagle's feathers, took in hand
> his bow of Chach and laid the deer-hide thong
> within his thumb-stall, straightened his left arm,
> and bent his right. The bow twanged as he loosed
> the shaft and pierced king Sawa's spine.[10]

In a treatise on armament by Mardi ibn 'Ali ibn Mardi al-Tarsusi, probably written in Syria by the end of the twelfth century, the author includes an elaborate chapter on archery[11] which describes variants of the Mongolian-release method, and the usage of the *angushtvaneh*[12] or protective thumb-ring (the Arabized version of which is *kushtuban*).

As his name indicates, Mardi al-Tarsusi probably hailed from Tarsus, but since most of his references were drawn from the methods of master archers (*'umala' al-rimaya*)

whose names (*nisbah*s) affiliate them to particular areas, indicating that they came from Khurasan and Central Asia,[13] it is fitting that in his treatise he would have used a Persian term (*angushtvaneh*) for the archery ring. This is further confirmation that archery rings were first adopted in those regions, and most probably introduced to the western Islamic world in the eighth century by the Khurasani army of the famous general of the Abbasids Abu Muslim al-Khurasani.

Yet another reference to thumb-protection devices from western Islamic lands occurs in Ibn al-Manzur's famous dictionary *Lisan al-'Arab* (completed in 689 H/1290 CE) under the entry *khayta'a*:

خنيعة

والخنيعة: هنة من أدم يغشي بها الرامي إبهامه لرمي السهام

khayta'a is something (or a small thing) made from skin/leather with which an archer covers his thumb to shoot arrows.[14]

It is, furthermore, worth drawing attention to the fact that the author of the dictionary uses an Arabic word instead of the borrowed Persian term (*angushtvaneh*) for the thumb-protection device, which indicates that, at least by then, the Mongolian-release method and consequently the need for archers to protect their thumbs had been well established among Arabic-speaking people.

"ROYAL ARCHERS" AND ARCHERY RINGS

Whereas triumphal themes and commemorative scenes portraying ancient Near Eastern sovereigns as "royal archers" abound on public buildings and objects related to government office from as far back as the fourth millennium BCE,[15] there seems to be no evidence of such representations celebrating the royal status of early Muslim rulers. This suggests that the convention of portraying rulers as supreme "royal archers" may have ceased after the Muslim conquest.

Although a number of medieval archery rings in The al-Sabah Collection, made from various materials and in different shapes and decorative styles,[16] with provenances from eastern and western Islamic lands, demonstrate that the

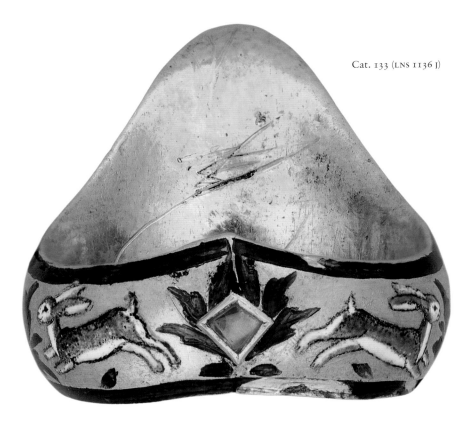

Cat. 133 (LNS 1136 J)

use of such rings had become quite popular, we are unaware of any depictions of archers wearing such rings on wall paintings or miniature paintings preceding the fourteenth century CE. Among the earliest known representations of archery rings is one worn by an attendant in a scroll fragment associated with the so-called "Siyah Qalam" group of paintings attributed to Tabriz or Baghdad, *c.* 1350–70.[17] Another appears in a folio from a dispersed manuscript of the *Shah-nameh*, likewise attributed to Tabriz around 1370, in which Zal, shooting an arrow at a bird, wears an archer's ring.[18] Slightly later, in a manuscript of Nizami's *Khamsah*, from around the end of the fourteenth to the turn of the fifteenth century, one of the Khaqan's envoys presenting soil and a sword to Iskandar (Alexander the Great) wears an archery ring.[19] Thereafter, representations of archery rings increase gradually,[20] and, from the fifteenth century onwards, as though to revive an ancient tradition, paintings are

increasingly replete with princes and heroes wearing archery rings in scenes related,[21] as well as unrelated, to archery.[22]

This raises the question of whether the archer's ring, in addition to being indispensable in discharging arrows, gradually became an object of adornment and princely regalia, as it appears to have become an artistic convention to designate illustrious personages in paintings by depicting them with such rings. Another piece of evidence in support of archery rings being components of princely regalia is that when subordinate figures are portrayed in an archery scene they are almost never represented wearing archery rings,[23] although it is certain that they would have had to wear some form of protective device on their thumbs.

Some examples (to name only a few) depicting rulers wearing archery rings in scenes not associated with archery include: a painting from a *Zafar-nameh*, dated Dhu 'l-Hijjah 839 H/June–July 1436 CE, in which Amir Timur wears an

archery ring at a feast in a garden;[24] the portrait of the Ottoman Sultan Mehmed II smelling a rose, painted in around 1460, in which the sultan wears an archery ring;[25] a page from a *Shah-nameh*, dated 899 H/1493–94 CE, in which emperors Kay Kaus and Kay Khosraw both wear archery rings in a garden setting;[26] Shaybani Khan wears an archery ring in a portrait ascribed to Bihzad, and dated to *c.* 1508;[27] and the portraits of sultans Sulaiman I and Selim II, by Nigari, from *c.* 1560 and 1570 respectively, in which both wear archery rings in garden settings.[28]

Dignitaries, likewise, were often portrayed wearing archery rings in contexts unrelated to archery. Noteworthy examples include the representation of a prince wearing an archery ring on a visit to a hermit (thus in a non-secular context), in a *Makhzan al-Asrar* manuscript, dated 25 Jumada 883 H/24 August 1478 CE;[29] a *Khamsah* "designed and supervised by Bihzad", dated 931 H/1524–25 CE, where Emperor Khosraw is seated under a canopy in a garden surrounded by his courtiers, all of whom wear archery rings;[30] and a page from a *Divan* of Hafiz, attributed to Tabriz between 1525 and 1529, entitled "The sighting of the new moon after Ramadan", depicts the prince and several courtiers, as well as those sighting the moon, wearing archery rings.[31]

On the basis of this artistic convention one could therefore assume that the painter of a fifteenth-century portrait, probably from Tabriz, in which a dervish is depicted wearing an archery ring, along with a quantity of gold jewellery that is untypical of dervishes, intended the individual to be perceived as a prince who had abandoned worldly life, a fairly common practice at the time.[32]

On the high social status conveyed by archery rings, and their association with illustrious personages, it is noteworthy that the Venetian chronicler Marin Sanudo reported in his *Diarii* that Piero Zen, the Venetian ambassador to the Ottoman court, in a letter dated 7 October 1531, writes that the Ottoman sultan had archery rings (as well as hilts and belt fittings) carved from a narwhal ivory tusk, which was alleged to be the horn of the legendary unicorn, in his collection of precious objects.[33]

ARCHERY RINGS AT THE MUGHAL COURT

Bearing in mind the influx from the Iranian world into India, and more specifically into the Deccan, the connection between archery rings and Central Asian princely regalia, and the Mughals' inclination to revive some of their erstwhile customs, it is likely that Emperor Akbar introduced the fashion of wearing archery rings to the Mughal court around the 1570s, as a large numbers of rings are depicted in manuscripts from the period.[34] From 1580 onwards such representations increase in paintings,[35] and the fashion endured throughout the early periods of Mughal rule, when the emperors Akbar and Jahangir were frequently depicted wearing archery rings, often with a number of them suspended from their sashes.[36]

Despite the fact that Emperor Shah Jahan is represented in fewer instances wearing an archery ring, and is only seen with archery rings suspended from his sash in a single portrait of him as a prince,[37] a larger number of archery rings inscribed in his name or title, or otherwise ascribed to him, have come down to us.

So far as we know, there are no representations of Emperor 'Alamgir wearing archery rings suspended from his sash. Furthermore, in later periods representations of archery rings seem to disappear altogether from Indian painting, conceivably due to the introduction of alternative methods of hunting and warfare.

ARCHERY RINGS INSCRIBED IN EMPERORS' NAMES

We know only of archery rings inscribed with the names of emperors Jahangir and Shah Jahan, and none with the names of emperors Akbar and 'Alamgir.

Among the three archery rings inscribed with the name of Emperor Jahangir, one is carved from white jade, decorated on the exterior with a gold-inlaid floral arabesque, originally set with gemstones that are now missing, and is engraved on the interior in a trefoil arch "Shah Salim", the emperor's name before he acceded to the throne; another is carved from dark-green jade, undecorated on the exterior,

and engraved on the interior in an elongated cartouche "Az [of] Jahangir Shah-e [son of] Akbar Shah" and is undated.[38] An additional dark-green jade ring with an engraved floral arabesque on the exterior is engraved on the interior with the emperor's calligraphic monogram: "Jahangir Shah-e [son of] Akbar Shah" and is dated "1032" (1622–23 CE).[39]

Of two jade archery rings bearing the name of Emperor Shah Jahan, one is carved from dark-green jade, and features on its interior a gold-inlaid inscription in a lobed cartouche, giving Shah Jahan's title, Second Lord of the Auspicious Conjunction,[40] the date and his regnal year: "Sahib-e Qiran Thani 4, 1040" (1630 CE);[41] another, carved from white jade, features a similar gold-inlaid inscription in a lobed cartouche, and likewise gives Shah Jahan's title, the date and his regnal year: "Sahib-e Qiran Thani 5, 1042" (1632 CE).[42] A gold archery ring set with rubies, diamonds and emeralds is inscribed on the interior with Shah Jahan's title, "Sahib-e Qiran Thani", but is undated.[43]

Finally a gold-inlaid steel archery ring in the collection, Cat. 128, is inscribed on the exterior with the ninety-nine names of God, and on the interior with the name of Shah Jahan, his title and the date: "Shihab al-Din Muhammad Shah Jahan Padshah Ghazi, 1062" (1651–52 CE).

Cat. 128 ARCHERY RING IN THE NAME OF SHAH JAHAN
Mughal dominions,
dated 1062 H (1651–52 CE)
Fabricated from steel inlaid with gold
Dimensions: Length 4.5 cm; width 3 cm
Provenance: Art market 2011
Inv. no. LNS 4962 J

This imposing archery ring is inscribed with the ninety-nine beautiful names of God (*Asma' Allah al-Husna*) in minuscule and exceptionally fine *thulth* script, considering the size of the inscriptions.

Along the upper edge of the ring and appropriately initiating the inscriptions is a cartouche inscribed "In the name of God the Merciful, the Compassionate", below which is a larger cartouche inscribed with the name of God and the pious phrase: "May His Glory be Magnified" (*Allah Jall Jalaluh*).

On the interior of the ring, a cartouche framed by paired fillets is inscribed with Surat al-Saff (Chapter 61: v. 13) from the Qur'an, proclaiming that imminent victory (of the Faith) is attained through God's assistance.

Pendent from the cartouche is a lobed medallion inscribed in the name of Emperor Shihab al-Din Muhammad Shah Jahan, his title, p. 367, Padishah Ghazi (Warrior King), the date 1062 (1651–52 CE), and a line that is now indecipherable owing to loss of the gold inlay and corrosion of the metal surface, which has obstructed the grooves of the inlay that might have allowed us to read the inscription in full:

نصر من الله وفتح قريب
شهاب الدين محمد
شاه جهان ١٠٦٢

It appears as though it was a customary practice of the emperors Jahangir and Shah Jahan to inscribe their names on the interiors of their archery rings, as demonstrated by several surviving jade archery rings so inscribed.[44] Aside from this example, however, all known archery rings of Shah Jahan are inscribed with a different title, Sahib Qiran-e Thani (Second Lord of the [Auspicious] Conjunction).[45]

Underside of ring, bearing a cartouche inscribed with Chapter 61, verse 13 from the Qur'an, and a lobed medallion with the name of Emperor Shah Jahan and the date 1062 H (1651–52 CE)

Cat. 129 JADE ARCHERY RING
Deccan, late sixteenth–early
seventeenth century
Carved from nephrite jade, inlaid
with gold in *kundan* technique
Dimensions: Length front to back 4 cm;
width 3 cm
Provenance: Art market 1999
Published: Sotheby's, London, 22 April 1999,
lot 279; Keene and Kaoukji 2001,
cat. 2.2
Inv. no. LNS 366 HS

In East Asia, jade has been noted for its purported beneficial properties since time immemorial. In medieval Arabic, Persian and Turco-Mongol sources, these properties included the prevention and cure of ailments, protection from lightning, and assurance of victory in combat. In his treatise on mineralogy and gemstones (*Kitab al-Jamahir fi Ma'rifat al-Jawahir*), Abi al-Rayhan ibn Ahmad al-Biruni relates that jade was called "the stone of victory" and was used for this reason by the Turks to adorn their swords, saddles and waist belts to achieve victory in combat.[46] As the use of bows and arrows was predominant in battle, what would have been more suitable than to possess an archery ring carved from jade?

This pure-white jade ring has now lost most of its gold inlay, with only traces remaining in the lower parts of the intaglio. As on the suite of ivory sword mounts comprising Cat. 101, the engraving on this ring is interspersed with tiny holes drilled considerably deeper than the carving of the motif to hold the gold inlay in place.

The decorative layout is typical of that found on most archery rings, in that it centres on a blossom on the front of the ring which bears vines that scroll along the shank bearing further blossoms and split palmettes, and close in upon a flower on the back of the ring. The flower on the front of the ring recalls the treatment of floral scrolls on the tents and floor covering in a painting depicting Muhammad Quli Qutb Shah of Golconda, dated to *c.* 1586–90.[47] Such flowers ultimately derive from Timurid conventions of floral rendering.

Cat. 130 **ENAMELLED ARCHERY
RING**
**Mughal dominions or Deccan,
early seventeenth century**
Fabricated from silver and
champlevé enamelled
Dimensions: Length 4 cm; width 3 cm
Provenance: Art market 2003
Inv. no. LNS 3238 J

Of rounded proportions and of a type that dips on the front and back with a pronounced curve on the sides like the ring worn by Emperor Shah Jahan in a portrait of him as a prince dated to *c.* 1616–17,[48] this ring also presents a colour scheme that is, to say the least, out of the ordinary.

On the interior and exterior of the ring virtually identical elegant arabesques of slender silver vines in reserve on a black enamel ground bear stylized blossoms in opaque pale green, pale blue and white enamel contained by extremely fine silver fillets on the upper and lower edges of the ring.

The stylized blossoms and unusual colour scheme are very closely related to the enamelled decoration on the interior of the seventeenth-century Shah Jahan jewelled archery ring in the Victoria and Albert Museum, decoration that Susan Stronge states either stems from an awareness of European Renaissance jewellery at the Mughal court, or could even be of European craftsmanship.[49] Manuel Keene agrees that the colour scheme of both the Victoria and Albert ring and our example, including the treatment of the floral and foliate motifs, which he compares to the decoration on the hull of a "gondola pendant" of the later sixteenth century, are of European inspiration, or possibly point to an Indian craftsman working very closely with a European jeweller.[50] I am inclined towards the latter interpretation: although the colour scheme and vegetal decoration are closely related to European Renaissance designs, the motifs in question are nonetheless treated in a stylized manner that does not conform to examples of European enamels from the period.

Enamelled arabesques on
front and underside of ring

Cat. 131 AGATE ARCHERY RING
Mughal dominions, early
seventeenth century
Carved from patterned agate

Dimensions: Length 4.5 cm; width 3 cm
Provenance: Art market 1999
Published: Sotheby's, London, 22 April 1999,
lot 279; Keene and Kaoukji 2001,
cat. 8.32
Inv. no. LNS 367 HS

This archery ring was cut by a master lapidary whose profound knowledge of the material he was carving allowed him to position a pair of perfectly circular, pale natural inclusions on the front of the ring to serve as decoration.[51]

The ring is of flattish and finely rounded proportions, and gabled on the back, where it dips to a point in the same manner as the rings depicted worn by Shah Jahan in his portrait as a prince.[52]

The upper edge is carved with a groove that does not come full circle on the front, perhaps so as not to distract from the natural inclusions.

Cat. 132 **SERPENTINE ARCHERY**
 RING
 Probably Deccan, early
 seventeenth century
 Carved from serpentine
Dimensions: Length 4.5 cm; width 3 cm
Provenance: Art market 1998, reportedly
 from Hyderabad
Published: Keene and Kaoukji, cat. 8.310
 Inv. no. LNS 2104 J

Generally related in form to Cats. 130, 133 and 150, in that it dips at the front and back and is of curvilinear contour, the ring here is flattish and elongated at the front, where it slightly recurves on the tip. The sides are pronouncedly rounded, as is the gabled back, which dips to a point. Deep grooves outline the upper and lower edges of the ring.

It is worthy of note that in paintings from around the end of the sixteenth and early seventeenth centuries princes and courtiers can be seen wearing a number of archery rings carved from multicoloured stones suspended from their belts.[53]

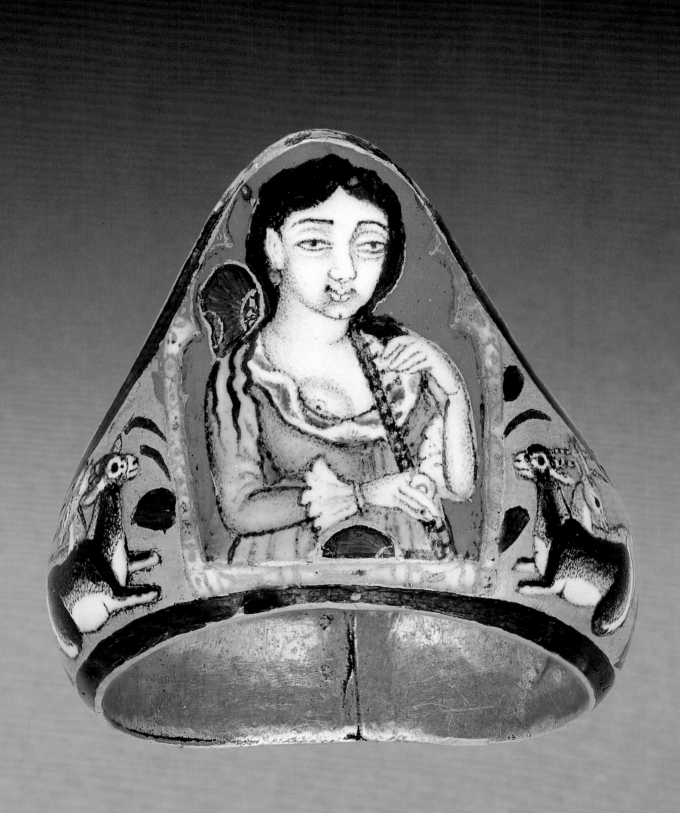

Cat. 133 ENAMELLED AND GEM-SET ARCHERY RING
Probably Deccan, early seventeenth century
Fabricated from gold with champlevé, basse-taille and painted enamels; set in *kundan* technique with a spinel
Dimensions: Length 5 cm; width 3 cm
Provenance: Art market 1994
Published: Keene and Kaoukji 2001, cat. 6.47
Inv. no. LNS 1136 J

This ring is of the same form as Cat. 132 in the general sense, but unlike any other ring of its type in decorative scheme. The front is adorned with an enamel portrait of a lady – in European dress but with Indian features – standing at an arched window and playing the veena. The entire composition is rendered in painted enamels, outlined and detailed in black and overpainted in gold on an opaque white ground, with the exception of the resonators of the veena, which are in transparent green enamel. The lady is depicted against a powder-blue ground, her white skin detailed with black stippling, her hair black, and her (visible) earring and dress in pale green.

The lady most likely represents the Todi Ragini, from the ragas or modes of Indian classical music that gave rise to the "Ragamala paintings", among which is the celebrated *ragamala* depicting a yogini playing the veena among animals, and more specifically deer.

On both sides of the arched window are pairs of male and female deer, and further around the shank are foliage and hares leaping towards the front of the ring. All the animals are rendered in tones of white, grey, tan and black painted enamels with stippled shading, and the foliage separating them on the plain gold field is in green champlevé enamel. On the back a cluster of green foliage is set with a flat kite-shaped spinel.

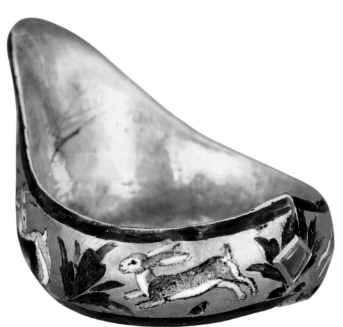

Back of the ring, with hares flanking a spinel and springing towards the front of the ring

Front, back and underside of ring

Cat. 134 ENAMELLED AND JEWELLED ARCHERY RING
Probably Deccan (perhaps Bidar), first half of the seventeenth century
Fabricated from gold; champlevé enamelled, set in *kundan* technique with rubies and turquoises
Dimensions: Length 4.5 cm; width 3 cm
Provenance: Art market 1999
Published: Christie's, London, 6 October 1999, lot 124; Keene and Kaoukji 2001, cat. 6.3; Calza 2012, p. 162, cat. IV.14
Inv. no. LNS 2216 J

This gold archery ring is decorated on the exterior with two intricate, overlapping and mutually complementary vine scrolls of slender split palmettes, foliage and gem-set blossoms on a ground of green enamel. On the interior, an identical arabesque in polychrome enamels is set against an opaque white enamel ground, once again (see Cat. 130) imbued with inspiration from European Renaissance motifs.

The decorative scheme centres on a large lobed and cusped medallion bordered by split palmettes, from which issue scrolling split palmettes, vines and foliage. The medallion encloses a ruby and turquoise flower from the petals of which develop complementary gold scrolls bearing gem-set flowers and foliage. Both vine scrolls reciprocally cover the sides and converge onto a white enamel bud and fleur-de-lys on the back of the ring.

On the interior the blossoms situated at the front of the ring are of transparent ruby-red enamel, and the ensuing blossoms are rendered in opaque yellow and pale-blue enamel as well as transparent blue enamel, and the foliage is in transparent green enamel.

In spite of its luxuriousness, the functionality of this archery ring is emphasized by the setting of the stones, which are flush with the surface so as not to snag the bowstring.

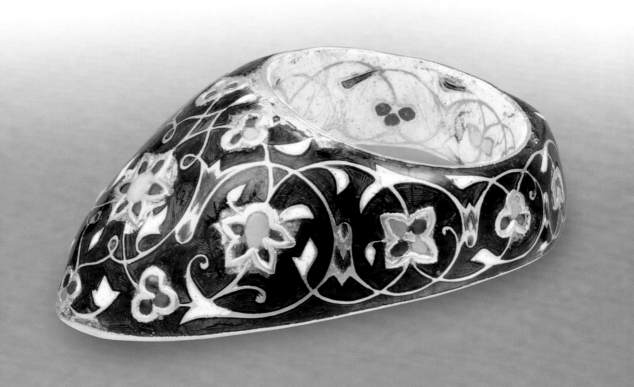

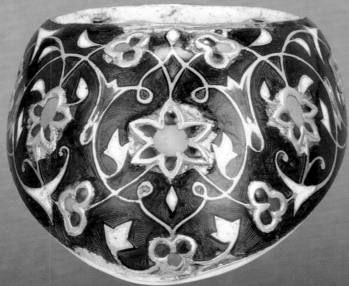
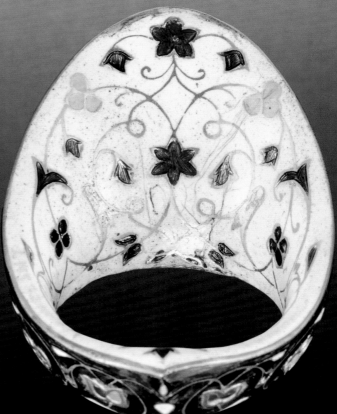

Front and back of ring

Cat. 135 ENAMELLED ARCHERY RING
Deccan (probably Hyderabad), first half of the seventeenth century
Silver, gilded, with champlevé and basse-taille enamels
Dimensions: Length 4 cm; width 3 cm
Provenance: Art market 1993
Published: Sotheby's, London, 21 October 1993, lot 602; Keene and Kaoukji 2001, cat. 6.6; Keene 2004b, pp. 110–11, figs. 16 and 17
Inv. no. LNS 978 J

The artist who laid out the grapevine motifs that adorn this archery ring was clearly not inclined to abide by the rules of symmetry that usually govern the decoration of this type of object. On the front of the ring the vine leaf flanked by two unevenly balanced bunches of grapes is slightly off centre. The number of leaves on the sides of the ring do not match and, on the back, one of the birds is pecking at a bunch of grapes, whereas the other appears to hold a vine in its beak.

The birds are rendered with black beaks, pale purple wings and cobalt-blue plumage with touches of opaque turquoise and black enamel. The sprawling vines and convoluted tendrils that run rampant on the surface are in middle-green enamel with dabs of opaque yellow, pink, turquoise and cobalt blue.

The interior of the ring is undecorated.

For an in-depth study about this colour scheme and style of enamelling, which is related to early European traditions and quite peculiar in comparison with the known types of Indian enamels, see Manuel Keene's article on the subject.[54]

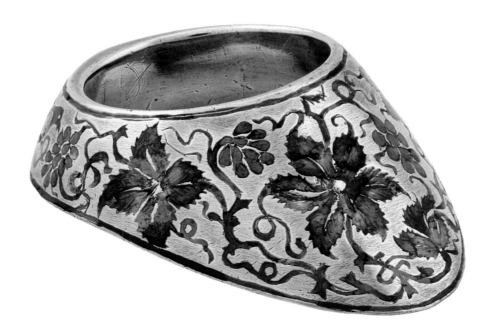

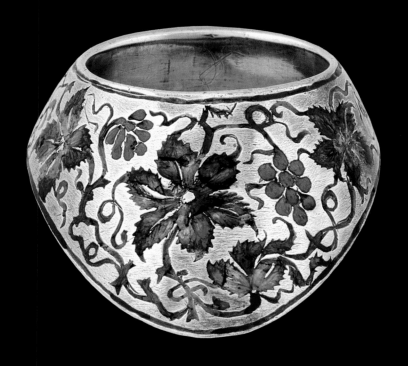
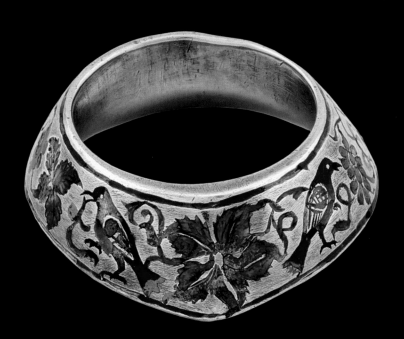

Cat. 136 ARCHERY RING
Deccan, probably Hyderabad,
c. **mid seventeenth century**
Silver, gilded, with champlevé and
basse-taille enamels
Dimensions: Length 4 cm; width 3 cm
Provenance: Art market 1994
Published: Christie's, London, 18 October
1994, lot 378; Keene and Kaoukji
2001, cat. 6.9; Keene 2004b, p. 105,
figs. 8 and 9
Inv. no. LNS 1208 J

Although rendered in the same style, this ring differs in form from the preceding rings in this chapter, and, for that matter from most known archery rings, in that its upper edge is flattened on the front and essentially squared off on the tip.

On the front of the ring two large leaves, from which develop blossoms in colourless enamel with touches of opaque yellow, and buds of pink enamel, flank a colourless enamel lotus blossom enlivened with cobalt blue. From the back of the ring two foliate stems scroll towards the front, bearing pink blossoms with opaque yellow buds and turquoise leaves as well as smaller cobalt-blue and opaque yellow blossoms.

The decoration on the exterior is symmetrical and in a rather formal style. In contrast, the interior presents a lively floral arrangement in which two foliate stems bear a multitude of curling leaves with touches of cobalt blue and a large lotus blossom in amber-coloured enamel enlivened with transparent pink, with a small cobalt-blue blossom on the tip of its petals.

On the back of the ring is a single sprig with a small cobalt-blue blossom.

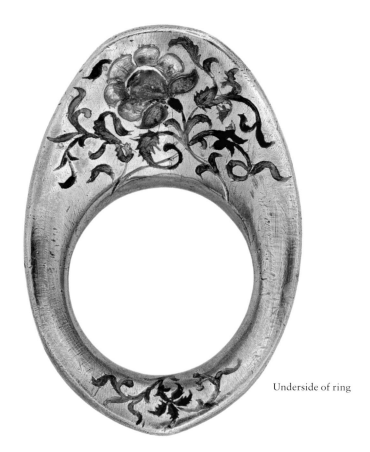

Underside of ring

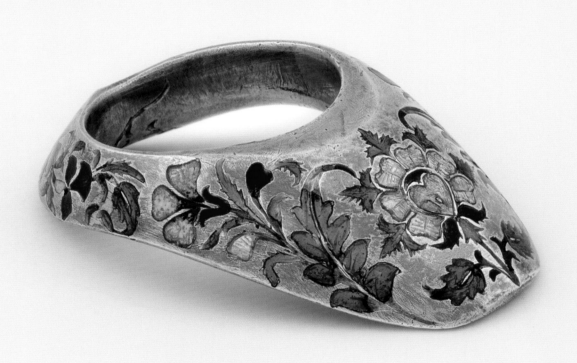

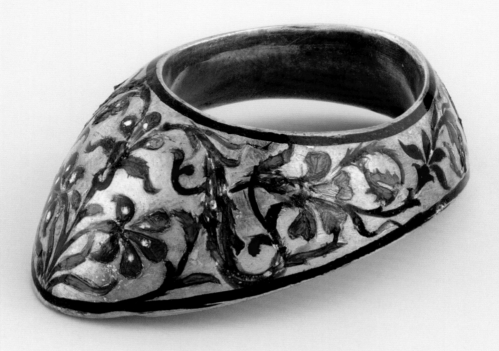

Side of ring

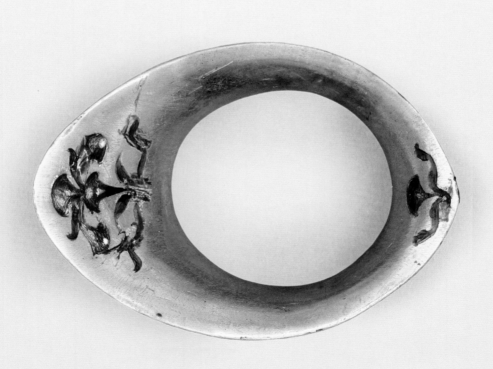

Underside of ring

Cat. 137 **ENAMELLED**
ARCHERY RING
Probably Deccan, *c.* **mid**
seventeenth century
Silver, gilded, with champlevé
and basse-taille enamels
Dimensions: Length 4 cm; width 3 cm
Provenance: Art market 2001
Published: Bonham's, London, 2 May 2001,
lot 664
Inv. no. LNS 2629 J

This archery ring is rendered in a style and colour scheme similar to that of the two preceding enamelled archery rings (Cats. 135 and 136), wherein the colours of the enamel are deliberately made to blend into each other. The foliate motifs are composed of elongated and undulating serrated leaves, and the colours include purple and black enamel. Black enamel also borders the upper and lower edges of the ring.

On the front of this ring the principal flowering plant bears purple blossoms with blue sepals detailed with dots of white enamel and grows from the tip of the ring amid a cluster of green undulating leaves. A pair of long drooping leaves issues from the upper blossom and frames the decorative motif on the front of the ring, setting it somewhat apart from the rest of the decoration.

In addition, a pair of foliate vines, in green merging into black and blue enamel and issuing purple and blue blossoms, scrolls from the front edge of the ring towards the back. On the back a blue blossom with purple sepals is enveloped by a pair of leaves pendent from the upper edge of the ring, forming an arch-like enclosure around the small blossom. It is noteworthy that the colour distribution of this small blossom is the exact opposite of that of the blossom on the front of the ring.

The underside of the ring is decorated on the front with fan-shaped blossoms, which seem typical of the Deccan, rendered in purple and blue detailed with white dots and growing amid leaves. On the back a fan-shaped purple blossom grows in between upswept leaves.

INK AND WATERCOLOUR
ON CARD, rendering
of Cat. 137
Dimensions: Height 10 cm; width 14 cm
Provenance: Art market 2002
Published: Bonham's, London,
10 October 2002, lot 66
Inv. no. LNS 3240 J

The Maharaja of Jaipur

**Cat. 138 ENAMELLED
ARCHERY RING**
Probably Deccan, *c.* **mid
seventeenth century**
Silver, gilded, with champlevé
and basse-taille enamels
Dimensions: Length 4.5 cm; width 3 cm
Provenance: Art market 2000
Published: Phillips, London, 3 October 2000,
lot 146
Inv. no. LNS 2262 J

Related in form and decorative style to the preceding examples, this ring features a symmetrical and rather formal floral motif on the front, and a lively floral arrangement on the interior of the ring. Here, as well, the flowering plants flow towards the middle of the shank, and feature a small bud on the back.

On the exterior a blue calyx pendant from the blue border suspends foliage that touches on the main green and purple blossom, which issues grey buds. The lateral stems each bear a smaller four-petalled flower, with cobalt-blue and purple petals enlivened with green, as well as fat purple buds, all of which are interrupted at the centre of the shank with green and purple overturned leaves.

On the back two small stems bearing large cobalt-blue buds enfold a tiny purple bud.

On the interior of the ring a purple flower with petals in a fan-shaped arrangement develops from an elongated trumpet-like calyx and issues curling leaves in green and blue blending enamels with touches of opaque yellow in the blue. Two serrated leaves flow towards the centre of the shank, where they end with black buds and serrated blue leaves. A small purple trefoil issuing large green leaves completes the decorative motif of the interior.

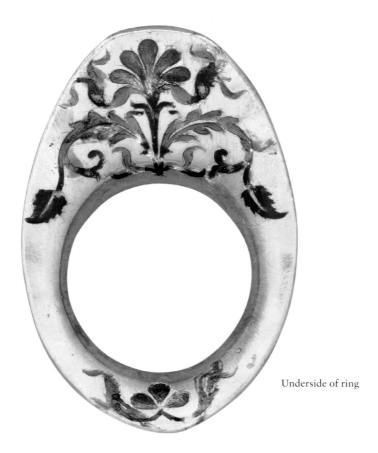

Underside of ring

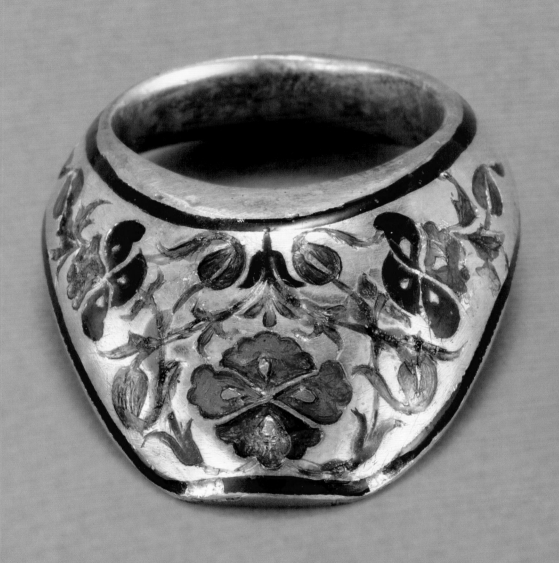

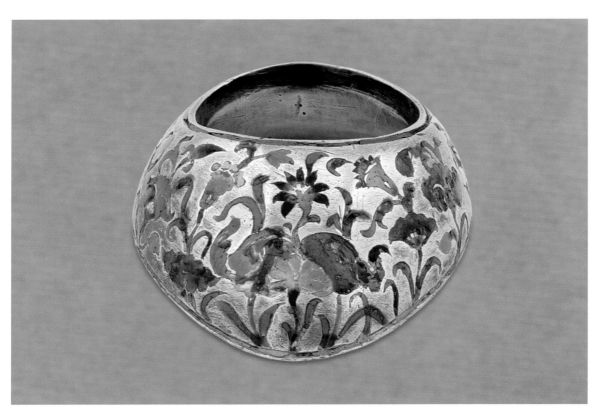

Front of ring

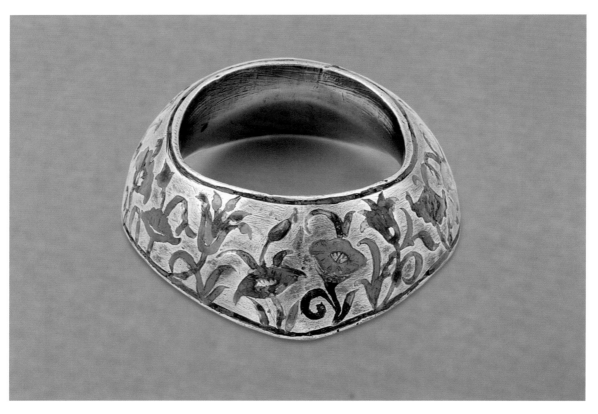

Back of ring

Cat. 139 **ENAMELLED**
ARCHERY RING
Probably Deccan (Hyderabad),
c. **mid seventeenth century**
Silver, gilded, with champlevé and
basse-taille enamels
Dimensions: Length 4 cm; width 3 cm
Provenance: Art market 1999
Published: Bonhams, London, 13 and 14
October 1999, lot 321;
Keene and Kaoukji 2001, cat. 6.7;
Keene 2004b, p. 110, fig. 15
Inv. no. LNS 2226 J

The lotus blossoms and leaves on gracefully undulating
stems that decorate this ring grow in irregular order along
the lower edge of the ring. The treatment of the enamel is
likewise characterized by the intention of the maker to allow
the colours to blend together, as is manifest throughout
the decoration, thus creating a beautiful soft and blurry
watercolour effect rendered in cobalt blue, turquoise
and purple with opaque ochre and black.

Opaque pale-blue fillets border the ring, and the
undecorated interior retains traces of gilding.

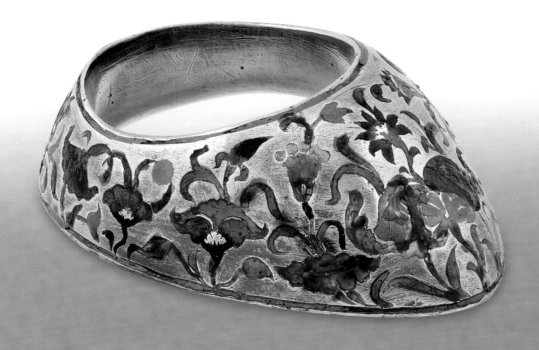

Cat. 140 **ENAMELLED
ARCHERY RING**
**Perhaps Deccan, around
c. mid seventeenth century**
Silver, gilded, with champlevé and
basse-taille enamels
Dimensions: Length 4.5 cm; width 3 cm
Provenance: Art market 2000
Published: Christie's South Kensington, 12
October 2000, lot 26; Curatola
and Kaoukji 2016, cat. 172
Inv. no. LNS 2269 J

Of rounded proportions, this ring is flattened on the upper edge of the back in a similar manner to Cats. 136 and 138. Atypically it features a large blue blossom with a yellow calyx and purple flowers with serrated edges (probably carnations) growing amid serrated leaves and flanked by a pair of parrots. The parrot heads are rendered in purple and sport large transparent enamel eyes and prominent blue beaks, their emerald-green bodies are crosshatched under the enamel and they have purple wings and blue feet. Enfolding the parrots are undulating serrated leaves that flow towards the back of the shank bearing a multitude of flowers and broader leaves.

On the back a small plant grows from the lower edge, amid two fan-shaped purple flowers enlivened on their fringed edges with transparent yellow enamel, and issuing from their tips serrated light-blue leaves that touch on the vines flowing from the front of the ring. The underside is decorated on the front with a blue carnation enlivened with purple, two petals of which are overturned and detailed with black enamel. On the back a small green carnation detailed with blue issues two purple leaves enlivened with green.

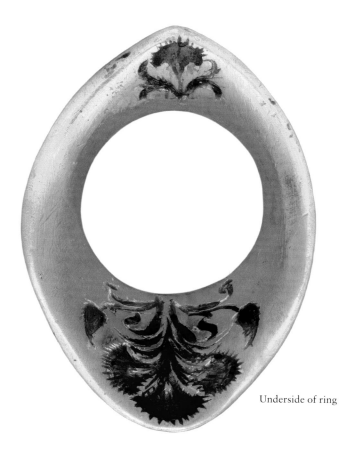

Underside of ring

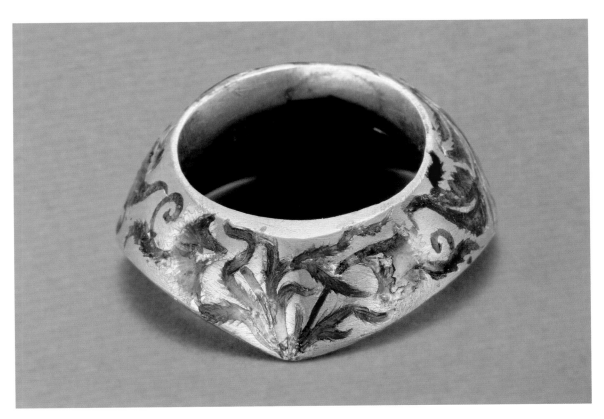

Back of ring

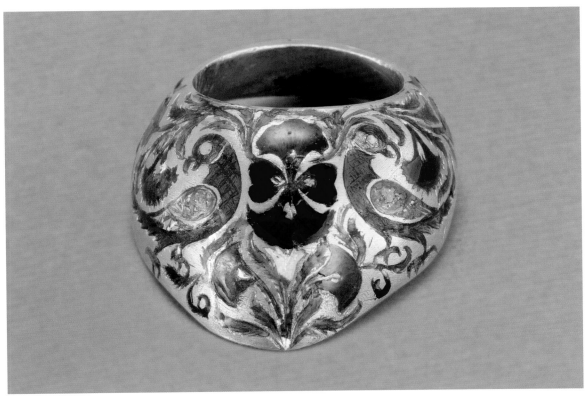

Front of ring

Cat. 141 ENAMELLED ARCHERY RING
Perhaps Deccan, mid–late seventeenth century
Silver, gilded and champlevé enamelled
Dimensions: Length 4 cm; width 3 cm
Provenance: Art market 1997
Published: Christie's, London, 8 October 1997, lot 396; Keene and Kaoukji 2001, cat. 6.8; Keene 2004b, pp. 107–08, figs. 12 and 13
Inv. no. LNS 1866 J

Here, as in the previous pieces, blossoms grow from the lower edge of the rim, but the colour scheme displays some changes; the floral motifs are rendered in cobalt blue detailed with turquoise and orange enamels, pink buds and undulating serrated foliage in transparent green thickening to translucent green enamel.[55]

A blue band of reserved quatrefoils borders the lower edge of the ring,[56] and a blue fillet its upper edge.

The interior of the ring, which peculiarly appears of more masterly rendering than the exterior, features a turquoise blossom issuing tendrils and foliage in green, cobalt blue and pink enlivened with opaque yellow enamels. On the back of the ring a single undulating floral sprig issues tendrils.

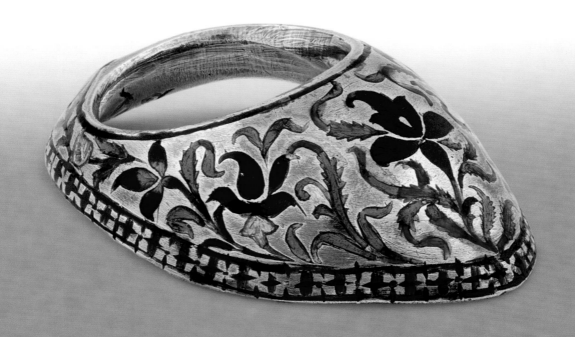

Underside of ring

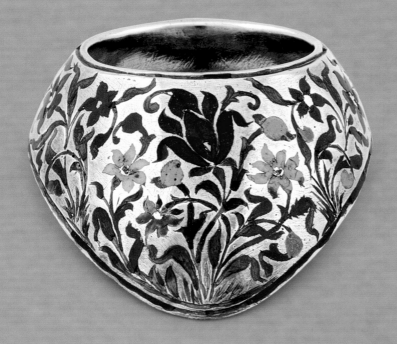

Front of ring

Underside of ring

**Cat. 142 ENAMELLED
 ARCHERY RING
 Perhaps Deccan, mid–late
 seventeenth century**
 Silver, gilded, with champlevé
 and basse-taille enamels
Dimensions: Height 1.5 cm; length 4.5 cm;
 width 3 cm
Provenance: Art market 1992
Published: Keene and Kaoukji 2001, cat. 6.10;
 Keene 2004b, p. 106, figs. 10 and 11
 Inv. no. LNS 336 J

Clusters of flowers grow in somewhat symmetrical fashion from four tufts of foliage on the lower edge of this ring, three on the front and one on the back. On the front the central tuft issues a blue lotus and two floral stems that scroll towards the back of the ring. The foliage and the three main blue blossoms are all rendered in transparent enamels, whereas the smaller blossoms are in opaque yellow, mottled pale blue and white, as well as dark purple enamels with touches of black, and the buds in turquoise and ochre.

The interior is covered with transparent green enamel and engraved in basse-taille with a naturalistic iris blossom flanked by two smaller irises amid lanceolate and serrated leaves.

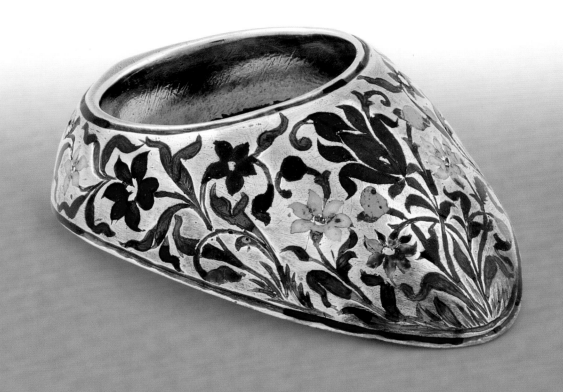

**INK AND WATERCOLOUR
ON CARD**, rendering of
**Cat. 142 reproducing loss of
enamel on the rim and tip**
Dimensions: Height 15 cm; width 10 cm
Provenance: Art market 2002
Published: Bonham's, London, 10 October
2002, lot 66
Inv. no. LNS 3239 J

AN INTRIGUING GROUP OF ENAMELLED ARCHERY RINGS

Identifying the origin of this series of archery ring (Cats. 143 to 149), which all appear to have been manufactured at the same time and in the same workshop, as well as the patrons for whom they were intended, would have been puzzling enough had not most of them (with the exception of Cats. 143 and 145) come with cards that associate them with the Maharajah of Jaipur. Moreover, two further rings (Cats. 137 and 142), which clearly do not belong stylistically in the same group, also come with cards bearing the name of the Maharajah of Jaipur.

In style of decoration and treatment of the enamelling the rings clearly differ from any examples previously known to us, except that they seem closely related both to the Deccan examples presented earlier in this chapter (Cats. 135 to 142) and to the Lucknow sword, Cat. 114. Whereas they appear to descend from the Deccan archery rings, displaying an attempt at some of the same decorative motifs but a much stiffer mien, the colour scheme inclines towards that of the enamels on the Lucknow sword. Among the decorative features that have migrated from the Deccan rings to our Lucknow examples (Cats. 143 to 149) is the combination of transparent and opaque enamels; the deliberate blending of the colours into each other; the composite flowers rendered with a stencil effect; and the slender, sweeping and whirling serrated leaves, a feature that can be observed in the Deccan archery rings.

Although the elegance in the overall handling of the decoration in the Deccan archery rings has not, unfortunately, been transferred to this group of rings, they do seem to provide evidence of an important link between the crafts of the Deccan and Lucknow.

There are a number of possible explanations for the nature of this link. The rings might have been manufactured by enamellers from Lucknow or Rajasthan who had been exposed to the archery rings from the Deccan, or who were even working with enamellers who had migrated from the Deccan. Whatever the precise origin of the rings, it is clear that they eventually came into the possession of Maharajah Sawai Ram Singh II (1835–1880), who had them painted in watercolours on cards with his coat of arms and the calligraphed legend "The Maharaja of Jaipur", possibly by art students who attended the Jaipur School of Art that he founded,[57] in view of inventorying archery rings in the Maharajah's collection.

Some of these cards reproduce damage to the rings that must have occurred before the watercolours were executed, as with the nicked gold surface on the interior of the shank of Cat. 148 and the loss of enamel on Cats. 142, 144, 146 and 147. Had the rings been commissioned by the Maharajah, rather than collected or inherited, it seems unlikely that he would have directed the artists to reproduce damage to the rings that must have occurred subsequent to their manufacture, whereas in an inventory it would be a priority to record and monitor such damage. In addition, there are two rings, Cats. 137 and 142, which unquestionably do not belong with this group but are likewise reproduced on cards, further suggesting that these records were part of the Maharajah of Jaipur's wider collection inventory, rather than accompanying the delivery of rings commissioned from a particular workshop.

Cat. 143 **ENAMELLED**
 ARCHERY RING
 Lucknow or Rajasthan, first
 half of nineteenth century
 Silver, gilded and basse-taille
 enamelled
Dimensions: Length 4 cm; width 3 cm
Provenance: Art market 2002
Published: Bonham's, London,
 10 October 2002, lot 66
 Inv. no. LNS 3246 J

The decorative scheme of this archery ring is characterized by the large size of the composite flowers in blues, turquoise and greens rendered in stencil effect on the front, sides and back of the ring. On the front the flower grows between serrated leaves and is rendered in cobalt blue detailed with touches of opaque yellow enamel. Flanking the flower are floral and foliate stems with colours blending into each other, surrounded by a profusion of tiny leaves and tendrils that undulate towards the back of the ring bearing green and cobalt-blue blossoms and opaque yellow and pale-green buds, which converge on a green blossom on the back of the ring.

On the interior a large turquoise flower detailed with opaque pale-green and cobalt-blue enamel grows among lanceolate leaves and issues cobalt-blue, opaque yellow and pale-blue buds. On the back of the interior an opaque pale-green bud and cobalt-blue buds grow amid leaves.

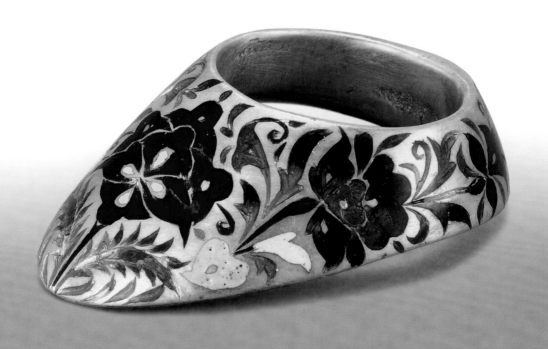

Back of ring

Underside of ring

Front of ring

Cat. 144 ENAMELLED ARCHERY RING

Lucknow or Rajasthan, first half of nineteenth century

Silver, gilded and basse-taille enamelled

Dimensions: Length 4 cm; width 3 cm

Provenance: Art market 2002

Published: Bonham's, London, 10 October 2002, lot 66; Curatola et al. 2010, cat. 277

Inv. no. LNS 3242 J a

Once again, a blossom rendered in a stencil effect fills the front of the archery ring. It is pendent from a profusion of sweeping foliate stems in cobalt blue, blending into green, that bear opaque yellow, pale green and pale blue buds. The stems curl and flow towards the back of the ring bearing large cobalt-blue *boteh* (paisley-shaped) buds, likewise treated in stencil effect and with serrated edges. On the back of the ring a green blossom with an opaque yellow calyx, almost identical to the blossom on the back of Cat. 149, issues foliate stems bearing opaque pale-green *boteh* buds with serrated edges that converge on the buds flowing from the front.

The decorative style on the underside of the ring relates it to a certain extent to some of the Deccan group of archery rings, in that the rendering is noticeably livelier than on the exterior. Twirling foliate stems each bear one black and two pale-green *boteh* buds, and smaller opaque yellow buds, as well as cobalt-blue buds detailed with yellow. On the back of the interior a cobalt-blue serrated bud issues green foliage.

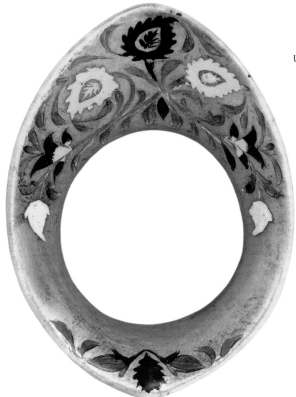

Underside and front of ring

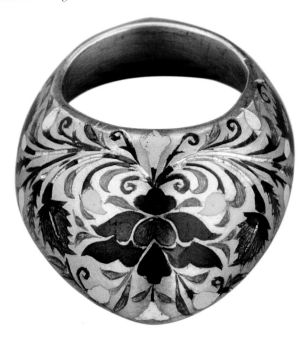

INK AND WATERCOLOUR ON CARD, rendering of Cat. 144 reproducing loss of enamel on the vines and slight nicks in the gold on the rim

Dimensions: Height 10 cm; width 15 cm
Provenance: Art market 2002
Published: Bonham's, London, 10 October 2002, lot 66
Inv. no. LNS 3242 J b

The Maharaja of Jaipur

Cat. 145 ENAMELLED ARCHERY RING
Lucknow or Rajasthan, first half of nineteenth century
Silver, gilded and basse-taille enamelled
Dimensions: Length 4 cm; width 3 cm
Provenance: Art market 2002
Published: Christie's, South Kensington, 18 October 2002, lot 92
Inv. no. LNS 3247 J

On the front of the ring, the stem of the large green flower detailed with opaque yellow enamel splits and, characteristically, flows back towards the centre of the shank, bearing cobalt-blue flowers and buds detailed with opaque pale-green enamel. On the back of the ring, the black stem of the opaque yellow flower with a pale-green calyx splits and flows towards the front, bearing green flowers with yellow calyces and pale green and pale blue buds that converge on the stems flowing from the front of the ring.

On the interior a large cobalt-blue blossom with a yellow calyx issues lively foliate stems and opaque yellow and pale-green buds. On the back of the interior, a large dark-green bud flanked by cobalt-blue buds grows among green leaves and cobalt-blue tendrils.

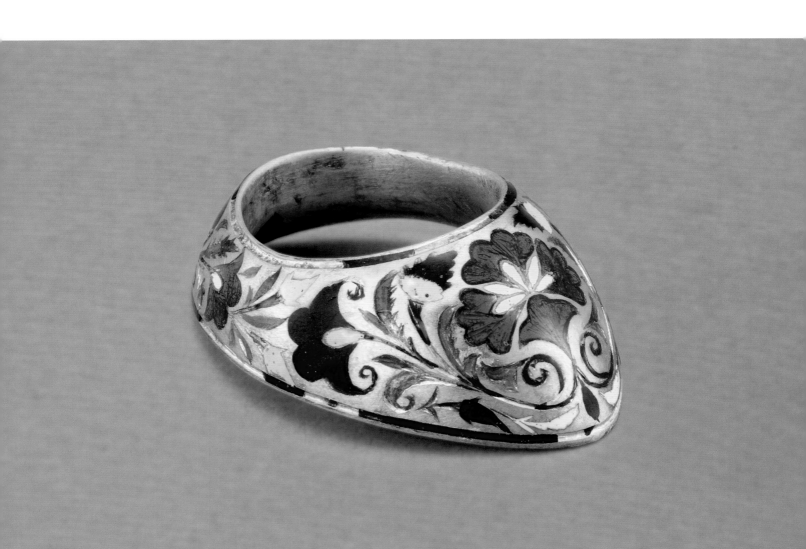

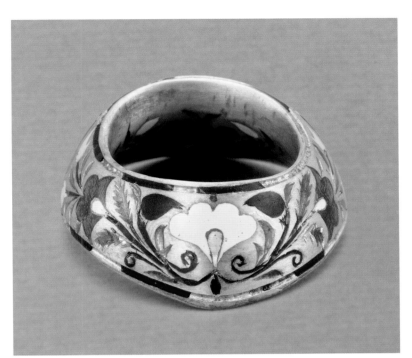

Back of ring

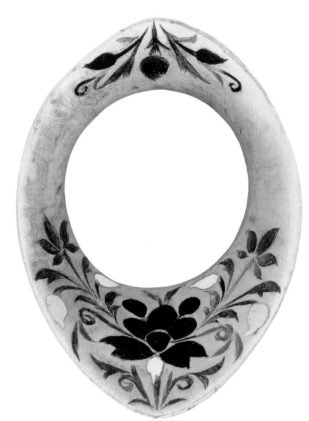

Underside of ring

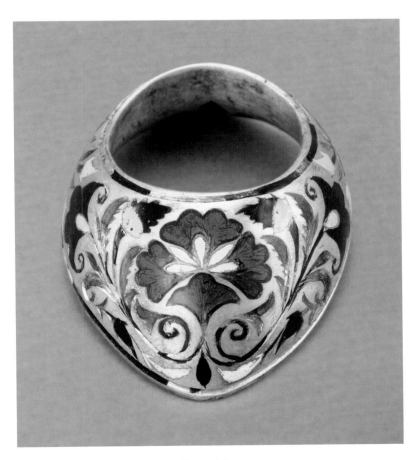

Front of ring

**Cat. 146 ENAMELLED
ARCHERY RING
Lucknow or Rajasthan, first
half of nineteenth century**
Silver, gilded and basse-taille
enamelled
Dimensions: Length 4 cm; width 3 cm
Provenance: Art market 2002
Published: Bonham's, London,
10 October 2002, lot 66
Inv. no. LNS 3243 J a

This archery ring is squared off at the tip and slightly flattened on the front of the hoop area; both features are similarly present on Cat. 136. On the front of the ring a transparent greenish-yellow blossom, pendent from the upper edge, is surrounded by a profusion of leaves and purple buds rendered in colours that are comparable to those on the Lucknow sword (Cat. 114). The small turquoise birds on the ring are also stylistically related to the birds on the scabbard of the Lucknow sword.

From the back of the ring foliate stems with purple, cobalt-blue, yellow and turquoise flowers with yellow and purple buds converge on the front of the ring.

On the interior, a profusion of leaves, a single yellow bud and a multitude of purple buds surround a large turquoise flower.

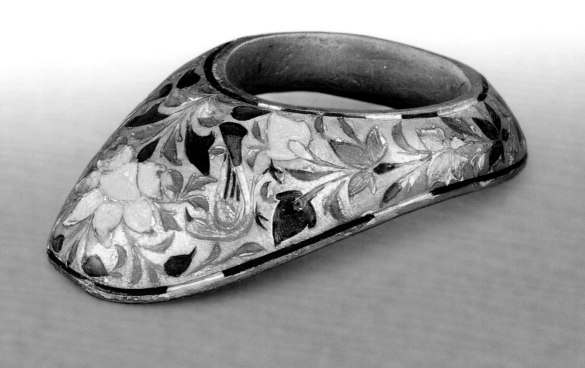

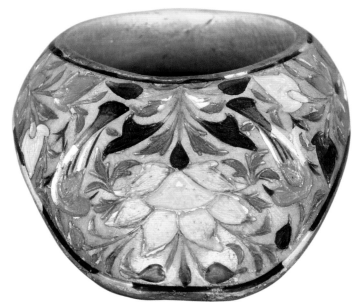

Front of ring, Cat. 146
(LNS 3243 J a)

**INK AND WATERCOLOUR
ON CARD,** rendering of
Cat. 146 reproducing loss of
enamel on the rim and edge
Dimensions: Height 10 cm; width 15 cm
Provenance: Art market 2002
Published: Bonham's, London,
10 October 2002, lot 66
Inv. no. LNS 3243 J b

The Maharaja of Jaipur

Cat. 147 **ENAMELLED**
ARCHERY RING
Lucknow or Rajasthan, first
half of nineteenth century
Silver, gilded and basse-taille
enamelled
Dimensions: Length 4 cm; width 3 cm
Provenance: Art market 2002
Published: Bonham's, London,
10 October 2002, lot 66
Inv. no. LNS 3244 J a

This archery ring is likewise squared off at the tip and flat around the hoop edge, which
is decorated with three purple and two yellow buds borne by stems that extend from the
floral arrangement on the front of the ring. There, three bright yellow blossoms with
turquoise centres are framed by foliate stems and serrated leaves issuing purple buds, as
well as two turquoise buds. The foliate stems flow, as is typical, towards the back of the
ring bearing yellow flowers with purple centres, and further turquoise and purple buds.
On the back, a yellow blossom with a purple centre issues two down-curling flowers and
purple buds that converge onto the foliate stems that flow back from the front.

On the interior of the ring a yellow flower detailed with purple grows amid two
yellow flowers and buds surrounded by a profusion of foliage.

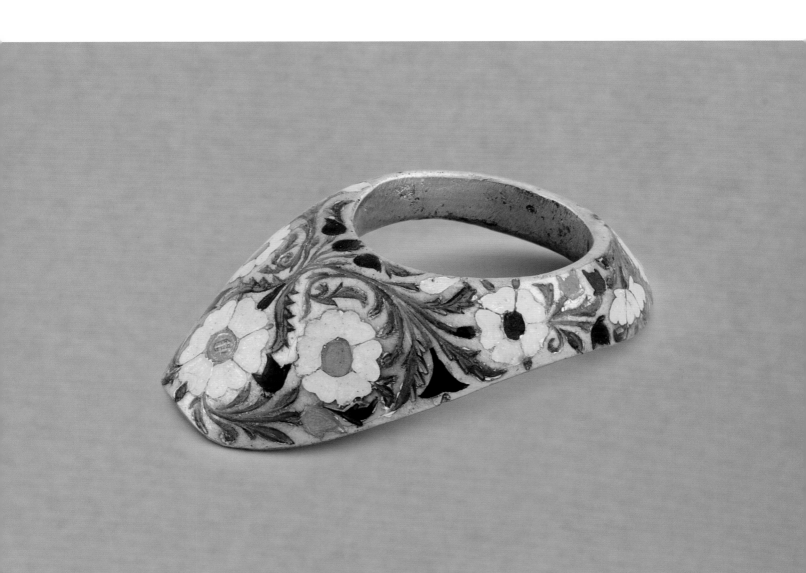

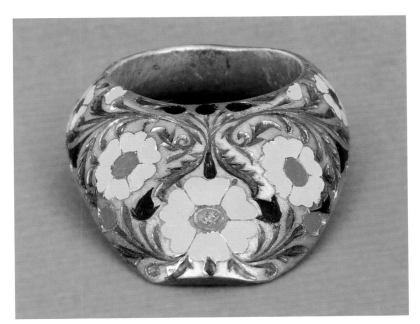

Front of ring

**INK AND WATERCOLOUR
ON CARD,** rendering of
Cat. 147 reproducing loss of
enamel on the rim and edge
Dimensions: Height 10 cm; width 15 cm
Provenance: Art market 2002
Published: Bonham's, London,
10 October 2002, lot 66
Inv. no. LNS 3244 J b

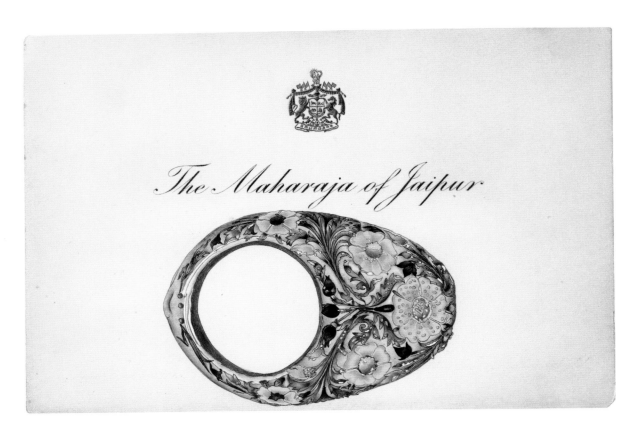

The Maharaja of Jaipur

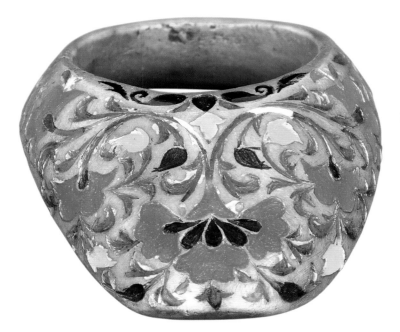

Front of ring

INK AND WATERCOLOUR
ON CARD, rendering of Cat.
148 reproducing nicks in the
gold on the interior rim
Dimensions: Height 15 cm; width 10 cm
Provenance: Art market 2002
Published: Bonham's, London,
10 October 2002, lot 66
Inv. no. LNS 3245 J b

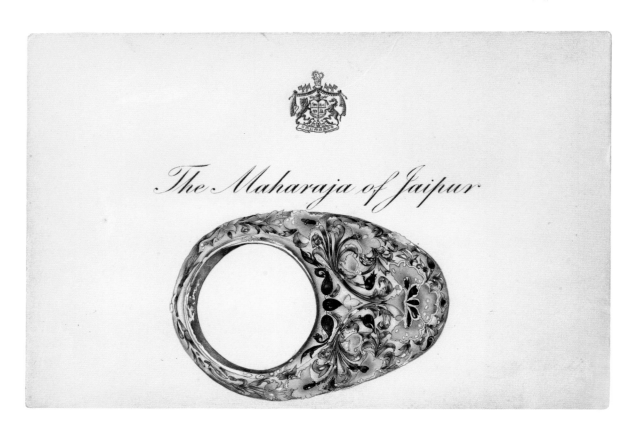

The Maharaja of Jaipur

Cat. 148 ENAMELLED ARCHERY RING
Lucknow or Rajasthan, first half of nineteenth century
Silver, gilded and basse-taille enamelled
Dimensions: Length 4 cm; width 3 cm
Provenance: Art market 2002
Published: Bonham's, London, 10 October 2002, lot 66
Inv. no. LNS 3245 J a

Likewise squared off on the tip and flat around the hoop, this archery ring is decorated on the edge of the hoop with an arrangement of purple buds and green leaves from which is pendent an opaque orange bud, recalling the orange enamel details on the Lucknow sword, Cat. 114. It is related in its decorative scheme to the previous example in that foliate stems twirl around the strident turquoise blossom detailed with purple on the front of the ring and flow towards the back bearing turquoise flowers, interspersed with purple and yellow buds.

On the back of the ring, a pendent turquoise blossom with a purple calyx issues foliate stems with yellow tendrils bearing purple and turquoise blossoms that converge onto the stems that flow backwards from the front of the ring.

On the interior, green foliate stems with orange buds form a niche around a large purple bird, possibly a flamingo on account of its curved beak.

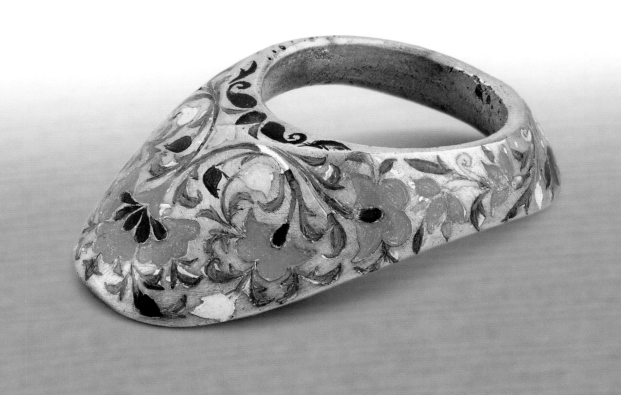

**Cat. 149 ENAMELLED
ARCHERY RING
Lucknow or Rajasthan, first
half of nineteenth century**
Silver, gilded and basse-taille
enamelled
Dimensions: Length 5 cm; width 3 cm
Provenance: Art market 2002
Published: Bonham's, London,
10 October 2002, lot 66
Inv. no. LNS 3241 J a

Of relatively large proportions, this ring has a peculiar cylindrical element projecting from the lower back edge of the shank. Its function is unclear and this feature has not been encountered elsewhere. It obviously did not serve to restrain the bowstring, however, since when the ring is worn on the finger the cylindrical element projects from the side opposite the bowstring, rather than the one adjacent to it.

On the front, a large green blossom is pendent from a cobalt-blue calyx from which issue sweeping, curling stems, closely related to those on Cat. 144, bearing opaque yellow, pale blue, pale green, black and green enamel *boteh* buds issuing tendrils and small leaves.

On the back, a green blossom with a yellow calyx issues foliate stems bearing pale-green and cobalt-blue *boteh* buds, and suspends a foliate stem with a cobalt-blue blossom on the cylindrical projection.

On the interior a large pale-green blossom with purple calyx and centre grows amid a profusion of leaves, interspersed with purple, yellow and green buds.

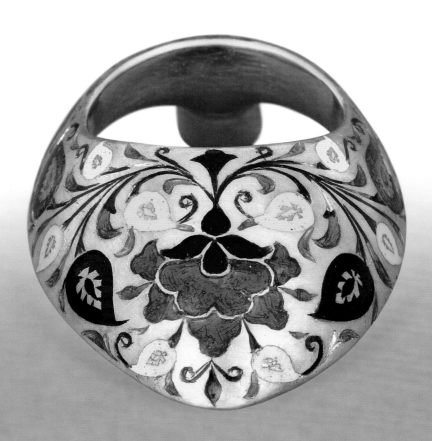

The Maharaja of Jaipur

INK AND WATERCOLOUR
ON CARD, rendering
of Cat. 149
Dimensions: Height 10 cm; width 15 cm
Art market 2002
Published: Bonham's, London,
10 October 2002, lot 66
Inv. no. LNS 3241 J b

Cat. 150 **JADE ARCHERY RING**
Mughal dominions or Deccan,
seventeenth century
Carved from jade
Dimensions: Length 4 cm; width 3 cm
Provenance: Art market 2002
Published: Christie's, South Kensington,
7 November 2002, lot 12;
Curatola et al. 2010, cat. 274
Inv. no. LNS 3285 J

Carved from pure white jade, this ring is generally of the same type as Cats. 131 and 132 in that it dips at the front and back and is of curvilinear contour, flattish and elongated at the front, but differs from these examples in that it does not recurve on the tip. The sides and upper and lower edges are rounded, as is the gabled back, which dips to a point.

Cat. 151 JADE ARCHERY RING
Mughal dominions or Deccan,
seventeenth century
Carved from jade
Dimensions: Length 4.5 cm; width 3 cm
Provenance: Art market 1998, reportedly
from Hyderabad
Inv. no. LNS 2102 J

Carved from white jade with faint traces
of tan, this unusually high ring is of
beautifully rounded proportions, slightly
incurving on the upper edge. It is gabled
and dips to a point on the back.

Cat. 152 CORAL ARCHERY RING
Mughal dominions or Deccan,
seventeenth century
Carved from coral
Dimensions: Length 4 cm; width 3 cm
Provenance: Art market 2001
Published: Bonhams, London, 17 October
2001, lot 567A; Curatola et al.
2010, cat. 276
Inv. no. LNS 2866 J

Carved from coral, this archery ring is of
rounded proportions essentially similar to
those of Cat. 151, coming to a point on the
front, and is gabled and dips at the back.

Interestingly, in a painting dated to
c. 1590, the ruler of Bikaner, Mota Raja
Rai Singh, who held high office at the
Mughal court, can be seen wearing a red
(presumably coral), a dark green (probably
jade) and a gold archery ring suspended
from his belt.[58]

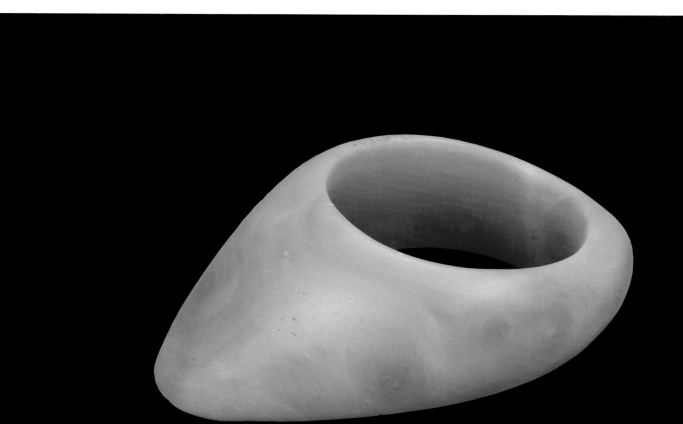

Cat. 153 JADE ARCHERY RING
Mughal dominions or Deccan,
seventeenth century
Carved from jade
Dimensions: Length 4.5 cm; width 3 cm
Provenance: Art market 1998, reportedly
from Hyderabad
Inv. no. LNS 2103 J

Carved from pale-green jade with faint
traces of tan, proportionately high, and less
rounded than the two preceding examples,
this ring curves in slightly along the upper
edge, and is gabled and dips to a point on
the back.

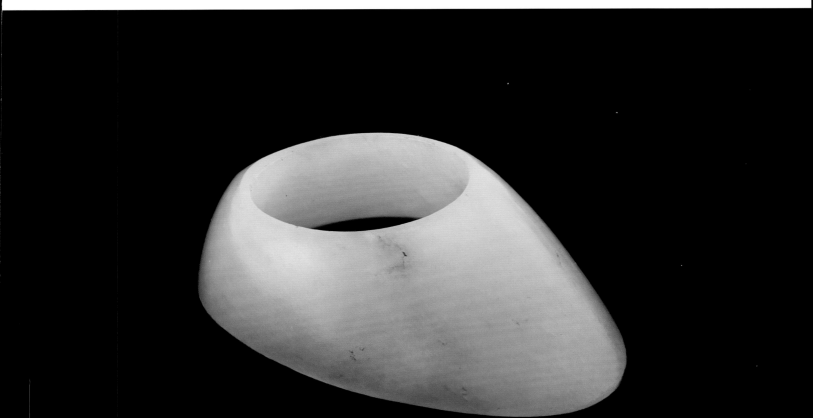

Cat. 154 **BANDED AGATE
ARCHERY RING**
**Mughal dominions or Deccan,
seventeenth century**
Carved from banded agate
Dimensions: Height 2 cm; length 4 cm;
width 3 cm
Provenance: Art market 1992
Published: Sotheby's, London, 22 October
1992, lot 415; Keene and Kaoukji
2001, cat. 8.33; Curatola and
Kaoukji 2016, cat. 171
Inv. no. LNS 747 J

Of high and finely rounded proportions,
the ring dips to a point on the back, and its
only form of decoration resides in the skilful
handling of the material, wherein translucent
and transparent bands of tan-coloured agate
border an opaque white band.

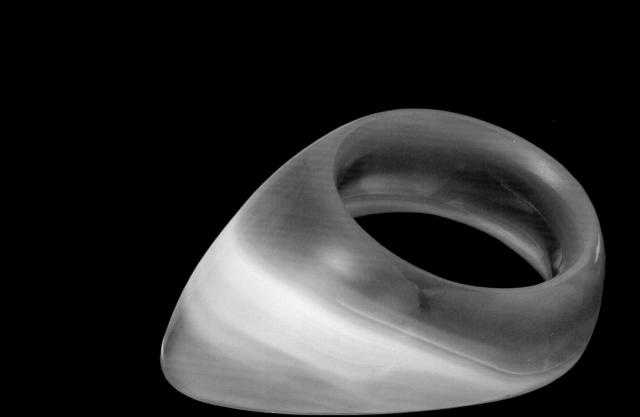

Cat. 155 ROCK-CRYSTAL
ARCHERY RING
Mughal dominions or Deccan,
seventeenth century
Carved from rock crystal
Dimensions: Length 4 cm; width 3 cm
Provenance: Art market 1980s
Inv. no. LNS 52 HS

This archery ring carved from pure, unincluded
rock crystal is of a rather peculiar stubby form,
and is pronouncedly broad and convex at the
front. Interestingly, it is of the same form as a
rock-crystal archery ring in the collection of
the Furusiyya Art Foundation, Riyadh, that
also appears unusually wide at the hoop.[59]
This might lead one to believe that the unusual
shape of our ring implies it was made for a stout
individual, but its hoop is of the same size as
that of most other archery rings.

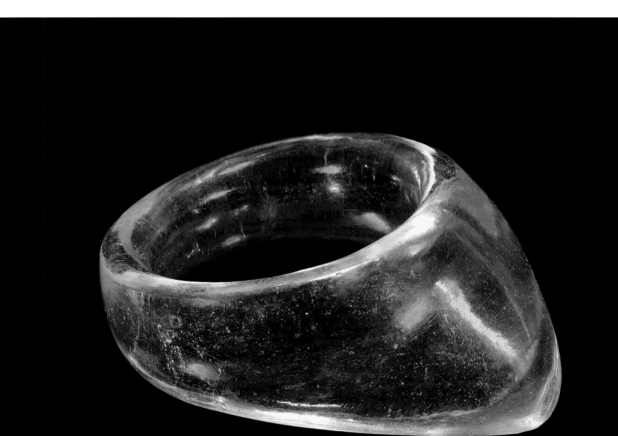

Cat. 156 JADE ARCHERY RING
Mughal dominions or Deccan,
seventeenth century
Carved from jade
Dimensions: Length 4 cm; width 3 cm
Provenance: Art market 2002
Published: Christie's, South Kensington,
7 November 2002, lot 12
Inv. no. LNS 3287 J

Of generally high proportions, very gently rounded
and gabled on the back, this ring is subtly carved
on the front with a pendent lily, which issues a pair
of buds from between its petals. Undulating vines
develop from the calyx of the pendent blossom, flow
towards the back of the ring bearing unfurling buds
and leaves, and touch on a quatrefoil on the back of
the ring. Where the vines touch on the lower petals
of the quatrefoil, buds develop from its upper petals
and flow towards the middle of the shank.

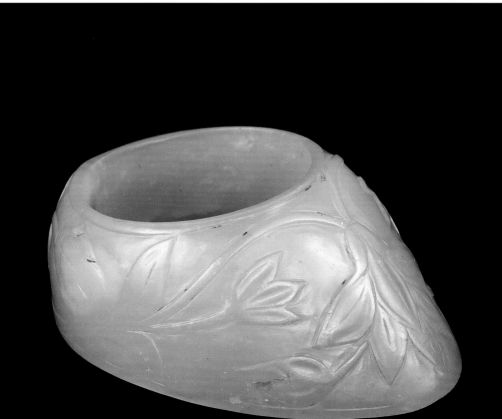

**Cat. 157 GEM-SET JADE
ARCHERY RING
Mughal dominions or
Deccan, probably late
seventeenth century**
Carved from jade, inlaid with gold
in *kundan* technique and set with
rubies and emeralds
Dimensions: Length 4.5 cm; width 3 cm
Provenance: Art market 1980s
Published: Qaddumi 1987, p. 151; Curatola
et al. 2010, cat. 275
Inv. no. LNS 40 HS

Undeniably simple and straightforward in its design,
this example is nevertheless quite elegant in its
decoration. On the front of the ring a ruby blossom
with a pale emerald centre in partially detailed gold
settings issues two emerald leaf-bearing vines. On the
back a ruby quatrefoil issues gently undulating gold
vines bearing ruby buds that flow towards the front
of the ring and touch on the leaf-bearing vines.

Simple gold fillets outline the upper and lower
edge of the ring.

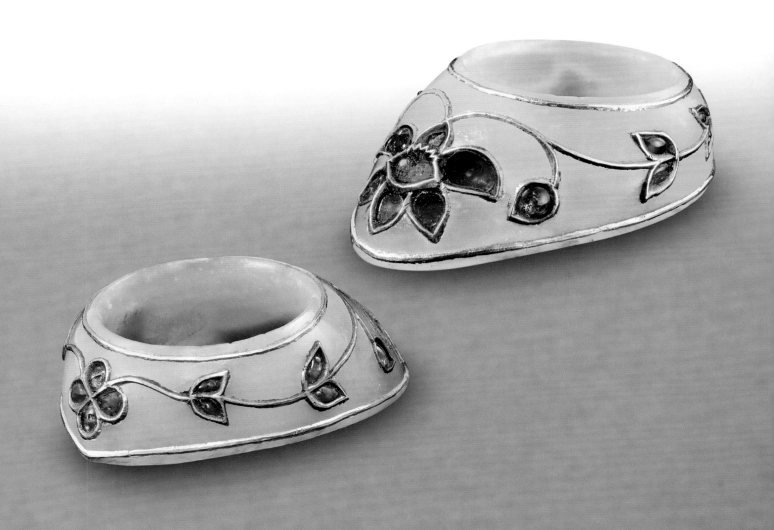

Cat. 158 **ENAMELLED AND GEM-SET**
ARCHERY RING
Probably Deccan, probably
early eighteenth century
Gold, champlevé and basse-taille
enamelled, and set with diamonds
in *kundan* technique
Dimensions: Length 4.3 cm; width 3.1 cm
Published: Christie's, South Kensington,
1 October 2012, lot 177
Inv. no. LNS 4985 J

Thick gold stems bearing a large diamond blossom and diamond buds in detailed
gold settings occupy the front of this archery ring, which curls up along its edge. In
contrast, fine gold tendrils and serrated leaves in reserve on the red enamel ground fill
the intervening surface. In further contrast, the sides and slightly gabled back of the ring
feature reserved gold vines bearing green enamel blossoms and leaves. It is noteworthy
that the treatment of the reserved foliate decoration is closely related to that on the
sword hilt Cat. 112, which is attributed to Hyderabad and dated 1213 H (1798–99 CE).

Sprigs of the same flowers that are featured on the back of the ring are repeated
on the interior, in white and black enamels on a green ground, an uncommon colour
scheme that is more closely related to European Renaissance enamels, and resembles
the interior of an eighteenth-century archery ring from northern India in the Victoria
and Albert Museum.[60]

Given that the decorative motif on the front of the ring is in such high relief,
one is left wondering whether this ring was ever actually used in archery, as the
decoration would have certainly snagged the bowstring.

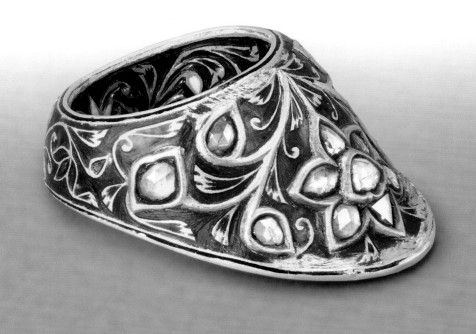

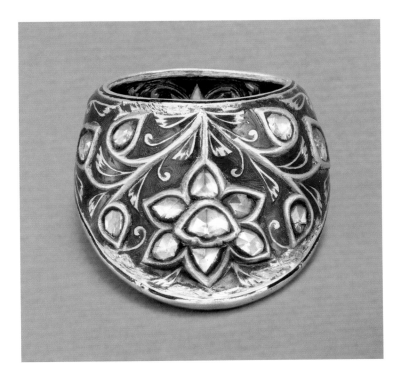

Front of ring

Back of ring

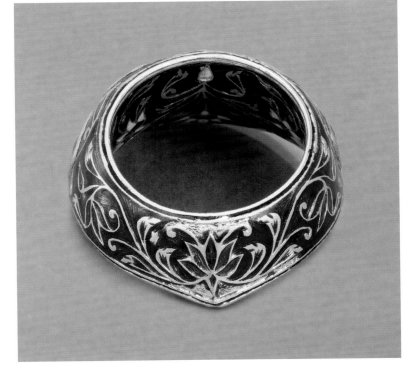

Underside of ring, Cat. 158 (LNS 4985 J)

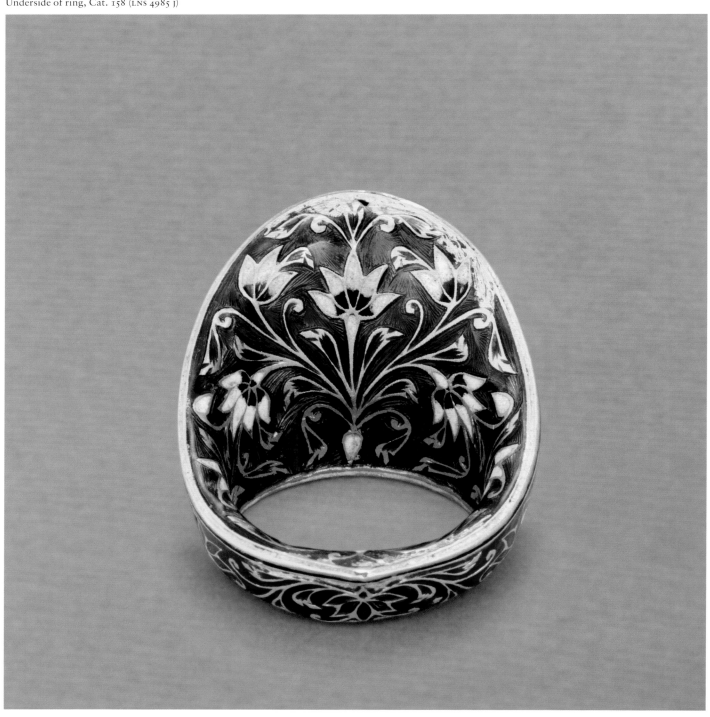

NOTES

1 Curtis and Reade 1995, pp. 50–51, cat. 5.
2 Rawson 1995, pp. 286–88, publishes three jade archery rings from the fifth–fourth century BCE, and on p. 286 states that: "the earliest surviving ancient Chinese thumb ring is that excavated from the tomb of Fu Hao at Anyang, c. 1200 BC."
3 See, for example, Baud 2010, p. 170, fig. 219, a third-century BCE replica of a relief from the Lion Temple, in "Moussawarat es-Soufra" in which a king wears an archer's ring, and p. 180, fig. 229, the gilded bronze figure of an "archer king" from the second century BCE excavated in the Great Temple of Tabo; likewise, a stone archery ring in the British Museum (inv. no. EA64043), and in the Oriental Institute, Chicago (inv. no. OIM 20302), as well as stone archery rings in National Museums Liverpool (inv. no. not available), and a stone ring in the Museum of Egyptian antiquities, Swansea (inv. no. not available).
4 For representations of archers on Indian stone reliefs, see Sivaramamurti et al. 1999, p. 397, fig. 482, a fifth-century CE combat scene between Yudhisthira and Jayadrathat; p. 384, fig. 423, a twelfth-century CE stone relief of a Chola archer; and p. 293, fig. 162, a thirteenth-century CE stone relief representing "Adipala killing buffalo demons".
5 Stronge 2015, p. 16, and footnote 16.
6 Kangle 2003, p. 132, notes 8–10, in the passage on archery where the author alludes only to bows and arrows: "8. Made from tāla, cāpa, wood and horn (and known as) kārmuka, kodanda and druna are the bows. 9. murvā, arka, sana, gavedhu, venu and sinews (of animals) are bow-strings. 10. venu, sara, salākā, dandāsana and nārāca are arrows."
7 Goswamy 1988, especially cat. 15, fol. 296v, in a miniature attributed to c. 1430 CE, where archers on horseback are drawing their bows with their fingers depicted in full view, thus allowing the viewer to see that their four fingers are folded over the string, and that none wear archery rings. An apparently rare instance from a manuscript of the Shah-nameh dated 11 Ramadan 841 H (8 March 1438 CE), attributed to Sultanate India, shows Rustam drawing his bow and wearing an archery ring, Skelton 1982b, p. 87.
8 Morse 1922, pp. 5–6.
9 The "Pur-i Vahman" dish in the State Hermitage Museum, St Petersburg (inv. no. S-247), Alexander 1996, pp. 122–23, cat. 94.
10 We are grateful to Manijeh Bayani for communicating the following reference from Firdausi's Shah-nameh (Dabir-Siaghi, vol. 5, XLII, p. 2220, lines 923–25), and the translation thereof

by A. G. Warner and E. Warner, The Shahnama of Firdausi, vol. VIII, London, 1915, p. 126.
11 The title of Mardi al-Tarsusi's treatise is تبصرة أرباب الألباب في كيفية النجاة في الحروب من الأسواء ونشر أعلام الأعلام في العدد والآلات المعينة على لقاء الأعداء (Counsel to the learned in warfare on means to avoid injury in combat, and instructions related to equipment and instruments that assist in enemy encounters), and the chapter on archery is ذكر فضيلة الرمي وأوصافه. For a published edition, see Boudot-Lamotte 1968.
12 Ibid., p. 117, fol. 60r.
13 Ibid., p. xv, among whom Mardi al-Tarsusi lists: "Abu 'Abdallah al-Tirmidhi, Muhammad b. al-Hasan al-Harawi, Abu al-Fath Sa'id al-Samarqandi, Muhammad b. Itarek al-Sarakhsi, Abu al-Hasan al-Kaghidi, Abu Musa al-Harrani, Hayawayh al-Balkhi."
14 Ibn Manzur 1968, p. 6.
15 For iconic manifestations of ancient Near Eastern sovereigns and gods depicted as archers, see for example: from the late fourth millennium BCE, the "Stele of the Priest-King hunting lions" in Aruz and Wallenfels 2003, fig. 5; from the second half of the third millennium BCE, the Akkadian victory stele of Naram-sin, and from the twelfth century BCE the boundary stone of the Babylonian king Marduk-nadin-akhe, both in Parrot 1961, pp. 176–77 and 319 respectively; from c. 1325 BCE, the representation of King Tutankhamun on his "war and hunting" chest, and from c. 1270 BCE, a relief depicting Ramses in his war chariot charging at an army of Hittites, both in Schulz and Seidel 1998, pp. 240 and 337, fig. 23, respectively; from the ninth–eighth century BCE, Ishtar as the goddess of war on the impression of a garnet cylinder seal, in Matthiae 1999, p. 40; from around 875–860 BCE, the Assyrian king Ashurnasirpal II in his chariot, and celebrating "after a bull hunt", both in Curtis and Reade 1995, pp. 50–51 and 54–55; and from 520–519 BCE, in Curtis and Tallis 2005, pp. 13 and 22, two Achaemenian royal attendants bearing the king's spear and bow behind King Darius on the commemorative rock relief at Bisitun. Also, various seals of office, ibid., p. 94, cats. 74–75, p. 158, cat. 202, and p. 221, cat. 398, and representations on coins, ibid., p. 200, figs. 320–27; and from the fourth–sixth century CE, the Sasanian kings Shapur II hunting boars and Peroz or Kavad I hunting rams, in Harper 1981, pls. x and xii respectively.

16 A bone and a bronze archery ring, respectively inv. nos. LNS 952 J and LNS 3290 J, both closely related to an "ivory" archery ring in the Damascus Museum, attributed to the fifth–seventh century CE (inv. no. NA); also in The al-Sabah Collection, bronze archery rings attributed to around the tenth–eleventh century: LNS 1347 J, LNS 1440 J, LNS 3289 J, LNS 3292 J and LNS 3291 J, the latter with what appears to be a talismanic inscription in linear Kufic; a bronze example decorated with a typical twelfth-century arabesque (LNS 323 M); a silver-inlaid bronze ring with a naskhi benedictory inscription (LNS 2795 J) from around the thirteenth century; a silver archery ring (LNS 1446 J) from around the thirteenth–fourteenth century; and a steatite mould for making archery rings (LNS 3102 J) from around the eleventh–twelfth century.
17 O'Kane 2003b, p. 6, fig. 8a, publishes a detail of the "Bridal Procession" scroll, clearly depicting the archery ring.
18 Gray 1977, p. 42.
19 Yusupov 1983, p. 33, fig. 3 (f. 118b).
20 See above note 7 (Skelton 1982b), the reference to the Shah-nameh manuscript dated 1438; in Barry 2004, p. 136, combatants wear archery rings in a miniature by Behzad, Herat, 1493; in Alexander 1996, p. 136, an archer wears an archer's ring in a miniature from the Hasht Bihisht, Herat, dated 1496.
21 Blochet 1975, pl. LXIV, publishes a miniature attributed to Herat, early fifteenth century, where Prince Ghazan wears an archery ring in a hunting scene. We are grateful to Dr Adel Adamova for communicating the revised attribution. Ibid., pl. XCVIII, Bahram Gur wears an archery ring in a hunting scene from a Shah-nameh, Herat, 1486; in Canby 1998, cat. 18, pp. 35 and 39, Rustam wears an archery ring in battle, in a Shah-nameh dated 1494.
22 Barry 2004, p. 277, a "prince prostrate at the feet of a hermit" wears an archery ring in a miniature from a Khamsa, Tabriz, c. 1470; ibid., p. 140, Bahram Gur reclining in the green pavilion wears an archery ring in a Haft Paykar, from Tabriz, c. 1478–90; Sims et al. 2002, p. 228, cat. 143, a "reclining prince reading" wears an archery ring in an album page attributed to Tabriz, c. 1530.
23 Nicolle 2002, pp. 162–63, cat. 120, where among a number of archers in a battle scene depicting Rostam defeating Ashkabus, only Rostam wears an archery ring.
24 Lentz and Lowry 1989, pp. 104–05, cat. 30.

25 Campbell and Chong 2005, p. 91, fig. 35. See also Necipoglu 2000, p. 29, "Mehmed's portrait also projects an image of refinement, counterbalanced by an allusion to his military achievements represented by the archer's thumb ring seen in the portrait of Shaybani Khan."

26 Lowry and Nemazee 1988, p. 107, cat. 22.

27 Melikian-Chirvani 2007, p. 55, and 56: "L'anneau d'archer que Shāybak Khān porte au pouce de la main droite n'est pas reproduit pour sa seule valeur ornementale. Il montre Shāybak Khān en qualité d'archer royal, de suprême guerrier chasseur, selon une conception du souverain aussi ancienne que l'Iran lui même"; and p. 85, footnote 28: "Les empereurs achéménides se représentent déjà au VIe siècle. a.v. J.-C. en archers, c'est-à-dire en chasseurs royaux." Regarding the subject of archery ring as royal attribute, see also Necipoglu 2000, pp. 27–28, "The Royal attributes of Shaybani Khan … include an archer's thumb ring on his right hand and a handkerchief."

28 Atil 1987, p. 34, figs. 10 and 11.

29 Lentz and Lowry 1989, p. 247, cat. 138.

30 Bahari 1996, p. 204, cat. 112.

31 Sims et al. 2002, p. 139, cat. 55.

32 Rogers 2010, cat. 209, pp. 178–79.

33 I am grateful to Professor Giovanni Curatola, for communicating and translating the reference from Marin Sanudo's Diarii, Sanudo 1899, vol. LV, col. 178.

34 It is noteworthy that prior to the 1580s the only personage wearing an archery ring in the Cleveland Museum Tuti-nameh of c. 1560–65 is a Brahman, a member of the highest Hindu caste, Chandra 1976, fol. 231v, and that the only archery ring depicted in the Hamza-nameh of c. 1562–77 is worn by 'Umar Ma'dikarb, Amir Hamza's lieutenant, Seyller 2002, p. 135, cat. 40.

35 Leach 1995a, p. 35, cat. 1.12, two apparently prominent personages wear archery rings in a miniature from the Chester Beatty Tuti-nameh, c. 1580; Welch 1978, p. 25, and miniature detail, p. 38 under entry no. VI, in a portrait miniature entitled "A Muslim nobleman", c. 1585, the nobleman wears an archery ring and suspends three more from his sash (in the style of the emperor Akbar); Blochet 1975, pl. CLXXXVII, the emperor Babur wears an archer's ring in a posthumous portrait of c. 1590; Leach 1995a, p. 102, cat. 1.188, King Hilar, who is waking up from a nightmare, wears an archer's ring in a miniature from the 'Iyar-i Danish, c. 1595; Canby 1998, p. 121, cat. 89, a hermit talking to a prince in front of his cave wears an archery ring in an illustrated folio from a Diwan of Shahi, c. 1595 (here, too, conceivably a prince who abandoned worldly life); Barry 2004, p. 74, in a royal manuscript of the Khamsa, Lahore, 1597–98, Sultan Sanjar wears an archery ring; Grube 1972, pl. LIII, cat. 239, in a Mughal album page dated 1020 (1611–12 CE) a European nobleman is depicted (with nimbus and emerald earring) at a jharoka, an enclosed ceremonial balcony, in "typical Elizabethan fashion" wearing a golden archery ring.

36 Stronge 2002, in numerous representations of the emperor Akbar in the Victoria and Albert Museum Akbar-nameh, from c. 1590–95. Interestingly, the son of Emperor Akbar's wet nurse and governor of Kabul, Zain Khan Koka, wears archery rings suspended from his belt in a miniature attributed to c. 1590–1600, Calza 2012, p. 99, cat. 1.10. See Leach 1995a, p. 387, cat. 3.15, portrait of Emperor Jahangir, c. 1620, wearing archery rings suspended from his sash, and p. 467, cat. 3.64, portrait of Emperor Jahangir, c. 1620, in which he wears what appear to be jewelled, jade and banded agate archery rings suspended from his sash.

37 Stronge 2002, p. 128, pl. 93.

38 Bharat Kala Bhavan museum, Benares, Morley 1971, p. 112, pl. 8 and fig. 239a.

39 Musée des arts décoratifs, Paris (inv. no. 30074).

40 Shah Jahan's adoption of the title "Second Lord of the Auspicious Conjunction" stemmed from the need to assert his Timurid lineage, as Amir Timur was titled "Lord of the Auspicious Conjunction".

41 Salar Jung Museum, Hyderabad, Nigam 1979, p. 34, and fig. 29 (inv. no. XLIX-1338).

42 Victoria and Albert Museum, London (inv. no. 1023-1871).

43 The State Hermitage Museum, St Petersburg, Ivanov 1990, cat. 93 (inv. no. VZ-703).

44 A dark-green jade archery ring on display at the Musée des arts décoratifs, Paris (inv. no. 30074) is inscribed in the name of Emperor Jahangir and dated 1032 H (1622–23 CE); a dark-green jade ring in the Salar Jung Museum, Hyderabad (inv. no. XLIX-1338) is inscribed in a lobed cartouche with Emperor Shah Jahan's title Sahib Qiran-e Thani, and dated 1040 H (1630–31 CE), Nigam 1979, fig. 29; and a white jade archery ring in the Victoria and Albert Museum (inv. no. 1023-1871) is inscribed in a lobed cartouche with Emperor Shah Jahan's title Sahib Qiran-e Thani, and dated 1042 H (1632–33 CE).

45 The translator of the Zafar-nameh Mr Pétis de la Croix relates that when Amir Timur was enthroned, he was given the title Sahib Qiran-e, Lord of the (Auspicious) Conjunction (of the two auspicious planets Venus and Jupiter) by the princes attending the ceremony: "Timur monta sur le Thrône, mit la couronne d'or sur sa tête, & se ceignit luy-même de la ceinture Imperiale en présence des Princes du Sang Royal & des Emirs, qui se mirent tous à genoux, & l'ayant félicité, luy firent de magnifiques presens, répandirent à pleines mains sur sa tête quantité d'Or & de Pierreries, selon la Coûtume, & luy donnerent le Titre de Saheb Caran" (Sharaf al-Din Ali Yazdi 1722, p. 203). As the Mughals claimed descent from Amir Timur, Shah Jahan adopted the title Sahib Qiran-e Thani (Second Lord of the [Auspicious] Conjunction).

46 Biruni 1984, p. 198.

47 Rogers 2006, p. 117, cat. 82.

48 Skelton 1982a, cover and cat. 41.

49 Stronge et al. 1988, cat. 93.

50 See Keene 2004b, pp. 108 and 110, and p. 122 n. 58.

51 A related archery ring with a single natural inclusion on the front is published in Skelton 1982a, cat. 382.

52 Skelton 1982a, cover and cat. 41.

53 Mota Raja Udai Singh of Jodhpur is portrayed wearing coloured archery rings suspended from his belt in a painting attributed to c. 1575, Beach 2000, p. 35, fig. 20. Emperor Akbar wears three-coloured archery rings suspended from his belt in a painting from the c. 1590–95 Akbar-nameh, Stronge 2002, p. 9, pl. 1.

54 Keene 2004b, pp. 99–123, especially figs. 16–17.

55 For a discussion regarding the introduction of new colours, see Keene 2004b, pp. 107–08, figs. 12–13.

56 Interestingly, the same type of border occurs in a Rajput painting from Pali, dated 1623, Beach 2000, p. 127, fig. 95, the date of which tallies with the attribution of an ivory Mughal dagger outlined with the same border in the Freer Gallery of Art, Washington, DC, Atil et al. 1985, cat. 34.

57 For more on the subject, see Tillotson 2006, pp. 149–52.

58 Brand and Lowry 1985, p. 81, fig. 47.

59 Mohamed 2008, cat. 386b.

60 Stronge et al. 1988, cat. 94, Victoria and Albert Museum, inv. no. 02528 IS; the enamelled interior of this ring is illustrated on p. 101.

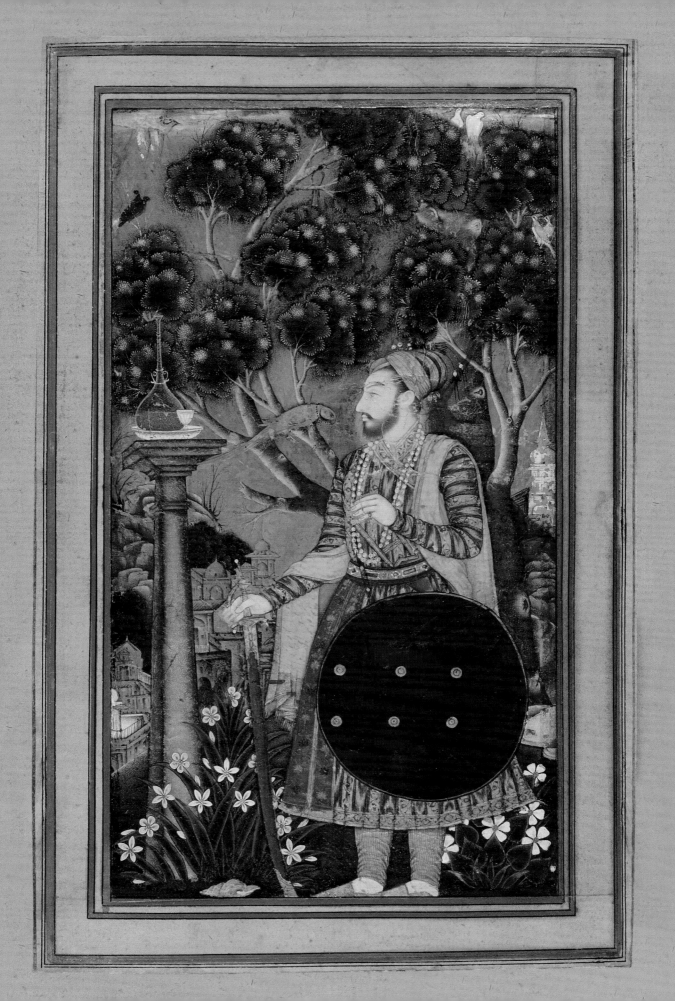

CHAPTER THIRTEEN
A JEWELLED SHIELD, BOSSES, HARNESS FITTINGS
AND DAGGER-CORD ORNAMENTS
ADDED FORMS OF DECORATION

JEWELLED SHIELDS, SHIELD BOSSES AND HARNESS FITTINGS

Magnificent accoutrements worn in battle or on parade were not simply luxurious displays of the splendour of the court and the wealth of its rulers and princes. They were also political tools that served to magnify the authority of their wearers, eliciting awe and reverence from both loyal subjects and adversaries. Shields were particularly significant in this respect: they not only had symbolic value as a means of defence, but also, because of their large size, could be viewed at greater distances than bladed weapons, making them especially effective for displaying the power and status of the bearer.

In antiquity and during the Renaissance period a variety of mythological themes and awe-inspiring subjects were adopted as protective symbols and frequently represented on armour. One of the most popular was the head of the Gorgon Medusa, whose eyes turned onlookers into stone and who had venomous snakes in place of hair.[1] The monster, whose name appropriately signified "protectress", was beheaded by the Greek hero Perseus, who used her head to ward off his opponents and turn them to stone, and later presented it to the goddess Athena to adorn her shield. The motif of the Medusa was therefore featured on protective battle gear, such as Alexander's breastplate in the famous Pompeii mosaic, and on Renaissance armour all'antica such as Emperor Charles V's shield dated 1541.[2]

Indian shields that have come down to us are typically manufactured from lacquered hide, reed or damascened steel; we know of no other jewelled shield like the example in this collection, Cat. 159, which is adorned with a sun mask, the ancient symbol of sovereignty linked to the Rajput Suryavansha dynasty, who claim descent from Surya or the Sun.

It is likely, however, that other jewelled shields existed but have not been preserved. Although it is possible that the magnificent jewelled shield bosses presented here (Cats. 162, 163 and 164) could have adorned jewelled shields, it is equally likely they adorned shields that were otherwise not jewelled.[3]

It is also worthy of note that shield bosses did not only serve to adorn shields, but also had a utilitarian function. As Indian shields were only held with the hand, as opposed to being slung over the shoulder with a strap as was the case elsewhere during ancient and early medieval times, they were fitted with a pair of handgrips fastened to the shield by means of rivets; hence the bosses, which served to conceal the rivets on the front of the shield.

In addition to the jewelled accoutrements of Indian nobility, sumptuous trappings that often constituted royal gifts or *khil'ah* bestowed on members of the court can be seen adorning their horses and elephants in most representations from the period. The harness strap-fittings presented here are superb examples of this lavish and refined practice, so characteristic of India.[4]

Portrait of Sultan Muhammad 'Adil Shah of Bijapur with suspended shield, Bijapur, *c.* 1635

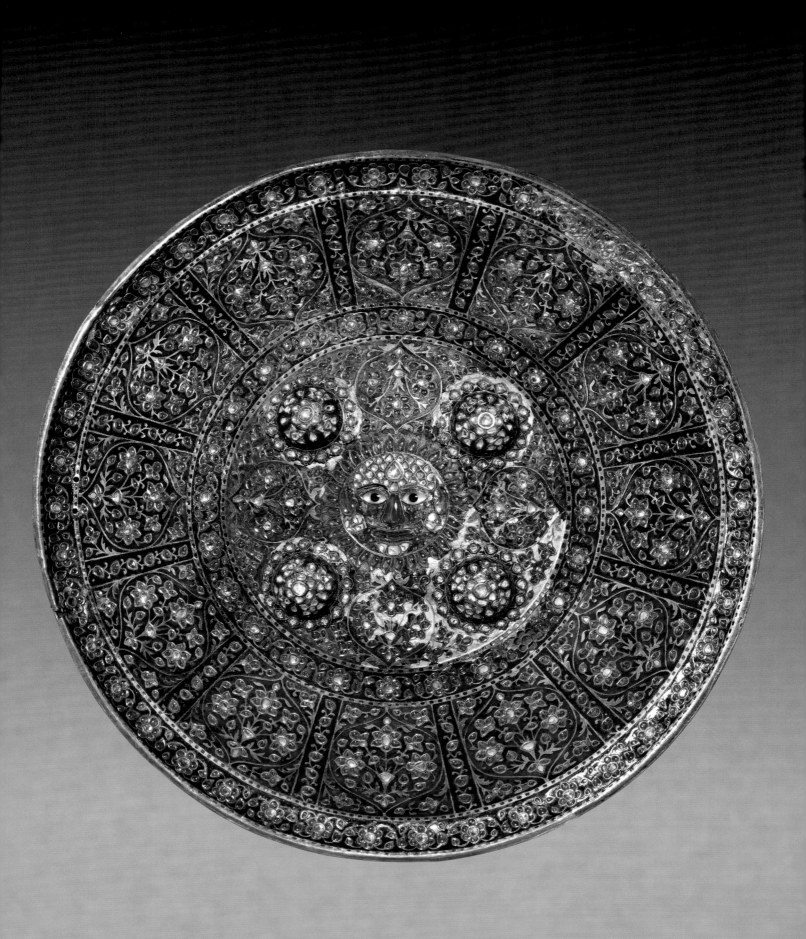

JEWELLED SHIELD, BOSSES AND FITTINGS

Cat. 159 SHIELD
North or central India, probably
late nineteenth century
Hammered from silver sheet,
champlevé enamelled and gilded;
set in *kundan* technique with
diamonds, rubies, emeralds, agate,
chalcedony and rock crystal
Dimensions: Diameter 49 cm; thickness 7.5 cm
Provenance: Art market 1999
Published: Keene and Kaoukji 2001, cat. 13.22
Inv. no. LNS 2162 J

An ancient and widespread symbol of sovereignty, the sun motif that adorns this shield links it to the Rajput Suryavansha dynasty, who claim descent from the sun.

This example was hammered from a silver sheet and lavishly decorated with medallions charged with ruby and diamond flowering plants, sprouting from ruby and diamond trefoils on a predominantly green enamel ground, framed by bands of ruby, diamond and emerald floral scrolls against a cobalt-blue ground.

In the centre of the shield, a green enamel sun mask, enlivened with reserved silver dots, is encircled by flame-like ruby rays and covered with diamonds on its forehead, at the centre of which is a large diamond "bindi". The prominent eyes are set with chalcedony inlaid with near black agate, and the eyebrows and moustache are set with ribbed rock crystal. The nose, mouth and ears are set with carved rubies, and the chin and hooped fish-shaped earrings with diamonds.

Surrounding the sun mask are four shield bosses, which served both to adorn the shield and to conceal the rivets that are fastened to the handgrips on the back of the shield. The bosses are covered in green enamel, with diamond floral motifs in detailed settings bordered by ruby petals and encircled by multilobed diamond collars. Between the bosses are cusped medallions with ruby and diamond flowering plants that recall the larger medallions around the edge of the shield, and likewise grow from ruby and diamond trefoils.

The back of the shield is decorated in the centre with a green and blue enamel flower partially concealed by the knuckle pad and handgrips that are attached to the shield bosses. The remaining surface is covered in a graduated lattice of toothed leaves with stylized iris blossoms bordered by floral scrolls.

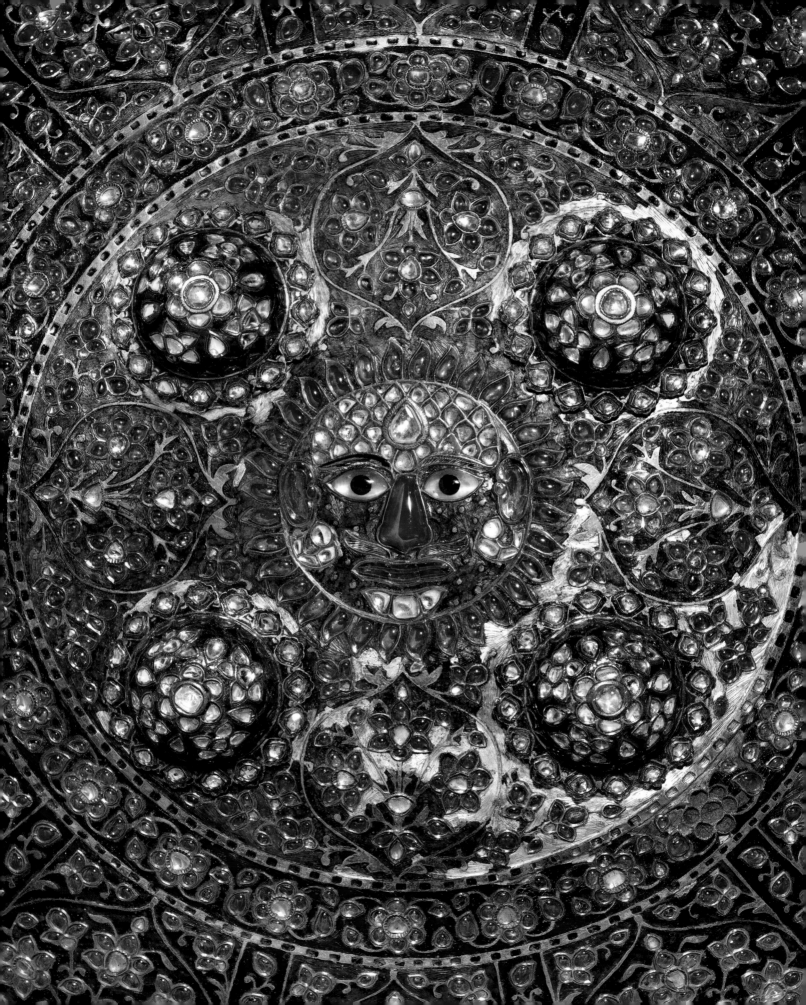

Back of shield with knuckle pad and
handgrips, Cat. 159 (LNS 2162 J)

Detail of gem-set sun mask
surrounded by four shield bosses

Detail showing a shield with a knuckle pad in a
folio, painted by Abid, from the *Padshah-nameh*
manuscript, *c.* 1633

Cat. 160 SHIELD BOSSES
Probably Mughal dominions,
perhaps late sixteenth–early
seventeenth century
Fabricated from silver sheet and
strips; hammered in relief and
gilded
Dimensions: Average diameter 4 cm; average
height 2.5 cm
Art market 1994
Published: Keene and Kaoukji 2001, cat. 3.11
Inv. no. LNS 1158 J a–c

This suite of gilded silver shield bosses,
modelled on frowning lion faces with
puckered brows presenting strikingly human
expressions, is very closely related to lion
and mythical faces depicted on European
armour from the Renaissance period.[5]

The backs of the fittings are also gilded
and fitted with a projecting open-ended
loop-fastener for attachment to the surface
of the shield.

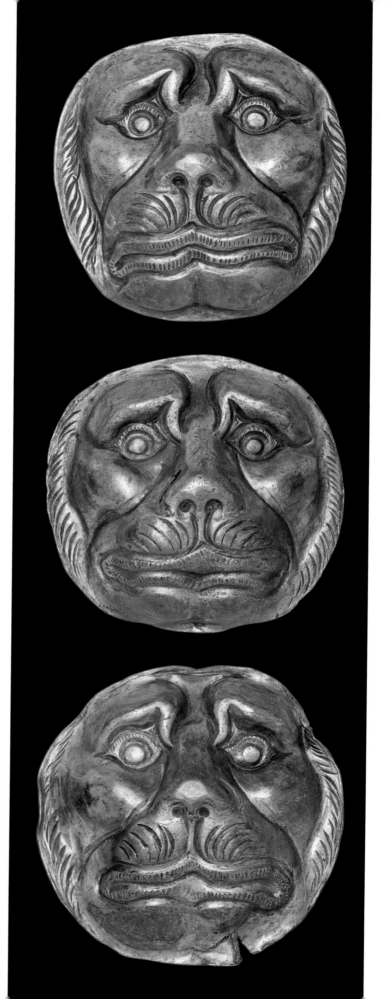

Cat. 161 **SHIELD BOSS**
Deccan or Mughal
dominions, first half of
the seventeenth century
Cast copper, champlevé
enamelled, gilded
Dimensions: Diameter 5 cm; height 1.5 cm
Provenance: Art market 1997
Published: Keene and Kaoukji 2001,
cat. 6.11
Inv. no. LNS 1745 J

One of a series of four or more bosses decorating the face of a shield, this boss is covered with opaque middle-blue enamel setting off six leaves overturned on their tips, yielding a whirling effect that is echoed by the overturned petals of the blossom at the centre of the boss. The leaves are partially gilded and retain only traces of their original green enamel. The central blossom, which has lost most of the original enamel, thus revealing the underlying copper surface, retains only the gilding that highlights the effect of the overturned petals.[6]

The edge of the boss is outlined with gilding, as are the opaque white enamel acanthus leaves that border the boss.

Cat. 162 **SHIELD BOSSES**
Deccan or Mughal
dominions, first half of
the seventeenth century
Fabricated from gold over a
bronze core; worked in *kundan*
technique and set with rubies,
diamonds and emeralds;
attachment post capped with
champlevé enamel

Dimensions: Average diameter 6 cm;
average height 3 cm

Provenance: Art market, 1997

Published: Christies, London,
8 October 1997, lot 350

Inv. no. LNS 1865 J a–d

One can only imagine the splendid shield that was originally fitted with these four bosses. Typically decorated in the form of flowers encircled by collars of cusped petals, the bosses are pierced on the top and fitted with a post covered with green enamel.

Surrounding the pin is a star configuration, set with emeralds, which recalls bosses represented on a shield in a painting from the *Padshah-nameh* entitled "The death of Khan Jahan Lodi", dated to *c.* 1633.[7] The stylized cypress trees that nest between the star branches are set with emeralds, rubies and diamonds and bordered by channel-set rubies. The cypress trees grow from small emerald mounds placed around the base of the domes, and ruby trefoils fill the intervening surfaces between the emerald mounds.

The petals that encircle the bosses alternate between three petals set with rubies and a petal set with an emerald. The undersides of the bosses exhibit a worn gilded-bronze surface.

Detail showing gem-set decorations,
with tips of stylized cypress trees and star
motif radiating from the pin of the boss

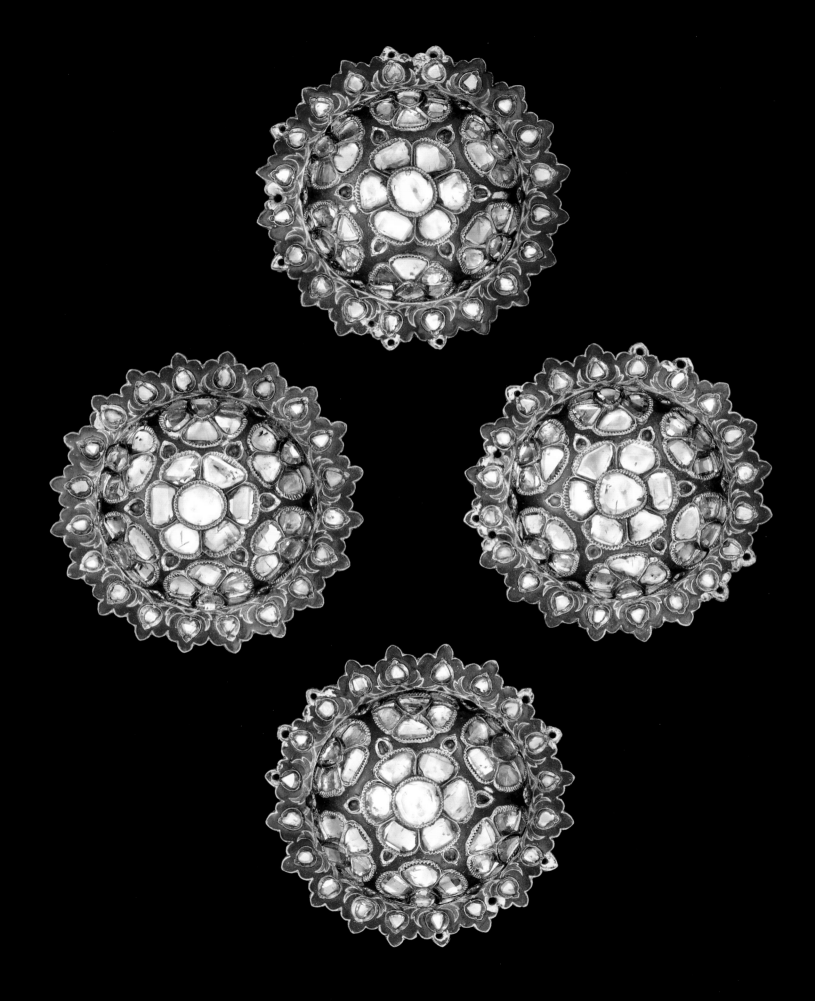

**Cat. 163 A SET OF FOUR SHIELD
BOSSES
Mughal dominions, probably
mid seventeenth century**
Fabricated from gold and
champlevé enamelled; worked in
kundan technique and set with
diamonds and emeralds
Dimensions: Average diameter 6 cm;
average height 2 cm
Provenance: Art market 1991
Published: Keene and Kaoukji 2001, cat. 13.11
Inv. no. LNS 209 J a–d

These lavishly decorated shield bosses are unfortunately all that
survives of what must have been a sumptuous shield. They are
covered with red enamel setting off diamond flowers augmented
with small emeralds in detailed gold settings.

The diamond rosettes in the centre of the bosses issue small
emerald leaves in scalloped settings from the outer edges of
their petals, and the surrounding diamond flowers are carried
by minuscule green enamel stems and have emerald calyces
issuing green enamel bracts. In between the diamond flowers
are small emerald leaves, corresponding to those surrounding
the central rosettes that grow from the base of the dome.

Around the border, diamond buds sit on the cusps of a
green enamel festoon of upswept split leaves cradling alternate
buds. The edges of the petal borders are covered with blue
enamel, and all but one have had holes pierced at a later stage
for attachment with wire, which has resulted in damage to the
surrounding enamels.

The bosses are of undecorated gold on the underside,
wherein each dome has a cylindrical void in the centre retaining
traces of a tube (now broken off flush with the edge) that once
served to attach the bosses to the shield and handle grip.

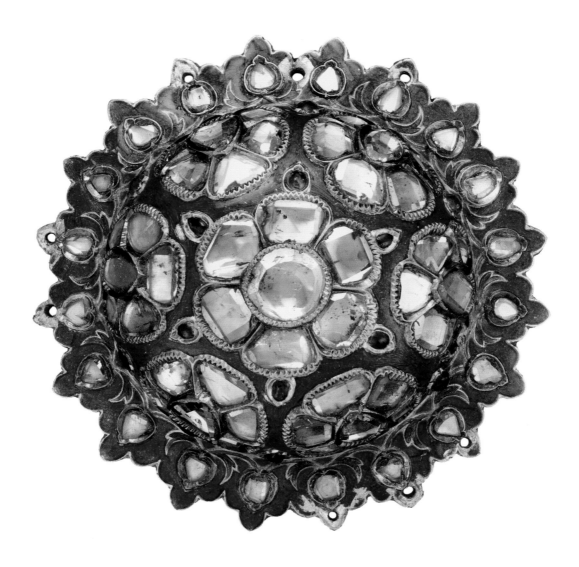

Diamond flowers on boss bordered by a green enamel
festoon cradling diamond buds, Cat. 163 (LNS 209 J)

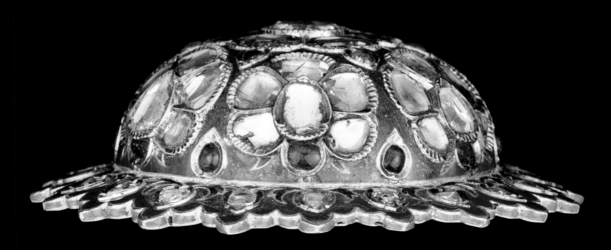

Side view showing minuscule enamelled stems bearing
diamond flowers with emerald calyces

Underside of boss

Cat. 164 SHIELD FITTINGS
Mughal dominions, probably mid seventeenth century
Fabricated from gold and champlevé enamelled; worked in *kundan* technique and set with diamonds and emeralds
Dimensions: Measurements (height × width), bottom to top: (a) 8 × 9 cm; (b) 7 × 7.5 cm; (c) 6 × 7 cm
Provenance: Art market 1997
Published: Keene and Kaoukji 2001, cat. 13.13
Inv. no. LNS 1819 J a–c

Even though these three crescent-shaped shield fittings were purchased as a set, and at a later date than the previous shield bosses Cat. 163, it is clear that the largest of the three fittings belongs with the previous set, or was at the very least produced in the same workshop. A close look at the overall decoration, the treatment of the gold settings and the layout of the floral scrolls, as well as the variance in the tone of the red enamel background, shows that the largest fitting is not from the same set as the other two. It is noteworthy that although the fittings are in the form of crescents, their edges are bordered with petals.

Interestingly, most shields depicted in the *Padshah-nameh* have four bosses that conceal the handgrip rivets, but also single crescent-shaped fittings set closer to the edges of the shields that were probably just for decorative purposes.[8] It is thus not surprising that these fittings are not part of a matching set.

The largest fitting is decorated in the centre with a large diamond rosette from which issue a succession of diminutive green enamel stems bearing pairs of diamond buds and diamond flowers with emerald calyces, which culminate at the tips of the crescent with large diamond buds. Whereas the two smaller fittings are not identical in their decoration, they are both decorated with reserved gold scrolls of diamond flowers (with emerald calyces on the middle-sized fitting), diamond buds and emerald leaves.

The lobed petals framing the larger fitting are set with diamond buds on the cusps of a pale-green enamel festoon, wherein upswept leaves cradle alternate buds, in identical fashion to the preceding fittings (Cat. 163). The rounded petals bordering the smaller fittings are set with diamonds on an emerald-green enamel ground.

The two largest fittings are backed with gold sheet. All three exhibit remnants of three cylindrical posts evenly spaced on their backs, and the largest was later pierced through on its outer perimeter between some of the bordering petals.

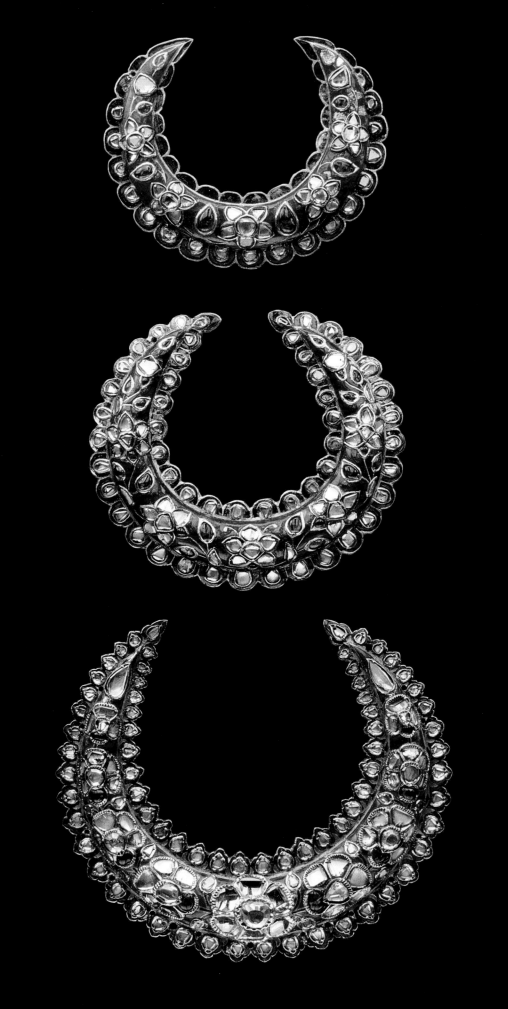

Cat. 165 **SHIELD BOSS**
Probably Deccan,
seventeenth century
Steel, overlaid with gold
Dimensions: Diameter 5 cm; height 1 cm
Provenance: Art market 1991
Published: Keene and Kaoukji 2001, cat. 7.7
Inv. no. LNS 312 M

A continuous scroll of large flowers and sweeping feathery leaves, with smaller leaves in the intervening areas, decorates the domical section of the boss and surrounds a raised rosette pierced in the centre to receive the fastening stud.

The border of the boss is composed of tangent fleur-de-lys executed in openwork.

HARNESS FITTINGS

Cat. 166 HARNESS FITTINGS
Probably Deccan, first half
of the seventeenth century
Fabricated from gold and
champlevé enamelled; set in
kundan technique with diamonds
and emeralds
Dimensions: Average measurements of domical
fittings: diameter 6 cm; height
3 cm; buckle 6 × 4 × 6 cm;
average measurements of strap
holders: 5 × 1.5 × 1 cm
Provenance: Art market 1991
Published: Keene and Kaoukji 2001, cat. 6.31
Inv. no. LNS 260 J a–f

Once part of a group of opulent harness trappings, this set of fittings is now solely composed of two domical haunch or bridle fittings, a buckle and three strap holders.

The two domical elements are fitted on their backs with three posts supporting a flat ring that would have served to set apart the haunch or temple straps coming from three directions; the rectangular buckle is fitted with a post for securing the strap; and the three rectangular strap holders are voided on the sides and bottom to allow the passage of straps.

The domical haunch fittings are decorated with a floral motif set with diamonds and emeralds in artful gold settings that are partially lobed and carved in the form of split palmettes on the sides of the petals and leaves. An exquisite and unusual detail is introduced by the finely chiselled bird heads from which grow the three flowering plants that surround the base of the domes. The base is encircled by pricked gold petals and by a corolla of diamond and emerald petals, bordered around the edges with opaque pale-blue enamel. On the back of the fitting the flat ring is covered with a chevron motif of green and opaque white enamel, and the cylindrical posts retain traces of green enamel.[9]

The gold settings of the diamond and emerald scrolling vines featured on the buckle are of the same character as those on the domical fittings, and in addition issue chiselled tendrils. The central post, which would have been hidden by a strap, is nevertheless decorated with a reserved gold scrolling vine with opaque white enamel flowers, and opaque light-green enamel and reserved gold leaves. On the back, a scroll of opaque white flowers and toothed green leaves outlined in gold flows uninterrupted on the red enamel ground, and the back of the post features a pattern of reserved gold lozenges composed of trefoils on a pale-blue field. The outer edges of the buckle are enamelled with green and white chevron motifs that proceed outward from a central lozenge.

The gold settings of the strap holders match the rest of the fittings, and here, in addition, the central blossom is surmounted by a small palmette. Flanking the strap slots, on either side of the fittings, are two enamelled bands, of which the upper is decorated with white circles on a green ground, and the lower with red rectangular compartments. The ends are decorated in three registers: the upper register has a white circle on a red ground; the middle recalls the centre of the chevron band at the edge of the buckle; and the lower has an extension of the band of red rectangular compartments. Framing the voided back is a green and white chevron band of the same type as that on the edge of the buckle.

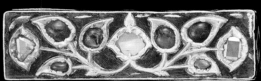
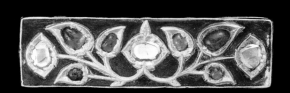
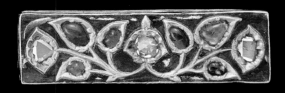

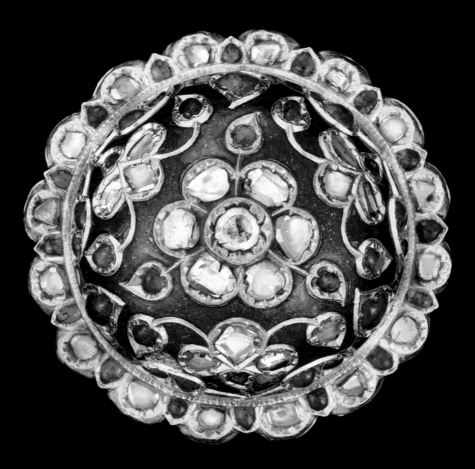

Domical fitting decorated with diamond flowers issuing stemmed
emerald leaves, and enamelled back, Cat. 166 (LNS 260 J)

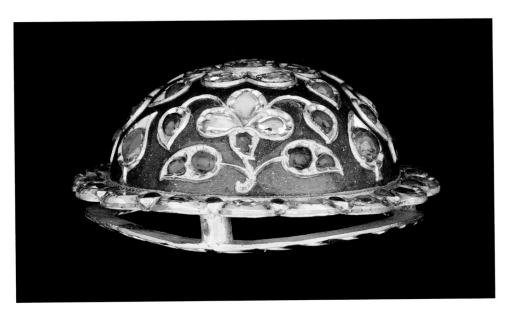

Side view of domical haunch fitting

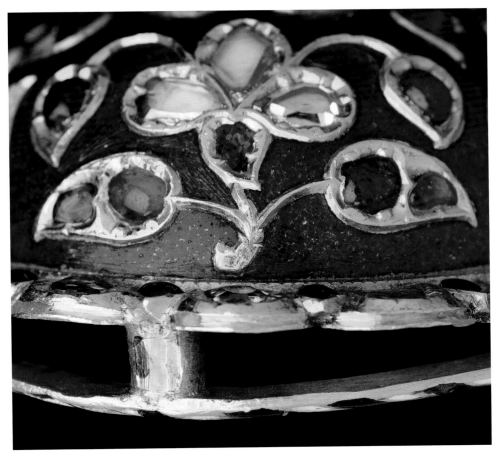

Detail showing the minuscule bird heads from which issue the flowering plants

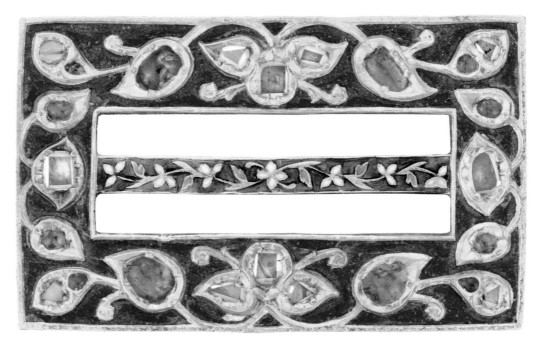

Gem-set and enamelled face of buckle, Cat. 166 (LNS 260 J)

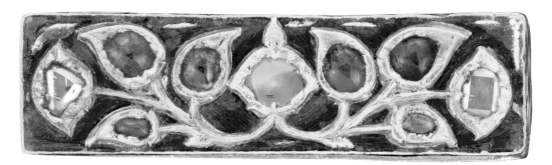

Gem-set and enamelled face of strap holder

Enamelled back of buckle

Enamelled back of strap holder

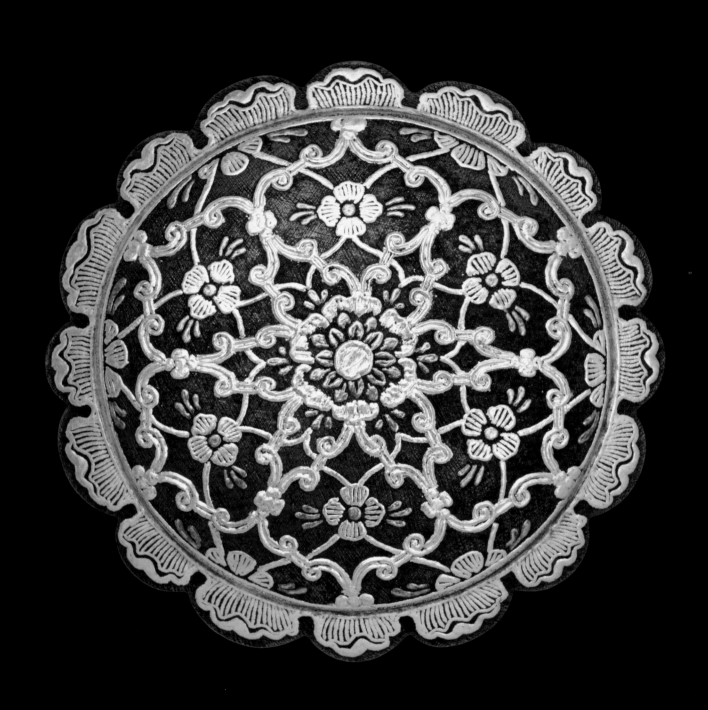

Cat. 167 HORSE STRAP FITTING
Probably Deccan, first half
of the seventeenth century
Steel, overlaid with two colours
of gold
Dimensions: Diameter 4.5 cm; height 1 cm
Provenance: Art market 1988
Published: Keene and Kaoukji 2001, cat. 7.6
Inv. no. LNS 151 J

On the back of this fitting are three typical
equidistant posts supporting a flattish ring
that serve to separate the harness straps.

The low domical surface is decorated
with a six-part arabesque in two colours
of thick, modelled gold that centres on a
six-pointed star radiating from a rosette.
The arabesque layout is composed of two
overlapping lattices of ogee medallions,
wherein the primary and more conspicuous
lattice is rendered in the modelled gold,
and the secondary lattice comprises
slender vines with large quatrefoils at their
points of intersection. The detailed petals
that border the dome are overturned on
their edges in a manner that resembles
auspicious Chinese cloud bands.

Cat. 168 HORSE STRAP FITTING
Mughal dominions or Deccan,
seventeenth century
Carved from nephrite jade; inlaid
with gold in *kundan* technique
and set with rubies
Dimensions: Diameter 5 cm; height 1.5 cm
Provenance: Art market 1998
Published: Keene and Kaoukji 2001, cat. 2.23
Inv. no. LNS 2101 J

This fitting has been carved from a single piece of jade,
including the three posts that support the ring and serve
to separate the straps that would be threaded through it.

The gently raised central panel and the central ruby
are outlined with "pricked" gold petals, and the five gold
stems issue ruby buds and blossoms in lobed settings.
The outer edge and the small petal-like ruby settings
around the edge are outlined with plain raised gold.

Back of strap fitting

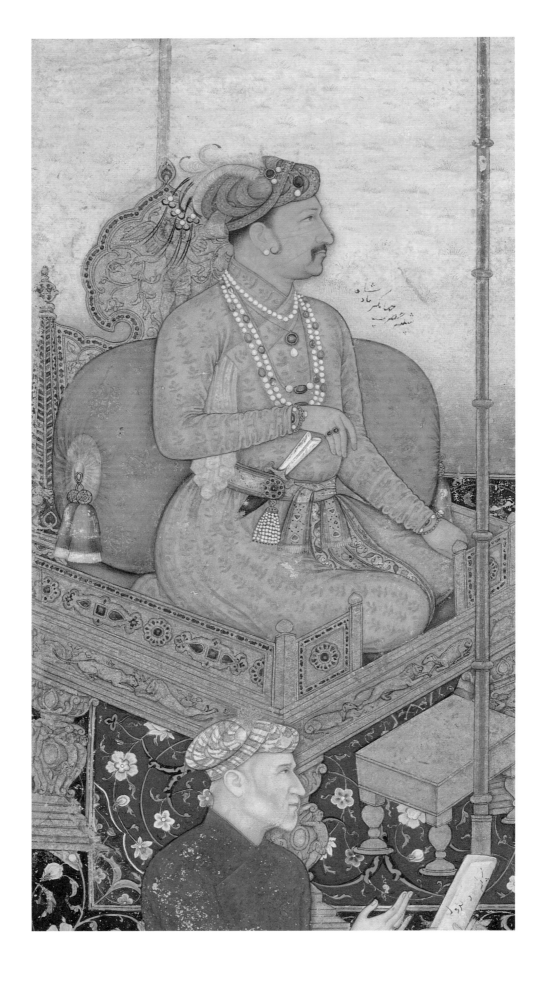

DAGGER-CORD ORNAMENTS

Suffice it to say, in a land whose penchant for beauty manifested itself in a compulsion to embellish what elsewhere might have been considered non-essential, it is not surprising that dagger cords were supplemented with ornaments, further adorning the richly decorated sashes and ornate weapons to which they were attached.

Daggers worn tucked in sashes were secured by means of a slender cord that was simultaneously wrapped around the sash and the dagger. Such devices can be seen in some manuscripts from the later Akbari period, including in an illustration from the manuscript of the *Raj Kunwar* (Allahabad, 1012 H/1603–04 CE) where the cord can be seen fitted with a circular jewelled ornament.[10]

The trend seems to have been popular under emperors Jahangir and Shah Jahan, when it appears that dagger-cord ornaments became a component of high-status dress and were worn as part of the standard attire of ruling princes and prominent members of the court.[11]

Detail from an illustration in the Minto Album by Bishitr, 1630–31, depicting Emperor Jahangir with a dagger-cord ornament and fob adorning his sash

Cat. 169 DAGGER-CORD ORNAMENT
Deccan or Mughal dominions, seventeenth century
Carved from nephrite jade; inlaid with gold in *kundan* technique and set with rubies and emeralds
Dimensions: Diameter 4.5 cm; thickness 1 cm
Provenance: Art market 1997
Published: Keene and Kaoukji 2001, cat. 2.24;
Schimmel 2004, fig. 68
Inv. no. LNS 259 HS

Rubies and emeralds in plain gold settings make up the rosette and whirling buds on the front of this dagger-cord ornament, and the gold fillet that outlines the edge, although displaying wear, retains areas of transverse linear engraving with "ticked" detailing, probably a vestige of petals.

The gently convex back is relief-carved as a rosette with petals curled back around their edges, and with rotational flutes that match the whirling movement on the front. The two integral lugs carved in the form of folded-over leaves are likewise detailed with fluting.

Two small holes of unknown purpose are pierced through the edge on opposite sides of the piece.

Rotating flutes and overturned petal edges on back of ornament

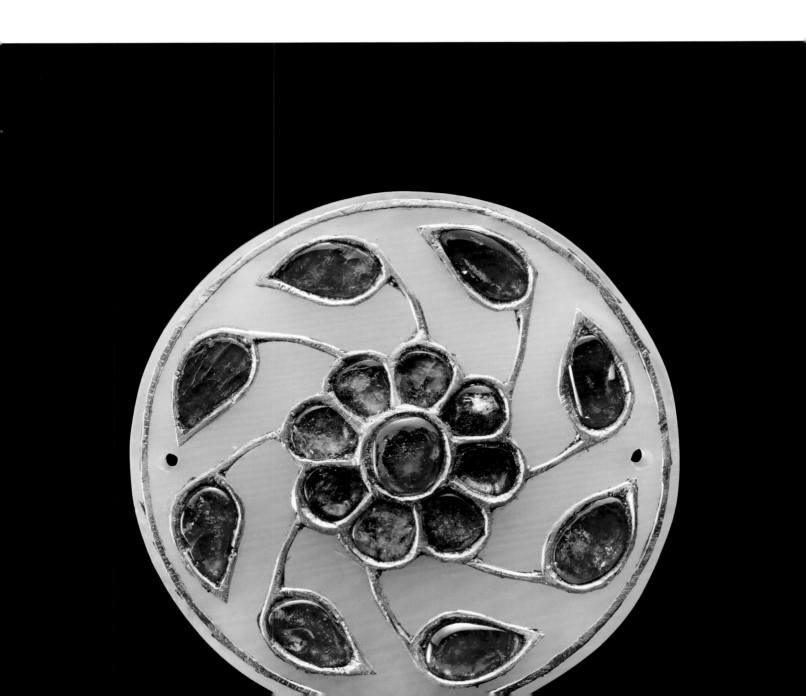

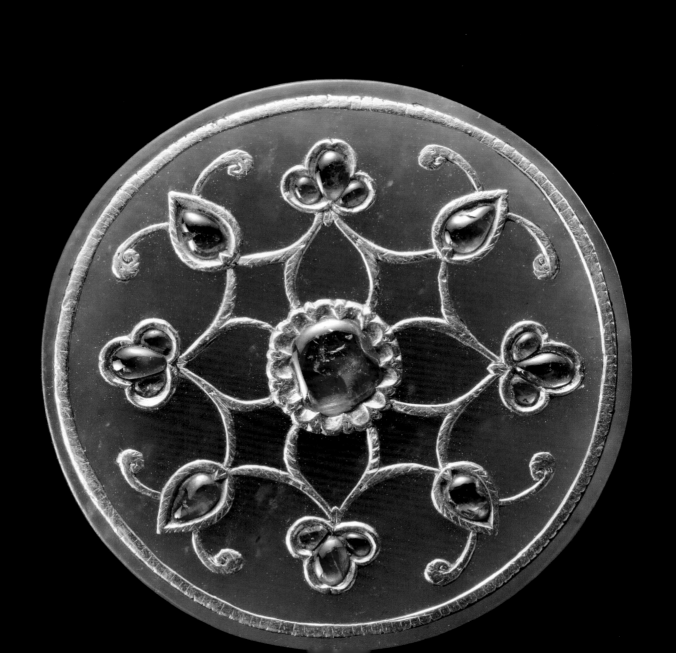

Cat. 170 **DAGGER-CORD ORNAMENT**
Probably Deccan, early seventeenth century
Carved from nephrite jade; inlaid with gold in *kundan* technique and set with rubies
Dimensions: Diameter 4 cm; thickness 1 cm
Provenance: Art market 1995
Published: Keene and Kaoukji 2001, cat. 2.25
Inv. no. LNS 1262 J

The radial eight-part floral composition on the front of this dagger-cord ornament is set with rubies in raised gold settings detailed with transverse linear engraving, and is outlined with a gold fillet engraved with petals.

The decorative motif essentially centres on a gold-outlined concave-sided "octagon" with ruby buds issuing pairs of tendrils at the apexes of the octagon points. In the centre a large ruby in a lobed setting, with small "ticked" cusps in the interstices of the lobes, issues four leaves outlined in gold whose tips are crowned by ruby trefoils, all resulting in a very pleasing motif that recalls Timurid styles of decoration.[12]

The undecorated back of the piece is carved with two integral rectangular-section lugs.

Back of ornament

Cat. 171 DAGGER-CORD ORNAMENT
Probably Deccan, first half of the seventeenth century
Carved from nephrite jade; inlaid with gold in *kundan* technique and set with rubies
Dimensions: Diameter 4 cm; thickness 1.5 cm
Provenance: Art market 1994
Published: Keene and Kaoukji 2001, cat. 2.26
Inv. no. LNS 212 HS

In contrast with the simplicity and formalism of its gem-set face decorated with swaying stemmed ruby buds, a motif that often appears on objects from the Deccan,[13] the back is finely carved as a fleshy four-petalled poppy of lobed outline, in which the lobed effect of the perimeter is accentuated by the subtly overturned petals. It is worthy of note that the treatment of poppy flowers of this type, which are frequently carved on the underside of Indian hardstone vessels and on the backs of ornaments from the period, is very closely related to the way in which such blooms are represented on metalware and jewels from the Hellenized East, especially the plastically overturned edges of petals and the addition of bracts to the centre of each petal.[14]

The ornament has two integral arched and undecorated lugs.

Modelled petals on back of ornament

Cat. 172 **DAGGER-CORD ORNAMENT**
Mughal dominions or Deccan, probably first half of the seventeenth century
Carved from nephrite jade; inlaid with gold in *kundan* technique and set with rubies, diamond, pearl, coral, zircon, blue sapphire, chrysoberyl cat's eye, yellow topaz and emerald
Dimensions: Width 3.5 cm; thickness 1 cm
Provenance: Art market 1997
Published: Keene and Kaoukji 2001, cat. 2.27
Inv. no. LNS 257 HS

The Hindu cosmological *navaratna* or nine auspicious gems set in this dagger-cord ornament are meant to confer upon the wearer the astrological influences afforded by the celestial bodies associated with the stones. The gems symbolize the sun and moon and seven planets; and, as certain planets convey malefic influences, the gems are set in a particular order to allow the beneficial and malevolent influences to counterbalance each other.[15] Typically, the sun is symbolized by the ruby; Venus by a diamond; the moon by a pearl; Mars by coral; the Dragon's Head (Rahu) by hessonite garnet; Saturn by blue sapphire; the Dragon's Tail (Ketu) by chrysoberyl cat's eye; Jupiter by yellow topaz; and Mercury by emerald.

In certain instances the *navaratna* gem types vary slightly, as is the case in this ornament, where the hessonite garnet has been replaced by a reddish-brown zircon.

In the raised rectangular centre, five rubies in a "cloisonné" setting represent the sun, and the petals are set in clockwise rotation starting from the uppermost petal with diamond, followed by pearl, coral, reddish-brown zircon, blue sapphire, chrysoberyl cat's eye, yellow topaz and emerald.

The back is finely carved in relief as a double-tiered rosette, wherein the inner and shorter petals extend to the centres of the larger petals, which end in three fleshy lobes, and it has two integral rectangular-section lugs.

Double-tiered rosette carved on back of ornament

Cat. 173 DAGGER-CORD ORNAMENT
Mughal dominions or Deccan, seventeenth century
Carved from nephrite jade; inlaid with gold and worked in *kundan* technique and set with a spinel and emeralds
Dimensions: Diameter 3 cm; thickness 1 cm
Provenance: Art market 1997
Published: Keene and Kaoukji 2001, cat. 2.28
Inv. no. LNS 258 HS

This small dagger-cord ornament of unusual design is decorated on the front with an oversized and highly stylized flower, in which a giant blossom is set with a spinel of elongated octagonal form. Carrying this flower is a short stem set on the border fillet, issuing further stems and emerald leaves of various forms that culminate in two abutted leaves above the blossom.

The back is slightly convex and carved as a fleshy, fluted rosette, with six relief-carved bracts radiating from a raised circular centre. The two integral lugs are rectangular in section and cut at their corners.

Carved, fluted petals on back of ornament

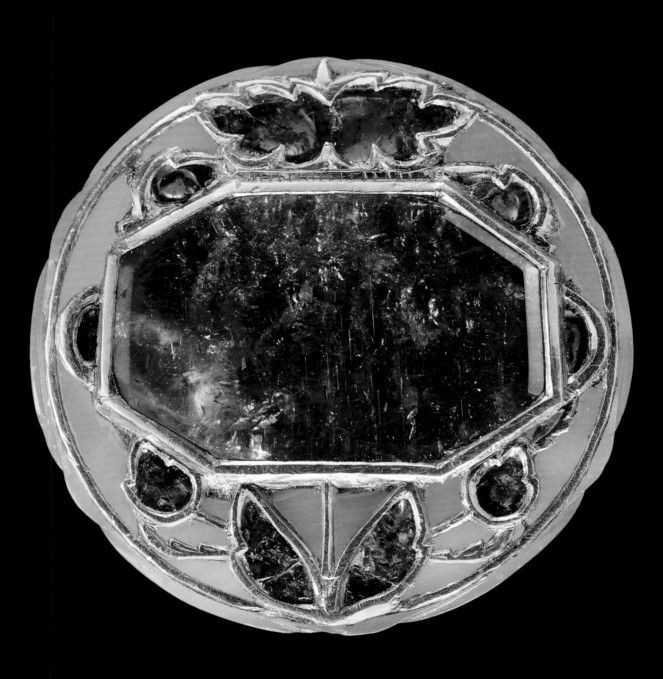

NOTES

1 See e.g. the bronze shield with a Greek Gorgon Medusa head found in the ruins of Carchemish on the Euphrates, destroyed by the Babylonians in 605 BCE, Boardman 1994, p. 23, fig. 2.3.
2 Pyhrr and Godoy 1998, cat. 32, as well as cat. 42, from *c.* 1550–55, and cat. 68, from *c.* 1570–80.
3 See e.g. the lacquer shield with enamelled bosses, Haidar and Sardar 2015, p. 255, cat. 150.
4 See e.g. the horse trappings of Sultan Husayn Nizam Shah I, Haidar and Sardar 2015, p. 55, cat. 7, and the trappings of Shah Jahan's horse, Beach and Koch 1997, p. 103, cat. 41.
5 See e.g. the lion face in the centre of the Charles V shield from 1533, Soler del Campo 2000, p. 54, cat. D.2. Also published by Pyhrr and Godoy 1998, cat. 20.
6 Regarding enamelling on copper, see Zebrowski 1997, pp. 90–92, cat. nos. 75–84.
7 The shield depicted on the right-hand edge of the painting, Beach and Koch 1997, p. 51, cat. 16.
8 Beach and Koch 1997, p. 51, cat. 16; p. 55, cat. 18; p. 75, cat. 29; p. 91, cat. 36.
9 For a scabbard in the Furusiyya Foundation that is bordered by the same type of chevron motif in the same colour scheme, see Mohamed 2008, cat. 221.
10 Leach 1995a, p. 208, pl. 2.55.
11 The Emperor Jahangir wears a dagger-cord ornament in a miniature attributed to *c.* 1625, Thackston 1999, p. 80, and Shah Jahan wears a similar ornament with pendent pearls in a miniature from the *Minto Album*, attributed to *c.* 1627–29, Leach 1995a, cat. 3.20, pl. 62. A good illustration of a dagger-cord ornament with tassel-cap and pendent pearls can be seen in a portrait of Shah Jahan attributed to *c.* 1657, from the *Padshah-nameh*, Beach and Koch 1997, cat. 3, and also worn by Emperor Jahangir and other princes and important members of the Mughal court, in cats. 5, 8, 13, 19, 32, 37, 43 and 44.
12 See e.g. the rosettes on the illuminated frontispiece of a Qur'an manuscript from *c.* 1425–50 Iran, Lentz and Lowry 1989, cat. 29.
13 See e.g. the daggers cats. 6, 10, 61 and 76, the edge of the locket of cat. 48, and on the edges of the chapes cats. 63 and 106.
14 The type is well illustrated in Inagaki 2002, pp. 47, 234–35, cat. 31; Pfrommer 1993, esp. cats. 4 and 6; and Sarianidi 1985, esp. cat. 4, fig. 43, and cat. 51, fig. 19.
15 Stronge et al. 1988, p. 89, cat. 83; Untracht 1997, pp. 304–09.

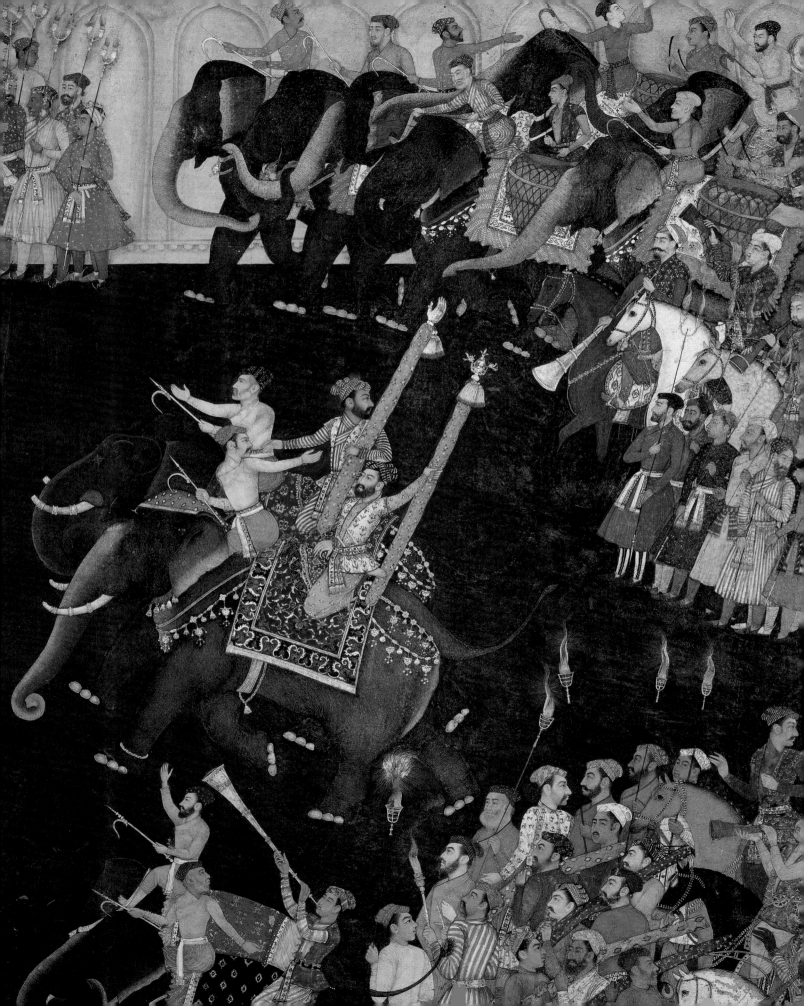

CHAPTER FOURTEEN
STAFFS AND INSIGNIA OF RANK
TRADITIONS OF COURT CEREMONY AND RITUAL

Since antiquity, court pageantry and ritual have involved the display of symbols of rank that, as is evident from the objects presented in this section, reflected both the splendour of the ruler, and by extension, that of his court.

Symbols of rank were generally associated with older traditions and themes that were perpetuated by societies that prided themselves on their ancestry and their observance of ancient rituals. Without expanding too much on the diverse histories of such objects, it is noteworthy that in the ancient Near East the royal staff and mace were a ruler's exclusive weapon from as far back as the Early Dynastic period (*c.* 3100–2686 BCE) in Egypt.[1]

Ornamented staffs were displayed in Indian courts as evidence of rank or to reflect the social status of courtiers. The complex ethnic origins among the grandees of the Indian courts, representing a diverse assortment of geographical and historical ancestries, produced an equally great assortment of livery and traditional objects indicating rank and status. Members of court were depicted in paintings of ceremonial events carrying maces and staffs of office with crescent moons and the double-bladed sword Dhu 'l-Fiqar, animal and bird heads, dragons (such as Cat. 174), gryphons, yak tails and hand finials (such as Cat. 175). Unfortunately only a few insignia denoting specific titles of office are described in literary sources, but a number are depicted in the *Padshah-nameh*, carried by notables during festivities at court, offering a good demonstration of the practice.[2]

Among the highest military ranks whose nomenclature is self-evident is the rank or *martabah* of the "fish" (*mahi-o marateb*), an insignia of the highest order that was borne in processions and as a battle ensign (Cat. 177). In paintings from the seventeenth century, standards erected on poles can be seen preceding personages of elevated rank in processions, a practice that had likewise prevailed since antiquity.[3]

Courtiers carrying insignia of rank during the wedding procession of Prince Shah Shuja' in an illustration from the *Padshah-nameh* attributed to Bhola, *c.* 1635

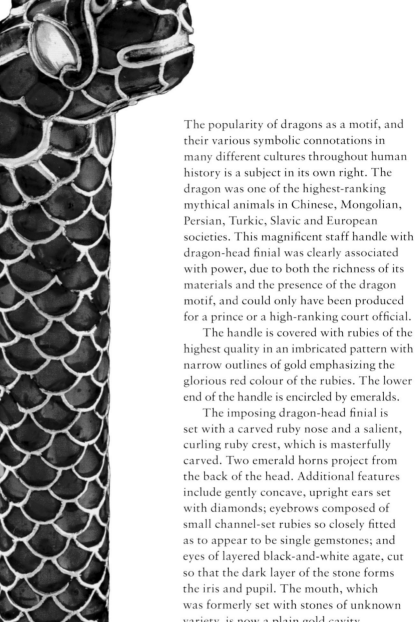

Cat. 174 HANDLE FOR A STAFF
Mughal dominions or Deccan,
late sixteenth–first half of
the seventeenth century
Gold over an iron core, worked
in *kundan* technique and set with
rubies, emeralds, diamonds and
agate
Dimensions: Length 10 cm; width 3 cm
Provenance: Art market 1996
Published: Keene and Kaoukji 2001, cat. 10.1;
Calza 2012, cat. III.6
Inv. no. LNS 1649 J

The popularity of dragons as a motif, and
their various symbolic connotations in
many different cultures throughout human
history is a subject in its own right. The
dragon was one of the highest-ranking
mythical animals in Chinese, Mongolian,
Persian, Turkic, Slavic and European
societies. This magnificent staff handle with
dragon-head finial was clearly associated
with power, due to both the richness of its
materials and the presence of the dragon
motif, and could only have been produced
for a prince or a high-ranking court official.

The handle is covered with rubies of the
highest quality in an imbricated pattern with
narrow outlines of gold emphasizing the
glorious red colour of the rubies. The lower
end of the handle is encircled by emeralds.

The imposing dragon-head finial is
set with a carved ruby nose and a salient,
curling ruby crest, which is masterfully
carved. Two emerald horns project from
the back of the head. Additional features
include gently concave, upright ears set
with diamonds; eyebrows composed of
small channel-set rubies so closely fitted
as to appear to be single gemstones; and
eyes of layered black-and-white agate, cut
so that the dark layer of the stone forms
the iris and pupil. The mouth, which
was formerly set with stones of unknown
variety, is now a plain gold cavity.

A continuous expanse of rubies of
the highest quality covers the remaining
modelled surface of the head, and a pair of
emeralds flank a diamond in a triangular
setting on the back of the head.

On the bottom of the handle are a
collar and a cavity in which are spiralling
threads for fitting the handle on a shaft.

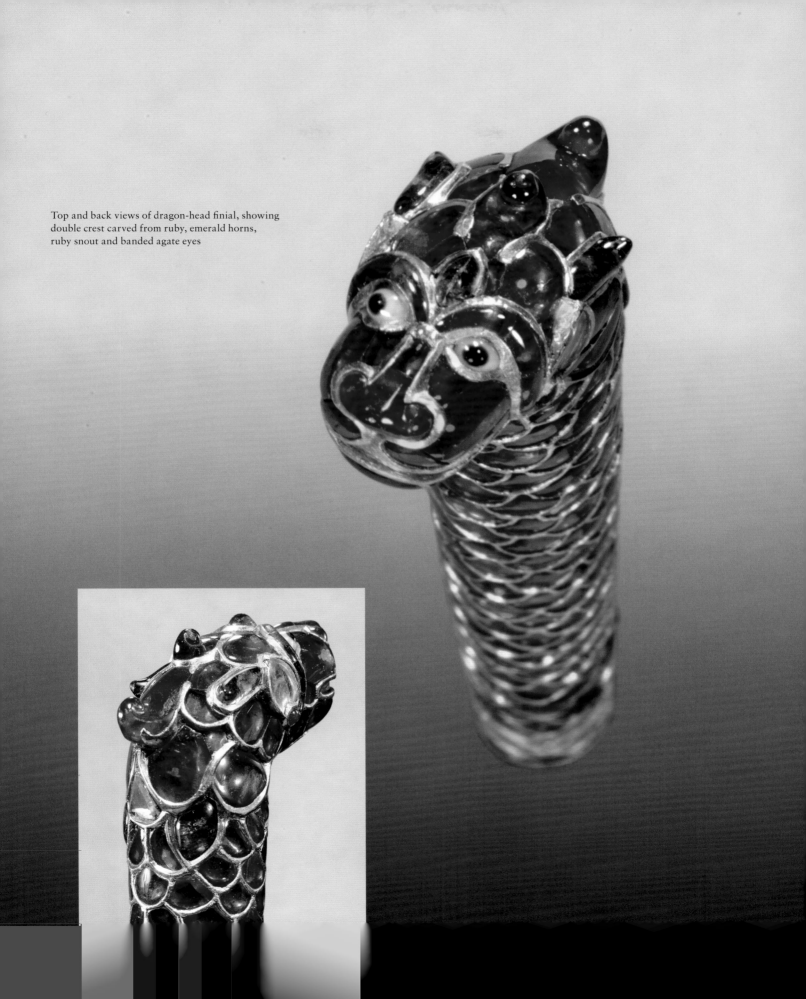

Top and back views of dragon-head finial, showing double crest carved from ruby, emerald horns, ruby snout and banded agate eyes

Cat. 175 CEREMONIAL STAFF
Probably Deccan, first half
of the seventeenth century
Carved from nephrite jade; shaft
segments threaded on an iron rod;
silver and gilded bronze fittings
Dimensions: Length 61 cm; width 5 cm
Provenance: Art market 1998, reportedly from
Hyderabad
Published: Keene and Kaoukji 2001, cat. 8.9
Inv. no. LNS 319 HS

Insignia in the form of a hand
adorned with a pinkie and thumb
ring and finial in the form of a
flower with fluted petals

Although it has been suggested that this object might be a backscratcher, this interpretation seems highly unlikely on account of the object's weight and size, which would have necessitated awkward manoeuvres for it to be used to scratch a person's back, even if the task had been performed by an attendant.

Furthermore, in paintings from seventeenth-century India courtiers are represented carrying staffs of office with folded-hand finials.[4]

The handle is made up of fourteen pieces of jade threaded onto an iron rod, and is divided by mouldings into twenty segments. A silver segment separates the handle from the hand, which is engraved with fine palm-markings and adorned on the pinkie and thumb with relief-carved finger rings, and around the wrist with a bracelet carved with shallow grooves.

On the lower end of the handle the last jade segment is encircled by relief-carved petals, and is separated from the finial by a flat bronze band with stippled floral decoration. The lower extremity of the handle is treated as a flower, with fluted petals and a small knob.

Cat. 176 **CEREMONIAL MACE**
Mughal dominions or Deccan,
seventeenth century
Carved from cryptocrystalline
quartzes (patterned and coloured
agates, chalcedonies and jasper)
threaded on an iron rod; gilded
bronze dividers

Dimensions: Length 55 cm; width 7.5 cm
Provenance: Art market 1998
Published: Christie's, London, 13 October
1998, lot 98; Keene and Kaoukji
2001, cat. 8.29

Inv. no. LNS 354 HS

Although flanged maces are not represented in
paintings as frequently as maces of the onion-
shape type, they can be seen in Iranian miniature
painting from around the middle of the fifteenth
century[5] and in Indian painting from the middle of
the sixteenth century onwards.[6] Most references
to flanged maces list them as having six flanges
(*shashpar* and *buzdigan*),[7] but on this mace the
head is carved with eight angular flanges.

 The banded tan and orange agate mace-head is
carved in the form of a cupped blossom, wherein
each flange is carved with a chevron cartouche that
straddles the constricted and carinated sections
of the mace-head. The spirally ribbed carnelian
knob finial is set in the centre of a relief-carved
eight-pointed star: the tips of the star fall in the
interstices of the flanges, which are carved on their
upper edges with a chevron-shaped groove that
further emphasizes the star motif.

 Forming the handle are nine cylindrical agate,
chalcedony and jasper segments of uneven length
and varying colour,[8] separated by gilded bronze
disc-shaped plates that terminate with a bulbous
finial of variegated green and red jasper that is
pierced for suspension and terminates with a
conical knob.

 The mace came in a wooden presentation box
that included a note, which stated on the recto:

Sceptre of the ancient / Sovereigns of
Hindostan / before the Musulman / Conquest.
Taken at the battle / of Sectabuldi[9] & presented
/ to Lord Amherst by F. Rattray Esq. / of the
Bengal Civil Service.

On the verso, handwritten in black ink, is
"Sir Richard Jenkins – Nagpoor".

 The partially gilded silver shaft, which would
have been raised on a pole, is fitted with a silver
moon crescent and gilded silver spheres.

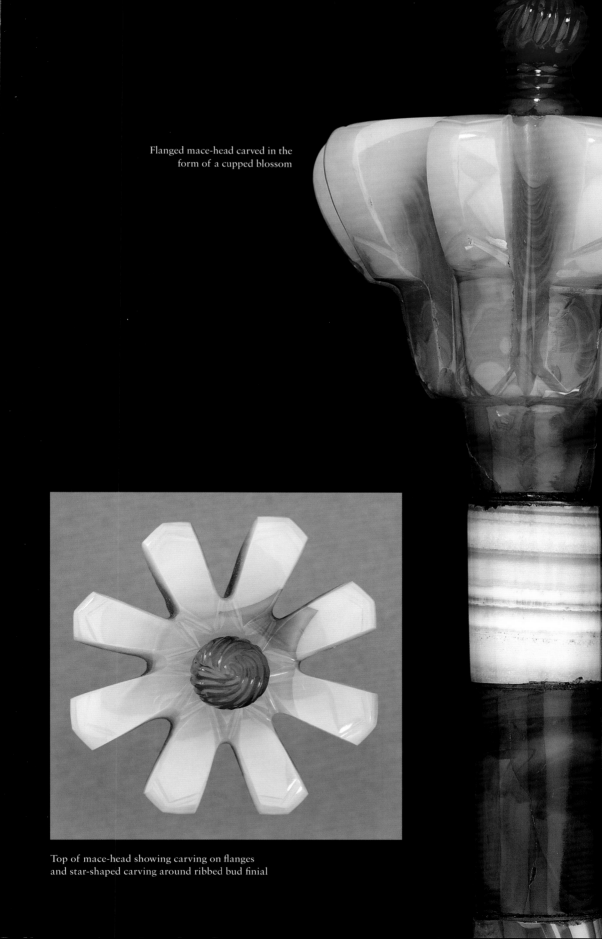

Flanged mace-head carved in the
form of a cupped blossom

Top of mace-head showing carving on flanges
and star-shaped carving around ribbed bud finial

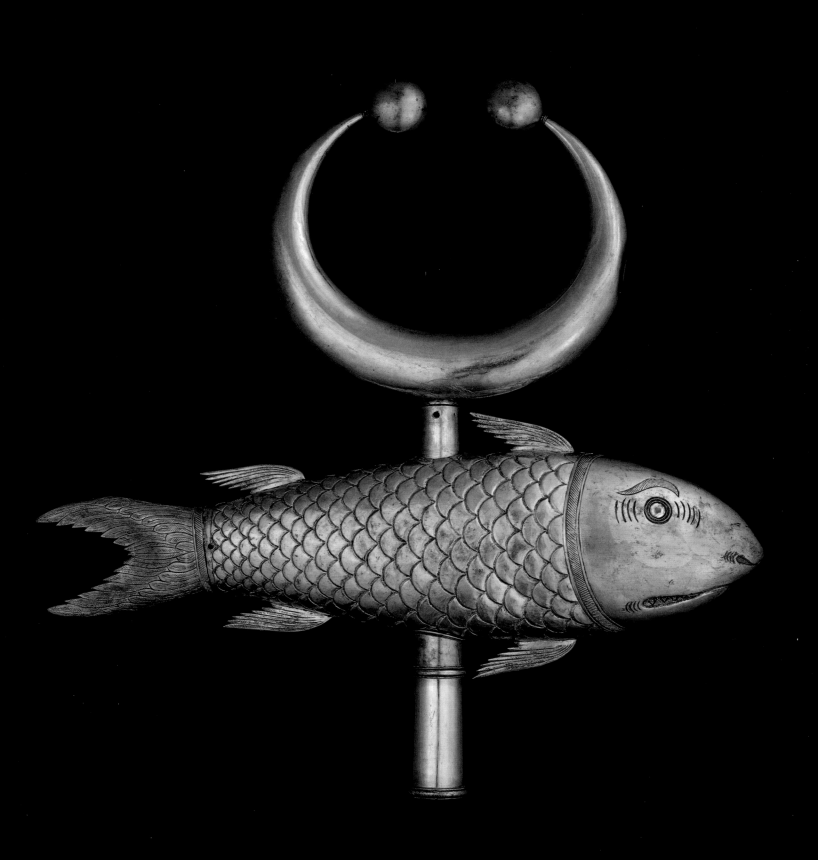

Cat. 177 **MAHI-O MARATEB
STANDARD**
**Mughal dominions or
Deccan, seventeenth century**
Fabricated from silver (hammered,
worked in repoussé, engraved and
ringmatted, partially gilded); eyes
inlaid with rock crystal (painted
details underneath)
Dimensions: Height of assembled pieces 50.5
cm; length of fish 50 cm
Provenance: Art market 1991
Published: Keene and Kaoukji 2001, cat. 8.30
Inv. no. LNS 306 M

Ceremonial standards in the form of fish were symbols of elevated rank,
but such a design in conjunction with a crescent moon and spheres
represented one of the highest ranks at court (*mahi-o marateb*).

This hollow, gilded fish standard is worked in repoussé with a scale
pattern, and the projecting fins and removable tail, which was originally
retained by two rivets, are incised with fine lines in a chevron pattern.
The fish's countenance is rendered with a near human expression,
wherein the eyes as well as the corners of the mouth and nares are
detailed with little wrinkles. The eyebrows are engraved with lines, and
the eyes are inlaid with rock crystal detailed with painted black pupils.
The surface of the clenched teeth and interior of the nares are ringmatted.

The partially gilded silver shaft, which would have been raised on a
pole, is fitted with a silver moon crescent and gilded silver spheres.[10]

Myths and symbolism centring on fish were manifold and wide-
ranging across ancient civilizations. In Hindu tradition the fish or
Matsya was associated with Brahma, the supreme spirit and creator
of the universe, and Manu, a progenitor of humankind and one of
the avatars of Vishnu. Matsya warned Manu of an impending deluge,
comparable to the flood-narratives in other ancient and monotheistic
religions, and rescued all the animals and plants preserved on Manu's
boat by dragging it to safety.

According to other ancient traditions, a fish was believed to have
upheld the globe, a view that was alluded to by the religious scholar
Abu 'l-Fadl 'Abd 'l-Rahman ibn Abi Bakr al-Suyuti (1445–1505 CE), who
in his explanation (*tafsir*) of *Surat al-Qalam* (Chapter 68, vv. 1–2) quotes
several traditionalists, among them Ibn 'Abbas and Ibn Marduwayh, as
having proclaimed that the letter *nun* represented the fish upon which
the globe had been placed.[11] Clearly, both themes made an impression on
the emperor Jahangir, who in a painting from *c.* 1620 attributed to Abu
'l-Hasan is depicted standing on a globe supported by a fish on which
reclines the figure of Manu, the progenitor of humanity.[12]

Further connections with India can be found, especially among the rulers of the Deccan, where the insignia of *mahi-o marateb* was reportedly "conspicuous",[13] possibly on account of an association with Khidr, the "servant of God" or prophet, who was the subject of a popular cult among Hindus and Muslims and is often portrayed standing on a fish. It has also been suggested that the fish with the lunar crescent and two spheres or stars (*kawakeb*) possibly symbolized the start of a new reign when the moon was in Pisces, and that later the fish was used separately, and over time became the emblem of the rulers of Oudh or 'Awadh.[14] The institution of *mahi-o marateb* has also been attributed to the Sasanian emperor Khusraw Parviz, from whom it was allegedly adopted by the Timurids, whence it passed to the Mughals.

It is evident from the foregoing that the *mahi-o marateb* sprung from a conflation of myths and that the symbol played a central role in the Indian sociocultural context.

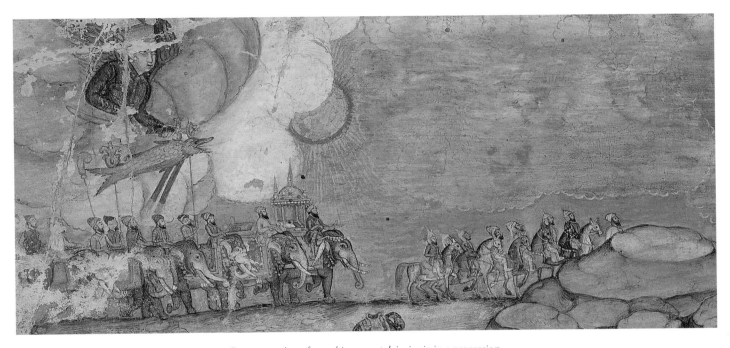

Representation of a *mahi-o marateb* insignia in a procession,
Deccan, possibly Golconda, late seventeenth century

NOTES

1 Wiese and Brodbeck 2004, cat. 80, p. 324.

2 For the various staffs of office, see e.g. Beach and Koch 1997, cats. 6–7, the event commemorating the submission of Rana Amar Singh of Mewar to Prince Khurram; cats. 12–13, the weighing of Shah Jahan on his forty-second lunar birthday; and cats. 27–28, the wedding procession of Prince Shah Juja'.

3 See e.g. the fish insignia carried by a standard-bearer in a painting from the *Padshah-nameh* attributed to *c*. 1633, Beach and Koch 1997, cat. 17, and carried in a princely procession in a painting attributed to the Deccan, *c*. 1700, Michell and Zebrowski 1999, col. pl. 9. Also, a fish standard in the Jagdish and Kamla Mittal Museum of Indian Art, Hyderabad, attributed to seventeenth-century Golconda or Bijapur, published in Welch 1985, pp. 323–24, cat. 219.

4 See e.g. the hand with folded fingers above a long staff held by a Turk (just in front of the elephant) in the painting attributed to *c*. 1605 entitled "Festivities on the occasion of the accession of Emperor Jahangir", Akimushkin 1996, pl. 176, fol. 21r; also, Beach and Koch 1997, esp. cats. 5, 27, 39 and 43, where the hand finials are also fitted with finger rings, and cats. 7, 8, 14, 19, 38, 41 and 44. Skelton 1982a, cat. 486, where Susan Stronge reproduces a dervish's staff and lists examples associated with axes, maces and a crutch, and an example serving as a dervish's staff from the *Gentil Album*.

5 In a miniature from a *Khamsa* attributed to "Isfahan, 868 AH/1463–4 AD (?)" and a miniature from a *Khawar-nameh* attributed to "probably Shiraz, *c*. 881 AH/1477 AD", Hillenbrand 1977, respectively, cats. 100 and 116.

6 In a folio from the *Hamza-nameh* attributed to 1557–77 depicting Amir Hamza fighting the people with elephant ears, one of them holds a flanged mace, Calza 2012, p. 175, and in a folio from a *Razm-nameh*, dated 1007 H/1598 CE, Smart et al. 1985, cat. 5, pl. 5. Also, from the seventeenth century, in a painting entitled "A night celebration of the Prophet's birthday" attributed to *c*. 1635, Akimushkin 1996, pl. 180, and particularly good representations in the *c*. 1650 *Shah-Jahan-nameh*, Welch 1978, pls. 31–32.

7 Pant 1989, pp. 81–87; Elgood 1979, p. 216.

8 A "bearer" holds a staff composed of different colour segments in a painting entitled "Dead lioness carried by bearers", attributed to *c*. 1600–04, Stronge 2002, p. 119, pl. 84.

9 Christie's, London, 13 October 1998, "The battle of Sitabaldi in the Central Provinces was fought between the British and the Mahratta forces of the Peshwa Baji Rao in 1817, a year before the British finally managed to dethrone him. William Pitt, Earl Amherst of Arracan was Governor General in India from 1823–1828."

10 See note 3 in the introduction to this chapter.

11 I am grateful to my colleague Mutlaq al-Jurayid for providing me with the reference to Suyuti 2003, pp. 618–21.

12 Pal 1993, p. 262, cat. 72.

13 EI2, pp. 536–37, "Maratib".

14 Ibid.

APPENDICES

BIBLIOGRAPHY

Adamova 1996
Adel Adamova, *Persian Painting and Drawing of the 15th–19th Centuries from the Hermitage Museum*, St Petersburg, 1996

Adamova and Bayani 2015
Adel Adamova and Manijeh Bayani, *Persian Painting: The Arts of the Book and Portraiture*, London, 2015

Ager 1997
Barry Ager, "Recent Re-discoveries in the Continental Early Medieval Collections of the British Museum", in G. De Boe and F. Verhaeghe (eds), *Method and Theory in Historical Archaeology: Papers of the Medieval Europe Brugge 1997 Conference*, vol. X, Zellik, 1997

Akimushkin 1996
Oleg Akimushkin et al., *The St. Petersburg Muraqqa': Album of Indian and Persian Miniatures from the 16th through the 18th Century and Specimens of Persian Calligraphy by 'Imad al-Hasani*, Milan, 1996

Alexander 1996
David Alexander (ed.), *Furusiyya: The Horse in the Art of the Near East*, vol. II, Riyadh, 1996

Amsterdam 1990
The European Emergence, AD 1500–1600, History of the World, Amsterdam, 1990

Anand 1979
Mulk Raj Anand, *Homage to Kalamkari*, Bombay, 1979

Andhare 1971
Shridhar Andhare, "The Dhola-Maru MS of the National Museum:

A Consideration in Style and Date", in A. Banaras (ed.), *Chhavi: Golden Jubilee Volume, Bharat Kala Bhavan 1920–1970*, Banaras, 1971

Aruz 2000
Joan Aruz, *The Golden Deer of Eurasia*, New York, 2000

Aruz and Wallenfels 2003
Joan Aruz (ed.) with Ronald Wallenfels, *Art of the First Cities: The Third Millennium B.C. from the Mediterranean to the Indus*, New York, 2003

Aruz et al. 2008
Joan Aruz, Kim Benzel and Jean M. Evans (eds), *Beyond Babylon: Art, Trade, and Diplomacy in the Second Millennium B.C.*, New York, 2008

Atil 1987
Esin Atil, *The Age of Sultan Süleyman the Magnificent*, Washington and New York, 1987

Atil 1990
Esin Atil (ed.), *Islamic Art & Patronage: Treasures from Kuwait*, New York, 1990 [also editions in French, 1993; Italian, 1994; German, 1996; and Arabic, 1999]

Atil 1997
Esin Atil (ed.), *Arte islamica e mecenato: Tesouros do Kuwait*, Lisbon, 1997

Atil et al. 1985
Esin Atil, W. T. Chase and Paul Jett, *Islamic Metalwork in the Freer Gallery of Art*, Washington, DC, 1985

Babur 1987
Zahirud-din Muhammad Babur Badshah Ghaznvi, *Babur-Nama*

(Memoirs of Babur), tr. Annette S. Beveridge, Lahore, 1987

Bahari 1996
Ebadollah Bahari, *Bihzad: Master of Persian Painting*, London and New York, 1996

Barrett and Gray 1978
Douglas Barrett and Basil Gray, *Indian Painting*, Geneva, 1978

Barrucand 1998
Marianne Barrucand (ed.), *Trésors Fatimides du Caire*, Paris, 1998

Barry 2004
Michael A. Barry, *Figurative Art in Medieval Islam and the Riddle of Behzad of Herat (1465–1535)*, Paris, 2004

Baud 2010
Michel Baud (ed.), *Méroé: Un empire sur le Nil*, Paris, 2010

Beach 1978
Milo Cleveland Beach, *The Grand Mogul: Imperial Painting in India, 1600–1660*, Williamstown, MA, 1978

Beach 1981
Milo Cleveland Beach, *The Imperial Image: Paintings for the Mughal Court*, Washington, DC, 1981

Beach 2000
Milo Cleveland Beach, *Mughal and Rajput Painting*, New Cambridge History of India, Cambridge, 2000

Beach and Koch 1997
Milo C. Beach and Ebba Koch with new translations by Wheeler Thackston, *King of the World: The Padshahnama. An Imperial Mughal Manuscript from the Royal Library, Windsor Castle*, London, 1997

Behl 1998
Benoy K. Behl, *The Ajanta Caves: Artistic Wonder of Ancient Buddhist India*, New York, 1998

Biruni 1958
Abi al-Rayhan Muhammad ibn Ahmad al-Biruni, *Kitāb fī Taḥqīq-ī-Mā li-'l-Hind, or, Al-Bīrūnī's India*, Hyderabad, 1958

Biruni 1984
Abi al-Rayhan Muhammad ibn Ahmad al-Biruni, *Kitab al-Jamahir fi Maʿrifat al-Jawahir*, 3rd edn, Beirut, 1304 H (1984 CE)

Blair 1970
Claude Blair, "A Royal Swordsmith and Damascener: Diego de Çaias", *Metropolitan Museum Journal*, New York, vol. III (1970)

Blochet 1975
Edgar Blochet, *Musulman Painting: XIIth–XVIIth Century*, New York, 1975

Bloom and Blair 1997
Jonathan Bloom and Sheila Blair, *Islamic Arts*, London, 1997

Boardman 1994
John Boardman, *The Diffusion of Classical Art in Antiquity*, Washington, DC, 1994

Boardman 2000
John Boardman, *The Greeks Overseas: Their Early Colonies and Trade*, London, 2000

Boardman 2001
John Boardman, *The Oxford History of Classical Art*, Oxford and New York, 2001

Bordeaux 1998
La route des Indes. Les Indes et l'Europe: Echanges artistiques et héritage commun, 1650–1850, Bordeaux and Paris, 1998

Borhan-e Qateʿ-Moʿin 1979
Mohammad Hosayn ebn-e Khalaf de Tabriz, *Borhan-e Qateʿ (Dictionnaire de la langue persane)*, ed. Mohammad Moʿin, Tehran, 1357/1979

Bosworth 2004
Clifford Edmund Bosworth, *The New Islamic Dynasties: A Chronological and Genealogical Manual*, Edinburgh 2004

Boudot-Lamotte 1968
Antoine Boudot-Lamotte, *Contribution à l'étude de l'archerie musulmane, principalement d'après le manuscrit d'Oxford Bodléienne Huntington no. 264*, Damas, 1968

Brand and Lowry 1985
Michael Brand and Glenn D. Lowry, *Akbar's India: Art from the Mughal City of Victory*, London, 1985

Bunker 1997
Emma C. Bunker et al., *Ancient Bronzes of the Eastern Eurasian Steppes from the Arthur M. Sackler Collections*, New York, 1997

Bussagli 1979
Mario Bussagli, *Central Asian Painting*, Geneva and New York, 1979

Çagman and Ölçer 2004
Filiz Çagman, Nazan Ölçer et al., *Mothers, Goddesses and Sultanas: Women in Turkey from Prehistory to the End of the Ottoman Empire*, Antwerp and Brussels, 2004

Calza 2012
Gian Carlo Calza (ed.), *Akbar: The Great Emperor of India*, Rome, 2012

Campbell and Chong 2005
Caroline Campbell and Alan Chong, *Bellini and the East*, London 2005

Canby 1998
Sheila Canby, *Princes, Poets and Paladins: Islamic and Indian Paintings from the Collection of Prince and Princess Sadruddin Aga Khan*, London, 1998

Canby 2014
Sheila Canby, *The Shahnama of Shah Tahmasp: The Persian Book of Kings*, New York, 2014

Carter 2013
Martha Carter, "From Alexander to Islam: Hellenism in the Arts in a Non-Mediterranean Environment", in *Splendors of the Ancient East: Antiquities from The al-Sabah Collection*, London, 2013

Caubet and Pouyssegur 1998
Annie Caubet and Patrick Pouyssegur, *The Ancient Near East*, Paris, 1998

Chadour-Sampson and Israel 2004
Beatriz Chadour-Sampson and Nigel Israel (eds), *Jewellery Studies*, London, vol. X (2004)

Chandra 1976
Pramod Chandra, *The Tuti-Nama of the Cleveland Museum of Art and the Origins of Mughal Painting*, Codices Selecti Phototypice Impressi: Facsimile vol. LV; Commentarium vol. LV, Graz, Austria, 1976

Chang 2012
Chang Kyong-hui Chium, *Kungnip*

Chungang Pangmulgwan, Arumdaun uri munhwajae 1, Seoul, 2012

Charbonneaux et al. 1969
J. Charbonneaux, R. Martin and F. Villard, *Grèce classique, 480–330 av. J.-C.*, Paris, 1969

Chuvin 1999
Pierre Chuvin et al., *Les arts de l'Asie centrale*, Paris, 1999

Clarke 2008a
Caspar Purdon Clarke, *Indian Art at Marlborough House: A Catalogue of the Collection of Indian Arms and Objects of Art Presented by the Princes and Nobles of India to H.R.H. the Prince of Wales on the Occasion of His Visit to India in 1875–1876*, Huntingdon, England, 2008 [reprint of 1898 edn]

Clarke 2008b
Caspar Purdon Clarke, *Arms and Armour at Sandringham: The Indian Collection Presented by the Princes, Chiefs and Nobles of India to His Majesty King Edward VII when Prince of Wales, on the Occasion of His Visit to India in 1875–1876, also Some Asiatic, African and European Weapons and War-Relics*, Huntingdon, England, 2008 [reprint of 1910 edn]

Coe 1989
Michael D. Coe et al., *Swords and Hilt Weapons*, London, 1989

Collins 2009
Paul Collins, *Assyrian Palace Sculptures*, Austin, 2009

Connolly 1989
Peter Connolly, "Greece and Rome", in

Michael D. Coe et al., *Swords and Hilt Weapons*, London, 1989

Cunningham et al. 1998
M. R. Cunningham, S. J. Czuma, A. E. Wardwell and J. Keith Wilson, *Masterworks of Asian Art*, Cleveland, 1998

Curatola and Kaoukji 2016
Giovanni Curatola and Salam Kaoukji, *Arts of Islamic Lands: Selections from The al-Sabah Collection*, Kuwait and Houston, 2016

Curatola et al. 2010
Giovanni Curatola, Manuel Keene and Salam Kaoukji, *Arte della civiltà islamica: Al-Fann*, Milan, 2010 [also editions in German, 2010, and English, 2011]

Curtis and Reade 1995
J. E. Curtis and J. E. Reade (eds), *Art and Empire: Treasures from Assyria in the British Museum*, New York, 1995

Curtis and Tallis 2005
J. Curtis and N. Tallis (eds), *Forgotten Empire: The World of Ancient Persia*, London, 2005

Czuma 1985
Stan J. Czuma, Kushan Sculpture: Images from Early India, Cleveland, 1985

Das 1998
Asok Kumar Das (ed.), *Mughal Masters: Further Studies*, Mumbai, 1998

Dehkhoda
Ali Akbar Dehkhoda, *Loghatnameh-ye Dehkhoda*, ed. M. Mo'in, Tehran, 1377/1999

Demange 2006
Françoise Demange (ed.), *Les perses sassanides: Fastes d'un empire oublié (224–642)*, Paris, 2006

Deva 1990
Krishna Deva, *Temples of Khajuraho*, vols I and II, New Delhi, 1990

Digard 2002
Jean-Pierre Digard (ed.), *Chevaux et cavaliers arabes dans les arts d'Orient et d'Occident*, Paris, 2002

Dye 2001
Joseph M. Dye III, *The Arts of India: Virginia Museum of Fine Arts*, Richmond, VA, 2001

Egerton 1880
Wilbraham Egerton, *An Illustrated Handbook of Indian Arms; Being a Classified and Descriptive Catalogue of the Arms Exhibited at the India Museum: with an Introductory Sketch of the Military History of India*, London, 1880

EI2
The Encyclopaedia of Islam, 2nd edn, vol. VI, Leiden, 1991

Elgood 1979
Robert Elgood (ed.), *Islamic Arms and Armour*, London, 1979

Elgood 2004a
Robert Elgood, *Hindu Arms and Ritual: Arms and Armour from India, 1400–1865*, Mapin, Ahmedabad, India, 2004

Elgood 2004b
Robert Elgood, "Mughal Arms and the Indian Court Tradition", *Jewellery Studies: Jewelled Arts of Mughal India*, London, vol. X (2004)

Elgood 2015
Robert Elgood, *Arms & Armour at the Jaipur Court: The Royal Collection*, New Delhi, 2015

Ettinghausen 1984
Richard Ettinghausen, "The Snake-Eating Stag", in Myriam Rosen-Ayalon (ed.), *Islamic Art and Archaeology: Collected Papers*, Berlin, 1984

Flindt 1979
Torben W. Flindt, "Some Nineteenth-Century Arms from Bukhara", in Robert Elgood (ed.), *Islamic Arms and Armour*, London, 1979

Flores and Vassallo e Silva 2004
Jorge Flores and Nuno Vassallo e Silva (eds), *Goa and the Great Mughal*, London, 2004

Galliano and Calvet 2004
Geneviève Galliano and Yves Calvet (eds), *Le royaume d'Ougarit: Aux origines de l'alphabet*, Lyon, 2004

Goswamy 1988
B. N. Goswamy, *A Jainesque Sultanate Shahnama and the Context of Pre-Mughal Painting in India*, Zurich, 1988

Gray 1977
Basil Gray, *Persian Painting*, Geneva, London and Basingstoke, 1977

Gray 1981
Basil Gray, "The Lahore Laur-Chanda Pages Thirty Years After", *Chhavi-2: Rai Krishnadasa Felicitation Volume*, Banaras, 1981

Grube 1972
Ernst J. Grube, *Islamic Paintings from the 11th to the 18th Century in the Collection of Hans P. Kraus*, New York, 1972

Gul Badan Begam 1983
Gul Badan Begam, *The History of Humāyūn: Humāyūn-Nāma*, tr. Annette S. Beveridge, New Delhi, 1983

Haidar and Sardar 2011
Navina N. Haidar and Marikar Sardar (eds), *Sultans of the South: Arts of India's Deccan Courts, 1323–1687*, New York, 2011

Haidar and Sardar 2015
Navina N. Haidar and Marikar Sardar (eds), *Sultans of Deccan India, 1500–1700: Opulence and Fantasy*, New York, 2015

Harding 1989
Anthony Harding, "Stone, Bronze and Iron", in Michael D. Coe et al., *Swords and Hilt Weapons*, London, 1989

Harper 1981
Prudence O. Harper, *Silver Vessels of the Sassanian Period*, vol. I: *Royal Imagery*, New York, 1981

Hillenbrand 1977
Robert Hillenbrand, *Imperial Images in Persian Painting*, Edinburgh, 1977

Huntington and Huntington 1999
Susan L. Huntington with John C. Huntington, *The Art of Ancient India*, New York and Tokyo, 1999

Ibn Battuta 1966
Abu Abd Allah ibn Abd Allah al-Lawati al-Tanji ibn Battuta, *Rihlat ibn Battuta al-musamma tuhfat al-nuzza'r fi ghara'ib al-amsar wa 'aj'a'ib al-asfar*, ed. Jamal al-Din al-Ramadi, Cairo, 1966

Ibn Battuta 1990
Ibn Battuta, *Voyages*, vol. III, tr. C. Defremery and B. R. Sanguinetti (1858), Paris, 1990

Ibn al-Manzur 1968
Aba al-Fadl Jamal al-Din Muhammad bn Mukarram ibn Manzur al-Ifriqi al-Masri, *Lisan al-Arab*, vol. VIII, Beirut, 1968

Inagaki 2002
Hajime Inagaki (ed.), *Treasures of Ancient Bactria*, Miho, Japan, 2002

Inju Shirazi 1975
Mir Jamal al-Din Husain bn Fakhr al-Din Hasan Inju Shirazi, *Farhang-e Jahangiri*, ed. Rahim 'Afifi, Mashhad–Tehran, 1351/1972–1354/1975

Ivanov 1990
Anatoly Ivanov, *Masterpieces of Islamic Art in the Hermitage Museum*, Kuwait, 1990

Jackson and Jaffer 2004
Anna Jackson and Amin Jaffer (eds), *Encounters: The Meeting of Asia and Europe, 1500–1800*, London, 2004

Jahangir 1978
Tuzuk-i Jahangiri, or, Memoirs of Jahangir, tr. Alexander Rogers and Henry Beveridge, New Delhi, 1978

Jenkins et al. 1983
Marilyn Jenkins, Manuel Keene and Michael Bates, *Islamic Art in the Kuwait National Museum: The al-Sabah Collection*, London, 1983

Jidejian 2006
Nina Jidejian, *Sidon through the Ages*, Beirut, 2006

Kalus 1980
Ludvik Kalus, "Inscriptions arabes et

persanes sur les armes musulmanes de la Tour de Londres", *Gladius*, vol. XV (1980)

Kangle 2003
R. P. Kangle, *The Kauṭilīya Arthaśāstra*, part II, an English translation with critical and explanatory notes, Delhi, 2003 [reprint of the 1972 edn]

Keene 1984
Manuel Keene, *Selected Recent Acquisitions*, Kuwait, 1984

Keene 2004a
Manuel Keene, "The Kundan Technique: The Indian Jeweller's Unique Artistic Treasure", in *Arts of Mughal India: Studies in Honour of Robert Skelton*, Ahmedabad, 2004

Keene 2004b
Manuel Keene, "The Enamel Road, from Siena, Paris, London and Lisbon, Leads to Lucknow", *Jewellery Studies*, London, vol. X (2004)

Keene and Kaoukji 2001
Manuel Keene with Salam Kaoukji, *Treasury of the World: Jewelled Arts of India in the Age of the Mughals*, London, 2001 [also editions in Spanish, 2004; German, 2004; French, 2006; and Arabic, 2011]

Khalidi 1999
Omar Khalidi, *Romance of the Golconda Diamonds*, Middletown, 1999

Khanna and Michell 2000
Balraj Khanna and George Michell, *Human and Divine: 2000 Years of Indian Sculpture*, London, 2000

Knox 1992
Robert Knox, *Amaravati: Buddhist Sculpture from the Great Stupa*, London, 1992

Komaroff 2011
Linda Komaroff (ed.), *Gifts of the Sultan: The Art of Giving at the Islamic Courts*, New Haven and London, 2011

Kossak 1997
Steven Kossak, *Indian Court Painting, 16th–19th Century*, London, 1997

Krishna 1981
Anand Krishna (ed.), *Chhavi-2: Rai Krishnadasa Felicitation Volume, Bharat Kala Bhavan*, Banaras, 1981

LaRocca 1989
Donald J. LaRocca, "The Renaissance Spirit", in Michael D. Coe et al., *Swords and Hilt Weapons*, London, 1989

Laufer and Pelliot 1913
Berthold Laufer and Paul Pelliot, "Arabic and Chinese Trade in Walrus and Narwhal Ivory", *T'oung Pao*, 2nd ser., vol. XIV, no. 3 (1913), pp. 315–70 [available at www.jstor.org/stable/4526349]

Laufer 1916
Berthold Laufer, "Supplementary Notes on Walrus and Narwhal Ivory", *T'oung Pao*, 2nd ser., vol. XVII, no. 3 (July 1916), pp. 348–89 [available at www.jstor.org/stable/4526501]

Lavin 1997
J. D. Lavin, *The Art and Tradition of the Zuloagas: Spanish Damascene from the Khalili Collection*, London, 1997

Leach 1986
Linda York Leach, *Indian Miniature Paintings and Drawings: The Cleveland Museum of Art Catalogue of Oriental Art*, part 1, Cleveland, 1986

Leach 1995a
Linda York Leach, *Mughal and Other Indian Paintings from the Chester Beatty Library*, vol. I, London, 1995

Leach 1995b
Linda York Leach, *Mughal and Other Indian Paintings from the Chester Beatty Library*, vol. II, London, 1995

Lentz and Lowry 1989
Thomas W. Lentz and Glenn D. Lowry, *Timur and the Princely Vision: Persian Art and Culture in the Fifteenth Century*, Los Angeles, 1989

Losty 2015
J. P. Losty, *Into the Indian Mind: An Insight through Portraits, Battles and Epics in Indian Painting*, London, 2015

Lowe 1973
W. H. Lowe, *Muntakhabu't-Tawarikh*, by Abdu'l-Qadir ibn-i Muluk Shah, known as al-Badaoni, vol. II, Delhi, 1973 [reprint of 1899 edn]

Lowry and Nemazee 1988
Glenn Lowry with Susan Nemazee, *A Jeweller's Eye: Islamic Arts of the Book from the Vever Collection*, Washington, 1988

Mahboubian 1997
Houshang Mahboubian, *Art of Ancient Iran: Copper and Bronzes*, London, 1997

Malashev and Yablonski 2004
V. Y. Malashev and L. T. Yablonski,

"Early Nomads in the Southern Foothills of the Urals", *Ancient Civilizations from Scythia to Siberia*, vol. X, nos. 3–4 (2004)

Markel 2010
Stephen Markel with Tushara Bindu Gude, *India's Fabled City: The Art of Courtly Lucknow*, Los Angeles, 2010

Marsden and MacKenzie 1987
Jonathan Marsden and Julia MacKenzie (ed.), *Treasures from India: The Clive Collection at Powis Castle*, London, 1987

Marshall 1975
Sir John Marshall, *Taxila: An Illustrated Account of Archaeological Excavations Carried Out at Taxila under the Orders of the Government of India between the Years 1913 and 1934*, vols I–III, Delhi, Patna and Varanasi, 1975

Martin 1968
F. R. Martin, *The Miniature Painting and Painters of Persia, India and Turkey from the 8th to the 18th Century*, London, 1968 [reprint of the 1912 edn]

Maryon 1960
Herbert Maryon, "Pattern-Welding and Damascening of Sword-Blades: Part 2. The Damascene Process", *Studies in Conservation*, vol. V, no. 2 (May 1960)

Matthiae 1999
Paolo Matthiae, *Ninive: Glanzvolle Hauptstadt Assyriens*, Munich, 1999

McInerney 2004
Terence McInerney, "Three Paintings by Abu 'l Hasan in a Manuscript of the Bustan of Sa'di", in *Arts of Mughal India: Studies in Honour of Robert Skelton*, Ahmedabad, 2004

Meister et al. 1988
Michael W. Meister, M. A. Dhaky and Krishna Deva (eds), *Encyclopaedia of Indian Temple Architecture. North India: Foundations of North Indian Style, c. 250 BC–AD 1100*, Princeton and Delhi, 1988

Melikian-Chirvani 1982
Assadullah Souren Melikian-Chirvani, *Islamic Metalwork from the Iranian World, 8th–18th Centuries*, London, 1982

Melikian-Chirvani 2004
Assadullah Souren Melikian-Chirvani, "The Jewelled Objects of Hindustan", *Jewellery Studies*, London, vol. X (2004)

Melikian-Chirvani 2007
Assadullah Souren Melikian-Chirvani, *Le chant du monde: L'art de l'Iran safavide, 1501–1736*, Paris, 2007

Michell 2007
George Michell, *The Majesty of Mughal Decoration: The Art and Architecture of Islamic India*, London, 2007

Michell and Zebrowski 1999
George Michell and Mark Zebrowski, *Architecture and Art of the Deccan Sultanates*, New Cambridge History of India 1:7, Cambridge, 1999

Missilier and Ricketts 1988
Philippe Missilier and Howard Ricketts, *Splendeur des armes orientales*, Paris, 1988

Mohamed 2008
Bashir Mohamed (ed.), *The Arts of the Muslim Knight: The Furusiyya Art Foundation Collection*, Milan, 2008

Morley 1971
Grace Morley, "On Applied Arts of India in the Bharat Kala Bavan", in A. Banaras (ed.), *Chhavi: Golden Jubilee Volume, Bharat Kala Bhavan 1920–1970*, Banaras, 1971

Morse 1922
Edward S. Morse, *Additional Notes on Arrow Release*, Salem, Massachusetts, 1922

Naser-e Khosraw 1986
Naser-e Khosraw's Book of Travels (Safarnama), New York, 1986

Necipoglu 2000
Gulru Negipoglu, "The Serial Portraits of Ottoman Sultans in Comparative Perspective", in *The Sultan's Portrait: Picturing the House of Osman*, Istanbul, 2000

Nicolle 2002
David Nicolle, "Armes et armures islamiques", in Jean-Pierre Digard (ed.), *Chevaux et cavaliers arabes dans les arts d'Orient et d'Occident*, Paris, 2002

Nigam 1979
M. L. Nigam, *Jade Collection in the Salar Jung Museum*, Hyderabad, 1979

North 1989
Anthony North, "Swords of Islam", in Michael D. Coe et al., *Swords and Hilt Weapons*, London, 1989

O'Kane 2003a
Bernard O'Kane, *Early Persian Painting: Kalila and Dimna Manuscripts of the Late Fourteenth Century*, London, 2003

O'Kane 2003b
Bernard O'Kane, "Siyah Qalam: The Jalayirid Connections", *Oriental Art, vol. XLIX, no. 2* (2003)

Pal 1986
Pratapaditya Pal, *Indian Sculpture: A Catalogue of the Los Angeles County Museum of Art Collection*, vol. I: *Circa 500 B.C.–A.D. 700*, Los Angeles and London, 1986

Pal 1993
Pratapaditya Pal, *Indian Painting: A Catalogue of the Los Angeles County Museum of Art Collection*, vol. I: *1000–1700*, Los Angeles, 1993

Pal et al. 1989
Pratapaditya Pal et al., *Romance of the Taj Mahal*, Los Angeles, 1989

Pant 1980
G. N. Pant, *Indian Arms and Armour*, vol. II: *Swords and Daggers*, New Delhi, 1980

Pant 1989
G. N. Pant, *Mughal Weapons in the Babur-Nama*, Delhi, 1989

Parrot 1961
André Parrot, *Sumer: The Dawn of Art*, New York, 1961

Payne 1926
C. H. Payne, *Akbar and the Jesuits: An Account of the Jesuit Missions to the Court of Akbar by Father Pierre du Jarric, S. J.*, London, 1926

Payne 1930
C. H. Payne (tr.), *Jahangir and the Jesuits, with an Account of the Travels of Benedict Goes and the Mission to Pegu, from the Relations of Father Fernão Guerreiro, S.J.*, London, 1930

Pfrommer 1993
Michael Pfrommer, *Metalwork from the Hellenized East*, Malibu, CA, 1993

Pope 1939
Arthur Upham Pope, *A Survey of Persian Art*, Oxford, 1939

Prior and Adamson 2000
Katherine Prior and John Adamson, *Maharajas' Jewels*, Paris, 2000

Pyhrr and Godoy 1998
Stuart W. Pyhrr and José-A. Godoy, *Heroic Armor of the Italian Renaissance: Filippo Negroli and His Contemporaries*, New York, 1998

Pyhrr et al. 2005
Stuart W. Pyhrr, Donald J. LaRocca and Dirk H. Breiding, *The Armored Horse in Europe, 1480–1620*, New York, New Haven and London, 2005

Qaddumi 1987
Ghada Qaddumi, *Variety in Unity*, Kuwait, 1987

Qaddumi 1996
Ghada al-Hijjawi al-Qaddumi (tr. and ed.), *Book of Gifts and Rarities (Kitab al-Hadaya wa al-Tuhaf)*, Cambridge, MA, 1996

Randhawa and Randhawa 1985
M. S. Randhawa and D. S. Randhawa, *Indian Sculpture: The Scene, Themes and Legends*, Bombay, 1985

Rawson 1995
Jessica Rawson, *Chinese Jade from the Neolithic to the Qing*, London, 1995

Reeder et al. 1999
Ellen Reeder, Michael Treister and Esther Jacobson, *Scythian Gold*, New York, 1999

Rice and Gray 1976
D. T. Rice and Basil Gray, *The Illustrations to the "World History" of Rashid al-Din*, Edinburgh, 1976

Richardson 1989
Thom Richardson, "China and Central Asia", in Michael D. Coe et al., *Swords and Hilt Weapons*, London, 1989

Rodriguez Lorente 1964
J. J. Rodriguez Lorente, "The XVth Century Ear Dagger: Its Hispano-Moresque Origin", *Gladius*, Madrid, vol. III (1964)

Rogers 2006
J. Michael Rogers, *Mughal Miniatures*, London, 2006

Rogers 2010
J. Michael Rogers, *The Arts of Islam: Masterpieces from the Khalili Collection*, London, 2010

Rogers et al. 1986
J. Michael Rogers, Filiz Çagman and Zeren Tanindi, *The Topkapi Saray Museum: The Albums and Illustrated Manuscripts*, London, 1986

Rosenfield 1967
John M. Rosenfield, *The Dynastic Art of the Kushans*, Berkeley and Los Angeles, 1967

Roth 2000
Helmut Roth, "The Silver-Inlaid Iron Belt Fittings in the Morgan Collection", in K. Reynold Brown, D. Kidd and C. T. Little (eds), *From Attila to Charlemagne*, New York, 2000

Roxburgh 2005
David J. Roxburgh (ed.), *Turks:*

A Journey of a Thousand Years,
600–1600, London, 2005

Sachau 1989
E. C. Sachau, *Alberuni's India*, New Delhi, 1989

Sanudo 1899
Marin Sanudo, *I diarii di Marino Sanuto*, ed. R. Fulin et al., vol. LV, Venice, 1899

Schimmel 2004
Annemarie Schimmel, *Empire of the Great Mughals: History, Art and Culture*, London, 2004

Schotten-Merklinger 1976/77
Elizabeth Schotten Merklinger, "The Madrasa of Mahmud Gawan in Bidar", *Kunst des Orients*, vol. XI, 1/2 (1976/77) [available at www.jstor.org/stable/20752470]

Schotten-Merklinger 1981
Elizabeth Schotten-Merklinger, *Indian Islamic Architecture: The Deccan, 1347–1686*, Warminster, UK, 1981

Schulz and Seidel 1998
Regine Schulz and Mattias Seidel (eds), *Egypt: The World of the Pharaohs*, Cairo, 1998

Semsar 2000
Mohammed-Hasan Semsar, *Golestan Palace Library: A Portfolio of Miniature Paintings and Calligraphy*, tr. Karim Emami, Tehran, 2000

Seyller 2002
John Seyller, *The Adventures of Hamza: Painting and Storytelling in Mughal India*, Washington, DC, and London, 2002

Sharaf al-Din Ali Yazdi 1722
Sharaf al-Din Ali Yazdi, *Histoire de Timur-Bec, connu sous le nom du Grand Tamerlan, empereur des Mogols & Tartares, en forme de journal historique de ses victoires & conquêtes dans l'Asie & dans l'Europe: Ecrite en persan par Cherefeddin Ali, natif d'Yezd, auteur contemporrain [Zafar Nama]*, tr. Pétis de la Croix, Paris, 1722

Shcherbina 2014
Ekaterina Shcherbina (ed.), *India: Jewels that Enchanted the World*, London, 2014

Sims et al. 2002
E. Sims with B. Marshak and E. Grube, *Peerless Images: Persian Painting and Its Sources*, New Haven and London, 2002

Sivaramamurti 1977
Calambur Sivaramamurti, *The Art of India*, New York, 1977

Sivaramamurti et al. 1999
Calambur Sivaramamurti, Amina Okada and Thierry Zephyr, *L'art en Inde*, Paris, 1999

Skelton 1982a
Robert Skelton et al., *The Indian Heritage: Court Life and Arts under Mughal Rule*, London, 1982

Skelton 1982b
Robert Skelton et al., *Facets of Indian Art: A Symposium Held at the Victoria and Albert Museum on 26, 27, 28 April and 1 May 1982*, London, 1982

Smart et al. 1985
Ellen S. Smart, Daniel S. Walker and Ellen Avril, *Pride of the Princes: Indian Art of the Mughal Era in the Cincinnati Art Museum*, Cincinnati, 1985

Soame Jenyns and Watson 1963
R. Soame Jenyns and William Watson, *Chinese Art*, New York, 1963

Soler del Campo 2000
Alvaro Soler del Campo, *Real Armería, Palacio Real*, Madrid, 2000

Spuhler 2012
Friedrich Spuhler, *Carpets from Islamic Lands*, London, 2012

Stone 1961
George Cameron Stone, *A Glossary of the Construction, Decoration and Use of Arms and Armor in All Countries and in All Times, Together with Some Closely Related Subjects*, New York, 1961

Stronge 2002
Susan Stronge, *Painting for the Mughal Emperor: The Art of the Book, 1560–1660*, London, 2002

Stronge 2010
Susan Stronge, *Made for Mughal Emperors: Royal Treasures from Hindustan*, London and New York, 2010

Stronge 2015
Susan Stronge with Joanna Whalley and Anna Ferrari, *Bejewelled Treasures: The Al Thani Collection*, London, 2015

Stronge et al. 1988
Susan Stronge, Nina Smith and J. C. Harle, *A Golden Treasury: Jewellery from the Indian Subcontinent*, London, 1988

Suyuti 2003
Jalal al-Din al-Suyuti, *Al-Durr al-Manthūr fī al-Tafsīr al-Ma'thūr*, Cairo, 2003

Swarup 1996
Shanti Swarup, *Mughal Art: A Study in Handicrafts*, New Delhi, 1996

Tavernier 1679
Jean Baptiste Tavernier, *Les six voyages de Jean Baptiste Tavernier, ecuyer, baron d'Aubonne, qu'il a fait en Turquie, en Perse, et aux Indes, Voyages de Perse*, book 3, vol. I, Paris, 1679

Temple 1905
Sir Richard Carnac Temple (ed.), *The Indian Antiquary*, vol. XXXIV, Bombay and London, 1905

Thackston 1999
Wheeler M. Thackston (tr. and ed.), *The Jahangirnama: Memoirs of Jahangir, Emperor of India*, New York and Oxford, 1999

Tillotson 2006
Giles Tillotson, *Jaipur Nama: Tales from the Pink City*, New Delhi, 2006

Tiradritti 2000
Francesco Tiradritti (ed.), *The Treasures of the Egyptian Museum*, Cairo, 2000

Topsfield 2008
Andrew Topsfield, *Paintings from Mughal India*, Oxford, 2008

Trever and Lukonin 1987
K. V. Trever and V. G. Lukonin, *Sasanidskoe serebro. Khudozhestvennaia kul'tura Irana III–VIII vekov: Sobranie Gosudarstvennogo Ermitazha*, Moscow, 1987

Trnek and Vassallo e Silva 2001
Helmut Trnek and Nuno Vassallo e Silva (eds), *Exotica: The Portuguese Discoveries and the Renaissance Kunstkammer*, Lisbon, 2001

Uldry 1994
Pierre Uldry, *Die Sammlung Pierre Uldry: Chinesisches Gold und Silber*, Zurich, 1994

Untracht 1997
Opi Untracht, *Traditional Jewelry of India*, London, 1997

Vaughan 2004
Philippa Vaughan, "Indian Subcontinent: From Sultanate to Mughal Empire", in Markus Hattstein and Peter Delius (eds), *Islam: Art and Architecture*, Königswinter, Germany, 2004

Watson 1981
William Watson, "Chinese Style in the Paintings of the Istanbul Albums", *Islamic Art*, New York, vol. I (1981)

Welch 1972
Stuart Cary Welch, *Le livre des rois: Le Chah-Nameh de Chah Tahmasp*, Lausanne, 1972

Welch 1978
Stuart Cary Welch, *Imperial Mughal Painting*, New York, 1978

Welch 1985
Stuart Cary Welch, *India: Art and Culture, 1300–1900*, New York, 1985

Welch et al. 1987
Stuart C. Welch, Annemarie Schimmel, Marie L. Swietochowski and Wheeler M. Thackston, *The Emperors' Album: Images of Mughal India*, New York, 1987

Wiese and Brodbeck 2004
André Wiese and Andreas Brodbeck (eds), *Tutankhamun – The Golden Beyond: Tomb Treasures from the Valley of the Kings*, Basel, 2004

Yetts 1916
W. Perceval Yetts, "The Eight Immortals", *Journal of the Royal Asiatic Society of Great Britain and Ireland*, Cambridge (October 1916) [available at www.jstor.org/stable/25189483]

Yule and Burnell 1996
Henri Yule and A. C. Burnell, *Hobson & Jobson: The Anglo-Indian Dictionary*, Hertfordshire, 1996

Yusupov 1983
E. Yu. Yusupov (ed.), *Miniatures, Illuminations of Amir Hosrov Dehlevi's Works*, Tashkent, 1983

Zebrowski 1983
Mark Zebrowski, *Deccani Painting*, London, 1983

Zebrowski 1997
Mark Zebrowski, *Gold Silver & Bronze from Mughal India*, London, 1997

Zettler and Horne 1998
Richard L. Zettler and Lee Horne (eds), *Treasures of the Royal Tombs of Ur*, Philadelphia, 1998

Ziegler 2002
Christiane Ziegler, *The Pharaohs*, London, 2002

AUCTION CATALOGUES

Bonhams, London
Islamic Works of Art, 14 October 1998
Islamic Works of Art, 13 and 14 October 1999
Islamic and Indian Art, 2 May 2001

Islamic Works of Art, 17 October 2001
Fine Jewellery, 10 October 2002
Islamic and Indian Art, 29 April 2004
Islamic and Indian Art, 10 April 2008

Christie's, Hong Kong
Fine Chinese Ceramics and Works of Art,
 27 October 2003

Christie's, London
Islamic Art, Indian Miniatures, Rugs and
 Carpets, 18 October 1994
Important Indian Jewellery, 8 October
 1997
Islamic Art and Indian Miniatures,
 14 October 1997
Islamic Art and Indian Miniatures,
 28 April 1998
Islamic Art and Miniatures,
 13 October 1998
Islamic Art, Manuscripts and Printed
 Books of Iranian Interest, 20 April
 1999
Magnificent Mughal Jewels, 6 October
 1999
Islamic, Indian and Armenian Art
 and Manuscripts, 12 October
 1999
Islamic Art and Manuscripts,
 12 October 2004

Christie's, New York
Indian and Southeast Asian Art, 16
 September 2008

Christie's, South Kensington, London
Islamic and Oriental Works of Art,
 14 October 1999
Islamic and Oriental Works of Art,
 12 October 2000
Islamic and Indian Works of Art,
 18 October 2002
Islamic and Indian Works of Art,
 7 November 2002
Arts of India, 1 October 2012

Habsburg Feldman, Geneva
Antique Jewellery, Miniatures, Objects
 of Vertu, Fabergé, Russian and Islamic
 Works of Art, Hôtel des Bergues,
 29 June 1988

S. J. Phillips, London
Fine Antique and Modern Jewellery,
 3 October 2000

Sotheby's, Geneva
Fine Jewels, 7–8 May 1981

Sotheby's, London
Islamic Works of Art Indian, Himalayan
 and South-East Asian Art, 30 April
 1992
Islamic Works of Art, 22 October 1992
Himalayan, Indian and South-East Asian
 Art, 21 October 1993
Islamic Works of Art and Indian,
 Himalayan and South-East Asian Art,
 19 October 1995
Islamic and Indian Art, 17 October 1996
The Indian Sale, 8 May 1997
Islamic Art and Indian Painting,
 22 April 1999
Arts of the Islamic World, 14 October
 1999
Arts of the Islamic World, 12 October
 2000
Arts of the Islamic World, 30 April 2003
Arts of the Islamic World, 15 October
 2003
Persian and Islamic Art, 12 October 2004
Exotica: East Meets West, 1500–1900, 25
 May 2005
Arts of the Islamic World, 5 April 2006
Arts of the Islamic World, including Fine
 Carpets and Textiles, 7 October 2009
Arts of the Islamic World, 24 April 2013

Sotheby's, New York
Indian and Southeast Asian Art,
 19 September 1996

Spink & Son, London
Indian & Islamic Works of Art,
 1 October 2000

GLOSSARY

acanthus leaf
A stylization of the *Acanthus mollis* leaf, widely used in decorative arts from the Classical period.

album pages (*muraqqa'*)
Compilations of paintings and calligraphic compositions by renowned painters and calligraphers, generally mounted back to back and assembled in the form of albums by rulers and notables.

areca or betel nut
A nut usually wrapped in betel leaves together with slaked lime and at times cloves and spices, chewed for its stimulant effect in a preparation referred to as *pan*.

bail
As used here, a flexible and movable hoop that serves to suspend a weapon and provide a swivelling or swinging function.

basse-taille
A style of enamelling in which the metal surface is engraved and covered with transparent enamels, allowing the relief decoration to be seen through the enamel.

bidri-ware
A type of metalwork consisting of a blackened alloy of zinc and copper inlaid with silver; it takes its name from the town of Bidar in the Deccan.

billets
As used here, small blocks or bars of metal subsequently processed into blades.

blade guard or cross guard
The section of a hilt that serves to protect the wielder's hand.

blued steel
Steel that has been treated for decorative purposes by a process resulting in a bluish-black surface, and which partially protects it against rust.

buduh
An esoteric talismanic formula often seen on blades and amulets, featured in letters, their numerical value or plain numerals inscribed in "magic squares", and in which the sum of the vertical, horizontal and diagonal rows all amount to the same sum.
 Regarding the inscription of *buduh* on blades, both the thirteenth-century lexicon *Lisan al-Arab* by Ibn Manzur and the eighteenth-century lexicon *Taj al-'Arus* by al-Zabidi report that *buduh* is the plural of *badh*, meaning 'strike', which in addition to its talismanic attributes is a suitable inscription to feature on blades.

cartouche
A decorative elongated oval compartment enclosing inscriptions or decorative motifs.

champlevé
An enamelling technique in which the areas to be covered or filled with enamel are excavated in the surface with gravers.

channel setting
A type of setting in which abutted stones are set in a line and are held only by grooves or notches in the outlining gold borders.

chape
A fitting that serves to protect the lower end of a scabbard.

chased
(Of metal) engraved with heightening details, at times in conjunction with repoussé work.

cloud band
A Chinese auspicious symbol in the form of a winding and curling ribbon representing immortality, good fortune and happiness that was extensively used in Islamic art after the Mongol invasions.

cloud collar
An ancient cosmic symbol comprising four cusped lobes that was originally believed to represent the gateway to heaven or opening at the apex of the sky. It was widespread in China and Central Asia and with time became a decorative motif used in architecture, on objects and on garments.

collet
A form of setting composed of a small sheet collar which holds a gem.

cuboctahedron
A polyhedron with eight triangular faces.

cypress tree
Believed by Eastern civilizations to be a sacred tree that originated in heaven.

edge
The sharp and cutting outer border of a blade.

falcata

An Iberian single-edged short sword that widens and dips towards the point, and descends from the Greek *kopis*; the name probably derives from the Latin *falcatus* (sickle-shaped).

ferrule

In the case of edged weapons, a metal cap in which hilts are inserted for reinforcement and which binds the hilt and blade.

fillet

A narrow or fine decorative band.

fullers

The grooves that run down a blade and serve to make it lighter, especially in the case of wider blades.

Indian numerology

A field that explores the effect and spiritual power of numbers and their influence on human lives.

inlaid steel

Steel decorated by a technique of engraving the surface and setting a precious metal, generally gold, in the depression and hammering it in place; in India referred to as *koftagari*.

jawhar steel

Steel characterized by swirling and wavy patterns that appear on the surface of a blade; also referred to as "Damascus" or "watered" steel.

kalamkari

A style of hand-painted or block-printed cotton textile produced in India. The name derives from the Arabic word for pen (*qalam*) and the Persian word for craft (*kar*) and signifies the craft of drawing with a pen.

knuckle guard

A curved band of metal or hardstone that extends from the pommel to the quillons and serves to protect the wielder's hand.

kopis

A Greek single-edged sword from around 500 BCE that widens and dips towards the point, also found in large numbers in Italy and Corsica.

kundan setting

A uniquely Indian technique of hyper-purifying gold and refining it to the point at which it becomes soft and malleable at room temperature. At this degree of purity the gold forms a molecular bond that allows the craftsman to shape the gold into any desired form and to apply it over a rigid surface without the need for soldering. *Kundan* setting enables the jeweller to hold gemstones in place without the need for claws, and bestows almost complete freedom of design.

lac

A resinous substance, extracted from trees or secreted by insects.

languet

A tongue-like implement projecting from quillons or cross guards of edged weapons, serving to stabilize the hilt in the scabbard.

locket

A fitting on the upper end of a scabbard that serves to reinforce it, and was most often fitted with a bail or lug for suspension of the weapon from the wearer's belt or sash.

lota

A round spouted vessel used in the subcontinent for religious practices and for personal hygiene.

lotus flower

A polyvalent symbol in ancient cultures, in India a symbol of the sun, the tree of life, purity of the soul, divine beauty and renewal or rebirth.

lug

As used here, a small pierced knob used for suspension or attachment by means of string.

makara

A crocodilian mythical creature symbolizing passion and death and representing an astrological god presiding over men's pursuits. According to the *Mahabharata*, makara spells were often recited over weapons.

mandapa

A pillared ritual hall leading to a temple.

naskhi

A calligraphic style of cursive script.

nasta'liq

A calligraphic style of cursive script developed in the Iranian world.

natural diamond crystals
Diamonds that are uncut and unpolished
and left in their natural cuboctahedral
form.

nephrite
A type of jade.

overlaid steel
Steel which has been cross-hatched by a
technique that allows the adhesion of gold
or silver that is subsequently burnished
onto the surface.

palampore
A mordant dyed and hand-painted cotton
fabric.

palmette
A decorative motif allegedly representing
a palm; when split in half it is referred to
as "split palmette".

pandan box
A container for areca nuts wrapped in
betel leaves.

plaquette
As used here, an ornamental metal
implement fastened to another metal
surface.

poll cap
A horse's head covering.

quillon or quillons
The transverse bar or cross guard in
between the hilt and blade that prevent
the hand from sliding onto the blade; also
labelled quillon block when the bars are
compact.

repoussé
A metalworking technique consisting of
producing raised decorative surfaces by
hammering the metal from the reverse (at
times also from the front) to produce a
design.

reserved or in reserve
In decoration, designating a motif left
in the original colour of the background
material.

ricasso
The thickening and unsharpened section
of a blade situated just below the quillons
or guard, and often fitted with decorative
plaquettes for additional reinforcement.

ridge
As used here, a narrow raised strip or
strips running along the centre of double-
edged blades, or along the back of single-
edged blades, serving for rigidity.

ringmatting
A technique executed by punching
circles on a metal surface either to
produce decorative motifs or for use as
background to the main motif.

shadow box setting
A setting style akin to a "deep frame"
in which a gemstone is set in the centre
of the four sloping or bevelled faces of a
bezel.

spinel
A gemstone, also referred to in medieval
times as Balas or Badakhshi ruby,
owing to the fact that it was mined in
Badakhshan, Afghanistan. The red

variety was favoured by monarchs on
account of its colour as an alternative to
rubies, which were not available in very
large sizes.

talab setting
A technique in which gemstones are
packed tightly side by side and held in
place only by the outlining gold, resulting
in surfaces that have the appearance of a
continuous field of gemstones.

tang
The extension of a blade that inserts into
the hilt or is sandwiched between the
facings of a hilt that serves to secure the
blade to the hilt, and is concealed when
the weapon is mounted.

thewa or Pratapgarh decoration
A decorative technique reportedly
practised by a family of jewellers from
the small principality of Pratapgarh
in Rajasthan, consisting of motifs in
openwork gold foil fused onto a substrate
of transparent coloured glass.

thulth
A style of cursive script (meaning "a
third" in Arabic), in which short letters
reportedly measure one-third the size of
the long letters.

PICTURE CREDITS

TABLE OF CONCORDANCE OF INVENTORY NUMBERS
AND CATALOGUE NUMBERS